Fight the Power!

PETER LANG
New York • Washington, D.C./Baltimore • Bern
Frankfurt am Main • Berlin • Brussels • Vienna • Oxford

Fight the Power!
The Spike Lee Reader

FOREWORD BY Spike Lee

Janice D. Hamlet and Robin R. Means Coleman,
EDITORS

PETER LANG
New York • Washington, D.C./Baltimore • Bern
Frankfurt am Main • Berlin • Brussels • Vienna • Oxford

Library of Congress Cataloging-in-Publication Data

Fight the power!: the Spike Lee reader /
edited by Janice D. Hamlet, Robin R. Means Coleman.
p. cm.
Includes bibliographical references and index.
1. Lee, Spike—Criticism and interpretation.
I. Hamlet, Janice D. II. Means Coleman, Robin R.
PN1998.3.L44F54 791.4302'33092—dc22 2008020638
ISBN 978-1-4331-0236-3

Bibliographic information published by **Die Deutsche Bibliothek**.
Die Deutsche Bibliothek lists this publication in the "Deutsche
Nationalbibliografie"; detailed bibliographic data is available
on the Internet at http://dnb.ddb.de/.

Cover design by Clear Point Designs

The paper in this book meets the guidelines for permanence and durability
of the Committee on Production Guidelines for Book Longevity
of the Council of Library Resources.

© 2009 Peter Lang Publishing, Inc., New York
29 Broadway, 18th floor, New York, NY 10006
www.peterlang.com

Printed in the United States of America

Contents

Part II: The New Race Man:
Doing the Right Thing by Any Means Necessary

Part III: No, Baby, No: Sex, Sexuality, and Gender Roles

Part IV: Inside Media Mogul Man

Foreword

SPIKE LEE

"Sal,
how come
you ain't got
no brothers
up on dat' wall?"

It has been 20 years since *Do The Right Thing* opened nationwide on June 30th 1989. Man, oh, Man how the time has flown by since that eventful year of *"1989—the number—another summer (get down), sound of the funky drummer, music hitting your chest—cause I know you got Soul,"* howled by Chuck D (Public Enemy), and the anthem that summer—FIGHT THE POWER. Since then, I have a lovely wife, 2 great kids and directed 15 feature films and 3 documentaries.

When I was told about this book I was thrilled. As I have traveled across this country many teachers and students have told me they taught or took a course on this film. I watched it recently and it still stands up. And unfortunately when we hear about Diallo, Louima or most recently Sean Bell, who can't recall the death of Radio Raheem at the hands of the NYPD.

I would like to thank the editors and the contributors of the book and that's the truth, Ruth.

Spike Lee
Brooklyn, NY
May 28, 2008

Preface

AUDREY THOMAS MCCLUSKEY

Having watched Spike Lee evolve from the irreverent, iconoclastic filmmaker of the 1980s to the closest representation of the establishment in black film production today, I am happy to see this first-rate collection dedicated to his impressive oeuvre. The trajectory of his extraordinary career began in 1986 when Lee was twenty-nine years old. Twenty-one years and over thirty films later, he is—at the age fifty—the best-known, most-heralded black filmmaker of all time.

When I presented Lee with the Oscar Micheaux Distinguished Achievement Award from the Black Film Center/Archive where I then served as Director, I noted the link between him and the pioneering filmmaker for whom the award was named. Lee, like Micheaux (1884–1951), is filled with grit and the desire to present an alternative cinematic image of black life, and he broke down barriers to do so. But unlike the shoestring operation that defined Micheaux's forty-plus film career, Lee's gift for the craft of filmmaking, appreciation of its history, and facility with its language differentiate him from his early predecessor.

Although his recent films have not always had success at the box office, he has developed a style that identifies "A Spike Lee Joint." Lee's identity as an independent ("I consider myself an independent filmmaker, who more often than not, uses the Hollywood system for financing and distribution," he told me in an interview), helped to burnish his early rebel image.

No doubt he has been a lightning rod for criticism along with the praise. More than other filmmakers of his stature, critics talk more about him than his films. One critic arrogantly scolded him for "looking backward" with his selection of historically based film subjects such as the biopic *Malcolm X* and his proposed film on Joe Louis. Interestingly, one did not hear this criticism of Martin Scorsese when he chose to make his historical epic *Gangs of New York* or his other films about historical figures.

At a recent film conference, Lee was accused of consuming too much of the limited oxygen supply for black filmmakers. But given the greatly expanded opportunities for black filmmakers resulting from new technologies and recent box office successes by black directors, this criticism loses its bite. Such examples show that the unique platform he occupies comes with hypercritical scrutiny.

Some critics also take umbrage at his "message" films, forgetting that Lee uses his films to teach. In his ancestry and personal history there is a long line of educators, including a great grandfather who founded a school for blacks in rural Alabama and his mother, aunt, and other relatives who became teachers. Lee has taught at several prestigious universities. I trace some of the didacticism in his films to this lineage and his nurturance in a culture of black middle class responsibility. ("If I had not been a filmmaker, I would have been a teacher," he said.)

At this juncture, the big question is: what difference has Spike Lee made, especially for black filmmakers? Will future generations bestow meritorious Spike Lee awards on achievers? I asked a New York University film school graduate, who at age twenty-nine has written, directed, and produced several short films and is looking forward to the release of his first feature, what Spike Lee means to him. In his view, Lee established a benchmark for black filmmakers. Without Lee, black filmmakers would not have the freedom of experimentation and subject matter that they now enjoy. This filmmaker has studied Spike Lee and respects him, but he told me, "I would not want to be him." In fact, in today's environment, he wonders if having a new Spike Lee burst upon the scene is even possible given the segmentation of markets and competition for recognition.

The robust activity and optimism among today's emerging black filmmakers remind me that the arc of Spike Lee's career may suggest a re-working of the classical hero who must slay the father in order to move beyond his shadow and gain independence. For black women filmmakers Lee also provides a reference point, although the Oedipal dilemma may be less poignant due, in part, to the masculinist frame of his work. Still, few would argue that Spike Lee, who shows no signs of slowing his productive pace, remains a force in contemporary filmmaking and popular culture.

The editors of *Fight the Power! The Spike Lee Reader* confirm that fact with insightful, and often provocative expositions on nearly every aspect of his work. They

have assembled a timely, well-paced collection by established and promising schol-ars. I predict that it will become an essential reference point for scholars, students, and film enthusiasts—until it is joined by part II.

We should expect no less from a volume with Spike Lee's name in the title.

Audrey Thomas McCluskey, Ph.D.
Associate Professor African American and African Diaspora Studies
Former Director Black Film Center/Archive
Indiana University, Bloomington

Acknowledgments

I t probably goes without saying that a book project, whether individually authored or an edited volume, is never done alone and involves so many other persons than those who get the honor of having their names printed on the cover. This volume has truly been a collective effort and the first person to whom we extend our gratitude is Spike Lee. Lee's impressive and extensive body of work made this volume necessary. He has challenged our thinking and perspectives on so many topics especially those involving Black interpersonal relationships, and for this, we are grateful. Special thanks is also extended to Lee's personal assistant, Jason Lampkin, who diligently responded to every phone call and email message we sent, helping us to complete this project.

We also wish to thank Mary Savigar at Peter Lang, who took an interest in this project and pushed it through: Valerie Best, Bernadette Shade, and other staff members at Peter Lang who were instrumental in getting this volume published. Our appreciation is also expressed to the anonymous reviewer of our book proposal who suggested that the proposal be accepted and offered valuable comments resulting in a much stronger volume. And, of course, we offer our deepest appreciation to the authors of the studies presented here.

On a personal note, I (Janice) wish to acknowledge and thank Susan Oppenborn, a doctoral candidate in English at Northern Illinois University, who devoted valuable time to retyping and reformatting reprinted articles, former and

current Northern Illinois University communication students: Wandretta Harden, Kristen Jacobsen, Laura Beitzel, Kristin Nash, Stephanie Smoot, Cheryl Bernard, Peter McKiernan, and Matt Rondone who researched and collected every article written about Spike Lee; Valerie Clawson, secretary in the Department of Communication at Northern Illinois University for her assistance in processing paperwork, and to my chair, Steve Ralston for his encouragement and financial support. I am also grateful to the College of Arts and Sciences and the Graduate School at Northern Illinois University. Their financial support helped immeasurably in acquiring many of the permission rights herein.

Finally, I especially want to thank my co-editor, Robin Means Coleman for accepting my invitation to work with me on this project although we barely knew each other. In the process of editing this volume I have learned so much from you and have been enriched by your insights. Thank you! It has truly been a pleasure working with you. Blessings!

I (Robin) would like to thank the faculty and staff in the Department of Communication Studies and in the Center for AfroAmerican and African Studies (CAAS) at the University of Michigan. I am honored to hold appointments in these two units. Each unit has supported this project by providing me with time, resources, and funding. Susan Douglas, chair of the Department of Communication Studies, and Kevin Gaines, director of CAAS were especially encouraging. I would also like to thank Branden Snyder, a student of political science at the University of Michigan, for his research assistant skills. A very special thanks to Emily Chivers Yochim, Ph.D. for contributing her critical and analytical talents to the evaluation of the book manuscript. Your insights helped us to achieve that final scholarly depth we were striving for. I thank all those who worked with me to review the chapters. Thank you to my husband, Randy Coleman, who has been particularly heroic in his support of me and of my work.

Janice and I are great colleagues, wonderful friends, and life-long Sisters. This was a collaborative effort that was divinely inspired, and we aren't inclined to ignore such inspiration. Blessings right back at you Janice! Now, see . . . I'm all weepy . . .

Reprinted with Permission:

"The Aesthetics of *Nommo* in the Films of Spike Lee" by Ronald Jemal Stephens, originally appeared as a chapter in K. Welsh-Asante, (ed). *The African Aesthetic: Keeper of the Traditions* (pp. 197–217). Greenwood Press. Copyright © 1993.

"Cultural Engineering and the Films of Spike Lee" by William A. Harris originally appeared as a chapter in Venise T. Berry, Carmen L. Manning-Miller (eds.). *Mediated*

Messages and African American Culture: Contemporary Issues (pp. 3–23). Copyright © 1996 Sage Publications.

"Spike's Place" by Norman K. Denzin is a chapter in Norman K. Denzin's *Reading Race: Hollywood and the Cinema of Racial Violence* (pp. 154–170). Copyright © 2002. Sage Publications.

"Athletic Iconography in Spike Lee's Early Feature Films" by Kerr Houston, originally appeared in *African American Review* (Vol. 38, no. 4, 2004, pp. 636–49). Copyright © 2004. Reprinted with permission from the author.

"Which Way to the Promised Land? Lee's *Clocker* and the Legacy of the African American City" by Paula Massood, originally appeared in *African American Review*. (Vol. 35, no. 2, summer 2001, pp. 263–279). Copyright © 2001. Reprinted with permission from the author. A longer version of this chapter appears in Paula Massood's *Black City Cinema: African American Urban Experiences in Film* (2003), Temple University Press.

"Passing for Human: *Bamboozled* and Digital Humanism" by Kara Keeling, originally appeared in *Women & Performance: A Journal of Feminist Theory* (Vol. 29, pp. 237–250). Copyright © 2005. Reprinted with permission from the author.

"Race and Sex in Black and White: Essence and Ideology in the Spike Lee Discourse" by Mark Lawrence McPhail, originally appeared in the *Howard Journal of Communication* (Vol. 7, 1996, pp. 127–138). Copyright © 1996. Taylor & Francis.

"Spike Lee Constructs the New Black Man: Mo' Better" by Sharon Elise and Umoje Adewole, originally appeared in *The Western Journal of Black Studies* (Vol. 16, no. 2, summer 1992, pp. 82–88). Copyright © 1992 Washington State University Press.

"Subject to Countermemory: Disavowal and Black Manhood in Spike Lee's *Malcolm X*" by Maurice Stevens, originally printed in *Signs* (Vol. 28, Autumn 2002, pp. 277–301). Copyright © 2002 The University of Chicago Press.

Introduction

ROBIN R. MEANS COLEMAN & JANICE D. HAMLET

"Wake Up! Wake Up! Please Waaaak-Up!!!!" was the rallying cry of student activist Vaughn "Dap" Dunlap (Laurence Fishburne) at the predominantly black Mission College in Shelton Jackson "Spike" Lee's 1988 *School Daze*. The intraracial clashes at Mission College centered on charged issues such as classism, colorism, homophobia, and the continued relevancy of Pan-African thought. In explaining his attention to these motley subjects, Lee offered, "what we did was use a (fictitious) historically black college as a microcosm of Black America, hoping to highlight the so-called differences that I feel are petty, that keep Blacks from being a unified people—class, skin color, hair type, that kind of stuff" (Aftab, 2005, p. 57). At the film's climax, in demanding that people—the students and administrators on campus, the members of the community surrounding Mission College, and, most importantly, the *School Daze* audience—metaphorically "wake up," Lee asked that (a monolithic) black people come to a realization about what is dividing the race and, ultimately, diluting its social power and pride.

Spike Lee has been emphatically calling for (black) people to "wake up" to the racial, social, political, economic, gendered, and class issues that have troubled American society for over two decades. As a film director, producer, screenwriter, author, educator, and public speaker, Lee asks much of his audiences—to think, to choose sides, to "wake up"—and if we are entertained in the process, all the better. Lee's personal goal as a film director has not been confined to seeking box office

success through the making of popular films. Rather, and perhaps more important-ly, his stated goal has been to produce films that challenge audiences to engage the sociopolitical complexities that abound in American society.

His political awareness has been the driving force behind his impressive body of work. During his twenty years in the film business, Lee has taken advantage of virtually every opportunity, through various media outlets, to initiate dialogue about society's social ills. Such a mission, it can be said, begins with the name of his production company, "40 Acres and a Mule Filmworks," which serves as an ever-present reminder of America's still unpaid debt to slave ancestors while also reveal-ing his intimate sense of history and racial politics. As such, "Fight the Power!," the theme song to Lee's 1989 film, *Do the Right Thing*, could easily be considered his personal and artistic mantra.

However, Lee's many texts also raise questions. What cultural meanings does Lee inscribe in his (re)presentations? What are we to take away from Lee's discourses—resistance, provocation, enlightenment, reaffirmation, and empower-ment? Alternatively, has Lee also embedded in his work heterosexism and homo-phobia, sexism and misogyny, a masculinist aesthetic and a middle-class sensibility? As such, what, then, is Lee, in representing a new generation of celebrity, filmmak-er, media mogul, actor, and face of a new black aesthetic, asking (black) Americans of the late twentieth century to wake up from, and to?

While cultural harm may be perpetuated, in part, by blacks themselves, as *School Daze* revealed, for Lee, the dire circumstances some blacks find themselves in, regardless of socioeconomic standing, are not entirely of their own making. Lee has consistently disseminated, through all forms of his discourses, the argument that we must become astutely conscious of the damage being done to black communi-ties, notably, often by those external to those communities. As such, Lee's messages, which many position as black nationalistic, have been stinging but reasoned in their tenor. For example, in a 2005 speech, Lee told an Ontario University audience that we should vote with our pocketbooks to convince artists, record companies, and media conglomerates that the images in today's music videos or lyrics in gangsta rap are unacceptable: "These artists talk about 'ho this, bitch this, skank this' and all the other stuff. They're talking about all our mothers, all our sisters. They're talking about their own mothers, grandmothers" ("Spike Lee derides," nd.).

Lee is as provocative as he is prolific in his myriad concerns. In a 2000 inter-view, Lee spoke about threats of cultural appropriation and of racial profiling. Here Lee's disdain for "sagging" pants was *not* directed toward black youth (unlike Bill Cosby in his now infamous speeches about the black underclass) but toward whites taking on the fashion trend:

There's nothing wrong with White people trying to appreciate Black culture. The problems arise when you don't realize the distinction between appreciation of one's culture and appropriation of one's culture. That's the difference. . . . It's like a fantasy: "I wanna be a gangsta, yo, yo, yo!" or "I wanna wear my pants down below my ass!" But that's very easy, because they're not going to be stopped by the cops. They want to have it one way, but not the other. (Said, nd.)

In a 2002 ABC *Good Morning America* interview, Lee noted a broad threat to America in blacks who fail to resist racism in government. When Trent Lott celebrated segregationist Strom Thurmond, saying Thurmond should have been elected president in 1948, Lee wondered what good it was to have two blacks, Secretary of State Colin Powell and National Security Advisor Condoleezza Rice, in positions of tremendous power in the White House if they fail to speak out against such insults (which Lott later recanted): "They are prominent African-Americans and they haven't said a peep" (Wolf, 2002), he said.

Inevitably, Lee was asked, "What do you think of Bill Cosby's recent speeches?" Lee, often black nationalist in his rhetoric, co-signed on [financial backer of the film *Malcolm X*] Cosby's conservative messages which centered on the deficiencies among the black underclass, stating,

We have young black children growing up thinking that if you get straight A's, act intelligent and try to get good grades, that somehow they're acting White or that they're a sellout. But if you're on the corner drinking a 40, smoking a blunt and holding your nuts, then you're black. Something is wrong. . . . People jumped on Bill Cosby, but he wasn't lying. (Powell, 2004)

So seemingly unlikely was Lee's alignment with Cosby's views on blackness and class that it merited headlines.

Depending on one's view, Lee, after nearly twenty years in the media courting business, is either softening, shifting, diversifying, or maturing in his thinking. As such, Lee prompts additional scrutiny of his role as cultural provocateur and social change agent.

Examining Lee as a Cultural Messenger

Fight the Power! The Spike Lee Reader concerns itself with the whole oeuvre that is "Spike Lee," as he, and it, have evolved over the last several decades. The focus here includes Lee as a film and TV commercial maker, an author and auteur, a documentarian and public speaker, a celebrity and businessperson. The audience for *Fight the Power!* is, ideally, from a wide range of disciplines seeking material for their edu-

cation, teaching, and research on interrelated themes of: Afrocentrism, cultural production, commodification, athletics, music, place and space, the urban, videography, satire, storytelling, heroism, misogyny, class, politics, race, ethnicity, (neo) black nationalism, masculinity, nonfiction filmmaking, family, corporatization, history, and independent film—to name a very few. *Fight the Power!* is about Lee, but not entirely. There is a wealth of messages and uses the reader may take away from the very polysemic scholarship presented here.

Our readers should be reminded how Lee emerged in the 1980s as outspoken, controversial, and headline grabbing: "a lot of times it is the light-skinned women who are more revolutionary; because they are trying to compensate" (Allen, 1988, p. 130). Likewise, we note how, more recently, Lee has broached change, "you can't be worked up for thirty years non-stop. . . . But it's important not to confuse the dwindling anger with an improvement in relations" (Nicodemus, 2006). And, how his claim of mellowing was followed (in the same interview) with a return to the more strident and dogmatic, "I've never believed in that melting pot shit. You have to be White for that." As such, the unifying theme of this book is that we encourage readers to begin to consider the implications of Lee's brand of evolving social consciousness and, relatedly, what his media products, which tend to reflect this consciousness, aspire to. Simply, we ask readers to reflect upon what Lee's various contributions to culture have been and upon the meanings we are to take away from Lee's discourses.

Fight the Power! The Spike Lee Reader offers a broad examination of the representational, cultural, and philosophical ideas that Lee has presented through a variety of outlets, ideas which have worked to inform not only the direction of cinema but also that of black cultural debate. Collectively, this reader centers on the question: what messages about race, gender, class, race relations, and race representations are being promulgated in Spike Lee's films and other cultural products? Lee as cultural provocateur, film auteur, and media mogul is our entrée into these discussions.

The scholarship presented here, then, is not easily categorized by era, medium, genre, topic, or theory. This is as it should be, for Lee himself has clearly not been so easily defined. However, we have presented critical, cultural scholarship as related to four themes: (1) Industrializing Social Consciousness; (2) The New Race Man: Doing the Right Thing by Any Means Necessary; (3) No, Baby, No: Sex, Sexuality, and Gender Roles; and (4) Inside Media Mogul Man.

Awaking from a Slumber

This reader begins with "Part I: Industrializing Social Consciousness," in which the question, "What do Lee's projects aspire to?" is first broached. The reader opens by

examining what it is that Lee wants his audiences to wake up from and what it is he wants us to wake up to. Ronald Jemal Stephens's chapter, "The Aesthetics of *Nommo* in the Films of Spike Lee," argues, in an examination of *School Daze* and *Do the Right Thing*, that Lee uses a host of characters as his mouthpiece to encourage African American audiences to "wake up" and "do the right thing." While it may appear that Lee has borrowed extensively from the Western storytelling and literary traditions by adapting strategic plots once employed in Plato's dialogues, this chapter posits that it is the African oral tradition that is of central importance. This observation of Lee's storytelling techniques suggests that cinematic art is used to liberate the psyche of the African American. In Chapter 2, entitled, "Cultural Engineering and the Films of Spike Lee," William A. Harris analyzes Lee's early films as tools for social change. Harris contends that although Lee has established a strong presence in the film industry and in the minds of his audience, his films are challenging and thought-provoking with didactic messages for several segments of this audience. Harris's analysis focuses on the protagonists in Lee's first five films in terms of the representation and philosophy contained in them. The exhortatory function of Lee's entertainment is placed within a conceptual framework known as "cultural engineering."

Lee has described his films as an attempt to underline and examine the power of images in constructing racial and class identities. An examination of such attempts is presented first in Chapter 3 in R. Colin Tait's chapter, "Politics, Class, and Allegory in Spike Lee's *Inside Man*." Here, Tait traces the presence or absence of "politics" throughout Lee's most recent films, accounting for the filmmaker's focus on corporate America. He considers *Inside Man* in terms of what he believes to be a trilogy of films (joined by *Bamboozled* and *She Hate Me*), which deals with politics explicitly. Fredric Jameson's essay, "Class and Allegory in Contemporary Mass Culture: *Dog Day Afternoon* as a Political Film" serves as a focal point for the author's discussion of Lee's films. This discussion of Jameson's essay serves as a template to consider how *Inside Man* both inherits and exploits the cultural currency of his earlier "political" films. In Chapter 4, Rachael Ziady DeLue takes up a related but distinct examination. "Envisioning Race in Spike Lee's *Bamboozled*" argues that *Bamboozled* stands as an attempt to articulate the source of that power, and it does so by doggedly highlighting the perpetual assignment of identity in the visual and seeable as well as in the act of seeing.

Bamboozled is also the focus of Chapter 5, "Ya Been Took, Ya Been Hoodwinked, Ya Been Bamboozled: Mau Maus, Diaspora, and the Mediated Misrepresentation of Blacks" by Tracey O. Patten and Deborah McGriff. Here the authors consider the social commentaries that Spike Lee presents in *Bamboozled*, with particular focus on the cross cultural connections that Lee makes with the rap group in the film, the Mau Maus. The authors argue that Lee uses the Mau Maus

and the diasporic postcolonial lens to illustrate the misrepresentation of blacks in the media as well as to highlight black people's complicity with the racist representation.

Part I concludes with Norman Denzin's chapter, "Spike's Place." Building on the criticisms of Lee by other notable film scholars such as Ed Guerrero, Amiri Baraka, Todd Boyd, and others, Denzin contends that Lee's films do not offer a site of radical cinematic racial resistance. Rather, his films embody a black postnationalist essentialism. This essentialism, Denzin argues, is compatible with the politics of a conservative black class. This argument is developed through a discussion of *She's Gotta Have It, School Daze, Do the Right Thing, Mo' Better Blues, Jungle Fever, Malcolm X*, and *Get on the Bus.*

What Is This "Black"?

It may be asked, "Why focus on Spike Lee?" Lee not only has emerged as an acclaimed, prolific (black) filmmaker, but also has been acknowledged by industry insiders and by critics as one of the most influential cultural provocateurs of the twentieth, and now twenty-first, centuries. Ed Guerrero (1993) notes Lee's ability to present imagery that stands as "counterhegemonic challenges to Hollywood's simplistic representations" (p. 142). Obviously, outside of the imagistic, Lee has also worked hard to position himself as a counterhegemonic figure. On being a sort of new "race man," with a new racial aesthetic in which he raises the issue of racial hierarchies in America, Lee explains, "everyone has their own journey, their own path. You just can't say because someone is black, that therefore they will have the same political point of view as the next man" (Mottram, 2000, "Spike Lee").

Indeed, Lee at times does not share the same politics as the next black person, and given the Cosby example, at other times he does. So, to paraphrase Stuart Hall (1992), what is this "Black" in Lee's popular culture? *Fight the Power! The Spike Lee Reader* considers the political aspirations of Lee's work; however, in "Part II: The New Race Man: Doing the Right Thing by Any Means Necessary," this interrogation into the performances of politics is extended to consider the social and interpretive conclusions Lee's corpus of films brings us to. Chapter 7 turns its attention to the recombination of a parade of replica jerseys, athletic anecdotes, and photos of athletes which has grounded Lee's early work in a relevant urban idiom. Kerr Houston, in "Athletic Iconography in Spike Lee's Early Feature Films," argues that such references allow Lee to nuance the themes of racial conflict, individual pride, and social history that consistently characterize his work.

Chapter 8 presents Mikal Gaines's "Spike's Blues: Re-imagining Blues Ideology for the Cinema," in which he critically evaluates the use of music in Lee's films and

argues that the films demonstrate an investment in transferring, or perhaps more appropriately, adapting, the creative idioms and practices of the blues as an ideology. Through a critical cultural reading of *Summer of Sam, Mo' Better Blues, Jungle Fever,* and *Bamboozled,* his discussion considers Lee's construction of blues cinema via moments where bodily violence and performance are brought into collision with one another.

Chapter 9 presents Paula Massood's focus on Lee's representation of life in the inner city. "Which Way to the Promised Land?: Spike Lee's *Clockers* and the Legacy of the African American City" attends to the ways in which *Clockers* reconsiders and revises the hood film in particular, and cinematic representations of the African American city as a whole. In the process, Massood examines how the film's spatiotemporal parameters dialogue with the traces of another time and space through the motif of the train. Massood argues that the presence of the train in *Clockers* inserts tropes of migration, mobility, and settlement into the narrative in order to place history, especially African American history, back into a dialogue with contemporary African American filmmaking.

In Chapter 10, Kara Keeling offers "Passing for Human: *Bamboozled* and Digital Humanism." Keeling posits that what has been called "cinema's identity crisis" also might be understood simply to be a part of a more general historical convergence of the philosophical trajectory of "the human" with conceptualizations of "the Black." Rather than engage in the debate about blackface and minstrelsy, Keeling explores what *Bamboozled* might offer to our thinking about digitization and film, representation and identity.

In Chapter 11, 'Say the Right Thing': Spike Lee, *Bamboozled* and the Future of Satire in a Postmodern World," Phil Chidester and Jamel Santa Cruze Bell contend that the postmodern milieu into which the film *Bamboozled* emerged is a mode of thinking and being in which the classical literary satire is no longer functional. At the same time, the rhetorical potential offered by the satirical form means that satire cannot be easily ignored or abandoned by those who might take advantage of its qualities. It is through this complexity that the authors argue that Lee's true genius can be discovered as a communicator and artisan.

Chapter 12, "Sounding Black: Cultural Identification, Sound, and the Films of Spike Lee," by Ellen Scott responds to the disproportionate attention to "the image" in analysis of cinematic texts. This chapter explores the use of sound (music, dialogue, and sound design) as a site of cultural identification, recognition, and even familiarity for viewers in the films of Spike Lee. Cinematic sound theorists have suggested that it is the soundtrack and not the image track that has the greatest potential to connote realism, because, unlike the image track, the soundtrack enters three-dimensional space and is a nearly indistinguishable imitation of the sound it indexes.

In All Seriousness

A "Spike Lee Joint" is often easy to recognize. There is Lee's trademark actor-on-a-dolly shot. There is the insertion of a character spouting a fountain of stereotypes and racial and ethnic slurs. In addition, frequently there is Lee himself, often in humorous, sometimes in self-deprecating roles. However, Lee is most powerfully omnipresent in projects in which he is uncharacteristically invisible—his nonfiction and documentaries. Never seen and rarely heard, Lee has been most evocative when the cultural moments he is introducing intersect with his nonfiction. The presentation of the ongoing plight of Hurricane Katrina victims and their dissatisfaction with government, insurance companies, and the nation's leadership in the television documentary, *When the Levees Broke: A Requiem in Four Acts*, earned Lee the George Polk Award, an Image Award, a Peabody Award, and two Venice Film Festival awards. In a promotional interview for the documentary, Lee unabashedly indicted Bush and his administration for being callous:

> You have a large population who happened to be poor, and if they did vote they didn't vote Republican anyway. Everybody was on vacation. Ms. Rice was buying Ferragamo shoes on Madison Avenue while people were drowning, then went to see *Spamalot*. Cheney was on vacation. Bush was on vacation, and even when the President cut short his vacation, he did not fly directly to New Orleans. He did not fly directly to the Gulf region. He had the pilot of Air Force One do a fly-over. (HBO)

Such statements would not be heard coming from Lee directly in *Levees*, but the sentiment would be strongly portrayed nevertheless.

Lee's nonfiction has played a crucial role in further circulating cultural messages surrounding blackness. In deciding to direct and put into theatres the comedy concert *The Kings of Comedy*, Lee presented to mainstream America the continuing tradition of black humor, notably performed before sold-out crowds in some of the nation's largest arenas. In turning his attention to the long-lingering grief of the families of the children killed in the 1963 Birmingham church bombing by Klansmen, Lee earned for his documentary *4 Little Girls* a Broadcast Film Critics Association Award, an Image Award, a National Educational Media Network Gold Apple Award, an Online Film Critics Society Award, and a Satellite Award. With *4 Little Girls*, another documentary film on football and lacrosse legend Jim Brown—*Jim Brown: An American Hero*—the *Kings* concert film, and *Levees*, Lee lets his subjects take center stage, as the subject matter is too serious or important for a comedic Lee cameo or trick dolly shots.

"The New Race Man" section concludes with a focus on Lee's efforts in imagistically presenting "fact" as Lee himself defines it. In Chapter 13, "They Hate Me: Spike Lee, Documentary Filmmaking, and Hollywood's 'Savage Slot'," Jasmine

Cobb and John Jackson seek to make sense of the differences established between Lee as a fictional storyteller and as a nonfictional documentarian. In a critical analysis of *4 Little Girls*, the authors consider why Lee's nonfiction films are interpreted by audiences differently (and often more acceptingly) than his fictional ones. The authors assess that the emphasis on Lee's prowess as a documentarian simultaneously works to demean him as a fiction filmmaker.

Bamboozled by Heterosexism

The rhetoric of Spike Lee, offered either personally or through his media products, can confound those who seek to pin down his ideologies and motivations. For example, Lee has been defined as a major contributor to black cinema, but his films *Summer of Sam* and *25th Hour* and his direction of television's *Pavarotti and Friends* remind us that he capably reaches outside of blackness-centered texts. Lee has also been described as being anti-Semitic, as evidenced by criticisms of his portrayal of the Flatbush brothers in *Mo' Better Blues* and his affinity for subjects associated with the Nation of Islam (*Malcolm X* or *Get on the Bus*). And yet, one of his most profitable films to date, *Inside Man,* extends Lee's long-proffered theme of reparations to the returning of stolen artifacts to Jewish Holocaust survivors or their descendents.

"Part III: No, Baby, No: Sex, Sexuality, and Gender Roles" attends to an arena in which Lee may be less complex and skillful and potentially "Othering" in his representations. This time, the question of what Lee's media products ascribe to is applied to the social and interpretive controversies his works present as it pertains to the depiction of sexualities and gender roles. Specifically, the chapters presented in this section argue that while Lee's discourses offer resistance, provocation, enlightenment, reaffirmation, and empowerment, his work, and therefore Lee himself, is dogged by heterosexism, homophobia, sexism and misogyny, and a particularly hypermasculinist aesthetic.

The section begins with Chapter 14, "Race and Sex in Black and White: Essence and Ideology in the Spike Lee Discourse," by Mark Lawrence McPhail, who attends to considerations of race and gender in the films of Lee that feature depictions of women in interracial relationships. McPhail argues that Lee's films subscribe to essentialist conceptions of race and gender that reify the same ideological and epistemological assumptions and practices that undermine both the representation of race and gender in mainstream media and the emancipatory potential of Afrocentric and oppositional discourses.

In Chapter 15, Sharon Elise and Adewole Umoja examine Lee's construction of gender, or rather Lee's failure to "sing a Black girl's song," through a critical assess-

ment of *She's Gotta Have It, School Daze, Do the Right Thing,* and *Mo' Better Blues.* While acknowledging that Lee's work contributes to the dismantling of white supremacist definitions of blacks and black life, the authors argue that his work fails to transcend the structures of black patriarchy. Thus, Lee's principal weakness is his inability to envision the black woman with the same complexity with which he envisions the black male. Elise and Umoja further argue that Lee's contributions will continue to alienate black women viewers and provide succor only to those who share his limitations.

Chapter 16, "A Critical Exploration of African American Women Through the 'Spiked Lens'" is the next in this section. In this chapter, Heather Harris and Kimberly Moffitt explore Lee's depictions of African American women and presentations of a black gender ideology, or what they call a "Spiked lens," in six of Lee's films to determine if and how the "Spiked lens" conforms to or confronts black hegemonic gender ideologies. Maurice Stevens's chapter (Chapter 17), "Subject to Countermemory: Disavowal and Black Manhood in Spike Lee's *Malcolm X,*" rounds out this section. In this chapter, Stevens argues that in telling the story of Malcolm X, Lee connects authentic black being in the U.S. with the vindication of idealized visions of black manhood and black femininity. To do so, however, Lee's telling of Malcolm X's life repudiates complexity in relation to racialized gender and instead summons restricted and condensed notions of black masculinity and womanhood.

Being All You Can Be: Trading 40 Acres for Some Shoes

While Lee presents an edifice that appears to be counter to the prevailing corporate hegemony, the question becomes, is he more or less socially conscious than, say, Hollywood or Madison Avenue, and are his projects in opposition to these industries? During the 1990s, Lee directed and appeared as character Mars Blackmon (from *She's Gotta Have It*) alongside Michael Jordan in Nike shoe commercials. Such intertextuality worked to blur the boundaries between the messages Lee presents in his films and in interviews about his films and those that promote a product and a corporation. Such cross-promotion of himself, his character, and his film in a Nike commercial exposes Lee to questions about crass self-promotion, as well as about working for a company with a questionable work environment and social impact. Further, there was the challenge whether (black nationalist) Lee, of all people, should be using his imagistic talents to turn a shoe marketed toward (black) youth into an expensive status symbol that many of those targeted could not afford. His contributions to the Nike shoe campaign worked so well that violent thefts emerged as young people stole the pricey, coveted Air Jordan sneakers from one another.

Lee has continued to direct commercials for Levi's 501 jeans, The Gap, Barney's of New York, Philips Electronics, Quaker Oats, Snapple, the U.S. Navy, and Ben & Jerry's ice cream. He has traded on his recognizable figure to appear in commercials for Nike, Taco Bell, Apple, and the National Basketball Association, to name a very few companies ("Black History: Spike Lee"). In acknowledging the disjuncture between what Lee is to represent and his advancing of music videos and militarization, Lee's maximization of profit stance will confound some:

> People ask me why do I do music videos and commercials. I really don't make a separation between film and commercials and music videos. To me they all come under the heading for me of cinema because I try to have a narrative in all three. The only difference is that the commercials you got thirty seconds, the music videos you have four minutes, and the movies you got three hours—if you're lucky. Also they pay a lot of money. (Lee, 1996)

In this last section of *Fight the Power! The Spike Lee Reader*, "Part IV: Inside Media Mogul Man," attention is given to Lee as author and auteur, husband and father, and social critic and entrepreneur. As a whole, these foci work to consider the social, cultural, and political impact of Lee broadly. As such, in Chapter 18, Andrew deWaard in "Joints and Jams: Spike Lee as Sellebrity Auteur" argues that Lee is uniquely positioned as celebrity-artist and businessperson in his negotiation between art and commerce. By analyzing the intricacies of this negotiation, we can witness the economic trials facing other contemporary filmmakers that necessitate the formulation of what he labels "the sellebrity auteur."

Critical engagement is directed toward Lee's cultural products for children in Chapter 19. Mark Orbe and A. Elizabeth Lyons in "Father, Husband, and Social/Cultural Critic: An Afrosemiotic Analysis of Children's Books by Spike and Tonya Lewis Lee" focus on an analysis of *Please, Baby, Please* and *Please, Puppy, Please*. The authors examine the various ways in which the children's books, through their text, colors, images, and characters, reflect different values consistent with Afrocentricity.

Finally, in Chapter 20, Lee's role as an entrepreneur and his impact on promoting the careers of other filmmakers is explored. Using objective financial measures on sales and profitability as well as a theoretical framework that examines the relationship between entrepreneurs and their communities, Yanick Rice Lamb, in "Spike Lee as Entrepreneur: Leveraging 40 Acres and a Mule," explores how Spike Lee has served as an industry role model, breaking down barriers to Hollywood and to Madison Avenue, as well as creating alternative routes. Lamb also presents how Lee has stimulated economic development in the Fort Greene area of Brooklyn.

Hopes for the Readers of *Fight the Power!*

While *Fight the Power! The Spike Lee Reader* works to sort through a number of debates, the question that remains still unanswered here is what we hope you, the reader, take away from this effort. In one sense, we can guess that because you are here, reading this Introduction, you bring to *Fight the Power!* some interest in these issues broadly, and in Spike Lee more specifically. We do not assume that readers of this book are "fans" or celebrators of Lee. In fact, we believe that often that which we attend to most in scholarship are those subjects that expose struggles and the problematic. What we hope you will bring to *Fight the Power!* is what Brooker and Jermyn (2003, p. 2) call "an academic wondering," that is, an eye toward noting strengths, weaknesses, new questions, and resolved debates around mediated cultural production through this single case that is Lee. In conceptualizing this book we brought the same kind of wondering to our process. We encourage more writings on Lee's nonfiction films and on his other nonfilm products. Scant scholarly attention has been paid to his contributions to advertising (e.g., Nike, Levi's, U.S. Navy) and public presentations. Similarly, Lee's press interviews over the last two decades reveal not only an emerging epistemology, but also an evolving construction of a public persona—toward what end has this persona functioned remains unexamined. As such, we hope that the reader will take away an understanding that *Fight the Power!* should be regarded as the "green light" for further research into Lee and his products. Quite simply, *Fight the Power! The Spike Lee Reader* seeks to stimulate, not forestall, continued debate.

References

Aftab, K. (2005). *Spike Lee: That's my story and I'm sticking to it*. New York: W.W. Norton and Co.

Allen, B. (1988, Feb.). The making of *School Daze*: Talking with Spike Lee. *Essence, 18*(50), 130.

"Black History: Spike Lee." Retrieved August 8, 2007 from www.gale.com/ free_resources/ bhm/bio/lee_s.htm.

Brooker, W., & D. Jermyn (Eds.) (2003). *The audience studies reader*. New York: Routledge.

Guerrero, E. (1993). *Framing blackness: The African American image in film*. Philadelphia, PA: Temple University Press.

Hall, S. (1992). What is this "Black" in Black popular culture? In G. Dent (Ed.), *Black Popular Culture* (pp. 21–33). Seattle, WA: Bay Press.

Lee, S. (1996, June 8). Spike Lee: Independent filmmaker. Speech delivered to the Imagination Conference, San Francisco, CA. Retrieved October 1, 2007 from http://www.inmotion magazine.com/slee.html

Mottram, J. (2000) "Spike Lee on *Bamboozled*." Retrieved October 1, 2007 from http://www.channel/4.com/film/reviews/feature.jsp?id=111926&page=1

Nicodemus, K. (2006, March 23). Sit, Wagner! Retrieved August 9, 2007 from http://www.sign andsight.com/features/673.html

Powell, T. (2004, June 22). Spike Lee sides with Cosby over comments. *People*. Retrieved October 1, 2007 from http://www.people.com/people/article/0,656035,00.html

Said, S.F. (2001) Getting spikey. Retrieved August 8, 2007 from http://www.thecontext.com/docsi/24942.html

Spike Lee derides gangsta rap lyrics in T.O. speech. (2005, March 15). Retrieved October 1, 2007 from http://www.ctv.ca/servlet/ArticleNews/story/CTVNews/1110895530836_14/ ?hub= Entertainment

Wolf, B. (2002, Dec. 17). Spike Lee blasts Trent Lott, Director calls on Blacks in Bush administration to speak out. ABC News. Retrieved October 1, 2007 from http://abcnews. go.com/Entertainment/story?id=101153&page=

Industrializing Social Consciousness

The Aesthetics OF *Nommo* IN THE Films OF Spike Lee

RONALD JEMAL STEPHENS

T hree of the most controversial feature films of the last decade were writ-ten, produced, and directed by Spike Lee, who has been a subject of debate among critics of all types. Lee has been tagged irresponsible in producing *She's Gotta Have It* because Nola, the lead character, "represented yet another exploitative stereotype of promiscuous black women" (Buchalter, 1988, pp. 8–14). Two years later, upon the release of *School Daze* (Lee, 1988b), a film about black college life with emphasis on fraternity life, there were complaints over the depic-tion of the class and color issues (DeCaro, 1987). While filming on location in Atlanta, Morehouse College administrators "rescinded their permission [to Lee] when they discovered that the plot pits one segment of black collegians, the wealthy 'wannabees . . . against their darker, poor brethren'" (Buchalter, 1988, p. 33). The latest criticism of Lee, however, has been that of inciting racial animosity and vio-lence because he used excerpts of one of Malcolm X's "Ballot-or-Bullet" speech-es, in the closing quotation in *Do the Right Thing* (Moore, 1989, p. 38).

Yet, despite these criticisms, Spike Lee's success as one of three major indepen-dent filmmakers has been based on his understanding of the African aesthetic. One writer says of Spike Lee's *School Daze* that "there hasn't been a Hollywood film this black since *Sweet Sweetback's Baadasssss Song*" (Hoberman, 1988, p. 78) Another adds that with *Do the Right Thing* "Lee brings to film a self-consciously Afrocentric aesthetic" (hooks, 1989, pp. 31–36), while other reviewers acknowledge that Lee's filmmaking techniques represent a new breed of African American filmmakers.[1]

Now, though analyses of *She's Gotta Have It* would add flame to the fire, this chapter argues, through an examination of *School Daze* and *Do the Right Thing*, that Spike Lee uses a host of characters as his mouthpieces to encourage African American audiences to "wake up" and "do the right thing." While it may appear that Spike Lee has borrowed extensively from the Western tradition by adapting strategic plots once employed in Plato's dialogues, this chapter posits that it is the African oral tradition that is of central importance. This observation of Lee's storytelling techniques suggests that cinematic art is used to liberate the psychic of the African American. Especially in *School Daze* and *Do the Right Thing* (Lee, 1989), the unification between the speaker (Spike Lee) and his audience (filmgoers) creates a persuasive atmosphere in which community values are voiced and redirected. In assuming that this is Spike Lee's objective as filmmaker, this chapter argues that art is used as a method to "uplift the race." Art serves as a vehicle for cultural renewal. Art is functional.

The objective of this chapter, then, is to highlight Spike Lee's cinematographic contributions by using Gladstone Yearwood's aesthetic criterion of an African American cinematic tradition, which asserts that an African American film "must be based on a demythification and demystification of institutional cinema" (Yearwood, 1982, p. 87). Second, in tracing the use of the African aesthetic in Lee's films, Paul Carter Harrison's conceptualization of *Nommo* has been employed. The influence of *Nommo* is critical to this discussion (Harrison, 1972). *Nommo*, the African concept that translates as the spiritual power of the word, is best exemplified through African American music and language. These artistic modes of expression—the spirituals, jazz, rhythm and blues, go-go music, soul, reggae and rap music, call and response, playing the dozens, and the use of ebonics—appear throughout *School Daze* and *Do the Right Thing*.

African American filmmaking has been the subject of discussion for nearly sixty years. Prior literature reveals that independent filmmaking by African Americans was determined through audience recognition of African features on screen (Cripps, 1979). Another assumption was based on the belief that if a film was directed by an African American filmmaker, it was an independent African American film.[2] African American audiences assumed that the intentional criterion of the African American filmmaker was of significance in determining the value of an artistic work (Yearwood, 1982). In determining the independence of African filmmakers born in America, however, previous research suggests that "economic control over cinema technology and institutions" must be established (Yearwood, 1982, p. 70). From Oscar Micheaux to Melvin Van Peebles to Spike Lee, the economic question and the issue of production control have surfaced.

Micheaux, the first African American filmmaker of the 1900s, has written, produced, and directed some thirty-four films over a period of twenty-five years. One

of the major obstacles Micheaux faced as an independent filmmaker, however, was his portrayal of the so-called "Negro." In reviewing his *Moon over Harlem*, it was clear that Micheaux fell into the Western "beauty" trap. Micheaux used light-skinned African Americans to portray an image of professional "black men and women" in order to "survive the competition from Hollywood" (Bogle, 1989, p. 109). In *Moon over Harlem*, Micheaux stresses the importance of leadership in the African American community, while at the same time "model[ing] his stars after white Hollywood personalities . . . [by] publiciz[ing] them as black versions" (Bogle, 1989, p. 114).

Of the same era as Micheaux other African American filmmakers sought to uplift the race by using different approaches. Although their presentation of African people appeared to be more realistic, the problems many of them faced routinely concerned the control of the economics involved in the production process. Emmett Scott, a former secretary to Booker T. Washington, for example, gained public recognition during the protest by the National Association for the Advancement of Colored People (NAACP) in the courts regarding the viewing of *The Birth of a Nation*. Scott wrote *Lincoln's Dream*, and accordingly "the script was submitted to Universal but rejected" (Bogle, 1989, p. 103). Months later Scott accepted money from whites who changed the film's title to produce *The Birth of a Race*.

Being blocked from gaining economic control over the production process has been the major dilemma for other African American filmmakers as well.[3] As a result, the creative visions of these early filmmakers with limited resources only "legitimized the paradigms of power within traditional cinema" (Yearwood, 1982, p. 72). So then by the time the Depression rolled around, there were only a few films being made for African American audiences, and they were films produced almost entirely by whites. A number of them featured African American entertainers in scenes singing rather than acting. Despite this fact, such entertainers as Lena Horne, Hazel Scott, Duke Ellington, Count Basie, Louis Armstrong, and Ethel Waters were employed during what Bogle calls the years of "the Negro Entertainment Syndrome" (Bogle, 1989, p. 118). In many ways, this entertainment aspect of filmmaking helped to highlight the richness of the African American's contribution to so-called American musical tradition.

With the African American consciousness movements of the 1960s, however, Hollywood began to introduce "black-oriented themes, black heroes, and new motifs—black sexuality, anger, and violence—into the American action film genre" (Reid, 1988, p. 33). As a result African American film directors were employed by Hollywood. In the early 1970s, Gordon Parks, Sr. was hired by Metro-Goldwyn-Mayer (MGM), after a successful make of *The Learning Tree*, to direct *Shaft* and its sequel *Shaft's Big Score*, two unpolitical films. Being fully aware of this fact, MGM hired Uniworld, an African American owned advertising agency to reach African

audiences. Capitalizing on Richard Roundtree's image as a "black superspade" with mainstream values and Isaac Hayes's music (which had become increasingly popular among youth), "Uniworld popularized *Shaft* by using the rhetoric of Black Power to attract a black popular audience" (Reid, 1988, p. 30). The success of Gordon Parks, Sr. served as the vehicle to open Hollywood's doors to other African American directors. The production of such films as *Superfly*, directed by Gordon Parks, Jr., and *Superfly TNT*, directed by Ron O'Neal, are excellent examples. Even a few popular African American actors were employed to produce "black action films." Sidney Poitier, for example, directed *Buck and the Preacher*, one of the first African American westerns "which demonstrated retaliatory violent black resistance to an oppressive white system" (Reid, 1988, p. 34).

Melvin Van Peebles, one of the most respected filmmakers of that decade, was better able to appeal to young African American audiences by rejecting traditional cinema standards. Van Peebles introduced an urban African American folkhero in his film *Sweet Sweetback's Baadasssss Song* to whet their appetite for an African aesthetic in film (Reid, 1988, p. 26) Despite the film's success, however, cultural nationalists and the middle-class argued that his work was not an independent African American film. The film was distributed by Cinemation Industries, a company responsible for producing and distributing popular low-budget porn films of that era (Reid, 1988, p. 30). Nevertheless, with the exception of *Sweet Sweetback's Baadasssss Song* and Poitier's *Buck and the Preacher*, conscious African American audiences in growing numbers began to express their disapproval of the images of African American life in the films presented by other African American directors. Reid explains the level of frustration and disapproval felt by audiences who attended many of these "black action films" produced by African American directors with Eurocentric values:

> Not understanding that black directors in Hollywood did not have total control of the production, black filmgoers tended to assume that black directors determined how Afro-American life was reflected in their films. Consequently, even though some blacks were proud that any black was named director, others criticized the black film directors if the film did not satisfy their hopes for positive representation of Afro-American life. Black cultural nationalists and blacks who emphasized middle-class values were the most adamant critics of Hollywood produced black action films. (Reid, 1988, p. 34)

In recent years, Robert Townsend's *Hollywood Shuffle* and Spike Lee's films have joined the ranks of the father of modern-day independent African American filmmaking, Melvin Van Peebles. As major independent filmmakers Lee and Townsend stand at the forefront for bringing their own visions to the screen through writing, producing, directing, and starring in their own films. Despite this fact, however, it appears that Spike Lee has been the most independent filmmaker (Buchalter,

1988, p. 33). Barry Michael Cooper adds "Lee has done more to demystify the Black experience—not only in Brooklyn, but nationally and, in a psychic sense, globally, too—than any other director in recent memory" (Lee, 1988a, p. 15). For Lee's presentation of African American life on film takes an Afrocentric perspective. "Lee embroiders his films with positive motifs of Black Power, capturing his city in the most vibrant tableaux and freshest rhythms" (Jones, 1989, p. 15). This Afrocentric perspective not only examines the psyche of the filmmaker but the images presented on screen and the audience's reactions to the film as well.

In introducing this perspective, four basic characteristics adapted by Gladstone Yearwood are discussed. In this work, Yearwood used Melvin Van Peebles as a model of an independent African American filmmaker (Yearwood, 1982, p. 71). In the present analysis, Spike Lee will be used, especially since his independence as a filmmaker has been most in line with Van Peebles's. According to Yearwood, an African American film must be based on an African American socio-cultural experience that "is not only formal but substantial; and [that] must emerge out of a historic experience" (1982, p. 71) Second, this "cinema seeks its place as history through an emphasis upon forms of production and control of the productive processes of cinema." (1982, p. 71). Third, the mission of the cinema is undoubtedly ideological in that it functions as a principal vehicle in the redefinition of social positions (Yearwood, 1982, p. 72). Fourth, African American cinema is a signifying practice, a mechanism which reproduces existing social relations and social positions through a limited productivity of the symbol (Yearwood, 1982, p. 73).

In analyzing the significance of Lee's cultural and historical experiences as an African American in *School Daze* and *Do the Right Thing*, Paul Carter Harrison's work, which offers significant insight into two of the most effective modes of unifying African people, will be examined. The collective force of African music and speech are the focus here. African American music is a manifestation of *Nommo* because it communicates the ethos and pathos of black people by speaking in "concrete form" (Harrison, 1972, p. 61). Further, as a form of storytelling, the call and response, "brings spiritual solidarity and power to the images created in language." When playing the dozens, he notes, *Nommo* creates power "beyond the natural frailty of the body" (Harrison, 1972, p. 39). Finally, *Nommo* as expressed through a variety of speech genres "is born out of an African sensibility for concise imagery; while having multiple cognitive choices, its meaning is subordinate to the context in which it is used, and defies interpretation unless one is familiar with the mode" (Harrison, 1972, p. 55).

Spike Lee's Films Reject Eurocentric Perspectives

Like Van Peebles's of the early 1970s, Spike Lee's major achievement as a filmmak-

er has been his rejection of the Hollywood establishment. Ossie Davis, a veteran African American actor and director, says of Spike Lee's independence:

> He [Spike] doesn't give much of a damn for Hollywood's opinion of himself or of his works. But he is perfectly willing to use Hollywood money—why not? Spike is first and foremost a business man, tough as nails. But that's about as close as he will allow Hollywood to come. Leave me the check, go home, and wait till I send for you. That's Spike's attitude, reminding me of Malcolm X a little. (Davis, 1988, p. 15)

In rejecting the values of traditional cinema, Spike Lee employed at least three structural principles as a filmmaker. First, Lee's rejection of romanticizing community life redefines film language for African American filmmakers and filmgoers. By highlighting issues real within the African American community and never explored on film before, Spike Lee comes in direct opposition "to the dominant ideologies of cinema" and the African American middle class. Originally Island Pictures was to produce *School Daze*, but after two months of delays Columbia Pictures agreed to finance the film. During the initial stage, Island executives expressed concern about the politicization of the script, feeling "the issue of divestment in South Africa would date the film" (Dickerson, 1988, p. 29). Although this position created a tense atmosphere between Spike Lee and themselves, in the final analysis the people at Island were simply unable to finance the film (Dickerson, 1988, p. 20).

The cultural debate over class and color, having its roots in slavery among enslaved Africans (the so-called field and house Negroes), created another atmosphere of conflict and confrontation. This conflict was first an opposition to the film by middle-class African Americans representing several historically African American educational institutions, who "feared that *School Daze* would portray a negative image of Black colleges, and more importantly of Black people as a whole" (Dickerson, 1988, p. 60). Atlanta University Center (AUC) college presidents, representing Morehouse, Morris Brown, Spelman, and Clark, wanted rights to read the script and a percentage of the profits from the film. When Lee refused to negotiate a contract under those terms, rumors began to spread around AUC campuses about the film.

> Women at Spelman thought that Kelly Woolfolk—who played Vicki, football player Grady's love interest—had the role of a prostitute. The students were influenced by the propaganda being pushed out by the administration. (Dickerson, 1988, p. 62)

As a result, Spike Lee did not get the audience most filmmakers hire as extras, nor location, to produce the quality film he had planned to produce. The initial filming of *School Daze* on AUC campuses, though met by certain ideological constraints, may be viewed as a significant reason for the cinema of transformation. Yet, despite the constraints, Spike Lee was able to manipulate "the hegemony of the eco-

nomic system built around Hollywood films" (Yearwood, 1982, p. 75).

Lee's refusal to dramatize African American collegian life not only placed him in direct opposition with Island Pictures and Atlanta University Center college presidents, but with at least one black media personality as well. Bryant Gumbel of NBC expressed disapproval of *School Daze* because it was a case of Spike airing "Black folks' dirty laundry" (Lee with Jones, 1989, p. 62) Despite it all, *School Daze* and *Do the Right Thing* were well received by the majority within the African American community. It was Lee's slow motion filmmaking method in the "Waaaak-Up" sequence of *School Daze* and the realistic examination of contemporary urban racism in *Do the Right Thing* that convinced movie-goers that he meant business. The former emphasized the importance of laying aside differences and unifying, while the latter explored contemporary racism.

During the transition period in which Spike Lee promoted *School Daze*, he wrote the script for *Do the Right Thing*. He learned that Columbia Pictures did not spend the necessary money to promote *School Daze* (Lee with Jones, 1989, p. 62). Within a few days before release, however, Lee discovered that word-of-mouth was a useful public relations device to promote the film. Word-of-mouth has always been an effective source of communication used in the African American community. It has its roots in the African oral tradition.

After writing the script for *Do the Right Thing*, Lee did not waste any time selecting actors and a production crew for the movie. A majority of actors for key roles were selected during script preparation, something not readily practiced by traditional cinema. In rejecting the romanticization of the film, Spike Lee chose to establish relations with the people on Stuyvesant Street, while at the same time, hiring them as part of the film. Giancarlo Esposito, starring in both *School Daze* and *Do the Right Thing* (he performed as Buggin' Out), highlights Lee's brilliance in selecting his cast and crew:

> The crew and cast of *Do the Right Thing* ... cared about the people on Stuyvesant Street. We organized a clothing drive, we gave away food, [and] we hired people from the neighborhood.[4]

In filming *Do the Right Thing*, Spike Lee chose the issue of racism in America as his central theme. In contrast to the political relations of Hollywood cinema, Spike Lee, working outside the studio, chose to deal with conflicts within the Bedford-Stuyvesant community and conflicts between the community and the police. In dealing with these community problems, Lee was able to shut down several crack houses, a move that helped to increase his credibility among Bed-Stuy community homeowners (Esposito, 1989, p. 63). To further control the production process, Lee hired the Fruits of Islam (FOI), the Nation of Islam's (NOI) security patrol, to patrol the set. Taking notes from such current events as "the Howard Beach inci-

dent, the Michael Stewart and Eleanor Bumpus murders, and the Tawana Brawley mystery," Lee put together a cinematic memo designed to put "the powers that be" on notice: "We will not sit back and patiently take the abuse any longer" (Cooper, 1989, p. 17).

A second principle employed by Lee concerns his refusal to produce traditional cinematic grammar and syntax. Similar to Van Peebles's rejection of pornographic scenes, Spike Lee did not concern himself with "erotic sexual acts" to appeal to audiences, despite his being accused of committing the sin in *She's Gotta Have It*, *School Daze* and *Do the Right Thing*. Instead Lee directed the attention of the audience to the concept of *Nzuri* in both *School Daze* and *Do the Right Thing* (Asante, K., 1993, pp. 1-20). In *School Daze*, for example, Lee explores the dynamics of male and female relationships to make his point. The intimate or love-making scenes involving Dap and Rachel are parallel to that of Julian (Big Brother Almighty) and Jane. What is of importance here is the use of the human body, the African's emphasis on beauty and goodness. Physical beauty does not necessarily mean that one is good. Rather beauty is defined by inner goodness. In many ways, this concept of beauty (attitude, personality, and behavior) can be best explained through the dualism presented between Dap and Rachel and Julian and Jane. Dap and Rachel, the so-called jigaboos, were engaged in a more intimate act of love-making, while Julian and Jane, the wannabees, interacted more superficially, by engaging in an exotic sexual affair. The message is to avoid being trapped in the Eurocentric method of love-making.

This reference to *Nzuri* enabled Spike Lee to introduce to his audience a cultural statement. In the diagram below, comparative values are portrayed in the film as one of the criteria misoriented African Americans employ to defeat or to praise. They are "use[d] . . . as a weapon," says Bill Lee (Spike's father), who composed the musical score for both films (Lee, 1988, p. 147.

Wannabees	Jigaboos
Straight Hair (Jheri curls/ Weaves)	Nappy Hair (braids/ natural hair)
Good/Beautiful	Bad/Ugly
The Haves/Middle Class	The Have Nots/Lower Class
Second Generation College Students	First Generation College Students
Nonpolitical	Political

It should be clear that the portrayal of the wannabees tends to reinforce the values of Europeans not only through their attitudes but through their physical appearance as well. Wannabee women and men have slim figures, use hair weaves or chemicals in their hair and wear blue contact lenses, while some of the so-called jigaboos carry more weight and wear their hair in braids and the natural style. Not only

does the difference explain the diversity in values among African Americans, but it is also an example of the difference between deep structure and surface structure. The scene in Madame Re-Re's, for example, which displays the conflict between the sisters is an excellent example. Madame Re-Re's was a phraseology created by Spike Lee which makes reference to Madame C.J. Walker. In that scene, the significance of the color and class issues is illustrated:

> The debate over Black beauty . . . in the film is a political statement unto itself. [The wannabees] are pursuing a Eurocentric form of beauty to the point that they deny all that is Afrocentric. Even though both forms of beauty are valid, the film says don't turn your back on what's really you. You notice that the Gamma Rays (the ultimate wannabees) look slightly ridiculous with their blue contact lenses, and their exaggerated hair styles. . . . Even more than their eye color, it has to do with their values and aspirations. (Dickerson, 1988, p. 24)

In *Do the Right Thing*, the physical features of Radio Raheem and Buggin' Out suggest an imagery of the so-called brutal "Negroes" as seen in such films as *The Emperor Jones*. But for Spike Lee these images portrayed by Hollywood are off the mark. In presenting the dualism, Spike Lee portrays Radio Raheem (with his love-hate ring) and Buggin' Out (with his bifocus and black power rhetoric) through close-up shots of their size and color as societal threats (as young and angry African American men making both political and economic statements). The way they walk and stroll around the neighborhood (displaying the deep structure of African American culture) and what they say echoes the domestic Black Nationalism of Malcolm X. In sampling Brother Malcolm on film, Spike Lee attempts to inform his audience "to control the economics in their communities" (Lee, with Jones, 1988, p. 282).[5]

In another scene in *Do the Right Thing*, Mookie's intimate relationship with Tina (the mother of his son, Hector) on the hottest day of the soaring midsummer heat (a metaphor for the explosion) addresses current issues involving interracial relationships between Puerto Rican women and African American men. In general, African American males are not involved in "hustling women" in the film as hooks (1989, p. 31) claims, but rather earning enough money to adequately care for themselves and their children.

A third principle adopted by Spike Lee concerns the demystification of the illusion of cinema. Lee's principal aim as filmmaker involves the ideological resistance of the African American community. In *School Daze*, the political differences among the wannabees and the so-called jigaboos are the central issue. And, though the image of Dap as a black nationalist appears a bit weak on screen, the philosophical difference on politics is clear. Dap wants Mission College to divest in South Africa. Julian, on the other hand, accepts the notion that divestment would hurt the

native South Africans most, an argument employed by liberals and conservatives to do nothing. It is a comparison between progressive black students who are culturally aware of themselves and black Greeks who are culturally apathetic.

In many ways, this film reflected a sense of collectivity among African Americans, despite the fact that there were real-life conflicts among cast members and fictitious conflicts between the fictitious Gamma Phi Gamma Fraternity and other students.

> We were determined to make a film which would allow Black folk to see themselves up on screen and really feel proud; proud about who they are and how they look. And since the film is about beauty . . . we knew that we had to make all the Black folks in the film look good. (Dickerson, 1989, p. 23)

In *Do the Right Thing*, Lee rejects the political subordination of African Americans. It is the language of imagery that Spike Lee brings to the screen that convinces African American audience members that it's time to "do the right thing." Buggin' Out's (a nickname reinforcing physical features and characteristics) argument with Sal, the pizza shop owner, ignited the fire. Convinced that Sal should hang photographs of African Americans as opposed to Italian Americans on his wall, Buggin' Out recruited Radio Raheem, the b-boy who did not know who to fight (who had problems with Sal earlier that Saturday afternoon over his b-box) to confront Sal. Earlier that day, Lee presented quick shots of racial slurs about practically every ethnic group living in America (Hispanics, Africans, Koreans, and Italians). This cross-cutting imagery rejects the idea that African Americans are subordinate to other ethnic groups, despite the fact that they own nothing in their own community. The most controversial imagery, however, came during the closing quotations when excerpts of the speeches of the Rev. Dr. Martin Luther King, Jr. and Malcolm X were displayed as a choice of two paths to take (dualism). Despite the fact that Malcolm X never really called for violence, critics accused Lee of inciting violence. When Malcolm X delivered this particular "Ballot-or-Bullet" speech, he was specific in stating that he does not advocate violence:

> I think there are plenty of good people in America, but there are also plenty of bad people in America and the bad ones are the ones who seem to have all the power and be in these positions to block things that you and I need. Because this is the situation, you and I have to preserve the right to do what is necessary to bring an end to that situation, and it doesn't mean that I advocate violence, but as the same time I am not against using violence in self-defense. I don't even call it violence when it's self-defense, I call it intelligence. (Malcolm, 1974)

It suggests that whenever an African American male adopts a position in opposition to the establishment, his ideas are distorted and misinterpreted. For Lee these

factors contribute to racial conflicts. Lee's symbolic message had more to do with the re-election campaign of Ed Koch and the election of David Dinkins than with anything else. Echoing Malcolm X who pointed it out in April 1964, Spike Lee was calling for "control of the politicians" in the community, what Brother Malcolm called "the political philosophy of Black nationalism" on April 3, 1964, at the Cory Methodist Church in Cleveland, and April 12, 1964, at the King Solomon Baptist Church in Detroit.

The Aesthetics of *Nommo* as a Collective Response

Although Harrison's ritualistic drama is the most appropriate application of *Nommo* in the performing arts to date, his complete analysis has its shortcomings. Harrison's interpretation of the role of the pimp in the African American community is simply incorrect. Rather than discuss the pimp as a deviant member within the African American community, Harrison employs the ideas of traditional theorists such as Roger Abraham who sees the pimp as a man of words in the community, without ever establishing a real basis for such an analysis.[6] On the other hand, Harrison is clearly on target regarding the concreteness with which black music speaks to people (1972, p. 61). For example, Spike Lee's use of African American music and language in *School Daze* and *Do the Right Thing* reinforces traditional African practices.

In many ways, Spike Lee is a modern-day griot. Lee's films are essentially storytelling mechanisms, historical artifacts and instructional voices that rely on modern technology to advice, in the same manner as the griots of ancient Africa. In traditional African societies, the duties of the griot included those of historian, reporter, adviser and story-teller (Niane, 1965, p. 17).[7] Similarly, Spike Lee's films serve the same purpose, except that he uses the available technologies to communicate relevant information. One method is through his use of African American music in film. Unlike Hollywood cinema, for example, Lee uses the *Nommo* of African music, in all its forms, to make cultural and historical statements about the experiences of the African people living in America. Especially in *School Daze* and *Do the Right Thing*, the music, accompanied by still photographs and unique camera angles, creates a certain urgency of "the social problem embedded in the mode" (Harrison, 1972, p. 66). In *School Daze*, for instance, the clearest example of this is through the Negro spiritual, "I'm Building Me a Home." In chronological order, still shots of a slave ship, Frederick Douglass, Booker T. Washington, Marcus Garvey, soldiers returning home from World War I, Mary Bethune, Paul Robeson, Jackie Robinson, Willie Mays, Joe Louis, Muhammad Ali, Adam Clayton Powell, Jr., Stokley Carmichael [Kwame Toure], Reverend Dr. Martin Luther King, Jr., Malcolm X and Jesse Jackson are in sequence with the song. And, when the vocal-

ist repeats the title of the song, "I'm building me a home," there is a collective feeling between the speaker (Spike Lee) and the audience (movie-goers) that says "Look how far we have come in this country despite all the obstacles placed before us. We can accomplish what we will, as Garvey once said. We have a long and proud history both abroad and here in this country, so wake up, America" (Stephens, 1988, p. 5).

While the intellectual analyses of the spirituals began with Du Bois as a method of social consciousness, (Du Bois, 1903, pp. 250-264) others, including Lovell, found that the spirituals represented "a desire for freedom, justice," and a "strategy by which . . . [to] gain an eminent future" (1969, p. 163). Fisher observed that the spiritual was a story-telling technique in which a historical story is told by African people to spread brotherhood (Fisher, 1953, p. 17). Howard Thurman (1947, p. 22) and James Cone in *The Spirituals and the Blues* (1979, pp. 30-34) support the same analysis by arguing that the spirituals represent the spirit of a humanizing people.

In *Do the Right Thing*, the dominant musical genre is rap music, and like the spirituals it is storytelling and a form of expression of a humanizing people. Public Enemy created the song "Fight the Power" specifically for *Do the Right Thing* as a message to the African American community. Public Enemy's "Fight the Power" reinforces two continuums within the African American community. First, the theme of the song reintroduces the soul music tradition once expressed by the Isley Brothers in the 1970s.[8] Second, the lyrics of the song make a cultural statement. This method of "speaking out against the powers that be" in "Fight the Power" "is an art product which should be expected, if not anticipated, given the historical and current realities which African people encounter here in the United States of America, amidst the throes of its predominantly Eurocentric culture" (Gray, 1989, p. 23).

"Fight the Power," then, is a vehicle for social transformation, and Public Enemy, like most contemporary rap groups, are essentially modern-day griots.[9] Thus, in *Do the Right Thing*, and *School Daze*, there are multi-griots. In *School Daze*, Lee, his characters and the spiritual "I'm Building Me a Home" exemplify the role of traditional griots. Similarly, in *Do the Right Thing*, Spike Lee, the hard core rap group Public Enemy and Lee's characters are griots. This unique dualism of the griot places Lee's films in the forefront as a story-telling mechanism, as a cultural statement, as politicized art with functional value. This method of story-telling should come as no surprise especially since African Americans are much like their African ancestors who placed a high value on the spoken word through *Nommo*.[10] Historically, Eurocentric filmmakers have attempted to document the African and African American oral tradition on film, not fully understanding its power and dynamics in the community. As a result, previous attempts to capture the essence of the

word on screen have failed. *Nommo*, however, allows Lee to convey the theme of cultural renewal. *Nommo* enables Lee to convey a unification between speaker and audience. Most importantly, Lee's films tend to convey the African Americans' "ethos and world view—useful cultural concepts which refer to essential aspects of a collective human experience" (Richards, 1985, p. 208). So what is seen on film is not only Spike Lee's opinion of racism in America but also an expression of the audience's resentment toward white supremacy. In *School Daze*, for example, Lee's reliance on the rhetoric of resistance and epic memory illustrates the significance of the African ethos. Observe how the call and response is used to convey a sense of collective power in the film when Dap Dunlap attempts to force Mission College to divest in South Africa. Dap relies on the rhetoric of resistance to appeal to the ethos of fellow students and Lee's film audience.

> DAP: Yo! This is it. Once again we, as a people, are late, late, and mo' late. But let us move on. How it is Columbia, Harvard, Yale, all those supposed greater institutions of higher learning, can beat us, Mission College, to the punch? . . . Can anybody answer this little question for me?
>
> AUDIENCE: What question?
>
> DAP: This question. How is it those schools that I mentioned . . . have divested their money in South Africa and we backward Negroes here at Mission College, are holding on to it like . . . a wino clutches to his last bottle? (Lee, 1988a, 186-187)

Because the call for divestment on university and college campuses was widespread throughout the nation, Spike Lee was able to include movie-goers, as opposed to excluding them, in Dap's call for economic sanctions. For, as Asante notes, spokespersons expounding the rhetoric of resistance employ the uses and usage of words, prevailing behaviors and the concept of hearership in choosing audiences.[11] Essentially, Spike Lee and Dap are rhetors who rely on words "accessible to [them] and to the majority of [their] audience" (Asante, 1989, p. 112). Equally important are the gestures, mannerisms and language usage adopted by Dap through Spike Lee, the filmmaker. White supremacy in the form of oppression for Africans abroad is clearly the instigator and reason for the protest and support. Thus, when the subject is introduced there is a sense of collectivity among immediate audience members (actors and characters) and distance audiences (movie-goers). Hearership refers to "the collection or gathering of persons who maintain, if only for the duration of the speech occasion, a special relationship with each other, if only for the hearing of the speaker" (Asante, 1989, p. 113).

In another scene in *School Daze*, Coach Odom exemplifies the importance of epic memory during the Homecoming game. In a rousing and inspiring talk to the football players, Coach Odom, using upward and downward inflection and var-

ious intonations and pitches, expresses the need for Mission College to win the game.

> Men, we have gathered here today to do a job. God explained to Jonah that the essence of love is to labor for something and to make something grow, that love and labor are inseparable. One loves that for which one labors and one labors for that which one loves. When we step out on that gridiron, it's what we've labored for all week. (Lee, 1998a, p. 251)

To maximize the essence of the message, Coach Odom then introduces a series of rhetorical questions, in which the players respond with "interjections":

COACH:	Do you want to let them down?
PLAYERS:	Hell no!
COACH:	Do you want to lose Homecoming for the fourth year in a row?
PLAYERS:	Hell no!
COACH:	Do you want me to lose my job?
PLAYERS:	Hell no!
COACH:	Do you like the devil?
PLAYERS:	Hell no!
COACH:	Well, the devil is in that other locker room. Can I get a witness?

Accompanying the biblical references, Coach Odom used natural hand gestures, bodily movements and facial expressions, while at the same time constantly stressing the right pitch and tone.

Vocal expressions exemplifying *Nommo* in *Do the Right Thing* are best explained through the language of Mister Senior Love Daddy, the radio Dee-Jay who is central to the plot of the film. Love Daddy tells everyone to "Waaaak up" before introducing his rhyming rap of the day's forecast. Here again is an example of the call and response. Da Mayor, an elder and unemployed community alcoholic who hustles to make ends meet, responds to Love Daddy's call by saying "Damn it's hot." Simply put, Da Mayor is saying, "you're right it is hot." Lee's use of ebonics, his naming Davis' character "da" to replace "the," has its roots in the African and African American oral tradition, a verbal tradition that substitutes the "th" sound with the "da" pronunciation. Further, no one knows whether Lee created the nickname as a symbolic representation of the mayor of New York, but it is clear that Lee is putting local politicians and youth in the African American community on notice "to respect their constituency and elders." Another example of call and response occurs when Mookie wakes Jade, saying "wake up," which connects *School Daze* to *Do the Right Thing*. Thus while these scenes may appear to be insignificant to most film critics, they are just the opposite for an Afrocentric analysis. Mister Senior Love Daddy's commentary throughout the film is essentially an example of the call to audiences to wake up physically, psychologically, socially, and economically.

Playing the dozens and the use of ebonics are illustrated through the same scenes. In *School Daze*, as the fellows are traveling from Dap and Grady's dorm room to Kentucky Fried Chicken in Booker's car, verbal exchanges emerge as a form of maintaining community and social norms. Once the fellows reach their destination, however, the bridge between "the campus and the community" emerges. Displaying the level of consciousness among African people, Spike Lee uses the confrontation to address the need for cultural love and unity. What follows is an example of ebonics when one of the brothers from the community says "Yall niggers are just like us, Niggers." Essentially, Lee highlights the African Americans' ability to switch language codes as well as the prevailing divisions within the community.

In *Do the Right Thing* the cornermen engage in verbal exchanges by using ebonics as well. While drinking beer and talking politics, the brothers on the block put one another in check through the use of word magic. All of this highlights the African American's use of deep structure, the usage of language that is often misunderstood by white Americans. Moreover, Lee's films emphasize the themes of economic power, cultural unity and political independence as possible solutions to uplifting African people born in America who continue to struggle to survive.

Conclusion

This chapter has explored the uses of the aesthetics of African American cinema, only to learn that control of the economic and production process of filmmaking is crucial to any discussion of African American cinematic work. From Oscar Micheaux to Melvin Van Peebles to Spike Lee, who represents a new breed of independent filmmakers, the issue prevails. Micheaux set the pace for Van Peebles and he served as a model for Spike Lee. Lee has taken the art to new heights, using dualism, deep and surface structure, and the concept of *Nzuri* to address contemporary issues. In examining his films, the aesthetics of *Nommo* in both music and language has reinforced not only the need for economic empowerment, but also the themes of cultural renewal and political independence. Lee's use of the prevailing forms of verbal communication that are practiced by both speakers and audiences also explains the power of the word. Through *Nommo* then, Spike Lee presents the African American situation on screen.

Nevertheless, critics working from Eurocentric perspectives have attempted to discredit Lee. Upon the release of his films *School Daze* and *Do the Right Thing*, film critics and a majority of the middle class have accused Lee of washing the African Americans' dirty laundry in public and of inciting racial tensions. At the same time, audience members within the African American community in particular have signaled their approval, saying right-on, keep on keeping on, Spike Lee; and com-

munity leaders representing different interests of the African American community have taken Lee's themes and called for action. In New York, the symbolism of Bed-Stuy raises numerous questions. Lee's work with the Bed-Stuy community, unlike other filmmakers, highlights the importance of an Afrocentric perspective in filmmaking. It demonstrates the importance of restoring unity, love and cultural renewal in a drug-ridden community, despite all the odds against it. Further, the symbolism is important in terms of analyzing David Dinkins's recent victory, which came in part, as a result of Lee's introduction of race relations in the city, an issue former Mayor Ed Koch chose to ignore. In Philadelphia, Temple University Chaplain David Gracie embraced Lee's "do the right thing" theme during African American history month to encourage "people to make the right decision to be more moral and committed" (Trent, 1990, p. A4). Finally, in Hollywood, Lee's brilliance has opened new doors for African American actors. Jasmine Guy, who is also known as Whitley Gilbert on "A Different World," recently credited Lee and Eddie Murphy with giving her the opportunity to be in the movies (Campbell, 1989, F1, p. 10).

Although Lee's creative genius has been credited by a variety of sources, he has not been recognized or accepted by Hollywood's old boy network. Recently, Lee was not nominated for best director during the Oscars (Matthews, 1990, p. 20) The significance of this omission has to do with the fact that "the powers that be" are operating from a different world-view than Lee. It is another example of different interpretations of the concept of good and beautiful (*Nzuri*) and its appropriateness for viewers. So often African Americans, in general, have been subjected to Eurocentric values, simply because in many incidences they see the world differently from those in control who dominate the production process. In rejecting Hollywood, Lee puts "African Americans in full effect, [to] show them as they really are" (Jones, 1989, in *Do the Right Thing*, p. 13). His approach to issues and people attempts to assist in redefining the way values are imposed on all Americans. That is why his message is to "wake up and do the right thing," and it has been argued that both on and off screen his work makes a significant contribution.

Notes

1. For a discussion of Spike Lee's abilities as a filmmaker, see Thulani Davis, "Daze of Our Lives: Did Spike Lee Get It with 'School Daze'?" *Village Voice* (March 22, 1988), 35+; Andrew Jones, "Howard Beach Memoirs: New York Filmmaker Spike Lee Works His Brooklyn Juju in a Tribute to his Neighborhood and an Unflinching Confrontation with Racism," *Montreal Mirror* (June 30–July 13, 1989), 13-14.

2. For a critical discussion of the misunderstanding on the part of African American movie-goers, see Cripps, *Black Film as Genre*, 3–12; Yearwood, *Black Cinema Aesthetics: Issues in*

Independent Black Filmmaking, 75–87; and Mark A. Reid, "The Black Action Film: The End of the Patiently Enduring Black Hero," *Film History*, 2 (1988), 3–36.

3. Peter Noble, *The Negro in Film* (London: Skelton Robinson, 1937), 234–40; Thomas Cripps, *Slow Fade to Black: The Negro in American Film, 1900–1942* (New York: Oxford University Press, 1977), 4–21. Yearwood (1982) and Bogle (1989) both note the endless discussions of myths, distortions, and the contributions of African Americans in film.

4. Giancarlo Esposito in *Do the Right Thing: A Spike Lee Joint*, 62. On a personal level, "Esposito says he feels responsible to do projects that uplift." See also Ann Kolson, "Turning from Roles as Villains," *The Philadelphia Inquirer* (Oct. 7, 1990), 2–L.

5. Lee, *Do the Right Thing*. Lee borrows the idea from Malcolm X's "Ballot-or-the-Bullet" speech in comparing the photograph of King and Malcolm shaking hands, 282.

6. Roger Abraham, *Deep Down in the Jungle* (Chicago: Aldine, 1969), 48–50, notes that the dozens—the game, or something like it—dates as far back historically as 1919. He further notes that the pimp, the man of words, played the game effectively. Harrison borrows from this notion—crediting the pimp as an expressive figure within the community. Harrison may have even made this analysis through some assumptions drawn after viewing such films as "Dolemite," "The Mack" and "Superfly." "Dolemite" was popular during the black exploitative film era of the 1970s for his rendition of The Signifying Monkey and Lion, and Shine. "Dolemite" represented the role of the pimp and street-talker. A similar interpretation can be drawn from "The Mack" and "Superfly." If not for the American slavery experience, the pimp figure would not have emerged, according to Zadia Ife in a conversation on the subject, Oct. 18, 1990.

7. Djibril Tamsir Niane, *Sundiata: An Epic of Old Mali* (London, England: Longmans Press, 1965), 17. Born of griot ancestors, Niane retells an old legend of ancient Mali based on the African oral tradition.

8. In the 1970s, the Isley Brothers released a song titled "Fight the Power." Sampling the lyrics of the Isley Brothers, Public Enemy reinforced the theme while at the same time creating something new.

9. For a discussion of rap music and its African roots see David Troop, *The Rap Attack: African Jive to New York Hip-Hop* (Boston: South End Press, 1988), 8, 19, 31; Ronald Stephens, "What the Rap Is About: A History and Criticism of Contemporary Rap Music and Culture," paper presented at the Speech Communication Association's Annual Conference, New Orleans, LA, 1988; and Robert Farris Thompson, "Hip-Hop 101's Course Description: Break Dancing Goes Back, Way Back," *Rolling Stone* (March 27, 1986), 95–100.

10. Janheinz Jahn, *Muntu*, trans. Marjorie Greene (New York: Grove Press, 1961), 133, notes "every human thought, once expressed, becomes reality. For the word holds the course of things in train and changes and transforms them. And since the word has this power, every word is an effective word, every word is binding."

11. Molefi K. Asante, *The Afrocentric Idea* (Philadelphia: Temple University Press, 1989), 113. A description of the rhetoric of resistance is discussed.

References

Abraham, R. (1969). *Deep down in the jungle*. Chicago: Aldine Publishing.

Asante, K.W. (1993) . The Aesthetic Conceptualization of Nzuri (pp. 1–20).In K. Welsh-Asante (Ed.), *The African Aesthetic: Keeper of the Traditions.* Westport, CT: Greenwood Press.

Asante, M. (1989). *The Afrocentric idea.* Philadelphia: Temple University Press.

Bennett, L. (1971, September). The emancipation orgasm: Sweetback in wonderland. *Ebony,* 106–110, 112, 114, 115, 118.

Bogle, D. (1989). *Toms, coons, mulattoes, mammies, and bucks: An interpretive history of blacks in American films.* New York: Continuum Publishing.

Buchalter, G. (1988, Feb. 28). The new black clout in Hollywood. *Los Angeles Times Magazine,* 8–14.

Campbell, R.H. (1989, Dec. 3). Jasmine Guy on her way. *The Philadelphia Inquirer,* pp. F1, 10.

Cone, J.H. (1979). *The spirituals and the blues: An interpretation.* New York: The Seabury Press.

Cooper, B.M. (1989) Foreword. In S. Lee, *Do the Right Thing: A Spike Lee joint* (p. 17). New York: Simon and Schuster.

Cripps, T. (1977). *Slow fade to black: The Negro in American film, 1900–1942.* New York: Oxford University Press.

———. (1979). *Black film as genre.* Bloomington: Indiana University Press.

Davis, O. (1988). Foreword. In S. Lee with L. Jones, *Uplift the race: The construction of* School Daze (pp. 3–6). New York: Simon and Schuster.

DeCaro, F. (1987, March 23). The subject is *School daze*: Film's color conscious message is getting some tough grades. *Detroit Free Press,* pp. B1–2.

Dickerson, E. (1988). *Uplift the race: The construction of* School Daze. (By Spike Lee with Lisa Jones). New York: Simon and Schuster.

Du Bois, W.E.B. (1903). Of sorrow songs. *The souls of black folk.* New York: Fawcett Publications.

Esposito, G. (1989). In S. Lee & L. Jones, *Do the right thing: A Spike Lee joint.* New York: Simon and Schuster.

Fisher, M.M. (1953). *Negro slave songs in the United States.* New York: Citadel Press.

Gray, C. (1989, November). A critique of Public Enemy's "fight the power," utilizing Kariamu Welsh-Asante's nzuri aesthetic model and Larry Neal's black aesthetic outline. [Humanities paper delivered at Temple University]. Philadelphia, PA.

Harrison, P.C. (1972). *The drama of nommo.* New York: Grove Press.

Herman, D. (1964). "Three thousand cheer Malcolm X at opening rally in Harlem" [Ballot-or-Bullet Speech Delivered at the Rockland Palace on March 22, 1964]. *The Militant 28*(13), 4–5.

Hoberman, J. (1988, Feb. 16). Hoodoo you love? *Village Voice.*

hooks, b. (1989, October). Counterhegemonic art: The right thing. *Z Magazine,* 31–60.

Jahn, J. (1961). *MUNTU: An outline of the new African culture.* (M. Greene, Trans.). New York: Grove Press.

Jones, A. (1989, June 30–July 13). Howard Beach memoirs: New York filmmaker Spike Lee works his Brooklyn juju in a tribute to his neighborhood and an unflinching confrontation with racism. *Montreal Mirror,* 13–14.

Lee, S. (1988a, January/February). Behind the scenes: Class act. *American Film,* 57–59.

———. (Producer and Director). (1988b). *School daze* [Film]. Forty Acres and a Mule Filmworks: Columbia Pictures.

———. (Producer and Director). (1989). *Do the right thing* [Film]. Forty Acres and a Mule Filmworks: Universal Pictures.

Lee, S. with Jones, L. (1988). *Uplift the race: The construction of school daze.* New York: Simon and Schuster.

———. (1989). *Do the right thing: A Spike Lee joint.* New York: Simon and Schuster.

Lovell, J. (1969). The social implications of the negro spirituals. In B. Katz (Ed.), *The social implications of early music in the United States* (p. 163). New York: Arno Press.

Malcolm X. (1974). Ballot-or-Bullet Address at the Cory Methodist Church, sponsored by the Congress for Racial Equality, April 3, 1964. In P.S. Forner (Ed.), *The voice of black America: Major speeches by Negroes in the United States, 1797–1971* (pp. 985–1001). New York: Simon and Schuster.

Matthews, J. (1990, Feb. 18). The Oscar edge begins to shrink. *The Philadelphia Inquirer*, p. D2.

Micheaux, O. (Producer and Director). (1939). *Moon over Harlem* [Film]. A Meteor Company Production.

Moore, T.S. (1989, July 10). Spike Lee explores racial conflict in *Do the right thing. Jet Magazine*, 36–38.

Niane, D.T. (1965). *Sundiata: An epic of old mali.* England: Longmans Press.

Noble, P. (1937). *The Negro in films.* London: Skelton Robinson.

Reid, Mark A. (1988) The Black action film: The end of the patiently enduring Black hero. *Film History, 2,* 3–36.

Richards, D. (1985). The implications of African American spirituality. In M.K. Asante & K. Welsh-Asante (Eds.), *African culture: The rhythms of unity* (pp. 207–231). Westport, CT: Greenwood Press.

Rickey, C. (1989, Nov. 24). Behind the scenes of *do the right thing. The Philadelphia Inquirer,* 5.

Smitherman, G. (1986). *Talkin' and testifyin': The language of black America.* Detroit, MI: Wayne State University Press.

———. (1973, October). The power of the rap? The black idiom and the new black poetry. *Twentieth Century Literature,* 260–71.

Stephens, R. (1988, October). What the rap is about: A history and criticism of contemporary rap music & culture. [Paper presented at the Annual Meeting of the Speech Communication Association]. New Orleans, LA.

Tate, G. (1986, September). Close-up: Spike Lee. *American Film,* 48–49.

Thompson, R.F. (1986, March 27). Hip-hop 101's course description: Break dancing goes back, way back. *Rolling Stone,* 95–100.

Thompson, G. (1989, July 5). *Do the right thing* asks the right questions. *The Philadelphia Inquirer,* 43–46.

Thurman, H. (1947) *The Negro spiritual speaks of life and death.* New York: Harper and Row.

Troop, D. (1988). *The rap attack: African jive to New York hip-hop.* Boston: South End Press.

Trent, S. (1990, Jan. 15). Lessons on doing right: A program recalls King's example. *The Philadelphia Inquirer,* pp. A1, 4.

Yearwood, G.L. (Ed.) (1982). Towards a theory of a black cinema aesthetics. In *Black cinema aesthetic: Issues in independent black filmmaking* (pp. 75–89). Athens, OH: Ohio University, Center for Afro-American Studies.

Cultural Engineering
AND THE Films OF Spike Lee

WILLIAM A. HARRIS

T he experience of African peoples during the past five hundred years in the diaspora is continually being documented by researchers and addressed by political actors. The ravages of slavery, poverty, and discrimination have taken a toll in human lives and aspirations. Too often these deprivations are the main factors in the construction of the African American reality.

The attempts at bringing about positive change for the African American population have multiplied in the twentieth century. As the century draws to a close, we can clearly identify political forces both inside and outside the African American community that have targeted both internal and external conditions as the essential locus for change. Additionally, we can identify instances in which the media of information or entertainment have been used as vehicles for social change in the African American cause.

The civil rights movement, beginning with the efforts of Du Bois and continuing through the legalist strategies of the National Association for the Advancement of Colored People (NAACP) and beyond, used its protests and petitions to seek a more livable American society for African peoples. Through executive and legislative initiatives on employment, housing, and voting rights, the forces of government also centered their efforts at change on the greater society. On the other hand, the government has implemented programs, such as Job Corps, Minority Enterprise Small Business Investment Company (MESBIC), and the War on Poverty,

designed to improve the opportunity structure of the black community. And workers in many fields within the black community have created political, educational, and religious organizations providing guidance and training for thousands of African Americans.

Documentary and entertainment film and television products have served to persuade the general American public and inspire the African American public concerning our collective progress on the road to universal freedom. The past decade has seen a resurgence of African American filmmakers. Aside from their remunerative motives, our present-day black directors and film writers seem determined to use their medium as a force for positive change in African American society. This chapter analyzes the work of Spike Lee as a tool of social change.

In the decade since his first commercially distributed film was screened in America's theaters, Spike Lee has established a presence in the film industry and in the minds of his audience. His films are challenging and thought-provoking, with didactic messages for the several segments of his audience. Clearly, he is urging us to *wake up!* But over and above our somnolence, Spike is concerned about aspects of our interpersonal and collective behavior. In his first five films distributed to mass audiences[1] certain themes appear continually. The analysis here focuses on the protagonists in these five films in terms of the representation and philosophy of four major themes contained therein. In the conclusion, the exhortatory function of Spike Lee's entertainment is placed within a conceptual framework known as cultural engineering.

The Oppression of African American Workers

African Americans face a cycle of deprivation regarding jobs, housing, and education. To develop socially and economically as an ethnic group, it is necessary to break into this cycle at some point. Spike Lee takes as a theme the oppression experienced by African American workers in the search for opportunity, and he depicts their struggle against that oppression. The inequities faced by the black worker are examined in *Jungle Fever*, *Mo' Better Blues*, and *Do the Right Thing*. In these three films, there are situations in which the hero is constrained in his efforts to actualize and progress in his career because of countervailing economic control by white entrepreneurs. The ethnicity of the white oppressor differs in each case, but the message is the same: There will be no increase in reward regardless of excellence in performance.

The inequities of the corporate world are shown to us in meetings between Flipper Purify and the bosses in *Jungle Fever*. When Flipper seeks the fulfillment of a promise that he would be made a partner in the firm, his quest is adamantly

refused. The senselessness of the routine stifling of black ambition is made apparent to us. We are led to believe in the rightness of Flipper's position. But he is not to prevail in his quest for a partnership because of some reason that we cannot really understand: "We can't do it right now. Now is not the time." It is as though Jerry and Leslie, the partners, are treating him as a child or a pet who is told, "You can have the candy when I say and not before." It is an arbitrary and capricious refusal to recognize his ability and contribution. Flipper is being cozened by white liberals who are willing to suffer the black presence in the workplace as long as they can continue to exert white control (see Tucker, 1972). It is possible to trace Flipper's extramarital affair with Angela Tucci to a similar scene with the bosses, when they insist that his request for a black secretary is unreasonable. Flipper, in turn, sees as unreasonable his role as the token person of color in the company, but he acquiesces and gives Angie a trial. When asked about his workday, Flipper replies that he is "just a poor black man facing the struggle in corporate America." We take the statement as a bit of cant and with a grain of salt, but the intricacies of the struggle are apparent in the scenes with the bosses.

In *Mo' Better Blues*, Bleek Gilliam and his agent, Giant, face a similar scene of rejection by whites in power in the organization (Lee, 1990, pp. 239, 249–251). The petition in Bleek's case is for a more equitable share of the profits being generated by his celebrated jazz quintet. First, Bleek's boyhood buddy and manager, Giant, approaches the owners of "Beneath the Underdog." Giant tries to evoke the clearly apparent popularity of the band as grounds for an increase in salaries. His argument is refused because of the originally negotiated contract. Artistry is one thing but business is another.

> MOE: It's out of the question.
> GIANT: Everybody's making money except the artists.
> MOE: Don't hand me that artist doo-doo. They don't have any financial risks. Go listen to the music. (He dismisses Giant with a wave of the hand.)

In his round with the owners, Bleek initially bases his appeal on the fairness of the situation.

> BLEEK: ... I came here to speak about the great sums of money you two are making off my music and the little I see in return.
> MOE: ... Giant, your manager, was the one who negotiated this deal. One you agreed to.
> JOSH: And it's always been our business policy to never ever—
> MOE: —ever never—
> JOSH: —renegotiate the deal.

Failing this, Bleek attempts a humanitarian argument.

BLEEK: I trust him. He's honest. I can't say that about you, Moe, or your first-class cousin.

MOE: Nobody can be trusted. Everyone steals. Everyone is crooked. The trick is to walk out of the deal with as much of your shirt on as possible.

BLEEK: Y'know what that sounds like? . . . like the long, long history of black artists being exploited.

MOE: Everybody exploits everybody. Friendship is one thing but business is another.

JOSH: We have a binding contract.

The club owners and the musician form a set piece in the entertainment world. The entertainer is always underpaid and the club owner is never making enough money. Yet, fortunes are made from the talents and careers of entertainers who die impoverished at an early age. Fairness is one thing but business is another. For all the good works of the John Hammonds and Norman Granzs in the music business, one wonders if our artistic geniuses would survive longer with less notoriety and a more equitable share of profits.

In *Do the Right Thing*, as Mookie attempts to discharge the duties of a young unwed father, it is clear that his job is a hindrance to his efforts. He is continually taunted and harassed by Pino, the boss's older son. And Sal, his boss, is unsympathetic to Mookie's needs, on the one hand, and crudely seductive toward Mookie's sister, Jade, on the other. In a brief scenario, Spike Lee reveals to us Sal's duplicity in his relations with Mookie. Following a break for a "quick shower" on the hottest day of the year, Mookie returns to face the music at Sal's Famous Pizzeria (Lee, 1989, pp. 204–205).

SAL: Mookie, you are pushing it. You're really pushing it. I'm not paying you good money to fucking jerk me around.
(Mookie has nothing to say.)

SAL: You're gonna be in the street with the rest of your homeboys.

PINO: 'Bout time, Pop.
(ANGLE-DOOR)
(Jade enters, and Sal looks up. He stops blasting Mookie and a very noticeable change comes over him.)

SAL: Jade, we've been wondering when ya would pay us a visit.

JADE: Hi, Sal, Pino, Vito.

VITO: What's happening, Jade?

JADE: Nuthin' really. How are you treating my brother?

SAL: The Mook? Great. Mookie's a good kid.

It does not make for a good day at the office.

Mookie and Flipper, the protagonists who react against or in the face of economic oppression, suffer further loss. But even Bleek, who continues to pursue his

art in the wake of inequity, suffers loss. What is the Leeian view of oppression? It is possible that he interprets oppression as an infection that emerges as a curse even if it is not directly hindering and disruptive.

Spike Lee's presentation of the continuing shortfalls of equity in the workplace of diversity forces white America to come to terms with the goals yet to be reached. One is moved to remove the blinders of denial and admit complicity in the daily grind of worker against worker. There is the need for a definition for "job" that differs from the definition of "sentence," or a definition of "work" that differs from that of "war." Spike Lee peeks behind the façade of the integrated workplace to discover the micro-level events that belie the statistics seen in affirmative action reports.

The Exploitation of Women

A theme that emerges in each of Spike Lee's first five films concerns the treatment of women by men. Spike's women are subject to the whims and fantasies of men. The women are controlled by men. Men are the actors, and women the acted upon. In *Jungle Fever*, the imbalance of the relationships is seen most clearly. The ultimate justification for Flipper's attraction to Angie and the disorganization of both their lives is that he was "curious." He even attempts to extend his control into her motivation for entering into the affair, by deeming her to have been curious as well. Because of the racial dynamics of American society, the concept of race leaps to mind as the motivating and salient element in the interracial affair we see in *Jungle Fever*. We should consider the matter further.

The seduction of Angie, although patently exploitative, is neither crass nor compulsive as Spike Lee presents it. On the contrary, it is extremely commonsensical and realistic. Flipper may be curious about the white woman, but his curiosity remains dormant until the stranger enters his space. Through a gradual process of overcoming prejudice, comparing experiences, gaining confidential insights, and becoming familiar, the two are drawn together. Their liaison is scripted and predicted by Hannibal Lector's generalization: "We covet that which we see every day" (Harris, 1989, p. 227).

Spike Lee has replicated the nuances of the archetypical extramarital affair. The realistic and typical romance presented in *Jungle Fever* originates in pedestrian rather than predatory urges and is enacted between acquaintances who have become familiar. We do not bed the hunk from the supermarket or the beauty from the laundromat. Instead, we are attracted incrementally to those whose form and face we have come to know. Our emotions are aroused by the familiar voice embodied by the sexual mysteries that we can only wonder about. This is the real love affair, the casting aside of discretion and frustration to act out the irresistible fantasy. This is

the love affair that occasions surprise on the part of friends and anguish on the part of spouses, the affair with the coworker or the spouse's close friend.

At the outset, Angie's complicity in the initiation of the affair is not completely manifest, if it exists at all. When Flipper tells her, "I've never cheated on my wife before," there seems to be no motivation for his confession. But before we can think twice, she has captured him completely. We learn later that we have probably witnessed the loss of her virginity, gone in the wink of an eye.

Angie's family life prior to Flipper is one of thankless drudgery. She is taken as a matter of fact to be the housekeeper and surrogate mother for her father and brothers, in addition to her frequent employment as a secretary. Her neighborhood boyfriend seems at first glance to be an equitable, though lackluster, partner. We must entertain the idea that Angie, at some point, sees Flipper as the exotic knight who will carry her away from a mean and predictable future. Her intention is not clear at the outset, but she eventually comes to broach the topic of bearing Flipper's child. She is not just having a fling.

In considering Flipper's motivation for beginning the affair, we should consider his work situation. Flipper has been rebuffed by the bosses in his request for an African American secretary. He grudgingly accepts Angie as an assistant; his grin often appears to be a gritting of teeth. He is also apprehensive about his chances for promotion at the firm. On the one hand, it is possible that Flipper, at some level, sees his seduction of Angie as a revenge against the bosses. On the other hand, Angie may represent a charm that Flipper must ingest in order to screw his courage in seeking the promotion. Note that it is only after the seduction that Flipper meets with the bosses about the partnership. And he emerges from the meeting enraged and empowered to go forth and found his own company. If the charm cannot work one magic, perhaps it can work another.

The concept of frustration and revenge arises again in connection with the behavior of Paulie Carbone, Angie's boyfriend in Bensonhurst. When we first see him, he is himself exploited in the same manner and for the same reasons as Angie. He is cast into the role of breadwinner and surrogate wife by his widowed father. In the end, however, he is seen to accost and approach a black woman, Orin Goode, for reasons that are not entirely clear. Is he exacting revenge against blacks, or perhaps against his father? It is of course entirely possible that he is, in fact, sincerely attracted to this lovely black woman. Whatever the case, in relationships constructed by Spike Lee, the male makes the moves, calls the shots, controls the pace of the affair.

Flipper's relations with his wife, Drew, are also self-absorbed. In their final scene, she is depicted crying while making love. Indications are that the errant husband has assumed and exercised a male prerogative in gaining access to her bed.

In his attack on the open secrets of American society, Spike Lee spares neither black nor white citizens. In the black community, his films often elicit the remark, "I'm not sure we should be talking about that." Surely those who make such remarks do not watch the 11 o'clock news. Spike invites us to abandon denial of negative patterns of behavior within the black community. He concentrates his commentary on the mutual mistreatment of black people in general and on the state of relations between males and females in particular.

One of the saddest exploitations of woman by man to be seen in films is suffered by Jane Toussaint in *School Daze* when she obeys the command to fornicate with Half-Pint. In the harsh initiation rite, Half-Pint was able to prevail in part because of the assistance of Jane and the other Gamma Rays. Julian, incensed, concocts a revenge to set his ego aright. Julian coerces Jane to lie with Half-Pint, offering her up as an intimate "gift" (Lee, 1988, pp. 314–315).

> JULIAN: I told your cousin I would take care of you and that's what I'm goin' to do.
> HALF-PINT: Big Brother Almighty, what are you talking about?
> JULIAN: Tonight I'm giving you a gift, from me to you.
> (Julian takes Jane by the hand.)
> (CLOSE-JANE)
> HALF-PINT: I can't.
> (Jane looks as if somebody has just slit her throat. All the color is out of her face and the tears soon follow.)
> JULIAN: What do you mean? I know, we all know, you're still a virgin. Go.
> (ANGLE-GAMMAS)
> (They begin chanting.)
> GAMMAS: Go! Go! Go!

Jane complies and is devastated by the experience. But her degradation is not complete until Julian drives the final nail into the coffin of her self-esteem (Lee, 1988, pp. 319–320).

> (Jane looks like a wreck, the tears have streaked her makeup. This is a woman who has lost all her self-worth.)
> (In rushes Julian. He grabs her by the hand and pulls her out from the Gammas.)
> [In the hallway.]
> JANE: I did what you said.
> JULIAN: What is that?
> JANE: I did it with Half-Pint.
> JULIAN: What?
> JANE: You told me.
> JULIAN: The hell I did. You gave it up to Half-Pint? How could you? I thought you loved me. Now you're boning my own frat brother. My own frat brother . . .

(At this point Jane is gone. She loses it. She's on the express to a breakdown.)
JANE: Why are you doing this to me?

She has become a used and discarded object. Our hearts go out to her and we fear for her sanity and survival. She has been a true believer in her man, right or wrong. But she is forced to accept betrayal.

Bleek Gilliam in *Mo' Better Blues* is the master of his horn and consort to two women. His world is under his control. His behavior is brazen and self-centered. A woman is, in fact, an object for Bleek, albeit a beautiful object such as a rare musical instrument. She exists to be mastered and performed upon, a medium in which to express the virtuosity of his sexual prowess. There are scenes between a commanding Bleek and each of the women, Indigo and Clarke, in which he boldly expresses his cocksman's philosophy (Lee, 1990, pp. 228, 231).

INDIGO: Bleek, you're a good brother, but you still don't know what you want.
BLEEK: Now I guess it's time for Confessions of a Modern Day Dog.
INDIGO: Like it or not, Bleek, you're a dog. A nice dog, but a dog, nonetheless.
BLEEK: I won't argue the point. You know how I am. It's no secret. With men-It's a dick thing.
CLARKE: . . . Let's be real. What you and I do is not make love.
BLEEK: What would you call it?
CLARKE: It's definitely not making love!
BLEEK: Boning!
CLARKE: You've been a lot more imaginative.
BLEEK: I got a million of them. The Mo' Better.
CLARKE: Mo' what?
BLEEK: The Mo' Better makes it Mo' Better.
CLARKE: Anyway . . . we don't make love, you don't love me. But in the meantime I'll settle for some of that Mo' Better.
BLEEK: I also got some of that In Case of Emergency Break Glass Dick. . . .

The women do not go gladly to their debasement. There are scenes between a contrite Bleek and each of the women in which they confront him about his lack of focus and commitment in the relationship. The motivation for the ending of these affairs is represented in a montage of misnaming and complaining in which each of the women rails against Bleek's infidelity. Bleek brushes off their challenges with a smirk and a shrug. After their departures, he makes a halfhearted attempt to fill his bed. It is clear throughout, however, that his principal muse is the muse of music, Terpsichore, and not the muse of romance, Erato. Only when his world is brutally crushed and his talent destroyed does Bleek come to earth and settle for the mundane existence of wife and home.

In *Do the Right Thing*, Tina gives us the impression that she is the harridan, the nagger, the constant complainer. Tina, in fact, represents a community of women

who are courted at an early age with promises that are never kept. They are compromised at first in terms of their reputations, and soon in terms of the time they must spend performing motherly duties. The rancor of their rhetoric matches the quality of male trustworthiness.

Mookie is a hustler. He is constrained from a serene and orderly lifestyle by the conditions of his existence. In Mookie's world, opportunities for remunerative work are few and opportunities for hedonistic play are many. Jobs are hard to find and paychecks are skimpy. Mookie gives us the impression of a person constantly on the move to ferret out the next slim opportunity. Mookie has obligations in the form of a woman and her son, whom he fathered. He has obligations to his reference group in the neighborhood. He has obligations to perform on the job. Rushing from one obligation to another, he discharges none fully. In a scene in which Tina has ordered a pizza, we see the frantic attempt by Mookie to cover all the bases. Neither Speedy Gonzales nor Superman could cover all the ground that Mookie attempts (Lee, 1989, pp. 225–228).

MOOKIE: Shit! I forgot [the ice cream].
TINA: Your memory is really getting bad. . . .
MOOKIE: I can run out and get it.
TINA: No! No! You won't come back either.
MOOKIE: I can't be staying long anyway.
TINA: How long then?
MOOKIE: Long enough for us to do the nasty.
TINA: That's out. No! It's too hot! You think I'm gonna let you get some, put on your clothes, then run outta here and never see you again in who knows when?
MOOKIE: A quickie is good every once in a blue moon.
TINA: You a blue-moon fool.
MOOKIE: Then we'll do something else.
TINA: What else?
MOOKIE: Trust me.
TINA: Trust you? Because of trusting you we have a son. Remember your son?

The lone exception to Spike Lee's gallery of exploited women is Nola Darling in *She's Gotta Have It*. Nola is so completely liberated, so predatory, so acculturated to the masculine approach to romance that she perplexes her lovers (Lee, 1987, pp. 340–341, 293).

MARS: Dependable? What? Are you on drugs? [Nola is] 'bout dependable as a ripped diaphragm.
JAMIE: That's cold.
MARS: I'm not lying. Make a date with her, it's fifty-fifty she shows at all, let alone late. Last year I got two playoff tickets, y'know, da Knicks against the Celtics. . . . I asked Nola if she wanted to go and she said, "Yes, I've always wanted to go to a

Knick game."
(CLOSE-MARS)

MARS: Do you know, she never showed. I missed the goddam first two quarters and guess what? Bernard King scored thirty-five points, just in the first half. . . . I wouldn't say Nola was dependable.

JAMIE: It was bad enough, Nola and all her male friends, but on top of that she had this one particular woman after her. That was a bit much for me. I had my suspicions about the both of them. I asked Nola point blank, was she involved with this female or what? She said no.

Nola is presented as happy and in control of her world. She sips the nectar from the flowers of manhood, but she does not entirely relinquish her space or her persona. She is centered. Although we are never quite sure of Nola's grand plan, she gives the impression of one who is surefooted in rocky terrain and trekking toward an ultimate Nirvana. The men cannot fathom her motive nor can they abide her equanimity (Lee, 1987, p. 336).

JAMIE: . . . You can see anybody but I can't. This shit has gone on long enough. I've tried to be open-minded but instead I'm being played for a sucker.

They do not recognize that she is recycling their own behavior, and without a doubt she populates their worst nightmares. Through Nola's eyes, we gain a view of male society as it appears to women in the boudoir. It is quite different from the view presented to men in the locker room. Spike Lee uses the character of Nola to hold up a mirror to male society (Lee, 1987, pp. 285–288).

[The COME-ON scene: Quick cuts of BOGUS MEN talking as if they were trying to rap to Nola.]

DOG #1: Slim, you so fine I'd drink a tub of your bath water.

DOG #2: I wanna rock ya world.

DOG #3: If I was you, I'm the kinda guy you'd want to take home to meet your mother. Don't you agree?

DOG #4: Baby, it's got to be you and me.

DOG #5: You may not realize this but you are sending out strong vibes tonight. May I continue? You're lonely, you're alone, you're sad, you're confused, you're horny. You need a man like me to understand you, to hold you, to caress, to looove you. You need me. What's your phone number?

DOG #6: I know I only saw you for the first time in my life one minute ago but I love you.

DOG #7: I know I only saw you for the first time in my life one minute ago but I love you.

DOG #8: I love you.

DOG #9: I love you.

DOG #10: I-

Doc #11: -love-

Doc #12: -you.

Doc #13: I got my B.A. from Morehouse, my M.B.A. from Harvard. I own a new BMW 318i, I make fifth-three thou a year after taxes and I want you to want me.

Doc #14: Did you know I'm related to Michael Jackson on my mother's side of the family and Prince on my father's? No lie. We can call 'em up right now.

Doc #15: Baby, I got plenty of what you need. Ten throbbing inches of USDA government-inspected prime-cut grade-A TUBESTEAK!!!
(He sticks out his tongue.)

Spike Lee forces us to consider black male repertoires and the possibility of role reversal. Through Nola's point of view, Spike Lee reveals males who act on the belief that "you're fine and you're mine." But, has he built the character of Nola on a real character type in the black community? Probably not. A black woman with multiple partners is a woman besieged, controlled, put upon, and demanded of on all sides. She has not the comfort and serenity of a Nola no matter what her age, income, or physical attributes are. Patently, Spike Lee is justly criticized by Simmonds (1988), who reminds us that liberation has economic and political dimensions that outweigh sexual freedom. Nola is, in fact, a man in a woman's suit, a persona constructed from the male standpoint.

Black-on-Black Crime

When we think of the violence that people wreak on one another, we must consider little murders of the soul as well as street violence in our communities. In large part, Spike's concerns about the ill treatment of black people by black people are reflected in his portrayal of relations between males and females. In addition to this, however, there are several other instances that bear analysis. In *School Daze*, for example, the brief confrontation between the college students and the townies represents the deteriorating connections between the socioeconomic classes of the black American population (see Wilson, 1980). At first glance, the townies' animosity appears to be related to folkways of territoriality. Obviously, the restaurant is a local hangout and not intimately identified with the campus. On closer examination, however, there is revealed a difference in worldview concerning intellectual manhood, political rhetoric, and black identity (Lee, 1988, pp. 274–278).

LEEDS: . . . We may not have your ed-u-ca-tion, but we ain't dirt either. . . . Are you black?
(Those three words stop Slice in his tracks.) . . .
(Slice walks up to Leeds, he's right in his face. The Fellas follow.)

SLICE: You got a legitimate beef, but it's not with us.

LEEDS: Who then?

SLICE: Don't ever question whether I'm black. In fact, I was gonna ask your country ass, why do you put those Jerri-curl, drip-drip chemicals in your black nappy hair?

EDGE: That's right, goddammit.

SLICE: And on top of that, come out in public with those plastic shower caps on your heads.

JORDAN: Just like a bitch.

MOSES: Who you calling a bitch?

BOOKER T: If the shoe fits.

(Leeds steps back, trying to take back the upper hand that the local yokels have obviously lost.)

LEEDS: I betcha you niggers think y'all are white. College don't mean shit, you'll always be niggers, always, just like us.

SLICE: You're not niggers.

(The Fellas leave, walking backwards, though; you never turn your back.)

The rage of townies is spontaneous and diffuse. The bewilderment of the college students is nearly complete; they grope for understanding. The scene is a border dispute between populations alien to one another. They are two groups with much in common who, because of the accidents of birth and background, are bound for different destinies. Yet, on each side, the possibility of acquiring the other's destiny is clearly so near and still so far.

Although the rage expressed in the standoff in *School Daze* is fairly gratuitous, a more brutal confrontation, for cause, is enacted in *Mo' Better Blues* when Bleek and Giant are severely beaten in the alley behind the club. Bleek loses more than a battle in that dark back alley; he loses the value of his artistic gift. He is never again to work as a performing artist. Bleek's fate is determined by the depth of his loyalty to his friend Giant, an addicted gambler. Giant himself has earlier fallen prey to the violence that accompanies his gambling habit. In a sickening scene, "Madlock methodically breaks all of Giant's five fingers on his left hand" (Lee, 1990, pp. 257–258). The message is that our weaknesses lead us to destruction and to the destruction of our loved ones.

The weakness of drug addiction creates symbiosis between the predatory drug dealer and the hapless junkie. The dealer has a serpentine reputation in the African American community: menacing, fascinating, treacherous, slick, and above all deadly. Gator's weakness in *Jungle Fever* leads to his death, made more tragic because his father is the executioner. Sam Jackson's portrayal and Spike Lee's direction reveal the descending way stations in the degrading spiral of the junkie's career. We are amused; we are horrified; we are immersed in the den of iniquity.

Aside from veiled or outright violence, Spike comments broadly and boldly on the divisive issue of skin color as it affects the minds and lives of African Americans.

In *School Daze*, the issue assumes tribalistic proportions (Lee, 1988, pp. 220–221).

> (Jane gives Rachel a long, hard look. She then flips her hair at Rachel and the Gamma Rays follow suit.)
>
> DORIS: It's not real.
> DINA: Say what?
> LIZZIE: You heard.
> (The Jigs stand up and the battle lines are drawn.)
> RACHEL: It ain't even real.
> JANE: You wish you had hair like this.
> DORIS: Girl, y'know you weren't born with green eyes.
> LIZZIE: Green contact lens.
> DINA: They're just jealous.
> RACHEL: Jealous?
> JANE: Rachel, I've been watching you look at Julian. You're not slick.
> RACHEL: If that was true he's not much to look at.
> JANE: Pickaninny.
> DORIS: Barbie doll.
> RACHEL: High-yellow heifer.
> DINA: Tar Baby!
> VIVIAN: Wanna Be White!
> KIM: Jigaboo!
> RACHEL: Don't start.
> JANE: We're gonna finish it.
> [Musical production number]

The Jigaboos and Wannabees are mobilized against one another while they ignore a common heritage. As African Americans, they suffer because their misguided focus allows the perpetuation of social inequities. As women, they suffer because they lack a unified and shared understanding of their subdominant status vis-à-vis males.

In *Jungle Fever*, both Flipper and Drew are haunted by childhood memories of taunts received because of a skin color that was said to be too light or too dark. The women's "war council" dwells on and revolves around the topic of complexion.

The issue of skin color as a divisive irritant within the African American population is an issue that will not be wished away or denied. In fact, possibly the best prospect for a solution is technological. A report from Arizona tells of research on melanotan, a compound that can increase the production of melanin and permanently darken skin (Freundlich, 1989). And there is the imminent possibility of genetic alteration, which can affect the physical characteristics of progeny far into the future (Kolata, 1994). The research is at the stage of animal trials. Help is on the way-for those who truly want it. The rest of Spike's representations of intragroup conflict are the teasings, cussings, and scuffling that are too often seen as merely cul-

tural. Spike Lee is bent on cultural change; his motive is as much to teach as to entertain.

Tranquility Is a Sometimes Thing

In reflecting on these themes in Spike Lee's films, one cannot help but be struck by the fact that they constitute a catalogue of misery, treachery, and deceit. Are we choosing to take the narrow, pessimistic view? Have we ignored the scenes of happiness and contentment and chosen to dwell instead on the deviance and violence? Admittedly there is joy in Spike's magic lantern. Nola's birthday fete is a creative tribute concocted by Jamie, the devoted lover. Spike frames it as a special moment by rendering the scene in color.

School Daze has moments of festivity and tenderness amidst scenes of intergroup rivalry and sexual exploitation. The Splash Jam is an unqualified gala, enjoyed with wild abandon by all factions of the college student body. The film has other celebrations, however, such as the Greek Show and the Homecoming parade, that are marred by the intergroup conflicts that infest the small campus.

The marriage between Bleek and Indigo marks a happy ending to *Mo' Better Blues*, as does the final scene between Da Mayor and Mother Sister in *Do the Right Thing* (Lee, 1989, pp. 258–259).

> (MOTHER SISTER'S BEDROOM-DAY)
> (Da Mayor wakes up in Mother Sister's big brass bed (she was born in it). At first he has no idea where he's at, then he sees Mother Sister sitting down across the room smiling at him.)
> MOTHER SISTER: Good morning.
> DA MAYOR: Is it a good morning?
> MOTHER SISTER: Yes, indeed. You almost got yourself killed last night.
> DA MAYOR: I've done that before.
> (Da Mayor gets up out of her big brass bed.)
> DA MAYOR: Where did you sleep?
> MOTHER SISTER: I didn't.
> DA MAYOR: I hope the block is still standing.
> MOTHER SISTER: We're still standing.

The opening scene of family life in the Purify household contains most of the tranquility to be found in *Jungle Fever*. Tranquility there is in Spike Lee's films, but mostly it is a sometimes thing.

Spike Lee seems to be a man mobilized by the clear and present danger to the African American social environment. He insists that we wake up and face the danger. And he will not cease in warning us of the enemy within and without.

In addition, there is a subtext in Spike Lee's work concerning the fleeting nature of life and its events. His treatment of the pleasures we derive from our existence, the products we create during our lives, and the relationships we form often emphasizes the transitoriness of the things we most enjoy and esteem. In *Jungle Fever*, the carnal pleasures of romance lead directly to trouble. By contrast, Nola in *She's Gotta Have It* is depicted exuberantly reveling in her sexual liberation. But as the tale ends, she makes a decision for self-imposed celibacy, however briefly it is enacted. Her contemplation of change from a life of worldly pleasure to the life of a nun is almost Buddhistic in its presentation. The soporific pleasure of narcotics leads to depravity and death in *Jungle Fever* and the hedonistic addiction to gambling leads to pain and destruction in *Mo' Better Blues*. Even the comforting pleasures of spiritual life enjoyed by the Good Reverend Doctor are wrenched and buffeted by an ugly reality in *Jungle Fever*.

Flipper's work is devalued by his bosses in *Jungle Fever*. Adding destruction to insult, his wife, in a fit of righteous rage, defenestrates all of his architectural drawings and equipment. Sal's pizza parlor in *Do the Right Thing* is reduced to a burnt-out hulk in the space of a few minutes of violence, the violence triggered by Sal's fit of pique. In *Mo' Better Blues*, Bleek is stripped of his musical artistry in a back alley brawl. Finally, the gala productions of the students in *School Daze* consist solely of ephemera—floats, costumes, dance routines—none of these will outlive even the mayfly.

Relationships in Spike Lee's films can spontaneously destruct. The elusive Nola is plainly not the woman who wants your engagement ring. In *School Daze*, even the seemingly durable relationship between Dap and Rachel, fired in the crucible of activism, cannot withstand the misunderstanding and slights that tarnish its luster. There is a contrary observation to be seen in *Do the Right Thing*; Da Mayor and Mother Sister find common ground amidst the turmoil of the neighborhood. The multiple romances of Bleek in *Mo' Better Blues* are clearly destined for disaster; we see this plainly from the outset. Finally, *Jungle Fever* presents us with a panorama of tenuous relationships. We can imagine further turmoil that is likely to occur in the collective lives of these characters after the curtain falls.

On the Upside: Scenes of Change and Resistance

Along with scenes of joy, Spike Lee offers us the vision of reconstructed social roles among African Americans. Flipper in *Jungle Fever* addresses the psychic battering of the corporate world with an entrepreneurial strategy of his own. His decision is emblematic of Walter Rodney's (1990) admonition against stagnation in the struggle:

If a person gets trapped in a previous moment of history, you find it hard to carry on a conversation with him or her because they are still out to defend something that you're not against, but you're not with because it is no longer the relevant thing. Why should we get caught up in making tremendous tirades against . . . the Europeans . . . look how these fellows exploited us? Why should we continually speak in this grand singular— the African is this and the European is the other? That was formulation that was necessary at a particular point in time, when we were still within the whole identity crisis, when we were trying to evolve a peoplehood. But the moment we move beyond that . . . we must look at real life (p. 69).

There is the ongoing necessity to "keep on steppin'." Now that African American society has committed slavery and oppression to its collective cultural memory, the task becomes less one of protesting the past and more one of planning for the future. We are treated to a reaffirmation of family roles as they are ultimately assumed by Bleek and Indigo in *Mo' Better Blues*, by the old couple in *Do the Right Thing*, as well as by Flipper and his family.

Spike Lee, in the sheer making of his films and in the themes therein, reflects the essence of Rodney's statement. We can also see how Lee's work resonates with the ultimate level of Afrocentric awareness, described by Asante (1988, p. 49). It is a case study in going beyond lament and ascending the learning curve of consciousness and contribution.

In a discussion of the East African context, Ali Mazrui (1972) provides some general principles for the conceptualization of media's role in social change strategies. Cultural engineering, according to Mazrui, involves using cultural products "for purposes of deflecting human habit in the direction of new and perhaps constructive endeavors" (p. xv). As the magic lantern of the cinema projects the magic mirror of our societal role models, our collective identity is reinforced through the wide dissemination of cultural images and political statements.

Without a great stretch of imagination, it is possible to transfer Mazrui's (1972, pp. 23–37) conceptualization of the relationship between societal development and the creative arts to the African American context. Cultural products, such as those generated by Spike Lee, serve three separate but essential purposes in the development process. Clearly, the content of the film conveys a powerful visual and verbal statement to the audience. Of equal importance, also, is the African American identity of the cultural worker. The cultural pride attached to productions by African American cultural workers enhances and magnifies the message of the films and their impact on the black audience. The third important role of these works is that of a bridge to the greater society. The American public gains access to authentic portrayals of black hopes and aspirations as well as black tribulations and motives. Further, the films eminently meet the exacting technical standards of the

film industry. They bring new talent and ideas, on and off camera, to the development of society and the arts.

Spike Lee's art is an art of advocacy. He is speaking in favor of the need for African American social solidarity even in his later films *Crooklyn* and *Drop Squad*. In his titles and credits, he is seen to juxtapose the images and ideas of Malcolm X and Martin Luther King, Jr. By doing so, he demonstrates to us that factions purported to be antagonistic in African American society have much in common. The best outcome of the widespread donning of "X" regalia in connection with the screening of *Malcolm X* (Lee, 1991) would be an affirmation that "'X' marks the spot where plans for African American progress begin." Through unity, there is a viable society to be gained; through conflict, there is a people to be lost.

Note

This is a revised version of an article published in the *Journal of American and Canadian Studies*, 11, 129–154 (1994) (Sophia University, Japan). This research was supported, in part, by funds from the Minority Opportunity Research Experience grant awarded to the University of Iowa by the U.S. Department of Education.

Spike Lee's first films are as follows: *She's Gotta Have It* (1986, distributed by Island Pictures, Los Angeles); *School Daze* (1988, distributed by Columbia Pictures, Culver City, CA); *Do the Right Thing* (1989, distributed by Universal Pictures, Universal City, CA); *Mo' Better Blues* (1990, distributed by Universal Pictures, Universal City, CA); *Jungle Fever* (1991, distributed by Universal Pictures, Universal City, CA); *Malcolm X* (1992, distributed by Warner Brothers, Burbank, CA) (all films produced by 40 Acres and a Mule Filmworks, Brooklyn, NY). All quotations from these films are used by permission of Spike Lee.

References

Asante, M.K. (1988). *Afrocentricity*. Trenton, NJ: Africa World Press.

Freundlich, N. (1989, March 27). This hormone may give you what the sun can't: A safe tan. *Business Week*, p. 64.

Harris, T. (1989). *The silence of the lambs*. New York: St. Martin's.

Kolata, G. (1994, November 22). Gene technique can shape future generations. *New York Times*, pp. A1 ff.

Lee, S. (1987). *Spike Lee's gotta have it*. New York: Simon & Schuster.

———. (1988). *Uplift the race*. New York: Simon & Schuster.

———. (1989). *Do the right thing*. New York: Simon & Schuster.

———. (1990). *Mo' better blues*. New York: Simon & Schuster.

———. (1991). *Five for five*. New York: Stewart, Tabori & Chang.

Mazrui, A.A. (1972) *Cultural engineering and nation-building in East Africa*. Evanston, IL: Northwestern University Press.

Rodney, W. (1990). *Walter Rodney speaks: The making of an African intellectual*. Trenton, NJ:

Africa World Press.

Simmonds, E.N. (1988). She's gotta have it: The representation of black female sexuality on film. *Feminist Review, 29,* 10–22.

Tucker, R. (1972). Some observations on neo-paternalism in black-white managerial relations. *African-American Studies, 3,* 7–11.

Wilson, W.J. (1980). *The declining significance of race.* Chicago: University of Chicago Press.

Class AND Allegory IN Spike Lee's *Inside Man*

R. COLIN TAIT

> What's breaking into a bank
> compared with founding a bank?
>
> —Bertolt Brecht

Spike Lee's *Inside Man* (2006) is the filmmaker's most recent foray into commercial filmmaking and his highest-grossing work to date. While the film could be seen as a success based on what seems to be Lee's abandonment of racial politics in order to cater to a larger, more mainstream audience, it is my assertion that the film is nevertheless as politically charged as any in Lee's oeuvre, if not more so. My reasoning for this claim is based on the film's scale and its global reach. The film grossed $183,960,186 in worldwide receipts (boxofficemojo.com, 2006) and was Lee's most successful film outside the United States. The scale of the film's political target is also important and should be viewed within the trajectory of the filmmaker's recent work, which is increasingly concerned with the larger effects of *institutions* rather than the depictions of *local problems* (*Bamboozled*, 2000; *The 25th Hour*, 2002; *She Hate Me*, 2004, as opposed to *Do the Right Thing*, 1989). Furthermore, as Andrew Sarris has noted, this film was Lee's first success at the box-office within his substantial career and therefore begs analysis within this framework (Sarris, 2006).

This chapter will trace the presence and absence of "politics" throughout Spike Lee's most recent films, accounting for the filmmaker's new focus on corporate America and will employ a multifaceted approach in order to do so. We must consider *Inside Man* within the trilogy of films beginning with *Bamboozled* and continuing to *She Hate Me*, all of which examine this corporate subject matter explicitly.

We also need to consider the intertextual references to the politically charged cinema of Sidney Lumet, whose cultural capital *Bamboozled* inherits from *Network,* 1976, and *Inside Man* from *Dog Day Afternoon,* 1975. I will trace the generic features of the heist film and its transformation since Lumet's 1975 movie using theorist Rick Altman's revisionist account of genre theory as my guide (1999). The discussion of this film under the rubric of genre, as we shall see, allows the theorist to claim that the heist film always negotiates alternative values that counter those of the overweening system of capital. These principles are not only embedded in the composition of the group—always consisting of varying classes, and importantly, races—but paradoxically, in the *moral* system that they hold (camaraderie, love). In the case of *Inside Man*, the group tellingly steals from one person who is *absolutely morally reprehensible*: Arthur Case's (Christopher Plummer) Holocaust diamonds are *repatriated* (rather than stolen) by a member of the heist gang, who is prominently represented as Jewish.

Fredric Jameson's 1977 essay, "Class and Allegory in Contemporary Mass Culture: *Dog Day Afternoon* as a Political Film," will serve as a theoretical model for my discussion of Lee's films. Jameson's method productively frames the issue, accounting for the manner in which political content in films from Hollywood— particularly those he considers "generic" and "subgeneric"—is managed and repressed within these forms. This discussion will serve as a template to consider how *Inside Man* (which explicitly references *Dog Day Afternoon*) inherits and exploits the cultural currency of this earlier "political" film. The goal here is to reveal how *Inside Man* (as a work of mass culture) represents a "working out" of the issues that face a particular culture in a politically inflected manner at the moment of the film's conception.[1] The key to this reading is the representation and democratization of the hostages within the site of the heist (the bank) and the film's subsequent depiction of race. This matter is complicated further when the hostages are forced to wear identical masks and jumpsuits, effectively stripping them of their diversity. Aside from race, *Inside Man* also affords us the rare opportunity to ruminate on the depiction of class within popular film, from the onscreen depiction of the global elite (the bank owner Arthur Case, Osama bin Laden's nephew) to the structure of the star system itself. In order to root our analysis within specific historical coordinates, it is also worth looking at the critical writing surrounding the films' reception, if only to see whether the popular perception of Lee's politics are present in criticism surrounding the film's release.

Using specific examples, we can see how the heist film's central tension always involves a tension between "haves" and "have-nots" and always establishes an alternative set of values within contemporary discourse. The film's narrative, then, utilizes two distinctive plots—the heist gang's "robbing from the rich" plot and the disgraced detective making good—in order to present an allegory that functions pol-

ysemously and does not need not be interpreted outright (Jameson, 1992a [1979] p. 26). In this fashion, the brutality of the hostages' treatment at the hands of both the heist gang and the police—particularly in their systematic processing—signifies a myriad of traumatic encounters, standing simultaneously for any and all historical traumas that it resembles, including The Holocaust, Guantanamo Bay, and The Middle Passage.

Perhaps it is necessary to frame my argument by asserting that even though this film was received as a genre piece, it was also uniformly and unequivocally accepted as a Spike Lee film. This implies that Lee's work is always received by critics with an eye to a particular political agenda, ultimately foregrounding its reception as a rumination of racial politics through a popular form. It is Lee's representation of his most culturally diverse cast since *Do the Right Thing*, as well as the film's reception and exhibition, that engenders the allegorical reading within the site of mass culture. Ultimately, these factors lead to my conclusion that *Inside Man* is more acutely political than many of his other works.

Intertextuality and Transnationalism

Inside Man's credit sequence foregrounds the film's multinational and intertextual composition in addition to elaborating its geographic specificity. Here, a panel van departs from the neighborhood of Brooklyn, New York, and makes its way to the heart of downtown Manhattan. The analysis of this scene can be split into three refracting fields. First, the movement of the van indicates the traversal of real-life space, establishing its setting in a specific time and place: New York, 2006. Second, the film's soundtrack plays a re-imagined version of a song, "Chal Chaiyya Chaiyya," originating from the Bollywood film *Dil Se* (*From the Heart*, Mani Ratnam, 1998). The song's inclusion foregrounds the film's intertextuality and speaks to its transnational composition. This opening sequence also elaborates the institutional themes of *Inside Man*. In addition to the previous two elements—the drive across the Brooklyn Bridge, the multinational film soundtrack—there is a third, namely the juxtaposition of institutional imagery of Manhattan's financial district against these aesthetic elements.

Inside Man's first several minutes presents the viewers with a similar array of imagery, confronting them with the early iconography of the financial origins of New York City, and this imagery, replete with one-shots of ships, gargoyles, and the New York Stock Exchange, recalls the phases of finance capital, from the Venetian period, to the Dutch, through the British and onto the American periods of what Giovanni Arrighi (1994) calls "The Long Twentieth Century."[2] The association of these periods of trade with slavery should not be lost on the viewer, as these are the

same institutions, still standing years later, that largely garnered their fortunes based on the sale of human goods. In this sense, the relationship between the global foundations of banking, trade, and shipping is made explicit, and the Dutch founded the means through which human cargo could be carried. That the banks still stand is testament to the legacy of compound interest, which allows them to remain pivotal institutions in the affairs of world finance. In short, the trade of human misery, and the banks' role in this practice (as is the case with nations in general), is representative of both the institution of the legacy born of this awful period, but also the degree to which these issues have merely been forgotten and institutionalized in the hallways and corridors of power, rather than disappearing altogether. This sequence, then, rehearses the inevitable collision between these two forces—bank and robber—and sets the stage for the larger work of the film. The centrality of diamonds within the film literally "crystallizes" these issues and speaks to the legacy of slavery and African exploitation, in addition to their removal during the Holocaust and their relocation to America in the "New American Century" years later.

"You've Seen *Dog Day Afternoon...*": Intertextuality and Genre Variation

Following the credit sequence, when the van finally arrives at its destination, an anonymous group enters the bank and takes everyone in it hostage. There are two important considerations in the hostage-taking, and this relates to the distance from the lackluster attempts by Sonny (Al Pacino) and Sal (John Cazale) in *Dog Day Afternoon*, as opposed to what is obviously a professional group. Sonny's haphazardness is contrasted by Dalton Russell's (Clive Owen) plan and obvious sense of purpose. It is also important to note the overall diversity of the people in this scene, as they represent all walks of New York City life, which Lee is careful to linger on in the scene previous to the robbers' entrance. They range from a Hassidic Jew, to a buxom woman obnoxiously talking on her cell phone, to a Sikh security guard, to a black father and son, to several Americans of Latin origin. The sheer diversity of the characters within this scene is extremely important, particularly in terms of an ensemble cast, and is noteworthy not only for the manner in which each of these races/ethnicities/genders are represented within a single cinematic space, but also the fact that they all get a chance to speak individually in the later interview section of the film, a rare phenomenon for background players. From the moment that a beat policeman wanders past the scene of the crime, it is clear that we are dealing with a culturally diverse and transnational set of circumstances. When Dalton informs him of the hostage situation in an *Afrikaner* accent, it is obvious that our

Figure 3.1. Al Pacino in *Dog Day Afternoon* (1975). Courtesy of Photofest.

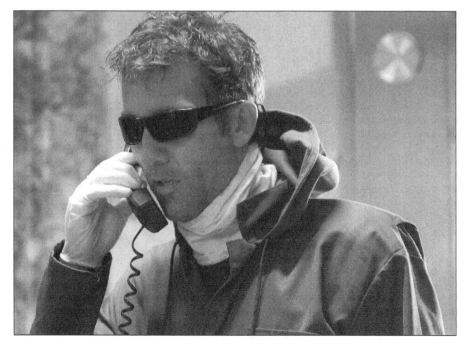

Figure 3.2. Clive Owen in *Inside Man* (2006). Courtesy of Photofest.

shifting presuppositions regarding identity—including race, ethnicity, and gender—will be the central focus of *Inside Man*.

As it is my intention to view *Inside Man* through the lens of Lumet's *Dog Day Afternoon*, it is also worth considering the degree to which the hostage/heist film genre has been transformed in the years since Lumet's film debuted. In this sense, it is essential that we account for the transformative nature of genre as provided by a theorist like Rick Altman.[3] An interesting intertextual reference is John McTiernan's loose remake of *Dog Day Afternoon*, the action film *Die Hard* (1988). While the connection between these films may not seem initially clear, *Die Hard* transforms *Dog Day Afternoon*'s initial conflict (Al Pacino's ultimate "little guy" against the institutions that bring him down) by altering the set of factors that lead the protagonist to be in the hostage situation. In other words, it presents us with a highly complex reversal of these circumstances. Rather than giving us a sad-sack protagonist, driven to rob because of his social class (Pacino), *Die Hard* provides us with a multinational crew of professional criminals. Though the German crew initially call themselves terrorists, demanding the release of their multinational compatriots from prison, the film's surprise is that they merely turn out to be robbers. In addition, their highly sophisticated plan to rob Nakatomi building of its millions of dollars of bonds involves stalling the police with errant demands while they drill through the locks of the building's main vault.

The shift of narrative agency, from a downtrodden robber/protagonist in *Dog Day Afternoon* (Sonny) to sympathetic policeman John McClane is also important, as it signals the transformation of scale and type of film within specific historical parameters. Regardless of this change, the basic formal templates of both films are essentially the same, albeit with this rearrangement in agency. In *Die Hard* and *Dog Day Afternoon* the sets of circumstances are remarkably similar, in addition to the casts of characters within these films. In this sense, the players are all the same—the FBI, robbers, single cop, and hostages—but the redistribution of sympathies is important in the consideration of *Inside Man*'s own variation of these parameters. With the hostage drama's return to New York City, the transfer of narrative agency is redemocratized within Lee's film. At the same time, there is a reflexive acknowledgement of the dearth of change to the form that its predecessors contain. We should also consider the change in viewer loyalty, brought about in the connection between the template of the robber—in other words from Alan Rickman's universally loved/loathed slick ringleader, Hans, to Clive Owen's Dalton.

Though Spike Lee does not make one of his cameo appearances in this film, he nevertheless incorporates himself into this cinematic tradition by including his own canon of films within this matrix of intertextual references. Lee consciously casts two actors from *Dog Day Afternoon* in *Inside Man*, Marcia Kurtz and Lionel Pina. In both cases, the actors reprise their roles and even share the same names in

both films. Kurtz plays a bank hostage in *Inside Man* named Miriam and has a fairly large part as a background player. Pina, famous for his declaration of "Hey, I'm on TV!" in *Dog Day Afternoon* after delivering pizzas to the hostages, has the same smart-aleck commentary in this film, stating that "[i]f they give me tip, I'm keeping it." This allows Lee to bridge the intertextual gap between the films by having Pina deliver "Sal's Famous" pizzas from Danny Aiello's famous burnt down pizzeria in *Do the Right Thing*.[4] By assigning background players with prominent roles, Lee further splinters the traditional narrative agency along class lines. This should come as no surprise to those familiar with later genre theory, as Rick Altman has proven with his discussion of the manner in which character redistribution and narrative agency is a standard practice within the ongoing development of a genre.[5]

From Robber to Police Detective and Back Again: Class and the Hostage Drama Film

Despite the aforementioned narrative division and mutation, there is another matter that we must negotiate in order to analyze the film. Though we can see that the class position of the protagonist remains stable throughout the three films that I have named, we still need to analyze why this occurs. As previously stated, Sonny's initial motivation for robbing the bank is a direct result of his strained economic circumstances. His personal issues include being on the welfare rolls and returning as a veteran of the Vietnam War. He also needs to raise his two children in addition to coping with societal issues that further pose problems to his existence, as there is a national recession and New York City has declared bankruptcy. At the same time, he must negotiate his outsider status as a gay man in the early 1970s. While John McClane's conflict at the beginning of *Die Hard* is not identical to Sonny's, they do share several unifying traits. McClane is a New York City cop whose wife has moved to Los Angeles to become a successful financier/executive. His discomfort with the trappings of wealth (and indeed his low[er] status) is reinforced with his discomfort in the limousine that his wife arranges to take him to the company's lavish office Christmas party, setting the stage not only for the action in the film but also the film's romantic conflict. This agency shifts once again in *Inside Man* to its protagonist, Keith Frazier (Denzel Washington), who experiences a similar (marital) set of circumstances within the film, which ultimately dictates his "lower" status.[6] The reference to marital problems may account for the critics' reading of each of these films as "domestic dramas."[7] Here, each of the films' protagonists must ultimately find a way to reconcile (and transcend) their socioeconomic conditions, and the films' plots engender these possibilities for them within their respective narratives.

This is not the first time that Lee has reinscribed class within his films, nor will it likely be his last. Even his films that feature white protagonists or members of an upper-middle class (*Summer of Sam*, *The 25th Hour*, *She Hate Me*), feature recurring police figures within them. It is also worth mentioning that often, as with actors in Lee's work (John Turturro and Denzel Washington are examples of this phenomenon), sometimes entire characters move between films. This trademark extends to character actor Isiah Whitlock, Jr., whose memorable Special Agent Flood debuts in *25th Hour* and recurs in *She Hate Me*. What I would like to suggest is that in this instance, and over the course of the other films, the figure of the police detective is emblematic of our reconception of class consciousness within the film world. The police detective is only able to move so far up the societal ladder without finding alternate (illegal) means of support, which is precisely what Frazier is accused of at the beginning of the film. The reconstitution and presence of black protagonists in police roles, as with Frazier's partner Detective Bill Mitchell (Chiwetel Ejiofor), is emblematic of the larger point that I believe Lee attempts to make. Here, the implication of solidarity with the lower class becomes inherently linked in the film world to the police detective, who becomes something akin to a modern-day Tom Joad (the protagonist in Steinbeck's *The Grapes of Wrath*). The same occurrences plague Bruce Willis's McClane, and perhaps this is why the film allows him to [albeit problematically] bridge the lines of class and race. At the very least, as is demonstrated in various readings of the detective in film history, it is this figure that is often called upon to negotiate our understanding of society. In short, the roles which are occupied by the police detective within the film increase our awareness of class divisions and class lines by nature of its representation within larger circumstances.[8] This is reflective of one of *Die Hard*'s earliest conversations where black limousine driver Argyle expresses his apprehension at driving the car (Argyle: "It's my first time driving a limo," McClane: "That's okay, it's my first time riding in one").

In *Inside Man*, this is precisely what occurs to Washington's character, as he is initially not only the object (and subject) of an internal police investigation, but is called upon to substitute as a hostage negotiator on this particular day. This occasion will provide Frazier the opportunity for advancement within his institutional structure—the police force—but it could just as easily mean the opposite, as he could be demoted or thrown off the force entirely. Within the overall matrix of power within the film, Washington's character occupies the lowest rung of a power structure. Frazier is subordinated as a go-between within the negotiations to be certain, but he is also put upon by his superiors to do things he might otherwise not consider. This comes into play later on in the film, as Madeleine White (Jodie Foster) tells Frazier (Washington) that he is asking questions that "are above his pay grade,"

to which Frazier responds, "then you'll just have to increase my pay grade."

Clearly, financial pressures dominate Frazier's background, as with Sonny and McClane, and the acquisition of money and lack thereof link him to his cinematic predecessors through the connection between marital/financial bliss and its ultimate symbol, the diamond ring. To reiterate my earlier point, it is significant that all of the protagonists of this film stem from the same financial circumstances, as Sonny attempts to rob the bank to pay for his new "wife's" sex-change operation, John is essentially emasculated at the beginning of *Die Hard* as a result of his wife's superior financial situation (in the 1980s no less), and Frazier cannot get ahead in his relationship (which is stuck at the "proposal" phase) because of his inability to pay for a diamond band, a plot point that recurs later in the film and ultimately allies him to Owen's character.

Historical Circumstances and Periodization of Films: Class and Allegory in Films

It might also be useful to periodize these representations of protagonists between films and submit that they may actually be historically contingent. This consideration includes two parts. The first of these involves the figurability of characters in relation to the roles they play in the films, and the second involves the notion of allegory and the way it defines their interpretation. Since each film corresponds to a particular era—the seventies, late eighties, and turn of the century, respectively—we can assume that the thematic variations to the heist/hostage drama genre embody the same historically specific features. This supposition includes the transformative nature of film, the various emphases that are highlighted, and the question of why they appear in certain historical circumstances. Taking a page from Fredric Jameson's essay, "Class and Allegory in Contemporary Mass Culture: *Dog Day Afternoon* as a Political Film" (1992b [1977]), allows the critic just such a model of analysis.

For Jameson, what is interesting about this film is not the way that it foregrounds its political agenda, but rather, the way that it *ultimately fails* to represent this issue. Jameson highlights the fact that there is a massive incompatibility between a film that is based on a historical situation—the real-life bank robbery in Brooklyn, 1972—and the manner in which it represents this task. Jameson uses the incompatibility of acting styles and, indeed, origins of actors to foreground and analyze the various tensions within the work. What is extremely important for our purposes and for the modification of his system is the manner in which Jameson describes Al Pacino's "bravura performance" of the film, ultimately citing it as the thing that detracts from the representation of the real-life event. In this way,

Jameson sees Pacino's performance—as a vestige or representation of the cinematic version of the "method"—as incompatible with the rest of the acting in the film (Jameson, 1992b [1977], p. 48). This mode of analysis affords us an opportunity to concentrate on the tensions within the filmic text, analyzing precisely what does not fit. In this regard, Jameson supposes that what is bad about the film is precisely what is good about it (p. 41).

Jameson proposes that that the star system itself provides the theorist with an analytic "in" to the text by way of certain truths which relate to class composition in the film. In this way, Jameson states that "we reach each of the major actors in terms of his distance from the star system." In other words "Sonny's relationship to Maretti is that of superstar to character actor, and our reading of this particular narrative is not a direct passage from one character or actant to another, but passes through our identification and decoding the actors' status as such" (p. 52). For Jameson, the issues of class that are purported to be the point of the film are themselves rendered moot in relation to the star system, which Jameson remaps in the following manner. He reconfigures the text in relation to the film's main star, Pacino, and recasts the acting styles in relation to Film, Stage, and TV accordingly. The manner in which the actors act (over or under) is dictated by their relation to and from the star system. Each of these roles, then, corresponds to a different class position/distinction within the film which is linked to the roles of robber, FBI man, and police detective. Furthermore, Jameson borrows the term "analogon" from Jean-Paul Sartre, referring to things that cannot be rendered directly in film but must be utilized in such a way that they come to stand for something else.

> Thus, the external, extrinsic sociological fact or system of realities finds itself inscribed within the internal intrinsic experience of the film in which Sartre ... calls the analogon: that structural nexus in our reading or viewing experience, in our operations of decoding or aesthetic reception, which can then do double duty and stand as the substitute and the representative within the aesthetic object of a phenomenon on the outside which cannot in the very nature of things be "rendered" directly. (p. 53)

It is through this lens that Jameson asserts that we can reconfigure our perception of class within cinema, as each of these positions within the film corresponds to the creation of a "cognitive map." This term relates to the way in which the contemporary subject perceives the world. Furthermore, it speaks to the usefulness of film in this regard, as it provides the film spectator a way to perceive class composition.

If, in Jameson's view, each of these positions can be said to "stand for" a class position, in a "structural nexus," then it should follow that these positions and their historical "figuration" will change under different historical circumstances. In other words, by examining the various poles that have been presented in these films, we should be able to anticipate the class relations in Jameson's structural "nexus." This

is precisely why I have used *Die Hard* as a bridging text between *Dog Day Afternoon* and *Inside Man*; Jameson's formulation of textual levels can serve as a guide in this discussion. At the same time, historically specific modifications which take place in the periods between *Dog Day Afternoon* and the 1988 film must be accounted for accordingly. Most significant is the splintering of positions in Jameson's matrix of class distinction to include a fourth pole beyond his initial triad of FBI/Robber/Police. It should be noted that this kind of splintering happens all the time as genres reconstitute themselves.[9] In this way, characters are created to function as love interests while at the same time allowing for the protagonist to still accomplish his set of goals. In Jameson's description of acting styles/class configurations, it is with the FBI (and its onscreen representative in the form of actor James Broderick) that he places the level of the institution. Here, Jameson uses the blank features of the TV actor in order to attribute the changing institutional composition of society. In other words, the challenge to the film's viewers lies in reading the FBI man's expression, which for Jameson is the same as their attempt to make sense of their contemporary world situation. It is the increasing corporatization by way of nameless, faceless forces that the viewer is trying to read, and this is represented in the new formulation of class through the star system and its link to the formal operations of the film.

In *Die Hard*, this set of circumstances has changed, and the vagueness and unease with which the viewer can read the new architectonics is given a name and a face to which they can attach their fears. In this respect, the institution of the Nakatomi Plaza constitutes a fourth pole in our class conception, as Mr. Nakatomi (James Shigata) becomes both the institution—as dictated by his name on the building/company—in addition to being a person in his own right. The merging is significant, as it accounts for the way in which the figurations of institutional and financial models find their way back into culture, particularly in the films of the late eighties. It is also worth considering the way in which the role of the FBI and institution are splintered, yet present in this film. In this fashion, John McClane must not only negotiate with the murdered figuration of capital (as Mr. Nakatomi is the literal embodiment of money) but the criminals who seek to place themselves in his stead. The ultimate destruction of the building and the death of all the foreign nationals in the film (the Japanese and German, respectively) may also speak to the film's need to restore an "American" order to the system of world finance. The relevance of this passage for my analysis of *Inside* Man can now be applied, but with one final addition. In *Inside Man*, it is the protagonist and the supposed "villains" who work in tandem to undermine the institutional figuration of capital, which in this case, lies within Christopher Plummer's portrayal of Arthur Case. It should also be clear that the audience's sympathies become divided by Lee's framing of Dalton as sympathetic and by allying him to Frazier. Case, in this very real sense, becomes

innately tied with Lee's institutional montage from the beginning, and it is this fact of his connection to an older form of finance capital which presents the main conflict in *Inside Man*. As opposed to the failed robbery of *Dog Day Afternoon*, where Sonny's bad timing reveals that there are only several thousands of dollars in the entire bank, or the Nakatomi Plaza's six million dollars in bonds, in *Inside Man* there is something much more elaborate going on within the film's vault. Finally, it should be noted that the crime in this film is largely victimless. What occurs instead is the robbers' repatriation of the Holocaust diamonds, as Dalton's crew is not only racially diverse, but also includes one Hassidic Jew who we can assume has hired the crew to get back the diamonds. In addition, Dalton provides Frazier with the means to take down Case by informing him of the real crime that took place long ago, in addition to providing him with the evidence (a traceable diamond ring) in order to do so.

In response, Mr. Case calls in the assistance of Ms. White (Jodi Foster) who is a fix-it woman to the international elite. Class is once again inlaid in the fabric of the film as Mr. Case's old style of capital (exemplified by the ornate, inlaid wooden designs of his office) is counterposed in the mise-en-scene of White's sleek high-rise office. In short, Case's office resembles an older, more secretive form of finance (an "old boys'" network, or "gatekeepers," as Lee is fond of saying), whereas White's is entirely different. This basic fact is reinforced with the scene just before Case calls White, where she is sitting down with one of Osama bin Laden's nephews in order to pull some strings which will allow him to purchase a $10 million apartment in Manhattan. Once again, it is important to note the multinational nature of this transaction, as New York's status as a multinational hub not only dictates the kinds of people that reside in the city but also the figures who will show up in the film.

The Erasure of Difference

Class, race, and difference are further problematized by the film's depiction of the hostage situation. All wearing identical jumpsuits and sunglasses, the robbers strip the hostages of all of their clothes and essentially turn an extremely diverse population of individuals into a unitary body by erasing their individuality, including sexual and racial difference, entirely. Following Jameson, the vacuum that is created by the erasure of difference and its subsequent lack of replacement with a particular politics affords the analyst an even greater field through which we can analyze the film. In this manner, because the hostages are so systematically dehumanized within this scene, it is necessary to interpret the scene with a multifaceted approach. The question remains: how should we attempt this analysis? Once again, Jameson's insistence

that *Dog Day Afternoon* operates polyvalently and allegorically affords us greater lee-way into analysis; by refusing the outright interpretation of the event, we can explore its tensions instead. It is not necessary for us to interpret the event in a one-to-one fashion, by stating that the event represents The Holocaust, Camp X-Ray, Japanese Internment, or the Middle Passage, but that it can represent a literal blank canvas over which it can stand for any or all of these events.

We can approach this scene in a manner similar to Jameson's attribution of soci-etal characteristics to the various classes within the Hollywood system. By viewing the movements of both the "robbers" within the film and Washington's Detective Frazier as an attempt by lower classes to undermine the authority of the higher-ups in society, we can see how the characters in the film surround the problem rather than approach it directly. Jameson defines this mode of analysis in his reading of *Jaws* (Spielberg, 1977), where he urges us not to interpret the shark as representative of anything in particular—it doesn't stand for anything—but rather as an object which allows the characters in the film (of different social statuses) to rally together in order to defeat it. In other words, the object is a target which unifies rather than abstracts characters from one another. We need to be careful, however, that our analysis does not stray too far into a distinctly semiotic reading of the antagonisms that are pre-sented in the work. It seems important to state that Case is not the outright "sym-bol" of capital but resembles Jameson's characterization of the shark in *Jaws*. In other words, "a multiplicity" of readings attributable to the shark allows for a "polysemous" reading (Jameson, 1992a [1979], pp. 26–27).

Once it is revealed that Case's safety deposit box contains a heinous secret—namely that Case's fortune was founded on his connections to Nazis and access to Holocaust diamonds when he was banking in Europe—the target against which the rest of the plot hinges is revealed. And it is Dalton (and his gang of "Steves"), Frazier, and Madeleine White, who turn against (and abandon) Case by the end of the film. In other words, an inherently moral system of values is counterposed against the rep-rehensible actions of Case, who becomes the film's central villain through his asso-ciation with Nazism. Finally, this statement should be measured against Frazier's sense of self-worth, which has made him immune to blackmail and has linked him to Dalton. In other words, his statement that "respect is the ultimate currency" must be measured by presenting an alternate value system within the film. In this sense, Dalton and Frazier are "good guys" in addition to being the good guys.

This phenomenon is precisely what occurs within *Dog Day Afternoon*, as Sonny's hostages, female bank tellers who represent the lower classes within society, come to care for his cause and express their solidarity with their kidnapper. They find themselves in precisely the same station as Sonny, as is the police negotiator Maretti (Charles Durning). At the same time, what *Inside Man* provides is the opportuni-ty for the viewer to see the object against which the characters should rally. In other

words, as in *Jaws*, the film's title could just as easily be "Case" as an indication of precisely the object of our derision in the film. Lee accomplishes this by inherently linking Case to a bank, in very much the same manner that Mr. Nakatomi and Nakatomi Plaza were inseparable in *Die Hard*. On the other hand, what occurs as the hostages are stripped of their identity and subsequently stripped of their rights in the horrifying arrest scene is akin to the systematic processing of Holocaust victims, slaves of the Middle Passage, or prisoners of Camp X-Ray. This scene and their subsequent interrogation at the hands of Frazier speaks to present and past systemic dehumanization of presumed guilty parties and echoes the earlier assertion of Vikram, the Sikh security guard who exclaims "whatever happened to my rights?" The bank robbery, then, merely serves as a pretense to mediate the conflict between disparate classes by providing a venue for this opposition. The presence of the diamond once again solidifies these issues by crystallizing the multinational currency of blood by way of its extraction from Africa, its subsequent removal in the Holocaust. What better place for this conflict to be staged than in the founding bank of Arthur Case's empire born of very abstracting principles of finance capital?

Inside Man's Allegory

Returning to my assertion about *Inside Man's* "blank canvas," we will find that the central issue does not become what the robbery ends up "standing for" but rather, what we can substitute for a reading within the central setting of the bank "heist." Central to this discussion is the perception of "crime" within the film and its virtual nature within the setting of the film. Lee plays with this interrelationship by including two major considerations within the structure of the film. The first of these is relayed to the viewer in flashback and is presented with its own cinematographic aesthetic. In this structural portion of the film, Detective Frazier attempts to restructure the events of the "crime" that occurred within the bank while the hostages suffered through their ordeal. What is at stake for Frazier is the necessity of having to reconstruct the event imaginatively, as the robbers have done away with all visual evidence and have done everything in their power to abstract the representation of the space and event. Indeed, it is revealed at the very end that even the "murder" of a hostage has been staged for the benefit of the police. Thus, it is only through the viewer's (and eventually Frazier's) reconstruction of the event that we can share a vision of what occurred within those several hours in the bank. At the same time, the film (and Lee) plays with the relativity of the situation in a manner which resembles Akira Kurosawa's *Rashômon* (1950), a film which parcels out perception and knowledge throughout the plot, ultimately leaving the spectator in a state of existential confusion.

The same challenge confronts Frazier, and the "unrepresentability" of further "blank spaces" and historical voids can help us to link the film to larger questions about it. Once again, allegory can come to our aid, which we can supplement by asserting that other historical events were never recorded but ultimately have always relied on individual accounts to form our consensus on what occurred within these periods. The mention of Holocaust diamonds within this film allows us to make that specific connection here,[10] but this may also be extended to the events that I have previously mentioned, including, I would add, the terrible September 11 attack and subsequent collapse of the World Trade Center towers.[11]

The same discourse of this void of representable space links this film to other issues including, but not limited to historical genocides (Armenian, Sudanese, Balkan republics among others), The Holocaust, and the legacy of slavery not only in the United States, but also the degree to which this was initially not an American but a transnational problem. Once again, we can link the contemporary manifestation of "transnationalism" to its previous incarnations, which I have briefly outlined not to court controversy but to link them to the larger issues that the film brings into focus. These issues continue to include uneven development between countries, spaces, and localities, which is realized in the formulation of a culturally diverse space (New York City) while at the same time embodying all the opposite principles (the September 11 attacks being the worst form of globalization in this specific way). At the same time, it is still possible to assert that at the heart of all these issues the institutionalization of trade and globalization has always been founded on one form of atrocity or another.

Topicality: Reading *Inside Man* as a Political Film

Perhaps it is possible to add one further pole to our analysis, and this relates to the notion of "topicality" within the films. This cursory reading and its application are inspired by Ernest Mathijs' view of the critical sources surrounding the reception of AIDS references in David Cronenberg's film *The Fly* (1986). In Mathijs' practice, local and contemporary issues are considered within the critical discourse surrounding the film, which locates its reputation and fixes this reception in a time and place (Mathijs, 2003). This principle relates to the manner in which cues that are present within the films are interpreted by critics and attach themselves to the films' public reputation. This analytic tool, whereby we view the criticism surrounding the movie's reception, can help us to measure some of the more irresponsible theoretical formulations of mine that the film's blank canvas engenders. In other words, by looking at the way in which the "blank spaces" are interpreted by the larger critical community, we can guide our analysis of the film's topical references. This process

can also aid us in firmly rooting the film in the moment of its conception and further historicize its intertextual references (the aforementioned *Dog Day Afternoon* and *Die Hard*) by relating these films to their historically contingent circumstances. We should attach several critical formulations which surround Lee's work; foremost among these is the critical reputation that Lee has created for himself as a political filmmaker. It is impossible, from a critical standpoint, for Lee *not* to make a political film, as his ongoing reputation ostensibly depends on Spike Lee saying highly politicized things about race and class in a straightforward fashion. In this sense, although Lee doesn't make one of his trademark cameos in this film, it is still undeniably "A Spike Lee Joint."

In a brief survey of critical reactions to the film, we should note that almost none of the reviewers was "fooled" into thinking that this was a typical heist film, and all considered the film as being consistent with Spike Lee's continued output. Amy Biancolli noted that "*Inside Man* may be a genre flick, but its direction is certifiably Lee" as it continued to express his "trademark themes and visual cues," including "his specialty," which she names as "the strapped-to-a-factory-belt dolly shot" (2006). Roger Ebert comments that because the film was directed by Spike Lee, "it is not without interest" (Ebert, 2006). For Ebert, "Lee finds so many interesting details that don't involve the plot that we're reluctant when he gets back to business." For Kit Bowen, the film not only has Lee's "signature stamp all over it" but he "has once again captured that New York state of mind" (Bowen, 2006).

Further cues, including Lee's foregrounding of racial issues are found in each of these reviews, with their writers all picking up the various threads that Lee left scattered throughout the film. These included Ebert's description of "a self-contained editorial" "involving a little boy and his video game" and the event where "[a] Sikh is accused of being an Arab terrorist, and you want to say, *People! Listen up! Guy with a turban! Sikh! Not Arab!*" (Ebert, 2006). Daniel Eagan speaks to the setting stating bluntly that "[o]nce the parameters of the script are set, Lee can settle down to what he does best: document the often prickly interactions of as many different New Yorkers as can fit into the story." (Eagan, 2006). J. Hoberman declares that "[t]he svelte, twisty plotting, complete with concentration camp references and Nazi-era villainy, is almost certainly [screenwriter] Gewirtz, but the ethnic vaudeville is pure Spike" (Hoberman, 2006). Anthony Lane, though he does not like the film, urges people to go see it, his rationale being that the "more it sags as a thriller, the more it jabs and jangles as a study of racial abrasion" (Lane, 2006). In addition, most reviewers also seem to have caught the allegorical features of the film's staging of the Holocaust/capital dichotomy, and all noted the film's intertextual reflexivity, with most quoting the film's most obvious line where Frazier says: "You've seen *Dog Day Afternoon*. You know how this turns out."

It is my hope that the critical view of this film will afford me to link up the alle-

gorical features of the film to the public reading of the film. In other words, I would like to assert that these fissures within the text are precisely what accounts for the film's appeal, not only to critics, but to audiences as well. Here I would maintain that the film's readability—in the sense of the audience's visceral reaction to the equally horrible treatment of all races within the film—allows Lee to infuse this generic staple with a politics that is extremely effective while at the same time conveying basic, simple truths with its cinematic strategies. These include the representation of events which resemble atrocities, staged for the benefit of the audience members so that they can agree on the universal abhorrence to these practices. *Inside Man*, for a heist thriller/hostage drama, contains no serious violence. It is important to consider that the violence that does take place *all occurs to the hostages within the film*. To this sensation I would add that the film's central mystery is a crucial feature of the film's success in addition to the manner in which it wears its "cleverness" on its sleeve. In other words, because *Inside Man* presents its political message within what is ultimately a generic film form, it results in a meaningful film by both popular and political standards.

Conclusion

Having worked my way through Spike Lee's film, it should be apparent that several issues come to the fore when considering *Inside Man* as part of the larger work of the filmmaker. First, it needs to be reiterated that Lee's critical reputation, by way of the intertextual qualities of his films (their consistency within Lee's cinematic universe), in addition to the way in which Lee's films are critically received, makes it impossible for a critic to regard *Inside Man* as anything but an inherently political text. If this idea is granted, it is then the task of the film analyst to formulate a method through which we can interpret the film both as an artifact of mass culture and a political text.

I have sought to formulate a coherent methodology through which we can view Spike Lee's *Inside Man* while at the same time accounting for the way in which the politics of the film are still measured and conveyed to a mass audience in a blockbuster form. I have attempted to prove that by leaving room for interpretation within *Inside Man*, the film, in addition to the director, can implicate his message by its allegorical reading via its blank spaces. Paradoxically, this means that the film becomes less specifically political and more universal instead. Furthermore, this involves the necessary discussion of intertextual sources and generic features of the heist film in order to account for the historically contingent circumstances that these modifications entail. Remarkably enough, by placing the specifics of his political agenda within what is an extremely entertaining generic form, Spike Lee succeeds

in creating his most effective political statement yet. Not only did *Inside Man* guarantee Lee's ongoing success by ultimately securing an industry model that will carry him through to Hollywood fortune—as the planned sequel to the film would seem to indicate—but he has finally broken through to the foreign market, which secures the longevity of his personal vision for years to come.

Notes

1. Fredric Jameson, "this model seems to me to permit a far more adequate account of the mechanisms of manipulation, diversion, and degradation, which are undeniably at work in mass culture and the media. In particular, it allows us to grasp mass culture not as empty distraction of 'mere' false consciousness, but rather as a transformational work on social and political anxieties and fantasies which must then have some effective presence in the mass cultural text in order subsequently to be 'managed' or repressed" (Jameson 1992b, p. 25).
2. See Giovanni Arrighi (1994) and his discussion of *Entrepôt* Capital in his book *The Long Twentieth Century.*
3. For a detailed reading of this phenomenon, see Rick Altman (1999), "Are Genres Stable?" in *Film/Genre*, pp. 49–62.
4. Spike Lee (2006) "Director's Commentary," *Inside Man.*
5. See Altman's discussion of the Biopic in "Are Genres Stable?," in *Film/Genre.*
6. Washington's history of playing policemen sets up an uneasy tension here for the viewer as well, as he ultimately won his Academy Award in the Best Actor category by playing precisely the "dirty cop" that he is accused of being in this film in *Training Day* (Antoine Fuqua, 2001).
7. For a discussion of the critics' overall reception of the domestic issues of *Dog Day Afternoon* and *Die Hard,* see Vincent Camby, "Lumet's *Dog Day Afternoon*," *New York Times,* September 22, 1975 and Gil Jawetz, DVDtalk.com, Feb. 28, 2006. For *Die Hard* see Hal Hinson, "Die Hard," *Washington Post,* July 15, 1988, Caryn James, "The police, terrorists and a captive audience," *New York Times,* July 15, 1988, which all discuss the protagonists' estrangement from their respective spouses.
8. For a detailed discussion of what Jameson dubs the "social detective," an account of the changing role of the investigator in films since the 1970s, see Jameson (1992c) "Totality as Conspiracy " in *The Geopolitical Aesthetic*, pp. 37–44.
9. Once again, see Altman's discussion of the Biopic in "Are Genres Stable?"
10. Perhaps the film could be linked to Giorgio Agamben's larger discussion of the "representability" of the Holocaust in *Homo Sacer: Sovereign Power and Bare Life*, 1998, among other texts.
11. The very name "Ground Zero" is an issue that Lee has attempted (in his previous film *The 25th Hour* where the void plays a central role) to represent, albeit in a problematic fashion.

References

Agamben, G. (1998). *Homo Sacer: Sovereign power and bare life.* (D. Heller-Roazen, Trans.). Stanford, CA: Stanford University Press.

Altman, R. (1999). *Film/Genre*. London: BFI Publishing Inc.

Arrighi, G. (1994). *The long twentieth century: Money, power and the origins of our times*. London: Verso.

Biancolli, A. (2006, March 30). If you're hostage to this one, escape through the plot holes. *The Houston Chronicle.*

Bowen, K. (2006) *Inside Man* [Review of the motion picture, *Inside Man*]. Retrieved April 8, 2007 from http://www.hollywood.com/review/Inside_Man/3486119.

Brecht, B. (1979). *The Threepenny opera* [Play]. In *Bertolt Brecht: Collected Plays, Volume Two, Part Two*. Edited and translated by John Willett and Ralph Manheim (p. 76). London: Eyre Methuen.

Camby, V. (1975, September 22). Lumet's *Dog Day Afternoon* [Review of the motion picture, *Dog Day Afternoon*]. *The New York Times*, Retrieved April 6, 2007 from http://movies.nytimes.com/movie/review?res=9E0CE3D61339E63BBC4A51DFBF66838E669EDE

Eagan, D. (2006, March 5) *Inside Man* [Review of the motion picture, *Inside Man*]. *Film Journal International*. Retrieved March 29, 2008, http://www.filmjournal.com/filmjournal/reviews/article_display.jsp?vnu_content_id=1002235432

Ebert, R. (2006, March 24). *Inside Man* [Review of the motion picture, *Inside Man*]. *Chicago Sun Times*, Retrieved April 9, 2007 from http://rogerebert.suntimes.com/apps/pbcs.dll/article?AID=/20060323/REVIEWS/60314002/1023

Fuqua, A. (Director). (2001). *Training Day* [Motion picture]. United States: Warner Brothers Pictures.

Hinson, H. (1988, July 15). *Die Hard* [Review of the motion picture, *Die Hard*]. *Washington Post*, Retrieved April 8, 2007 from http://www.washingtonpost.com/wp-srv/style/longterm/movies/videos/diehardrhinson_a0c8da.htm.

Hoberman, J. (2006, March 24). Catch me if you can: By-the-numbers heist flick spiked with ethnic vaudeville. *The Village Voice*, Retrieved April 8, 2007 from http://www.villagevoice.com/film/0612.hoberman.72609.20.html

James, C. (1988, July 15). The police, terrorists and a captive audience. [Review of the motion picture, *Die Hard*]. *New York Times*, Retrieved April 3, 2007 from http://movies.nytimes.com/movie/review?res=940DE1DD133FF936A25754C0A96E948260

Jameson, F. (1981). *The political unconscious*. Ithaca: Cornell University Press.

———. (1992a). Class and allegory in contemporary mass culture: *Dog Day Afternoon* as a political film." In *Signatures of the Visible* (pp. 35-54). New York: Routledge. (Originally published 1977).

———. (1992b). Reification and utopia in mass culture. In *Signatures of the visible* (pp. 9–34). New York: Routledge. (Originally published 1979).

———. (1992c). Totality as conspiracy. In *The geopolitical aesthetic* (pp. 1–84). Indiana: Indiana University Press.

Jawetz, G. (2006, February 28). *Dog Day Afternoon* [Review of the motion picture and DVD *Dog Day Afternoon*]. Retrieved April 4, 2007 from http://www.dvdtalk.com/reviews/read.php?ID=20390

Kurosawa, A. (Director). (1950). *Rashômon*. [Motion picture]. Japan: Daiei Motion Picture Company.

Lane, A. (2006, March 27). Unsocial studies. *The New Yorker*, Retrieved April 7, 2007 from http://www.newyorker.com/archive/2006/03/27/060327crci_cinema

Lee, S. (Director). (2006). Director's commentary. *Inside Man* [Motion picture]. United States: Universal Pictures.

———. (Director). (2004). *She Hate Me* [Motion picture]. United States: Sony Pictures Classics.

———. (Director). (2002). *The 25th Hour* [Motion picture]. United States: Buena Vista Pictures.

———. (Director). (2000). *Bamboozled* [Motion picture]. United States: New Line Cinema.

———. (Director). (2000). *Summer of Sam* [Motion picture]. United States: Buena Vista Pictures.

———. (Director). (1989). *Do the Right Thing* [Motion picture]. United States: Universal Pictures.

Lumet, S. (Director). (1975). *Dog Day Afternoon* [Motion picture]. United States: Warner Brothers Pictures.

———. (Director). (1976). *Network* [Motion picture]. United States: Metro-Goldwyn-Mayer.

Mathijs, E. (2003). AIDS references in the critical reception of David Cronenberg: "It may not be such a bad disease after all." *Cinema Journal 42*(4), 29-45.

McTiernan, J. (Director). (1988). *Die Hard* [Motion picture]. United States: Twentieth Century Fox Film Corporation.

Ratnam, M. (Director). *Dil Se (From the Heart)* (1998). [Motion picture]. India: India Talkies.

Sarris, A. (2006, April 9). *Inside Man's* not *so* lousy; Plus: Spike and me on TV. *The New York Observer*, Retrieved March 29, 2008 from http://www.observer.com/node/38656.

Spielberg, S. (Director). (1975). *Jaws* [Motion picture]. United States: Universal Pictures.

Envisioning Race IN Spike Lee's *Bamboozled*

RACHAEL ZIADY DELUE

America is a land of masking jokers.
—Ralph Ellison, "Change the Joke
and Slip the Yoke" (1995 [1958])

There is power in looking.
—bell hooks, *Black Looks:
Race and Representation* (1992)

Seeing White

In an episode from the first season (2003) of *Chappelle's Show* that served up a pitch-perfect parody of the television news show *Dateline*, the comedian and actor Dave Chappelle plays a black white supremacist. The sketch introduces his character by way of a television news reporter (played by a middle-aged white male actor) who has been dispatched to a rural southern community to interview the notorious and best-selling white supremacist author and organizer Clayton Bigsby. The reporter stops at a run-down farmhouse and asks an African American man (Chappelle) sitting on the porch where he might find Bigsby. He is stunned to learn that the man with whom he is speaking is, in fact, Bigsby, and he is even more astounded when he realizes that Bigsby is blind and, because he has never seen himself, has no idea that he is African American. The reporter's after-the-fact voiceover explains: None of Bigsby's friends or associates—all of them white—have had reason to tell him. An orphan who attended a school for the blind, Bigsby was the only African American student in attendance, so the administration decided that

it would be easier to raise him as white. The cohort of white supremacists of which he is a part, believing him too important to the "movement," assiduously conceals his identity by, among other things, insisting that he don a Ku Klux Klan hood and robe when he appears in public. In the final scene of the sketch, Bigsby delivers a "white power" rant to an adoring crowd and, in response to the audience's expressed desire to see his face, removes his hood. To say the crowd is shocked by this revelation would be an understatement; one young man (whose admiration for Bigsby had, earlier in the sketch, been made manifest as sexual desire) is so flummoxed that his head (literally) explodes, staining the crowd and Bigsby's snow-white Klansman's robe with a smear of blood and brains.

The sketch is both gut-wrenching and intensely funny. It warrants consideration here because it declares in no uncertain terms what critical race theory has made emphatically clear: "race," as understood and deployed as a category in contemporary culture, is a construction, a historical invention compelled and constituted by social, political, and economic interests with momentous material consequences. That is to say, what might be called Bigsby's unknowing or unconscious whiteface—the masking of self with the supposed traits (physical or otherwise) of another race or ethnicity—as well as what is characterized in the sketch as the ease with which one identity is substituted for another (call the young man white, and that is what he becomes), assists in laying bare and *de*naturalizing, through analogy, the rhetorical and historical processes whereby racial and/or ethnic differences are established and naturalized.

Chappelle's sketch also makes explicit what writers such as W.E.B. Du Bois (1990) and James Baldwin (1998) drew attention to long ago and what other scholars, including those that constitute what might be described as the field of whiteness studies, have articulated in recent years: "white" is itself a constructed category, an invented "race," but one that has remained unmarked and unseen by many (Bigsby's blindness is here a figure for this very invisibility), such that whiteness has assumed normative status within American culture and cultural production, with significant material results (hooks, 1992; Morrison, 1992; Dyer, 1997; Hill, 1997; Wray & Newitz, 1997; Kincheloe, Steinberg, Rodriguez, & Chennault, 1998; Berger, 1999, 2004; Cuomo & Hall, 1999; Roediger, 1999, 2002; *After Whiteness*, 2003; Stallings, Gonzales-Day, Jones, & Roediger, 2003; Talty, 2003; Yancy, 2004[1].) Bigsby's whiteness is a declaration—a discursive act—and not an essence. In illuminating it as such, Chappelle makes visible the formerly unseen. He makes whiteness a color even as he denies this color any claim to objective, essential status. In having the white supremacist audience members see Bigsby's whiteness at the very moment of its disappearance, Chappelle's sketch compels an understanding of whiteness as something tangible and visible—a real product of discourse and historical acts—but, at the same time, as something invented and fantastical, a thing

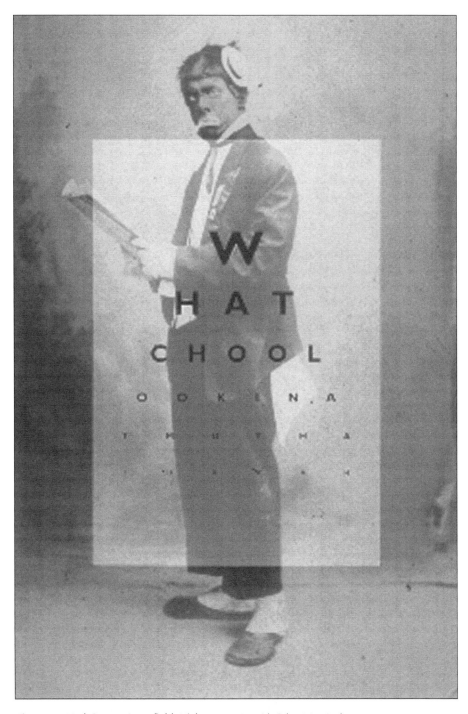

Figure 4.1. Mark Steven Greenfield, *Nightmare*, 2001, Iris Print, 38 x 24 in.

that we must discern and grasp if only in order to dismantle and destroy, what the artist/scholar Adrian Piper has characterized as a process of going "whiteless" (Piper, 2001, p. 65).

"What choo lookin at mutha fukkah": so asks Mark Steven Greenfield's *Nightmare* (2001), a vintage photograph of an actor in blackface overlain with the white square of an eye chart, here transparent, the letters of which spell out the phrase in question (Figure 4.1). One of a series of such images produced by Greenfield collectively titled "Blackatcha," *Nightmare* subverts the operations of the image—the representation of African American men as ludicrously dandified, sad-clown buffoons—by giving this "African American" (perhaps a white actor in black-face, but this is indeterminate) a voice to accompany a now-assertive gaze, made such by the spoken words.[1] For Greenfield, such recoding works to enable what he has characterized as a necessary ritual of exorcism: "These images have haunted us for a very very long time—unless we exorcise the demons that these images have conjured up, we'll never really be free" (*The Legacy of Blackface*, nd.). The "Blackatcha" images, and *Nightmare* especially, also work to describe the drama of visibility and invisibility at the heart of both blackface and the construction of race in contemporary culture. By drawing attention to the manner in which blackface encodes "blackness" as literal color, as a layer of cosmetic, corked skin, Greenfield points at the historical and discursive processes by which race has been rendered a matter of visual representation—a thing visible and seen at the surface, like so many black letters on a white ground (what Frantz Fanon, in *Black Skin, White Masks* [1967, p. 112], evoked with the phrase "the racial epidermal schema," and what Kwame Anthony Appiah and Henry Louis Gates, Jr. [1992, p. 628], characterize as a corporeal definition of race, a rooting of African American identity "in one's embodiment as a black body").[2]

Nightmare also diagrams the whitening function of blackface, the manner in which looking at color made manifestly visible generates a palpable sense of color's absence in/on the body of the white viewer, what Susan Gubar (1997) describes as an interplay of hypervisibility and invisibility: the hypervisibility of blackness (made such by way of blackface) set up against the invisibility of black subjectivities and/or the invisibility of whiteness as a race. As Gubar writes, blackface ensures the almost palpable visibility of difference and, thus, secures the fantasy of whiteness.[3] The white rectangle of the eye chart through which the viewer of *Nightmare* is compelled to look stands as a figure for the lens or screen of whiteness generated by the act of looking at blackface and the consequent reification of whiteness by way of this made-white look (as well as the precariousness and instability of this whiteness, articulated here by its status as a transparent, ghostly haze).[4] The almost-coalescence of white screen and "black" body generated by the superimposition of rectangle on photograph also calls to mind what Eric Lott (1992) (following Homi Bhabha's

[1983, 1984] and Stuart Hall's [1988] theorizations of othering and difference) has described as a drama of simultaneous identification and disavowal (I am curious about or desire you, but I am not you) at the center of blackface minstrelsy. The eye chart itself, in part because it makes us look close and hard, insists that the work of *Nightmare* is the work of seeing and that meaning itself resides in the very act of looking. Here, we do not just look at the work as we would any work of art but, rather, we *perform* looking in engaging and mimicking the experience and operations of an eye exam, a diagnostic test where looking *is* the subject, not just the thing that gets us to the subject. The chart thus insists on the centrality of looking and being looked at—of visualization and visibility—in the imagining and ascription of racial identity. In other words, when confronted with the eye chart, we *know* we are looking (we don't just passively see); the eye chart thus forces us to acknowledge and know that race is representation, both the product of acts of perception and visualization *and* those acts themselves. Indeed, what Greenfield seems to say here is that the categories of "black" and "white" and the idea of race more generally are the products of not just images *of* bodies and faces but are constituted by the very acts of looking that bring bodies and faces before the eyes or by the looks that are emitted from (or trapped in) the representations themselves. So, in addition to giving voice to a formerly silent or, rather, silenced body and subject, the question asked by *Nightmare*—"what choo lookin at . . ."—in that it draws attention to the fact that the viewer's look is more than just passively part of the meaning of the work, implies a different but related question: What is at stake in looking at me? Put another way: What is it in the end that your eyes see or bring into being by virtue of this look?

Bamboozled

I spend time with Chappelle's black white supremacist and with Greenfield's *Nightmare* in the context of a chapter on Spike Lee's *Bamboozled* (2000) because it strikes me that the three, despite their disparate mediums and venues, share similar concerns and thematic investments. In addition to addressing the manner in which race as an idea and category, and whiteness in particular, have been visually construed or oriented, bound to a set of visual signifiers or codes (color central among them), both Chappelle and Greenfield explore the operations and negotiations of visibility (seeing, not seeing, looking, being looked at, encoding and decoding visual cues) whereby race is constituted or recognized (or misrecognized) in contemporary culture. What Chappelle and Greenfield maintain regarding the visibility and visualization of race and the agency of looking/seeing in the invention and sustenance of the idea of racial identity resonates with a number of claims

aired or explored by Lee's film which, as I shall argue in what follows, is manifestly about the act and exigencies of representation itself, from image-making to self-fashioning and beyond. Lee (Crowdus & Georgakas, 2001) describes his film as an attempt to underline and examine the power of images in constructing racial identity; I would add to this that *Bamboozled* stands as an attempt to articulate the *source* of that power, and it does so by doggedly highlighting the perpetual assignment of identity in the visual and seeable as well as in the *act* of seeing. Thus it offers up a series of case studies whereby Lee posits the process of signification, where race or ethnicity are concerned, as a matter of visualization or, more to the point, *envisioning*, a term that I mean to evoke the exchange between viewer and viewed.[5] By taking blackface minstrelsy as a subject by way of a narrative that imagines a revitalization of the genre in the twenty-first century; by making the creation, manipulation, and viewing of images conspicuous themes; and by engaging the film's viewers in activating its meaning, Lee's *Bamboozled* asks (even if it does not always answer) a series of questions about who and what make identity and, also, about what, really, we are "lookin at" when we envision others and ourselves.

Since its release, *Bamboozled* has received a great deal of attention on the part of scholars and critics interested in or upset by, among other things, the film's relationship to stereotype and its unapologetic (if sharply critical) showcasing of blackface minstrelsy. The present chapter builds on this rich commentary by offering an account of a particular set of concerns manifest in Lee's project, intended or otherwise, and does not pretend to tell the whole story of the film or its cultural and political meanings and ramifications. As an art historian, I was drawn to the film's complex dramatization of visualization and envisioning and, for this reason, I pay attention in this chapter to those things that any art historian might attend to: things that get looked at and things or people that look, as well as the operation of looking itself. In what follows, then, I isolate particular moments or devices in the film so as to point to larger themes. What results is a collection of observations and analyses ranging from an examination of masking (or "facing") to a consideration of what I call the curatorial impulse of Lee's film (its collecting and arraying of images and objects from the past and present), all of which I set into orbit around the larger question of the relationships among race, identity, and looking, with the film's interest in the idea of whiteness (something given little attention in previous writing about *Bamboozled*) always in mind.

Envisioning

Bamboozled stars Damon Wayans as Pierre Delacroix, a screenwriter at the television network CNS (Continental Network System). Delacroix's white boss,

Dunwitty (Michael Rapaport), who professes himself "blacker" than Pierre (and deploys "black" slang and his African American wife and biracial kids to prove it), admonishes him to produce a blockbuster show. Delacroix responds by pitching a pilot so offensive and racist—"Mantan: The New Millennium Minstrel Show," starring two street performers, Manray (Savion Glover) and Womack (Tommy Davidson), who perform in blackface—that, as Delacroix imagines, it will lead to the firing of both him and Dunwitty. Instead, the show becomes a huge hit (as well as the target of protests led by the Reverend Al Sharpton and Johnnie Cochran), with millions of Americans tuning in to watch characters such as Mantan (Manray), Sleep 'n Eat (Womack), Honeycutt, Aunt Jemima, and Lil' Nigger Jim dance and cut up in a watermelon patch on an Alabama plantation. Initially horrified at the evil he has unleashed, Delacroix eventually finds himself defending the show and, awash in self-delusion, believing in its social good. Even his disgusted and disappointed assistant, Sloan Hopkins (Jada Pinkett Smith), finds herself appreciating the show's humor as well as the brilliant performances turned out by its cast. Sloan's brother Julius (Mos Def), who calls himself Big Blak Afrika, and the Mau Maus, the politically minded but fumbling collective of rappers and musicians to which he belongs, respond to the show by kidnapping its star, Mantan, setting off a chain reaction of violence that brings the film to a devastating, murderous close.

The early minutes of *Bamboozled* present us with the film's main character, Pierre Delacroix, in his clock-tower apartment looking at himself in a mirror. A few minutes later Lee gives us a shot of a white man conspicuously avoiding Delacroix's greeting and gaze as the two share an elevator at the headquarters of CNS. In between these two moments, Delacroix looks directly into the camera (at us) and describes, as if after the fact, what he intended by way of his twenty-first-century minstrel show. As an introduction to the film, then, we have Delacroix looking at himself and at us and we have someone not looking at him. This is Lee's way of telling his viewers that looking will be at issue in his story and that our own looking will be implicated in and will assist in generating his narrative. At the center of the film, Lee gives us a show within a show within a show: a minstrel show staged for a studio audience and then broadcast on television, all of this offered up as a spectacle for the viewers of the film. Looking is doubled and tripled here (as it is when we watch the film's protagonists watching vintage footage of minstrelsy on their own small screens) so as to reinforce its central and decisive role.

Lee's characters are not simply bodies that move through the world. Rather they are constituted by the things that surround them, the embodied outcomes of elaborately staged and studied visual displays. We encounter the person of Dunwitty, for example, as one object or image among the many arrayed in his office: African masks, framed posters of African American athletes, original works of art that take African Americans as their subjects (Figure 4.2). Lee compels us to see

Figure 4.2. Dunwitty's office, *Bamboozled*, 2000.

Dunwitty as an integral part of this tableau, showing us not only how his identity, and identity in general, are enmeshed in and thus constituted by the fabric of representation of which an individual is a part but also demonstrating, through the staging of this tableau for the viewer, for *us*, the role of the look in the construction and assignment of identity. In similar but not identical fashion, Delacroix is presented through and as a series of images seen: a clock face, black collectibles (most notably the "Jolly Nigger Bank"), the African mask that frames his face when he enters Dunwitty's office (he has been summoned there after arriving late to a staff meeting) such that he appears to have horns, the board game Othello on the shelf behind his mother as we hear his voice speaking to her over the phone, a framed reproduction of the American painter John Singleton Copley's *Watson and the Shark* (1778) that appears above his office couch, a photograph of a half-grinning, half-snarling Mike Tyson that he passes as he storms out of Dunwitty's office in disgust (Figures 4.3 and 4.4).[6] In choosing to insert Delacroix into this mutating and serial tableau of stereotypical images of blackness—automaton, nigger, devil or cuckold, tragic Moor, hapless underling (in *Watson*), and violent brute—Lee renders literal the idea that looking at someone is a matter of imposing a mask onto the face of that other, that what we see when we look at someone else is a representation generated by that very seeing: the visual cue of dark skin, for example, pushing the eye to see what the mind has been made to know about "blackness." We cannot see Delacroix as he is (whatever he may be), nor can Delacroix fashion himself except by way of imposing other masks—those of whiteness—on his own person.[7] The inescapability of identity as visualization and envisioning is made explicitly manifest at the end of the film, in the scene where Delacroix, facing the imminent murder of Manray at the hands of the Mau Maus, appears to come to grips with what he has done and how he feels about it. Yet self-consciousness and self-perception are figured as the putting on of yet another mask, for Delacroix's breakthrough is signaled by his application of blackface; self-knowledge becomes the seeing of the self-as-image (burnt cork smeared on skin) through the eyes of someone else (consumers of minstrelsy performance).

Throughout Lee's film, he compels us to see characters by way of their reflections, just in case we failed to catch on that for him identity is always a matter of representation and envisioning, of what is shown and what is seen, here figured as

Figure 4.3. Delacroix framed by an African mask in Dunwitty's office, *Bamboozled*, 2000.

Figure 4.4. Poster of Mike Tyson in Dunwitty's office, *Bamboozled*, 2000.

the creation of image through the effect of mirroring: Delacroix in his bathroom mirror or in the rear view mirror of his car (as he drives away from the club where he caught his father's act), or Delacroix reflected in a shiny table surface while interviewed by a radio talk-show host; Manray and Womack reflected in their dressing room mirrors as they "black up" for their starring roles in "Mantan: The New Millennium Minstrel Show," Manray's body reflected in the tabletop on which he dances at Dunwitty's request (Figure 4.5).[8] The film's cinematography

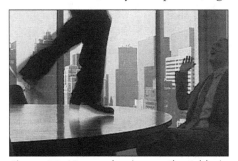

Figure 4.5. Manray dancing on the table in Dunwitty's office, *Bamboozled*, 2000.

provides further reinforcement. Throughout *Bamboozled*, Lee positions the camera so that his scenes are not always windows onto the world, as if seen by the naked eye from an embodied point of view within a linear-perspective scheme; rather, the world of *Bamboozled* is askew, seen from above and below or from around the corner, under the table, or way, way, way down the hall. Such skewing, in that it draws attention to the manner in which a lens frames and constructs a scene, makes the viewer palpably aware of the camera's presence and, by extension, its looking. This awareness, I believe, is meant to register on the viewer's part as an awareness of the world as a thing not simply *there*, but looked at and brought into being by us, as constituted by the gaze as that which we see and know. We recognize the camera as a kind of eye, and as a lens through which an actual eye has looked, and we identify with it as such.

It is no accident that the staging of many of the film's most potent scenes—the changing of Manray's name to Mantan, Manray and Womack's introduction to the history of the minstrelsy tradition, Delacroix's accumulation of black collectibles and his death at the hands of Sloan while in blackface and surrounded by this army of

Figure 4.6. John Singleton Copley, *Watson and the Shark*, 1778, oil on canvas, 71 3/4 x 90 1/2 in., National Gallery of Art, Washington, D.C., Ferdinand Lammot Belin Fund. Image courtesy of the Board of Trustees, National Gallery of Art.

toys and figurines, including the potent Jolly Nigger Bank—occurs under the watch of the Copley painting (Figure 4.6). The work depicts a boat full of men, including one who is black, attempting to save a struggling Brook Watson from a shark attack in Cuba's Havana Harbor (Copley based his painting on an incident that occurred in 1749).[9] The painting has received a great deal of attention on the part of historians of American art and has been interpreted in a variety of ways (Stein, 1976; Boime, 1989; Masur, 1994). Given the centrality of the black figure in the composition (unusual for the time and place) as well as the context of the action (a major port in the network of eighteenth-century transatlantic trade routes) it seems appropriate, as has been suggested, that the painting be understood as bearing some relation to the history of slavery in the New World. As Albert Boime (1989) has argued, the painting, which was commissioned by Watson, a British subject opposed to the American Revolution, may have been meant to evoke the hypocrisy of the American colonies, which agitated for freedom and independence

even as they continued to trade in slaves. Although it is impossible to determine from the film itself whether or not Lee meant to invoke this particular strand of meaning by way of the painting's inclusion, Copley's picture shows up in Delacroix's office for a reason, for nothing about the staging of Lee's scenes and the accoutrements that decorate them is accidental or unmotivated (this is in part what makes the film so visually and iconographically rich). Among other things, the painting serves to foreshadow action and events to come; for example, when Manray and Womack meet with Delacroix and Sloan for the first time, Manray sits on the couch directly beneath the figure of the brutalized Watson (his leg has been ripped off by the shark), a juxtaposition that intimates Manray's murder at the hands of the Mau Maus at the end of the film.

The painting also evokes and comments on Delacroix's own death. Boime (1989) has suggested that Watson's injury is offered up in the work as a kind of judgment for the merchant's own involvement in the transatlantic slave trade, the image thus serving as a plea for absolution, here shown as granted by the black figure, his hand raised as if to pardon the stricken white man. Understood as such, we might take the figure of Watson to be a figure for Delacroix, who Lee posits as engaged in a twenty-first-century version of the slave trade—neo-minstrelsy, or the entertainment industry more generally—and who is consequently punished (killed) for his sins. Neither the painting nor the film truly forgive. The black sailor may raise his hand in a gesture of pardon, but he lets the rope that he holds go slack, as if to say (borrowing from Greenfield's re-voiced minstrel in *Nightmare*): "no absolution for you, mutha fukkah." *Bamboozled* reproduces this tableau—stricken, prostrate sinner lorded over by angry judge—in one of its final scenes, thus creating a literal double of the painting: Sloan stands over Delacroix, arm raised and gun in hand, as Delacroix pleads with her to spare his life (Figure 4.7). This confrontation takes

Figure 4.7. Sloan and Delacroix in front of Copley's painting, *Bamboozled*, 2000.

place directly in front of Copley's picture and mirrors almost exactly the poses of and interaction between black sailor and white Watson in the painting. At this point, we come to understand the painting on another level, as something more than a means of foreshadowing or of fleshing out character. Copley's painting, here and throughout the film, declares in no uncertain terms that who we are can only be what we are represented as, that all of us are nothing more than images cast and seen, like so much paint on canvas or cork on skin. The scene tells us this by making bodies (Sloan's and Delacroix's) and painted apparitions (Copley's figures) utterly inter-

changeable, by making the "real" and representation one and the same.

It should be noted that the inclusion of Copley's painting is but one of many instances where Lee injects the theme of history into his film. He does so by, among other things, exhuming images from the past, constructing makeshift historical archives (of the history of blackface, for instance), or deploying allusions to past events. The most obvious example of Lee's archaeologizing consists of his focus on minstrelsy and its history in the United States, what is made present by way of Delacroix's resurrection of the tradition as well as by the inclusion throughout the film of vintage footage of minstrel shows and blackface performers, by the amassing of black collectibles, and also by way of Sloan's persistent historical research, including her preparation of research portfolios for use by Manray and Womack. Lee also evokes history by way of the ill-fated Mau Maus: the history of black nationalism in the United States as well as the history of European colonization of Africa, for the name "Mau Mau" refers to those who rebelled against British colonial rule in Kenya in the 1940s through 1960, with tragic consequences for the rebels and those sympathetic to them, thousands of whom were killed or executed by British troops (Odhiambo & Lonsdale, 2003; Anderson, 2005). As with Sloan and Delacroix, who mime or analogize the history described in Copley's painting, Lee's Mau Maus, who rebel violently against the minstrel show and what it represents and, as a result, are massacred by the NYPD, exist parallel to if not exactly as a mirror image of the history of Kenya's struggle for independence. On the one hand, such an evocation ennobles the Mau Maus, who are not portrayed in an altogether favorable light by Lee. But on the other, such a link to or imitation of the past—by way of name and by virtue of action—along with the link represented by Sloan and Delacroix's mimicry of the Copley tableau, might be taken as a resignation to the idea that history repeats itself, as a grim surrender to the suspicion that all historical actors are simply characters in a perpetually rerun television show, or automatons set into motion by the press of a button or the turn of a key (as with the Jolly Nigger Bank or a wind-up Sambo doll), mechanistically reprising the same old roles, as if history is itself a continuously looped picture show, a kind of haunting, perhaps, in the end nothing but a series of images that play and replay until the end of time. Repetition or recirculation of images figures prominently in *Bamboozled*—from the repetition and replaying of certain shots throughout the film to the wrenching repetition of images of blackface in scene after scene in the montage at the film's close to the repeated gestures of the toy-automatons that dance the same jig or play the same tune over and over and over again as the credits roll—as if to suggest that our manifestation as representation to ourselves and in the eyes of others, our status as nothing more than image projected onto skin, is as inescapable as death. Even the seeming elasticity and mutability of whiteness—the easy-in easy-out attitude toward ethnicity and racechange available to whites, here represented

by Dunwitty's black act and reinforced by the failure of Delacroix's white one—is nothing more than an illusion, a fantasy of agency with history's and culture's images behind the curtain calling the shots.[10]

Masking

The African masks featured in *Bamboozled* (in Dunwitty's office) that signal Lee's interest in identity as representation and envisioning, that point up how human interaction constitutes looking at bodies in such a way that they *become* representation, clusters of code awaiting a deciphering look, also serve to emphasize, as I began to suggest in the previous section, the manner in which this very code refuses to offer up anything approximating the "real." Lee's film invokes the literal function of a mask—the obscuring of identity behind image—so as to describe how looking is itself a masking operation that voids or absents identities in favor of the images asked to take their place, as if extro-mitted from the eyes doing the seeing. This is the primary function of blackface, what Lee puts at the center of his film: insomuch that blackness manifests and is apprehended as nothing more than a layer of burnt cork, a disembodied, material *thing*, the interaction between the painted face of a blackface minstrel and his/her audience renders blackness as static, empty, absent, and void of agency (both Gubar [1997] and Michael Rogin [1992] describe blackface as a kind of murder).

Lee makes evident the masking and obliterating effects of blackface and the idea that all human interactions and relationships are mediated by the masks we see people as or force them to wear by way of Lee's/Delacroix's virtuoso yet vile resurrection of the blackface minstrelsy tradition. The combination of deplorable content and brilliant execution—the show features Savion Glover, after all, and his and Tommy Davidson's back-and-forth bit in the chicken coop, as an example, is inspired—in large part makes *Bamboozled* such a powerful punch in the gut. The fact that Lee makes his point by staging an actual show—one seen by a studio audience and in turn watched by us—serves to reinforce the idea that the visualization of identity is always the product of a look, that looking itself is a form of masking, and that it is in the space of an exchange between viewer and viewed that both seer and seen are defined. Delacroix's blackface at the end of the movie shows us just how many layers one would have to drill through or excavate in order to begin to see beyond the mask: he imitates black actors in blackface (Manray and Womack) imitating turn-of-the-century (*circa* 1900) black actors in blackface who in turn imitated nineteenth-century white actors in blackface who themselves appropriated their material from caricatures of the ways and airs of whites as performed by slaves and free blacks in the 1830s and 1840s.[11]

Delacroix's blackface thus iterates what Lee sees as the present inescapability of the imposed mask of blackness, here made doubly visible (blackface on black skin), through which others see and define him; unable to register as anything but "black" in the eyes of others, and realizing as much, Delacroix resigns himself to the mask. With this gesture, Lee links what W.E.B. Du Bois (2001,pp. 18–19) called the sensation of double-consciousness—the "sense of always looking at one's self through the eyes of others, of measuring one's soul by the tape of a world that looks on in amused contempt and pity"—to the operations of masking whereby replacing the individual with an image or idea of his/her "kind" (an idea both inspired by and projected onto the surface of his/her skin) brings identity into being. Delacroix is Du Bois's split self, always looking at himself through two sets of eyes and thus unable to see himself as anything but the image he is made out to be (hence his gesture of self-masking). So too, Manray and Womack, who, in watching the animated introduction to the first episode of "Mantan: The New Millennium Minstrel Show," where their characters (Mantan and Sleep 'n Eat) appear as exaggerated versions of their already grotesque minstrel selves, see themselves through the eyes of others as nothing more than two-dimensional, animated images on a television screen, as nothing more than the masks that others force them to wear.

In much the same way that *Bamboozled* works to show how the idea of blackness consists in the making and seeing of image, the construction and imposition of a mask (what blackface literalizes), Lee's film invests in making whiteness visible as yet another mask, that is, as an idea or invention, as opposed to an essence or a thing that just *is* and always has been. The film does so by, among other things, working to make whiteness strange and, I would add, obscene (at least to those for whom whiteness was not already these things), thereby dismantling its false normativity and dislodging its authority.[12] Where white was unmarked, Lee marks it; where it was invisible or absent, Lee makes it present (as blackness has had to be made present—through things like blackface and other stereotypical imagery—in order to ensure the sustenance, but also the invisibility, of whiteness).[13] This is accomplished in the film by way of whiteface, what Margo Jefferson, in reference to the Dunwitty character, has aptly called "a minstrelized performance of whiteness" (Minding the Messenger, 2001).

Lee signals the device of whiteface at the beginning of the film, where we see Delacroix fastidiously applying bright white shaving cream to his bald head and skimming it off in slow and

Figure 4.8. Delacroix shaving his head, *Bamboozled,* 2000.

studied semicircular strokes with a razor, as if engaged in a kind of ritual (Figure 4.8). The gesture evokes bodily adornment more than it does routine morning hygiene and, as such, must be understood in relation to the central ritual of the film: blackface and, in particular, Manray and Womack's ritualistic (and, thanks to Sloan, historically accurate) blacking up. That the final scene of the drama gives us Delacroix in blackface only reinforces the idea that we should see this first instance of Delacroix's laying on of color in similar terms, and that we should understand Delacroix, who acts stereotypically white (just as Dunwitty acts stereotypically black), as just one more character in the minstrel show of the modern age. The careful scraping off of shaving cream after its application may be read as a figure for the unacknowledged and unseen existence of a white mask to rival that of blackness (the mask is there, but it has been rendered invisible), what Ralph Ellison (1995) characterized as a counterfeit identity passing tragically for truth. Whiteness's visibility is made such by virtue of our witnessing its removal from view and its subsequent sublimation or secretion in Delacroix's affected speech and in the giddy, desperate top-o-the-morning-to-you greetings he dispenses to his coworkers at CNS (not to mention his enrollment in a Pilates class, which in the film, as with his speech and his goofy greetings, encodes his behavior as "white"); these exaggerated affectations register as anything but natural and their jarring and bizarre effects work to make us see whiteness as something unnatural, abnormal, and odd.[14] A sly and potent twist on the "Optic White" paint of Ellison's *Invisible Man*, the shaving cream scene illuminates the manufactured nature of whiteness as well as its locatedness in optical effects and their envisioning. Ellison's protagonist and his coworkers at Liberty Paints devote assiduous attention to the complex chemical concoction of the whitest of all white paints ("our white is so white you can paint a chunka coal and you'd have to crack it open with a sledge hammer to prove it wasn't white clear through!") so as to create the illusion of snowy purity; despite the fact that it is shot through with tones of gray, the paint is *seen* as white by Kimbro, the boss, and thus judged to be such, what serves as a metaphor for the manner in which racial identity is located in or assigned to what is available to the eye (Ellison, 1972, p. 190). Delacroix's "whiting up," smears of shaving cream replacing strokes of Optic White, the wiping away of foam analogous to the willing away of tarnishing gray, similarly describes identity as an optical drama wherein representation (the thing seen) replaces subjectivity and is read as the real. In *Bamboozled*, an individual is constituted by putting on and/or taking off a mask so that others see him/her in a particular way, or by being made to wear a mask (black, white, or otherwise) by those who look.

One might compare Delacroix's clock tower apartment (where the shaving scene unfolds), with its huge circular window and the blinding light that it lets in, to the basement hovel occupied by Ellison's (1972) narrator, where 1,369 light bulbs eliminate all trace of darkness and shadow. Both are places that figure a desire to

Figure 4.9. Delacroix in front of clock-face window in his apartment, *Bamboozled*, 2000.

be seen (writes Ellison [1972, p. 499]: "Without light I am not only invisible, but formless as well"), but for Delacroix, this being seen is contingent on a kind of whiting-out, the substitution of one mask for another (what Ellison's [1972] narrator disparaged as a misguided striving toward whiteness). Indeed, in the opening scenes of *Bamboozled*, Lee shoots directly into the sun as it pours through the clock-face window, so that parts of Delacroix's face appear as if devoured by the morning light, rays of sun dissolving his flesh in a white-hot glow (Figure 4.9). Unlike Ellison's basement dweller, who will shed his old skin and leave it behind when he leaves his hole, Delacroix paints on a new one, but he is no better off than before; whiteness, Lee seems to be saying, is as illusory and false as any other racial mask, and just as obscene.[15]

Curating

In *Invisible Man*, Ellison's protagonist wakes up one morning at Mary's place, where he has rented a room while in New York, and sees adjacent to his bedroom door something he had not noticed before:

> the cast-iron figure of a very black, red-lipped and wide-mouthed Negro, whose white eyes stared up at me from the floor, his face an enormous grin, his single large black hand held palm up before his chest. It was a bank, a piece of early Americana, the kind of bank which, if a coin is placed in the hand and a lever pressed upon the back, will raise its arm and flip the coin into the grinning mouth. (Ellison, 1972, p. 277)

Horrified at Mary's possession of such a hateful and "self-mocking" image in her home, he smashes it repeatedly against the heat pipes that run through his room until it shatters, coins pouring out as if spilt innards. In a state of panic and wishing to hide the bank's destruction from Mary, he bundles up the coins and shards into a package that he conceals in his overcoat, planning to dispose of it on his way downtown. His attempt to deposit the bundle in the trash in the alleyway behind Mary's house is foiled by a woman who doesn't take kindly to strangers (especially uncouth blacks from the south) throwing any old thing in her cans. He then deposits the package curbside as he crosses the street, but a man, thinking he dropped it by mistake, retrieves it and chases him down; forced to accept the

detested bundle, he puts it in his briefcase and carries it with him, making a mental note to dispose of it later in the day. However, it is not until months later that he recalls its presence there and realizes that he has been carrying it with him every day. Unable to rid himself of it, although desperate to do so, and subsequently shadowed by it wherever he goes, he, in a sense, has been haunted by the bank, as a murderer is tormented by the ghost of his slain victim (or, one might say, as Du Bois's African American is shadowed by his double, the self seen through the fear- or hate-filled eyes of others).

A similar haunting occurs in *Bamboozled*. When Delacroix's minstrel show becomes a hit, Sloan presents him with a congratulatory gift: a vintage piggy bank that matches the description of the haunting bank in *Invisible Man* and, as Sloan explains, goes by the name "Jolly Nigger Bank" (Figure 4.10). Close-ups of the bank alternate with shots of Sloan and Delacroix taking turns depositing coins into the bank's red-lipped and disfigured mouth; the high-pitched clanking sound of each coin falling against the cast iron

Figure 4.10. "Jolly Nigger Bank," *Bamboozled*, 2000.

walls of the repository shatters the tense silence of the scene. As the film proceeds and Delacroix's show becomes a sensation, his office fills with black collectibles in the "Jolly Nigger Bank" vein (including a children's game called "Bamboozled" with a grinning figure in blackface on its box, what is in fact a painting in Lee's collection by the contemporary artist Michael Ray Charles, who served as a visual consultant for the film) (Figure 4.11). Shortly after he fires Sloan for opening Manray's eyes to the history, meaning, and implications of the blackface the latter wears, and having been vigorously scolded by his tearful mother for putting a "coon" show on the air, Delacroix sits alone in his office and hallucinates that the bank comes to life, its arm slapping back and forth, hand striking at mouth as it feeds itself invisible coins. A bit later, the hallucination repeats itself; as Delacroix sits in his office awaiting the outcome of the Mau Maus' kidnapping of Manray, the bank appears to a horrified Delacroix to be moving on its own, the clank-clank of hand against mouth more vigorous and far more unsettling than before. Much as was Ellison's protagonist, Delacroix is here presented as haunted by an image, driven near-mad by an inanimate object that derives its agency and power from the looks it receives: that of Delacroix, who hallucinates its animation, and those of historical viewers, who have been taught through their envisioning of images or spectacles such as this one to see blackness through the mask of just such a grinning and corked-up face.[16]

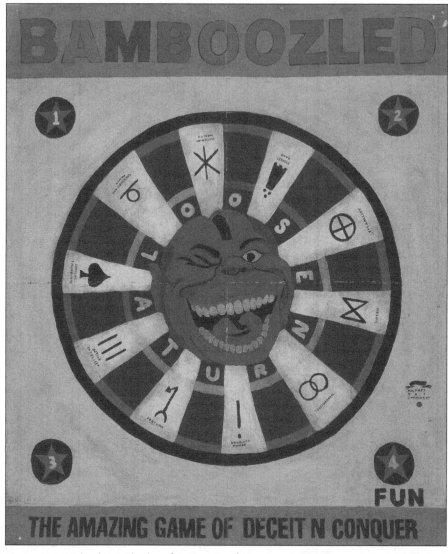

Figure 4.11. Michael Ray Charles, *(Forever Free) Bamboozled,* 1997, courtesy Tony Shafrazi Gallery.

A way for Lee to express in visual terms Delacroix's tragic but inevitable capitulation to the racist mask he has striven to avoid being seen through and as, these accumulating collectibles—shelf after shelf of blackface toys and figurines—along with the haunted Jolly Nigger Bank, also serve to raise a series of questions about the stakes of looking at racist images (from footage of blackface performances to blackface artifacts) and the power or agency that inheres in this looking. I say this because what Lee does in his film is, in essence, collect and curate; he amasses and

arrays images and objects from history much as if he were installing a museum exhibition, complete with video monitors (here, spooling historical clips) to supplement and illuminate the objects showcased on walls and in vitrines. The masks and other *objets d'art* displayed in Dunwitty's suite make Lee's allusion to museum collection and display manifestly clear, as does the display of Copley's *Watson and the Shark* on Delacroix's office wall. Indeed, the manner in which Lee stages his characters' offices as collections of objects that, collectively and by way of the manner in which they are arrayed, present a narrative about the subject on view, not only evokes the techniques of narrative and display employed by museums of art, but also calls to mind the dioramas of natural history museums where human and animal bodies are contextualized and made to mean by virtue of the accoutrement-filled settings that their artist and scientist keepers create for them (these staged spaces also recall the history of the exhibition of humans—African, African American, Native American, and otherwise—at fairs, zoos, and laboratories in Europe and the United States) (Lindfors, 1999; Holmes, 2007). And the collecting, amassing, and displaying that Lee undertakes in the space of his film seem also to evoke a kind of archiving, the creation of a store of images and objects that, collectively, provides access to ideas and events of the past (and present), here the tradition of minstrelsy, one that Lee understands to be alive and kicking, its invisible yet toxic presence in entertainment and popular culture haunting us as the Jolly Nigger Bank haunted Delacroix and his predecessor in *Invisible Man*. Lee signals his interest in the idea of an archive—understood as a collection but also as a selection of images that reflects and constitutes ideology—by, among other things, Sloan's recourse to the archival in her research into the history of the minstrel show, from her careful documentation and reproduction of the process of blacking-up to her creation of portfolios of images and information for use by Manray and Womack, the latter amounting to the creation of an archive or, one could say, an exhibition in miniature.[17]

In positing *Bamboozled* as a kind of museum space, where objects and images are collected and put on display and the featured exhibition consists of a minstrel show supplemented by related artifacts—the Jolly Nigger Bank among them, its spectral mien an evocation of the exhuming and archaeologizing of the past undertaken in a museum setting—Lee asks a series of questions analogous to those asked by theorists of museum culture and museum spaces who are interested in the power and agency of display: What is at stake in deliberately and studiously collecting and arraying racist images and in the viewing that such images and displays invite and evoke? What is at stake in *showing* these things, in asking people to look at them again and again? What happens, exactly, in the space of this exchange between viewer and viewed?

Lee is not the first to ask this question of black collectibles and other racist

imagery, of course, although *Bamboozled* helped generate an ongoing conversation on the subject (Ebert, 2000; Minding the Messenger, 2001; Wallace, 2001; Nyong'o, 2002; Harris, 2003). In "The Blackface stereotype," an essay written to accompany a series of striking and subversive photographs of black collectibles taken by David Levinthal, Manthia Diawara (1999, p. 7) undertakes to account for what he calls "the current resurgence of interest in Blackface memorabilia" among collectors, and black collectors especially.[18] As does Lee, Diawara sets aside debates about positive and negative images so as to focus on the acts and implications of collecting and displaying; he locates power in the appropriation and subsequent corruption and deformation of blackface stereotypes as brought about by the imposition of new content and meaning. As examples, he cites the work of the contemporary artists David Hammons and Kara Walker (Figure 4.12). We might add Greenfield's manipulated and text-adorned photographs of blackface performers to this list (recall that Greenfield described his work as a form of exorcism, something like what Diawara evokes in his description of strategies that employ reclamation, evacuation, and reconstitution but, importantly, not the total obliteration that exorcism desires), as well as the work of Michael Ray Charles, which appropriates and restages blackface stereotypes, as in the aforementioned painting that shares its title with Lee's film as well as *Hello, I'm Your New Neighbor* (Figure 4.13), both of which come from Charles's series "Forever Free." Of Charles, Lee (1998, p. 3) has said, "He makes you laugh while he's killing you," a statement that could easily describe the effect of Lee's own film.

Yet the fact that the *New York Times* refused to print ads for *Bamboozled* testi-

Figure 4.12. Kara Walker, *Crest of Pine Mountain. Harper's Pictorial History of the Civil War (Annotated)*, 2005, offset lithograph and silkscreen on white wove paper, 39 x 45 in., Princeton University Art Museum. Museum purchase, Kathleen Compton Sherrerd Fund for Acquisitions in American Art, 2005-78. Photo: Jeff Evans. © Photo: Trustees of Princeton University.

Figure 4.13. Michael Ray Charles, *(Forever Free) Hello, I'm Your New Neighbor*, 1997, courtesy Tony Shafrazi Gallery.

fies to the discomfort many people feel when confronted with such imagery and echoes the criticism leveled by various artists and critics against art, like that of Walker and Charles, that makes contemporary use of blackface imagery or other racial stereotypes from the past; the image that adorns the DVD release of *Bamboozled* and which features an ink-black, clown-lipped, and corn-rowed child— a so-called "Pickaninny"—clutching a watermelon and standing in a cotton field (Figure 4.14) gives some idea as to why the ad campaign met with resistance and

Figure 4.14. *Bamboozled* poster, Copyright MM, New Line Productions, Inc. All rights reserved. Poster appears courtesy of New Line Productions, Inc.

discomfort (*New York Times*, 2000). The devastating power of such imagery, some argue, cannot be overcome by recontextualization or reconfiguration, and to reintroduce this imagery into circulation, even in transgressive form, only reproduces its original dehumanizing effects (Diawara, 1999).[19]

Lee, it hardly needs saying, would argue otherwise—"I'm of that school that thinks we should show that stuff," he has said (Crowdus & Georgakas, 2001, p. 7)—and he does so with a vengeance in *Bamboozled*, what I take to be an attempt to build a moving and constantly mutating museum, or at least the foundation for one, where looking at blackface is restaged in such a way, as it is to literal effect in the film itself, so that this act of looking becomes something other than what it originally was: not a looking that distorts and reifies, marks and masks, but a looking that exposes these very processes for what they are. Lee, then, puts

looking itself on display in *Bamboozled*'s museum, such that the history of looking is articulated, showcased, and beheld. In the same way that Greenfield reconfigures envisioning in *Nightmare* and the rest of the "Blackatcha" series—so that masks return the gaze and even speak—and in a manner similar to the artist Fred Wilson's "mining" of the Maryland Historical Society in 1992, where he re-arrayed its collection and archives so that long-suppressed aspects of Maryland history, as well as the museum- and display-based processes by which this history was suppressed, came to light—Lee's minstrel show and the black collectibles he puts on display tell a history not just by showing what that history looked like but by making manifest the work of visualizing and envisioning that brought that history (and those images) into being (Wilson, 1994). In forcing us to re-look at blackface and blackface minstrelsy in the space of a movie-museum that puts the very act of looking, along with its effects, on view, Lee, curating against a deep historical grain, gives us something like an anti-museum, an array of artifacts (from piggy banks to human beings) that refuse to be contained, that work to shatter the structures of sight that in the past

had confined these artifacts to the invisible but always-present glass cases of racism's, and whiteness's, vision of the world.[20] One might understand Lee's anti-museum as a scripted haunting, where he makes the past present and forces us to grapple with tragic memories and vile ghosts (as we must when faced with Walker's art [Berry, English, Patterson, & Reinhardt, 2003; Shaw, 2004]), all in a carefully configured and choreographed space that struggles to make certain that we confront such memories and ghosts with new eyes, that aims to ensure that looking at these things doesn't amount to more of what Lee, through Womack, calls "the same old shit." With haunting, the idea appears to be, comes a reconfigured agency: seen anew, looked at another way, Jolly Nigger Banks, dancing Sambos, and Pickaninnies in cotton patches now expose and eviscerate the very masks they wear, the masks that reflected off sleek porcelain and shiny metal bodies and burned into the skin of those they were created to caricature.

Bamboozled's Double-Bind

There is good looking and bad looking at Lee's museum. Delacroix's accumulation of racist imagery and objects represents a failed project of re-envisioning, whereas Sloan's collection of clips is meant to stand as a successful reconfiguration of the way we look and see; yet it is not perfectly clear, in the end, which mode of vision rules the day.[21] *Bamboozled* articulates in no uncertain terms what Richard Dyer (1997, p. 1) has said about the place of representations of race and ethnicity in contemporary culture: "racial imagery," he writes in *White*, "is central to the organization of the modern world." Indeed, Lee's film appears to resign itself to this fact, or at least a version of it: identity, at bottom, entails masking or "facing," whether self-imposed or otherwise. We are all minstrels, *Bamboozled* seems to suggest, representations rather than "real" selves because all of us are constituted by what of us is seen; we are all "masking jokers," in Ralph Ellison's words (1995, p. 109), engrossed in fooling ourselves that what we see is how it is. Such resignation rules the day, it seems, because Lee comprehends that such imagery, as understood in the broadest of terms—from pictures to people's bodies—along with the identities mashed together from this imagery, are a function of the seeing that brings them into being, of us just looking at other people and piecing them together—encoding them bit by bit—based on what and how we see. Because we cannot stop looking, Lee seems to be saying, because the world already appears to us as if a museum, everything on display, we (*all* of us) cannot dismantle the connection between identity and visibility, perceived essence and envisioning, at least not without great difficulty or a radical (perhaps impossible) reorientation of our perceptual sets. Along with the "black" man of *Nightmare* whose "mutha fukkah" registers anger and bitterness at

being made/defined/identified by virtue of being looked at, Lee's movie-museum shows us the double-bind of vision: seeing is the problem and the solution at one and the same time. Greenfield makes his viewers see their own seeing (with eye chart and white screen as emblems and instigators of the operations of vision), what before operated invisibly and with impunity, suggesting as he does that until we envision what our vision does, we cannot move ahead so as to dismantle the operations of this self-same sight. Lee's film makes us look and participate in the envisioning that creates and sustains racial identities and stereotypes; looking is the thing that his film forces on us frame after frame (look at me, look at this, don't drop your eyes, you know you want to look). He thus shows us how looking—at minstrelsy, at black collectibles, at racist images previously shoved under the rug or left to rot in hidden archives—and how looking's reconfiguration, by way of something like a movie-museum whose displays dismantle our habitual, historical, and haunted sight, may in the end provide the only way out.

Notes

1. The granting of visual agency to the individual depicted—giving him the power to look—reverses even as it draws attention to historical prohibitions against black looking under slavery and segregation (hooks, 1992).

2. Michael Rogin (1992) considers the idea of epidermal consciousness in relation to blackface. See Pinder (2002) for further discussion of Fanon's understanding of the visibility of race (as understood in terms of multiracial identity and contemporary art in the United States).

3. See also Rogin, 1992; Lott, 1993; and Roediger, 1999, pp. 115–131.

4. For a discussion of the "white look," something similar to what I describe here, see Roediger, "White looks: Hairy apes, true stories, and Limbaugh's laughs," in Hill, 1997.

5. In his illuminating analysis of *Bamboozled*, W.J.T. Mitchell (2005, pp. 301, 308), in describing the film's articulation of "the very process by which race is pictured," discusses Lee's interest in the power of images and makes a claim related to the argument that I will make here, calling the film "a metapicture—a picture about pictures, a picture that conducts a self-conscious inquiry into the life of images, especially racial images, and the way they circulate in media and everyday life."

6. I thank Gisela Carbonell-Coll for drawing my attention to the presence of Copley's painting in the film.

7. Lee's reference to Othello evokes both Hollywood's stereotyped visions of Shakespeare's Moor, wherein blackness and tragedy are mutually implicated, as well one of the play's major themes: the inability to see beyond falsehoods and lies—to discern the gap between appearance and reality—and understand others for what they truly are. As with many of Lee's allusions—from Copley to Ellison—his allusion to Othello may be read in multiple, even contradictory ways.

8. Identity, in *Bamboozled*, is of course also a function of what is heard (inflections of speech,

choice of vocabulary, the adoption or rejection of various forms of slang or colloquial speech); Delacroix's affected accent is particularly important in this regard.

9. Naming and renaming play a significant thematic role in *Bamboozled*—Pierre/Peerless; Julius/Big Blak Afrika; black/blak; the Mau Maus; the verbal fumbling of one of the white CNS writers as he struggles to find a proper designation for African Americans—and Lee's exploration of the implications of such name changes (imposed and self-declared) constitutes part of the film's larger exploration of identity and its construction.

10. For discussion of the relative ease with which those identified as white may racechange as compared to those identified as not white, see Gubar, 1997, esp. chaps. 1, 2, and 4.

11. For the history of blackface, see Cockrell, 1997; Gubar, 1997, esp. chaps. 1 and 2; Lott, 1993; Mahar, 1998; Rogin, 2002; Saxton, 1975; Toll, 1974.

12. I borrow the idea of strangeness from Richard Dyer (1997) and that of obscenity from Amelia Jones (Stallings, Gonzales-Day, Jones, & Roediger, 2003). As bell hooks (1992) has pointed out, such strangeness is not a new thing for many African Americans for whom whiteness can connote not just the strange but also the terrorizing. I should note here that my discussion of whiteness as articulated and explored in *Bamboozled* owes much to Dyer's study (1997, esp. chaps. 1 and 2).

13. See Dyer (1997). Toni Morrison's (1992) groundbreaking *Playing in the dark: Whiteness and the literary imagination* is one of the most important and eloquent examinations of the dependence of "whiteness" on the visible presence of its perceived converse, "blackness." See also Ralph Ellison, "What America would be like without Blacks" (1970), in Roediger, 1998, pp. 165–166, where the author describes blackness as "a marker, a symbol of limits" for defining American-ness and/as whiteness.

14. Lee plays fast and loose with stereotypes in *Bamboozled*, something that many critics found troubling, self-defeating, reactionary, or dangerous.

15. By this I do not mean to suggest that Lee posits whiteness as harmless and easily dispensed with; rather, Delacroix's death is a metaphor for the tragic and violent material/historical consequences of the invention and sustenance of the idea of whiteness.

16. For more on images and agency, see Mitchell, 2005.

17. For discussion of *Bamboozled* and the idea of the archive see Wallace, 2001. Here, Wallace, as she did as a panelist at a discussion of Lee's film at New York University (Minding the messenger, 2001), suggests that Lee misrepresents the rich if at times troubling history of black performance by presenting only a partial archive and doing so in a manner that decontextualizes what is presented.

18. It is worth noting that a number of the black collectibles seen in the film are from Lee's own collection (Crowdus & Georgakas, 2001).

19. For further discussion and debate regarding the meanings, effects, and contemporary uses of black collectibles (also called black memorabilia), see Goings, 1994; Harris, 2003; and The Past Is Prologue, 1997.

20. For a related discussion of Lee and curating, see Nyong'o, 2002.

21. One might also see Delacroix's collecting as a form of curating, wherein the amassing and display of black collectibles, and by extension the (desired) knowledge and control over such things, functions in a manner analogous to that described by bell hooks (1992 p. 166) regarding blacks' curiosity about whites: "as though such knowing worn like an amulet, a

mask, will ward away the evil, the terror."

References

After Whiteness. (Exhibition) (2003). Chicago: Ispace.

Anderson, D. (2005). *Histories of the hanged: Britain's dirty war in Kenya and the end of empire.* London: Weidenfeld & Nicolson.

Appiah, K.A., & H.L. Gates, Jr. (1992). Editor's introduction: Multiplying identities. *Critical Inquiry, 18,* 628.

Baldwin, J. (1998 [1984]). On being 'White'... and other lies. In David R. Roediger (Ed.), *Black on White: Black writers on what it means to be White* (pp. 177–180). New York: Schocken Books.

Berger, M. (1999). *White lies: Race and the myths of Whiteness.* New York: Farrar, Straus, and Giroux.

———. (Ed.) (2004). *White: Whiteness and race in contemporary art.* Baltimore, MD: Center for Art and Visual Culture, University of Maryland Baltimore County.

Berry, I., D. English, V. Patterson, & M. Reinhardt (Eds.) (2003). *Kara Walker: Narratives of a Negress.* Cambridge, MA: The MIT Press.

Bhabha, H.K. (1983). The other question: The stereotype and colonial discourse. *Screen, 24,* 18–36.

———. (1984). Of mimicry and man: The ambivalence of colonial discourse. *October, 28,* 125–133.

Boime, A. (1989). Blacks in shark-infested waters: Visual encodings of racism in Copley and Homer. *Smithsonian Studies in American Art, 3,* 18–47.

Cockrell, D. (1997). *Demons of disorder: Early Blackface minstrels and their world.* Cambridge: Cambridge University Press.

Crowdus, G., & D. Georgakas. (2001). Thinking about the power of Images: An interview with Spike Lee. *Cineaste, 26,* 4–9.

Cuomo, C.J., & K.Q. Hall. (Eds.) (1999). *Whiteness: feminist philosophical reflections.* Lanham, MD: Rowman and Littlefield.

Diawara, M. (1999). The Blackface stereotype. In David Levinthal, *Blackface* (pp. 7–17). New York: Arena Editions.

Du Bois, W.E.B. (1990 [1920]). The souls of White folk. In *Darkwater: Voices from within the veil* (pp. 17–29). Mineola, NY: Dover Publications.

———. (2001. [1903]). Of our spiritual strivings. In *The souls of Black folk: Essays and sketches.* Chicago: A.C. McClurg & Co. In Patricia Hills (Ed.), *Modern art in the U.S.A.: Issues and controversies of the 20th century* (pp. 18–19). Upper Saddle River, NJ: Prentice Hall.

Dyer, R. (1997). *White.* New York and London: Routledge.

Ebert, R. (2000). Bamboozled. Retrieved July 30, 2005, from http://rogerebert.suntimes.com/ apps/pbcs.dll/article?AID=/20001006/REVIEWS/10060301/1023

Ellison, R. (1972 [1952]). *Invisible man.* New York: Signet.

———. (1995. [1958]). Change the joke and slip the yoke. In John F. Callahan (Ed.), *The collected essays of Ralph Ellison* (pp. 100–112). New York: The Modern Library.

Fanon, F. (1967 [1952]). *Black skin, white masks* (Charles Lam Markmann, Trans.). New York: Grove.

Goings, K.W. (1994). *Mammy and Uncle Mose: Black collectibles and American stereotyping.*

Bloomington, IN: Indiana University Press.

Gubar, S. (1997). *Racechanges: White skin, Black face in American culture.* New York: Oxford University Press.

Hall, S. (1988). New ethnicities. In Kobena Mercer (Ed.), *Black film/British cinema, ICA documents 7* (pp. 27–31). London: British Film Institute/Institute of Contemporary Arts.

Harris, M.D. (2003). *Colored pictures: race and visual representation.* Chapel Hill: University of North Carolina Press.

Hill, M. (Ed.) (1997). *Whiteness: A critical reader.* New York and London: New York University Press.

Holmes, R. (2007). *The Hottentot Venus: The life and death of Saartjie Baartman, born 1789–buried 2002.* London and New York: Bloomsbury.

hooks, b. (1992). *Black looks: Race and representation.* Boston, MA: South End Press.

Kincheloe, J.L., S.R. Steinberg, N.M. Rodriguez, & R.E. Chennault (Eds.) (1998). *White reign: Deploying Whiteness in America.* New York: St. Martin's Press.

Lee, S. (1998). (No title). In *Michael Ray Charles* (p. 3). New York: Tony Shafrazi Gallery.

The legacy of Blackface: Artists take on roots of racist performance tradition. (nd.). Retrieved August 15, 2005, from http://www.npr.org/templates/story/story.php?storyId=1919122

Lindfors, B. (Ed.) (1999). *Africans on stage: Studies in ethnological show business.* Bloomington: Indiana University Press.

Lott, E. (1992). Love and theft: The racial unconscious of Blackface minstrelsy. *Representations, 39,* 23–50.

———. (1993). *Love and theft: Blackface minstrelsy and the American working class.* New York: Oxford University Press.

Mahar, W.J. (1998). *Behind the burnt cork mask: Early Blackface minstrelsy and antebellum American popular culture.* Champaign, IL: University of Illinois Press.

Masur, L. (1994). Reading Watson and the Shark. *The New England Quarterly, 67,* 427–54.

Minding the messenger: A symposium on *Bamboozled.* (2001). *Black Renaissance/Renaissance Noire, 3,* 8–32.

Mitchell, W.J.T. (2005). *What do pictures want? The lives and loves of images.* Chicago and London: University of Chicago Press.

Morrison, T. (1992). *Playing in the dark: Whiteness and the literary imagination.* Cambridge, MA: Harvard University Press.

New York Times turned down ads for Spike Lee film. (2000). Retrieved May 25, 2007, from http://www.imdb.com/title/tt0215545/news

Nyong'o, T. (2002). Racial kitsch and Black performance. *Yale Journal of Criticism, 15,* 371–391.

Odhiambo, E.S.A., & J. Lonsdale (Eds.) (2003). *Mau Mau and nationhood: Arms, authority, and narration.* Oxford: James Currey; Nairobi: EAEP; Athens, OH: Ohio University Press.

The past is prologue but is parody and pastiche progress? A conversation. (1997). *International Review of African American Art, 14,* 17–29.

Pinder, K.N. (2002). Biraciality and nationhood in contemporary American art. In K.N. Pinder (Ed.), *Race-ing art history: Critical readings in race and art history* (pp. 391–401). New York and London: Routledge.

Piper, A. (2001). Whiteless. *The Art Journal, 60,* 63–65.

Roediger, D.R. (1999). *The wages of Whiteness: Race and the making of the American working class*

(rev. ed.). New York and London: Verso.

———. (2002). *Colored White: Transcending the racial past*. Berkeley and Los Angeles: University of California Press, 2002.

———. (Ed.) (1998). *Black on White: Black writers on what it means to be White*. New York: Schocken Books.

Rogin, M. (1992). Blackface, White noise: The Jewish jazz singer finds his voice. *Critical Inquiry, 18*, 417–453.

———. (2002). *Blackface, White noise: Jewish immigrants in the Hollywood melting pot*. Berkeley and Los Angeles: University of California Press.

Saxton, A. (1975). Blackface minstrelsy and Jacksonian ideology. *American Quarterly, 27*, 3–21.

Shaw, G.D. (2004). *Seeing the unspeakable: The art of Kara Walker*. Durham: Duke University Press.

Stallings, T., K. Gonzales-Day, A. Jones, & D.R. Roediger (2003). *Whiteness: A wayward construction*. Laguna Beach, CA: Laguna Art Museum.

Stein, R. (1976). Copley's "Watson and the Shark" and aesthetics in the 1770s. In Calvin Israel (Ed.), *Discoveries and considerations: Essays on early American literature and aesthetics presented to Harold Jantz* (pp. 85–130). Albany, NY: State University of New York Press.

Talty, S. (2003). *Mulatto America: At the crossroads of Black and White culture: A social history*. New York: HarperCollins.

Toll, R.C. (1974). *Blacking up: The minstrel show in nineteenth-century America*. New York and Oxford: Oxford University Press.

Wallace, M. (2001). *Bamboozled*: The legacy. *Black Renaissance/Renaissance Noire, 3*, 33–38.

Wilson, F. (1994). *Mining the museum: An installation* (L.G. Corrin, Ed.). Baltimore: Contemporary; New York: New Press.

Wray, M. & A. Newitz (Eds.) (1997). *White Trash: Race and Class in America*. New York: Routledge.

Yancy, G. (Ed.) (2004). *What White looks like: African-American philosophers on the Whiteness question*. New York and London: Routledge.

Ya Been Took, Ya Been Hoodwinked, Ya Been Bamboozled

Mau Maus, Diaspora, and the Mediated Misrepresentation of Blacks

TRACEY OWENS PATTON AND DEBORAH MCGRIFF

Our chapter examines discourses of African diasporic consciousness and postcolonialism as presented in the 2000 film, *Bamboozled*, written and directed by Spike Lee. Specifically, we are concerned with making sense of Lee's presentation of a group he dubs the Mau Maus—a black nationalist coalition situated within and inspired by hip hop culture. In the context of black Atlantic intellectualism as well as select Pan-Africanist ideologies related to the Mau Maus of Kenya, our central position is that in presenting the Mau Maus, their nationalist rhetoric, and African diasporic attachments within the context of the satiristic *Bamboozled*, Lee is making a claim about America's twenty-first-century misunderstanding of the African diaspora. Lee is also commenting on the cultural and political history of the continent of Africa, its relationship to the West as a result of the slave trade and colonialism, Africa's neocolonialism struggles, and the U.S. response to its revolutionary movements. Finally, Lee is making a discursive claim about the Kenyan Mau Mau movement as he uses their revolution and illustrates black people's complicity with the structural-cultural diaspora.

In order to explore the multilayered meanings of diaspora and postcolonialism, we first advance the importance of diasporic critique. Second, a brief critical analysis of the history of the Mau Maus in Kenya is presented while linking this analysis with the meanings surrounding Lee's presentation of the Mau Maus in

Bamboozled. Finally, we critically analyze Lee's Mau Maus through the structural-cultural dialectic of diaspora.

A Critical Review of Structural and Cultural Diaspora

Nkrumah posited,

> the fact that I speak English does not make me an Englishman. Similarly, the fact that some of us speak French or Portuguese does not make us Frenchmen or Portuguese. We are Africans first and last, and as Africans our best interests can only be served by uniting within an African Community. Neither the Commonwealth nor a Franco-African Community can be a substitute. (Hadjor, 1988, p. 89)

Nkrumah's quote demonstrated an assertion about diasporic identities that is not confined to a specific geographic area, location, or even language because diaspora is the combination of both fluidity and fixity. Diaspora refers to a group of people who share a common cultural heritage who have been dispersed from their traditional homeland, country, or region. James Clifford, professor of History of Consciousness, noted that diaspora is a term that has been widely used in decolonization, global communication, immigration, and travel within and across nations. "Diasporas usually presupposed longer distances and a separation more like exile: a constitutive taboo on return, or its postponement to a remote future. Diasporas also connect multiple communities of a dispersed population" (1997, p. 246). Political Science professor Cedric Robinson (1983) noted that "before the African and New World Black liberation movements of the post-Second World War era, few Western scholars of the African experience had any conception of the existence of an ideologically based or epistemologically coherent historical tradition of Black radicalism" (p. 95). Diasporic movements with reference to "identities, cultures, ethnicities and group formations" with respect to geography, space, or time went unacknowledged as they were seen as "ideological movements," not diasporic movements (p. 96). Part of this invisibility as Clifford aptly noted, seems to be "complexly related to Africa and the Americas, to shared histories of enslavement, racist subordination, cultural survival, hybridization, resistance, and political rebellion" (1997, p. 252). While many immigrant groups construct their identity in ways that allow them to gain political status, influence local and national politics, create resistance movements, or harbor romantic appeals for the country they left behind; for example, the "old country," not all "diasporic populations come from elsewhere in the same way that 'immigrants' do. For example, in assimilationist national ideologies such as those of the United States, immigrants may experience loss and nostalgia, but only en route to the welcoming ideals of a new home in a new place. Such ideologies are

designed to integrate immigrants, not people in diasporas" (Clifford, 1997, p. 250). Diasporic groups often do not or cannot fully assimilate into mainstream culture and this may be true for Africans in American, British, and Caribbean cultures, to name a few, since there is no teleology of return. In addition, groups who are subject to structural prejudice may not have the opportunity to assimilate as other groups who may be able to adopt the myth/history of the nation-state (Clifford, 1997, pp. 249–251). Therefore, diaspora represents transnationality, political struggles, local community, and historical displacement (p. 252).

Diaspora is a term that signals a shift in thinking about ethnic minorities because it acknowledges cultural fluidity, transnationalism, and multilayered discursive positionality and "how these are sustained within the cultural boundaries of diasporic experience" (Cottle, 2000, p. 26). Further, diaspora offers a more complicated outlook on understanding ethnic minorities. Oftentimes diasporic experiences are examined in a unidirectional perspective, one culture to the United States.

How would diasporic movements look, in this case the Kenyan Mau Mau movement, if the movement was *from* the United States to Africa? As it has been well established, the Italian invasion of Ethiopia in 1935 and the fifth Pan-African Conference in Manchester in 1945 are credited with bringing an awareness of Pan-Africanism, which was rooted in the black diaspora of the Americas, to Africa (Birmingham, 1998). It is this significant diasporic movement that is reflected in the speech and actions of the *Bamboozled* Mau Maus. Their goal, like the conference in Manchester, was to create "a ground swell of black aspiration and solidarity" (Birmingham, 1998, p. 7).

As intercultural scholars Jolanta Drzewiecka and Rona Tamiko Halualani illustrated, "the dispersions of peoples lead to the fragmentation of culture and to fluid notions of identity, [and that] diasporic identities are often built on claims to 'natural' or 'original' identities with the homeland" (2002, p. 344). Further, diaspora offers a more complicated outlook on understanding ethnic minorities. Rather than make solid distinctions and boundaries between groups, diaspora acknowledges one's rhizomatic past (Gilroy, 1993), because there are no specific roots; the routes traveled (voluntarily or involuntarily) link people together. Lee uses satire to examine the discursive practices and actions of the *Bamboozled* Mau Maus as they travel the routes of the diasporic divide navigating their cultural dislocation to find their selective African revolutionary roots. This cultural dislocation is evident in the film *Bamboozled*.

Summary of *Bamboozled*

In *Bamboozled* we follow Pierre Delacroix, an African American Harvard graduate and television executive at Continental Network Systems (CNS) who is under

pressure to produce a new Black comedy. Delacroix, who has spent his career trying to put forth quality shows depicting African American life, has hit the glass ceiling. The only way he can be released from his contract is if he is fired; quitting is not an option for him because "only quitters quit" (*Bamboozled*, 2000). Delacroix believes he will be fired when he "gives them a coon show" (*Bamboozled*, 2000) which he sees as an opportunity to expose the racist ideology of the network executives. The show, *Mantan: The New Millennium Minstrel Show*,[1] takes place in Alabama on a watermelon plantation with the main characters appearing in blackface along with the Alabama Porch Monkeys (the show's band) and backup dancers appearing as Sambo, Aunt Jemima, and Lil' nigger Ben, all of whom also appear in blackface. *Mantan: The New Millennium Minstrel Show*, initially a "shock," becomes an audience favorite and a huge ratings success. According to Spike Lee, "Delacroix gets tricked into thinking he has some power on the show. And then once the show becomes a hit, he gets intoxicated like everybody else and therefore becomes protective of it. That's when the downward spiral really begins" (Sragow, 2002, p. 194). However, not everyone embraces the show, specifically a quasi-revolutionary group known as the Mau Maus. The Mau Maus believe they represent disenfranchised Blacks—those who have not been in control of the ways they have been represented historically and currently in the media.

The *Bamboozled* Mau Maus' Diasporic Link

Lee's use of the name Mau Maus for this group evokes a diasporic connection to the Mau Maus of Kenya, a revolutionary group who fought against colonialism and for the freedom of African people. It is the postcolonial condition where the Mau Maus' diasporic experience is significant because it "confront[s] us with the postcolonial histories and geographies that underwrite the production of North America" (Shome & Hegde, 2002, p. 254). The Mau Maus have their own postcolonial diaspora which stretches from Kenya to the United States. As numerous scholars have reminded us, postcolonial studies attempt to understand diasporic politics through a focus on how individual groups renegotiate their identities in those conditions and the effect of and resistance to colonization (Appadurai, 1990; Hall, 1990; Gilroy, 1993; Clifford, 1997; Shome & Hegde, 2002). In *Bamboozled* it is the Mau Maus who inadvertently enact the history and legacy of colonialism, postcolonialism, and diaspora as they try to renegotiate their identities as blacks in America, and the mediated identities of all blacks, as they try to resist the mediated identity thrust upon them due to the *Millennium Minstrel Show*. An argument can also be made that the Mau Maus in *Bamboozled* are also representative of the African American freedom fighters of the Black Power Movement. In fact, the *Bamboozled* Mau Maus, like black nationalist movements in the nineteenth and twentieth cen-

turies, are organized as a "political response to racial oppression and colonial domination" (Hadjor, 1988, p. 88).

The *Bamboozled* Mau Maus, in their attempt to overthrow the confinement and stereotypes of the black colonial body, use some strategies from the previous black generations (e.g., slave revolts, abolitionism, Garveyism, The Civil Rights Movement, and the Black Power Movement). The Mau Maus who seek to educate and empower blacks through their music tried out for *Mantan: the New Millennium Minstrel Show* but were rejected. Failing to have their political voice heard through the mainstream commercial media, they adopt quasi-revolutionary tactics, propagated in cyberspace, to be heard. This strategy can be said to be reflective of the path taken by the Mau Maus of Kenyan and other black revolutionaries in the United States who, when shut out of the mainstream media, chose extreme measures to have their voices heard.

However, a word of caution is apt because, ultimately, the success of *Mantan: The New Millennium Minstrel Show* leads to the deaths of the Mau Maus, Delacroix, and Mantan himself, the show's star, and to the further (imagistic) disenfranchisement of blacks. As such, Lee uses the Mau Maus to create a discursive diasporic frame of reference. "In many respects, diasporas are not actual but imaginary and symbolic communities and political constructs; it is we who often call them into being" (Palmer, 1998, p. 8). The *Bamboozled* Mau Maus are offered up by Lee as in representational alignment with those

> American black nationalists stubbornly ignored the possibility of legitimate competing national interests arising within the black race. They perceived correctly enough, that all African peoples were oppressed by whites, but rashly assumed that this common experience of oppression could be the basis of a pan-racial national consciousness. (Moses, 1996, p. 5)

The *Bamboozled* Mau Maus ignored the competing ideologies that other blacks on the show had, like employment (the black performers) and the desire to be entertained (the multiracial audience), even if their behavior was complicitous in maintaining the white supremacist hegemonic order and was supportive of structural and naturalized racism. The *Bamboozled* Mau Maus merely focused on the militancy of the Kenyan Mau Maus while failing to reveal underlying issues of economic and political self-sufficiency. In their failure to comprehend the multiple dimensions of revolutionary rhetoric they become caricatures of the Kenyan Mau Maus.

Kikuyu Kenyan Mau Maus: A Historical Link

The Mau Maus of Kenya (late 1940s–1956) were a revolutionary group who attempted to gain independence from colonialist Britain. The Mau Maus formed

in the late 1940s to protest the seizure of land for white settlers and to push for freedom from colonial rule. The goals of the Kenyan Mau Maus were to fight for their religious and cultural traditions and "remove white settlers from Kenya and create an independent state" (Klahn, 2002). The Mau Mau was a militant nationalist movement that originated among the Kikuyu people of Kenya. The first president of the group, Jomo Kenyatta,[2] was "the man the British wanted to exclude from power" (Lonsdale and Odhiambo, 2003, p. 4) because he advocated resistance to British domination. While the British portrayed Kenyatta as violent, Kenyatta urged the Mau Maus to focus on *uhuru* (freedom), not violence. Through Kenyatta's imagined vision of a Greater Kikuyu society, he urged "his urban masses to forget the past; but simultaneously also urged them to remember another past in which 'we all fought for *uhuru*—freedom'" (p. 4). Kenyatta's view of nationhood and independence, however, eventually ran counter to the Mau Mau reality. "Kenyatta denounced Mau Mau in 1952 by equating it with poverty, irresponsibility and criminality . . . he condemn[ed] it as a disease which needed the strong medicine of hard work and honesty to cure" (Ogot, 2003, p. 11). Additionally, Kenyatta condemned the Mau Mau's use of violence, violence, and preached racial tolerance (p. 19). Kenyatta refused to link Mau Mau to the imagined Kikuyu independent community and the Kenyan independent nation-state (p. 11). Despite Kenyatta's disdain for what Mau Mau had become, membership in the revolutionary group was high.

Kikuyu Mau Maus fought against "Christian missionaries and the supporters of the independent churches" (Klahn, 2002, np.). Just as the colonizer rejected the idea of an independent Kenya, so too did the mission churches who were "keen to mould the indigenous Africans into a European way of life" (Klahn, 2002, np.) by attempting to make Kenyans loyal to "European religion" and loyal to the colonialist state. As a result of colonialism, Kenyans were largely divided into two camps: the Mau Mau Kikuyu and the Loyalist Kikuyu, which resulted in gruesome battles. Mau Mau Kikuyu fighters not only attacked white settlers, but also native Kenyan loyalists, children, and chiefs through violent methods such as "burning bodies, removing heads and limbs, and leaving bodies in unidentified states" (Klahn, 2002, np.). In response to the violence, the colonial government declared a state of emergency, on October 20, 1952, giving authorities sweeping powers of arrest and detention. Kenya gained its independence in 1959 and the state of emergency ended January 1960 (Ogot, 2003, p. 9).

Kenya paid a high cost in moving from precolonialism-to-colonialism-to-postcolonialism. The deaths, violence, and chaos incurred in the country exemplify the colonizer's desire to control the now postcolonial body. How people are perceived affects how they are controlled. Postcolonialism offers ways of thinking about diaspora and diasporic consciousness that may reveal the ways in which the

visual and the discursive are linked. Among the things, what remains in the post-colonial landscape are the expressed and enacted residuals of institutional racism and the creation of new racism. While these discursive practices appear benign when compared to overt acts, they are more insidious because the word or action becomes naturalized and normalized. Thus, overt acts of containment and mistreatment of another do not need to be systematically supported by the nation-state. Forms of *new racism* are discursively expressed, enacted, and confirmed by talk, text, every-day conversation, laws, movies, and news reports. The battles against colonialism, postcolonialism, institutional racism, and new racism that the Kikuyu Mau Mau fought are not unlike the battles Lee exemplifies in *Bamboozled*.

Bamboozled Mau Maus, Diaspora, and Postcolonialism

Figure 5.1. *Bamboozled*'s Mau Mau. Courtesy of Photofest.

The *Bamboozled* Mau Maus are a multiracial[3] group who lyrically present themes of social justice and black empowerment. These Mau Maus represent a satirical com-mentary on the current state of rap and what Lee says "has evolved to a modern day minstrel show" (Sragow, 2002, p. 195). Critiques have been made regarding the authenticity of several well-known Black rap artists as being from middle-class back-grounds but "representing" or performing as black "gangstas." Even Big Blak Afrika,

the leader of the *Bamboozled* Mau Maus, masks his middle-class background and assumes the role of the mediated image of the black rap artist. In doing so, Big Blak Africa is complicitous in perpetuating new racism. One can ask, is rap *The New Millennium Minstrel Show* devoid of historical consciousness and understanding?

As Robinson (1983) posited, the "Black radical tradition cast doubt on the extent to which capitalism penetrated and re-formed social life and on its ability to create entirely new categories of human experience stripped bare of the historical consciousness embedded in the culture"; the movement gave people the power to question authority; it "drew them more and more towards the actual discourse of revolutionary masses, the impulse to make history in their own terms"; and it "forced them to re-evaluate the nature and historical roles of ideology and consciousness. After all it had been as an emergent African people and not as slaves that Black men and women had opposed enslavement" (p. 245). This path toward black radical tradition as outlined above can be seen in Kenya.

> Like those in the 1950's who took to the mountains and forests of Kenya to become the Land and Freedom Army, the material or "objective" power of the enemy was irrelevant to their destinies. . . . *This was a revolutionary consciousness which proceeded from the whole historical experience of Black people and not merely from the social formations of capitalist slavery or the relations of production of colonialism.* (Robinson, 1983, p. 243–244, italics in original)

Kenyan Mau Maus saw the whole picture, whereas Lee's Mau Maus saw only the social formation of capitalist slavery. The Kenyan Mau Maus went to the mountains and essentially went off the grid; Lee's go to the media. Lee's Mau Maus show that they are very much in the system and using the system to stereotype black violence. The *Bamboozled* Mau Maus use, as Audre Lorde (1984) so aptly noted, the "Master's tools" to take down the establishment, and, thus, reify the violent stereotype and fail to illuminate strategies beyond violence that freedom fighters in the Black Atlantic and Pan-Africanist movement used. And not unlike those in the "Black radical tradition," we have, in the words of Robinson, "defined the terms of their destruction: the continuing development of a collective consciousness informed by the historical struggles for liberation and motivated by the shared sense of obligation to preserve the collective being, the ontological totality" (pp. 245–246). The actions of the *Bamboozled* Mau Maus clearly show the lack of historical consciousness and understanding of the black radical tradition when they chose to publicly execute Manray (Mantan) without anticipating that they themselves would be destroyed. The black radical will be destroyed, as Malcolm X said, "by any means necessary." The destruction of the *Bamboozled* Mau Maus parallels the Kikuyu Mau Maus in that the actions of the Kikuyu in their struggle for freedom against colonialist Britain paid a high cost. By the end of the war, "over 90 per cent of the

war dead were Kikuyu" (Lonsdale & Odhiambo, 2003, p. 3). In recounting the death toll in the Pan-African and Black Atlantic movements (civil rights movements and U.S. slave revolts), Robinson found that these numbers are not unusual.[4] Like those before them, the *Bamboozled* Mau Maus paid a similar price.

Like the Kikuyu Mau Maus, the Mau Maus in *Bamboozled* have a goal of freedom, *uhuru*, but the goal dissolves into violence. For example, the Mau Maus kidnap Mantan, who has just quit the minstrel show, take him to an undisclosed warehouse, alert the media, and plan to execute him live on the Internet. The Mau Maus execute Mantan in a flurry of bullets and celebrate believing that they have just "saved the race" when in actuality, their violent actions continue to degrade, demean, and disenfranchise rappers and, to a larger extent, blacks in general, because while "brother was killing brother" they were still subject to societal stereotypes. Despite Pan-Africanist and Black Atlantic movements and ideologies which, among other things, focused on pride in oneself, in race, and in education, and denounced charges of white superiority, the *Bamboozled* Mau Maus in their piecemeal approach to utilizing pan-African strategies and actions reinscribed negative white stereotypes of blacks.

On the surface, it may appear that Lee's Mau Maus may see their actions along the black radical tradition that Robinson detailed of having a collective consciousness and informed historical struggle for liberation. However, it becomes clear they have gleaned bits and pieces of Black Atlantic and Pan-Africanist ideologies from mainstream media itself (the very thing they are fighting). For example, they take white supremacist hegemonic reductionist versions of black social movements so that the actions of the black foremothers and fathers are reduced to palatable sound bites or reductionist violence, such as their lyrics that pertain to Frantz Fanon, "I ain't wretched yet"; "Forty-one shots" in reference to Amadou Diallo who was shot forty-one times by white male New York police officers; and "Do you like the British, head on a spear, contusions ear to ear" (see *Bamboozled soundtrack lyrics*, nd.). In fulfilling this violent stereotype of the "other," the *Bamboozled* Mau Maus lend justification to and validate new racism, even as they are impacted by postcolonialism and continue to be a colonized body—a body still impacted by the legacy of colonialism despite the Civil Rights and Black Power Movements. A critical analysis of the *Bamboozled* Mau Maus is conducted through a two-pronged approach in understanding the structural and cultural diasporic politics.

Bamboozled Mau Maus
through the Structural and Cultural Diaspora

In *Bamboozled* the Mau Maus underscore the dynamic formation of diasporic groups within postcolonialism. This rap group, through their music and actions,

lament the continued disenfranchisement of Black people. Because of hip hop consciousness regarding societal issues, the *Bamboozled* Mau Maus are not deterred when they are not chosen as the band to front *Mantan: The New Millennium Minstrel Show* and seek to challenge white colonialism and postcolonialism through more extreme means when they kidnap Mantan and execute him live on the Internet. Through their rap and actions they seek to empower Blackness in all its multiracial guises, thus confronting white hegemony. In addition, for them, an enemy or hindrance to the cause of equality, like in the film *Bamboozled*, is anyone—regardless of color—who perpetuates black oppression in favor of continued white supremacy, which is why Mantan and the show also become targets. *Mantan: The New Millennium Minstrel Show* becomes a target because the multiracial audience becomes active participants—donning blackface—in the mistreatment of blacks in this mediated venue. However, much like the Kikuyu Mau Mau, the Mau Maus ended up killing black people while the "colonizer" of the airwaves, the network, remains untouched.

In turn, *Bamboozled* Mau Maus, in an attempt to challenge the continued racist cultural diasporic representation of blacks, and black complicity with racist representation, kill Mantan. In their efforts to rid society of another virulent racist show, the Mau Maus kill the most accessible object of their oppression—the black star of the show because, as Smooth Blak raps, "Black race cats sell out to the blackface" (*Bamboozled soundtrack lyrics*, nd.). Therefore, rather than kill the executive who wanted to have blacks in blackface, the Mau Maus unleash their violence against another "brother" who is also trapped by the naturalized positionality of new racism and institutionalized racism. So as the *Bamboozled* Mau Maus fight against colonization, postcolonialism, and the commodification of black culture through mediated representation, they make links with the diasporic past to Africa through the American diaspora. The *Bamboozled* Mau Maus, like the Kenyan Mau Mau, reify their own racist positionality in the United States through their words, language, and violent action.

This fact is exemplified by the shootout with the police where all Mau Mau members are killed except for one—1/16th—the white/black rapper. Despite the fact that 1/16th (his name indicates his fraction of "Black blood") chooses his racial identity as black, the enforcers of new racism (the police) do not see him as a black man; he is a white man because he looks white and therefore can "pass" or be ascribed the identity of whiteness. In the shootout that ensues between the police and the Mau Maus in the alley outside the studio after Mantan is killed, the police spare 1/16th's life but kill his black cohort. One of the last images of the Mau Mau is 1/16 yelling, "Why didn't you kill me too! I'm Black!" (*Bamboozled*, 2000).

To create a sense of "social blackness that would authenticate him" (Hess,

2005, p. 374) 1/16th used his whiteness as a platform, despite the general societal emersion in new racism which still qualifies, marks, and defines people on the color of their skin, for example, their visual representation. In light of this fact, 1/16th's argument for "authentic" blackness is akin to Armstrong's (2004) three forms of hip-hop authenticity, found in Hess (2005): (1) "initially evident": being true to one-self; (2) claiming "local allegiances and territorial identities"; and (3) establishing a connection to "an original source of rap through locale, style, or links to an estab-lished artist" (pp. 7–8). Frankenberg (2001) would refer to 1/16th's behavior as "marking and cloaking" (p. 74) where 1/16th can choose to claim an identity that makes him marginal (black rapper), yet white hegemonic society can accept him as "white" based on his skin hue. As Hess expounded, "[white] artists have obscured their white privilege, made white identity a selling point, and even argued that underneath their white skin they are essentially black" (2005, p. 376). None of the *Bamboozled* Mau Mau members were able to negotiate for fair treatment; howev-er, in invoking the color caste hierarchy, the one who looked white was spared. Thus, 1/16th is the only survivor of the Mau Mau retribution because he looks white despite his diasporic identification with black culture.

The only victims of Mau Mau violence are the black bodies that die in the movie. No white body was killed. Similar to the Kikuyu Mau Mau, there was lit-tle disruption to the nation-state or the hegemonic order; the chaos was controlled and status quo reified. Diasporic groups typically construct communication exchanges between the host country and the home country in order to provide some benefit for the group. However, the violent communication exchanged between the *Bamboozled* Mau Maus and the nation-state was one that reified black American status as marginalized other and their (racist) image as acceptable entertainment for everyone. Through the Mau Mau actions, the status quo remains and the racist stereotypes of blacks remain prominent.

Conclusion

Of the polysemic interpretations that can be made from viewing and critiquing *Bamboozled*, one point remains salient: through institutional racism and new racism we have all been duped by mediated misrepresentation of the other since we con-tinue to be observers and participants in the continued recreation and reification of minstrelsy in the twenty-first century sans blackface. According to Spike Lee, "My people have to wake up and realize what's going on and our responsibility in it. I mean, back in the day we didn't have a choice. Hattie McDaniel and Bojangles did-n't have a choice. Nowadays we don't have to do this stuff. So anything you do is on you" (Samuels, 2002, p. 188). There is still much work needed when we attempt

to critically analyze an involuntary minority group through the structural-cultural diasporic lens as victims of and participants in race mediated misrepresentation. The historical rootedness and memory come from the disenfranchised experience and life in America (*Bamboozled* Mau Mau) or the precolonial desire (Kikuyu Mau Mau). In Spike Lee's *Bamboozled*, Lee uses the Mau Mau to show not only the diasporic connection but also how blacks can be complicit in the creation and recreation of the structural-cultural diaspora.

Notes

The first portion of the title is taken from a speech delivered by Malcolm X entitled, "Address to the People of Harlem on the 'White Man,'" 1963. An earlier version of this manuscript was presented by the first author to the International and Intercultural Communication Division for the National Communication Association Convention, Miami Beach, FL, 2003.

1. During the 1940s, Mantan Moreland (the inspiration for Savion Glover's character Mantan) became one of America's top black stars. Although he starred in several of the era's black-directed "race" movies—which were shown to segregated audiences in major urban centers—he became best known for his portrait of the wide-eyed, scared-to-death chauffeur, Birmingham Brown, in the Charlie Chan movies. See *Bamboozled* 2000.

2. In 1945 Kenyatta, along with Kwame Nkrumah of Ghana (who was an assistant at the time to George Padmore and his protégé), were in attendance of the fifth Pan-African Congress which was held in Great Britain. Other black leaders in attendance included Marcus Garvey's widow and W.E.B. Du Bois (Birmingham, 1998). The congress was critical to the formation of an international dialogue on pan-Africanism.

3. Visually this rap group mirrors the multiracial dimension that is currently seen in rap and hip hop today. However, 1/16th would not label himself as white, as he chooses to label himself black, thus focusing on the racial marker, "one drop of Black blood." The U.S. racist past created a division between those who are considered black and those who are not, based on visible representation. According to the U.S. one-drop rule, anyone who is at least 1/32nd black is black.

4. Robinson (1983) detailed violence against blacks in chapter 7: "When we recall that in the New World of the 19th Century the approximately 60 whites killed in the Nat Turner insurrection was one of the largest totals for that century; when we recall that in the massive uprisings of slaves in 1831 in Jamaica—where 300,000 slaves lived under the domination of 30,000 whites—only 14 white casualties were reported, when in revolt after revolt we compare the massive and often indiscriminate reprisals of the civilized master class (the employment of terror) to the scale of violence of the slaves (and at present their descendants), at least one impression is that *a very different and shared order of things existed among these brutally violated people.* Why did Nat Turner, admittedly a violent man, spare poor whites? Why did Toussaint escort his absent 'master's' family to safety before joining the slave revolution? Why was 'no white person killed in a slave rebellion in colonial Virginia?'" (p. 243).

References

Appadurai, A. (1990). Disjuncture and difference in the global cultural economy. *Public culture*, 2, 1–24.

Armstrong, E.G. (2004). Eminem's construction of authenticity. *Popular Music and Society, 27*, 335–355.

Bamboozled (2000). A brief history of blackface, minstrels & African Americans on TV. Retrieved January 10, 2005 from http://www.newline.com/sites/bamboozled/minstrelshow/briefhistory.html; (website now discontinued).

Bamboozled soundtrack lyrics (nd.). Retrieved October 28, 2002 from http://www.stlyrics.com/lyrics/bamboozled/blakizblak.htm

Birmingham, D. (1998). *Kwame Nkrumah: The father of African nationalism* (Rev. ed.). Athens, OH: Ohio University Press.

Clifford, J. (1997). *Routes: Travel and translation in the late twentieth century.* Cambridge, MA: Harvard University Press.

Cottle, S. (2000). Introduction media research and ethnic minorities: Mapping the field. In S. Cottle (Ed.), *Ethnic minorities and the media* (pp.1–30). Philadelphia, PA: Open University Press.

Drzewiecka, J.A., & R.T. Halualani (2002). The structural-cultural dialectic of diasporic politics. *Communication Theory, 12*(3), 340–366.

Frankenberg, R. (2001). The mirage of an unmarked Whiteness. In B.B. Rasmussen, E. Klinenberg, I.J. Nexica, & M. Wray (Eds.), *The making and unmaking of Whiteness* (pp. 72–96). Durham, NC: Duke University Press.

Gilroy, P. (1993). *The Black Atlantic: Modernity and double consciousness.* Cambridge, MA: Harvard University Press.

Hadjor, K.B. (1988) *Nkrumah and Ghana: The dilemma of post-colonial power.* London: Kegan Paul International.

Hall, S. (1990). Cultural identity and diaspora. In J. Rutherford (Ed.), *Identity: Community, culture, difference* (pp. 222–237). London: Lawrence and Wishart.

Hess, M. (2005). Hip-hop realness and the White performer. *Critical Studies in Media Communication, 22*(5), 372–389.

Klahn, J. (2002). Colonial impact. Retrieved November 19, 2002 from http://www.geocities.com/maumau/2002uk/john.html; (website now discontinued).

Lee, S. (Writer/Director), & J. Kilik. (Producer). (2000). *Bamboozled* [Motion picture]. United States. New Line Productions.

Lonsdale, J., & E.S. Odhiambo (2003). Introduction. In E.S. Atieno Odhiambo and John Lonsdale (Eds.), *Mau Mau & nationhood: Arms, authority, & narration* (pp. 1–7). Oxford: James Currey.

Lorde, A. (1984). The master's tools will never dismantle the master's house. In A. Lorde (Ed.), *Sister outsider: Essays and speeches.* Berkeley, CA: Crossing Press Feminist.

Moses, W.J. (1996). Introduction. In W.J. Moses (Ed.), *Classical Black nationalism: From the American Revolution to Marcus Garvey* (pp. 1–42). New York: New York University Press.

Ogot, B.A. (2003). Mau Mau & nationhood: The untold story. In E.S. Atieno Odhiambo & John Lonsdale (Eds.), *Mau Mau & nationhood: Arms, authority, & narration* (pp. 8–36). Oxford: James Currey.

Palmer, C. (1998, September). Defining and studying the African Diaspora. *Perspectives: Viewpoints Column.* American Historical Association. Retrieved June 18, 2007, from http://www.historians.org/perspectives/issues/1998/9809/9809VIE2.CFM

Robinson, C.J. (1983). *Black Marxism: The making of the Black radical tradition.* London: Zed Press.

Samuels, A. (2002). Spike's minstrel show. In C. Fuchs (Ed.), *Spike Lee interviews* (pp. 187–188). Jackson, MS: University Press of Mississippi.

Shome, R., & R.S. Hegde (2002). Postcolonial approaches to communication: Charting the terrain, engaging the intersections. *Communication Theory, 12*(3), 249–270.

Sragow, M. (2002). Black like Spike. In C. Fuchs (Ed.), *Spike Lee interviews* (pp. 189–198). Jackson, MS: University Press of Mississippi.

Spike's Place

NORMAN K. DENZIN

It [*Clockers*] will be the final movie of its sort [hood]....
It was our intention to be the final nail in the coffin.... It's
dead! It's over! Move on! I loved *Boyz N the Hood* and
Menace II Society, but ... the genre is at its end now.
 —(Spike Lee quoted in Weinraub, 1995, p. B1)

It [*Clockers*] is the 'hood' movie to end all hood movies.
 —(Taubin, 1995b).

You are sellin' your own people death
 —(Tyrone's mother to Strike in *Clockers*)

And this ain't no TV movie violence bullshit neither.
This stuff out here is real. Real guns kill you dead.
 —(Strike to Tyrone in *Clockers*)

Spike Lee's *Clockers* (1995)[1] ends the black filmmaker cycle of ghetto-action-drug-hood movies. Somehow this seems fitting. Lee's 1989 *Do the Right Thing* launched a generation of young black filmmakers.[2] Singleton, the Hughes brothers, and others would use the apparatuses of cinematic realism, and the resources of black youth culture and the hip hop movement to tell stories about young black men in the hood. These were coming-of-age, didactic, social problems-based films about black male angst. They located racism, gangs, drugs,

and racial violence in the urban wastelands of Reagan and Bush's postindustrial America (Watkins, 1998, p. 170).[3]

Building on the criticisms of hooks (1990, 1996), Wallace (1992), Baraka (1993), Lubiano (1997), Watkins (1998), Gray (1995, p. 52), Guerrero (1993) pp. 140–151), Kellner (1997, pp. 76–77), Giroux (1996, p. 40), Bambara (1996, pp. 193-198), Boyd (1997, pp. 25–26), Gilroy (2000), Tate (1992), and others, I will argue that Lee's films do not offer a site of radical cinematic racial resistance.[4] Rather, his movies (like Singleton's) embody a black postnationalist essentialism (Wallace, 1992, p. 125). This essentialism is compatible with the politics of a conservative black middle class.

Baraka contends that Lee is the quintessential buppie. His texts are caricatures of "the black revolutionary politics and art of the 1960s" (Baraka, 1993, p. 147). According to Ellis (1989), Tate (1992), and Boyd (1997, p. 25), Lee's "New Black Aesthetic" is clearly inherited from the Black Arts Movement of the 1960s. Boyd (1997, p. 25) suggests that this new aesthetic "shamelessly borrows" from these earlier, more radical political formations.

I will develop these arguments, through a discussion of *She's Gotta Have It* (1986), *School Daze* (1988), *Do the Right Thing* (1989), *Mo' Better Blues* (1990), *Jungle Fever* (1991), *Malcolm X* (1992), and *Get on the Bus* (1996), giving primary attention to *Do the Right Thing* and *Clockers*. I begin by examining Lee's broader cinematic project. I then locate *Do the Right Thing*, *Clockers*, and the hood movies within that context.

Lee's Cinematic Realism

As realistic cinematic texts, Lee asserts that his films "Tell it like it is. ... They force America to come to grips with the problems of racism" (Lubiano, 1997, p. 101). Lee's films make race visible. He sees himself as a voice for the real, a voice that affects the realities of racism. Cinematic realism is the bedrock of his project. He establishes reality through a narrative camera that transparently invokes an authoritative sense of immediacy and authenticity (Lubiano, 1997, p. 104). Lee's realism thus discloses the truth about racism's realities. He invites his viewers to "accept what is offered as a slice of life because the narrative contains elements of 'fact'" (Lubiano, 1997, p. 105).

In this way Lee uses the apparatuses of cinematic realism to make the lives of African Americans visible to white America. His films are littered with shots of graffiti painted on walls. The graffiti on Sal's pizzeria in *Do the Right Thing* state, "Tawana told the Truth" (Lubiano, 1997, p. 105). Realism's claims to truth thus become self-evident, but whose truth is being told?

Of course realism is itself a cinematic production. When Lee says he is "Telling it like it is" he is telling it like it is according to a cinematic and narrative logic that is deeply ideological and embedded in the so-called "New Black Aesthetic." On this aesthetic, hooks (1994) observes that Lee (and Allen and Albert Hughes) refuses to "see that while there may be aspects of fictional reality portrayed in a film that are familiar, the film is not documentary ... it is a fiction" (p. 150). Further, the purpose of the Black Aesthetic is to do "more than tell it like it is—it's to imagine what is possible" (hooks, 1994, p. 237).

There is very little black consciousness or political activism in Lee's movies. His films restate, in elegant cinematic form, the "place of our present" (Baraka, 1993, p. 153). His is a socio-comedic, or allegorical, realism (Baker, Jr., 1993, p. 167). It refuses the mission that defined the Black Arts Movement in the 1960s, namely the project that used art as a form of cultural and political resistance.

Lubiano (1997, p. 98) contends that it may not be possible for a radical race consciousness film to earn money within the politics of Hollywood.[5] However, as Boyd (1997) observes, Lee and the filmmakers in the current era have successfully traded on the commodity status of a new, less radical, more middle-class blackness. "This has allowed them to infiltrate mainstream white institutions while still providing some sense of an African American aesthetic" (pp. 25–26). In this way, paradoxically, these films have "contributed to ... the end of what Stuart Hall calls the essential black subject" (Gray, 1995, p. 52).

The claim for being radical lies at the level of Lee's cinematic politics. His highly individualized style foregrounds his presence in the text. (He acts in nearly every one of his films.) His films are filled with multiple narrative lines and plots. His stories are open-ended (Watkins, 1998, pp. 161–162). Visually, he uses jump-cuts, tilted camera angles, fluid crane shots, and extreme close-ups. Actors speak directly to the audience (Reid, 1993, p. 103). While his stories are reworked for a white and black middle-class audience, they are grounded in black cultural imagery, codes, and idioms (Reid, 1993, p. 104; Baker, Jr., 1993, pp. 170–171). His musical scores use contemporary black jazz artists (Terence Blanchard, Bill Lee, Branford Marsalis Quartet). Quotations from Zora Neale Hurston open *She's Gotta Have It*. The mural in Nola's loft refers to "Malcolm X, Bob Marley, the liberation struggle in South Africa, and recent racial killings of black New Yorkers" (Reid, 1993, p. 97).

Lee's films self-consciously foreground a racial politics that attempts to force white America to recognize the problems of race (Lubiano, 1997, p. 101). At the same time, Lee has been at the forefront in bringing more blacks into the American film industry. His typically all-black films create a hermetic space, or worlds of blackness that "seem entirely removed from the dominant White culture" (Baker, 1993, p. 156). In these spaces he examines the subordinate statue of African Americans

within the worlds of dominant white capitalism (Watkins, 1998, p. 139; Shohat, 1991, p. 240).

In his fifteen feature films, to date[6] Lee explores the ideological conflicts between light- and dark-skinned African Americans, as well as between middle- and working-class blacks, black hip hop culture, black urban poverty, and drug addiction. He consistently examines the tensions, hierarchies, and ambiguities that operate in black culture, repeatedly returning to the multiple ways in which gendered blackness is socially constructed and given meaning (Watkins, 1998, p. 146).

In making his version of the black world visible, Lee explores a handful of themes. Always interpreted from the black, male, heterosexual perspective, these themes include: black sexuality, the sexually active, independent black woman, interracial sexual relations (*She's Gotta Have It, Jungle Fever*); identity politics and the fraternity-sorority system on an all-black college campus (*School Daze*); race politics, interracial group conflict, black middle-class family life (*Do the Right Thing, Jungle Fever, Crooklyn*); the world of African American jazz (*Mo' Better Blues*); black male politics (*School Daze, Get on the Bus*); sports and the black athlete (*He Got Game*); Jewish, Italian, and black community relationships (*Do the Right Thing, Mo' Better Blues, Summer of Sam*); black history (*Malcolm X, Four Little Girls*); gangs, the hood, drug addiction, and inner-city violence (*Clockers*).

From this film cycle, the following themes are apparent. Lee is opposed to miscegenation, is antigay, endorses a compulsory heterosexual identity politics, regards blackness not as a political category, but as a signifier of cultural identity, and does not imagine a new multicultural America based on a new black militancy (Marble, 1992, p. 302). Nonetheless, it is also clear that Lee regards himself as a major cinematic spokesperson for black America.[7]

But Lee's Afrocentric aesthetic is not the radical or militant aesthetic of the Black Arts Movement of the 1960s and 1970s (Baraka, 1993). His is a conservative aesthetic that appears radical. Culturally, Lee's films reproduce a neo-nationalistic, essentializing masculinist gender and identity politics. Such moves undermine his claim to be a politically radical or progressive filmmaker (Lubiano, 1997, p. 108). Lee's films reproduce long-standing black stereotypes. The problems of race are reduced to liberal solutions, solutions that are remarkably conservative; namely more jobs, hard work, no drugs, no guns, and less prejudice (hooks, 1989, pp. 177–178). No black power movement here; blacks just need to stay in their place and aspire to the goals of the black middle class. This is a neo-nationalism about race, not class or gender.

Sex and Class in *Spike's Place*

Bambara (1996, p. 193) observes that when the images of women in Lee's films are

"programmed together, a disturbing picture emerges." Lee's gender politics are compulsively patriarchal, heterosexual, homophobic, and misogynist. Posters of naked women are nailed to the wall in the barbershop in the short film, *Joe's Bed-Stuy Barbershop*. These same posters reappear in *Mo' Better Blues*. In *School Daze* (*SD*), a male character speaks of "pussy," and another says "Meow." Nola is raped in *She's Gotta Have It* (*SGHI*), as Jane is in *SD*.

Lee (1988) says of these forced-sex scenes: "It's a sexual act that transforms things In *SGHI*, it's Jamie's rape of Nola, and in *SD* it's ... Dap finding out that Julian [Jane's lover] coerced Jane into going to bed with Half Pint" (p. 113; also quoted in Reid, 1993, p. 95). The use of rape as a narrative device for moving the story forward can only be judged as misogynist.[8] If this is how it is in black male sexual culture, then Lee's challenge is to not reproduce the rape narrative. Rather his challenge is to imagine how it might be different, how a new, nonviolent, loving sexual politics might be lived into existence.

Homophobia is invoked with the phrase "Puerto Rican cocksuckers" in *Do the Right Thing* (*DRT*); the "fairy" and Richie characters in *Summer of Sam*, the declaration by Errol, the killer in the last stages of AIDS in *Clockers*, "I ain't no homosexual!," and the negative treatment of Opal, Nola's lesbian friend in *SGHI*. Real men, in *SD*, are not virgins, and not fags; being sexual is a "dick-thing." In *DRT* and *SGHI* women are presented as the constant subjects of the male erotic gaze. While men may have multiple lovers, women cannot. Thus Nola, the woman with three lovers (Jamie, Mars, Greer) in *SGHI*, is called a freak by the men in her life. But Mars qualifies the use of this term: "All men want freaks in bed, we just don't want 'em for a wife."

Nola arouses masochistic and insatiable male sexual fantasies. She is the sexual other who cannot be contained or controlled, and "fifteen bogus men offer their sex to her" (Reid, 1993, p. 98). She is defined solely through her sexuality, which is rooted in her body, but defined in male, heterosexual terms. She is dependent on men for her sexual definitions of self (Reid, 1993, p. 97). She is not a sexually independent black female protagonist (Reid, 1993, p. 98).

SGHI is a depressing, denigrating portrait of black women (hooks, 1996, p. 235). We share Nola's despair when, at the end of the rape scene, Jamie asks, "Whose pussy is this?" and she answers, "It's yours."

Lee demoralizes uncontrolled female sexuality. Sexually independent women are presented as threats to the black male heterosexual identity (Wallace, 1992, p. 129). Thus Flipper reacts angrily in *Jungle Fever* when Vivian, Gator's crack addict girlfriend, states "I'll suck your dick for $5." He turns to his young daughter, "Don't you ever do anything like that!" (He later calls Vivian a whore.) Lee equates oral sex with prostitution, gay sexuality, and AIDS. More broadly, however, oral sex is connected to a "vast range of illicit sexual practices and psychosexual developments

beyond the pale of compulsory heterosexuality" (Wallace, 1992, p. 129). This includes such "perverse passions as interracial sex [*Jungle Fever*] and drug addiction" (Wallace, 1992, p. 129).

Lee, according to hooks (1994, p. 158–159), exploits the culture's voyeuristic obsession with interracial sex. Interracial romances are treated in some detail in *Jungle Fever* and *Malcolm X*, but Lee appears "unwilling and possibly unable to imagine that any bond between a white woman and a black man could be based on ties other than pathological ones" (p. 159). Lee seems unable to have much "sympathy for, or insight into … women" (Kassabian, 1991, p. 259). Every black female in *DRT*, for example, "whether she be mother, daughter, or sister, is constructed at some point as a sex object" (hooks, 1989, p. 182; also quoted in Reid, 1993, p. 105). Jones (1993) is even harsher: "the Black women in Lee's [films] … embody traditional "female" concerns, monogamy and physical appearance … in stark contrast to the *real* issues faced by the men in [his] films" (p. 254, italics in original).

And so it is for *SD*, which also, as noted above, has its rape scene. In this film, as he does in *Jungle Fever*, Lee uses dark and light skin color as a method of coding race and sexuality. He reproduces the stereotype that connects uncontrolled (or wild) female sexuality with darker skin, and controlled, civilized sexuality with whiteness (Wallace, 1992, p. 130; Lubiano, 1997, p. 116). In *SD* the Jigaboos are black women with Afro hairstyles. The Jigaboos are in conflict with the Wannabees, light-complexioned black women who have straight hair. "The Wannabees wanna be White, and Jigaboos wanna be 'wannabees' … don't nobody wanna be Black" (Baraka, 1993, p. 148).

A complex identity and gender politics is played out within this color aesthetic. The Militant is militant because he hates light-skinned persons. The women establish their sexual identities through what they wear, their eye color, their makeup, and whether or not they straighten their hair (Lubiano, 1997, p. 116). The film ends on a curious and superficially radical note, calling for everyone to "Wake Up." But the charge seems aimed more for the audience than to the *Animal House* characters who live in this black college world (Baraka, 1993, p. 148).

The film's homophobia blends into its negative treatment of women. It reproduces, at this level, Robert Park's assertion that "the Negro is the lady of the races" (1950b, p. 280; quoted in Lubiano, 1997, p. 116). Yet, as Lubiano observes (1997, p. 116), Lee shows black men that they can counter this feminist/gay impression by being "real" men, by being straight, black, and powerfully sexual.[9]

Mo' Better Blues adds anti-Semitism to the mix of negative stereotypes that Lee presents in his films. The brothers Moe and Josh who own the club where Bleek plays "parade the worst stereotypes of 'New York Jews'. They are cheap, money-grabbing, brash, loud and offensive" (Kassabian, 1991, p. 259). Kassabian (1991) observes that "Their characterization … is beneath the dignity of further comment"

(p. 259).[10]

Baraka (1993) suggests that the "essential centers of Spike's films are always in contradiction to the metaphor of his announced themes" (p. 152). So *School Daze* is about blackness and skin color and identity politics, not about black colleges and the value of higher education in the black community. And *She's Gotta Have It* is about black men and their sexual identities. Just *Jungle Fever* is about the inability of the black or white family to accept its own pathologies, including drug addiction and violence.

Thus Lee's films skim the surface of the problems they take up, seldom registering new understandings or criticisms of race, gender, and oppression in the black community today. The structures of racism, gender, sexuality, and class conflict in the end are left unanalyzed (Baraka, 1993, p. 153).

Do the Right Thing

Little new can be written about *DRT*, which is Lee's third feature film (see hooks, 1990, pp. 173–184; Denzin, 1991, pp. 125–136; Baker, Jr., 1993, pp. 168–175; Baraka, 1993, pp. 148–149; Guerrero, 1993, pp. 148-155; Bogle, 1994, pp. 318–323; Kellner, 1997; as well as Reid, 1997, pp. 100–108; Watkins, 1998, pp. 157–169).[11] In *DRT* Mars (he of two earlier lives, one with Michael Jordan,[12] the other in *SGHI*) becomes Mookie. The college student is now a messenger and delivery man for the white bourgeoisie. The militant is "bugged out" and the black scholar is named Smiley. He mumbles and stutters. He "is a spastic who sells pictures of Malcolm and Dr. King" (Baraka, 1993, p. 149). As hooks (1990) observes, "it is bitterly ironic that the two black leaders whose images are sold in the community were highly educated, articulate critical thinkers, yet the person who attempts to keep their memory alive ... is inarticulate" (p. 179). Paradoxically, the mainstream political character is Da Mayor, a disillusioned alcoholic. His advice to Mookie is "Do the Right Thing." It is never clear what that is.

The film was inspired by the Howard Beach killings in Queens in December 1986. Michael Griffith, an African American, was fatally beaten by "Italian-American youths armed with baseball bats when he was leaving a pizzeria in the predominantly white Howard Beach section of Queens" (Pouzoulet, 1997, pp. 37–38; also Kellner, 1997, pp. 103-104). But nothing in the film refers directly to this episode.[13]

It is the hottest day of the year.[14] It is closing time at Sal's. Radio Raheem (Bill Nunn) walks in with his boom box blasting "Fight the Power." He demands that Sal put up the posters of Malcolm and Martin on the pizzeria's Wall of Fame (which only contains photos of famous Italian Americans, including Sinatra, Stallone, and

DeNiro). Sal (Danny Aiello) tells him to "turn off the jungle music now!" He picks up a baseball bat and smashes the radio. Mookie tells him to stop. Raheem and Sal fight. A crowd appears. The police come. Radio Raheem is killed by the police. A race riot starts. Mookie throws a garbage can into Sal's front window. The crowd rushes in. Smiley drops a match. Fire breaks out. Sal's pizzeria burns down.

For the militant blacks in the film, Sal's Pizzeria symbolizes the oppressive presence of white capitalism in the ghetto. Sal's refusal to place the photos of Malcolm and Martin on the walls of his establishment represents this oppression. In a symbolic ending, Smiley places the photos of Malcolm and Martin on the Wall of Fame. Thus is maintained the essential tension of the film: violence (Malcolm) versus nonviolence (Martin). Ironically, these two forms of black revolutionary struggle are reduced to the location of two photographs on a wall. But surely, as hooks (1989, p. 176) notes, black liberation goes beyond the question of a picture on a wall, beyond the issue of representation.

Public Enemy's rap song urges the viewer to "Fight the Power," but how this struggle should be carried out is never clarified (Kellner, 1997, p. 77). Mookie throws a garbage can through Sal's window, and this is the act that triggers the final violence in the film. But the next day he is paid overtime by Sal. For fighting the power, Mookie gets his job back with double pay ($500). Sal has insurance money to cover the costs of rebuilding his pizzeria. Nothing has changed.

Lee seems to suggest that Mookie has done the right thing. After all he is paid off. In this gesture Lee weakly implies that a "violently aggressive Black energy of revolt can lead to Black economic empowerment" (Baker, 1993, p. 173). In contrast Radio Raheem challenged the members of the community to boycott the pizzeria because Sal would not post the pictures of African Americans on his Wall of Fame. The murder of Raheem suggests that Lee does not endorse the use of this classic form of protest connected to Martin Luther King. Indeed the film trivializes these forms of black struggle (Guerrero, 1993, p. 149).

This trivialization is further accented by comparing Buggin Out and Raheem with Mookie, who is "the film's calculating middleman, positioned between Sal and the community" (Guerrero, 1993, p. 149). Lee reduces the film's conflict to a dispute between personalities, to personal and group bigotry, not to the larger structures of institutional racism. The futility of political action is connected to mob action, and a fleeting episode of disconnect that produces Raheem's death and the torching of Sal's place (Guerrero, 1993, p. 154). White racist patriarchal capitalism easily absorbs hits like this.

Raheem's murder trivializes the civil rights and black liberation movement. In turn, Mookie can scarcely be regarded as a leader of the nonviolent masses. Baraka (1993, p. 149) observes that Mookie enters the struggle late, and appears uncommitted and alienated from the other members of the black community. For Baraka,

this late entrance into the battle "elaborates Spike's class stand with excruciating clarity! ... [His] is some kind of petit bourgeois 'leadership'" (p. 149).[15]

By showing a young black male instigating violence, Lee reinforces the arguments of the New Right. Young black males are threats to law and order in America. In perpetuating this stereotype, Lee suppresses the racism of Vito and Pino, Sal's sons. By letting their hatred of blacks stand, Lee legitimates their racism. But ostensibly they do the right thing by not entering into the violence. And in the end, as the police murder a young black man, nobody comes forward to help. At the same time, the film reinforces the idea that the "'lunatic' violence erupting in 'segregated' black communities finally hurts black people more than anyone else" (hooks, 1990, p. 175).

The film's messages are contradictory. Lee tells the viewer to "Fight the Power" and "Do the Right Thing" (Kellner, 1997, p. 77). But what is the right thing? Right for whom? Nonviolence appears to be a questionable tool for social change. However, it is not clear that violence offers a viable alternative. Kellner (1997) suggests that "one could even read the film as questioning social violence, by demonstrating that it ultimately hurts the people in the neighborhoods in which it explodes" (p. 77). In interviews Lee (1989) aligned himself with Malcolm. He stated, "The character I play ... is from the Malcolm X school of thought: 'An eye for an eye'. Fuck the turn-the-other-cheek shit. If we keep up that madness we'll all be dead" (p. 34; also quoted in Kellner, 1997, p. 104).

Despite its contradictions, the film,

> better than any other film of the period ... touched on a great deal of the discontent and unexplained anger that was so much a part of urban life during the Reagan eighties. The movie says ... that race relations in America remain abysmal; that racism and ethnic tensions underlie the façade of American life. (Bogle, 1994, p. 322)

It is this façade that the hood movies of the 1990s exploited. And of course, in a strange perversion of Malcolm's principles, the "eye for an eye" school of thought would be taken to a new level in the hood films. Now young black men with automatic weapons in their hands, and driven by a warped code of violence, could establish their self-identity by murdering a member of an opposing street gang. At one level this is the legacy of *DRT*.

And this is sadly ironic, for as hooks (1990) observes, Lee understands that art is political, that film can be a medium "to chart new political agendas without aesthetic compromise ... art can serve as a force shaping and transforming the political climate" (p. 184).

Thus Lee says to his white viewers, "Listen, if white America has to squirm for two hours, if they're really uncomfortable watching this film, that's just too fucking bad. Because that's the way it is all the time for black people" (Lee, quoted in

hooks, 1990, p. 173). But many blacks also find the film hard to watch (hooks, 1990, p. 182). This is so for many reasons, including: the use of racial stereotypes to represent black males (Sweet Dick Willie, ML, Coconut Sid), the focus on racism as prejudice; the sexist treatment of women; "the causal treatment of a symbolic incest scene" (hooks, 1990, p. 182);[16] the fetishistic display of designer clothing and ethno-fashions (hooks, 1989, p. 177); and the treatment of black males as victims.

Clockers: Men with Guns and Drugs

There is a benign, ironic, playground-like simplicity to *DRT*. The film has no guns, drugs (except alcohol), homeboys, or drive-bys. There is no violent rap, only Public Enemy saying "Fight the Enemy." The enemy is white capitalist society, not the Mafia, or gangbangers who belong to the Crips or the Bloods. There are no prisons, no black (or brown) Godfathers, and there is little of the disturbing interethnic hatred that characterizes *American History X*. Lee's violence takes the form of hate speech, epitomized when black, white, Korean, Puerto Rican, and Hispanic men hurl racial insults at one another. The burning of Sal's is an afterthought, an accident. The playful innocence of *DRT* is not present in *Clockers*, which Ebert (1998, p. 155) calls a murder mystery.

Clockers is not a typical hood movie.[17] It does not have the brooding existential themes that mark *Boyz N the Hood, Menace II Society, Colors, Bound by Honor,* or *American Me*. This is a story about drug dealers, called clockers, because they work around the clock (Rollyson, 1996, p. 90). It is not about a drug addict (although they are present) or a young man in the hood who is being told to stay away from the violent hip hop street and drug culture. It is not a coming-of-age film, *per se*.

However, the first shots in the film's montage title sequence tell the viewer that this is a story with hood themes. The camera "travels across a succession of grisly police photos of murder scenes—black male bodies torn apart by bullets" (Taubin, 1995a,b). These bodies are "sprawled awkwardly on the pavement, their blood staining the concrete, they seem to have been halted in mid-flight, astonished by the fact of their sudden death" (Ebert, 1998, p. 154). This credit sequence segues into a scene with four black teenagers (clockers) rapping about rap and rap performers on the benches in front of the projects. The all too aliveness of these young men stands in stark contrast to the credit sequence's "corpses which are so graphically dead" (Bradley, 1995, p. 29).

This scene quickly turns into a police shakedown. A squad car shrieks to a halt. Police officers accost the young men ("What are ya carrying?"; "Where's the vials man?"; "Open your fuckin' mouth man, lift up your tongue"; "Take off your fuckin' pants, or whatever you call 'em"; "Spread your butt cheeks man, spread 'em, let's go"; "Pull up your pants bitch"). A mother watches this scene from a fourth-floor apart-

ment window. The police car drives off, and the young men are left with their pants down around their knees. Welcome to Strike's world.

This is primarily a story about two people, Rocco Klein (Harvey Keitel), a street-weary cop, and Strike (Ronnie Dunham), the key clocker. Strike deals drugs, but he does not take them. Strike has his own crew of dealers who live in Brooklyn. Strike works for Rodney, the neighborhood drug czar. The benches are where Strike and his crew meet. Still a teenager, Strike is trapped in a world he wants no part of, the world of crime, drugs, dealing, and violence. His situation is symbolized by his bleeding ulcer.

Ebert (1998) is right. This is a murder mystery, and it is told in four acts. In Act 1 the viewer is taken into Strike's world. In Act 2 a murder occurs. In Act 3, the hunt for the murderer unfolds. Rocco believes that Strike did it. The narrative lurches forward, through a series of confrontational scenes between the hunter (Rocco) and the hunted (Strike). In Act 4, a second murder occurs, the murderers are revealed, and the story ends with Strike leaving town.

Act 1: "I Love Trains"

Strike knows his life is out of control, but he does not know how to change it. Lee's camera, with "its erratic rhythms and circular patterns" (Taubin, 1995b), brilliantly catches the confining claustrophobic tensions in Strike's world. Everything he encounters seems to increase his sense of being confined, like a bug under a bell jar. Incessant rap music pounds against his ears. He is constantly hassled by the police, other dealers, and users. Twice he is symbolically raped: once by the police, once by Rodney. He is battered by a protective mother, stomped by a black housing cop. Everywhere he turns people seem to be watching him. He seeks escape inside his apartment, where his Lionel electric trains run around and around on a single track (Taubin, 1995b). Strike is in love with trains. ("I don't like sports. I like trains.") He has videos of trains, recordings that tell their names and histories. He dreams of a world beyond the projects. His trains will take him away from that world; they "represent an open track out of clocking into freedom" (Ebert, 1998, p. 155; also Rollyson, 1996, p. 91).

Rodney mentors Strike, and Strike mentors 12-year-old Tyrone. Tyrone's mother is mad at Strike for corrupting her son ("You all nothing but good for nothin' death dealin' scum"). André the Giant is a cop who warns Strike:

> I been lookin' out for you since you was a little boy. You mess with that little boy Tyrone, I gonna mess you up so much, you wish I killed you ... you don't have to live like this. There's more than just those projects out there. Don't you wanta go somewhere you never been before? I mean you love trains, but you've only ridden the subway.

Strike's mother rejects him and his life style. In contrast she has only praise for her other son, Victor, a driven man, who holds down two jobs, is happily married, and is the father of two young children.

Act 2: The Murder

Rodney tells Strike that he can advance his career by killing Darryl Adams, a dishonest drug dealer ("Nigger stealin' from me") who is also the night manager at Ahab's, a fast-food restaurant and market. Rodney tells Strike:

> You're like my son. I had a dream last night. I'm standin' in the desert with all my kids. They're laid out like they're my army. God came up and pointed to you and said, 'This one's going to be your soul and staff.' God said that. Strike, you really want off the benches, you deal with Darryl for me.

Strike stands outside Ahab's with a gun but is unable to approach Darryl. He runs into Victor in a bar and tells him he needs a man murdered. Victor is drunk, angry, and depressed but tells Strike he has a friend who can take care of Darryl. Strike walks away and confronts Darryl. In the next scene Strike is part of a crowd, looking at the corpse.

The police take control of the situation. (Spike Lee is present as a bystander, dressed as a utility repair man.)

COP: Welcome to the show that never ends … we got a black male, dead man, neighborhood says there was four shots fired, shooter does a Carl Lewis.

The police roll the body over. Darryl's head, oozing blood, sticks to the concrete street.

COP: Live by the gun, die by the gun.
ROCCO: Kid had brains, bing, bing, bing, ricochet rabbit. … Another stain on the sidewalk.

Act 3: The Hunt

In the next scene Victor confesses to the shooting, telling Rocco it was in self-defense. "This guy flexed on me, just jumped out of nowhere. I shot him." Rocco doesn't believe Victor.

ROCCO: Where'd you carry the gun? Were you there [Ahab's] before, with your kids?
VICTOR: My two kids, I barely see my two kids. I'm always working. When I come home I'm exhausted. Have you ever come home so tired, you hated the sound of your own kids cryin'? Your own flesh and blood. My wife says, so quit a job. You got two. … I'm tryin' man. I'm really tryin'. I'm tryin' to move us out of the projects.

ROCCO: Victor, if you did pull the trigger, there has to be a reasonable answer, other than
 what you've told me here. Why would Darryl, the night manager of Ahab's, try
 to rob you in his own parkin' lot? I think there had to be somethin' personal.
Victor: It was self-defense.

Rocco believes Strike is the murderer, and that Victor is covering for him. He
tells his partner Mazilli, "This confession sounds like horseshit." Mazilli disagrees,
"Why would Victor willingly go to prison to protect his brother? He got religion,
comes in, makes a confession Give it up! We got the shooter." But Rocco will
not let it go. He confronts Strike, "I'm not happy about this. Your brother fessed up
. . . what do you think happened? Did you know Darryl Adams? . . . You clockin'?
How long you been clockin'?"

Rocco's men harass Strike. They stop him on the street, and force him up against
a wall, arms outstretched: "Strike my man, this is a new day Law and order, a
new budget. Crack down on drugs and crime, niggers and spics."

Strike seeks solace with his trains. He shows Tyrone his train set, which is laid
out in one large room in his apartment:

Look, Lionel trains, they was built in the early 1900s. They run on dry cell batteries.
World War Two the motherfuckers started getting' electricity. They made new ones.
[*The train passes a sign with a large gun in the corner that reads "No More Packing."*]

Like a good mentor, Strike next shows Tyrone how to cut and separate cocaine:

STRIKE: If I ever see or hear about you messing with this stuff man I'll put a cap in
 your ass. [*He gets a gun from beneath his bed mattress and points it at Tyrone.*]
 And this ain't no TV movie violence bullshit neither. This stuff out here is real.
 Real guns kill you dead I keeps this for all those ill niggers out there, like Errol.
 That brother's crazy If he ever creep up on me I gonna get his ass, and you
 better be prepared to do the same Listen, any flash shit you want in the
 world, this how you get it, pumping this white shit right here, hustlin' and don't
 forget that shit neither. You smart, answer me this, boss buys a key for $22,000
 cuts it up into thirty-five $10 bottles, boss takes 60 percent, $17,000 profit, leav-
 in' up $7,000, 50 percent of which is mine. How much for me?
TYRONE: $3,500.
STRIKE: My man, keep hittin' them books. If I ever catch you playin' hookie, I put a cap
 in your ass.

Braced again by Rocco, Strike collapses from his bleeding ulcer and is hospi-
talized. Rodney picks him up as he leaves the hospital:

What, you and homicide fuck buddies now? . . . We got another big order comin' in.
God created anything better than crack cocaine, he kept that shit for himself. I mean
that shit is like truth serum, it will truly expose who you are . . . I don't never want to

hear about you usin' that shit. [*The screen moves back and forth between shots of youth and adults buying and smoking crack cocaine, and shots of Strike with his train set, staring out of the window.*

Rocco's men increase their surveillance of the drug scene in Strike's neighborhood. Five white yuppie youths in a silver Mercedes Benz, with Connecticut plates, are placing their order outside Ahab's. They are confronted by a white policeman:

> What's up boys? Hey, nice car you got. Whatcha come down from Connecticut to buy some hamburgers and malts? Buy anything else today? You like soul food? You like to wear lipstick? You like skirts? You ever suck a black man's dick? Big, sixteen inch tall baby? Cause if I toss this car and I find any drugs I got twelve baboons in a cage gonna be callin' you boys Mary all night long. Whose got the drugs? Give 'em up now.

Rocco picks up Strike and drives him to the precinct station. In an exercise in hate speech, they hurl the following words back and forth at one another:

> ROCCO: I know you did it! You're a cold-blooded, evil, junkyard nigger. ... You're nothin' but a cold fuckin' fart.
>
> STRIKE: You don't know nothin' about me. You're nothin' but a racist ass, nigger-hatin' cop.
>
> ROCCO: I read you like a Marvel fuckin' comic book. I been inside your fuckin' pea-sized brain twenty fuckin' years. You don't play me. I play you.

Rodney watches this scene. He gives Strike a ride away from the station. In the front seat of his car he forces a gun into Strike's mouth:

> If I ever hear about you talkin' to that homicide one more time, that Rocco motherfucker ... if I hear my name come up at all, I'll know it was you and I'm gonna kill you. Do you understand me? Now get your motherfuckin' ass out of my car.

Act 4: Leaving Town

As Rocco and Mazilli are picking up Rodney on a warrant, Strike is preparing to leave town. Rocco tells Rodney that Strike served him up. In a note to his landlord, Strike writes, "Dear Mr. Herman Brown, I had to leave suddenly. If my little brother swings by, he can have my train set." While packing, he discovers that his gun is missing. He stops and gives Victor's wife $5,000 for bail. She tells him he needs to talk to his mother. Rocco stops Strike and tells him, "Rodney makes bail tomorrow. He believes you turned him in. Do me a favor and tell me what really happened."

The clockers turn against Strike, "You fuckin' snitch. You ratted on Rodney!" Rodney calls Errol from jail, "Strike put me here. You know what you gotta do." Strike visits his mother, who is sleeping. He softly kisses her and leaves.

Errol comes after Strike with a gun. Tyrone sees Errol before Strike does. Tyrone pulls out the gun he has borrowed from Strike (shades of Caine and Anthony from *Menace II Society*) and kills Errol.

André begs Rocco to let Tyrone go. Rocco speaks to Tyrone:

> ROCCO: You did wrong, you know that. You were scared. You get straight A's. You're smart. Don't they call you white boy. All you wanta do is do the right thing. So you get a gun to protect yourself and your mother. So there you are ridin' your bike, but you got the gun, it's for protection. All of a sudden there's Errol, the stone killer standin' right in front of you . . . you see him reaching for a gun, stuck in his waist, you know he is gonna get you. You never fired that gun before. You're scared. There's no time to think, his finger is on the trigger. Boom boom. The gun just appeared in your hand. That's what happened and if I ask you what happened, when I turn the tape recorder on, you're gonna tell me that's what happened. Now where did you find the gun?
>
> TYRONE: In the bushes near my building . . . I, I, I borrowed it by accident from Strike. I was tryin' to give it back to him, but he doesn't talk to me anymore.

In front of a crowd, which includes Strike's mother, true to his promise, André kicks and stomps Strike for messing with Tyrone:

> ANDRÉ: You ruined that boy's life, you fuckin' parasite! It's motherfuckers like you that mugged Rosa Parks.
>
> STRIKE: Who's Rosa Parks?
>
> ANDRÉ: You stupid, ignorant motherfucker. You're done with these streets, done with this project, done with New York. If I ever see you again I'll kill you.

Rodney comes after Strike, who runs back to the police station, where Rocco blames him for what Tyrone did: "He did it for you. He was protecting you. Now he's a 12-year-old murderer. . . . You tell me how Rodney pressured you into cappin' Darryl Adams. Tell me the truth" (On the split screen there is a shot of Darryl firing a gun at Victor.) Strike's mother enters the room:

> MOTHER: If you don't get your hands off my son, you better. Victor called me from the bar [*shot of Victor on the phone, "Look, I'm sick and tired, somebody's gotta pay"*]. He came back in the house an hour later, crying, "I shot somebody ... it was like somebody else was pullin' the trigger" [*shot of Victor shooting Darryl*]. That's what happened. What is going to happen to my son?
>
> STRIKE: [*To mother*] Did you get the money from Sharon [Victor's wife]?
>
> MOTHER: [*Throwing the money in his face*] My son Victor said it was self-defense. Believe him!

Strike's world is collapsing. Sledgehammer in hand, Rodney shatters all the glass in Strike's car. (In big letters, Mazilli writes "YOU IS DEAD" on the side of the car.)

ROCCO: So where you wanta live Ronnie?

STRIKE: I don't know. You tell me.

ROCCO: We's going to the Port Authority Bus Terminal.

STRIKE: Take me to Penn Station …. Look, Rocco, before I get out man just answer me this one question. Why were you so gung ho about all this shit man? Most cops, brothers killin' other brothers, no big thing. What made you care about me, Victor, Darryl Adams, Tyrone?

ROCCO: If I ever see you again, I'll book you on charges of criminal solicitation and conspiracy to commit murder. I'll let André beat you down again. I'll pick up Rodney on the same charges and I'll make sure you two share the same cell. Same fuckin' bed. Do you understand me clearly?

STRIKE: Ya, I understand you clearly. I just wanta say thank you. You know for gettin' me out of town [*a beeper goes off*]. That ain't mine man. I stopped doin' that.

As Strike exits the car, a black man in a suit, white shirt, and bow tie comes near Rocco's car, shouting, "Get your copy of *Final Call*." He holds the newspaper up to the car window. The headlines read, "Justice in Black and White."

The camera turns to Victor leaving the police station, where he is met and embraced by his wife, mother, and sons. The screen fills with a shot of a dead black man on the benches, blood running from his head, a gun in his hand.

MAZILLI: Another stain on the sidewalk.

COP 1: They should blow these projects to Timbuktu.

COP 2: Why bother, they kill each other anyway, one of those self-cleaning ovens.

Mazilli walks across the street, past Spike Lee, as the utility repair man. Lee is drinking a quart of beer ("That kid looks like he got shot up").

In a final sequence Tyrone is playing with Strike's train set, talking to his mother. He is repeating Strike's story about the history of trains: "When trains ran on batteries, you know, and after World War II, right, when people started getting electricity in their houses they made these."

Lee segues from the electric train set to a real train, showing Strike gazing out of a train window as it crosses a high plains Western desert landscape, passing a sign that reads "NO MORE Packing." A piano softly plays in the background as the train glides over its tracks. The afternoon sun fills the coach with amber light. And Strike's face, cupped between his hands, shares the screen with the white glow of the sunset reflected through the train window.

Reading the Film: The Critics' Response

According to the *New York Times* (2000) 30,000 Americans die annually by gunfire, including 4,000 children and teenagers. There are more than 190 million

firearms in civilian hands, about 65 million are handguns. Lee wants the guns to go.

In Lee's world "there are no positive choices for black men born into the underclass" (Taubin, 1995a; also Giroux, 1996, p. 44). This is his didactic message. There is no escape. Young black men must stop killing one another. Black on black crime must stop. The young men in this world are practicing genocide on themselves, and cheap guns are the cause. Drugs, *per se*, are not the issue. The clockers don't use drugs. Drugs are a way of life, a way to make money, though death is a cost of doing business (Ebert, 1998, p. 155).

The film's colorful, garish exterior street scenes and dark, gritty interiors have the "texture of oversaturated 16mm Kodachrome" (Taubin, 1995a). These high color intensities give the film an expressive, jarring surrealistic visual intimacy. It is as if its colors are too vivid. They are at once desolate and hallucinatory. This is Lee's intention, to place the viewer inside Strike's visual world, to let us get inside his skin, make us feel the agony of his experience.

The critics were generally favorable, praising Lee's bold, naturalistic narrative for its brooding, unsettling quality (Bradley, 1995, p. 29; Sterritt, 1995; Turan, 1995). Sterritt (1995) argued that Lee was finally taking up problems that can no longer be ignored, namely the destructive world of crack cocaine and its effects on African American neighborhoods and families. Pawelczak (1995) observed that Lee's film is the visual equivalent of rap, that it has rap's flamboyance and rawness, the buzz of street slang, and hyperactive visuals, although the streets are clean, "the urban ubiquity of drug litter is absent ... there are no vials, no needles" (Bradley, 1995, p. 32).

According to Bradley (1995, p. 32) this absence weakens the film's impact, reinforcing the impression that Lee's social vision has tinges of what Paul Gilroy (quoted in Bradley, 1995, p. 32) calls, "brownstone pastorale." Lee is angry because black youth culture has no historical memory. Strike asks "Who's Rosa Parks?" At the same time, the larger sociohistorical context is missing in the film, including the connections to the Mafia (Pawelczak, 1995). (This theme was not present in Price's original novel, which focused primarily on the world of those at the bottom of the drug hierarchy.) Lee was also praised for showing how the cynical, dark world of the racist cops psychologically collides with the world of young black children growing up in the ghetto (Turan, 1995).

It is hard to identify with any of Lee's characters. I feel distance from Strike, perhaps even pity, as he gazes out of the train window. I worry about Tyrone, who is now deep into Strike's fantasy world of trains. In the end I am drawn to Strike's mother, who pleads Victor's case. I rejoice as Victor is reunited with his wife, mother, and sons outside the Halls of Correction. With Rocco I feel only pity, but, curiously, I share Rodney's anger at Strike as he destroys Strike's car.

Lee's representations of white racism are not attractive. He presents the white police as unfeeling men who have little, if any, respect for black youth and their place in the black community. A murder is just another bloodstain on the sidewalk. The projects are self-cleaning ovens—shades of Nazi racism. Black men in jail engage in homosexual rape and they love young white boys.

Lee vividly captures Strike's world, and its scenes of harassment and interrogation, the racist slurs, profanity, "the streams of vituperation and tirade" (Denby, 1995). At this level Lee sets himself against a black culture that has become too accepting of violence, guns, and dead young men lying in the street. He is relentless in the delivery of the message, "No More Packing—no more guns" (Denby, 1995), but this works against the narrative. Lee wants it both ways. He wants to send a moral message while maintaining emotional distance from his subject matter (Turan, 1995). And the moral message is dubious. Rocco tells Strike to get out of town. Ebert (1998) asks, "Is that the answer? That the infection of drugs and guns is so deep that the only sane action is to get out of town?" (p. 155).

The Oliver Stone-like moralizing is off-putting (Mathews, 1995). In the end the polemicist trips up the dramatist when he tries to tie up all the loose ends in this weak murder mystery (Ansen, 1995; Taubin, 1995b). "It's an opera without a tragic ending" (Schickel, 1995). When the mystery is taken away, this wants to be, as Taubin (1995b) argues, the "Hood movie to end all hood movies." It may not be that, but it effectively captures the prison house of racism that circulates every day in the hoods and barrios of black and brown America.

Conclusions

In the end no one can dispute the fact that Lee's cinematic apparatus works. He is a gifted filmmaker, with an eye for nuance, the vernacular, the everyday, black and white popular culture, and the multiple spaces that make up the black public sphere.[18] Most troubling, as argued above, are his politics. Lee merges the new black aesthetic with a non-hegemonic black neo-nationalism. This is not a nationalism based on radical political practice or a call for cultural resistance. Through the skillful cinematic use of black idiom, popular music, and fashion, Lee's film evokes a vernacular neo-nationalism. This has the effect of creating a feeling of momentary empowerment, an empowerment that affirms black experience in the present (hooks, 1990, p. 178). But this is a noncritical nationalism. Lee never directly engages the world of his characters; they function as one-dimensional archetypes (hooks, 1990, pp. 178–179). Indeed, as Baraka (1993, p. 153) argues, his men and women lack both agency and the will, or desire, to resist (also hooks, 1989, p. 179).

Watkins (1998, p. 135) disputes these criticisms, arguing that Lee's cultural pro-

ductions[19] invoke race pride ("Stay black!"), while successfully blending popular cul-
ture resistance and identity politics. According to Watkins, Lee appropriates
"resources from the dominant culture industry to establish a base . . . from which
to launch commodities . . . that vigorously enunciate what Cornel West character-
izes as the 'new cultural politics of difference'" (p. 135). For West (1990), this pol-
itics of difference is a strategy that turns the cultural worker into a critical organic
catalyst. This is a "person who stays attuned to the best of what the mainstream has
to offer . . . yet maintains a grounding in affirmative and enabling subcultures of crit-
icism" (p. 33). West calls for prophetic critics and artists of color to be "exemplars
of what it means to be intellectual freedom fighters" (p. 33). These are cultural work-
ers who are simultaneously located within the mainstream, while being "clearly
aligned with groups who vow to keep alive potent traditions of critique and resis-
tance" (p. 33).

Watkins contends that Lee is such a worker, noting that he has openly criti-
cized the racial politics of Hollywood, while demanding that black filmmakers have
greater creative control of their films. Watkins further asserts that Lee's represen-
tational strategies and "directional signature . . . [show how] . . . black American film-
making can be deployed to engage, if not occasionally oppose, competing discourses
about race and the culture wars that drive the social and political struggles of the
period" (p. 136).

Is this enough? One wonders. Kellner (1997) observes that Lee's "politics of
identity . . . works primarily to indict racism and to promote the interests of black
identity and pride, channeled largely through cultural style" (p. 100). Yet, Kellner
notes that Lee's films do attack "at least some of the many forms of sex, race, gen-
der, and class oppression. While they might not ultimately provide models of a
'counterhegemonic cinema' . . . they provide some engaging and provocative cine-
matic interventions that are far superior to the crass genre spectacles of the
Hollywood cinema" (p. 100).

Is this enough? Baker (1993) compares Lee to the grandfather in Ralph
Ellison's novel *Invisible Man*. The grandfather talks about the "Black man living with
his 'head in the lion's mouth' and acting as a 'spy in the enemy's camp' in order to
make a successful way out of 'noway' in America" (p. 174). In some senses, Lee is
like Ellison's grandfather, only he is getting "paid in full" for reporting decisively from
the inside on the straight skinny of racism and domestic colonialism in these
United States" (p. 174). But in his way, and one wishes his reports were more mil-
itant, and more decisive.

Notes

1. *Clockers* (1995). Universal Pictures release of a 40 Acres and a Mule Filmworks Production.
 Producer: Martin Scorsese, Spike Lee, and Jon Kilik; Director: Spike Lee; Screenplay:

Richard Price and Spike Lee, based on the novel by Richard Price. Director of Photography: Malik Hassan Sayeed; Cast: Harvey Keitel (Rocco Klein); John Turturro (Larry Mazilli); Deroy Lindo (Rodney); Mekhi Phifer (Strike); Isaiah Washington (Victor); Keith David (André the Giant); Pee Wee Love (Tyrone); Regina Taylor (Iris Jeeter); Tom Byrd (Errol Barnes). For reviews see Ansen (1995), Brown (1995) Denby (1995), Mathews (1995), Medved (1995), Pawelczak (1995), Schickel (1995), Sterritt (1995), Taubin (1995a,b); Turan (1995); also Pouzoulet (1997), Reid (1997, p. 8). For critical assessments of Lee's projects more generally, see the essays in Reid, 1997b:, especially Kellner, 1997, and Pouzoulet, 1997; also Reid, 1993, pp. 104–108; Baraka, 1993; Baker, 1993; Boyd, 1997, pp. 24–30; hooks, 1990, pp. 173–184; 1992, pp. 126–127; 1994, pp. 155–164; 1996, pp. 165–166; Lubiano, 1997; Watkins, 1998, pp. 107–168.

2. Watkins (1998) asserts that Lee's *She's Gotta Have It* (1986) "established the precedent for the reemergence of black cinema as a viable commercial product" (p. 108).

3. Of course other hood movies would appear after 1995, including: *Set It Off* (1996), *Dangerous Minds* (1996), *Hoodlum* (1997); even Lee's *He Got Game* (1998) would take up the ghetto-centered narrative once more. Paris Barclay's *Don't Be a Menace to South Central While Drinking Your Juice in the Hood* (1996) is a spoof of this film cycle. I disagree with Watkins (1998, p. 170), who contends that the ghetto-action film cycle is not necessarily associated with Lee.

4. Watkins (1998, p. 135) disagrees, asserting that Lee embodies what Cornel West (1990) calls the new cultural politics of difference and resistance. Reid (1997) suggests that Lee's black nationalism resembles the type of white populist heroes found in Frank Capra films. "Lee's populism . . . features a black individual caught in the claws of white industry and institutions . . . and patriarchal conventions" (p. 15). Kellner (1997) ironically reads Lee's aesthetics within a radical Brechtian model but finds that Lee's black cultural identity politics do not contain a politics of resistance or black liberation.

5. Still, Lee openly criticizes the Hollywood establishment and its treatment of black filmmakers. In turn, his films have generally been denied Oscar nominations (Katz, 1998, p. 811).

6. *She's Gotta Have It* (1986), *School Daze* (1988), *Do the Right Thing* (1989), *Mo' Better Blues* (1990), *Jungle Fever* (1991), *Malcolm X* (1992), *Crooklyn* (1994), *Clockers* (1995), *Get on the Bus* (1996), *Girl 6* (1996), *Four Little Girls* (1997), *He Got Game* (1998), *Summer of Sam* (1999), *Bamboozled* (2000), *Original Kings of Comedy* (2000).

7. Lee vigorously campaigned to be the director of *Malcolm X*, for example. Guerrero (1993, pp. 198–201) reviews the controversy surrounding this project.

8. Lee justifies these representations thus: "I know that black men do a lot of things that are fucked up and I've tried to show some of the things that we do" (Lee, quoted in hooks, 1996, p. 232).

9. In *Get on the Bus* Lee returns to the issue of gay sexuality. Flip (André Braugher), the aspiring actor, constantly mocks, taunts, and ridicules the two gay men on the bus, as he brags about the number of women he has seduced.

10. But see Baraka, 1993, pp. 151–152.

11. Danny Aiello won an Oscar nomination for Best Supporting Actor, and Spike was nominated for Best Original Screenplay (Bogle, 1994, p. 323).

12. Lee made a series of Nike ads with Michael Jordan, in which he played a character named Mars Blackmon (Watkins, 1998, p. 134). Like Jordan, Lee had to confront charges concern-

ing Nike's labor practices and the fact that its ads encouraged working-class black youth to "covet high-priced shoes" (Watkins, 1998, p. 265).

13. Lee (1989) indicates that he was making an illusion to the Howard Beach incident in the film "by using a pizza parlor. The white kids ... could be the sons of the owner of the pizzeria" (pp. 24–25).

14. Lee (1989) describes his use of the notion of the hottest day:

> While I was in the grocery store, I heard a radio broadcast that two Black youth had been beaten up by a gang of white youths in Bensonhurst Just the other day some Black kids fired up a white cab driver in Harlem. New York City is tense with racial hatred. Can you imagine if these incidents had taken place in the summer, on the hottest day of the year? (pp. 32–33).

15. Or, as in *Summer of Sam* (1999), he functions as a television journalist, reporting from the sidelines.

16. Here hooks is referring to the scene near the beginning of the film when the camera focuses on Mookie (Lee) lying in bed with Jade (his sister in the film, and his sister in real life, Jolie Lee), and Mookie's touching Jade's body in a way that has an erotic dimension (hooks, 1990, p. 182).

17. Richard Price wrote the script, which was based on his novel of the same name. Originally Martin Scorsese and Robert DeNiro were scheduled to make the film. They dropped the project, to make *Casino*. Lee then came in as director, and Harvey Keitel took the part written for DeNiro (Rollyson, 1996, p. 92). Lee rewrote Price's script. Denby (1995) suggests that the film seems to combine two different time periods in New York City, "the late-eighties peak of the crack madness ... and the Giuliani era of greater police vigilance, with its nonstop surveillance of drug dealers" (p. 72).

18. For example *Bamboozled* (2000) uses the format of a contemporary minstrel TV show to turn blackface into a national craze.

19. These productions include, of course, Lee's film production company, 40 Acres and a Mule, his retail store, Spike Lee Joint, his music recording company, and his music video productions. These are all located in the Fort Greene section near Brooklyn Heights, which is where Lee was born, and still lives (see Pouzoulet, 1997, p. 33; Watkins, 1998, p. 134). In December 1996 Lee announced a collaboration with the Madison Avenue advertising agency DDB Needham, which handles accounts for McDonald's and Budweiser. This led to the formation of Spike/DDB, with Lee the 51 percent majority shareholder, president, and creative director. Anheuser-Busch, the owners of Budweiser, sponsored a promotion tour and advance bookings for Lee's 1996 film *Get on the Bus* (Gilroy, 2000, pp. 242–243). Multiculturalism and blackness have become big international business. Lee leads "a new contingent of cultural brokers: a hip vanguard in the business of difference" (Gilroy, 2000, p. 242).

References

Ansen, D. (1995, September 25). Review of *Clockers*. *Newsweek*, p. 92.

Baker, H.A., Jr. (1993). Spike Lee and the commerce of culture. In M. Diawara (Ed.), *Black American cinema* (pp. 154–176). New York: Routledge.

Bambara, T.C. (1996). *Deep sightings & rescue missions*. (T. Morrison, Ed. and preface). New York: Vintage.

Baraka, A. (1993). Spike Lee at the movies. In M. Diawara (Ed.), *Black American cinema* (pp. 145–153). New York: Routledge.

Bogle, D. (1994). *Toms, coons, mulattoes, mammies, and bucks: An interpretative history of blacks in American films* (3rd ed.). New York: Continuum.

Boyd, T. (1997). *Am I black enough for you? Popular culture from the "hood" and beyond*. Bloomington: Indiana University Press.

Bradley, D. (1995). Spike Lee's inferno, the drug underworld. *New Times*, Arts & Leisure, pp. 29, 32.

Brown, G. (1995, September 19). Review of *Clockers. Village Voice*, p. 71.

Denby, David. (1995, September 18). Review of *Clockers. New York*, p. 72.

Denzin, N.K. (1991). *Images of postmodern society: Social theory and contemporary cinema*. London: Sage.

Ebert, R. (1998). Review of *Clockers*. In *Roger Ebert's video companion* (1998 ed., pp. 154–155). Kansas City: Andrews and McMeel.

Ellis, T. (1989, May 15). The new black aesthetic. *Before Columbus Review*, pp. 4, 23.

Gilroy, P. (2000). *Against race*. Cambridge, MA.: Harvard University Press.

Giroux, H.A. (1996). *Fugitive cultures, race, violence & youth*. New York: Routledge.

Gray, H. (1995). *Watching race: Television and the struggle for "blackness."* Minneapolis: University of Minnesota Press.

Guerrero, E. (1993). *Framing blackness: The African American image in film*. Philadelphia: Temple University Press.

hooks, b. (1989). *Talking back: Thinking feminist, thinking black*. Boston: South End Press.

———. (1990). *Yearning: Race, gender, and cultural politics*. Boston: South End Press.

———. (1992). *Black looks: Race and representation*. Boston: South End Press.

———. (1994). *Outlaw culture: Resisting representations*. New York: Routledge.

———. (1996). *Reel to real: Race, sex and class at the movies*. New York: Routledge.

Jones, J. (1993). The construction of black sexuality. In M. Diawara (Ed.), *Black American cinema* (pp. 247–256). New York: Routledge.

Kassabian, A. (1991). Review of *Mo' Better Blues*. In F.N. Magill (Ed.), *Magill's cinema annual: 1990: A survey of the films of 1989* (pp. 158-261). Englewood Cliffs, NJ: Salem Press.

Katz, E. (1998). *The film encyclopedia*. (3rd ed., rev. by Fred Klein & Ronald Dean Nolen). New York: Harper Perennial.

Kellner, D. (1997). Aesthetics, ethics and politics in the films of Spike Lee. In M.A. Reid (Ed.), *Spike Lee's "Do the Right Thing"* (pp. 73-106). New York: Cambridge University Press.

Lee, S. (1988). *Uplift the race: The construction of "School Daze."* New York: Simon and Schuster.

Lee, S. (1989). *Do the Right Thing: A Spike Lee Joint*. New York: Fireside Press.

Lubiano, W. (1997). But compared to what? Reading realism, representation, and essentialism in *School Daze*, *Do the Right Thing*, and the Spike Lee discourse. In V. Smith (Ed.), *Representing blackness: Issues in film and video* (pp. 97-122). New Brunswick, NJ: Rutgers University Press.

Marble, M. (1992). Race, identity, and political culture. In G. Dent (Ed.), *Black popular culture: A project by Michele Wallace* (pp. 292-303). Seattle: Bay Press.

Mathews, J. (1995, September 13). Review of *Clockers*. *Newsday* Part II, p. 82.

Medved, M. (1995, August 11). Review of *Dangerous Minds*. *New York Post*, p. 43.

New York Times (2000, September 5). Editorial: The Scourge of Guns, p. A30.

Pawelczak, A. (1995, December 11). Review of *Clockers*. *Films in Review*, p. 100.

Pouzoulet, C. (1997). The cinema of Spike Lee: Images of a mosaic city. In M.A. Reid (Ed.), *Spike Lee's "Do the Right Thing"* (pp. 31-49). New York: Cambridge University Press.

Reid, M.A. (1993). *Redefining black film*. Berkeley: University of California Press.

———. (1997a). Introduction. In M.A. Reid (Ed.), *Spike Lee's "Do the Right Thing"* (pp. 1–15). New York: Cambridge University Press.

———. (1997b). *Spike Lee's "Do the Right Thing."* New York: Cambridge University Press.

Rollyson, C. (1996). Review of *Clockers*. In B.A. Falmer & C.P. Scanlon (Eds.), *Magill's cinema annual: 1996: A survey of the films of 1995* (pp. 90-92). Detroit: Gale Research.

Schickel, R. (1995, September 18). Review of *Clockers*. *Time*, p. 108.

Shohat, E. (1991). Ethnicity-in-relations: Toward a multicultural reading of American cinema. In L.D. Friedman (Ed.), *Unspeakable images: Ethnicity and the American cinema* (pp. 215–250). Urbana: University of Illinois Press.

Sterritt, D. (1995, September 13). Review of *Clockers*. *Christian Science Monitor*, p. 13.

Tate, G. (1992). *Flyboy in the buttermilk*. New York: Fireside Press.

Taubin, A. (1995a, September 19). Review of *Clockers*. *Village Voice*, p. 71.

———. (1995b, October). Review of *Clockers*. *Sight and Sound*, p. 45.

Turan, K. (1995, September 13). Review of *Clockers*. *Los Angeles Times*, p. 1.

Wallace, M. (1992). *Boyz N the Hood* and *Jungle Fever*. In G. Dent (Ed.), *Black popular culture: A project by Michele Wallace* (pp. 123–131). Seattle: Bay Press.

Watkins, S.C. (1998). *Representing: Hip hop culture and the production of black cinema*. Chicago: University of Chicago Press.

Weinraub, B. (1995, September 11). Black film makers are looking beyond ghetto violence. *New York Times*, pp. B1, B4.

West, C. (1990). The new cultural politics of difference. In R. Ferguson, M. Gever, T.T.Minh-ha, & C. West (Eds.), *Out there: Marginalism and contemporary culture* (pp. 3–32). Cambridge, MA: MIT Press.

The New Race Man

Doing the Right Thing
by Any Means Necessary

Athletic Iconography
IN Spike Lee's
Early Feature Films

KERR HOUSTON

B y virtually any standard, Spike Lee is a dedicated follower of professional sports. In winter, he can often be seen courtside at New York Knicks games, jawing at opposing players; in interviews, he has claimed that he grew up wanting to be a professional athlete. He made headlines in late 2001 by auctioning a ticket to Michael Jordan's comeback game and donating the proceeds to a September 11 relief effort, and he borrowed a phrase from the lexicon of baseball line scores in titling *Five for Five* (the book that accompanied the release of his film *Jungle Fever*)—implying that his fifth project, like his previous four trips to the plate, had resulted in a hit.

This lively interest in sports has clearly influenced his more recent work, as several of his latest films have featured athletes as subjects and actors. But his interest in sports also colored, if a bit less obviously, his first five feature films, none of which deals with explicitly athletic plotlines. From a slew of references to Knicks great Bernard King in *She's Gotta Have It* to the Mets telecast that accompanies our first look at Angela Tucci's brothers in *Jungle Fever*, allusions to professional sports—and specifically to New York sports—form a consistent pattern in Lee's early films.

Certainly, such references point in part to the close relationship between Lee's visual style and contemporary urban fashion. Air Jordans and Laker jerseys, after all, are not unique to Spike Lee joints; they were common sights on New York

streets in the late 1980s. But much as Lee blended hip-hop tunes with Negro spirituals and jazz melodies in creating the complex soundtracks that echoed the very diverse voices of his characters, his references to athletic gear and jargon are not simply received stylistic statements.[1] In Lee's first five films, when characters chat about professional sports or wear a particular team's jersey, the references usually advance our specific understanding of both the speaker and the situation. As S. Craig Watkins (1999) has noted, Lee's characters often represent distinct fields of discourse and perform specific narrative functions (p. 140). Lee's use of athletic iconography furthers this strategy, using established cultural codes as a means of characterization, and it creates, by extension, a general atmosphere of competition, or conflict, in which voices and visual images jostle and compete for legitimacy. While a parade of replica jerseys, athletic anecdotes, and photos of athletes thus grounds his early work in a relevant urban idiom, such references also allow Lee to nuance, as we shall see, the themes of racial conflict, individual pride, and social history that consistently characterize his work.

Lee's interest in athletic iconographies has no better, or better-known, ambassador than the flamboyant Mars Blackmon, the likable loser who is one of Nola Darling's suitors in the breakthrough 1986 film, *She's Gotta Have It*. Dressed when we first see him in a Knicks jacket and a Georgetown teeshirt, Mars knits himself to two high profile basketball squads of the early 1980s: to the New York NBA team that starred the acrobatic King, and to the Georgetown program that had won a national title in 1984, and finished second in the 1985 college tournament. The Knicks jacket, of course, also links Mars to the city in which he works as a bike messenger. The shirt is less geographically specific, but a quick look at Georgetown's hoops program in the 1980s reveals an equally basic relevance. Georgetown, then coached by John Thompson and thus one of the few teams in the country with an African American behind the bench, fielded several of the nation's best college teams in the mid-1980s—and some of its blackest. Led by Thompson, who spoke candidly on race and recruited heavily from Washington's inner-city high schools, Georgetown's squads were often entirely comprised of African Americans. Thus, by wearing the gray Georgetown tee, Mars suggestively links himself to college stars like Patrick Ewing and Alonzo Mourning, but also to a quiet sense of black pride.

Such a claim may seem tenuous, or overeager—how much pressure, after all, can a cotton shirt bear? A good deal, it would seem. In discussing promotional shirts issued in conjunction with his first two films, Lee argued that "somebody wearing your T-shirt is a walking billboard" (Grant, 1997, p. 18). In his early films, he often extended this idea, using tee shirts to indicate his characters' political views and stylistic habits; as Douglas Kellner noted, the white and black tee shirts worn by a racist Pino and a more open-minded Vito in *Do the Right Thing* hint at their racial atti-

tudes (1997, p. 78). And this interest in the symbolism of shirts could also encompass the world of professional sports. In *Five for Five*, published in conjunction with his fifth film, Lee reflected on the number five, and soon turned to the numerology of baseball jerseys: "Joe DiMaggio, Johnny Bench, and Ed Charles—they wore the number five" (Lee, 1991, p. 11). Lee, in other words, knew his uniforms and knew what they stood for.

So do his characters. In *Do the Right Thing* (1989), the white cyclist who runs over Nikes worn by Buggin' Out is initially harangued for his clumsiness, but his critics soon turn to his shirt, a replica Larry Bird jersey, as a more concrete subject of ridicule. Invoking the best-known white basketballer of the 1980s, Clifton's shirt (cut from the Celtic green that the team wore on road trips, and thus suggesting a basic foreignness) stands out in black Bed-Stuy. In fact, his jersey not only marks him as foreign, but also creates, when read in context, a clever visual tension between Clifton and the group that surrounds him. Ahmad, one of the young men who gather to mock Clifton, wears a replica Magic Johnson jersey. This juxtaposition seems certainly intentional; Johnson and Bird were the two most prominent stars in the NBA before the emergence of Michael Jordan, and their rivalry was built around a series of dichotomies. Bird was an occasionally awkward Indiana country boy who played for an East Coast team, while the more urbane Magic played a fluid and fast-paced game in Los Angeles. In fact, the two players came to epitomize, for a number of writers, an explicit difference between white and black basketball. Jeff Greenfield had treated this difference as early as 1975, arguing that the black game was characterized by a basic grace and fluidity, in contrast to a white game, epitomized by the Celtics, that tended to be "jagged, sweaty, stumbling, intense" (1999, pp. 375–376)—all adjectives that would seem to apply to Clifton as well. In several ways, then, Lee's decision to clothe Clifton in a Bird jersey appears remarkably appropriate: Clifton, like Greenfield's typical white ballplayer, is sweaty and stumbling, and he literally fouls Buggin' Out (by sullying his sneakers). He is, like the athlete summoned by his shirt, a white man in a predominantly black league.

Perhaps because the image of Bird as an isolated white star was so powerful in the 1980s, Lee referred to the Celtic star in several of his early films.[2] Without exception, Bird's name is uttered to invoke racial isolation, primarily whiteness estranged. At one point in *Mo' Better Blues*, for example, a performing comic jokes onstage about Giant, who sits alone at a bar. The comic compares Giant to a white man "trying to sneak in here in the colored section," and then swiftly transitions into an anecdote about Bird and the Celtics. The implication, of course, is that Bird, like Giant, is an outsider. Similarly, in *She's Gotta Have It*, Mars's frustration with Greer's affected style finds its voice in an implicit reference to Bird at the awkward Thanksgiving dinner. After suggesting that Greer had voted for Reagan, Mars (who overtly states his preference for Jesse Jackson) extends his essentially racial

attack with a reference to basketball: "What do you know—you're a Celtics fan." Hoping to embarrass the straight-haired Greer, Mars questions his rival's adherence to black principles by accusing him of voting for a white presidential candidate and of following a white basketball team.[3]

A second reference to Bird in *She's Gotta Have It* shows, however, that the Celtic star did not necessarily indicate discord in Lee's films. In a touching conversation in a city park, Mars and Jamie, another lover for Nola's affection, find rare common ground in a discussion about hoops. Taking a seat beside Jamie, Mars rather predictably steers the conversation toward the Knicks, saying that he had once been stood up at Madison Square Garden by Nola, and had consequently missed the entire first half of a Knicks game in which King had scored 35 points and even dunked over Bird. For Mars, King's performance was doubly triumphant, as it led the Knicks to victory and defeated Bird's white team. But Jamie, more moderate than Mars, stands up for Bird, noting that "the White boy's bad, and you gotta give him credit. Larry Bird's the best player in the NBA." A shocked Mars can only sputter, "The best? He's the ugliest motherfucker in the NBA!" But his comeback, which focuses on Bird's appearance, tacitly admits Jaime's point about Bird's talent. Bird thus works (again) as an emblem of racial difference, but he also functions as an analogy for whites like Clifton in *Do the Right Thing*, who carve out a niche in Lee's neighborhood; because such men are exceptions, black characters admit, perhaps even grudgingly admire, their earned right to work in Bed-Stuy or in the NBA.

Those white men are never completely accepted, though. In Lee's early films, open references to, or affiliations with, black athletes constitute one of the truest forms of black pride and individual strength. In a tender scene in *She's Gotta Have It*, a confident Nola wears a Bernard King jersey as she oils Mars's scalp. The jersey recalls Mars's description of King's triumphant dunk over Bird, but it also means that Nola is dressed like a King, while Mars, stripped of his athletic gear and so reduced to his glasses, is more fan than athlete. Hyperbolized as a huge pair of eyes, he is subsequently forced to gaze as Nola finally opts for Jamie, instead of Mars himself. Association with an athlete and an athlete's accoutrements can imply, then, strength or potency. For when Nola appears in a pair of Everlast boxing shorts after she dumps Greer, the conceit is confirmed. Epitomizing a long history of African American women as combative beings, Nola's literally competitive clothing marks her as a powerful woman.

Although idiosyncratic in several senses, Lee's 1988 *School Daze* did allow him to expand his references to professional sports. An example appears in the film's opening sequence: A print of a slave ship gives way to a series of photos of famous African Americans and critical moments in African American history. The montage includes several images of Black athletes, including Jackie Robinson in a white Brooklyn Dodgers uniform, Willie Mays, and Muhammad Ali. Preceded by pho-

tographs of influential musicians, and followed by images from the Civil Rights movement, these pictures of athletes thus form an implicitly important segment of African American history. More than a year before the release of *Do the Right Thing*, Lee thus created, in a sense, a Wall of Fame that rivals Sal's forthcoming tribute to Italian Americans: a bank of portraits of cultural heroes linked as much by race as by accomplishment.

Robinson seems especially carefully chosen for the *School Daze* sequence. He was, of course, the first African American to play ball in the major leagues, and he went on to a Hall-of-Fame career as a second baseman with the Dodgers. The photo of Robinson thus depicts an African American baseball player and a famous episode in the history of American integration. But it also bears more local relevance. Robinson was born in Cairo, Georgia, in 1919, and then spent his entire ten-year career in the majors with the Brooklyn Dodgers. In a loose sense, his life thus paralleled Lee's own, as the young director (although a native Brooklynite) had moved from Morehouse, in Atlanta, to Brooklyn after graduation. This associative link between Lee and Robinson would become more concrete in *Do the Right Thing*, when Lee, as Mookie, would wear a Robinson jersey throughout most of the film. But the opening moments of his second film intimate an admiration for Robinson that is at once cultural and personal.

Allusions to professional sports in Lee's second film are equally precise. Dap, an idealistic black undergraduate who covers the walls of his room in emblems of a general pan-African pride (a Red Stripe poster evokes Jamaica and a poster of Nelson Mandela recalls Dap's fight for divestiture), includes a poster of Patrick Ewing, in his Georgetown basketball blue. The implication, again, is that Ewing is an appropriate icon for young blacks interested in their roots. On the one hand, Dap follows Mars in his admiration for a contemporary African American athlete. On the other hand, for the film's first extended dance sequence, in which Jigaboos and lighter-skinned Wannabes taunt each other, Lee uses flamboyantly contrasting colors to point toward an active social conflict, rather than passive individual association. Both groups of women wear loose shirts that evoke football jerseys, and the clashing colors of the shirts (blue and orange for the Jigaboos, and silver and black for the Wannabes) depict the ideological distance between the women. But this difference is not only chromatic; it is also symbolic, as the colors reference one of U.S. football's best-known rivalries, between the Oakland (or Los Angeles, as they were in 1988) Raiders, who wear black and silver, and the Denver Broncos, who share the blue and orange of the Jigaboos. Thus, Lee uses vigorous colors to symbolize the gulf between the two groups of women—as befits a face-off during Homecoming weekend. In fact, Coach Odom's pregame speech also references jerseys' colors significantly. In a rant that conflates athletic intensity and religious fervor, the coach condemns the visiting team's dark uniforms by screaming, "The

devil's wearing black jerseys!"

The ensuing montage, in which the Mission boys are soundly whipped, is intriguing for the fact that at no point do we see any football being played. Lee turns his camera on the scoreboard and shows us the bleachers, the coach, and the players on the sidelines, but he never films a single down or tackle. Critic Stanley Kauffmann pointed to a similar lack of formulaic conceit when he remarked on the conspicuous absence of drugs in *Do the Right Thing* (1994, pp. 81–82).[4] The absence of real athletic competition is just as notable in all of Lee's early works, which, I am arguing, allude often but only tangentially to sports, not in portrayals of real or imagined plays but through such codes as still photographs, emblazoned caps, and coy verbal references. In *School Daze*, one character combines basketball imagery with "the dozens" to deploy the African American vernacular ritual of signifyin(g) on another character: "I heard your mama held Kareem to 15 points." In Lee's films, sports are filtered through such folk rituals, through the doubled gaze of filmic images of television screens, and through characters' memories, but curiously, sports persistently function as trope and sign, for they are not pictured directly.

This absence does not signify that there are no athletes in Lee's films. There clearly are. The Jigaboos and the Wannabes dance a vigorous number that is nothing if not athletic, and the dance of the Gammas similarly requires strength and flexibility. But these moves are made by characters not dressed for formal athletic competition. In setting the stage for the Mission football game, and in then turning his camera to the crowd, Lee implicitly suggests that the spectators are the true competitors of sports events. As a result of repeated indirect references to sports and of Lee's concurrent reluctance to picture athletic action, his sets become allegorical fields, and his characters, like the Wannabes and Jigaboos, are virtual rivals. Interestingly, the tensions created through these "athletic" rivalries are never resolved. The social and personal conflicts at the center of Lee's early plots cannot be resolved through the "play" of professional sports, but instead only by genuine social, and political, action: by Nola Darling's choice of a single lover, or by Mookie's decision to heave a trash can through the window of a pizzeria—or, perhaps, by a gesture of viewers who constitute Lee's actual audience itself. Lee's athletic references imply a tense context of conflict, but his Brechtian impulses reject any simple or allegorical resolution through purely passive identification.

Spike Lee's third film also uses costumes in creatively symbolic ways. Overseen by Ruth Carter (who had also designed costumes for *School Daze* and who would work on later Lee productions), the costumes in *Do the Right Thing* are bold and idiosyncratic, and they generally suggest a basic individualism. Many of them, of course, have no connection to athletics. On the one hand, the fiery, skintight leotard worn by (Rosie Perez acting as) "Tina" in the film's grinding opening sequence points to an overtly physical confidence, and the "Bed-Stuy: Do or Die" teeshirt that

affirms Radio Raheem's devotion to his hood evokes brazen pride in place. Raheem's hand-lettered shirt also ties him to the graffiti that cover the walls of his neighborhood and links him to the substance of those graffiti, which refer to otherwise anonymous acts of urban violence. On the other hand, the audacious Hawaiian print worn by (Danny Aiello acting as) Sal hints at a very different relation to the same environment. Covered in cactuses, Sal's shirt suggests life in the heat of an internal desert: a sadly appropriate image for the proprietor of the only white-owned business in a neighborhood that is, in several senses, overheated. Raheem's shirt, then, presents his environment as a source of pride, while Sal's shirt signifies an environment that can sustain life, but is nonetheless hostile. Even their costumes, then, underline the irreconcilability of the views of the two characters, and the allusively military iconography of Raheem's camouflage shorts further conveys that this is not a conflict that will be solved peaceably.

Moreover, Lee uses wardrobe to emphasize the theme of conflict in *Do the Right Thing* through the several costumes that refer directly to sports celebrities and, by extension, to relevant episodes in sports history. For example, for most of the film, Mookie sports what is perhaps the most interesting costume choice, a Jackie Robinson jersey. Because Robinson was a Brooklynite by circumstance (but not birth), his white jersey links Mookie to the city of Brooklyn in the same way that Raheem's teeshirt declares his territorial allegiance to Bed-Stuy. The white jersey implies that Mookie is on his home turf. Less literally, Mookie's replica jersey also points to one of his primary roles in the movie: Just as Robinson had broken baseball's color barrier (and much as Lee was doing groundbreaking work in the largely white film industry), Mookie embodies, as he wears the jersey, a brand of racial tolerance. He works for a white-owned pizzeria, he (gently) throws Buggin' Out out of the pizzeria after the initial flap about the Wall of Fame, and he dates a Latina. In short, while wearing the Robinson jersey Mookie seems to work toward a sense of compromise in an obviously tense setting.[5]

But after he showers, he sheds his Robinson jersey, donning instead a shirt emblazoned with the logo of Sal's Famous Pizzeria. In the process, Mookie also seems to move away from the spirit of proud integration connoted by the Robinson jersey and becomes more openly abrasive. Wearing a shirt bearing the name of a white restaurateur, rather than a celebrated African American, Mookie soon tries to shut the door on four patrons who arrive at the pizzeria shortly after closing, thus working toward a stark, forceful division instead of a peaceful compromise. A few minutes later, in the film's climactic scene, he completes his movement away from compromise by lobbing a trashcan through the window of the pizzeria. Both shirts, then, evoke ruined structures that once stood in Brooklyn—Sal's parlor still smoking, and Ebbets Field, the home of the Dodgers, demolished in 1960—but they also loosely relate to the two divergent courses of political action that are suggested in

the film's recurring juxtapositions of Martin Luther King, Jr. and Malcolm X. Mookie's Robinson jersey suggests a more peaceful integration, within the parameters of an extant system, while frustrations expressed in his pizzeria shirt imply a much more violent, and less patient, standpoint.

Perhaps the most important (and the most expensive) piece of athletic iconography in *Do the Right Thing* is the pair of sneakers on Buggin' Out's feet. Air Jordans, introduced by Nike in 1985 in conjunction with Michael Jordan's rookie season, had already been retooled several times by early 1989. Popular with a wide range of consumers, the shoes bore a number of connotations. Obviously, they could evoke Jordan, the young Chicago Bulls guard whose fluid, acrobatic moves seemed to defy gravity. At the same time, they also spoke (albeit rather more obliquely) of wealth, and even of an insistence on blackness. Retailing for roughly $70 per pair, the shoes cost Jordan substantially more, as the NBA fined him $1,000 every time he wore them in a game, because of their illegal black detailing. Undeterred, he wore them on the court night after night.

These various associations, of course, dovetail rather neatly with Buggin' Out's personality; the shoes fit him, in other words, in several senses. Incensed by the absence of photographs of black athletes in Sal's pizzeria, Buggin' Out wears a product named for a black athlete. In fact, Michael Jordan's style of play was sometimes read, like that of Magic Johnson's before him, as the epitome of black hoops. Thus John Edgar Wideman, in 1999, argued that Mike and Magic had introduced a degree of spontaneity and play that was deeply African American, and they had rendered basketball "more of a player's game, returned it closer to its African American roots on the playground" (p. 396). Buggin' Out's strident calls for the addition of photos of Blacks to Sal's Wall of Fame also find a loose parallel in Jordan's insistence upon flaunting the league's rule against black detailing: Both men question existing prohibitions of blackness. Finally, the shoes also allow Lee to heighten the contrast between Buggin' Out and Clifton, who accidentally sullies the sneakers. Clifton, sweaty and unkempt (and apparently just a bit out of control), has clearly been exercising; he thus contrasts with Buggin' Out, who wears athletic shoes but remains composed, and hardly perspires on the hottest day of the summer. Alarmed at the blemish on his pricey shoes, Buggin' Out quickly protests, only to learn that Clifton has recently bought a townhouse on the block. Here is another point of difference, as Buggin' Out wears his wealth as part of an outfit as symbolic as it is functional, while Clifton has invested his money in real estate instead of his outward appearance. As wide as the rift between Mookie, who finds time to shower and change shirts while on the clock, and Sal, one of the few characters to own a business on the block, the distance between Buggin' Out and Clifton is depicted as the distance between costume and real estate, between accessories and assets.

One other obvious reference to Jordan, and to Jordan's image, in Lee's third film

involves a violent visual pun. Jordan, a virtual acrobat in the air, was famous by 1989 for his long, graceful leaps: As Michael Eric Dyson has argued, the nearly unbelievable ability to defy gravity, commonly known as his hang time, was a central aspect of Jordan's image (1999, p. 411). Lee, in fact, advanced the image in several television commercials that he shot for Nike; in one, aired in 1990, a fictional professor explains Jordan's abilities in humorously formal scientific jargon, and in others, a pathetic Mars hangs weakly from the rim, in a sharp contrast to Jordan's easy motions. Jordan's soaring dunks seemed, to many, illustrations of how the game should look, and Wideman's essay, while florid, might again be taken as typical: "When it's played the way it's spozed to be played, basketball happens in the air, the pure air; flying, floating, elevated above the floor, levitating the way oppressed peoples of this earth imagine themselves in their dreams . . ." (1999, p. 389). But at a critical moment in *Do the Right Thing*, Lee gives hang time a very different meaning. As Radio Raheem is suspended in a chokehold by the police, his breath constricted and then cut off by a billy club, Lee cuts for an instant to Raheem's feet, clad in large Nikes, and dangling helplessly above the ground. Ed Guerrero is right that the image functions as "a gruesome metonym for lynching" (2001, p. 78), but it is also, when taken in context, a bald reference to Jordan, and it is, if unexpected, terribly powerful. In a perversion of Jordan's autonomous grace, Lee shows a powerful man suspended entirely against his will and fatally unable to return to earth. Raheem's murder is thus doubly difficult for (black) spectators to gaze upon because it is pictured in a way that perverts Jordan's singular grace and agility.[6]

In fact, Lee goes still farther in blurring the line between sport and violence. During the brawl between Sal and Raheem, Lee abruptly cuts to one of the photos on the pizzeria wall: an image from a 1951 bout between Rocky Marciano and Joe Louis, the great African American prizefighter. The iconography of the photo, of course, is closely linked to the two men who grapple on the restaurant floor; it evokes Raheem's earlier speech about the fistfight between Love and Hate, which he had described as a vicious boxing match, and it involves, like the conflict between Raheem and Sal, an African American and an Italian American. In both fights, moreover, it is the black man who is ultimately defeated. And in Raheem's case, this defeat is openly violent. A reference to professional sports thus elides into an image of violence—repeating a transition in a conversation of the three old men on the sidewalk, who speak first of Mike Tyson's boxing, and then of his long history of muggings. As Gerald Early has noted, the line in the United States between the boxer, or the athlete in general, and the criminal has always been fine; in Lee's film it is repeatedly erased, as Sal also turns a baseball bat into a weapon (1999, pp. 383–384). At the end of the film, however, the hot violence of the city street will congeal and give way to a pickup basketball game: Violence, in turn, gives way to sport. Through such transitions, Lee implies that sport and violence are closely relat-

ed, and if we rarely see a basketball court in his early work, perhaps it is because the sweaty, constricted city block offers a stand-in arena for the struggling characters in their Laker blue and Celtic green.

In the opening scene of Lee's 1990 *Mo' Better Blues*, four children arrive at Bleek's door to see if he can play; one boy wears a Mets cap, and another a Mets jacket. Inside, Bleek's father watches the Mets play on television. The New York ball club, in other words, unites the neighborhood, and an interest in the Mets links generations. But little Bleek, when he appears, wears a generic red baseball cap, rather than Mets gear; he may share a broad interest in baseball, but he lacks the appropriate gear. And he also, we soon learn, stands on the other side of another divide. When he asks if he can join the other boys, his mother insists that he stay inside and practice his trumpet. Quickly, Lee then offers a concise visual emblem of Bleek's quandary. While the young boy holds his trumpet, his father holds a baseball, promising that he will take Bleek to a game. Baseball or trumpet: Opposed to each other in the first moments of the film, the two objects represent two alternative traditions, two disparate communities. In his fourth film, Lee uses baseball, which he characterizes as a sort of communal history, and jazz, built around strands of spontaneity and individual genius, as twin discourses that must ultimately be reconciled.

Baseball and jazz are verbally and visually related to one another throughout *Mo' Better Blues*. When we first see Giant, he uses a sports metaphor to criticize the sax player in Bleek's band. "It's your team," he tells Bleek, "it's your band. You're the coach . . . Fire his ass." A few minutes later, to provide our first view of the interior of Bleek's apartment, Lee takes two slow, fluid shots of a large fragment of a baseball scoreboard and the album cover of Coltrane's classic *A Love Supreme*. Baseball and jazz once again: Thus Bleek's abode integrates the same traditions that dominated his childhood. Even unpredictable events suggest the close relationship in his life between sport and music. A game of catch with his father ends abruptly because of a mild arm injury, and in the very next scene, in which Clarke and Bleek make love, a minor lip injury aborts a kiss.

But jazz and baseball are not pure parallels; rather, Lee presents them as distinct traditions that offer different lessons. In *Mo' Better Blues*, baseball establishes generational continuity. An adult Bleek plays catch with his father; later in the film, when Bleek has a son, his own father offers the grandbaby a glove and a ball. These two objects, present in the film's opening scene as well, tie the familial generations to each other, and they firmly structure the movie. At the same time, the references to baseball also imply an interest in a specifically African American history. As Bleek and his father play catch, they wear replica jerseys that link them to specific traditions. Bleek wears a Giants jersey with the number 24, recalling Willie Mays, the great New York Giants outfielder. His father wears a Pittsburgh

Crawfords jersey, which evokes a Negro League team that has folded decades before. The home white of Bleek's jersey links him, as it does Mookie's in *Do the Right Thing*, to the city that rises around him; the history of both shirts implies a respect for the achievements of black ballplayers both before and after integration. And both of these allegiances are voiced again, if subtly, when we see Giant betting on a slate of major league games. His name recalls the Giant uniform worn by Bleek, and his complaint about the Mets—"the Mets need some more black ballplayers"—baldly extends the pride in race suggested by the jerseys.

Jazz, of course, is also a primarily black enterprise. Although Bleek's quintet plays in a club that is owned by two Jews, the musicians and the bulk of the audience are African Americans. Spike Lee pays tribute to his own father, a successful composer who scored music in each of Lee's first five films, by emphasizing the connection of history to jazz through props like the Coltrane album. Bleek's devotion to music significantly precludes his entry into several forms of community. As a child, his trumpet lessons come before his young friends; as an adult, he makes it clear to Clarke that his practice time is not to be interrupted. Music is, by implication, a solitary and almost monastic pursuit, one unabashedly privileged over friendship or love. The frictions that drive Bleek's saxophonist to leave the band are first visible in the form of long solos: Shadow is too interested in his own music. Even Bleek's instrument, capable of such sweet sound, becomes a blunt weapon in the hands of the thugs who rough up Giant. Music divides, and even injures.

In *Do the Right Thing* (1989), Lee had directed Sal brandishing a baseball bat to demolish Raheem's boom box. In *Mo' Better Blues* (1990), Lee directs the violent use of a trumpet to rupture the various links between sports and aesthetics, baseball and jazz, that the film has earlier established. In the end, then, it is Bleek's mission to steer a course between the two, and he can accomplish this mission only by softening his nearly militaristic attitude toward music. Thus, the film closes with a scene that echoes its opening, despite an interval of years, but offers one major modification. Four kids again appear at a doorstep, and, holding a football instead of a baseball, they come to see if Miles, Bleek's son, can come out. The son's name suggests, of course, a conscious connection to jazz history, and the situation itself, so close to Bleek's own childhood, evokes continuity and repetition. So, too, does the initial response of Miles's mother: She mentions the importance of practicing his instrument. But Bleek, subtly rupturing the sense of cyclicality, intervenes, letting the boy run outside to join his friends and thus establishing an appropriate balance between past and present, and music and sport.[7]

Lee's next release, *Jungle Fever* (1991), centers on an adulterous relationship between Flipper Purify, a black architect, and Angela Tucci, his white secretary, and continues the filmmaker's exploration of themes that emerge in his earlier work. Set

entirely in New York City, the film examines frictions within and between Italian American and African American urban communities, while also addressing issues as diverse as male and female eroticism, drug abuse, religious conservatism, and police brutality. It opens and closes, like *Mo' Better Blues*, with intentionally similar scenes that link the contents of each picture to larger issues in African American aesthetic traditions, and, once again, in Lee's film pictorial and verbal references to athletics function as powerful rhetorical and thematic devices.

A potent example of the eloquence and relevance of Lee's athletic references appears in the splashy opening sequence, a thoughtful synthesis of several iconographies. While Stevie Wonder's title track plays, Lee alternates shots of Bensonhurst and Harlem, alluding to the neighborhoods of his two protagonists and visually situating the film in the city. This urban accent permeates the opening credits that, figured onto traffic signs, insinuate the daunting distance between the racial worlds that Flipper and Angie separately represent. In the middle of the sequence, Lee includes a shot that condenses several of the film's themes and foreshadows a later discussion. We see a wall, presumably in Brooklyn, covered in graffiti supporting the Italian national soccer team (forza azzurri) and the New York Rangers. The graffiti suggest a basic urbanism, as in *Do the Right Thing*, but they also differ significantly from the extradiegetic scrawls on the wall in the earlier film ("Dump Koch"; "Tawana told the Truth"). Here, the voice is not imperative, and it does not try to address the viewer directly; rather, it is exhortative, and it implicitly addresses, in plain Italian, the Italian team. In other words, the syntax of the graffiti suggests a closed ethnicity instead of the open possibility of political action that is central to *Do the Right Thing*. In this light, however, the reference to the Rangers suggests, in conjunction with a subsequent conversation in the soda shop, a strand of equally exclusive racism. As a small knot of Italian Americans discusses sports later in the film, one of them notes that African Americans "took over sports. . . . What we got left—hockey?" Hockey, in other words, is a racial preserve; if soccer implies Italian pride, hockey, in the same frame, would seem to denote a white exclusivity. The graffiti and conversants exclude Flipper, the black lover, from the Italian American community before viewers have met him.

References to professional sports also distinguish the homes of the two primary families. When we first see the Tucci family at home in Bensonhurst, they are watching the Mets on television; the game soon becomes a foil against which Angela's two brothers lay down barely concealed racist remarks. On the one hand, they bid good riddance to Darryl Strawberry, an African American star who had left the Mets for Los Angeles after the 1990 season; they've concluded that any born-again player is not worth retaining. On the other hand, when Flipper is kicked out of his home by his wife, he returns to his childhood home where his walls are decorated with a photo of the 1970 world champion New York Knicks and a

cover of *Sports Illustrated* (from February 4, 1974) that pictures Muhammad Ali over the caption "Ali Again." The images, presumably posted by the young Flipper, imply a relatively distant past, two decades gone and thus contrast the discussion of the Tucci brothers, who dismiss a player who had left the Mets less than a year before. Flipper's outdated photos conjure in him a powerful nostalgia that underscores the fresh loss of his wife; they evoke quietly and ironically the sort of lost past that he seems to contemplate as he lies in his boyhood bed. Finally, the pictures of basketball and boxing, sports fully racially integrated by the end of the twentieth century, describe a socioethnic realm that is implicitly condemned in the exclusive, racist graffiti and soda shop conversations of Bensonhurst.

Basketball and boxing, the sports depicted in Flipper's room, also color two critical moments in his adult experience. When Flipper tells Cyrus, his closest friend, about his extramarital affair, he does so on an otherwise empty basketball court. In fact, Cyrus implies that the two friends have had numerous momentous conversations on the same spot. Basketball in Harlem is thus linked to a tradition of honesty and confession in black (male) friendships. Boxing, meanwhile, bridges Flipper and Angie. After a difficult dinner with Flipper's parents, in which his father flatly condemns their relationship, Flipper and Angie playfully shadow box in a parked car. Their innocent jabs surely express their frustration with the difficult circumstances of their disruptive relationship, but the punches soon reveal a common sports interest, too—although it is tellingly characterized by racial difference. When Flipper, throwing ghost punches, mentions Tyson, Angie replies that Tyson was trained by Gus D'Amato, meeting his reference to a black fighter with a reference to an Italian American coach. Sparring, Angie lists several great Italian fighters; in turn, Flipper argues for the primacy of Ali, and their mock punches gradually melt into an embrace. Their body language thus echoes the tone of their conversation, in which an ethnocentric "argument" melts onto warm common ground. Despite their culturally different perspectives, Angie and Flipper share an interest in boxing history.

But any sense of union is immediately and irrevocably ruptured by the arrival of two white police officers, who mistake Flipper for a rapist and violently pin him against the car. Race and racist assumptions destroy the two lovers' separate peace. The cops' real violence powerfully mocks the couple's playful shadowboxing of a few moments earlier. Just as Lee's camera focuses on a still image of Marciano and Louis in the middle of the mêlée in *Do the Right Thing*, *Jungle Fever* links boxing and police brutality, apparently hinting that racial divisions underlie both athletic contests and urban conflicts. Sport, again, is inextricably related to violence, and Angela and Flipper, nominal lovers, are cast against their will into a larger context of competition.

Such an image solves nothing. More metaphor than manifesto, it distills the

film's central themes without pointing to an obvious solution and describes diffi-culty without offering a remedy. Of course, there may be no easy remedy. Scholarship on *Do the Right Thing* has slowly moved toward an acceptance of the ambiguity and ambivalence that color Lee's early work, and many of his references to sport involve a comparable complexity, creating what Henry Louis Gates has called a porous qual-ity that centralizes choice (1989, p. 1). The team jerseys and the recurring references to the Mets or the Celtics allow Lee to individualize his characters and to create a broadly competitive arena, but they do not indicate, as easily, a winning strategy. Apparently, social ills must be resolved outside the bounds of Lee's films.

In a sense, Lee's reliance on symbols culled from the world of professional sports yields a very public version of exactly what Buggin' Out finds missing in Sal's pizzeria: a pantheon of famous African Americans. Through intelligent references to historical and contemporary athletic figures, Lee creates a landscape of accom-plished black stars, and Buggin' Out's cries for fair representation could be satisfied, suggests the camera, if he would only look about him—or, in the parlance of the film, if he would only wake up.[8] But the precise contours of such irony are tricky. If the jerseys and shoes reflect, on the one hand, an identification with heroes and inscribe a sense of community, they are also, on the other hand, mere passive props; if they recall heroes, they also imply, through contrast, a lack of true heroism in the hood. At the same time, it would be naïve to deny that the replica jerseys and high-priced sneakers also represent a consumer culture that defines, as Douglas Kellner has argued, Lee's characters as much in terms of what they wear as what they are (1997, p. 99). Lee uses athletic codes in a thoughtful manner, but it should not be forgotten that he was employed by Nike for most of the late 1980s and early 90s, and that he directed several TV ads for the shoe giant. In fact, his ads often featured visual styles and even characters that were directly related to his early films, and his films in turn often seemed influenced by the marketplace: in one of the most pow-erful scenes of *Do the Right Thing*, Sal and Mookie throw $100 bills at each other in front of the smoldering pizzeria—with the broad Nike swoops on their shoes prominently featured.

Iconographic, cinematic, and thematic decisions, then, should not be divorced from economic realities. But in Lee's case, perhaps the opposite is also true. In late 2001, Lee auctioned a ticket to a Knicks game, and gave the resulting $101,300 to a fund for children and widows set up by the New York Fire Department in the wake of the September 11 attacks. Interestingly, Lee had originated this idea in his char-acter Bleek: During a scat in *Mo' Better Blues*, Bleek offers to give up his courtside Knicks tickets as a proof of his love for Clarke, and the character's equation of sports spectatorship with self-sacrificial civil service thus anticipates the director's.

For Lee, then, the world of sports is clearly not a pure realm of escape; rather, it is both a living industry and a source of meanings both individual and social.

Knicks jackets, in Lee's early films, can assert a particular ideology, and Knicks tick-ets, in Lee's hands, can provide genuine charity. In short, Lee signifies on a famil-iar set of cultural forms to offer thoughtful social critique.[9] Familiar jerseys suddenly refer, in their new context, to widening rifts and to historical analogies. They also suggest, in Lee's hands, a new attitude toward sports. Lee came of age in the 1980s, and thus is a decade younger than a generation of black sports fans who had seemed to care, as Gerald Early argued of the mid-1970s, "nothing for nostalgia and love, instead desiring only the newest currency in the improvisations of style and moves" (1999, p. 380). Currency (in the form of Nike contracts) remains important in Lee's early films, but one of his particular strengths has been to realize that nos-talgia and love, and politics and history, also have a place in a thriving U.S. film industry, and that they can be represented, to a degree, through the rich inheritances and the developing idioms of professional sports.

The social conflicts at the center of Lee's early plots cannot be resolved through the "play" of professional sports but instead only by genuine social and political action.

Notes

1. For a thoughtful analysis of Lee's use of music in *Do the Right Thing*, centered on an argu-ment that the film's use of polyphony is essentially political, see Johnson, 1997.

2. In the production notes for *Do the Right Thing*, Lee humorously refers to his apparent reliance on the figure of Larry Bird: "I'm sorry, Larry Bird, but your name will be mentioned in a film of mine once again" (Lee & Jones, 1989, p. 27).

3. Lee would gain a sort of revenge on the Celtics in 1992; according to Alex Patterson, while giving a very popular series of guest lectures at Harvard, Lee (jokingly?) refused to admit any Celtic fans (Patterson, 1992, pp. 226–227).

4. Kauffmann was not alone in his curious objection; see Lyne, 2000 for a survey of complaints regarding Lee's omission of drugs.

5. On the symbolism of the choice of a Robinson jersey for Mookie, George writes: "The Jackie Robinson jersey that Mookie wears does not suggest that he's a racial pioneer but that he's a man watched closely by interested parties on both sides of the racial divide. Both sides think he's loyal to them—that's how he survives" (1991, p. 80). Kellner (1997, p. 78) and, later, Guerrero (2001, p. 17) also discuss the same subject. Lee's production notes from the film, however, suggest that the inclusion of the Robinson jersey was largely fortuitous: "I knew I wanted my character Mookie to wear tight basketball shorts underneath a pair of loose-fit-ting shorts. I got this from basketball players. . . . So, I had an idea for the bottom of my cos-tume, but I was stumped on what to wear on top. Cecile Holmes, one of the bigwigs in Black music at CBS records, knows I'm a baseball fan, and once gave me a Jackie Robinson jer-sey. The night before we started shooting, I was still undecided about my costume, then I remembered the jersey" (Lee & Jones, 1989, p. 110).

6. Raheem is thus not like Mike. But he does resemble, before his violent death, another NBA star perhaps even closer to Lee's heart. In raising a single, solitary fist after defeating Puerto Ricans in a boom box showdown, Raheem echoes the trademark gesture of Walt Frazier, a prominent Knick guard in the 1970s who lived and dressed, like Raheem, flamboyantly, but celebrated with a raised fist.

7. In this sense, Bleek occupies a position characterized by the same sort of difficult dualism or ambiguity noted by James McKelly in an article on *Do the Right Thing* (1998, p. 220).

8. As Guerrero has pointed out, Lee further undermines Buggin' Out's protests by placing a large billboard of Mike Tyson behind him, even as Buggin' Out calls for the inclusion of Black images (2001, pp. 37–38).

9. McKelly offers a useful definition of signifying: it "manifests itself as a vernacular stratagem which on the one hand puts to use the modes of discourse which the colonizing hegemonic discourse has made available to it, yet on the other hand always already imbues these culturally endorsed forms with a 'signal difference' which renders them at once both conventional yet subversive . . ." (1998, p. 224).

References

Dyson, M.E. (1999). Be like Mike? Michael Jordan and the pedagogy of desire. In G.D. Caponi (Ed.), *Signifyin(g), sanctifyin; & slam dunking: A reader in African American expressive culture* (pp. 407–416). Amherst: University of Massachusetts Press.

Early, G. (1999). The hero of the blues. In G.D. Caponi (Ed.), *Signifyin(g), sanctifyin; & slam dunking: A reader in African American expressive culture* (pp. 379-387). Amherst: University of Massachusetts Press.

Gates, H.L., Jr. (1989, July 9). *Do the Right Thing*: Issues and images. *The New York Times* (p. 1).

George, N. (1991). Do the right thing: Film and fury. In S. Lee (Ed.), *The Films of Spike Lee: Five for Five* (pp. 77–81). New York: Stewart Tabori & Chang.

Grant, W. (1997). Revisiting the times: *Do the Right Thing* revisited. In M. Reid (Ed.), *Spike Lee's* Do the Right Thing (pp. 16–30). New York: Cambridge University Press.

Greenfield, J. (1999). The Black and White truth about basketball. In Caponi, G.D. (Ed.), *Signifyin(g), sanctifyin; & slam dunking: A reader in African American expressive culture* (pp. 373–378). Amherst: University of Massachusetts Press.

Guerrero, E. (2001). *Do the Right Thing*. London: BFI.

Johnson, V. (1997). Polyphony and cultural expression: Interpreting musical traditions. In M. Reid (Ed.), *Spike Lee's* Do the Right Thing (pp. 50–72). New York: Cambridge University Press.

Kauffmann, S. (1994). *Distinguishing features: Film criticism and comment* (pp. 81–82). Baltimore: Johns Hopkins University Press.

Kellner, D. (1997). Aesthetics, ethics, and politics in the films of Spike Lee. In M. Reid (Ed.), *Spike Lee's* Do the Right Thing (pp. 73–106). New York: Cambridge University Press,.

Lee, S. (Ed.) (1991). *The films of Spike Lee: Five for five*. New York: Stewart Tabori & Chang.

———— and Jones, L. (1989). *Do the Right Thing*: A Spike Lee joint. New York: Fireside.

Lyne, W. (2000). No accident: From Black power to Black box office. *African American Review*, *34*, 39–59.

McKelly, J. (1998). The double truth, Ruth: *Do the Right Thing* and the culture of ambiguity. *African American Review, 32*, 215–227.

Patterson, A. (1992). *Spike Lee*. New York: Avon Books.

Watkins, S.C. (1999). *Representing: hip hop culture and the production of Black cinema*. Chicago: University of Chicago Press.

Wideman, J.E. (1999). Michael Jordan leaps the great divide. In G.D. Caponi (Ed.), *Signifyin(g), sanctifyin; & slam dunking: A reader in African American expressive culture* (pp. 388–406). Amherst: University of Massachusetts Press.

Spike's Blues

Re-imagining Blues Ideology for the Cinema

MIKAL J. GAINES

The blues is an impulse to keep the painful details and episodes of a brutal experience alive in one's aching consciousness, to finger its jagged grain, to transcend it, not by the consolation of philosophy but by squeezing from it a near-tragic, near-comic lyricism. As a form, the blues is an autobiographical chronicle of personal cat-astrophe expressed lyrically.

—Ralph Ellison (1964)

As an art form, the blues idiom by its very nature goes beyond the objective of making human existence bear-able physically or psychologically . . . Man's primary concern with life is to make it as significant as possible, and the blues are part of this effort.

—Albert Murray (1970)

It's all blues.

—Robert Guenveur Smith as Huey P. Newton,
A Huey P. Newton Story (2001)

The unifying sentiment of the above definitions is an insistence that the blues exists and has existed as more than a musical form wrought from the "peculiar" experience of Africans in America.[1] Rather, the blues—as ideology and practice—encompasses what is perhaps one of the most complex and fruitful analytic figures in the black expressive tradition; it is a creative strategy of subsistence, resistance, power, and transcendence that affirms humanity even in the face of failure and existential absurdity (Murray, p. 147). If the question of whether or not the blues is a viable system of black agency were all that were at stake, however, then the discourse surrounding the blues would hardly be so hotly contested. Even the eloquence of Ellison's definition is belied by his adherence to a rigorously individualistic worldview and a highly romanticized idea of trauma's reconstructive potential. But such characteristic contradiction seems hardly the fault of Ellison alone and is instead endemic to the liminality of blues. Ellison and Murray's characterizations both, in fact, suggest that the blues is constituted through epistemological fluctuation, paradoxical or outright contradictory stasis within systems of meaning, as well as its capacity for seeming incoherence. The blues is about finding a way not simply to exist but to thrive with spirit and dignity intact even in the most impossible of circumstances. This desire to have some say about how and what the world should be and how one can or should be in it means that "blues people"[2] frequently disrupt dominant discourses.[3] They develop means to continually fend off encapsulation by expressing the most irreconcilable aspects of their lives not as totalizing breaks in subjectivity but instead as fully recognized (yet never wholly defining) parts of self-consciousness. The blues is to claim one's tragedy rather than to be claimed by it.

Many others have similarly pointed toward the blues, noting its meaning-making capability. Houston Baker (1984) has somewhat notoriously argued that the blues is a "matrix" or "womb" wherein conflicts that arise in structures of authority can be mediated (pp. 3-9).[4] More recently, Valerie Prince (2005) incorporates feminist critique and spatial analysis to situate women at the center of the African American search for home, which she argues is a vital aspect of the blues tradition. Perhaps most relevant for my purposes here, Adam Gussow (2002) has argued that encounters with the abject black body have informed black subjectivity since Reconstruction. It is this concern with how violence and abjection affect the way the blues is experienced and enacted that brings me to the work of Spike Lee.

Some well-recognized issues consistently emerge throughout Lee's work: racial and gender conflict, the pleasure and peril of cultural expression and representation, contests of oppression and resistance to name just a few. However, Gussow's argument sheds new light on the unrelenting recurrence of bodily violence that also frequently characterizes Lee's narratives. While his films are often violent, this violence appears less as a nihilistic inevitability and more as a vengefully didactic, inexorable

ghost. Such an understanding of violence and its function subsequently shapes his characters' expressive practice in precarious ways. More specifically, Lee's protagonists' chosen means of expression frequently reflect the violence of their respective vernaculars and reconfigure what Julia Kristeva (1982) in *Powers of Horror* calls "approaching abjection" (pp. 1–32). From the rape of Nola Darling in *She's Gotta Have It* (1986) to the displaced corpses of *When the Levees Broke: A Requiem in Four Acts* (2006), Lee's protagonists continually find themselves in confrontation with that which "disturbs identity, system, and order. [That which] does not respect borders, positions, rules. The in-between, the ambiguous, the composite" (Kristeva, p. 2). Indeed sometimes Lee's protagonists embody precisely such a position themselves. This relationship between abjection and expressive practice is then Lee's attempt to adapt the familiar ideology of the blues to the cinema.

It is important however, to distinguish Kristeva's primarily psychoanalytic idea from what is a more readily felt and collective historical process for marginalized peoples. Rather than private neurosis, abjection stems from a particularly profound and *collective* awareness of bodily vulnerability, an ever-looming sense that the next moment could mean violation, infiltration, or even devastation of the highest order. Therefore the threat of the abject or of becoming the abject is not an exclusively psychological one for people under real threat of terror; it is an essential part of their lived experience and affects accordingly the decisions they make. Based on a legacy of trauma,[5] the abjection that plagues blues practitioners in Lee's films does more than threaten the intelligibility of the self and instead assumes that any useful understanding of consciousness is always already dependent on the simultaneous vulnerability and durability of others: a collective continuum of pain and joy, subjection and transcendence. As Jonathan Lake Crane (1994) has said about abjection:

> Occasionally, our all too perfect images of self are exposed to attack. The source of distress, that which lies behind the revolt against self, is the abject. The abject are those objects, oftentimes bodily detritus, that desecrate our narcissistic mirage of self by effacing the boundary between myself and that which is not "I." The abject provides proof that our idealized portraits of pristine flesh and whole egos, are unfortunately, nothing more than brittle fantasies. . . . If we are to maintain the integrity of our illusions of self, we must work to expel from conscious consideration those objects and abjects that reveal the true constitution of the subject. . . . The abject can return to consciousness . . . and we are forced to restyle the unsullied self-images we manufacture for ourselves. (p. 30)

Although Crane is speaking about abjection in context of the horror film, his underlying polemic is to reclaim it as a socializing process. I argue that the abjection found in the blues similarly assumes that personal subjectivity has communal significance, political implication, and discursive power.

By examining specific moments in Lee's *Summer of Sam* (1999), *Mo' Better Blues* (1990), and *25th Hour* (2002), I will argue that Lee has created a "neo-blues subject": one whose deliberately violent *play* is meant to "signify"[6] upon the abject and create alternative systems of meaning. Through his protagonists, all performers in their own way, Lee interrogates the blues as a mode of survivability, mobility, adaptability, agency, and potentially freedom. But two immediate problems arise in "Spike's blues." First, Lee's conception of the blues is largely masculine, which perhaps comes as no real surprise given his penchant for male-centered stories. Moreover, Lee's bluesmen replicate the superbly phallic, hypermasculine rhetoric of classic blues stylization and also what Gussow calls "intimate violence": the cutting, shooting, stabbing, and other bodily marking that "blues subjects"[7] perform on one another that is frequently "celebrated as a locus of power and self-making" (p. 196). Richie in *Summer of Sam*, Bleek Gilliam in *Mo' Better Blues*, and Monty Brogan in *25th Hour* all inhabit vernacular cultures in which violence is common, and each displays a coexistent fascination and fear with the prospect of his own abjection. While Richie uses the aesthetics of punk, sadomasochistic play, and indeterminate sexuality to embrace the abject, Bleek scoffs at the threats to his subjectivity through violent jazz performance. *But the blues is sometimes vicious.* Sometimes it bites back at the hand that feeds it. Richie and Bleek both learn this lesson the hard way. As a man awaiting prison, however, Monty's abjection is certain from the moment the narrative begins, and his means of dealing with that reality call into question just what role violence ultimately has to play in the blues ideology that Lee envisions. Ultimately then, "Spike's blues" is a matter of finding a way to *play* with new weapons, some of which carry many of the same problems as the old.

A Song for Richie

Lee's *Summer of Sam* tells the interconnected stories of several characters living in a predominantly Italian Bronx neighborhood during the summer of 1977. The historic summer is of course remembered for the reign of serial killer David Berkowitz, the end of disco and the beginning of punk, a record-setting heat wave, a citywide blackout, and the Yankees' trip to the World Series. In the middle of all of this is Richie (Adrian Brody). Perhaps no single figure in all of Lee's films so thoroughly embodies the paradoxical position of the neo-blues subject, and at no time is this more dynamically articulated than during the montage sequence that occurs midway through the film. A set of parallel performances provides the seemingly random sequence with its continuity; Richie's sadomasochistic "dance" at an underground gay porn theater is juxtaposed against another performance wherein

he plays guitar along with The Who's "Baba O'Reilly" in his garage apartment. The montage also includes one of serial killer David Berkowitz's ritualistic executions, numerous characters' drug experimentation, and a revenge-prompted assault amongst other shots. The violence in this sequence as well as the violence that structures the rest of the film's narrative is consistent with the trope of abjection typical in the blues tradition. *Summer of Sam* is therefore an attempt to create a cinematic blues text that casts the central character Richie as a neo-blues subject not through his affiliation with a racially oppressed class but instead through his disruptive use of expressive practice within vernacular culture.

Richie is presented as a cultural offender and Other from the moment he enters the story, a characterization that according to Dan Flory (2002) marks the film as a lynching parable featuring Richie as the primary victim (pp. 174–190). Richie's friends from the neighborhood, Anthony (Al Palagonia), Brian (Ken Garito), and Joey T. (Michael Rispoli), are shocked when he appears—returned from a stay in another country called Manhattan—sporting a union jack t-shirt, spiked hair, and a faux British accent. These material alterations, however, are only the beginning of several means that Richie uses to try and subvert an imbricated set of collapsible identity markers, for example, race, class, ethnicity, nationality, gender, sexuality, etc. Richie's subversion is predictably met with vicious resistance by the neighborhood culture police. These watchmen, Richie's friends, sit atop the neighborhood's pecking order and have little interest in Foucauldian surveillance, preferring the suppressive force of the Louisville slugger to the regulating power of the panopticon.[8] The stereotypically bigoted and short-tempered men read his affiliation with the emerging punk rock scene in 1977 New York as a mark of deviance akin to membership in a satanic cult (Flory, 2002, pp. 181–182). Thus, when they lynch Richie at the end of the film because they suspect he is the serial killer "Son of Sam," their "disciplinary violence" seems practically inevitable.[9] Nearly all the film's characters exhibit excessive and decadent behavior. Yet, none of them seems to offend to the degree or in precisely the way that Richie does because they still maintain some level of "normalcy" equivalent to a broader sense of whiteness (Flory, p. 183). Richard Dyer has argued that, "All concepts of race are always concepts of the body and also of heterosexuality" (1997, p. 20). Taking heed to Dyer's claim then, Richie is a threat not simply because he no longer looks like a guy from the neighborhood, but also because his appearance carries with it political weight that undermines an interdependent system of signs. While this affirms a reading of the narrative as a lynching parable, it is still limited. What it does not adequately account for is Richie's motivation or the pleasure garnered from his performances.

Dressed in a tight-fitting sleeveless shirt covered in safety pins, a spiked dog collar, cut-off shorts, spiked hair, and a combat boots, Richie begins his performance at the theater by pulling a pocket knife from his crotch. He then goes about stab-

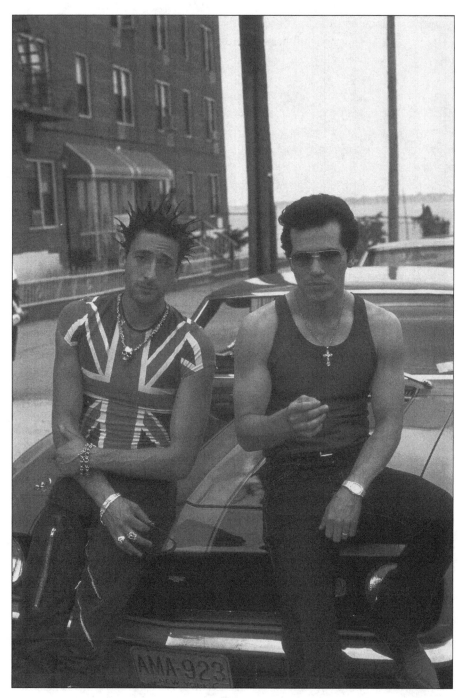

Figure 8.1. Adrian Brody and John Leguizamo in *Summer of Sam* (1999) Courtesy of Photofest.

bing and slicing into a strung-up, pillow-stuffed doll covered in a white sheet. His action stimulates raucous applause evidencing pleasure along what can only be unfixed axes for the audience. Their response suggests that they enjoy Richie's act, but just what they are taking pleasure in is more illusory. Is their pleasure a result of their own symbolic abjection? After all, the audience is entirely white, and the white sheet seems like a not-so-subtle reminder of the uniform of the Ku Klux Klan. Is it Richie's "sadism," as defined by Linda Williams (1989): "the sexual perversion that haunts masculine sexual identity and animates a quintessentially masculine desire to see, to know, and to control"? (pp. 46–47) Does the audience's pleasure come from witnessing him enact the kind of violence that they only dream about? Is it sexualized pleasure derived from both of these? Is it simply the quality of Richie's performance as good art? Perhaps all of the above?

The aesthetics of Richie's costume offer some insight here. Yes, much of his appearance is consistent with punk stylization, but his hot pants are undoubtedly meant to appeal to queer sensibilities. The collar and safety pins on the other hand seem more typical of sadomasochism in that they comingle significations of submission, suppression, and protection with penetration, evisceration, and violation, and in this instance, all these are kept close to the skin. Richie's costume could, at least in theory, expose his fragile body to harm and indeed with his consent. But the potential power in his signifyin(g) here is qualified by incidental costs. Another strand in the montage implies that Richie has begun prostituting himself in order to buy a new sunburst Fender Stratocaster so that he can further support his career as a punk rock musician. Yet this "prostitution" is as ambiguous as the precise dynamics of the pleasure in his stage performance. We are, after all, only given a brief shot of Richie entering the "Ladies Only" bathroom with one of the business-suited audience members of his stage show. While it is certainly implied that he is prostituting himself, the nature of this prostitution remains uncertain. The viewer does not know if Richie is actually having sex with this man or others at the theater. He could very well be performing another more private show similar to the one he performs on stage. Or perhaps finding a way to explore his newly emerging sexuality while simultaneously laying bare the power exchange evident in the transaction? What is certain is that this is a part of his identity that he demands remain secret. In fact, one of the only moments wherein Richie does physical violence unto a real person comes later when "Bobby the Fairy," the respective neighborhood queer, threatens to reveal the secret performances at the club to others in the neighborhood. Richie grabs Bobby and begins to strangle him, even threatening to kill him if the secret is revealed. Richie's desire to keep this part of himself closeted hints at the high stakes of his attack of the hanging effigy and foreshadows his own lynching later in the film.

Richie's mutilation of the doll begins with a kind of teasing dance where he passes the knife along the genital region and throat. He then escalates to wild stabbing and by the end of the montage sequence he is literally ripping the feather-stuffed doll into pieces. The performance signifies on the abjection of lynching as a spectacular, communal, and ritual exercise. Amy Louise Wood (2001) identifies the politics of Southern lynching as a ritual in which "white Southern men enacted and inscribed their ideologies of race and sex onto the bodies of African American Men" (p. 195). Lynching photography, then, creates a blurring or conflation of the visual image of violence and the methodology of social control that it represents; the two become indistinguishable, thus real and representational violence reifies white hegemony (Wood, pp. 195–196). Richie's "performance lynching" can be read as a more complex instance of this same operation. First, the imagined threat of homosexuality, and especially the homosexual body, displaces the position that the imagined threat of black male sexuality would normally have occupied in the lynching act. Second, Richie's dress destabilizes white heteronormative masculinity while his violent behavior simultaneously reaffirms it. Third, these destabilizations and reaffirmations operate as projections of white desire and fear. Fourth, Richie's play then enacts, as pleasure, a dichotomy of that desire and fear. And finally, the pleasure/pain play supplants actual sex with a kind of sexy violence. The audience for Richie's show could, after all, have chosen to attend a more traditional peep show. They instead seem to be deriving very idiosyncratic pleasure from an act that is only implicitly sexual. Perhaps then, the violence is the sex—it is what gets Richie's audience off.

Returning now to the issue of Richie's pleasure, it is vital that the montage positions Richie's sexy stage violence as parallel to his private garage performance. One transitional cut in the montage even moves directly from a close up of Richie's hands ripping the doll to a close up of his hands playing guitar. The inevitable synthesis of these images prompts the question: What is the difference between his sexually violent pornographic performance and the creative musical performance? Is there really a difference at all? In the case of an actual lynching there is of course actual subjection of an actual body, but in these performances there is only symbolic abjection as in the eviscerated doll or the guitar used in his garage concert. Richie "plays" both the instruments in similar ways, attacking with a kind of soulful violence—a simultaneously destructive and creative invocation of purposed force that demonstrates control over the seemingly chaotic. Additionally, however, there is a shot of a similar all-white guitar inexplicably falling from the sky in slow motion only to crash into pieces at Richie's feet at one point during the montage. There is no indication of when or why this happens, and the white guitar still mysteriously hangs in Richie's apartment at the end of the film. It is also worth noting that he uses his hard-earned sunburst model to stave off his lynchers, although to

no avail. There are then three symbolically abject bodies: the doll which is a clear symbol of the hegemony Richie hopes to reject; the guitar from his garage performance used as a phallic blues weapon which, despite its power, is never fully liberating; and the mysterious white guitar, perhaps a phantasmagoria of patriarchal white power that Richie is unable to shed.

While Richie is clearly the focal point of disruption, his violence hardly appears in a vacuum. After all, the violence portrayed in the recreation of David Berkowitz's murder of a young couple kissing in a parked car seems hardly as ambiguous in meaning as that in Richie's performance. Or does it? The highly stylized, hyperkinetic presentation of the murders—which are set in direct relation to Richie's performances—does indeed suggest that Berkowitz's violence informs Richie's responsive, performative subjectivity as much as the emerging punk scene, numerous forms of sexual and drug experimentation, or the repressive atmosphere of his neighborhood. A later scene wherein Richie performs in a punk club using the words from one of Berkowitz's infamous letters as lyrics only reaffirms this. I am not suggesting that *Summer of Sam* presents David Berkowitz as a bluesman but rather that the montage situates Berkowitz's reign of terror as both a motivating and symptomatic force that further heightens and distills the paranoid, intolerant, and brutal terrain already present. Thus if Gussow's claim that the blues subjects of the Reconstruction, Post-Reconstruction, and Jim Crow Eras were deeply affected by the violence pervading their culture, than *Summer of Sam* suggests that the violence of 1977 New York was no less an influential force among the people there. No, Richie does not face the same obstacles of black blues subjects of generations past. His white male privilege allows him special agency in deciding whether or not to disrupt dominant discourses and how to do so most effectively. But by willingly casting his lot with the Other he does become vulnerable to his own set of physical, psychic, and spiritual penalties.[10]

The blues ideology that Lee creates in *Summer of Sam* is on the one hand a far cry from that which Billie Holiday sung about in "Strange Fruit,"[11] but on the other hand there are marked similarities: a pervasive atmosphere of terror, disciplinary white violence, and the distinct formulation of vernacular performativities.[12] The disciplinary white violence committed by the men in Richie's neighborhood is, however, more complex than I have heretofore indicated. Consider for instance the revenge-beating carried out by Anthony, Brian, and Joey T. This violence plays on two peculiar planes of irony. First, the vigilantes are seeking out retaliation on behalf of "Bobby the Fairy" who is disparaged and generally disregarded by these characters in other scenes in the film. Yet, when the opportunity arises for them to act violently on his behalf, they jump at the chance. Part of their reaction is simply in keeping with their characterization. All these characters, Joey T. especially, are prone to violence and do not hesitate to use it (or at least the threat of it) as their

primary means of engaging in almost all discourses. The shots of these characters leading vigilante mobs through the darkened streets in search of the Son of Sam later in the film illustrate even more frighteningly how quickly such individual modes of violence can be dangerously subsumed by hegemonic forces. These characters perform vengeance for Bobby then in order to insure cultural privilege; their vigilantism reinforces their own status in the cultural hierarchy. It is as if they were saying that "no one gets to pick on our queer (or our nigger) but us."

The other irony in the boys' unusual defense of Bobby is that Richie is later lynched in large part because his sexuality is made suspect. This flexibility in Richie's identity is coalesced into a whole list of associations: "killer, fag, pimp, punk-rocker . . . queer, pervert, degenerate, whatever the fuck it is. I mean—c'mon. Who wants something like that around here anyway?" Apparently no one does, despite the film's very detailed attempts to situate Richie as the most compassionate and understanding of all the characters that populate its narrative.[13] The montage works to create points that reveal the junctures where the culture is itself in a state of flux and Richie is the central point of disruption. He is able to give a creative voice to this liminal space through his performances but unfortunately also pays a hefty price for this expression in the end. Richie is the neo-blues subject, and while racial privilege inevitably separates him from Black blues subjects of the past, it does seem significant and unexpected that a filmmaker with racial politics as declarative as Lee posits a nonessentialist conception of the blues. That said, the blues of *Summer of Sam* results in little more than survival. Whatever strategies Richie has enacted to challenge the boundaries of his culture and thus reform them so as to create a space for himself are lost in the final confrontation with malicious physical violence. This is not reason enough to abandon the potential that Lee's neo-blues might offer. Instead I would like to examine some of the other instances where Lee has attempted to adapt the familiar tropes of the blues to the screen.

Mo' Better Blues Weapons

Summer of Sam was not Lee's first exploration of blues ideology through tropes of abjection and performance. One is of course reminded of the traumatized community that is forced to witness Radio Raheem's (Bill Nunn) execution at the climax of *Do the Right Thing* (1989).[14] It seems only natural then that Lee's most deliberate homage to blues culture would follow shortly after in *Mo' Better Blues* (1990). As in *Summer of Sam*, Lee has created a highly conflicted blues subject whose powerful expressivity seems equal part blessing and curse. Trumpeter Bleek Gilliam (Denzel Washington) is narcissistic, chauvinistic, passionate, disciplined, and immensely talented. Accordingly, his subjectivity is almost entirely dependent upon

a capacity to use his musical ability as a phallic reinforcement of masculine sexual prowess—a characterization that fits squarely within the "traditional sex roles that Hollywood [has ascribed to jazz musicians]" (Gabbard, 1992, p. 32). Although Bleek has a much more well-established tradition upon which he can ground his identity, he and Richie have much in common: special talents (grounded in the use of their hands),[15] an unwavering dedication to their craft, and desire for masculine play that grants them discursive access and the potential for disruption. To be clear though, the stakes are not the same for both characters. Richie deliberately outcasts himself from his community while in search of new home, while Bleek is a well-recognized community fixture.[16] And while Richie's lynching seems almost like karmic repercussion for his soulfully violent performances, Bleek mistakenly assumes his phallic power can reach beyond the stage to challenge the murderous weapons of the jook.[17]

Mo' Better Blues has the loss of Bleek's discursive access, his blues power, taken away from him not by forces from outside but by those from within the very vernacular culture that nurtured it. This pivotal moment comes when Bleek aids his friend Giant (Spike Lee). Giant is accosted by two collection agents who plan to extract payment for his gambling debts in flesh. The overt stylization evident in the *Summer of Sam* montage is foreshadowed here in the crosscutting between the brutal attack and a simultaneous musical performance by Bleek and his quintet—a compositional move that implies a psychic linkage between the two. Bleek's performance here is also fueled by one of the oldest of blues motivations: romantic jealousy. Bleek gets into a fight with his bandmate Shadow (Wesley Snipes) over their common love interest Clarke (Cynda Williams) in the previous scene. Their rivalry is consistent throughout the film but up until this point seems more a conflict of artistic tension and masculine ego. When Bleek discovers that Shadow is having sex with Clarke, however, their rivalry turns into "blues rage" of the same kind that Gussow suggests is an always looming threat (2002, p. 221). Thus the deployment of specific compositional devices, the rising action of the narrative, and of course the music, composed and performed by Lee's most frequent musical collaborator Terence Blanchard, informs this climatic moment wherein Lee's use of blues ideology becomes most visible and visceral.[18]

The collection agents, Madlock (Samuel L. Jackson) and Rod (Leonard L. Thomas), drag Giant out of the club in slow motion. These slow motion shots are crosscut with Bleek performing in real time. Giant calls out to Bleek only to have his shouts quickly stifled by a punch to the stomach. Bleek acknowledges the distraction with a look but never stops performing. While Bleek's concern for Giant will be purposefully channeled into his performance, we are left to wonder if his initial refusal to leave the stage comes from an unwillingness to sacrifice his masculine stage persona. Giant and the two men continue toward the camera until the

image is abstracted, and then there is an abrupt cut to the reverse angle where the viewer sees the door of the club's back entrance kicked open. Madlock and Rod enter the alley and begin beating Giant. Each strike is delivered singularly with each blow increasing in volume and intensity. The hits, rather than sounding only violent, actually begin to sound musical in their percussive quality—they become the rhythm to a kind of *beating song*. It would seem then that Madlock and Rod have their own blues to play. Giant again calls out to Bleek just before being struck again. An abrupt cut back to Bleek's performance follows. By this point, Bleek's performance has become decidedly more violent as well. He aggressively points his trumpet, screaming with harsh and focused blasts that punctuate a steady stream of rapid fire notes. Again, the editing makes it appear as though Bleek is trying to answer Giant's desperate pleas through his instrument in a psychic display of call and response. It also seems significant that Bleek is performing in an almost absurdly fast swing style. Given swing's rhythmic derivation from blues and gospel forms, this can be read as blues accelerated to a fever pitch that threatens to consume itself.

More cross-cutting between Giant's beating and Bleek's hyperkinetic performance follows. Each punch to Giant's face becomes a scream from Bleek's trumpet. Each kick to his stomach is mirrored by a rumble on drummer "Rhythm Jones' (Jeff "Tain" Watts) bass drum or a loud cymbal accent. The acceleration of the cuts increases, making the parallel connection between Bleek's performance and Giant's beating blatant and the tone reminiscent of a Frank Miller pulp fiction style graphic novel in its exaggeration and deliberateness.[19] After squealing to an abrupt climax, Bleek exits the stage and proceeds to the alley to discover Giant lying beaten and broken. This initiating confrontation with the abject so stokes Bleek's anger and frustration that he punches Rod in the face, only to be quickly counterpunched by both the attackers. Bleek then deflects one of Madlock's punches with his trumpet. Madlock quickly takes the trumpet and strikes Bleek in the face twice, consequently splitting the flesh of his lip. The injury is compounded because we recognize that it has ravaged precisely the part of Bleek's body that provides him his power. This is of course foreshadowed in an earlier scene when Clarke playfully bites his lip only to have him angrily react: "I make my living with my lips!" Indeed Bleek's expressivity is as much a product of his firmly regimented lifestyle as it is of learned physicality. Thus what Lee stages here is a transaction in bodily blues currency. While Bleek does make a failed attempt at returning to the stage, this is ultimately the end of his career as a musician. Bleek's survival is going to demand more than simply healing of his disabled body.

Krin Gabbard (1992) reads this sequence as one of castration and argues that Bleek's humiliating return to the stage is essentially a reenactment of that castration (pp. 53–54). Gabbard also argues that the conventions of Hollywood cinema demand that Bleek be forced from the stage before he can take his proper patriar-

chal place (p. 53). There are three problems in this reading: (1) Gabbard too strictly interprets the film as it is concerned with the milieu of jazz representation and does not fully acknowledge its larger engagement with blues culture; (2) the character and presentation of Bleek's assault are more complex than Gabbard allows for; and (3) there is more at stake in Bleek's response to abjection than his own subjectivity. Again, Gussow's discussion of blues violence is helpful:

> Blues weapons are a seemingly limitless figural resource, thanks to the rhetorical instability that accompanies them—a function of the sentience or nonsentience of the (bodily) surfaces they not only threaten to violate, but delight in metaphorically transforming themselves into. (p. 222)

Bleek's trumpet manifests in precisely such unstable ways in the "comeuppance" sequence. He is not simply castrated but is first made impotent when he tries to use his trumpet to shield himself from the attack. He mistakenly believes that he is equipped to *play* on the same level as Madlock and Rod. Instead, he is stripped of his phallus and assaulted with it. Bleek's body is literally penetrated, and while the impact of castration (symbolic or otherwise) on the masculine psyche cannot be underestimated, it is not synonymous with rape. And yes, I am indeed suggesting that Bleek's assault is a symbolic gang rape. Consider for instance how Rod holds Bleek down so that Madlock can have his turn and vice versa. One cannot help but be reminded of graphic rape scenes in films such as *I Spit on Your Grave* (1978) or *The Accused* (Kaplan, 1988). The way Madlock and Rod virulently cheer each other on as if at a sporting event is also indicative of the psychic conflation of sex and violence in the mutilation rituals that commonly accompanied spectacle lynching in the late nineteenth and early twentieth centuries (Wood, 2001, p. 196). Then as now, *Mo' Better Blues* seems to suggest, there is an inescapable undercurrent of desire in the blues to mark others' bodies so as to construct signifyin(g), flesh and blood texts of abjection.

To describe Bleek's attack as rape rather castration also makes more sense given his attempt to play again. Why, after all, would a castrated man risk revealing his lack to all? Thus the terror of castration (fear of removal) might be clearly differentiated from rape (terror of instilling pain, scarring). But Bleek is unsuccessful at hiding the trauma of his rape too. After a melancholy performance of "Harlem Blues" by his former love interest Clarke and old band mate Shadow, Bleek attempts to play a rendition of "Again, Never." He is, however, unable to hit the notes the song requires because his embouchure has been destroyed by the attack. Bleek's pain comes from both that which has been put in him and that which has been taken away.

To witness Bleek's failed performance here is similar to how Elaine Scarry (1985) has described the torture victim's return to speech. Because the pain of tor-

ture so dramatically reduces common articulation down to its most guttural, primal forms, it is like being present for the birth of language itself (pp. 172–173). Bleek's trauma demands that he find new means of speech. He exits the stage mid-performance, giving his trumpet away to Giant. He quickly rushes to the home of his other former love interest, Indigo, begging her to "save [his] life." The humiliation Bleek experiences does not *force* him to levy his pride, but rather *allows* him to beg Indigo to pull him from out of the depths. It is this cry for help, a cry for what essentially becomes a black feminine strategy for blues ideology that ultimately counters the film's earlier outpouring of masculine blues violence. Bleek's phallic weaponry proves useless in the struggle for discursive access—it cannot compete with brash, beating, blues weapons that occupy the space offstage. The narrative's answer to this is the feminine blues weapon of the womb. As Valerie Prince (2005) has observed, however, there is danger here too in embracing of the womb at the expense of the woman.[20] While Lee does not make this final move uncritically, neither is it without significant limitations.

Bleek and Indigo's marriage, as well as the birth of their first child (not coincidentally named Miles after the legendary trumpeter), is a powerful blues strategy precisely because it demands Bleek's submission to a woman's will, a recognition of her as a whole person, and a new sense of self grounded in multigenerational communion. Just as generations of slaves passed along the knowledge of struggle—often through the marks made upon their bodies both physical and otherwise, as well as constantly evolving strategies for coping and overcoming that struggle—onto future blues people, *Mo' Better Blues* has its bluesman, with the help of the blues woman, pass along his knowledge to the next generation. Bleek passes his beating song along to his son, and because of Bleek's experience in blues culture, he can also help his son better understand how not to be consumed by it. In this sense, *Mo' Better Blues* succeeds where *Summer of Sam* fails. Much of this apparent embrace of a feminist blues ideology is perhaps easily recuperated however. The final scene, which essentially revises the opening of the film, features a more mature Bleek allowing his son to go play with his friends instead of being forced to practice by his mother as he had been. Bleek has become the caring and *involved* black father that will not simply capitulate to pathological black matriarchy.[21] Lee's need to reaffirm black men's familial dominance and counter claims about black sexual deviance should not, however, be read solely as a reflection of Lee's personal gender politics. More accurately, the desire to instill black manhood—coded specifically as black men's responsibility to build heteronormative, Christian, nuclear households—has been one of the dominant rhetorical patterns of black racial uplift for well over a century.[22] This same rhetoric is of course the overwhelming narrative thrust of Lee's *Get on the Bus* (1996) as well as the Million Man March that inspired it.[23]

Mo' Better Blues' final narrative turn ultimately offers a valuable lesson then: that like his forbearers, the neo-blues subject's decisions are always beholden to culture both vernacular and dominant. Bleek is not simply left beaten and broken, but we should be equally skeptical about a re-imagining of blues that reasserts such highly normative standards.

Make Me Ugly

Monty Brogan (Edward Norton) is not a performer by trade and does not initially appear to have much in common with Richie or Bleek. He does, however, share with them an alternative performative personality that is invoked because of an uneasy relation to the abject which in this case is signified by the penitentiary and more specifically the prisoner. *25th Hour* is set on the eve of Monty's impending incarceration for drug distribution, and throughout the film his imprisonment is presented as a veritable annihilation of personal subjectivity. Although there is not a single scene of Monty actually in prison, to *go away* is presented as a descent into a space without hope, absent useful articulation, populated only by the living dead. As Kristeva (1982) has said about the corpse:

> seen without God and outside of science, is the utmost of abjection. It is death infecting life. . . . It is something rejected from which one does not part; from which one does not protect oneself as from an object. Imaginary uncanniness and real threat, it beckons to us and ends up engulfing us. (p. 4)

Hence "the prisoner" comes to represent a similar threat: subject to the law but not its protections (crimes against the condemned, e.g., prison rape, are rarely treated as crimes but as appropriate punishment); stripped of citizenship rights (the felon loses the right to vote); silenced in dominant discourse (except when used as the target of homophobic humor or demonized for political gain). Fortunately, Lee's narrative resists the impulse to make Monty a victim by situating his singular plight in a larger context of familial betrayal and the highly fraught emotional climate of post-9/11 New York. The result is a compelling and informed critique of the ethics of punishment.

Who is to blame for Monty's difficulty? How? To what extent? And what then can be done to account for the wrongs of the past? Such are the questions prompted by an ethics of punishment. Lee constructs in *25th Hour* a blues that challenges punishment—essentially based on what is frequently a faulty dichotomy of offense and retribution—by drawing attention to its imprecision, its ineffectiveness as a means of understanding human suffering. The ethic of punishment wrongly assumes that injury and antidote exist in easily separable dimensions. The blues proposes

instead that the remedy to any illness usually carries with it some small dose of the infection. To punish also assumes that vengeance can fully account for the toll trauma takes on mind, body, and spirit while the blues recognizes that the pain of trauma is not so easily quantifiable nor the path to healing so simplistically fulfilling. Perhaps most problematically, punishment assumes that there is always a clear path of accountability, a singular moment of right- or wrong-doing by a singular individual. The blues proposes that any act of heroism or villainy is only one in a series of existential crises with multiple perspectives and solutions.[24] So rather than a simplistic parable about sowing and reaping, *25th Hour* positions culpability as both an individual and collective problem that can be usefully though not wholly reconciled by the creative use of unconventional blues weapons. Three scenes in particular reveal Lee's alternative blues healing and subsequently how a relation to the abject can be more than a debilitating encounter with the decaying self: the opening, Frank and Jacob's conversation while overlooking Ground Zero, and Monty's beating.

Abjection enters into *25th Hour* aurally before the visual narrative even begins. The sounds of a dog being beaten play overtop the opening company credits. Then a speeding yellow muscle car appears and comes to an abrupt stop, having noticed the wounded animal on the side of the road. Enter Monty with his friend Kostya (Tony Siragusa). First Monty asks for Kostya's gun so he can perform a mercy killing but quickly discovers that the dog still has some fight left. Monty finds the dog's (Doyle) stubbornness endearing and decides to rescue him, but not before it wounds him on the neck: "a love bite *for* [my emphasis] saving his ass." The diction is telling; Doyle's love bite is an anxious mix of sentiment and aggression, a simultaneous "thank you" and "fuck you" which is reiterated in Monty's extended soliloquy later in the film.[25] The brief sequence also characterizes Monty as someone who tends to turn toward the abject rather than away from it. He is able to see in Doyle's abject body something of himself, or at least that which he values: toughness of spirit, loyalty, perseverance. From the very beginning then, Lee's film advocates in abjection more than an endless cycle of stifling repression and terrifying reemergence within the psyche.

In another scene, Monty's friends Frank (Barry Pepper) and Jacob (Philip Seymour Hoffman) meet in Frank's lavish apartment that just happens to overlook Ground Zero. As they gaze down on the cold, barren landscape they have a heated exchange about Monty's troubles, and Frank, obviously the more cynical of the two, claims that "[Monty] fucking deserves it" because his lifestyle has been "paid for by the misery of other people." Frank's lack of sympathy could not be more ironic or pointed considering his own occupation and immediate surroundings. An earlier scene has already established Frank as an egotistical Wall Street businessman who delightfully capitalizes on the unemployment rate; other people's misery hard-

ly seems like a weight on Frank's conscience. If he were held to his own apparent moral code, would he not bear some responsibility for the gaping wound just outside his window? But there is more to the scene than Frank's apparent hypocrisy.

In fact, it is in this scene that Lee establishes the film's most compelling, albeit heavy-handed, analogy via the mise en scene: Monty's prison conviction is to his drug dealing as the 9/11 attacks are to U.S. foreign policy. The notion that Monty (or the nation writ large) deserves anything, good or bad, implies that what one deserves is relevant in the contexts of terrorism and trauma. But that the goal of terrorism is to make all subject to the imminent potential of harm, regardless of their "guilt" or "innocence," calls such an assumption into question. The reason that Lee conjures up the analogy, then, is to reveal the pitfalls of this kind of ideological zero-sum game of transgression and reprisal. In other words, a debate about whether an act of terrorism (or dealing drugs) is justified in a particular circumstance obscures more fundamental issues: first, that violence is chiefly about the manipulation of force so as to affect relations of power and accordingly, to do violence unto another or to have violence done unto oneself has important implications in self-making; second, that because there exists some sense of commonality even in the most alienating social structures, painful fractures in subjectivity must already exist before someone is more willing to exploit the inherent vulnerabilities of others rather than nurture a communal capacity for compassion, pleasure, and joy; third, that violence is neither inevitable nor wholly eradicable and so we must find out how it can be put to productive use; and finally, that there is an alternative to an ethic of punishment. That is to say, that there is a way of addressing the wrongs people commit against one another so as to encourage collective responsibility and not narcissistic retreat.

25th Hour's violent climax is perhaps the closest Lee offers to such a strategy. After a long walk along the waterfront, Monty, Frank, Jacob, and of course Doyle make their way to an underpass. The garden and fountain that adorn the background in addition to the almost ethereal light that drifts into the tunnel provide a confrontationally pastoral aesthetic—as though peace itself was intruding on the grieving process of a city still in mourning. Monty then asks for a final favor from Frank: "make me ugly." Frank initially responds with confusion until Monty blatantly calls his loyalty into question and then hits Jacob. It is here that Monty's performative self is revealed. Bleek's musical virtuosity and Richie's arresting stage presence are replaced by Monty's unique ability to sense others' weaknesses and manipulate desire. After all, the drug dealer is not so much in the business of selling drugs as preying on the desire to anesthetize oneself from the pain of insecurity. The key to Monty's performance here therefore is his ability to sense Jake's guilt and forcefully remind him that it will not be silenced without a thorough exorcism. He becomes the trickster deploying a kind of benevolently playful but malevolently deceptive

schizophrenia in order to elicit Frank's wrath.

On the surface, Monty's motivation seems not altogether foreign to that of his blues kinsmen: a matter of preserving or destabilizing gender and sexual identity. But the idea that Monty would knowingly subject himself to brutality to stave off prison-rape rings hollow. Surely he knows that no such nonsensical gesture is likely to ensure his safety once incarcerated. So why then would he deliberately provoke his own abjection? Lee has already suggested in *Summer of Sam* and *Mo' Better Blues* that violence is transformative for the perpetrator and victim but *25th Hour* goes even a step further, substituting a beating for a healing. So it is that when Frank does finally attack Monty, first with hesitation and then with rapturously cathartic passion, that the beating song takes on all the feeling of a vernacular supplication, a hypermasculine "pleading of the blood."[26] Strangely though, it is not Monty's subjectivity that appears in need of reconciliation but Frank's. It is Frank who ultimately has to admit to himself that Monty does not simply "deserve it"— at least not anymore than anyone else. It is also Frank whose mitigating wails (essentially blues inflected field hollers) and bloody-fisted beats that hammer out the core chords of the beating song.[27] It seems no coincidence that the cacophony of sounds suddenly ceases right at the height of the attack; the abrupt silence signals a break in the fever, the blues equivalent of transcendence. Frank finally draws back his bloodied hands and seems able to do little more than weep. Before stumbling away, Monty hugs Frank as if to thank him, although the viewer is never allowed to hear what he says.

Unlike Doyle's abjection or even the psychic reopening of wounds Lee infers in the Ground Zero sequence, the violence is here immediately present and devastating. Despite this, though, this beating fails to signal only abjection and seems also like healing. Frank is finally able to say, with his fists, everything that was bound by the restrictions of verbal iteration. Monty simultaneously apologizes while helping to remove the burden of blame from his friend's shoulders. This is possible because of the most important factor that separates Monty from the class of other blues subjects that pervade Lee's films; he is the one who actually instigates and, in fact, demands his own abjection rather than running away from it. However distorted the logic, this is a decidedly masculine endeavor and it seems to work to some degree. There is some level of healing though it is transitory, uncertain, and elusive- as healing that comes in the form of violence could only be.

Conclusion

While I have focused on pronounced moments in three of Lee's films, there are inflections of "Spike's blues" throughout his body of work. Gator's (Samuel Jackson)

mysterious two-step just before being murdered by his own father in *Jungle Fever* (1991), Manray's (Savion Glover) dance for his life at the climax of *Bamboozled* (2000), Huey P. Newton's (Roger Guenveur Smith) shadowboxing ballet in *A Huey P. Newton Story*, and John Henry Armstrong's (Anthony Mackie) unexpected reconfiguration of the nuclear family in *She Hate Me* (2004) all point toward a continual effort to create cinematic blues texts wherein characters create compelling new ways of *playing* in seemingly immobile spaces. I have focused on *Summer of Sam*, *Mo' Better Blues*, and *25th Hour* because these films demonstrate Lee's initial investigation into blues ideology as well as some of his revisions of it. While Lee's blues is severely limited by its gender politics, it challenges racially essentialist ideas about access to blues methodology, recuperates the inherent violence of blues culture as more than an unfortunate distraction by articulating the multivalent power of blues weaponry and ultimately configures the blues as an alternative system for the construction of subjectivity through radical reevaluation of the abject's potential. I have only touched on the implications of what it means to adapt blues modes to the screen let alone all that is at stake when a figure like Lee is the one to do so. But what is certain is that the blues persists. It is more than what people do and what they do with it, though it is both of these.

Notes

1. I use "peculiar" here deliberately to reference W.E.B. Du Bois's well-known discussion of "double consciousness" in the introduction of *The Souls of Black Folk* (1997 [1903]).

2. I of course borrow the expression "blues people" from Amiri Baraka (1963) *Blues People: Negro Music in White America*.

3. Mae Gwendolyn Henderson (2000) poses discursive "disruption," what she calls "the initial response to hegemonic and ambiguously (non)hegemonic discourse—and revision (rewriting or rereading) together" as model for reading black women's literature (p. 348). Henderson's discussion of discursive practice and more specifically, how certain kinds of expression demand new interpretive strategies have wide implications. The agency that she affords specifically to black women's writing, however, should not be forgotten.

4. Several critics have challenged Baker's "blues matrix" for its dependence on poststructuralist rhetoric as well as its chauvinism. Some of the more specific critiques on the latter account come via Valerie Prince (2005) *Burnin' Down the House*, Michael Awkward (1989) *Inspiriting Influences: Tradition, Revision, and Afro-American Women's Novels* and Ann du Cille (1992) "'Who Reads Here?': Back Talking with Houston Baker."

5. Ron Eyerman (2002) argues that "as a cultural process, trauma is mediated through various forms of representation and linked to the reformation of collective identity and the reworking of collective memory" (p. 1) He goes on to say: "As opposed to psychological or physical trauma, which involves a wound and experience of great emotional anguish by an individual, cultural trauma refers to a dramatic loss of identity and meaning, a tear in the

social fabric, affecting a group of people that has achieved some degree of cohesion" (p. 2). As my analysis of Lee's work will show, I believe that Eyerman's separation between the individual and collective is far too neat and that the legacy of the blues tradition complicates such distinctions considerably.

6. I use "signify" here similarly to the way that Henry Louis Gates (1989) has discussed in *The Signifyin(g) Monkey: A Theory of African American Literary Criticism*. Gates claims about signifyin(g): In opposition to the apparent transparency of speech, this poetry calls attention to itself as an extended linguistic sign, one composed of various forms of the signifiers peculiar to the Black vernacular. Meaning in these poems is not preferred; it is deferred, and it is deferred because of the relationship between intent and meaning, between the speech act and its comprehension, is skewed by the figures of rhetoric or signification of which these poems consist. This set of skewed relationships creates a measure of undecidability within the discourse, such that it must be interpreted or decoded by careful attention to its play of differences. Never can this interpretation be definitive, given the ambiguity at work in its rhetorical structures (p. 53). Although drawing on some of the similarly problematic poststructuralist sources as his contemporary Baker, Gates' discussion is useful in suggesting a mode of revision and expropriation.

7. Gussow uses "blues subjects" to refer to those who "found ways, more or less covert, of singing back to [the] ever-hovering threat [of lynching as spectacle]" (pp. 4–5.)

8. See Michel Foucault (1975; 1977; 1995) *Discipline and Punish: The Birth of Prison*. While Foucault's argument concerning the shift from public punishment to the surveillance of the "panopticon" is persuasive in the context of the penal system, it does not account for the persistence of public punishment in America not only in the lynching ritual but in rites of territorial segregation of which the 1925 Ossian Sweet case is a prime example. See Kevin Boyle (2004) *Arc of Justice: A Saga of Race, Civil Rights, and Murder in the Jazz Age*.

9. Gussow uses "disciplinary violence" to describe that which "terrorize[d] black southerners, particularly men, into submitting to an emergent system of racial segregation and remaining a captive and exploited source of agricultural labor (pp. 2–3).

10. Robin Wood's (1984) "the return of the repressed" shares much with Kristeva's abjection. Adding a Marxist component to his psychoanalytic framework, Wood argues that it is "the Other" which threatens normality (the status quo under capitalism). The Other can take many forms based on specific temporal cultural prohibitions: *other* people, woman, the proletariat, other cultures, ethnic groups within the culture, alternative ideologies and political systems, deviations from ideological sexual norms, and/or children" (p. 168–170). Wood would likely see in Richie a clear threat to hegemony; Richie's non-heteronormative sexuality seems like precisely what his friend Vinnie (John Leguizamo) hopes to repress in himself. Vinnie's resentment at Richie's freedom is perhaps also what prompts him to lure Richie to his doom at film's end. The notion of Vinnie and Richie as sexual doppelgangers is so alluring that it should receive its due diligence at another time.

11. See David Margolick and Hilton Als (2001) *Strange Fruit: The Biography of a Song*.

12. Saidya Hartman (1997) has argued that the presence of terror in black slave life was so frequent and intense so as to continue to inform black subjectivity well beyond bondage into the turn of the twentieth century. Hartman suggests, in fact, that the impact of terrorism was so profound that it infiltrated even the most "innocent amusements." See *Scenes of Subjection: Terror, Slavery, and Self-Making in Nineteenth-Century America*.

13. Wood suggests that such ambivalence toward the monstrous Other is really part of the secret wish we have for the destruction of our simultaneously repressive and oppressive social structure (p. 191). There is truth to this, but still Wood underestimates the willingness of those who benefit from that social structure to maintain it at extreme cost including violent eradication of threats. See George Lipsitz (1998) *The Possessive Investment in Whiteness: How White People Benefit from Identity Politics.*

14. Protagonist Mookie's (played by Lee himself) clever decision to sacrifice property rather than life might make him Lee's first blues subject!

15. Carlo Rotella (2002) has examined the cultural value of creative and recreational masculine "work" in postindustrial cities in *Good with Their Hands: Boxers, Bluesmen, and Other Characters from the Rust Belt.*

16. The prolonged debate between Bleek and Shadow suggests that his regard is highly qualified. Bleek is, after all, quite skeptical about the black audience's ability to support truly innovative art: "If we had to depend on black people to eat, we would starve to death."

17. Much of Gussow's emphasis on violence in black expressive practice, what he calls "the predicament of blues culture" (p. 202), is an attempt to counter the ambivalence on the subject found in the work of Zora Neale Hurston and Robin D.G. Kelley. See Hurston (1981) *The Sanctified Church: The Folklore Writings of Zora Neale Hurston*, (1935) *Mules and Men*, and "Characteristics of Negro Expression" (1934) and Kelley (1994) *Race Rebels: Culture, Politics, and the Black Working Class.*

18. Gabbard (1992) argues that Blanchard's "post-phallic" style undermines Bleek's characterization but this sequence suggests that Blanchard's playing is ultimately subject to the larger narrative. See "Signifyin(g) the phallus: 'Mo' Better Blues' and Representation of the Jazz Trumpet" (p. 41).

19. The influence on both Lee and Miller is likely that of Soviet montage style, filtered most prominently via Francis Ford Coppola in films such as *The Godfather* (1972) and *Apocalypse Now* (1979).

20. See Prince (2005) *Burnin' Down the House: Home in African American Literature*, especially chap. 4–5.

21. Theories that have attributed continued disenfranchisement and discrimination toward African Americans to a disproportionate number of woman-led households such as in the now notorious "Moynihan Report" have been rightly attacked. See United States Dept. of Labor Office of Policy Planning and Research (1965) *The Negro Family: The Case for National Action.* Brenda Stevenson's assertion that African American families have frequently operated under "matrilineal" leadership rather than in discreet, patriarchal units is perhaps one of the most challenging theses to such patently racist and sexist arguments. See Brenda Stevenson (1996) *Life in Black and White: Family and Community in the Slave South.*

22. For more on masculinity and racial uplift see Marlon Ross (2004) *Manning the Race: Reforming Black Men in the Jim Crow Era* and Steve Estes (2005) I *Am a Man!: Race, Manhood, and the Civil Rights Movement.*

23. See Judith Newman (2004) "Men, Masculinity, and Mourning on the Wall: National Manhood and Male Romance."

24. The multiplicity of perspectives surrounding a singular event is another theme that runs through Lee's body of work. The *Rashamon*-style confessionals of *She's Gotta Have It* (1986) come to mind immediately.

25. The "Fuck you" monologue is in actually a dialogue between conflicted parts of Monty's own fractured self. While his rant is directed at multiple targets including the city's various ethnic groups, Islamic-fundamentalist terrorists, the NYPD, and his own friends, it culminates in Monty's accepting responsibility for his own plight. I mention the scene here because it offers a glimpse of Monty's doppelganger who emerges to taunt Frank at the film's climax.

26. I refer here to James Baldwin's (1976) description of the ritual in the evangelical black church in which members plead for the soul of another caught in the sublimity of revelation. In practical terms, Baldwin's description of the ritual is a spiritual account of subjectivity and the fight to survive internal conflict (pp. 137–138).

27. Lee confesses in the director's commentary track that one of Pepper's punches mistakenly made real contact and nearly broke Norton's nose.

References

Awkward, Michael. (1989). *Inspiriting influences: Tradition, revision, and Afro-American women's novels*. New York: Columbia University Press.

Baker, Houston. (1984). *Blues, ideology, and Afro-American literature: A vernacular theory*. Chicago: University of Chicago Press.

Baldwin, James. (1976). *The devil finds work*. New York: Dell Publishing.

Baraka, Amiri Imamu. (1963). *Blues people: Negro music in White America*. New York: W. Morrow.

Boyle, K.(2004). *Arc of justice: A saga of race, civil rights, and murder in the Jazz Age*. New York: H. Holt.

Coppola, Francis Ford. (Director). (1972). *The Godfather*. [Motion Picture]. US: Paramount Pictures.

———. (Director). (1979). *Apocalypse Now*. [Motion Picture]. US: Zoetrope Studios.

Crane, Jonathan Lake. (1994). *Terror in everyday life: Singular moments in the history of the horror film*. Thousand Oaks, CA: Sage Publications.

Du Bois, W.E.B. (1997 [1903]). *The souls of Black folk* (Eds.) David Blight & Robert Gooding Williams. Boston: Bedford Books. (Original work published in 1903.)

Du Cille, Ann. (Fall 1992). Who reads here?: Back talking with Houston Baker. *Novel 26*, 97–105.

Dyer, Richard. (1997). *White*. New York: Routledge.

Ellison, Ralph. (1964). *Shadow and act*. New York: Random House.

Estes, Steve. (2005). *I am a man!: Race, manhood, and the civil rights movement*. Chapel Hill: University of North Carolina Press.

Eyerman, Ron. (2002). *Cultural trauma: Slavery and the formation of African American identity*. Cambridge, UK; NY: Cambridge University Press.

Flory, Dan. (2002). The epistemology of race and Black American film noir: Spike Lee's *Summer of Sam* as lynching parable. In Kevin L. Stoehr (Ed.), *Film and knowledge: Essays on the integration of images and ideas*. pp. 174–190. North Carolina: McFarland and Co.

Foucault, Michel. (1995). *Discipline and punish: The birth of prison* (2nd ed.). New York: Vintage Books.

Gabbard, Krin. (1992). Signifyin(g) the phallus: *Mo' Better Blues* and representations of the jazz trumpet. *Cinema Journal 32*(1), 43–62.

Gates, Henry Louis. (1989). *The signifyin(g) monkey: A theory of African American literary criticism* (2nd ed.). New York: Oxford University Press.

Gussow, Adam. (2002). *Seems like murder here: Southern violence in the blues tradition.* Chicago: University of Chicago Press.

Hartman, Saidya. (1997). *Scenes of subjection: Terror, slavery, and self-making in nineteenth-century America.* New York: Oxford University Press.

Henderson, Mae Gwendolyn. (2000). Speaking in tongues: Dialogics, dialectics, and the Black women's writers literary tradition. In Winston Napier (Ed.), *African American literary theory: A reader* (pp. 348–368). New York: New York University Press.

Hurston, Zora Neale (1981). *The sanctified church: The folklore writings of Zora Neale Hurston.* Berkeley: Turtle Island.

———. (1990 [1935]). *Mules and men.* New York: Perennial Library. (Original work published in 1935.)

———. (1999 [1934]). Characteristics of Negro expression. In Gena Dagel Caponi (Ed.), *Signifyin(g), sanctifyin', and slam dunking: A reader in African American expressive culture* (pp. 303-306). Amherst: University of Massachusetts. (Original work published in 1934).

Kaplan, Jonathan. (Director). (1988). *The Accused.* [Motion Picture]. US: Paramount Pictures.

Kelley, Robin D.G. (1994). *Race rebels: Culture, politics, and the Black working class.* New York: Free Press.

Kristeva, Julia (1982). *Powers of horror: An essay on abjection.* (Leon S. Roudiez, Trans.). New York: Columbia University Press.

Lee, Spike. (Director). (1986). *She's Gotta Have It.* [Motion Picture]. US: 40 Acres & a Mule Filmworks.

———. (Director). (1989). *Do the Right Thing.* [Motion Picture]. US: 40 Acres & a Mule Filmworks.

———. (Director). (1990). *Mo' Better Blues.* [Motion Picture]. US: 40 Acres & a Mule Filmworks.

———. (Director). (1991). *Jungle Fever.* [Motion Picture]. US: 40 Acres & a Mule Filmworks.

———. (Director). (1999). *Summer of Sam.* [Motion Picture]. US: 40 Acres & a Mule Filmworks.

———. (Director). (2000). *Bamboozled.* [Motion Picture]. US: 40 Acres & a Mule Filmworks.

———. (Director). (2001). *A Huey P. Newton Story.* [Motion Picture]. US: 40 Acres & A Mule Filmworks.

———. (Director). (2002). *25th Hour.* [Motion Picture]. US: 40 Acres & a Mule Filmworks.

———. (Director). (2004). *She Hate Me.* [Motion Picture]. US: 40 Acres & a Mule Filmworks.

———. (Director). (2006). *When the Levees Broke: A Requiem in Four Acts.* [Motion Picture]. US: 40 Acres & a Mule Filmworks.

Lipsitz, George. (1998). *The possessive investment in Whiteness: How White people profit from identity politics.* Philadelphia, PA: Temple University Press.

Margolick, David, & Hilton Als. (2001). *Strange fruit: The biography of a song.* New York: Harper Perennial.

Murray, Albert. (1970). *The Omni-Americans: New perspectives on Black experience and American culture.* NY: Outerbridge & Dienstfrey.

Newman, Judith. (2004). *From Panthers to Promise Keepers: Rethinking the men's movement.* Lanham, MD: Rowman & Littlefield.

Prince, Valerie. (2005). *Burnin 'down the house: Home in African American literature.* New York: Columbia University Press.

Ross, Marlon. (2004). *Manning the race: Reforming Black men in the Jim Crow era.* New York: New York University Press.

Rotella, Carlo. (2002). *Good with their hands: Boxers, bluesman, and other characters from the Rust Belt.* Berkeley: University of California Press.

Scarry, Elaine. (1985). *The body in pain: The making and unmaking of the world.* New York: Oxford University Press.

Stevenson, Brenda. (1996). *Life in Black and White: Family and community in the slave South.* New York: Oxford University Press.

United States Department of Labor Office of Policy Planning and Research (1965). *The Negro family: A case for national action.* Washington: Superintendent of Documents, U.S. Government Print Office.

Williams, Linda. (Summer 1989). Power, pleasure, and perversion: Sadomasochistic film pornography. *Representations. 27*, 37–65.

Wood, Amy Louise. (2001). Lynching photography and the "black beast rapist" in the southern White masculine imagination. In Peter Lehman (Ed.), *Masculinity: Bodies, movies, culture* (pp. 193–211). NY: Routledge.

Wood, Robin. (1984). An introduction to the American horror film. In Barry Keith Grant (Ed.), *Planks of reason: Essays on the horror film* (pp. 164–200). London: Scarecrow Press.

Which Way
TO THE Promised Land?

Spike Lee's *Clockers* and the Legacy of the African American City

PAULA MASSOOD

Nothing is experienced by itself, but always in relation to its surroundings, the sequences of events leading up to it, the memory of past experiences.... Every citizen has had long associations with some part of his city, and his image is soaked in memories and meanings.

—Lynch, 1960, p. 1

In the closing scene of Spike Lee's *Clockers* (1995), Strike Dunham—the film's young, ulcer-prone protagonist—escapes from the life-threatening dangers of urban life. In the film's final frames we witness both an emigration and a migration as Strike concurrently leaves behind his past and heads toward a more promising future. This in and of itself is neither new nor innovative. We are familiar with Hollywood's happy endings, provided so that audiences can walk out of the theater with a feeling of satisfaction, having experienced narrative closure. The way the scene is shot adds to its redemptive qualities: Infused with a golden light, Strike heads into the sunset before the screen fades to black.

Even before *Clockers'* release, Lee announced his intentions for the film. In a variety of press releases and published interviews, he stated that he wanted *Clockers* to be more than just another "hood" film—what he referred to as the "black gangster, hip-hop shoot-'em-up . . . drug genre" (Schaefer, 1995, p. 47). One of Lee's primary concerns was to differentiate *Clockers* from hood films such as John

Singleton's *Boyz N the Hood* (1991) and the Hughes Brothers' *Menace II Society* (1993). As Lee stated after the film's release, "It was always our intention that if we succeeded with this film, that this might be the final nail in the coffin and African-American filmmakers would try telling new stories" (Bernstein, 1997, p. 202). While *Clockers* is wholly conscious of and reliant upon the hood films immediately preceding it, the film occupies a different position from those with which it is most closely aligned. For instance, its self-conscious appropriation and revision of many of the conventions of the hood film problematize a clear-cut alignment of it with earlier examples of the genre. Indeed, its use of hood conventions is too consciously self-referential, a fact apparent in the film's narrative, style, and shifting character identification. *Menace II Society* is also a self-referential text, especially in its conscious appropriation of many of the narrative elements of *Boyz N the Hood*, yet whereas *Menace's* self-consciousness accepts hood conventions while expanding upon them, *Clockers* deconstructs and problematizes them. It may be, in fact, just this process of revision that transforms the hood film into something else entirely.

It is not my intention to examine all of the ways in which *Clockers* either succeeds or fails to fulfill generic requirements. Instead, I want to start from the understanding that *Clockers* utilizes iconography similar to that in a number of other films set in African American urban spaces in the 1990s, but I want to expand upon this observation by suggesting that Lee broadens this urban sign system in discrete ways. In fact, Lee's film fuses the hood with the traces of another time and space by linking contemporary Brooklyn to an African American past through specific changes to Richard Price's novel, on which the film is based. This chapter focuses on the ways in which *Clockers* reconsiders and revises the hood film, in particular, and cinematic representations of the African American city as a whole.[1] In the process, I examine how the film's spatio-temporal parameters dialogue with the traces of another time and space through the motif of the train. My argument is that the presence of the train in *Clockers* inserts the tropes of migration, mobility, and settlement into the narrative in order to place history, especially African American history, back into a dialogue with contemporary African American filmmaking. The difference between Lee's film and more identifiably "historical" films like Mario Van Peebles' *Posse* (1993) and Bill Duke's *Hoodlum* (1997) is that *Clockers* is set in a contemporary location and uses the conventions of a contemporary genre. Ironically, this is accomplished primarily by referencing the mode of transportation so central to the establishment of an urban black population.

A knowledge of the circumstances involved in the production of *Clockers* is crucial for understanding the significance of Lee's role in the final product. Price's novel focuses on the experiences of two very different characters, Strike, a small-time drug dealer, and Rocco Klein, a New Jersey homicide detective, both of whom are brought together when Rocco is assigned to investigate the murder of a local drug-

dealer. The original story was optioned by Martin Scorsese, with Robert DeNiro slated to star as Rocco. Price, already well known for other scripts based on his novels, adapted the screenplay. When Scorsese and DeNiro left the project to work on Scorsese's *Casino*, Lee was hired to direct, with Scorsese continuing his involvement as a coproducer. Lee, also a co-producer, rewrote the script, making a number of changes that significantly altered the film. In these alterations are located the most telling links to what I am calling the "hood chronotope," after Mikhail Bakhtin's concept of the literary (narrative) chronotope, and to the historical foundations of the cinematic urbanscape.

As defined by Bakhtin, a "chronotope" is a "unit of analysis for studying texts according to the ratio and nature of the temporal and spatial categories represented" (1981, p. 425). The chronotope functions as "materialized history," where temporal relationships are made literal by the objects, spaces, or persons with which they intersect (Bakhtin, 1981, p. 247). Often a particular chronotope is linked to a certain genre or sub-genre and helps to define it. This has certainly been the case with hood films from the early 1990s, which have been characterized by their relationship to particular spaces (Los Angeles, New York) and particular times (contemporary). It is my assertion here that *Clockers* draws on elements of the hood chronotope—urban setting and contemporary time frame (aided by soundtrack, costuming, and extratextual references)—but revises them by setting up a dialogue between the hood's present and its past. We can see this in three of the most important modifications made to the original story: changes in main character, setting, and conclusion.

First, in reconceptualizing the narrative, Lee focuses on Strike (Mekhi Phifer), a young drug dealer, or clocker. This represents a change from both the novel and the original screenplay.

The novel alternates point of view between Strike and Rocco (Harvey Keitel), an approach which aids in the development of the psyches of both characters and provides background information for the tension informing the pair's interactions as Rocco first investigates Victor (Strike's brother), but then changes his focus to Strike. In his screenplay, Price changed the novel's original structure by shifting primary point of view to Rocco alone. The effect was to provide Rocco with a more fully developed psyche, at the expense of Strike's characterization, a change most likely influenced by DeNiro's casting. Lee's change, however, expanded audience identification with (and thus sympathy for) a character traditionally lacking psychological development in most of the films focusing on similar protagonists, with the possible exceptions of Tre in *Boyz* and Caine in *Menace*.[2] Like Caine, Strike is often an unsympathetic character. Unlike the Hughes brothers, however, Lee wanted more thoroughly to explore the trials and tribulations, the pressures and the motives behind Strike's choice to clock rather than starting from the presumption that

such a decision is made inevitably or comes "naturally."[3] Furthermore, Lee's film more fully and sympathetically acknowledges the effects of Strike's and his crew's presence on the surrounding community: in particular, his family and his neighbors.

Lee chose to focus on the same subject matter that many hood films depict; however, Strike's characterization—as a young, black man coming of age in the inner city—is one that is more three-dimensional (at least with regard to his motives, doubts, and limitations) than the majority of related characterizations since he's provided with a well-defined psychology. This approach makes Strike more sympathetic: He is not only charismatic but he is also plagued by enough of a conscience that he is literally eaten up from the inside by ulcers over the stress of his daily activities. Also, in an interesting expansion and explication of street morality, Strike becomes even more sympathetic when he has trouble carrying out orders to murder another dealer. This shift reframes the more cold-blooded characterizations of Caine, Doughboy, or Bishop from *Juice* (Ernest Dickerson, 1992), who elicit no remorse over similar murderous acts.

The fact that Strike is not a conventional drug dealer is further emphasized by the scenes in which he interacts with authority figures. Unlike earlier cinematic renderings of gangsta characters and more like Rusty Cundieff's satirical *Fear of a Black Hat* (1993), *Clockers* problematizes the "hard" exterior associated with both their cinematic and musical variations.[4] Strike is relatively soft—he drinks a Yoo Hoo-like soft drink called Moo Moo rather than the ubiquitous "forties" malt liquor; he collects and plays with model trains; and, most importantly, he is often emasculated in the face of authority. In almost all of his interactions with authority figures, Strike is inarticulate (in the novel he even stutters when tense), ineffectual, and childlike—behaviors that hint at his youth and inexperience. An interesting correlative to this is the fact that all the authority figures complicating Strike's life are distanced from him by generational factors (with Andre the housing cop coming the closest in age), as well as the more obvious structural and ideological factors. Generational miscommunication and disappointment reside at the core of many of the hood films' tensions, with agency and neighborhood control often ceded to a younger generation and elders characterized as ineffectual. *Clockers* inverts this relationship, not necessarily as a critique of Strike so much as to reinsert the influence of elders back into contemporary African American popular culture.

Living in the City: Brooklyn's Many-Storied Pasts

My sisters and I and the other black children were a minority at P.S. 84, but we were not much concerned about it. Blacks from the islands and the growing number from the South would in a few years reverse the racial make up of the [Brownsville] neighborhood, and the change would be accompanied by mounting bad feeling, but at that time [the

1930s] the race line was not drawn in the same way it is today. As I remember it, the school was about 80 percent white, mostly Jewish children; all the teachers were white, and nearly all were Jewish. We were not particularly conscious of that fact, either.

CHISHOLM, 1994, P. 47

The second change Lee made was in shifting the novel's setting from the Roosevelt Houses in Dempsy—a fictional New Jersey location roughly based on Jersey City—to the "Nelson Mandela Houses" of Brooklyn (in actuality the Gowanus Houses, located on the border of the borough's Cobble Hill and Boerum Hill sections). The effect of this move is quite significant, despite Lee's claim that "projects are projects" (Bradley, 1995, p. 32). First, by relocating to Brooklyn, Lee situated the film in the already storied and familiar spatial parameters of the hood. While the majority of hood films were set in Los Angeles, a few significant examples, such as *Straight out of Brooklyn* (Matty Rich, 1991) and *Juice* were located in New York City; only one, *New Jersey Drive*, was set in New Jersey. This move contributes to the film's already complex interweaving of references and temporalities. On the one hand, the film's frenetic camera techniques, identifiable urban location, rap-based soundtrack, up-to-the-minute fashions, and references to contemporary African American popular culture announce its similarities with hood films and elements of the hood chronotope, especially *Menace*.[5] But this shift in location must also be viewed in the context of Lee's entire cinematic oeuvre, which, from almost its beginning, has both acknowledged and explored the past in the context of the present—symbolized most often by references to particular characters' (and by extension the city's) Southern roots. This appears in Lee's work as early as *Joe's Bed-Stuy Barbershop: We Cut Heads*, and has continued throughout his career, most notably in *School Daze*, *Do the Right Thing*, *Malcolm X*, and *Crooklyn*. Thus, the move to Brooklyn locates *Clockers* in a particular urban history, which acknowledges the effects of migration and ghettoization.

In order to see how this works, it is important to understand Brooklyn's history as an African American community, a history that is overlooked in most studies of urban African American migration as it pertains to metropolitan areas such as Los Angeles, Chicago, Detroit, and even New York City, where discussion is often limited to Harlem. During the Great Migration, Harlem, in particular, played a crucial role as a black city within a city—a "promised land"—for many rural migrants. However, Brooklyn has its own concurrent history as a home for a large African American population, a result of the same demographic shifts that helped constitute Harlem. As early as the turn of the century, Brooklyn—specifically the areas of Bedford and Stuyvesant—was home to an established black, predominantly middle-class population. In addition, as historian Ernest Quimby notes, through the twenties many Harlem blacks migrated the short distance to Brooklyn "seek-

ing social mobility and escape" from the factors that had already begun to turn their area into a ghetto (1979, p. 229). The expansion of the New York City subway system (specifically the A-train) to the borough in 1936 facilitated the migration of Harlemites to Brooklyn, resulting in increases in the number of migrants and in the area's African American population (Quimby, 1979, p. 232). This local migration, combined with the continuing addition of new arrivals from the rural South and the Caribbean, expanded the neighborhood's black population, a phenomenon remembered in the Chisholm quote which introduces this section. The area's demographic growth continued through mid-century (especially with the employment offered by the Brooklyn naval yards) and into the 1980s. At this time, as David McCullough argues, Bed-Stuy became synonymous with black and has remained so ever since (1983, p. 212). Not coincidentally, this last development also coincides with Lee's career, so much so that, in the 1980s, cinematic representations of black Brooklyn became synonymous with Spike Lee.

With the expansion of Brooklyn's African American population, the Bed-Stuy, Brownsville, and Boerum Hill sections of Brooklyn, among others, transformed from being relatively integrated to increasingly isolated and marginalized, as other ethnic groups emigrated to different parts of the borough (Bensonhurst), to other New York City boroughs (Queens, Staten Island), or to the suburbs (Long Island, Westchester County, New Jersey). Property speculation, absentee landlords, and governmental disinterest in the sixties and seventies resulted in the destruction of the area's property values and the increasing segregation and concurrent ghettoization of the black community—a ghettoization similar to that experienced in Los Angeles, Detroit, Chicago, and other major metropolitan areas. This was complicated by the construction and subsequent abandonment (through decreases in funding and governmental interest) of low-income housing projects, of which the Gowanus (Nelson Mandela) Houses are a prime example. As Quimby observes, "Anti-blockbusting campaigns, urban renewal, and the construction of exclusively low-income housing projects . . . erode[d] the sense of community, prevent[ed] social mobility, thwart[ed] economic and political mobilization, and allow[ed] the containment and administrative manipulation of Blacks" (1979, p. 236). A similar view of projects in general has been expounded by Richard Price, a product of them himself, who observes, "What was amazing to me was how the projects went from launching pads for working-class families to just terminals where generations are stacked up in the same apartment because there's no place to go" (Werner, pp. 10–11). Both observations echo the concerns of many contemporary African American filmmakers, who use similar metaphors of entrapment in depicting discrete city spaces.

All of this adds complexity to Lee's seemingly simple or innocent choice to relocate *Clockers* to Brooklyn, especially the area' s significance as a terminal point of sorts. While it may have been that it was cheaper and easier to shoot in Brooklyn,

or that Lee was more comfortable working in a familiar location, neither factor diminishes the importance of the choice of Brooklyn for the film's setting. On the one hand, the borough is the final destination of the majority of New York's subway lines that run southeast. Brooklyn is where you get off, unless you want to head all the way back through Manhattan to Queens—though characters in *Clockers*, except for Victor (Isaiah Washington), never head in that direction.[6] As I have suggested, Brooklyn was also the end point for many who had experienced multiple dislocations and migrations—the Middle Passage, the South, Harlem. In this history, Brooklyn is more than just a stopover or transitional point, as places such as Memphis were for many migrants. Brooklyn is the literal end of the line after many shifts and movements. And, as Price's observation regarding the transformation of housing projects suggests, Brooklyn became a metaphorical terminal point as well, as what was once the hope of moving from the poverty of the rural South, or the urban decay of Harlem, became the stagnation of the projects and economic displacement. In this sense, the ultimate irony of all this mobility is that its end result is entrapment.

The architectonics of *Clockers* clearly make this point. Most of the film is shot in the projects' central courtyard, a tree- and bench-lined circular plaza with a raised concrete platform that the community has ceded to Strike, his crew, and the crack business. According to Amy Taubin, this area "is both stage and prison—an inversion of Foucault's panopticon. Trapped within it, Strike is under constant surveillance, vulnerable to aggressors who enter from all sides" (Brown & Taubin, 1995, p. 71). This aspect of the projects is also noted in the novel:

> Strike scanned the canyon walls of the Roosevelt Houses. There were thirteen high rises, twelve hundred families over two square blocks, and the housing office gave the Fury [Housing Police] access to any vacant apartment for surveillance, so Strike never knew when or where they might be scoping him out. (Price, 1992, p. 4)

Furthermore, the construction of this particular mise-en-scene is illustrative of Foucault's concept of the "spatialization of power," as formulated by Edward Soja, in which cultural hierarchies are mapped onto specific landscapes (1989, p. 21). Here, the projects become a carceral city, in which the surrounding buildings act as sentries, looking down on the activities taking place below, guarding the boundaries of the projects, and barring movement from within their perimeter.

Perhaps the "heterotopia" is a more appropriate Foucauldian concept with which to describe the film's rendering of the Mandela Houses. According to Foucault, a heterotopia is a "countersite" in which "all the other real sites that can be found within the culture are simultaneously represented, contested, and inverted." The foundation of Foucault's heterotopia is its dual roles as actually lived space (his examples include prisons, asylums, and cemeteries) and "other" spaces which

are "absolutely different from all the sites that they reflect and speak about" (p. 24). Importantly, as Soja discusses, heterotopias "are constituted in every society, but take quite varied forms and change over time, as 'history unfolds' in its inherent spatiality" (1989, p. 17). In this understanding of heterotopias, Soja not only indicates Foucault's fundamental concern with space and power-and the related and equal importance given to the intersections of space and time ("heterochronies," according to Foucault)[7]—but he also points to the ways in which we can begin to understand the historicity behind Price's comments about the projects, and various characters' experiences of the shifting definitions of the Mandela Houses.

As a socially constituted space, the Mandela Houses both reflect and refract their neighboring communities, societies, and histories. *Clockers*, especially its focus on boundaries, indicates that the projects (and most of their residents) may abut the surrounding communities, but they are not necessarily "of" the community. True, they contain social relations which mirror the society constituting them, but the projects are roped off from the community, with most pro-filmic events occurring there. What lies beyond the heterotopia of the Mandela Houses is an urban frontier not freely accessible to the characters imprisoned within the projects' visible and historic barricades. Most of the characters show little inclination or desire to leave their immediate surroundings, at least not if they don't have to. In fact, the majority of characters seem to have been stripped of the ability even to envision an alternative existence—perhaps the most telling way that we can understand the space as a heterotopia. Strike and Victor differ from the other characters because they, especially Victor, can see outside the projects.[8] Victor works two demeaning and underpaid jobs in order to save enough money to move his family out of the projects, a desire based on the possibility of a literal shift out of their present environment and on a more figurative desire for social (and economic) mobility from the underclass to the working/middle class. Strike's flight, on the other hand, is mostly imaginary, as his fantasies about trains carry him away from his surroundings only in his mind. Strike doesn't experience real movement until the end of the film, though it is at least foreshadowed by these earlier scenes. The paradox of this situation is frustratedly articulated by Andre to Strike: "There's more than just these projects out there, you know. Don't you want to go someplace you've never been before? . . . you love trains but you've only ridden the subway." Here, the stasis of the projects is clearly juxtaposed against the movement of subways and trains. By this time, however, subways offer no real exit—a clear reversal of their role from earlier in the century. It may be that Strike's knowledge of trains—and the fact that he has already moved out of the projects—will be his ticket out.

Before moving on to a discussion of the third change from the novel, I'd like to consider the ways Lee reframes the film's city spaces in relation to the conventions of the hood chronotope. On the one hand (and as I have already mentioned),

the shift of settings brings the narrative into a closer relationship to the familiar boundaries of the hood as seen in films like *Juice, Straight out of Brooklyn, Just Another Girl on the IRT* (Leslie Harris, 1993), and *New Jack City* (Mario Van Peebles, 1991). Visually, the mise-en-scene resembles the spatial integrity of many of its predecessors, especially in the way that it calls attention to its location through prominently placed "signage"—the Nelson Mandela Houses and the references to Brooklyn and "Crooklyn" being the most obvious. Yet the film reworks the hood films' emphasis on "real" space (real streets and street signs, and the calling out of specific urban areas, for example) by constructing a space that is concurrently real (shot on location) and manufactured (announced by the self-referentiality of the film's editing, camera movement, cinematography, and mise-en-scene). In its reworking of these conventions, *Clockers* transforms the hood chronotope into chronotopic traces, which then dialogue with other generic and historical traces or motifs. According to Gary Saul Morson and Caryl Emerson, a chronotopic motif serves as an "aura" of another genre (1990, p. 375)—a reminder of another space and time. In *Clockers* the train, a reminder of another place and time, is the central chronotopic motif dialoguing with the hood.

The film's locations are both familiar and recognizable to most of its targeted audience. However, the way that the film breaks down this a priori generic spatial integrity makes it interesting for my analysis, and indicates the way that the hood gradually diminishes in importance from black-directed films released after *Clockers* (or, alternatively, it returns as a trope or trace in a selection of these later films, for instance F. Gary Gray's *Set It Off*). As I have stated, almost all of the action takes place within the confines of the projects, even though the two main characters, Rocco and Strike, are not themselves residents (Strike, however, was raised there). Most of the scenes are exterior shots, filmed on location in the projects' central plaza. The film rarely shifts to interior shots, instead centering its narrative attentions on the activity in this park-like area. In Lee's articulation of the space, especially in the opening shots, the plaza differs from more conventional renderings of inner-city space. For example, it is green, lush, and infused with a rich light that calls attention to the colors found in both the space's vegetation and the clothing worn by the *Clockers*. Furthermore, it is lively and filled with the comings and goings of members of the community, a pleasant and ironic setting for crack entrepreneurs. Yet even in this shift from the more dystopian and desolate urbanscape of the hood film, the plaza maintains an integrity with its real location, the Gowanus Houses. It appears to be "authentic."[9]

The film's excursions outside of this space draw attention to the constructed nature of its mise-en-scene and, by relation, foreground the constructedness of representation as a whole. Lee's experimentation with filmic form is well known, and *Clockers* is no exception. In fact, it is a continuation of the development of certain

"signature" techniques, such as the effect of placing characters and camera on a moving dolly while taking care to keep the changing background in focus. The film foregrounds its own processes of manufacture, especially in its camera movement, editing, mise-en-scene, and cinematography. In particular, the variety of film stock and lighting techniques calls attention to the tactile nature of the film's images. The film's mise-en-scene also draws attention to Lee's experimentation. Lee has always been known for constructing specific sets to meet his diegetic needs, a fact that provoked criticism in the mainstream press for *Do the Right Thing* because it changed the look and nature of an existing city block in Bed-Stuy. In *Clockers*, the projects remain virtually untouched. It is the surrounding spaces—Ahab's, the bar, Strike's apartment, the train—that are differentiated from the Mandela Houses.

The film differentiates the bar and Ahab's from Strike's apartment and the train through changes in setting, sets, and lighting. The Kool Breeze and Ahab's are defined through their relationship to pro-filmic violence: They are the sites in which violence is first planned and then performed, respectively. In effect, they enable the entire narrative in that the actions that take place in these spaces set off the remaining chain of events. Both sites, which we only see at night, are characterized by brightly lit and colorful signage—Ahab's complete with a revolving whale that blows out steam through its airhole. The spaces are also the sites of some of the film's most aggressive cinematography. For instance, the scene in which Strike confronts Darryl (Steve White) before presumably murdering him is introduced in a close-up of a tabloid headline reading "Crooklyn" before the camera tracks back to reveal a deep focus shot with Strike in the foreground (from a low angle) and a billboard announcing "No More Packing" above his head. Significantly, Ahab's—and this scene in particular—will be revisited in various characters' flashbacks, with a gritty image quality diluting the hypersaturated colors of the original scene.

The Kool Breeze is also introduced by its brightly lit sign, which appears in an establishing shot prior to a cut, first to television images of a rap video, and finally into the interior of the bar. Once inside, the editing and cinematography are quite conventional, with Victor and Strike framed in a two-shot as they discuss Darryl. Similar editing and cinematography are maintained when Rocco and his partner (John Turturro) enter the bar to question its patrons. In both of these examples, time occurs in the narrative present, and the Kool Breeze is introduced through the rap images on television which link the activities presented in the videos and advertisements for malt liquor with those taking place in the bar. Later in the film, the bar, like Ahab's, will be returned to in flashbacks. In these flashbacks, the cinematography is gritty, the colors are diluted, and the rap images have disappeared.

These spaces, articulated through their relationship to violence, differ from those that are more closely associated with Strike—his apartment and the train, which can

only be described as lush. Strike's apartment is a run-of-the-mill tenement space, characterized by aged woodwork and walls, and installment plan furniture. As such, the apartment is indistinguishable from other spaces of lesser narrative importance, such as Victor's apartment in the projects. Yet it is the way that the space is shot that makes it so interesting. As in the later scenes with the train, the scenes set in the apartment are fused with a golden, glowing light, streaming through two windows in the background and providing everything in the middle- and foregrounds with a slight halo. But there is no narrative reason for this use of lighting. In fact, the narrative undercuts this treatment in the activities that take place in these scenes: One time Strike, in a misguided attempt at mentoring, is teaching Tyrone, a neighborhood kid, how to cut and weigh crack cocaine; and the second time Strike is preparing to leave town. In both examples a direct narrative link is made with the trains, foreshadowed in these scenes but not realized until the film's conclusion. Prior to teaching Tyrone about the drug business, Strike shows him his collection of model trains and teaches Tyrone their history, a history that will be reiterated by Tyrone to his mother at the film's conclusion. Later, when Strike is preparing to leave town, he pauses long enough to write a note to his landlord, leaving his trains to Tyrone. The rendering of the train in the film's conclusion has already been foreshadowed here.

As I mentioned above, it is only in *Clockers*' cinematic articulation of the Mandela Houses—and a few other scenes (mostly street scenes, especially around Rodney's store and the police station)—that the film's cinematography is clearly influenced by the hood chronotope. These scenes help define and articulate the urbanscape, a space already identified in earlier films as the hood. Yet the scenes outside of the boundaries of the projects indicate that *Clockers* is more than an appropriation of hood film conventions. Its manufacture of these "other spaces," these heterotopias, indicates a self-conscious attempt to point to the possibility that the cinematic city might be more manufactured than it first appears. In fact, it might be, as in Ahab's, the Kool Breeze, and Strike's apartment, an entirely constructed terrain. This, in and of itself, already delineates *Clockers* from the "hip hop . . . drug genre." But it is where the traces of the hood chronotope and Lee's self-conscious image manufacturing start to dialogue with the train that the text's polyphony expands to acknowledge history, especially the links between the city and African American migration.

Take the A(mtrak) Train: Trains, Sites, and Chronotopes

In classical narrative cinema the train was generally given the role of integration and linkage, of stabilization, especially in terms of American national identity: the mythology of assimilation to a "universal" American identity

KIRBY, 1997, P. 10

The significance of the shift in setting, and its relationship to what Paul Gilroy refers to, in another context, as "movement, relocation, displacement, and restlessness" (1993, p. 133), is evidenced in Lee's third and most crucial change from the novel—Strike's fascination with trains. In the novel, Strike has few interests outside of making money and dealing drugs. He "had never really liked music. He had never cared about sports, even girls that much if he thought about it" (Price, 1992, p. 622). Strike's world revolves solely around his relationship with Rodney and the other *Clockers*. This conforms with the novel's strategy of splitting point of view between Strike and Rocco, and its less sympathetic approach to Strike's character. In the film, however, Strike's hobby of collecting model trains humanizes his character—for who would expect a drug dealer to have any interests outside of the criminality that defines and limits him (the same criminality that defined and limited him in the novel, and that wholly limits Caine in *Menace*)? Lynne Kirby suggests that between 1880 and World War I the "cult" of toy trains "firmly linked masculinity with railroading" (1997, p. 78). However, she continues, African American boys "were barred" from fulfilling dreams of "glamorous railroad careers as engineers because of skin color," ironically undercutting the mythology of assimilation Kirby discusses in the comments opening this section. The most that young black men could hope for was to become Pullman porters, though Kirby notes that this was also a position of "esteem" (1997, p. 80). What is interesting here is that it is Strike's hobby, rather than his drug dealing or gun, that defines him as a man. Yet Strike's interest in and knowledge of the history of trains were viewed as insignificant by most viewers and critics of the film, if they mentioned it at all. For the more cynical viewers, the trains were nothing more than the enabling metaphor for the film's "rapturous" finale, or, worse, as just another detail of the mise-en-scene, simply an excuse for Strike's outfit of overalls at the beginning of the film (Brown & Taubin, 1995, p. 71).

While the trains humanize Strike, they also alter the novel's conclusion. Rather than leaving town on a Greyhound bus from the Port Authority bus terminal as he does in the novel, the cinematic Strike flees on a train from Penn Station. The change is made more powerful by the way Lee shot the final scene: filtered with golden light and soft-focus lenses, a marked difference from the gritty cinematography constituting most of the film. The combination of Strike's hobby and *Clockers'* conclusion enables Lee to further historicize contemporary cinematic representations of the black city.[10] *Clockers'* metonymic use of trains thus points to the interconnected histories of African American migration, the rise of inner-city ghettoes, and the subsequent demise of a black middle class, and gives ironic import to Amy Taubin's observation that "no one can escape from the past" (p. 76). Furthermore, the train references the related tropes of mobility and entrapment, two of the most recurrent themes in African American cultural production in the twentieth centu-

ry and in African American films from this time period, and a central theme of hood films.

To understand all this it is important that we remain aware of the complex historical role migration has played as a central trope in African American cultural production in particular, and the African diaspora as a whole. Here my interests and theoretical inclinations intersect with those of Paul Gilroy as developed in *The Black Atlantic*. For Gilroy, among others, an understanding of the construction of identity, and a politics of identity, is directly related to the concepts of location and dislocation. As he states, "It would appear that there are large questions raised about the direction and character of black culture and art if we take the powerful effects of even temporary experiences of exile, relocation, and displacement into account" (1993, p. 18). While in this context Gilroy is discussing the influence of freely chosen travel experiences on particular individuals—W. E. B. Du Bois and Richard Wright, for example—his observations regarding the significance of movement are relevant to the experiences of African Americans in general. The question thus becomes not only how does travel affect an individual's ideological outlook and sense of self, but also how does massive migration affect or transform cultural production and reception and how is this further shaped by limitations on movement and agency? In short, how have "successive displacements, migrations, and journeys (forced and otherwise) come to constitute . . . Black cultures' special conditions of existence" (p. 111)?

Arthur Jafa's notion of "primal sites" (1993) is also relevant here, especially as it relates to the ways in which time, especially history, has a complex relationship to space in African American cultural production. In a review of *Menace II Society*, Jafa stresses the importance of understanding the role of primal sites in "black film practices grounded in African-American cultural assumptions." According to Jafa, primal sites are "those group experiences, such as the Middle Passage, that have determined so much of the psychic makeup of the African-American community." Furthermore, it is only through an understanding of such sites that we can begin to comprehend the ways in which African American filmmakers (in this discussion) reconfigure "hegemonic norms into conventions and methodologies better suited to African-American expressivity" (p. 11). In his historically informed understanding of African American aesthetics, Jafa importantly (though perhaps unconsciously) links space and time. In Jafa's explanation, a primal site is defined as a group experience such as the Middle Passage. In this attempt to define what is fundamentally a temporal metaphor, Jafa relies on spatial terms. In effect, what he accomplishes in this link of spatial and temporal boundaries is similar to my understanding of the cinematic chronotope, especially as it pertains to representations of urban space and its relationship to black culture and history.

Keeping in mind the history of migration and how it relates to the film's

Brooklyn location, Strike's fascination with trains is a particularly telling addition, especially if we understand the train as a chronotopic motif. In *Clockers'* narrative, the train forms just this sort of spatio-temporal unity, characteristic of the chronotope, that fuses the history of twentieth-century African American migration, the growth of an identifiable black city space, and the ghettoization of the black city together into one sign. In this context the train symbolizes the contradictions and contestations of African American mobility by signifying a past, a present, and—in the case of the film's conclusion—a possible future that is immeasurably intertwined with the city.

Border Crossing: Spike, Strike, and the Legacy of the Porter

It is no accident that Lee's additions to *Clockers* would include the train because the train chronotope helps link the film's urban present with both its urban and rural pasts. However, the train also raises important questions regarding African American mobility, both in its literal movement from place to place and in the figurative sense as a symbol of African American social mobility. Mobility and entrapment have been themes in African American films from almost their very inception and increasingly became a central thematic concern (in both film and literature) as the nation's black population's association with the city increased, and the city became equated with a dystopian economic and social prison (no more city on the hill). In short, the focus on mobility became more pressing as the urbanscape went from promised land to ghetto.

Clockers is no different in this respect, as it, like the hood films it references, focuses on the sense of entrapment and lack of agency that the project's prison-like spaces engender in its characters. As I have mentioned, most characters are content to remain in the confines of the hood, living (and often dying) in the same limited spaces. In fact, they can't envision any other existence. But some of the characters—Victor and Strike, in particular—look beyond the hood, and desire (Strike belatedly) an escape from their surroundings. Victor and Strike thus provide the link with the second aspect of the film's concern with mobility, that which is concurrently linked to the literal mobility of escape, and to a more figurative social mobility and agency. This expands my understanding of the role of the train chronotope in the film. Not only does the train represent a form of travel—Strike's escape—but it also references social mobility, especially in the links it makes to African American history and the Pullman porter.

In this regard, I would like to return to Paul Gilroy's discussion of the train chronotope and its relationship to the Pullman porter. According to Gilroy, "The porters worked in ways that both continued patterns of exploitation established dur-

ing slavery and anticipated the novel forms of debasement and humiliation associated with contemporary service work" (1993, p. 133). In other words, the seeming social mobility of the porter's position rested upon a limited foundation. Paradoxically, the porter's movement illustrates the curiously constructed and conscripted terms of progress as experienced by African Americans—and, by extension, black diasporic peoples—in what Gilroy defines as early modernism. For in this moment of massive industrialization (of which the train and film are by-products), and its attendant opening of new frontiers, some boundaries—however much they gave the illusion of shifting—may ultimately have remained the same. For Gilroy, the history of the train presents a significant mediation of the contradictions and limitations of African American mobility, specifically as it relates to the experiences of the Pullman porter and the Jim Crow car. Gilroy identifies the porter as "an important symbol of the new opportunities and the new constraints that fell upon Blacks in the 19th century" (p. 133). In a similar way, the city symbolized new opportunities and constraints, or as Charles Scruggs has outlined, "the city as a symbol of community, of home" and "the city of brute fact in which blacks in the 20th century have had to live" (1993, p. 4). Porters "enjoyed" increased mobility—both physical and economic—but this was always mediated by their positions as servants. If not porters, then African American passengers were segregated to the Jim Crow cars.

An important facet of the porter's existence was that his job equipped him with the often problematic ability to move between worlds—to cross borders. While serving the train's white passengers, the porter also possessed a "freedom" that allowed him to move into (though never to occupy) cars not allowed other African American passengers. In this position, porters mediated the tension between two segregated poles. Strike's position in the narrative, because it is so closely aligned with trains and the concurrent references to migration and mobility, is similar to that of the porter, but this similarity is not unproblematic. At the beginning of the film, there is little to differentiate Strike from his clocker counterparts. The murder of a local dealer linked with his boss, Rodney Little, and Victor's subsequent confession mark Strike for the unwanted attention of the homicide detectives. As Rocco and his partner increasingly interact with and harass Strike, his safety within his community and with Rodney drastically decreases because he is increasingly forced out of this world. The detectives, Rocco in particular, purposely pursue Strike, and their most effective weapon is to "out" him by talking to him in full view of the community. In effect, Strike is forced to become an unwilling and literal border-crosser, rather than just an imaginary one with his trains. But the more he is insinuated into the detectives' world, the more his life is endangered. Ultimately, Strike's movement between the two worlds becomes the threat—he is imagined to have crossed a line—that forces Rodney to order his execution. The end result of this maneuvering is that

Strike is compelled to leave town and is rejected by his family, the community, the police, and Rodney.

Strike's experiences are indicative of the danger inherent in African American border-crossing, a danger, however, that is more fully exemplified in Victor's experiences. In a discussion focusing on Chester Himes's *A Rage in Harlem*, Manthia Diawara (1993) identifies the train's ability both to offer mobility and to contradict that which it symbolizes. As he notes,

> The train's power . . . coincides with the devaluation of Black life. The train is also powerful because of its mobility; nothing hinders its traversing of Harlem, and its movements into the white world which connotes power, economic prosperity, and freedom. Mobility empowers the train . . . and the lack of mobility constitutes a check on the freedom of Black people. (1993, p. 530)

Nowhere are the pressures of these contradictions more apparent than in Victor's struggles to break free.

Everyone, especially Strike, is surprised when Victor confesses to Darryl's murder. In the course of his investigation, Rocco is convinced that Strike committed the murder, not Victor, because, in Rocco's words, "Victor's a good kid, not the murdering type." Victor is presented sympathetically throughout the narrative: He is a family man who is supporting a wife, two kids, and his mother from the income of two jobs. In addition, he is trying to save enough money to move his family outside the projects by purchasing a co-op and becoming a property owner. By all accounts, Rocco is correct to look to Strike for the murder, since Strike is the homeboy, the clocker, the criminal with a record.

Cracks start appearing in Victor's near-perfect facade, cracks that are directly linked to his ambitions. In the course of Rocco's investigation, he hears nothing but praise for Victor. But Rocco also learns of a couple of incidents in which Victor had disputes with different young men from the neighborhood, all of whom flash large piles of cash at Victor and verbally demean him. By the film's conclusion, we learn that Victor was responsible for Darryl's death, and that the motive is what Diawara, among others, has referred to as "Black rage . . . a set of violent and uncontrollable relations in Black communities induced by a sense of frustration, confinement, and White racism" (1993, p. 528). In Mrs. Dunham's flashback version of events, we see Victor succumb momentarily to his rage, which is then directed at Darryl, a representative of every frustration preventing Victor's dreams from coming to fruition, of every situation stripping him of his agency. While Darryl is the target, the cause of his death is related more to Victor's realization that his dreams for mobility are undervalued, even in his own community (or at least in the youth that control it). Strike, on the other hand, is a porter figure because he shifts between two worlds; however, unlike the porter, Strike is eventually forced to choose a new world, since

he no longer fits into either. Thus, Diawara's and Gilroy's identification of the contradictions inherent in the role of the porter indicates the cultural context from which the trains in *Clockers* emerge and identifies the train as an important primal site of African American movement.

The film concludes with golden shots of Strike riding on a train, literally heading into the sunset. These shots are intercut with images of Scientific (Sticky Fingaz), one of Strike's clockers, lying dead in a pool of his own blood, as Tyrone plays with Strike's trains (now located in his apartment) while passing on their history—Strike's legacy—to his mother. It would be easy to read this ending as overly optimistic, "rapturous," or moral. Or one could conclude that the film lapses into a nostalgia or a pessimism "which views the city as bad" (Diawara, 1993, p. 535), but to do so would be to miss the point. To paraphrase Gilroy again, there are important questions to be raised about black culture if the effects of experiences of even temporary movement and displacement are taken into account. While Strike's train ride might lead out of the city, it signifies the themes of mobility and escape at the core of many contemporary African American cinematic, especially hood, narratives. To leave the city is perhaps in the final analysis not an act of nostalgia or a form of anti-urbanism, for there is neither the suggestion that Strike is returning to his rural roots nor that he is fleeing from urban life in general. It might be that in this ending Lee is illustrating Gilroy's explication of "the association of self-exploration with the exploration of new territories," at least for Strike (1993, p. 133). In relocating his version of events to Brooklyn and by utilizing the train in a metonymical manner, Lee constructs a version of the contemporary African American city that concurrently acknowledges its history of migrations while avoiding the nihilism of many contemporary hood films set in similar locations. In the process he expands the boundaries of current African American cinema and provides at least one of his protagonists with agency, no small feat.

Notes

1. I am using the term African American city to refer to those specific areas of cities that have been historically the centers of African American residency and culture—for instance, New York City's Harlem and certain areas of Brooklyn (and Manhattan's San Juan Hill and Little Africa before them), Los Angeles' Central Avenue district and Watts, and Chicago's South Side. At issue here is the way in which the phrase demarcates more than just a specific and locatable geographic area; it also signifies black cultural ownership (often only symbolic) and occupancy of certain urbanscapes.

2. *Boyz* offers perhaps the nineties' most sympathetic rendering of an inner-city African American youth. But Tre does not belong here because he neither deals nor uses drugs, nor

is he involved with gangs. In fact, as a college-bound overachiever, Tre is the epitome of the American Dream.

3. As Lee states, "I really wasn't interested in telling a cop's story. I was much more passionate about telling the story of this young African-American kid who comes from a strong family, who's gone off the straight and narrow and has turned to a life of drugs" (Bernstein, 1997, p. 202).

4. On this phenomenon, see Boyd (1997), Dyson (1993), and Kennedy (1994). In Kennedy's piece, Tarantino observes, "Someone said to me at Sundance when *Reservoir Dogs* was there, 'You know what you've done, you've given white boys the kind of movies Black kids get. You know like *Juice*, and . . . *Menace II Society*, looking cool, being bad, with a fuck you attitude'" (p. 32).

5. In an interesting twist, Lee changes many of the real products and references to fictional spin-offs of African American popular culture. The result is not only parodic, but also is often critical of those aspects of pop culture that are closely aligned with gangsta life. For example, a television commercial advertising malt liquor appropriates and burlesques the misogynist and hypermasculine content of many gangsta rap music videos. Since the ad appears in a cutaway from a scene in which Strike and Victor unexpectedly meet in a bar, the combined technique of video playback and hip-hop soundtrack contributes to the ad's grotesque images and cannot help but be read as an indictment of its content. Yet while the above description makes the scene seem didactic, the images remain on screen momentarily, and no other commentary is supplied. A more didactic example of Lee's critiques of thug life comes in a billboard advertising loose tobacco. The billboard appears twice. On the first occasion it is set in the background of the frame as Strike heads toward Ahab's (fast food) Restaurant on the way to shoot Darryl. The composition is compelling, with Strike in the foreground and his gun hidden underneath a newspaper (whose headline not coincidentally reads "Crooklyn") and the billboard looming above him in the background. The low-angle shot positions the sign's text, "No More Packing," directly above Strike's head and functions as a kind of Greek chorus, commenting on the action taking place in the foreground. A similar billboard appears at the film's conclusion. As Strike is leaving town, heading into the sunset via Amtrak, the sign, in the distance, momentarily crosses his view. Again, the billboard acts as a sort of chorus; however this time the meaning of the text is far less oblique since the earlier sign set up the relationship between packing and guns. The text is not so much a comment in this instance as it is a direct demand for a change in behavior. In effect, the sign functions almost on a similar plane as the text at the beginning of *Boyz* which details the number of black-on-black homicides, or in Furious's speech regarding the drugs, liquor, and violence killing off black inner-city communities. Whether on its literal level of smoking, or its figurative level as gun-related violence, the billboard demands a stop to deadly behaviors.

6. Almost all the film's action is set in Brooklyn. In fact, the story shifts only once to another location, when Rocco visits the Manhattan boutique that had previously employed Victor as a security guard.

7. Without delving much further into the topic of heterotopias and heterochronies, I would like to suggest the similarities they share with my use of Bakhtin's chronotope. As the chronotope combines spatial and temporal elements into a discrete unit of analysis—a

given object, space, or person—so too does the heterotopia allow for time in its rendering of space ("history unfolding in its inherent spatiality"). While I would hesitate to go as far as identifying the film's rendering of the projects as a chronotope, I do believe in the correlations between the two concepts. The reason that I would not consider the projects to be a chronotope here is because of their relationship to the hood chronotope and to the African American urbanscape in general. They are but one aspect of the urbanscape's spatialized history.

8. It's no accident that discussions of spatiality, especially as related to the heterotopia, often utilize metaphors of vision and, to a lesser extent, self-constitution. We can see this even in Foucault's discussion of the heterotopia, in which he equates the mirror with his understanding of the heterotopia: "The mirror makes this place that I occupy at the moment when I look at myself in the glass at once absolutely real, connected with all the space that surrounds it, and absolutely unreal, since in order to be perceived it has to pass through this virtual point which is over there" (1986, p. 24). Strike's fantasies of movement might fulfill a similar operation. On the one hand, they are real (at least by the end of the film), yet in order to be perceived and finally realized, they have to pass through (as well as be enabled by) his trains.

9. The film's concern with the intersections between the manufactured and the real are introduced in its opening credits, which appear over photographic recreations of the victims of actual drug-related homicides. This, more than Singleton's statistics, graphically points to the dangers of inner-city living.

10. *Clockers* is not the first contemporary African American film to use the railroad. The train is significant in *Posse* as a symbol of both promise and demise and links the film's late nineteenth-century setting with its contemporary context. A more interesting use of trains appears in Charles Burnett's *To Sleep with Anger* (1990), which itself references his earlier *Killer of Sheep* in its characters' journey along the rails. In *Sheep* the train injects a Southern rural past, in the form of trickster Harry Mention, in a Los Angeles' family's modern present. Another related appearance of the train—at least symbolically—is in *Boyz*'s opening vignette, in which Tre, Ricky, Doughboy, and friends walk along the tracks in South Central on the way to look at a dead body. The most obvious reference for this was the earlier *Stand By Me* (Rob Reiner, 1986); however it can be traced back even further to Burnett's *Killer of Sheep*, which contains similar scenes of young boys playing on the tracks. In fact, the shots are so similar (complete with throwing rocks) that I would go so far as to suggest that the scene in *Boyz* is a quotation of the earlier film. Significantly, the possibilities and limitations for young boys living in the inner city are directly linked to the railroad.

References

Bakhtin, M.M. (1981). *The dialogic imagination*. (C. Emerson & M. Holquist, Trans.). (M. Holquist, Ed.). Austin: University of Texas Press.

Bernstein, J. (1997, December). Spike Lee. *Face*, 202.

Boyd, T. (1997). *Am I Black enough for you?: Popular culture from the hood and beyond*. Bloomington: Indiana University Press.

Bradley, D. (1995, Sep. 10). Spike Lee's inferno, the drug underworld. *New York Times*, 29, 32.

Brown, G., & A. Taubin. (1995, Sep.). Clocking in: Two critics rate Spike Lee's ultimate hood movie. *Village Voice 19*, 71, 76.

Chisholm, S. (1994). Back to Brooklyn. In A.W. Sexton & A.L. Powers (Eds.), *The Brooklyn reader* (pp. 42–51). New York: Harmony Books.

Diawara, M. (1993). Noir by noirs: Towards a new realism in Black cinema. *African American Review 27*, 525–37.

Dickerson, E. (Director/Writer), & G. Brown (Writer). (1992). *Juice* [Motion Picture]. Island World.

Dyson, E.M. (1993). *Reflecting black: African-American cultural criticism.* Minneapolis: University of Minnesota Press.

Foucault, M. (1986). Of other spaces. (J. Miskowiec, Trans.). *Diacritics 16*(1), 22–27.

Gilroy, P. (1993). *The Black Atlantic: Modernity and double consciousness.* Cambridge, MA: Harvard University Press.

Jafa, A. (1993, June). Like Rashomon but different: The new Black cinema. *Artforum*, 10–11.

Kennedy, L. (1994, Oct.). Natural born filmmaker: Quentin Tarantino versus the film geeks. *Village Voice 25*, 32.

Kirby, L. (1997). *Parallel tracks: The railroad and silent cinema.* Durham: Duke University Press.

Lynch, K. (1960). *The image of the city.* Cambridge, MA: MIT Press.

McCullough, D. (1983). *Brooklyn—and how it got that way.* New York: Dial.

Morson, G.S., & C. Emerson. (1990). *Mikhail Bakhtin: Creation of a prosaics.* Stanford: Stanford University Press.

Price, R. (1992). *Clockers.* Boston: Houghton Mifflin.

Quimby, E. (1979). Bedford-Stuyvesant. In R.S. Miller (Ed.), *Brooklyn USA: The fourth largest city in America* (pp. 229–238). New York: Brooklyn College Press.

Schaefer, S. (1995, Aug. 25). Spike makes *Clockers* timely. *New York Post*, 47.

Scruggs, C. (1993). *Sweet home: Invisible cities in the Afro-American novel.* Baltimore, MD: Johns Hopkins University Press.

Soja, E.W. (1989). *Postmodern geographies: The reassertion of space in critical social theory.* New York: Verso.

Passing FOR Human

Bamboozled and Digital Humanism

KARA KEELING

According to the influential theorist of new media, Lev Manovich, the rise of digitization has led film to experience an "identity crisis." Manovich frames this crisis in terms of the ways that the arrival of the digital age undermines cinema's identity as an indexical media technology, throwing into question the very "terms and categories used to theorize cinema's past" (Manovich, 2002, p. 294). His reference to cinema as an "indexical media technology" is to cinema's claims to be a technology of "reproduction" whose images directly reference images existing in what he refers to as "prefilmic reality." According to Manovich, with the incursion of the digital into film, cinema becomes "a subgenre of painting," akin to animation. In this chapter, I argue that what has been called "cinema's identity crisis" also might be understood simply to be part of a more general historical convergence of the philosophical trajectory of "the human" with conceptualizations of "the Black."

In this context, the critique of the history of racist imagery on film and television set forth in Spike Lee's 2000 film *Bamboozled* proves instructive. *Bamboozled* has been written about and discussed primarily in the context of a debate about blackface and minstrelsy. Rather than contribute to that lively debate, I explore here what *Bamboozled* might offer to our thinking about digitization and film, representation and identity. I find it significant that a movie shot largely on digital video and later released on film is a vehicle for one of the most far-reaching critiques of

the racist imagery that has been a salient characteristic of American film and television throughout the twentieth century. I mention that large segments of *Bamboozled* were shot on digital video and then translated to film for theatrical release in order to call attention to the way that the technology involved in the film's production, distribution, and exhibition functioned not only as a means to produce moving images, but also as a way of translating between two distinct regimes of the image, the well-worn filmic and the emergent digital. A consideration of *Bamboozled* offers an opportunity to explore some of the interplay and differences between these regimes of the image, especially insofar as the logics of identification are assumed to operate differently in each regime as a result of the claims each makes on what Manovich (2002) terms "prefilmic reality." The filmic regime of the image claims to be an index of that reality, thereby encouraging identification between the image and its presumed referent, while the digital complicates that schema of identification by calling into question the very notion of a "prefilmic reality" to which the digital image might lay claim.

At the end of his influential book, *The Language of New Media*, Manovich states,

> to use a metaphor from computer culture, new media transforms all culture and cultural theory into an "open source." This opening up of cultural techniques, conventions, forms, and concepts is ultimately the most promising cultural effect of computerization—an opportunity to see the world and the human being anew, in ways that were not available to "a man with a movie camera." (2002, p. 333)

This opportunity also is an invitation to consider what it might mean to rethink the concept of "the human" from within a cultural terrain that can now be characterized in terms previously thought to be particular to expressions of blackness.

The (European) Human and His (African) Other

Contemporary cultural studies discourses of "the human" usually invoke two related, but discrete, constructions of it at the same time. They invoke "the human" that is a product of Western philosophy—one of the legacies of the Enlightenment—as well as a polyvalent, expansive, and still malleable notion of "the human" that informs discourses on human rights insofar as those discourses take as their primary referent the 1948 Universal Declaration of Human Rights (UDHR). The UDHR can be understood as part of an ongoing construction of a political ideal of "the human" that has not yet been fully realized or articulated. Certainly, the UDHR and its political deployments have been influenced by a number of sources and, largely because that document's notion of "the human" is itself heavily indebted to the Enlightenment's exclusionary construction of "the human," there remains consid-

erable debate about the extent to which the UDHR is relevant or useful to the interests of those working to end the oppression and exploitation of non-Westerners by the West and/or of developing countries by overdeveloped countries or of the global South by the global North.[1]

Clearly, the UDHR was influenced by the legacy of Enlightenment and post-Enlightenment European thinkers. Yet, the strains of thought and the political and economic exigencies informing the creation of the UDHR are complex and various, and there continue to be valuable negotiations around "the human" that that document constructs. I will refer to the UDHR's construction of "the human" and the struggles over it as the political ideal of "the human." As a result of the ongoing struggles over it, "the human" of the UDHR cannot be reduced to the history of European philosophical constructions of "the human." Yet, the project of constructing a political ideal of "the human" might be held open to the influence of recent critiques of "the human"—critiques that were crystallized during the Enlightenment and the French Revolution, challenged and furthered by Hegel and Kant, and inherited by those of us engaged with continental philosophy and the humanities today.

We can understand European Enlightenment and post-Enlightenment constructions of "the human" to be that notion of "the human" that most closely informs cultural claims to "the human," including cultural deployments of humanism.[2] My argument regarding this "human" will be that it ought to be exploded from the inside (or, more accurately, that it *has* been exploded from the inside so we might as well develop a critical repertoire to deal with it). In this way, what resides within it (as its Other) might be unfettered and transvalued.

Theorists and critics of black culture have grappled with both Kant and Hegel's formulations and uses of "the Negro" in order to articulate and negotiate questions concerning the ontological status of "the Negro" and, hence, the specificities of his culture. Engaging primarily with Hegel's *Lectures on the Philosophy of History* and on his *Phenomenology of Spirit*, many of these theorists have presented "the Negro" as a European construct formulated as the Other term in the progressive movement of consciousness toward Reason. These readings of Hegel point out that Hegel's "Negro" occupies the space (Africa) and time of that which is not human so that "the human" and his culture might cohere as such in contradistinction to "the Negro."[3]

Though "the Black" and "Black culture" are European concepts that have been necessary to the Europeans' attempts to understand themselves and their cultures in collective terms, they nonetheless have been the site of innovations and struggles by black people, the very people those concepts have come to contain. Indeed, one of the general arguments that I am making here is that these innovations and struggles within the terrain of black culture are instructive today for theorists of cul-

ture in general and of digital culture in particular because the distinctions between black culture and European culture can no longer be assumed to cohere (if, indeed, they ever did). The aim of this essay is to suggest that a critical theoretical engagement with the dynamics of black people's ongoing struggle with(in) film and television's "Black image" can provide theorists and other producers of digital culture with a context for understanding those aspects of the processes of identity and identification that today are being felt by broader segments of the population. Today, the temporalities of culture in general have begun to conform to the temporalities previously posited as particular to black culture, and the extant political potentials of "the human" have started to parallel those available through an examination of the historical relationship between the logics of commodification and "the Black." The saturation of culture by the logics of Capital, the temporal rearrangements that accompany that process, and the philosophical implications of deconstruction, in my view, present us with a historical constellation in which black cultural insights and innovations are especially important to a general exploration of the possibilities for a cultural politics that might offer support to innovative and egalitarian alternatives to existing hegemonic relationships and the organizations of life those relationships currently secure.

I appreciate the work of those theorists who have undertaken the task of rethinking the relationship between black culture and European culture in terms that acknowledge their initial formulation as opposites but resist repositing them as dichotomies, opting instead to illustrate the extent to which each has contained and relied upon the other for its structuring logics. In this, I take James A. Snead's 1981 essay "On Repetition in Black Culture" to be exemplary. There, Snead argues that "Black culture is a concept first created by Europeans and defined in opposition to 'European culture'" (Snead, 2003, p. 15). Remarkably, however, Snead's analysis of this relationship hinges upon the temporality that Hegel attributes to each of those cultures. Referring to Hegel's description of African culture in his *Lectures on the Philosophy of History*, Snead writes,

> Hegel's definition of Black culture is simply negative: Ever-developing European culture is the prototype for the fulfillment of culture in the future; Black culture is the antitype, ever on the threshold. Black culture, caught in "historylessness," is nonetheless shielded from attack or assimilation precisely by its aboriginal intangibility (though particular Blacks themselves may not be so protected). According to Hegel, the African, radical in his effect upon the European, is a "strange form of self-consciousness": unfixed in orientation towards transcendent goals and terrifyingly close to the cycles and rhythms of nature. The African, first, overturns all European categories of logic. Secondly, he has no sense of history or progress, but instead allows "accidents and surprises" to take hold of his fate. He is also not aware of being at a lower stage of development and perhaps even has no idea what development is. Finally, he is "immediate"

and intimately tied to nature with all of its cyclical, non-progressive data. Having no self-consciousness, he is "immediate"—i.e., always there—in any given moment. Here we can see that, being there, the African is also always already there, or perhaps always there before, whereas the European is headed there or, better, not yet there. (2003, p. 16)

Snead's striking reworking of Hegel's construction of "the African" and "African culture" as the antithesis of "the human" and "European culture" provides us with an understanding of the temporality of the African as that which is always there before the European (for which Enlightenment thinkers constructed "the human" as a proxy) gets there. Remarkably, Snead embraces Hegel's conceptualization of the African and African culture, claiming that "Hegel was almost entirely correct in his reading of Black culture, but what he could not have guessed was that in his very criticism of it he had almost perfectly described the 'there' to which European culture was 'headed'" (2003, p. 16).

Snead's argument, then, embraces Hegel's formulation of black culture in order to fold it back into itself, or to invaginate it so that the African might be understood as that from which the movement of the European (the human) derives and black culture might be understood as the crucible for a European progressive culture that ultimately arrives at that which was already there before, black culture. The human unfolds in time while the black is internal to time—the black haunts the human's past, present, and future. Snead's reading opens onto an understanding of the black as a radically historical construct, rather than one that is static and ahistorical. The "historylessness" Hegel attributes to black culture because of its proximity to the cycles and rhythms of nature is precisely a recognition that the temporality of black culture upsets the linear, chronological temporality European culture claims. Snead's formulation of "the African" as the human's "Other" here opens onto an understanding of black subjectivity as nonchronological time and of Black culture as that time's presentation.

According to the terms Snead provides, we can understand Hegel's African as "a strange form of self-consciousness" that is "immediate" and tied to the cycles and rhythms of nature, existing in time rather than progressively moving through it. Another way to describe this subjectivity might be to claim that black subjectivity is nonchronological time, a description of black subjectivity which is consistent with the formulation of a contemporary subjectivity advanced by post-structuralist European thinkers, most prominently by Gilles Deleuze who asserted in his work on cinema that "the only subjectivity is time, non-chronological time grasped in its foundation, and it is we who are internal to time, not the other way round" (Deleuze, 1989, p. 82). Snead's reading of Hegel helps to illuminate that Black subjectivity (a historically specific subjectivity constructed as "the human's" negative condition of possibility that I have reformulated here as nonchronological time) is there before

European subjectivity gets there. European subjectivity arrives at black subjectivity under the pressure of post-structuralism and, at least in Deleuze's formulation, cinema. In other words, with the advent of cinema and its regimes of the image, European subjectivity, which had been moving progressively forward through linear time, arrives at an understanding of itself as non-chronological time.

Clearly "non-chronological time" is not a commonly advanced description of subjectivity. It is, however, a formulation of subjectivity that recognizes the coexistence of "temporalities that are always simultaneously branching out toward several different futures" (Mbembe, 2002, p. 258).[4] For this reason, it is a formulation of subjectivity open to the creative innovations of the unforeseeable and the unpredictable. Such a subjectivity cannot be called "human," if we understand "the human" to mark a linearly progressive rational movement toward self-consciousness. Yet, it might be understood as that which "the human" has become, that to which it was heading—the Black.

Bamboozle-ing Cinema: Digitization and Cinema's "Identity Crisis"

For me, the feeling of working with *Bamboozled* is akin to what I imagine it might be like to wade through a pool of shit that keeps getting deeper with every advance into it. *Bamboozled* presents itself as a satirical investigation of the abiding allure of racist imagery in American popular culture, but the film's narrative system ultimately is unable to control what its images unleash. Quoting directly from both Elia Kazan's 1957 film *A Face in the Crowd* and Sidney Lumet's 1976 film *Network*, *Bamboozled* revels playfully in intertextuality, making visual and narrative references to a large body of images and other phenomena from American popular culture. Incessantly referring outside of itself, it works most profoundly and effectively on the levels of excess and affect (which is why I think that wading through a pool of shit is an apt metaphor for what it is like to work with and against this film—to work with *Bamboozled* is to engage with the slippery, messy, and, often, repulsive racialized detritus of the American popular culture industry).

One of the film's achievements is to have made perceptible, among the conditions of possibility for the logic of identity and identification enacted by and secured via film, a construction of blackness as a terrain of hypercommodified visibility. By so doing, *Bamboozled* helps us to see that this terrain of hypercommodified visibility, previously thought to be the province of blackness, has expanded under the pressures of the regime of the digital image to the point of its becoming the "open source" upon which the new media draws. Here again, we can say about cinema's presumed identity crisis that blackness was always there already.

Bamboozled recycles offensive imagery in ways that collapse the historical distance between the images in widespread circulation today and those images from the past that we claim to abhor. In so doing, it creates an uncomfortable viewing position for its spectators, not unlike the one Frantz Fanon described as a black spectator of Hollywood films in the 1940s, an account that has been embraced by contemporary film theorists as a paradigm through which to understand the processes of black identification and cinema. Fanon's experience of the cinema is one in which his heart makes his head swim. It is an experience of cinema that can be characterized as operating according to a structure of anxiety, anticipation, and uncertainty wherein the projected image of a "Negro groom" functions as an index of what Manovich refers to as a prefilmic reality that is radically incommensurate with Fanon's own sense and understanding of that reality. Yet, because of film's drive to legitimate itself as an indexical medium (a claim that I seek here to complicate) coupled with the way that colonialist discourses privileged vision as a site of access to knowledge about sociocultural hierarchies and one's place within them, the projected image of "the Black" serves as a proxy for all blacks, finessing and reinforcing the specular logic of identification on which colonial and neocolonial power relies and carrying a disproportionate burden of representation.[5]

Challenges to the cinema's insistence upon the integrity of its images as indices of prefilmic reality have been fundamental to the long history of critiques of cinema's racist imagery. Through its exaggerated presentation of racialized images and attitudes (a crucial component of what it presents as its satire), *Bamboozled* undermines film and television's claim to be indexical media technologies and reveals what many black spectators of mainstream cinema have insisted all along: the relationship between the projected black image and "prefilmic Blackness" problematizes cinema's claims to function as an index of a prefilmic reality. Where images of blacks are concerned, cinema's indexical identity has always been in crisis or, at least, it has always been interrogated and undermined. We might say that the case of the black image in the history of mainstream cinema contains the seeds of the crisis in cinema's identity as an indexical medium. The black image in mainstream film has operated according to the very characteristics that Manovich now attributes to digital cinema, those of animation.

Bamboozled brings this point to the forefront through its explicit use of animation. While Manray, Womack, and Sloan are watching the premiere of their television variety show, *Mantan: The New Millennium Minstrel Show*, they are surprised and disturbed by the animation of Manray and Womack's characters in the show's title sequence. Manray asks why they made his nose so big and Sloan objects, saying, "this is not right." The three characters' comments about the television show's digitally animated opening parallel their reactions in an earlier scene upon seeing film images of Mantan Moreland. Noting his exaggerated, seemingly physically

impossible gestures and expressions, Womack objects, "that's not funny" and Manray asks, "how did he get his eyes to do that?" These two scenes draw a distinct parallel between the racist caricatures featured in the animation that opens the fictional television variety show in the year 2000 and the actual black and white film images of a black actor in the 1940s (the era referenced by Fanon in his descriptions of his experiences as a film spectator). By so doing, they reveal that the black film image of the 1940s already operated as an animation, and they contextualize the contemporary production of the black image, even a computer generated image, within a broader historical narrative of that image's production in American film and television, calling into question progressivist claims to that history.

The use in *Bamboozled* of what are now referred to as "Black collectibles," racist caricatures of black people whose currency has been reinvigorated via value-laden claims to historical knowledge, also calls into question a linear narrative of historical progress vis-à-vis the sociocultural and economic status of blackness. These collectibles can be understood as standing in for the type of cultural forms and possibilities that remain rooted in a chronological, progressive temporality, the temporality through which Hegel's "human" moves.

The "Black collectibles" are associated most closely with Pierre Delacroix, the character responsible for creating *Mantan: The New Millennium Minstrel Show*. The first black collectible Pierre receives is a "Jolly Nigger Bank," a gift Sloan chose for him because it reminds Sloane of "a time in our history when we were considered inferior, subhuman, and we should never forget." The implication of Sloan's statement is that blacks have reached a time in history when they are no longer considered subhuman. Hers is a humanist claim to a progressive history of U.S. race relations, a claim whose legitimacy is proven to Sloan by her present ability to purchase and collect the racist paraphernalia of the past as reminders of the configuration of past racisms. Her exhortation to Pierre—that we "never forget" that we were considered subhuman—is ironic within the broader context of the film's narrative. Pierre creates *The New Millennium Minstrel Show* out of a sense that it will be so racist that it will make an exaggerated point about the television industry's present traffic in more subtle stereotypes, but instead it taps into those very sentiments about and conceptualizations of blackness that Sloan thought lay in the past behind them. Eventually, in the film, the black collectibles crowd Pierre Delacroix's office to such an exaggerated, excessive extent that they become overdetermined materializations of the limited range of possibilities for a black subjectivity that remains rooted in a linear, progressive humanist notion of black history.

Part of the detritus of antebellum American culture, black collectibles feature more and more prominently in *Bamboozled*'s *mise-en-scène* (especially in Pierre's office) as the popularity of the minstrel show he created grows. The black collectibles, like the history of black images in American culture more broadly, are part

of what authorizes our understanding of what appears on screen. We might think of them as manifestations of the past conceptions of the world that, instead of having been left behind, linger in ways that continue to inform our present recognition of what appears onscreen. Usually existing only in off-screen space as part of that past which is excluded from but crucial to what appears on screen, these collectibles find greater and greater entry into *Bamboozled*'s *mise-en-scène*, crowding in on Pierre until he becomes virtually indistinguishable from them. By bringing what has persisted in the off-screen space of mainstream cinema into the scene, *Bamboozled* makes those collectibles, and the linear, progressivist temporality invoked when black people collect them, available for redefinition or annihilation. In the scene, they, like animation, minstrelsy, and blackface, are part of the context wherein cinema's present images achieve their legibility.

In the most remarkable scene featuring the black collectibles in Pierre's office, the Jolly Nigger Bank begins to voraciously consume coins, completely of its own volition, much to Pierre's amazement. Animated, the Jolly Nigger Bank (which is, according to Sloan, "not a repro," but *circa* the turn of the century) reminds us that the production of blackness has been part and parcel of processes of commodification and that black subjectivity cannot be thought outside of those processes. The animated Jolly Nigger Bank offers a possible point of entry into a discussion of the convergence of nonchronological time with processes of commodification, a discussion that might further enrich the ongoing construction of the political ideal of the human, especially if it were to draw on the insights that a serious critical engagement with black subjectivity and black culture makes available. *Bamboozled* presents black culture as a terrain on which relationships between black subjectivity and money are worked through, reworked, negotiated, resisted, and reimagined. *Bamboozled* frames a milieu in which black culture enters the circuits of mass mediation, a frame that allows it to ask crucial questions regarding "how to renegotiate" social bonds "corrupted by commercial relationships" (Mbembe, 2002, p. 250). Interrogations into the possibilities for negotiating viable and life-sustaining social bonds in a milieu permeated by the terms of commerce are (or ought to be) fundamental to contemporary sociopolitical and/or cultural claims to "the human."

Rendering Pierre Delacroix virtually indistinguishable from the history of racist imagery congealed in the collectibles, *Bamboozled* asks an urgent question: is there a subjectivity capable of exploding the prison house of racism's historical legacy? To that question, we might add further, how might such a subjectivity still be conceptualized as "human?"

The answers *Bamboozled* provides ultimately are unsatisfactory. By positing a notion of a pre- or an un-commodified black culture, *Bamboozled* subverts the innovations accorded it by the digital regime of the image the film embraces and contextualizes, innovations that, upon further investigation and with further criti-

cal deployments, might provide a framework within which to reframe (or, possibly unframe) "the human." Moreover, *Bamboozled*'s narrative stalls at a humanist critique of the history of film and television's racist imagery and the damage it does to black people, suggesting that black people also ought to be able to lay claim to the power of cinema's presumed ability to index "prefilmic reality" and to the structures of subjectivity and identification that power secures and supports in order to correct its misrepresentations of them. In other words, *Bamboozled* ultimately attempts to recuperate and deploy a cultural humanist claim to cinematic representation, a claim it has undermined through its remarkable use of black collectibles and via the insights it makes available regarding the black image as animation. The humanist claims of *Bamboozled*'s narrative ring hollow, but what the film makes available to future thinking via its stylistic system and the excesses of its narrative—compelling accounts of the failures of linear progressive temporality and of the convergence of black subjectivity and processes of commodification—raises the possibility that even the European has been simply passing for "the human" all along and that black subjectivity and black culture, those very concepts created to serve as "the human's" Other, provide the most fertile soil to till for ways to understand what it means to be "human" in the digital age.

One of the seeds recently planted in black culture, *Bamboozled* opens up a consideration of the fact that the terrain of the moving digital image is coincident with that over and through which Capital flows. It dramatizes the convergence of blackness and money in ways that call into question any conceptualization of subjectivity and culture that fails to consider how the mechanisms of commodification and flows of money inform the very processes whereby we define, locate, and understand ourselves via identification. While new media might have, as Manovich has argued, a transformative effect on culture and cultural theory, opening up cultural techniques, conventions, forms, and concepts for redefinition, *Bamboozled* reminds us, by putting black collectibles into the scene, that culture as commodity carries its past into its present in ways that insist that we reckon with the logics of blackness, logics which best inform our efforts to think through the set of possibilities available in the digital regime of the moving image and the forms of subjectivity and temporality that regime makes available to thought.

Notes

Thanks to John L. Jackson and an anonymous reader for helpful comments, responses, and suggestions on earlier drafts of this chapter. Pieces of this chapter have been presented to audiences at the University of North Carolina at Chapel Hill's Communication Studies Department Colloquium and at the Society for Cinema and Media Studies' annual conven-

tion. Comments from both audiences informed the present version of this chapter. Michelle Dent also provided editorial comments that helped me to clarify certain arguments presented here. Chandra Ford's careful reading of this chapter in its early stages strengthened it considerably. All remaining errors and oversights can be attributed only to me.

1. The slippages in my language here reflect the complexity of the debates around the UDHR, the struggle around its conceptualization of "human rights," and the perceived flexibility of "the human" it constructs.

2. The divisions between the philosophical, political, cultural, and historical articulations of "the human" are artificial and tenuous, but I rely upon these schematizations in my very brief discussion here in order to point toward the need for a more sustained theoretical interrogation of "the human" that might provocatively enrich and challenge ongoing struggles over the range of possible organizations of social and economic life currently authorized by recourse to that category. I rely on these divisions, in other words, to hold open a space of possibility within the human so that my critique of "the human" does not rule out innovative activism and struggles around "human rights." My aim is rather to contribute to imaginings about the range of possibilities for framing and enacting the human and, hence, the rights to which it might claim.

3. See, for instance, Krell (2000). For a discussion of the relationship between "the Negro" and "the human" that takes as its point of reference the figure of "the Negro" in the work of Immanuel Kant, see Judy (1991).

4. Mbembe begins his essay with an epigram by Deleuze in his *Cinema 2* (also cited in the present chapter) asserting that "the only subjectivity is time." One of Mbembe's aims in that essay is to "reinterpret subjectivity as time" in order to intervene in a variety of discourses about and conceptualizations of Africa and the African that, according to Mbembe, foreclose the possibilities for "rethinking those temporalities that are always simultaneously branching out toward several different futures." Mbembe's rethinking of subjectivity involves a convincing critique of dominant ways of conceptualizing Africa and African identity and subjectivity, a critique offered in an effort to advance an alternate organization of them.

5. For an extensive discussion of what Fanon offers to contemporary theorists of film and visual culture, see Keeling (2003).

References

Deleuze, G. (1989). *Cinema 2: The Time-Image*. (H. Tomlinson & R. Galeta, Trans.). Minneapolis: University of Minnesota Press.

Judy, R.A.T. (1991). Kant and the Negro. *Surfaces 1*(8). Retrieved March 27, 2008from http://pum12.pum.umontreal.ca/revues/surfaces/vol1/judy.html.

Keeling, K. (2003). In the interval: Frantz Fanon and the problems of visual representation. *Qui Parle 13*(2), 91–117.

Krell, D.F. (2000). The bodies of Black folk: From Kant and Hegel to Du Bois and Baldwin. *Boundary 2, 27*(3), 103–134.

Manovich, L. (2002). *The language of new media*. Cambridge, MA: MIT Press.

Mbembe, A. (2002). African modes of self writing. (S. Rendall, Trans.). *Public Culture 14*(1), 239–273.

Snead, J. (1981). On Repetition in Black Culture. *Black American Literature Forum* 15(4),146–54.

Snead, J. (2003) On Repetition in Black Culture. In Kara Keeling, Colin MacCabe, & Cornel West (Eds.), *Racist Traces and Other Writings: European Pedigrees/African Contagions* (11–33). London: Palgrave Macmillan.

"Say the Right Thing"

Spike Lee, *Bamboozled,* and the Future of Satire in a Postmodern World

PHIL CHIDESTER AND JAMEL SANTA CRUZE BELL

I t is, by all accounts, an unusual way to open a major motion picture. As Pierre Delacroix, the central character in Spike Lee's brilliant if troubled *Bamboozled* (2000), prepares for the morning in his spacious New York City penthouse, a narrative voice that turns out to be Delacroix' own recites a pair of definitions pulled directly from *Webster's Collegiate Dictionary*:

> Satire: 1A) A literary work in which human vice or folly is ridiculed or attacked scornfully; B) The branch of literature that composes such work

> Irony: Derision or caustic wit used to attack or expose folly, vice, or stupidity

Lee may well rank among the most challenging of contemporary American filmmakers, but the motive behind choosing such a scene to introduce his latest cel- luloid epic remains, even for him, a maddeningly vague one. On the one hand, by so clearly and adamantly labeling his work in its opening moments, the director might be saying more about his expectations for his audience than about the film itself. In other words, Lee's definitions may have been presented to ensure that view- ers would not misread *Bamboozled* as a straight comedy or, at the other extreme, as some form of inward-gazing documentary on the entertainment media machine. On the other hand, however, lurks an even more intriguing possibility. By openly defining his work as a satire, Lee may actually be providing his own commentary on the film rather than simply explaining the narrative direction it is about to take.

In sum, Lee's insistence that *Bamboozled* is a satire in the classical sense could serve to construct a foundation for an even more complicated and demanding cinematic work: namely, a satirical take on satire itself.

It is evident that popular audiences and critics alike have had a good deal of trouble understanding the meanings that Lee intended to project and reinforce in his *Bamboozled*. Movie fans' reactions to the work have been often visceral; viewers have embraced what on the surface would seem to be yet another filmic statement by Lee on the struggles endemic to the contemporary African American experience yet have also bristled at many of the film's horribly racist depictions. For their part, critics have contended that the film is at once too complex (Black, 2003) and too obvious (Anderson, 2005), a "sledgehammer satire" (Bernardinelli, 2005) that lacks the refined focus of its forebears in the genre.

But it is this staggering range of responses that raises intriguing questions about the nature and influence of Lee's work as a presumably satirical text. How might a single collection of celluloid images succeed so broadly as a statement on contemporary treatments of race while at the same time failing so dramatically to meet the formal expectations of modern satire? Further, given the fractured quality of the ongoing response to the film, what might a close analysis of *Bamboozled* reveal about the ways in which satire might function—or fail to function—among audiences in a contemporary American society?

We contend that the rather awkward rhetorical space that *Bamboozled* occupies in today's media milieu has much less to do with any actual aesthetic or communicative quality of the work itself than with the decidedly postmodern social sensibility into which Lee's film has been introduced. The precise nature of postmodernism as a distinct mode of being and thought has, of course, been under contention for decades. A number of scholars suggest, for example, that the postmodern condition is linked to a specific historical period (Hassan, 1987; Lovejoy, 1989; Docherty, 1993; Taylor, 2002; Berger, 2003), while others argue that a postmodern attitude or style has emerged as a response to contemporary mores in a number of different epochs (Jencks, 1991; Eagleton, 1996; Kramer, 2002). But if a postmodern approach to being necessarily includes a constant resistance of existing approaches and expectations, as Lyotard (1983) suggests, then the process also involves forging new rules and expectations of its own—a complex and often ill-fitting effort at "working without rules in order to formulate the rules of what *will have been done*" (Lyotard, 1983, p. 46). What is generally agreed upon by those who have examined the postmodern condition is that the end result of this active interrogation of the status quo is a contemporary episteme steeped in irony (Tyler, 1987; Nash, 2001; Kramer, 2002), a mode of thinking and being that at once manages to question the meanings inherent in every representation and to wholly embrace each projected image or idea for the qualities which it presents.

Such widespread and persistent skepticism has, of course, influenced to a profound extent the ways in which message senders communicate to and with the masses, and in particular when those messages carry a persuasive intent. As a classical rhetorical form that is designed to affect change through a blend of wit and criticism (Collins, 1996), satire would seem to be ideally suited to function in a postmodern episteme that itself questions at every turn the taken-for-granted ethics and actions of the status quo power structure. As Bloom and Bloom (1979) note, "Disposed toward didacticism, satire best makes its points by attending to sources and instances of failure in human behavior or institutions. As part of his [sic] intention, the satirist criticizes contemporary shortcomings within a context whose values, ideally, outlast occasions or crises of the moment" (p. 33). Yet much evidence exists to suggest that the opposite is, in fact, true: in sum, that postmodern modes of thought have effectively neutered satire's ability to critique the behaviors of the elite and through this critique to encourage amelioration of an epoch's most enduring social ills.

Jameson (1991), for one, contends that even simple parody is no longer possible in a postmodern age; because representations are so enthusiastically embraced on their own terms, such images simply cannot be forwarded as forms of ridicule and as invitations to change. Likewise, Bignell (2000) observes that, because postmodern works produce the postmodern as they present themselves, such texts cannot comment on the conditions into which they are introduced. In other words, regardless of the specific quality or intended meaning of a given work, its destiny is only to become one more facet of an overall ironic sensibility—a moment of expression shorn of any individual potency by the conditions which it may well have meant to hold up to wider scrutiny. Finally, while Bloom and Bloom (1979) contend that satire is as much an attitude as a specific literary technique, they are also quick to mourn the reduction of a once proud form of persuasion to a mere expression of "bitter drops of invective," to a mode of thought that is entirely incapable of effectively arguing for a more hopeful tomorrow.

By all accounts, then, it would seem that the postmodern ethos has neutralized satire's ability to point out folly and to call for widespread social correction, and in the process has also eliminated from the artist's arsenal a historically important weapon of persuasion. Yet a close reading of Lee's *Bamboozled* suggests an intriguing alternative. Perhaps satire as a powerful rhetorical force has not been rendered powerless in postmodern times; perhaps, instead, the form has merely been forced to take on a different character—to assume a more elaborate, if less direct and blatant, approach to its historical role as a catalyst for social change. *Bamboozled*, we contend, is a mediated document that sits at the confluence of these powerful forces: on the one hand, satire as a thoroughly modernist manipulation of language, and on the other, a postmodern ethos that refuses to acknowledge the superiority

of any given perspective or the value of any attempt at widespread social correction. And as a result of its unique positioning as a filmic text, an assessment of the meanings that emerge from Lee's master work may teach us much about how all forms of communicated messages function in a contemporary world.

Using insights gained through a rhetorical analysis of *Bamboozled's* linguistic content and filmic images, this paper will explore the means by which Lee's work serves to resist postmodern limitations on the satiric form and, in the process, to restore a good deal of the form's potency as a rhetorical expression. Next, we will interrogate the dimensions and characteristics through which postmodern modes of thought have come to limit the satiric form's ability to persuade its intended audiences. Four aspects of postmodern thought in particular would seem to be responsible for curtailing satire's intended persuasive effects: the erasure of any distinction between signified and signifier; an active questioning of any notion of textual authorship; an eschewing of shared group values or experiences based on objective norms; and a disputing of the difference between reality and representation. Finally, we will argue that, by managing to simultaneously resist and work through these limitations, *Bamboozled* ultimately emerges as perhaps the first true postmodern satire—a result that speaks for Lee's power as not only a successful filmmaker but as a skilled contemporary scholar of rhetoric as well.

Bamboozled—The First True Postmodern Satire?

On its surface, Lee's *Bamboozled* would seem to fit in every particular the formal expectations for a classic satirical work. The film openly ridicules the behaviors and ideals of an existing power structure, in this case the executives and writers at a fictional American television network. Further, the film invokes its sharp social criticism through a flood of highly exaggerated images and scenes, depictions that could hardly be misread by audiences as representations of actual happenings. Yet there also exists beneath the seething surface of Lee's cinematic landscape a sense that these representations are not so overstated after all—a quality that is wholly necessary to the film's potential success as a modern-day example of a classical satire.

Lee's work tells the story of Pierre Delacroix, an up-and-coming screenwriter at CNS, a New York City-based television network. Fed up with the kinds of blatantly stereotypical depictions he is expected to generate as the organization's sole African American creative head, Delacroix decides to prove his point by pitching a sitcom idea that even CNS's racist administrators would find too offensive to air. Employing a pair of Black street performers as his central characters, the writer announces his latest "great idea" to his supervisor, Mr. Dunwitty: *Mantan's New Millennium Minstrel Show,* a "variety hour" that borrows directly from the minstrel

tradition of the late nineteenth and early twentieth centuries. True to the form, Delacroix announces that the show's all-black cast will perform in blackface, and it is soon decided that the program should be set in a southern watermelon patch, the better to emphasize the characters' shiftless and lazy natures. But far from serving to highlight the network's insensitive treatment of African Americans as he had intended, Delacroix's proposal is instead warmly embraced by Dunwitty and CNS. It isn't long before a team of all-white writers has transformed the *Minstrel Show's* characters into even more crudely drawn caricatures—and not much longer still before a mixed-race audience has taken to the program in droves, going so far as to don blackface themselves as they enthusiastically cheer the live tapings of the show. In the end, Delacroix and many of his fellow conspirators in *Bamboozled* are left to consider the nature of a contemporary African American identity, the influences of media depictions on that identity and their own complicity in reinforcing the tired stereotypes that continue to plague the Black experience.

That Lee's complex work has been broadly misunderstood as a contemporary form of the classical satire—and, in light of such a misunderstanding, that the film is clearly doing much more than simply following the expected form and plot structure of a classical satire—is evidenced in the critical and popular response to the film. As noted earlier, *Bamboozled* has been panned for both its obviousness and its subtlety; Roger Ebert (2000) suggests that the film is simply too powerful in its persistent presentation of blackface as a racist image to effectively convey its intended message, while another review suggests that the first half of the film may function effectively as a satire, but the second half collapses into mere farce ("Bamboozled," 2005). Such criticism, we contend, says less about the quality of *Bamboozled* as a filmic text than about the critics' own misunderstanding of the exigencies and constraints into which the work was introduced, and about their failure to recognize the ways in which *Bamboozled* at once embraces and transforms aspects of the classical satire in order to preserve some measure of satire's rhetorical power as a form of expression in postmodern times. In addressing and responding to each of the constraints that postmodernism has placed on the satirical form, Lee manages to construct a profound call for social and cultural change while at the same time responding to the narrative challenges imposed by a decidedly postmodern episteme.

The Image as Narrative Tool

If postmodernism's insistence that representations be accepted on their own terms and not as focal points of shared meaning has effectively curtailed satire's ability to communicate its message of change, then Lee's *Bamboozled* overcomes the obstacle by actively embracing postmodernism's fascination with the image as image. At

one level, *Bamboozled* as a holistic expression functions as nothing else but a meta-image of its own, a complex comment on or visual lesson about the nature of images themselves. Lee populates the movie screen at every turn with reminders of the power of seeing: characters gazing at themselves in mirrors or staring into television screens; camera lenses capturing the looks on the painted faces of audience members as they watch *Mantan's New Millennium Minstrel Show* unfold on the live studio stage. Further, many of the frames of Lee's film are shown upon close examination to be constructed of multiple images themselves. Dunwitty's office, for example, is littered with objects of African art and the photographs of celebrated African American athletes; and over time, Delacroix comes to decorate his own workspace with images from America's racist past.

The fact that both characters treat these visual depictions with the same sense of distant admiration—neither can easily identify with the cultures and conditions that produced these images—is hardly important to the persuasive message that Lee constructs and reveals as the film progresses. Inundated with discrete visual images that often seem only haphazardly connected to the work's master narrative, viewers of the film eventually come to understand that they have been effectively drawn into and victimized by the "bamboozle" themselves, and by the very kind of group consensus that has led to the abuses of racism that the work is purportedly attacking. In a telling scene early in the film, the studio audience for the *New Millennium Minstrel Show* pilot reacts with a good deal of discomfort to the program's racist jokes and horribly stereotypical depictions. Yet the occasional act or remark does ring true as the show moves along, and an occasional chuckle rises above the murmuring. Viewers look around at their fellow audience members, seeking approval for their own individual urges to laugh—and as might be expected, by the time the taping has drawn to an end, the entire congregation erupts in approving cheers. Of course, it is only as viewers of the *film* come to realize that they, too, have been drawn into an acceptance of the show in the same way that the work's audience-within-an-audience has been convinced to embrace these racist images, that the true satirical power of Lee's filmic images is fully expressed.

Yet the full satirical effect of *Bamboozled's* wholly postmodern treatment of the image as image extends well beyond the film audience's recognition of its own complicity in *seeing* as a form of racist activity. For Lee, the postmodern necessity of treating images as discrete entities, shorn of any shared meaning, hardly prevents the artist from infusing his or her visuals with true persuasive force. In fact, the filmmaker seems to have discovered that, by piecing together entire collections of images, the artist can suggest a certain narrative visual logic, a history that is founded not in material fact, but in the invitation to read a series of visuals as a related whole. The best single example of this important phenomenon is reserved for *Bamboozled's* final scene. Forced at gunpoint to consider what his *Minstrel Show* has

contributed to, Delacroix watches a ferocious montage of quick scenes that chronicle the history of African American depictions in film and television. Denied any true historical context for these images, the viewer is compelled to read them as a single contemporary depiction, and to consider how those images not made present in the montage—snippets from hip-hop videos, scenes from modern buddy films, etc.—would themselves fit seamlessly within this collage. It is a compelling moment in *Bamboozled,* a moment that speaks quite powerfully of and to Americans' willingness to see these images as precisely that, as nothing more than distant portrayals, and one that reflects Lee's understanding of the postmodern milieu into which he would introduce his film as a satirical form.

Despite postmodernism's refusal to attach any consistent meaning to a given visual, then, Lee has discovered a means of turning postmodernism's fascination with the image as image into a potent satirical tool—a means of encouraging audiences to recognize and consider the meanings that cannot help but accrue to the patterns of images that collect around any given social circumstance or ideal.

Authorship as Self-Reflection

Lee's filmic strategy for dealing with a second significant limitation imposed on the satirical form by the postmodern condition—namely, the episteme's active and persistent questioning of the nature of authorship itself—is effected through a careful balance of self-promotion and self-abasement within the framework of *Bamboozled's* complex narrative. The success of any classic satirical work is largely dependent upon the audience's identification of a distinct author, of the author's perspective on pertinent social norms and issues and of his or her communicative intentions for the work at hand. Lee's singular and highly original voice as a filmmaker, as well as the persistence over time of his filmic attack against matters of racial injustice in contemporary America, are qualities that would suggest that he is one among very few of today's artists who might have a chance at constructing and presenting a successful satirical work in postmodern times. In other words, viewers who are at least somewhat familiar with Lee's oeuvre as a director would certainly be much less likely to "misread" the messages intended by *Bamboozled's* biting and often disturbing depictions than would those audience members who approach the film knowing only, for example, that this seemingly bluntly racist diatribe has been presented by an African American filmmaker. It is Lee's reputation as one of the nation's most potent artistic voices on the issue of racial injustice that prevents audiences from consuming *Bamboozled* as nothing more than a dazzling pastiche of bitter invective and self-hate.

Still, one might reasonably argue that Lee's notoriety as a filmmaker alone is simply not enough to overcome postmodernism's insistence that the true moment

of authorship is in the text's reading and not in its creation. And the director recognizes this constraint on the potential success of his film. Far from relying on the work's opening credits alone to establish his authorship, Lee generously litters the scenes of *Bamboozled* with explicit reminders of his highly personal involvement in the text at hand. Two examples in particular reveal the extent to which Lee recognizes and understands authorial presence as a key to the successful exposition of the classical satire. In an early scene in the film, Delacroix is challenged by his boss, Dunwitty, to name the African American athlete who is depicted in one of the framed photographs on the television executive's wall. That the screenwriter cannot, in fact, correctly identify the player is not nearly so important to the meaning of the scene as is the sense that the moment so clearly evokes yet another scene in which a proprietor and a guest squabble over photographic images—a scene inside Sal's Pizzeria in Lee's 1988 epic, *Do The Right Thing*. And if Lee's willingness to use *Bamboozled* as an opportunity to remind viewers of his own filmmaking lexicon is lost on anyone in this more subtle celluloid moment, the director has no problem making the point more abundantly clear later on in the work. In a particularly telling scene, Delacroix expresses his opposition to CNS's decision to have the *Minstrel Show* characters perform in blackface. No self-respecting producer would make such a request, the screenwriter insists—and to punctuate the point, Lee unexpectedly cuts to a brief shot of Denzel Washington as the title character in Lee's own *Malcolm X*, invoking his familiar diatribe against white America for the "bamboozle" it has foisted upon its black citizens.

That this moment of dazzling intertextual juxtaposition serves, in part, to provide *Bamboozled* with its title is obvious; that the shot also reminds the viewer of Lee's reputation and power as a filmmaker is also evident. But what might be lost in this exchange between author and audience member is the extent to which such a narrative decision also serves to interrogate Lee's own participation in the bamboozle. Is it not true, the scene argues, that *every* depiction that calls for an actor to deny or render as caricature the authentic self is itself a form of blackface? And if Lee's images in a film as seemingly authentic as *Malcolm X* can be called into question in this way, how much more compellingly might one contend that *Bamboozled* itself is highly guilty of perpetuating the very same tired stereotypes that it so clearly intends to lampoon? By the time the viewer has accompanied Lee to the end of his nearly two-hour long march through the most foul and degrading of racial territory, the answer is more than evident. Sloan's gunpoint demand that Delacroix "look to what you contributed to"—namely, a videotaped montage of film and television depictions of African Americans across the twentieth century—becomes as well an invitation to Lee to examine his own filmic contributions to that panorama of images. It is a moment of self-reflexive deconstruction that somehow both fits well within a postmodern approach to the notion of authorship (Chidester,

Campbell, & Bell, 2006) and confounds a postmodern denial of the author through the very power of Lee's personality—a staggeringly complex balance that contributes in a profound way to the potential success of the director's satirical document.

A Range of Normative Values

In much the same way that Lee manages in *Bamboozled* to both embrace and defy postmodernism's tendency to efface the author as the fount of a text's meaning, the director also transforms his epic into a satirical statement that both acknowledges postmodernism's eschewing of any shared social norm and argues quite compellingly for the need for a consensus among a variety of normative positions. That so many critics have joined Kipp (2004) in contending that *Bamboozled* functions through its first half as an effective satire, only to collapse into a confusing, unfocused mess, only confirms the fact that the work is forced at some point to abandon the clearcut formula of the classical satire in favor of some other mode of expressive persuasion—and an analysis of *Bamboozled's* narrative and imagery effectively reinforces that presumption. Serving at its outset as a direct and biting attack against the white power structure's continued misunderstanding and misrepresentation of the black experience in a contemporary America, the film gradually broadens its scope, eventually including a lampoon of African Americans themselves for their own willing participation in the bamboozle. Entering the narrative as a lowly street performer who lives day-to-day at the whim and pleasure of his more affluent New York City neighbors, Manray eventually comes to wield his television fame like an overseer's whip against the flesh of his own backup dancers; at the same time, Sloan's role as the film's conscience simply cannot overcome her disdain for her brother's often admittedly laughable attempts to claim a racial identity of his own.

In the end, viewers are denied in *Bamboozled* an opportunity in the classical satirical sense to openly identify with the work's author by joining in a concerted attack against a single, more powerful target. Instead, Lee would seem to argue that if we as viewers are all victims of a persistent hierarchal structure, we are also at least somewhat responsible for victimizing those beneath us on the social ladder. In an interview with Lyons (2000), the director defines satire simply as a form that "gets everybody"—and in bringing his satirical barbs to bear against a variety of targets, Lee has discovered a way to both tap into the classical satire's rhetorical power and to satisfy postmodernism's insistence on highly individualistic approaches to the notion of any code of ideals and behaviors.

Exaggeration as a Revelation of Character

Finally, the power of Lee's message in *Bamboozled* is effectively enhanced by the

Figure 1 1.1. *Bamboozled* (2000) "Da Bomb" malt liquor. Courtesy of Photofest.

director's treatment of his core narrative personalities not as traditional satirical caricatures, but as sympathetic individuals with whom audience members can readily identify. If a bold exaggeration of event and behavior is, indeed, a hallmark of the classical satire, then Lee's work clearly intends to function, at least in part, as a satirical text. From the bitingly over-the-top advertisements for "Da Bomb" malt liquor and "Timmy Hilnigger" jeans that accompany the television broadcast of *The New Millennium Minstrel Show* to the laughable cultural stereotypes that emerge as Delacroix and Sloan hold auditions for the program's house band, *Bamboozled* seems intent on pointing out the ludicrous nature of the depictions of the black experience that so often parade across our movie screens and television sets. But what does lending one's flesh to such tired, one-dimensional portrayals mean for those who participate themselves in the representations—and further, what does it say about those who have proven so eager to consume these images?

If Lee's satirical net is cast incredibly wide in *Bamboozled*, it is his evident willingness to concede at least some sense of humanity to his targets that is arguably his most potent weapon as a classical satirist in the postmodern tradition. Examples abound in the film of Lee's penchant for presenting a given caricatured stereotype, then lifting the corner of the representational sheet to reveal something more real and substantive beneath. Delacroix's father, the epitome of the crude black stand-

up comic eking out a living on the "chitlin circuit," exposes in a conversation with his son a sense of resignation and self-defeat that speaks volumes about Lee's grasp of the history of the African American as artist; and the director's depiction of Sloan's brother Julius (AKA "Big Blak Afrika") as a man struggling for a strong sense of self in a way balances the crudeness of his portrayal as a prototypical street rapper with no knowledge of history or awareness of social decorum. And in perhaps the single most important unifying thread in the work, Lee effectively portrays the mounting sense of self-loathing the characters feel as they continually reapply their charcoal faces before taking the *Minstrel Show* stage. Any sort of dialogue proves wholly unnecessary to viewers of the film as they watch the performers watch themselves in the backstage mirrors, a thick black paste of burnt cork gradually covering their features and taking their humanity away.

It is this very daring—and remarkably challenging—attempt to portray both the satirical caricature and the humanness beneath that highlights Lee's response to the postmodern alienation of the image from its object of representation, a claim that should have effectively neutered the rhetorical power of the satire. Functioning together with Lee's filmic efforts to negotiate a livable space between social expectations and individual values, as well as his wholly postmodern presentation of the image as a site of meaning and power, this complex treatment of character in *Bamboozled* contributes in a significant way to the film's satirical force as well as its clear sense of humanity.

Satire as a Persuasive Tool in a Postmodern World

The remarkable complexity of Lee's *Bamboozled* is, then, not only a testament to the filmmaker's intelligence and skill, but also a clear reflection of the restraints that postmodern modes of thought have imposed on the satirical form. Four qualities of satire in particular would seem to be contained or even neutered by the postmodern milieu—a result that clearly demands creative attention and careful evaluation if any contemporary work such as Lee's is to succeed in a specifically satirical role. First, effective satire requires the audience's perception of a gap between what is being presented in a text and the meanings that are to be derived from that text (Bohnert, 1995); postmodernism, in contrast, erases any distinction between signifier and signified (Bignell, 2000), thus preventing audiences from gaining any insights from the space that might exist between representations and meanings. Second, the satiric effect relies on audiences' understanding of the author's intent (Connery & Combe, 1995); postmodernism denies the very notion of authorship and the authority of perspective that follows from it (Klinkowitz, 1988). Third, to effectively speak to the need for changes in social attitudes or behaviors, satire must present a set of moral values with which the audience may openly identify (Griffin,

1994)—and postmodernism eschews the idea of any meaningful or necessary norm-based or shared group values or experiences (Norris, 1990). Finally, because classical satire functions largely through moments of exaggeration and understatement, it requires a clear perception of the difference between reality and representation (Highet, 1962)—and postmodernism has long since denied that there is any sort of reality to be represented by the text (Gibson, 1996).

Considering the extent to which these qualities of postmodernism do, in fact, impinge on the effective functioning of satirically minded texts in our contemporary society provides a useful lens through which to understand *Bamboozled* as a work with an evident intention of functioning as a satire. Further, this review of both postmodernism and of satire as a classical literary form also helps us to recognize which moments in *Bamboozled* are most clearly functioning as a rhetorical response to the exigencies imposed by the postmodern condition on any mediated attempt at encouraging widespread social persuasion and change. This framework reveals the power and promise of Lee's film as perhaps the strongest single example of the postmodern satire at work.

A Gap Between Representation and Meaning

While there exist nearly as many working definitions of classical satire as there do of postmodernism itself, most scholars and literary critics agree that the functional engine of the satire is the audience's awareness of a disconnect between the characters and events that are presented in a given work and the meanings that audience members are expected to attach to those representations. According to Booth (1974), the classical satire cannot function unless audience members recognize that the proffered images differ to some extent or degree from an objective reality that exists outside the text. It is this gap between what is known and what is shown that opens up a space for an ideological lesson of sorts (Bohnert, 1995). But if classical satire is a distorting mirror that at first seems to exaggerate the differences between material reality and mediated depiction, it also serves to narrow that perceived gap as the specific satirical work unfolds—in effect, to reveal that reality itself is full of inconsistencies and absurdities (Highet, 1962). And herein lies the most significant challenge to any would-be satirist: striking the ideal balance between reality and exaggeration in order to most effectively persuade one's target audience. Because all potent satirical works are required to open up such a large space between reality and representation, there are always innumerable subject positions available for audience members to identify with—a quality of polyvalence that forever threatens the success of the satiric text by divesting the author of any long-term control over the meanings of his or her aesthetic creation (Connery & Combe, 1995; Gring-Pemble & Watson, 2003).

But if there is a real danger that some audience members might read a given satirical work as pure farce at the same time that others are consuming it as a wholly realistic depiction of the present social milieu, such a threat would seem to be all but annihilated by a postmodern tendency to collapse any distinction between object and representation, between textual signifier and material signified. Such a differentiation is, of course, absolutely necessary in order for any message to carry meaning beyond its own material qualities; hence, if postmodern modes of thought have proven so willing to accord value to the image as image alone (Baudrillard, 1983), then they have also relinquished any ability of the mediated representation to present a consistent message, let alone to communicate through its expression as a part of any social or historical narrative (Bignell, 2000). In postmodern times, or so Mitchell (1994) argues, images can teach us about nothing but images themselves; any sense of a material reality to be critiqued (or at the very least to be accurately recreated) is effectively collapsed and deconstructed (Norris, 1990).

In sum, if the perception of a gap between reality and representation is a necessary condition in order for the satirical text to critique present conditions and to formulate a meaningful call for social change, then postmodernism's persistent treatment of the image as a form of reality in its own right would seem to have effectively neutralized one of the promising avenues through which satire has long pursued its rhetorical aims. This constraint represents a significant challenge to anyone who seeks in contemporary times to wield the satirical form as a persuasive tool.

A Question of Authorship

A second quality that would seem to be required in order to successfully execute the satirical effect is an audience recognition of the author and his or her perspectives on the social issues at hand. It is just such an understanding that prevents viewers and readers from concluding that a given work has been intended as nothing more than a realistic representation of contemporary characters and circumstances or, perhaps, as a hopeful depiction of a desired utopia (Feinberg, 1967). In the world of the satire, the author of a work is a figure of some significance, an individual upon whom the audience relies to assess current conditions and to offer his or her expert observations on the value of given social norms (Petro, 1982). In fact, open and active identification between author and audience would seem to be itself a necessary condition for the successful presentation of any satirical work. Noting that satire is a militant form of irony, Frye (1957) suggests that author and audience members alike must agree upon the undesirability of the work's characters and behaviors; if such an agreement is not reached, then the text becomes nothing more than a personal diatribe on the part of its creator. Wholly aligning themselves with the work's author and against his or her targets of derision may, indeed, be the only means

through which audience members can avoid admitting their own hypocrisy as fellow participants in the targeted characters' maligned acts (Connery & Combe, 1995). Thus, if Gring-Pemble and Watson (2003) contend that satire is at heart a form of audience distancing from the work's characters, Burke (1968) is quick to point out that every effort at dis-identification also implies a move to identify with something or someone—and in the case of the satirical form, that process of identification requires an author with whom the individual viewer or reader can actively and enthusiastically ally.

But if a direct identification of and open alliance with a distinct author on the part of the audience is vital to the overall success of the classical satire, then the postmodern condition's treatment of authorship as its core philosophical concern (Lovejoy, 1989) would seem to have forever neutralized the satiric form's persuasive potential. According to Connor (1989), postmodern texts shift audience attention from the text itself to its performance as a mode of communication; in essence, the individual work becomes an image of itself, wholly separated from its manufacture and presented as a product to be consumed by the viewer or reader. This transposition effectively separates author from text, and in the process assigns to the audience member the responsibility for creating meaning through his or her interaction with the message at hand. The reader becomes the actual subject of the text's performance (Fish, 1972); and as a vast collection of experienced texts rather than a centered, holistic individual (Nash, 2001), it is the reader who becomes the true "author" of a work that is always under construction, that is forever seeking a sense of its own significant identity (Falck, 1994). In sum, if the authority of a text lies in its reading rather than in its production and presentation (Klinkowitz, 1988), then an awareness of the original author's political leanings and creative tendencies will offer little help as a lens through which to evaluate his or her expressive products—a result which would seem to open up any text to a staggering multiplicity of possible readings and to deny any communal understanding of a text as a form of social commentary.

A Shared Moral Compass

Perhaps the single most important quality of the satire as a catalyst for social correction is its ability to distinguish between a widely embraced set of moral values and groups of behaviors that are generally acknowledged as falling short of meeting these social standards. By presenting a dramatic "target" who actively and aggressively violates social norms (Harris, 2004), the author of the satire invites his or her audience members to forge an identification with both author and the greater society through the process of condemning both the character and the character's inappropriate acts and beliefs. Satire presumes shared perceptions of good

and evil (Griffin, 1994); further, in being responsible for the work that focuses audience attentions on both the values themselves and on the actions that violate these norms, the author emerges as a self-appointed guardian of society's standards, ideals, and truths (Gring-Pemble & Watson, 2003).

The reward that awaits audience members as they join the author in casting condemnation on the sins of targeted members of a given social collective, according to Bloom and Bloom (1979), is a certain sense of personal righteousness; for Feinberg (1967), it is the pleasure of superiority and a safe release of aggression. As a literature of power and attack (Connery & Combe, 1995), the classical satire becomes a means of critiquing the existing power structure in society (Petty, 1999) and of asserting one's own innocence and moral ascendancy as a non-participant in the acts and behaviors stigmatized by the satiric work. As Glynn (1993) notes, even Bakhtin's "Menippean" satire—a carnivalesque celebration that openly mocks serious cultural forms—functions by contending that even the most extreme public acts are morally superior to the power structure's hypocritical morals. In other words, even this most extravagant of examples serves to reinforce this significant rule of the form: that the effective satire must set up a clear opposition between a set of cherished social values and the behaviors of certain targets that are shown to violate these norms and expectations.

But if a sense of shared values is, indeed, necessary in order for the classical satire to operate as an effective catalyst for social change, then the postmodern ethos would appear to hinder in every way satire's ability to function in this regard. A postmodern mode of thought denies the consistent and persistent moral, social, and historical meta-narratives (Lyotard, 1984) that anchor the norms and values of individuals and societies alike. Postmodernism is both an encouragement to and the end product of a progressive alienation from myth and history (Bignell, 2000); in place of such enduring points of perspective, it produces a transcendent subjectivity that claims no time or place (Gaggi, 1989). For Clendinning (2002), postmodernism is "complexity and contradiction, messy vitality, richness over clarity, many levels of meaning, a combination of forms, decoration and ornament for its own sake, mixed media, symbolism, representationalism, and starting with the listener's value system rather than seeking to impose the composer's values on the listener" (p. 135). In other words, postmodern forms of expression encourage highly individual readings from the individual audience member's perspective, whether that point of view is founded in an aesthetic evaluation or an ethical one. Distinctions between social and cultural values are effectively collapsed (Connor, 1989); as a result, works of art can no longer serve as forms of commentary that are outside of the society upon which they would cast their critical judgment. In the end, there is simply no privileged truth in postmodern times (Norris, 1990); as a result, the same texts can serve to both condemn and celebrate, to reject and embrace the most common behaviors and beliefs

of the day (Jameson, 1988). Such a way of thinking and being clearly and severely limits the ability of any text to effectively function as a satire in the classical sense.

A Form of Exaggeration and Caricature

A final literary technique to which satires have historically turned in order to point out folly and to demand social change is that of depicting presumably authentic behaviors and events through the lens of exaggeration and understatement (Feinberg, 1967; Harris, 2004). While a familiarity with an author and his or her predilection for using satire is certainly helpful to audiences as they attempt to "correctly" read a given text, the extent to which a work's depictions are seen to depart from actual happenings is also clearly vital to the purpose and success of the satirical work. Viewers and readers must recognize that the text at hand is, indeed, satirical in intent; they must reject any literal or direct meaning and seek, instead, an alternative significance to what has been presented (Booth, 1974). For if classical satire is a distorting mirror (Highet, 1962), it is still a mirror; even in its most blatantly carnivalesque expressions (Glynn, 1993), it reveals a nugget of truth, of correspondence between the wildly exaggerated behaviors of screen, stage, and page and the real-world acts of real-world individuals and groups (Tiefenbrun, 1975). It is this gradually revealed similarity between the real and the exaggerated that drives the satire as an ironic form and that ultimately gives the satire its true persuasive force.

Unfortunately, classical satire's potential as a rhetorical form would seem to have been severely limited by postmodernism's eagerness to embrace all modes of representation as moments of reality unto themselves. According to Gibson (1996), the very idea of representing the "real" is outmoded in our contemporary times; what has emerged, instead, is a mediated environment in which discrete bits of others' expressions are forged together to create texts devoid of any sense of authorship or historical significance—texts that refuse to be clearly and permanently identified as either parodic cliches or as serious comments on social norms and conditions. In fact, for Lyotard (1992), postmodern expression makes no claim to represent reality but rather argues that the "real" is nothing more than a vague indication that something might, indeed, exist outside of or beyond the represented. "The postmodern would be that in which the modern invokes the unpresentable in presentation itself," Lyotard notes, "that which refuses the consolation of correct forms, refuses the consensus of taste permitting a common experience of nostalgia for the impossible, and inquires into new presentations—not to take pleasure in them, but to better produce the feeling that there is something unpresentable" (p. 15).

This refusal to distinguish between actual, material experience and the highly individual meanings that are invited by the postmodern text's collage of images and

ideas represents the final blow to the classical satire's ability to effectively function among contemporary audiences. By erasing the gap between presentation and meaning, by denying any connection between text and author, by according to the individual viewer or reader the ability—and the responsibility—to reach highly personalized conclusions about social norms and behaviors, and by collapsing any distinction between reality and representation, the postmodern ethos would seem to have effectively and permanently neutralized satire's power as a communicative form.

It was into this very aesthetic and philosophical malaise that Spike Lee introduced his *Bamboozled* in 2000. It is a film that has clearly been forged to a keen edge within the crucible of the postmodern milieu and it is a film that, as a result, has managed to address as satire one of the most persistent social issues of our contemporary American times.

Conclusions and Implications

Taken together, Lee's wholly necessary assaults on postmodernism's persistent denial of the satirical form have clearly shaped the quality and character of *Bamboozled* as a filmic text. Postmodernism's insistence on the value of the image as image demanded that Lee resort to the most extreme of measures to establish the work's satirical intent; at the same time, the compelling need for his viewers to identify with some aspect of the goings-on depicted on the silver screen—whether with the author himself or with given qualities of his characters—in order for the satire to function effectively drove the director to reveal and emphasize the inherent humanity of his celluloid figures as well. In sum, Lee refuses to allow any of his audience members to stand comfortably outside of the action as they cast their judgment on the norms and behaviors of others. If the original minstrel shows' vicious lampoons of freed slaves' "uppity" behaviors in the age of American Reconstruction simply did not function as satires because of the power differential between performer and target, then Lee would seem to argue in *Bamboozled* that similar power imbalances in the U.S. society of today should not serve as an excuse for the behaviors of any members of the contemporary social strata. Simply put, we are all both victims of and perpetrators of the grand bamboozle—and as a result, we are all equally responsible for considering the gap that exists between our own senses of self and the images that we daily project to other members of the social collective.

What emerges from *Bamboozled* is a clear blueprint for the effective presentation and rhetorical function of the postmodern satire. First, Lee argues that satire can no longer serve to shore up a sense of broad group belonging; instead, the form becomes a means of providing a wholly individual and individualized lesson on mores and behaviors in a social world. Second, Lee contends that all satire is, in the

end, nothing more than self-satire; far from revealing through its depictions the sins of others, satire must invite us to consider and question the nature of our own acts as part of the overall social fabric. Third, the director makes a compelling argument for satire's function as a hybrid form. Far from presenting mere caricatures of abhorred values and events, a postmodern mode of thought demands that the satire reveal both the caricatures themselves and the motivations behind these images—a requirement that would seem to rule out the potential success of any work that would follow to the letter a classical approach to satire. And finally, the post-modern satire emerges as a powerful lens through which to consider not only one's behaviors, but one's sense of authenticity as well.

According to Harris (2004), the satire as a rhetorical expression is an ultimate-ly impotent form in our contemporary world. Simply put, the author of a satire can-not make audience members *act*; he or she can only encourage viewers to *see*. Still, it is difficult to maintain the position that one's sense of self as a social depiction has nothing at all to do with one's decision to behave in certain ways and to encour-age like behaviors in others; as Nehring (1997) notes, identity in postmodern times is ultimately negotiated and achieved through discourses that are not authentic to the self. In the end, then, to consider the fractured and widely varied depictions of others across a range of mediated texts is to understand the self in a more profound and fundamental way. And as perhaps the first true postmodern satirist, Spike Lee continues to produce and provide the texts that may help us to negotiate a more meaningful place for ourselves in an elaborate and perplexing world—not as mem-bers of given social or racial groups united by a limiting meta-narrative but as individuals with our own experiences to gain and our own stories to share as we work together to counter our most persistent social and racial ills.

References

Anderson, J.A. (2005, January 25). Bamboozled [Review of the motion picture *Bamboozled*]. Retrieved January 25, 2005 from http://www.rottentomatoes.com.

Bamboozled (2000). S. Lee, director: 40 Acres and a Mule Productions.

"Bamboozled" (2005). Retrieved January 25, 2005 from http://www.haro-online.com.

Baudrillard, J. (1983). The evil demon of images and the precession of simulacra. In T. Docherty (Ed.), *Postmodernism: A reader* (pp. 146–156). New York: Columbia University Press.

Berger, A.A. (2003). *The portable postmodernist*. Walnut Creek, CA: AltaMira Press.

Bernardinelli, J. (2005, January 25). Bamboozled [Review of the motion picture *Bamboozled*]. Retrieved January 25, 2005 from http://www.rottentomatoes.com.

Bignell, J. (2000). *Postmodern media culture*. Edinburgh, UK: Edinburgh University Press.

Black, R. (2003). Satire's cruelest cut: Exorcising Blackness in Spike Lee's *Bamboozled*. *The Black Scholar 33*(1), 19–24.

Bloom, E.A., & L.D. Bloom. (1979). *Satire's persuasive voice.* Ithaca, NY: Cornell University Press.

Bohnert, C. (1995). Early modern complex satire and the satiric novel: Genre and cultural transposition. In B.A. Connery & K. Combe (Eds.), *Theorizing satire: Essays in literary criticism* (pp. 151–172). New York: St. Martin's Press.

Booth, W. (1974). *A rhetoric of irony.* Chicago: University of Chicago Press.

Burke, K. (1968). *A rhetoric of motives* (2nd Ed.). Berkeley, CA: University of California Press.

Chidester, P., S. Campbell, & J. Bell. (2006). "Black is Blak": *Bamboozled* and the crisis of a postmodern racial identity. *Howard Journal of Communication 17*(4), 287–306.

Clendinning, J.P. (2002). Postmodern architecture/postmodern music. In J. Lochhead & J. Auner (Eds.), *Postmodern music/postmodern thought* (pp. 119–140). New York: Routledge.

Collins, R.F. (1996). A battle for humor: Satire and censorship. *Le Bevard. Journalism and Mass Communication Quarterly 73*(3), 645–656.

Connery, B.A., & K. Combe. (1995). Theorizing satire: A retrospective and introduction. In B.A. Connery & K. Combe (Eds.), *Theorizing satire: Essays in literary criticism* (pp. 1–13). New York: St. Martin's Press.

Connor, S. (1989). *Postmodernist culture: An introduction to theories of the contemporary.* Oxford, UK: Basil Blackwell.

Docherty, T. (1993). Postmodernism: An introduction. In T. Docherty (Ed.), *Postmodernism: A reader* (pp. 1-31). New York: Columbia University Press.

Eagleton, T. (1996). *The illusions of postmodernism.* Cambridge, MA: Blackwell.

Ebert, R. (2000, October 6). Bamboozled [Review of the motion picture *Bamboozled*]. Retrieved January 25, 2005 from http://www.rogerebert.suntimes.com.

Falck, C. (1994). *Myth truth and literature: Towards a true post-modernism* (2nd Ed.). Cambridge, UK: Cambridge University Press.

Feinberg, L. (1967). *Introduction to satire.* Ames, IA: Iowa State University Press.

Fish, S.E. (1972). *Self-consuming artifacts: The experience of seventeenth-century literature.* Berkeley, CA: University of California Press.

Frye, N. (1957). *The anatomy of criticism.* Princeton, NJ: Princeton University Press.

Gaggi, S. (1989). *Modern/postmodern: A study in twentieth-century arts and ideas.* Philadelphia: University of Pennsylvania Press.

Gibson, A. (1996). *Towards a postmodern theory of narrative.* Edinburgh, UK: Edinburgh University Press.

Glynn, D. (1993). Reading supermarket tabloids as Menippean satire. *Communication Studies 44,* 19–37.

Griffin, D. (1994). *Satire: A critical reintroduction.* Lexington, KY: University Press of Kentucky.

Gring-Pemble, L., & M.S. Watson. (2003). The rhetorical limits of satire: An analysis of James Finn Garner's *Politically Correct Bedtime Stories. Quarterly Journal of Speech 84*(2), 132–153.

Harris, R. (2004, October 24). The purpose and method of satire. Retrieved October 24, 2004 from http://www.virtualsalt.com/satire.htm.

Hassan, J. (1987). Toward a concept of postmodernism. In T. Docherty (Ed.), *Postmodernism: A reader* (pp. 146–156). New York: Columbia University Press.

Highet, G. (1962). *The anatomy of satire.* Princeton, NJ: Princeton University Press.

Jameson, F. (1988). Postmodernism and consumer society. In E.A. Kaplan (Ed.), *Postmodernism and its discontents: Theories, practices* (pp. 13–29). London: Verso.

————. (1991). Postmodernism, or the cultural logic of late capitalism. In T. Docherty (Ed.), *Postmodernism: A reader* (pp. 62-92). New York: Columbia University Press.

Jencks, C. (1991). Postmodern vs. late-modern. In I. Hoesterey (Ed.), *Zeitgeist in Babel* (pp. 4–21). Bloomington, IN: Indiana University Press.

Kipp, J. (2004, September 8). Bamboozled [Review of the motion picture *Bamboozled*]. Retrieved January 25, 2005 from http://www.movieweb.com.

Klinkowitz, J. (1988). *Rosenberg, Barthes, Hassan: The postmodern habit of thought.* Athens, GA: University of Georgia Press.

Kramer, J.D. (2002). The nature and origins of musical postmodernism. In J. Lochhead and J. Auner (Eds.), *Postmodern music/postmodern thought* (pp. 13–26). New York: Routledge.

Lovejoy, M. (1989). *Postmodern currents: Art and artists in the age of electronic media.* Ann Arbor, MI: UMI Research Press.

Lyons, T. (2000, October 10). Look Black in anger: Spike Lee's *Bamboozled* inhabits a gray area between satire and racism. Retrieved January 25, 2005 from http://www.eye.net.

Lyotard, J.F. (1983). Answering the question: What is postmodernism? In T. Docherty (Ed.), *Postmodernism: A reader* (pp. 38–46). New York: Columbia University Press.

————. (1984). *The postmodern condition: A report on knowledge* (G. Bennington & B. Massuni, Trans.). Minneapolis: University of Minnesota Press.

————. (1992). *The postmodern explained.* Sydney, Australia: Power Publications.

Mitchell, W.J.T. (1994). *Picture theory.* Chicago: University of Chicago Press.

Nash, C. (2001). *The unravelling of the postmodern mind.* Edinburgh, UK: Edinburgh University Press.

Nehring, N. (1997). *Popular music, gender, and postmodernism: Anger is an energy.* Thousand Oaks, CA: Sage.

Norris, C. (1990). *What's wrong with postmodernism: Critical theory and the ends of philosophy.* Baltimore: Johns Hopkins University Press.

Petro, P. (1982). *Modern satire: Form studies.* Berlin: Mouton.

Petty, B. (1999, April). Satire. *Arena Magazine* 36.

Taylor, T.D. (2002). Music and musical practices in postmodernity. In J. Lochhead and J. Auner (Eds.), *Postmodern music/postmodern thought* (pp. 93–118). New York: Routledge.

Tiefenbrun, S.W. (1975). Mathurin Regnier's *Macette:* A semiotic study in satire. *Semiotica* 13(2), 131–153.

Tyler, S.A. (1987). *The unspeakable: Discourse, dialogue, and rhetoric in the postmodern world.* Madison, WI: University of Wisconsin Press.

Sounding Black

Cultural Identification, Sound, and the Films of Spike Lee

ELLEN C. SCOTT

My name is M.O. And don't you forget it. Takin' out your boys and you don't know how I did it.... Don't step my way 'cause I just might have a gun. May be loaded or just might not be cause I'm a menace to society. My name not Sticky Fingaz But I still get ill. So back the fuck up and just Chill!... I'm like an Energizer(™) don't never die Bu, bu, bu, bu [verbally-produced gunshot sounds] Nice try!
—(*Clockers*, 1995, Spike Lee)

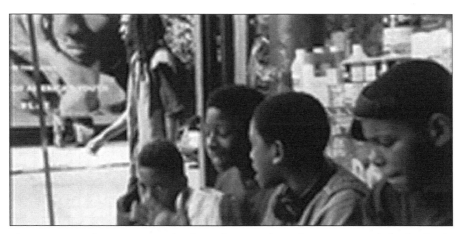

Figure 12.1. Semidiegetic rap strongly informs the scene that is the centerpiece of *Clockers'* cyclical narrative (*Clockers*, 1995, Spike Lee, DVD time code: 1:02:08)

The above epigraph is the text of the lyrics of the "freestyle" rhyme that overlays and punctures the narrative of a tracking shot occurring exactly at the middle of Spike Lee's 1995 film *Clockers*. The rhyme emanates from one of four young boys (around thirteen years of age), all of them apparently aspiring clockers (aka middlemen between drug dealers and their clientele), who sit on the first story windowsill of a store owned by a local drug dealer named Rodney. The camera only briefly centers on the boys, and even this momentary ocular attention marginalizes the boys by way of an extremely oblique camera angle that renders their full faces, and thus their affective facial cues illegible (Figure 12.1). Quickly even the minor visual attention paid to these boys is dispensed with. The camera instead follows an anonymous black man with long dreadlocks as he crosses the street toward the project. Speeding ahead of him and grasping the camera's attention is an out of place gold Mercedes Benz, which crosses the street ahead of the man and stops on the corner with a large sign that says "Nelson Mandela Housing Projects." A long shot, reveals a white male teenager in a yellow polo shirt, who, looking over his shoulder suspiciously, gets out of the Benz and takes a package—presumably containing drugs—out of a silver mesh metallic trash receptacle on the corner and returns to the vehicle to drive away. Without a cut, the extended tracking shot then tracks *back* across the street, following the movement of a pleasant and average-looking African American teenage girl—who accompanies two younger girls, one riding piggyback and one holding her hand.

This sequence does much to establish the culture of that corner—and the range of activities that occur there. This elaborate establishment of locale is consonant with Lee's continued and well-evidenced affinity for the establishing shot, classically a feature of the cinema but one commonly left out of the faster-paced, block-buster driven contemporary Hollywood film. The scene also evidences the episodic style of Lee's films—even though this is the middle of the film, all of the characters in this scene are new to the viewer—this is a sort of "time out" from the narrative. But why does Lee include this scene? What, precisely does it "establish" about the film? Is this scene only an example of the illegible quality Timothy Corrigan has suggested symptamotizes the auteur-driven stylistics of contemporary cinema (Corrigan, 1991)[1]? In many ways the scene does indeed deny the ease of legibility typical to classical Hollywood and could be read in many ways. We might notice and interpret the presence of female passersby, a rarity in this male-dominated narrative, who the cameras follow as they cross the street toward Rodney's store, bringing our vision back to the rhyming quartet. We might also take as key to interpretation of the scene the vast number of children walking with their parents in the background (there are three such pairings). Both of these features of the scene operate in stark juxtaposition to the masculine homosocial space represented by Rodney's store. But somehow these observations fail to capture the scene's

meanings. Indeed the documentary quality of the scene—its seeming lack of intentionality and "slice of urban life" character as it follows passersby—undermines the legibility of the scene and makes it unclear whether the scene has a single protagonist.

The key to understanding this scene is given, in large part, in its use of music. During the entire sequence, the rhyme (cited above) dominates the soundtrack; that is, although the image track leaves the boys behind, the soundtrack stays with them. How and why does Lee use this particular style of music here? It is, crucially, the music and the sonic prominence of the commentary of these boys that complicates what might be simply seen as a scene about white kids buying drugs.

Employing a style of blocking which we might associate with the entangled city walking often represented in film noir, Lee territorializes the problematic imposition of white desire (here for illegal drugs) on black youth and family. However, the steadiness of the music (which does not change volume even as the visuals shift away from the boys) is the basis upon which Lee focalizes the scene through the boys, grounding viewers' perception in the sonically rendered perspective of the young boys whose commentary achieves, as the camera leaves behind their image, supranarrative and authoritative voice-over status. The verbal commentary produced is an imagined narrative of the power of the gun. In the lines "ha-ha-ha I saw your mom in the building; throwing up my guns to the ceiling bu-bu-bu [gun shot sounds]: here I go again. Bu-bu-bu: cats are coming in," M.O., the young man who delivers the rhyme, mixes the genre of "your mama" jokes with the motifs of an action or gangster film. Here he literally laughs at his opponent's mother as he imagines using his gun not to shoot her but to gain power over the building—the place in which he resides. The neat narrative in the rhyme ends with M.O. leaving the building without a trace, because no one saw his face. It is in these lines that the imagined narrative of power and potency (as hypervisibility gained by the power of the gun and invisibility gotten by the sort of categorical anonymity of black masculinity) gets wrought. The marginal, yet diegetic presence of these boys on this soundtrack gives these young men a hold on the scene's meanings even if it announces this hold as decentralized and diffuse. This scene, I argue, demonstrates a quality of Lee's films worthy of note: namely, their complicated, and often counterideological use of sound. The obtrusive counternormativity of Spike Lee's sound design in this scene is symptomatic of the use of sound in Lee's text and offers up, I will argue, an alternative ideology and narrative from that offered by the film's visuals.

Spike Lee's films have long had a reputation for encapsulating and representing a particularly palpable experience of "the real," while at the same time using nonstandard visual techniques that we might consider expressionistic to achieve this effect. Although this may seem somewhat paradoxical, indeed Lee's films manage

to use their status as representation (a status that the films claim rather than attempt to disavow),[2] in order to point viewers toward an extra-textual real that is both referent for the cinematic index and its culmination.[3] The sense of the real in the 1990s hood film cycle emanated from the timeliness and newness of the revelation that these films provided, but also from viewers' sense of the presence and resonance of this "real" outside of the theaters in increasingly African American, increasingly drug-infested, and increasingly impoverished inner cities. Realism in Spike Lee's highly expressionistic films of the 1990s always was more than the sum of its parts—one grounded in localized subjectivity and an aestheticization of recognizable "everyday" motifs of vernacular black urban culture.

Although much attention has been given to Spike Lee's style and technique and to his unique auteurial vision, only a few of these scholarly explorations have engaged, in any extended manner, with his sound design and with the powerful ways in which Lee mobilizes the sonic elements, sound motifs, and audible "signs" in his texts, offering them as a site for audience identification that competes in potency with the visual (Gabbard, 1992, 2000; Stam, 1991; Johnson, 1993-94).[4]

But un- or under-explored in most analyses is the effect of Lee's sound design upon audience identification and the model of aural spectatorship that Lee's films promote. What is the effect of Lee's sound design on audience identification with his films and how do the elements of dialogue, musical score, lyrical and non-lyrical songs (both those emanating from within and outside the narrative), sound effects, and their combination through the process of mixing affect the viewer's overall experience of the film? What if any effects do these elements have on the film's positioning of its spectators with regard to dominant ideology? It is my contention that it is in the realm of the sonic, rather than the visual, that Lee's *Clockers* most clearly represents the maturation of the so-called hood film cycle of the early 1990s and provides reflexive commentary upon the earlier films of the genre. Particularly I will argue that, through the film's soundtrack, Lee offers spectators a different set of options for cinematic identification than the earlier hood films, undermining the action/gangster aesthetics of films such as *Boyz n the Hood* and *New Jack City* which with a few noteworthy exceptions (moments that Lee himself seems to be citing) generally conform to the Hollywood blockbuster action films in terms of sound design. Lee, on the other hand uses conventional *melodramatic* scoring that causes viewers to read the film as "tragedy." As is also true in earlier African American focused works films such as Oscar Micheaux's *Birthright* (1939) and Shirley Clarke's *Cool World* (1964), rather than music being confined to the will of the diegesis, in Lee's films, music exceeds the diegetic realm and is often used to point to a "place" outside the diegesis, undermining the sovereignty of the narrative. Likewise, Lee's choice of popular music points, with utopian tonal and lyrical strains, toward an alternative iteration of black masculinity to that presented on the image track or

within the narrative. Lee, composer Terence Blanchard, and sound designer, Skip Lievsay, unmoor the soundtrack from its usual service to both the image and the narrative, positing sound as an almost entirely separate realm, a realm of marginality but also abundance, excess, and unbounded expressive potential. Similarly, Lee and his sound team use the power of the word to challenge the image track. They explore the ability of sound to provide a cultural depth of field—a rich store of information about culture—that challenges the stereotypical, flattening tendencies of the screen image, which distinctly lacks volume.

In many ways, the narrative of *Clockers* fits the mold of the gangster genre and of the previous hood films that emerged in the early 1990s. *Clockers*, based on a novel by Richard Price, a middle-class Jewish man who grew up in the Bronx projects, tells the story of Ronald "Strike" Dunham (Mekhi Phifer), an African American youth who is employed as clocker for local drug dealer Rodney Little (Delroy Lindo). Rodney gives Strike the opportunity to move up in the business by murdering another clocker by the name of Darryl Adams, one he says has been stealing. When Darryl ends up dead after he has taunted a gun-toting Strike, we feel that Strike has committed the crime. Enter Rocco Klein (Harvey Keitel), a middle-aged, white-ethnic homicide detective charged with investigating the crime. Klein, and his partner Larry Mazilli (John Turturro) are perplexed about who has committed the crime. When Victor, Strike's brother, who has two jobs and a wife and two kids, confesses to the crime, Detective Klein doubts his story, thinking he is covering up for his brother Strike. Rocco repeatedly attempts to visit Strike to find out whether or not he perpetrated the crime. As the cops turn up the heat on Strike, Rodney disavows having ever told him to kill Darryl Adams. Finally, Rocco arrests Rodney, telling him that Strike ratted on him during Strike's interrogation in order to pressure Strike into confessing whatever details he knows about the Darryl Adams murder. His plan has unintended consequences, however, as Tyrone (Strike's adolescent friend) shoots Errol (Rodney's best friend) so that he won't harm Strike. Finally, it is revealed by Strike and Victor's mother that it was indeed Victor who, so worn down by the stress of carrying the burden for the family and the race, strikes out with severe anger. Detective Klein performs a double act of mercy, retooling the narrative of Errol's killing to absolve Tyrone and putting Strike on a train for the west—telling him never to return to the projects. [5]

Even at a glance, Lee's sound design differed profoundly from these earlier films. Although not a self-consciously "musical" film like Lee's jazz epic, *Mo' Better Blues* (1990), Lee's *Clockers* is important to our understanding of Lee's sound design because, in many ways, it is his film most concerned with the urgency of translation. The solving of the murder of Darryl Adams and of Strike's predicament rests in the ability of characters, particularly Strike and Rocco, to display cultural competencies in conflicting cultural contexts—to break through the background noise

and create meaningful sound. Although there are elements of the soundtrack that strain immersive effects of the cinema, the sometimes Brechtian sonic elements in *Clockers* provide a dynamic set of identificatory possibilities for the hearer or "audio-spectator" of Lee's film. Clearly, Lee uses sound as a way to privilege spectators who have a preexisting knowledge of black culture (or those spectators with a knowledge of African American music and history). However, Lee's soundtracks do more than this: disturbing Hollywood's use of music by introducing various alternative paradigms. In a film where 360° camera angles unmoor and unsettle our connection to the visual, the sound track provides grounding for the cinematic spectatorship.

Identification and Sound

As previously stated, I am arguing that Spike Lee's films not only have a particular kind of sound design but that this sound design inspires a relatively unique form of identification for spectators. But what precisely is meant by identification? At its most basic, identification is the process by which viewers engage, psychologically with the cinema, a process that involves a recognition of similarity between oneself (or one's world) and the cinematic characters, world, or happenings.[6] More specifically, it is a process of adoptive recognition, one that involves recognizing one's own relationship to the object that inspires identification. As theorist Jean Mitry has elucidated, what is "real" about film is not the plot, the acting, the special effects, or the subject matter. Rather, what feels real is the fact the screen material can be linked to what we know and remember; it can be recognized. "Since we only recognize what we already know . . . action and motives of the film . . . must have been experienced, if only in the imagination" (Mitry, 1997, p. 85).

Christian Metz has suggested two possible modes of cinematic identification: secondary and primary identification. Secondary identification is identification with characters. Primary identification is identification with the act of viewing, a positionality that causes the viewer to say: "I take no part in the perceived. I am the all perceiving" (Metz, 1982, p. 48).

With this theory, Metz posits an extra-narrative form of identification—an identification with cinematic *form* and *apparatus*, one that challenges the centrality of "content" and suggests a sort of *marginal* identification with the act of viewing. While theorists have rightfully critiqued Metz for positing a universalizing gaze, one that does not differentiate according to race or gender, Metz's notion of an extra-narrative form of identification is worthy of further examination with regards to 1990s black cultural production and reception (hooks, 1992, p. 16; Diawara, 1993, p. 216). Although I am suggesting the usefulness of Metz' notion of the all-perceiving subject, I want to break with the tradition of discussing this spectator-

ship in terms of the visual. Lee promotes and structures into *Clockers* a primary iden-
tification saturated in the auditory.

This aural all-perceiving is in part the by-product of the aesthetics of New
Hollywood. As Rick Altman has noted:

> Whereas [Nineteen-] Thirties film practice fostered unconscious visual and psycholog-
> ical spectator identification with characters who appear as a perfect amalgam of image
> and sound, the Eighties ushered in a new kind of visceral identification, dependent on
> the sound system's overt ability, through bone-rattling bass and unexpected surround
> effects, to cause spectators to vibrate—quite literally—with the entire narrative space.
> It is thus no longer the eyes, the ears, and the brain that alone initiate identification and
> maintain contact with a sonic source; instead, it is the whole body that establishes a rela-
> tionship, marching to the beat of a different woofer. Where sound was once hidden
> behind the image in order to allow more complete identification with that image, now
> the sound source is flaunted, fostering a separate sonic identification contesting the lim-
> ited, rational draw of the image and its visible characters. (Altman, 1995)

This bone-rattling action aesthetic is greatly in evidence in films like *New Jack
City* where crushingly loud music and soundtracks not only inscribe but overdeter-
mine the images they accompany. Lee's sound design "riffs" off of the use of sound
in post-1980s cinema that Altman describes above, using the cinema's possibility
of pinpoint accuracy in sound representation to posit cinematic sound as a portal
to an alternative "space" than that represented in the visual. But by refusing to shock
viewers with sound, Lee ultimately critiques the action aesthetics that underlie the
visceral identification that dominated in the 1990s, using sound not as spectacle but
as *depth*, as a revelatory medium designed as content.

We identify with Strike but not in ways standard to the hood films, in which
we identify with the protagonist not because we understand his or her particular
emotional state or structural constraints but rather because of the particular set of
perils or feats he or she is faced with within a given, activated narrative geography.
This identification depends on the activation of a set of physical obstacles, whose
geography the audience is made to feel both through special effects and usually
through a scene where our hero nearly falls to these perils. Many of the hood films
of the 1990s seem to unproblematically activate this action paradigm and project
action-based tension onto the urban "ghetto" milieu in ways designed to stir audi-
ence identification. While this re-appropriation of the action genre is at times
plainly a homage to blaxploitation aesthetics (and may even be designed to jolt view-
ers into social action), the conformity of the craft and aesthetic paradigm of the early
hood films to those made by the industry limits their effectiveness in critiquing
Hollywood images of African Americans and in creating "thoughtful" cinema.
These films corroborate Hollywood's villainization of "some black men" by demo-
nizing and villainizing certain hood residents on the sound and image tracks. For

example, in *New Jack City,* by suggesting that the problems of the hood (and their solutions) are somehow reducible to violent action these films limit the emotional complexity and strain the realism of their own conceptions of the hood. In Lee's *Clockers,* on the other hand, both the score and the frequent Brechtian musical interludes, which are both non-diegetic (as in the scene where Strike attempts to "gat" Darryl) and diegetic (as in the M.O. freestyle), challenge the audience's tendency to read the hood film as an action film and cause the audience to read the hood predicament in quite different ways. In what follows, I will assess how Lee mobilizes various aspects of the soundtrack in order to prompt audience identification with his films through sound. I will address separately how Lee uses merchandized music, score, lyrical content, and dialogue to motivate audience response.

"Feelin' the Soundtrack"

Like many New Hollywood films, Lee's films also hold out the possibility of identification with musical cuts on the soundtrack alone—of identification with the multilayered, full sonic aesthetic of the film's merchandized music. Although this brand of identification is nearly autonomous from narrative structures, it is one that participates intertextually in a broader set of cultural narratives about selfhood and what it is to BE at a particular point in history. The top-forty hits of our time become, in ways that Lee makes palpable, the soundtrack of our lives. These songs, whether played at a club one frequents, at home in one's room, from a boom box onto the streets, or in one's walkman, cooperate in defining racial, ethnic, gendered, local, and generational identity through what they say about us and through the kinds of actions they come to narrate. When one must go to the cinema, in many senses, music comes to us. The common trope of claiming a musical track as "my song," and the relationship to music that this statement of ownership conveys, connotes the often quite powerful sense of identification that the sonic realm has the ability to command. Identification with music is premised on the unique ability of the artist to combine evocative tonality, instrumentation, voice, meaningful lyrics, and increasingly also effects to connote something intensely claimable as personal and universal. Lee, like other New Hollywood directors, recognizes the power of music as an autonomous site of identification and for the articulation of utopia. However, by referencing a variety of musical traditions, Lee uses the New Hollywood merchandized soundtrack to confront auditors with historically referential, complicated sampled sounds that operate, much like his image track as challenge, stumbling block, and site of knowledge acquisition.

As Paul Gilroy has suggested, African American musical traditions had an important political project as well in the 1990s. They challenged the "relatively nar-

row understanding of freedom centered on political rights" by exploring "areas of thinking about freedom and the desire to be seen to be free"(Gilroy, 1995, p. 67). Gilroy notes, however, the unique potential of sonic for representing (African American life) not only because of the prevalence of oral tradition as a representational mode in African American culture but also because of the unique, migratory quality of sound. For this Gilroy cites Emmanuel Levinas:

> In sound, and in the consciousness termed hearing, there is in fact a break with the self-complete world of vision and art. . . . Whereas in vision, form is wedded to content in such a way as to appease it, in sound the perceptible quality overflows so that form can no longer contain its content. A real rent is produced in the world, through which the world that is here prolongs a dimension that cannot be converted into vision. (Gilroy, 1995, p. 65)

The ability of sound to literally surround the spectator makes it electrically and ecstatically possible for sound to instantiate, represent and make palpable the "here" and "now" that the distant, screen-bound image cannot. The sonic can traverse the distance between the spectator and the screen and can inhabit the three dimensional, cultural, and relational space of the theater auditorium. Lee exploits and explores these dimensional and representational possibilities of sound in ways unique to his auteurist perspective in *Clockers*.

The sonic diversity of Lee's text is not merely window-dressing for the narrative but ends up being central to the resolution of the plot and also, crucially, to the subjectivities of its characters, subjectivities that are constantly in question throughout the film and that are revealed and solidified through musical accompaniment. We can intuit from the very beginning of *Clockers* that music is a central concern: not only does music serve an incredibly important function in the title sequence, one I will discuss at greater length in the coming pages, but three different songs ("People in Search of a Life" sung by R&B artist Marc Dorsey, "Return of the Crooklyn Dodgers" performed by the Crooklyn Dodgers '95, and "Children of the Ghetto," rendered in haunting acoustic falsetto by Philip Bailey, member of Earth, Wind, and Fire) with entirely different tonal qualities mark the first six minutes of the film's narrative, signaling that music is doing more in the film than creating mood. With ample use of musically accented establishing shots, sonically embellished tracking crane shots, and 360° "spherical" cinematography, like that employed in the "under the El" sequences in *Malcolm X*, in *He Got Game*, and in the opening narrative sequence of *Clockers*, Lee links music to place and to subjectivity, creating a sense of aura that blends the personal subjectivity of his characters with sense of space. In doing so, Lee demonstrates the inextricability of time (as rhythm), place, and self, posting a version of subjectivity that, as aurally constituted, cannot be reduced to the visual or to the visual signifiers that typically represent blackness.[7]

Deepening the Soundscape: Rap in *Clockers*

The first narrative scene of the film is powerful in its use of sound as a site of identification and sonic "interpellation." The track by the hip-hop group Crooklyn Dodgers (Chubb Rock, Jeru the Damaja, O.C., and DJ Premier), entitled "Survival of the Fittest/Return of the Crooklyn Dodgers" imparts to the film a powerfully local flavor (thus privileging local spectators and those familiar with Brooklyn).[8] This localization of song (and film) is accomplished by the first lines of the song "Straight from Crooklyn, better known as Brooklyn, never taking shorts cause Crooklyn's the Borough" (which is a sample from Black Sheep's "Who got the Props?") and the repeated, hook lyrics, "Crazy ass Crooklyn kids; Represent to Brooklyn: all night" that ricochets over the tail end of the track. The powerfully local character of this track is made even more obvious in the music video, which literally sports banners exalting Crooklyn and highlights local folk. Far from strictly creating mood or stirring emotion, which is how film music is often discussed, songs in *Clockers* operate to create a sense of geography and local aura.[9] Through the line "We did it like that and now we do it like this," a sample from the Crooklyn Dodgers' earlier song on the soundtrack for Lee's 1993 film *Crooklyn*, Lee makes his auteurial mark through rap, diminishing the lines of separation between real-world hip hop and cinematic diegesis.

But the tracks by the Crooklyn Dodgers do more than simply set our scene: they perform cultural commentary and develop an achronological but nevertheless powerfully historical narrative, one that informs the narrative of the film. By injecting this commentary into the initial scenes of the film, Lee sets the counterideological agenda for the entire film. The first rap lyrics in "Survival of the Fittest" are "Now clock, kids, who got the cocaine? Don't tell me it's the little kids on 'Soul Train' . . . It comes from other places—not the tinted faces." The first stanza of the rhyme begins with a question that will structure both the rest of the song and the *Clockers* narrative, namely "Who got the cocaine?" The vernacular phrasing of the question leads to its polysemy: it is legible as either a historical question, that is, "who *originally brought* cocaine?" or as one pertaining to the present: "Who *now has* the cocaine?"—both questions that the rhyme attempts to sort out. Within merely a few stanzas and a very short space of time, these lyrics draw attention to the racial politics and sordid history of crack cocaine. This politics will become a text in this song and the film itself. Immediately after proclaiming that it is not the little kids on *Soul Train* who are responsible for crack, Chubb Rock proceeds to demystify the source of these rumors in the media by stating: "Journalistic values are yellow and then of course falters. You watch Channel Zero with that bitch Barbara Walters. She'd have you believe Black invented crack." Rather than crack being invented by African Americans, Rock suggests that "President Lyndon [Johnson] had the formula way

back in sixty-three with Kennedy. Yes, the double cross. Remember that's when they blew his fucking head off? Vietnam vets come back looking like one-armed pets." Here, Rock points directly to the history of crack, one that Lee deliberately mobilizes as a frame for the film. Rock further links crack to another Federal debacle of the 1960s—the Vietnam war. This political commentary on crack—the film's indirect subject—is continued throughout the song. When Jeru takes the mic, he will eventually—and with considerable local and transnational political savvy and lyrical motility—critique "clips [i.e., gun cartridges]: Probably the same one/that killed Noriega; chips that power nuclear bombs, power my Sega; Subliminal hypnotism and colonialism leaves most niggas dead or in prison" but also in the film itself.

In sum, these lines also refer to the lengthy history of crack in America, dating it back to the 1960s and weaving in critique of the ahistorical nature of the white-dominated news and entertainment media. The song implicitly draws connections (connections made more explicit in the music video which features "visual samples" from the film comprised almost entirely on images of Strike being beaten) between the maimed Vietnam veterans and the maimed victims of the drug trade. This extra-textual reference to crack's history provides for those with a keen ear, a structuring narrative, privileging and rewarding those who are paying close aural attention.

Lee uses this musical accompaniment as a way to bring structuring voices into the narrative from the outside—as an appendix and a conceptual cadence. The extended musical sequence has an episodic quality that functions as a pathway to a different space—one outside the film's narrative, outside the film's narrative space. It gives us access to a marginalized space branching off from the narrative—to the alternative, to the subordinate, and to the "sonic" realm, one with differing rhythms and modalities than narrative space. Additionally, auditory spectators are introduced to an entirely different perspective through this musical accompaniment. If you have missed these musical additions and the images provided by their lyrical content, you have missed much of the meaning of the film.

But Lee does much, in this scene and throughout, to ensure that we don't miss these important sonic thruways. Crucial to apprehending the full meaning of this scene is the sound mixing and the relationship between the sound and image tracks in this scene. The scene opens with a sequence of two lengthy establishing shots of the projects; the first is an almost panoramic shot that shows the buildings and the street, revealing the geography of the projects. The second shot, which establishes Strike, is significantly closer, delimiting its purview to the plaza between the two hulking towers. Lee then tracks in to an intimate close-up on our protagonist. In this scene Strike is rigorously centered in the frame and sits at the center-point of the spherically organized projects.

In this, the first scene of the film, Lee explicitly and jarringly alters the hierarchy of sound, which typically foregrounds diegetic sound over nondiegetic sound in order to allow for narrative and vocal intelligibility. Here, Lee alters this code of hierarchy, foregrounding the music rather than the diegetic sound in a way that makes it a viable site for identification. However, not only does he foreground the music, but he mutes the diegetic sound altogether. By suspending the real time pacing of the visuals and reverting to slow-motion, the music comes to not only control the pacing of the scene but actually to be the most realist element of it, replacing the real time rhythm we have lost through slow motion. In these scenes and in these sequences, Lee acknowledges, although I do not think he imitates or approximates, the impact of music videos on African American aesthetics, style, and visual culture. In addition, he noticeably hesitates in beginning the narrative, and the absence of narrative action brings the music to the fore. Although the main character, Strike, is introduced, he does not move the narrative forward at all in this scene, a fact which underscores his lack of mobility and agency. When he strolls up to the camera, we assume that the narrative will move forward, but he then proceeds to sit down in front of the camera, obstructing the narrative's forward movement, upsetting our expectations, and making himself the object of the camera's gaze.

Nor do the cops move the scene's narrative forward. The inscription of the image of the (silenced) cops, who are introduced just as Chubb Rock pronounces Barbara Walters a "bitch" and begins to discuss the conspiracy of John F. Kennedy and Lyndon Johnson to bring crack into the country. It is no coincidence that the first moment white people are indicted in the song is the same moment our visual attention settles on the cops. Rocco and Larry are completely overcome by this fulminating musical diatribe and offer no index of their presence on the soundtrack. Those listening closely are caused to link the detectives to this indictment of the system of mass media repression. Although Rocco and Larry are not sonically registered here, the same cannot be said of the black youth in the scene. The young kids in the scene are linked in to this extra-diegetic music: the repeated "ding" that punctuates the layered musical sampling on the Crooklyn Dodgers' cut seems to emanate from the bicycles that neighborhood kids ride in the direction opposite the police car. In this scene the simplistic cinematic trope of blackness as musical accompaniment, oft posited by films of the classical era, is challenged as black cultural production through the medium of rap is introduced as content: by slowing the image track and therein drawing attention to the soundtrack, Lee instructs viewers that in order to get the most out of the sequence one must read not only the visuals but listen to the commentary.

If slowing the image track, and leaving completely absent any diegetic sound, were not enough to signal the musical track as a site of identification in this scene, Lee further links his narrative to the hip-hop text he has just cited by having the

first lines of dialogue in the film pertain directly to rap. The first scene of the film begins with several of the "clockers" debating the merits of Chuck D, Arrested Development, and "positive" rapper camp by comparison with Wu Tang, TuPac, and G-Rap and other more hard-core rappers. Furthering the musical intertextuality and heightening our sense of familiarity is the use Sticky Fingaz and Fredo Star, both members of the rap group Onyx, as major characters (Sticky Fingaz plays Scientific and Fredo, "Go"). Their prominence in the debate on the state of hip-hop in the mid-1990s is a tongue-in-cheek reference to the world of hip-hop that privileges viewers who have a sense of the goings on in the world of rap. This sequence widens the transgressive metaleptic space between the diegesis and the extra-narrative world (Genette, 1980, p. 236).

The viewer with synergistic, intertextual knowledge is rewarded in New Hollywood with the fruits of tremendous legibility. More than creating an alternative space, rap leads the narrative's debates about crack, centering it in a specific cultural milieu. Rap functions as a sonic parallel to direct address, a visual effect consistently employed by Lee. This use of rap contrasts with the ways the musical genre is called to operate in some other hood films, as a fixed signifier of "black culture" or blackness. Rap contributes to Lee's cinematic options for identification by implicitly asserting an alternative form of identification: the concept of "feeling" someone.

Lee, himself the son of a jazz musician, does this because he is concerned about music and acknowledges the power of music as a form of cultural expression for black folks. His mode of address draws on a call and response paradigm specific, but not exclusive, to African American cultural traditions. Call and response is not typically used in American cinema because film is assumed to be a one-way channel of communication. But Lee uses music here—and dialogue about music—to draw the spectator to respond to existent, contemporaneous cultural discourses. Thus although viewers may or may not directly talk back to the screen, Lee activates an accessible set of cultural discourses that could create an internal dialogism of response to the issues represented on screen.

Compare this sonic aesthetic with the use of sound in the early sequences of *New Jack City*. Rap appears in the first action sequence in *New Jack City*, as Pookie (Chris Rock) runs away from Scotty Appleton (Ice-T), an undercover cop whom he has just robbed. In this sequence, rap is used to heighten the intensity of the action and as a signifier of the explosive energy the scene contains. Beginning just at the moment where Pookie begins to run, the music follows the trajectory of the action and the narrative, rather than bringing its own discourse to the text. The lyrics are not highlighted and do not compete with the screen action or dialogue. Rather than operating in a meditative way, as it does in *Clockers,* rap is used to connote the intensity of urban life. In general the overall soundtrack of *New Jack City* conforms

tropes of the action film and specifically cites the Blaxploitation films of the 1970s. Rap is not privileged as its own discursive space—nor as consciousness—but is rather caused to conform to the needs of the narrative. Sound effects including loud gun-blasts, several explosions, accompanied by scoring that relies heavily on the use of drums and is designed to intensify audience suspense and tension mar(k) the soundtrack. In Lee's *Clockers*, sound effects are kept to a minimum. There is, how-ever, one montage sequence in the early part of the film (DVD time code 17:34) accompanied by a hip-hop influenced rendition of "For the Love of Money" that uses sonic tropes similar to those in *Clockers*; diegetic sound mixes with nondiegetic, and the pristine and tonally upbeat sound violates the image track. But in *New Jack City*, the aesthetic of the sound design, like that of the overall film, mimics (or re-appropriates) that of the action film and the gangster genre.

Scoring

Another aspect of the sound-scape that challenges traditional modes of identifica-tion is found in the scoring. By contrast with his work in *Mo' Better Blues*, and oth-ers of Lee's films, Blanchard did not use jazz instrumentation or style in *Clockers*. Surprisingly, Blanchard used the sonic conventions of family melodrama—or even an epic film—rather than either the jazz scoring he often used or the gangster film scoring used in other hood films. Blanchard used an orchestral arrangement in order to carry out his themes, employing over thirty violins, fifteen violas, and with somber, brooding piano and clarinet music frequently represented on the score.

Although we might expect melodramatic scoring in scenes depicting familial conflict, we are less likely to expect it in scenes depicting conversations between cops and between drug dealers and clockers. The similarity in scoring across characters—with the heavy use of violins—and the sonic motifs remind us more of a family melodrama than of a film about "the streets" and they therein disrupt our expecta-tions. Almost never do we have scenes here like those scenes in *Boyz n the Hood*, where the sounds of gunshots literally scare us and the music heightens the inten-sity in ways that it does in the action genre. Why, we ask, the slow, elegiac violin and horn melodies, barely distinguishable from those that have accompanied inti-mate conversations between Rodney and Tye, as Rodney angrily destroys Strike's car?

This disruption in some ways presents a challenge to the presentation of films about black death as gangster or action films. Soaring orchestrals marked by slow-ly paced violin, woodwind, horn, and piano riffs, contribute to the film's overall mes-sage about the tragedy of the death of black people in inner-city ghettos, the complicity of a system in these black-on-black crimes, and the inappropriateness

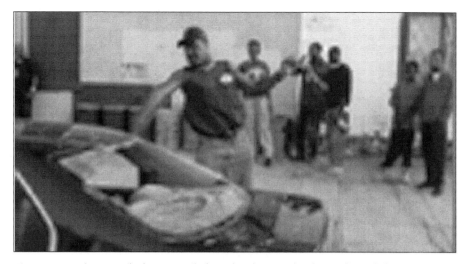

Figure 12.2 Rodney angrily destroys Strike's car, but the soundtrack contributes little energy to the acts (*Clockers*, 1995, Spike Lee; DVD time code 1:58:00)

of exploiting these stories with a flashy, action aesthetic. Blanchard's use of highly emotional scoring—even in scenes where the action and dialogue have more in common with the action film—decreases the suspense of the narrative and suggests both the doom and the tragedy that ought to—but so often does not—accompany narratives of black male demise. Particularly affecting is the use of a melodramatic combination of horns and violins, swelling to new heights in the scene where Veronica and a few other women seek out and then smoke crack. Here as we have not heard elsewhere, the bass takes on low menacing tones typically connoted with villainy. As the women actually smoke the drug, the scene takes on an epic scoring that is marked by heavy use of violins. As the women buy and smoke crack, the soundtrack depicts not the ecstasy of getting high but rather the epic tragedy of their condition (DVD time code 1:15:18–1:18:18)

Throughout the film, comic cues are conspicuously absent. The score refuses to neatly mirror, resonate with, or amplify screen actions, opting instead as a more distant commentary on the overall narrative, one that expresses the overall message of the tragedy of the drug situation and drug culture. These musical elements are linked to one another rather than to the narrative or the images they accompany. While the image track reveals the actions, Blanchard's slow-paced, low-toned, wind- and violin-driven score and the soundtrack operate above the narrative as counterpoint and alternative voice on the action.

There also is a lack of traditional, highly distinct character-based "cues." Although a siren-esque piano riff is used for the cops, Strike only receives a cue after

he has left the drug trade, thus signaling his development of a separate subjectivity. Up to this point, moments when Strike is alone on camera have been overdetermined by the sounds of mass-marketed rap, as we see both in his introduction and in the scene where he is trying to get the courage to kill Darryl.

Although effects of scoring on viewers may vary, the score does not appear to moralize on specific characters or events. For example, very similar and highly sympathetic orchestral accompaniment is used in the intimate scenes between drug dealer Rodney and Strike and those where the neighborhood cop, Andre cautions Strike about getting involved with drugs. While the theme of masculine pedagogy is shared across these scenes, the content of the advice given differs markedly, although we would not know this from the scoring, which seems to equalize the two men. Similarly, although the film's moral authorities (Andre and Iris, Tye's mother) question the effects of the relationship between Strike and Tyrone, upbeat, guitar riffs, and wordless vocals by Des'ree grace the scene in which Strike reaches out to Tye, giving him a haircut and buying him a Sega. In this scene, as in many others, the sonic elements do not change to register with the dialogical revelations of the scene and its consequent shifting moods but rather act almost like magnified diegetic sound—almost like the film's own radio. In the very next scene, however, the score seems to offer the exact opposite moral message, as strong, surging orchestral music marked by violins accompanies Iris's condemnation of Strike's relationship with Tye, the very relationship the previous scene's scoring had seemed to celebrate.

Songs and the Making of Black Subjectivity

The mis-match between sound and image tracks becomes even more pronounced in Lee's use of non-hip-hop lyrical music. Not only does *Clockers* foreground the soundtrack but it also uses the narrative musical forms of the ballad, the lament, and the dirge. Not only is this nondiegetic music loud, but its lyrics offer alternative narratives which branch off from those offered on the image track. In *Clockers*, Lee and Lievsay did not use rap alone but rather included music hailing from a number of other traditions, including Soul, R&B, and even Top-40 Rock, including tracks from Seal, Des'ree, Marc Dorsey, Philip Bailey, etc. At a time when appropriation of rap by the dominant culture was evidenced by the signing of rap artists to major mainstream labels and the development of films designed to merchandize rap-filled soundtracks, Lee kept a consistently generically and generationally diverse soundtrack in his films including Stevie Wonder, Mahalia Jackson, Winton Marsalis, and others. What is more, the lyrics in the songs Lee samples for his films perform the work of cultural commentary, hailing voices and representational styles from vari-

ous generations. Lee also hears these musicians out, sampling long portions of them within his films. Rather than operating outside or inside the diegesis, many of the songs in *Clockers* instead operate around its borders, commenting meaningfully, incisively, and sometimes at great length on the scene.

Figure 12.3 The first image we see in *Clockers* is nearly abstract close up image of the fatal bullet wound of Darryl Adams, whose murder is the central motivation for the drama (shown on the left). A slow zoom out from the photograph reveals the bottom of Adams' face and his shoulder (not pictured). A series of bloody images that appear to be police photographs, follow (see image on the right), but the soundtrack is eerily calm.

By contrast with the function that some cognativists suggest music serves for Hollywood films, it is most often the lack of emotional consonance between image and music—or the fact that the music captures an apparently inappropriate emotion, that marks Lee's films, proffering hearing as an alternative cinematic competency. A prime example of this is the title sequence of *Clockers*. Lee said of this scene that he centered on the autopsy photos "for effect; we wanted viewers to know, before they even settled in their seats, that our film was about serious business. This movie is the exact opposite of the big-budget action films you see which are full of cartoony killings. We weren't going to treat life cheaply in *Clockers*" (Pizzello, 2002, pp. 99–100). Visually, this opening scene serves to cause viewers to cringe over the outrageous inhumanity of black death. In introducing the film this way, Lee forces viewers to look at the drug problem not through the "war on drug" paradigm but through the real horror of homicide. However the soundtrack undermines the "horror aesthetic" of Hollywood that these static shots alone might suggest. Music becomes a point of identification in the first sequence but also of sonic irony, provided by an emotional mismatch between sound and action—what Michel Chion calls "anempathetic" effects (Chion, 1994, pp. 8–9).[10] What becomes the focus of the title sequence of this film about "clockers"—and by extension drug dealing—is not the crime or the systematic politics but rather the intrinsic sadness of black death. This sadness is carried almost entirely in the lyrics of the song, which tells of people in search of a life—looking for freedom in a bottle and a needle.[11] The cho-

rus of the song approximates the airy lamentations of Marvin Gaye in "What's Goin' on?" and within a vocal style that sounds hauntingly like Stevie Wonder, it states: "Somewhere in life there's a joie de vivre between the hope and reality. There in a mirror and in the street—that's where you'll find people in search of a life."[12] Like a number of other songs of the mid-1990s (e.g., Nas' "If I ruled the world"), the song envisions another world, a utopian place between "hope and reality" where "people in search of a life" can find refuge. The song's lyrics, as well as the cinematography of the scene, insert us in the realm of the spectators, placed at a distance behind the yellow line. But both the music and image track—and most especially their combination challenge us, requiring to know what kind of spectators we will be. The scene also admits the serious irony of black death as the unifying spectacle for the new media, community, cops, and entertainment, causing viewers to identify with this irony through the mismatch between the sound and the image track. The unremitting images maintain their grisly focus, leaving us powerless to avert the cinematic gaze. We have no control to avert the gaze of the apparatus from this death, much less to alter its outcomes. The camera focuses on the sites of puncture, the wounds themselves rather than on the exhilarating, if frightening fear of the victim. Like lynching photographs, these shots do not depict the experience of horror or fear; they document the brutality of death itself. Here, Lee points to the vulnerability of spectatorship, acknowledging that having the best seat in the house, a close-up view of murder is not as empowering as it is damaging. This further underscores the film's overall message about the tragedy of black death. The music provides an ambivalent counterpoint; we may identify with the lyrics, which lay out the tragic utopianism that will come to define the film's overall sound design, but we cannot condone or bear its eerily soft tones—its calmness and its smoothness. Ultimately, as we listen to the words, however, the music provides a space of reflection and a degree of respite.[13]

In *Clockers*, the same unusual use of extra-diegetic lyrical music is evident in the scenes where Rodney and Strike meet in the park. In this scene, Seal's "Bird of Freedom" asserts itself loudly, barely below the volume of the dialogue. Not only is the volume unusually loud, but the lyrics seem to bear no relationship to the scene's content. In a song apparently written for the soundtrack, the lyrics of Seal's "Bird of Freedom" like those of "Silent Hero" and "People in Search of a Life" lyrically grasp for a place of freedom (Seal consistently refers to finding a place "away from everywhere" and even at one moment suggests that the addressee "take to the skies and fly"), but the lyrics also contain elements that acknowledge isolation, desolation, and lament. Seal actually has to instruct the addressee not to give his life away or to have the blues. In this song—as Seal initiates a discussion—he literally hails black youth. Lee enables this discussion by giving aural space to Seal's call and allowing it to override narrative concerns, overtaking, by volume, aural pride of place. In

slow, deliberate tones, Seal's ambiguous lyrics tell listeners, specifically hailing "brothers," that it's "alright to flow." Further ambiguity is introduced in the chorus line which says: "they need you bad for what they never had." Who specifically is referred to here is unclear (does "they" refer to the community? To Rocco? To Tye?) The image track, however, does little to clarify, as it seems entirely disconnected from these lyrical suggestions. Strike and Rocco discuss various mundane facts related to the murder, in what is essentially a typical interrogation. Whether we read the music track or the visual track as primary, the relationship between the two is not evident.

This same apparent dissonance between sound and image track is present as well in a later scene in *Clockers*. Having heard that Strike was the one who supplied Tye with a weapon that he used to shoot Errol, Andre publicly beats Strike as a crowd watches. The scene ends with Strike's hobbling away in flight from both Andre and an angry Rodney who believes that Strike has turned him in to the police. The scene is not only among the most violent in the film, but the violence lasts a *long* time, consuming nearly three minutes of screen time. Nevertheless, throughout the entire scene, the soundtrack features the tonally and lyrically up-beat Des'ree song "Silent Hero"—the same song from which Lee took nonlyrical samples for the scene where Tye and Strike are first developing their relationship. One interpretation is that this lyrical accompaniment links Strike's beating to the absent (and now jailed) Tye, and to the very friendship that prompts Andre to beat Strike. In this sense, the song could act as signifier of the missing child. But from a spectatorial perspective, the dissonance between the activity on the sound and image track leads us not to feel as intently any suspense concerning Strike's outcome—the soundtrack seems to assure us that Strike will be alright.

Figure 12.4 Andre's beating of Strike is accompanied by "Silent Hero," a breezy song by Des'ree, accompanied by an acoustic guitar. The lyrics state: "He only wants to be a hero. He wants to fly but his wings won't let him go. He wants to travel but don't wanna go solo. Daddy, when I grow up I want to be a silent hero."[14] The sound and image track do not congeal.

Why does Lee provide us with music that contrasts with the scene's action? In these scenes, the lyrics on the soundtrack operate as a meta-narrative, creating a parallel fabric of textuality to the image track that transcends the workings of any particular scene and reveals the message, or subtext, of the film itself, as well as its narrative trajectory. While the tonal and lyrical elements of these songs may cause us to eschew visceral identification with Strike by failing to underline the brutality of the scene, for some viewers, the Des'ree song, like "Bird of Freedom" nevertheless causes us to identify and engage with Strike's future, his potential, and the mental and spiritual struggles that the image cannot adequately reveal. In this scene, as elsewhere, the music provides a sense of consistency—operating as a sort of an establishing element, more fixed and reliable (calmer and more reassuring) than the image track. Regardless of its connections to the end of the narrative, the lack of consonance between sound and image acts as an irritant, causing a lack of standard identification with the cinematic image track and thus frustrating the seamlessness of the textual effects. This produces an "alienation effect" similar to that Brecht suggested might be politically useful in his discussions of epic theater (Brecht, 1964, pp. 85, 91). By jolting the viewer out of narrative identification with characters, Lee uses a "wake up" aesthetic designed to produce social action. Lee is also, perhaps, suggesting multiple valences and meanings for the same conversation, thus realizing the multiperspectival, polyphonic elements of the scene. Even when the scene's action or the overall narrative would seem to deny it, Lee's choice of lyrical music suggests a structure of hope that moors the sympathy of audiences and knowingly foreshadows Strike's eventual hopeful (if still painful) end. Music does not call us to "feel" the action but leads us to understand its resonant cultural and historical meanings—to feel them in the deeper sense implied by the hip-hop reappropriation of the word.

Trading Verbs: Speech and Dialogue in *Clockers*

Verbal sound has four powerful functions in *Clockers* that lead the soundtrack to have a firm grasp on spectators: verbal sound has the power of invocation, recognition, inscription, and translation. First, people's words have the power over images, literally the power of invocation; words produce images and conjure narrative. For example, while Strike is being beaten by Andre, he calls out "Mommy" and suddenly an image of his mother appears on the image track. Also during several sequences, the voice is the source of the narrative that unfolds on screen—in the manner typical for flashbacks in contemporary cinema. For example, even when Strike lies about who killed Darryl Adams, the visual track follows the narrative carried through Strike's voice, reproducing his various faulty versions of the crime. This undermines

the reliability of the image track and suggests the root of visual and cinematic narrative in the unstable acts of speech.

Another way that the sound track functions as a site of identification is by providing spectators with familiar dialect and accents in its characters. Not only are the accent and dialects authentically recognizable, but the same easy familiarity of the ethnic, warm-toned dialogue that was a feature of *Do the Right Thing* is present here. Lee also obscures the differentiation between musical sound and dialogical sound by having his characters use poetic speech. An area where the lyrical nature of dialogue becomes particularly obvious and important for audience identification is dialect, which Lee consciously puts to work through casting and scripting. The verbal track also has the power of inscription in *Clockers*. As I have already described, in the case of police descriptions of Darryl Adams the words of the officers both predict and circumscribe the body's wounds and frame our understandings of them.

But by far the most important way in which the verbal track commands primary attention is through its powers of translation. *Clockers*, perhaps better than *Do The Right Thing*, instantiates Bakhtin's notion that all speech is interconnected and derived from other speech acts. Using accent and vocabulary, Lee locates his characters geographically, culturally, and generationally, providing points of identification for people from various locales. Far from being a marker of the "essential," it is instead the shifting nature of language—its trade—that is thematized in *Clockers*. On repeated occasions, Lee's characters repeat and mimic one another. Rocco must understand the life on the streets from the perspective of Strike (he even says "I want to see what you see"); Strike must be able to quickly shift from talking with the cops to talking with Rodney and Tye. Therefore, these two men, with histories that draw them apart, are forced to talk to one another. This cross-cultural translation is highlighted by motif of verbal imitation in *Clockers*. For example in the scene where Rocco meets up with Strike to discuss the killing of Darryl Adams, they exchange not only humor but mirror and translate each other's language for the purposes of communication. Strike says he knows Darryl Adams "just by eye" and Rocco repeats the statement "just by eye," ironically centering their verbal conversation on occularity. The two also exchange jokes in their conversations in ways that seemed designed to highlight the act as an exchange. When Rocco says that Strike probably looks exactly like his brother at night, Strike replies, "what you think all niggas look alike at night?" Rocco responds, jokingly, "Hey, I can't even tell you guys apart in the day." "Oh, you got jokes!" Strike responds, with a chuckle. A few moments later Detective Klein asks Strike, whose memory strategically fails him, "Did you ever hear of Alzheimer's?" Strike responds, "what's that, some kind of beer?" "Wiseguy," Rocco rejoins. The fact that these two men, coming from differing backgrounds can share witticisms across positions—and about the very stereotypes that would seem to entrap them—is an essential part of the appealing nature of Lee's

New York-inspired interracial imaginary. On a more plot-centered level, in order for the mysteries of *Clockers* (Darryl Adams's murder and Strike's fate) to be resolved, there must be acts of translation across various cultural and institutional positions. Although distinct ethnic dialects become legible, here, what is remarkable about them is precisely that their legibility gives way to imitation and, by extension, translation. In this masculine world, it is through acts of verbal performance that violence is avoided and bonds are cemented. Not only does Lee strive for authenticity in dialect, but he reveals the particularities of its application by frequently highlighting the ability of characters—black and white—to code-switch.

Perhaps the best scene for demonstrating how the sonic rather than the visual grounds the spectator is the flashback scene where Rodney, forced by Errol, first kills a man. It also occurs as a part of the center-point sequence of the film, occurring right after the sequence analyzed in the first paragraph of this chapter. The scene is shot in a gritty, obscuring noirish darkness that is blacker than noir, although it utilizes noir's parallel between darkness and an overwhelming sense of wrong. The scene is illuminated only by a yellowish light that pulses in and out, rhythmically punctuating the darkness. It is because of the darkness that we need the soundtrack so desperately to ground us and to orient our attention to the pool of darkness and black flesh that the camera only selectively reveals. Crucially, this originary moment of violence (the first moment where Rodney is forced to use a gun) is the only scene where we hear actual gunshots. None of the characters in this scene, however, is rendered evil nor are their deaths sensationalized. From the very start of the story and scene, Rodney, whose voice-over narrative adds to our sympathy for him, explains why Errol forced him to shoot the man. This scene underscores the fact that at no point in *Clockers* is there a death about which we are happy—nor is any character villainized by the film. This aesthetic is quite different from *Boyz n the Hood* where the audience is prompted to hate (at least momentarily) members of the rival gangs. It also stands in stark contrast to the demonization of drug dealers in *New Jack City*, which appears for example, in the film's final scenes, where we witness the death of Nino Brown. *New Jack City*, an action-based cinematic phenomenology based on urgency and revenge justifies the violence against the crack dealers, obscuring the fact that they are merely pawns in a larger system. The soundtrack confirms the evil of Nino Brown, both by the scoring and by the audible comments by the congregating crowd that the cops should "kill him." In *Clockers*, by contrast, neither Errol nor the drug dealers are portrayed as evil. Without the cinematic construction of urgency through sound, we are not provoked to take sides. Nor do we overidentify with the horror of the scene in such a way as to desire the demise of Errol, who we already know has since become a victim of AIDS.

Conclusion

The hood films collectively and consciously challenged the dominant narrative of the drug trade offered by the war on drugs paradigm. Long before *Traffic* (2000), they suggested the hold that the drug traffic had on the African American community and its frightening effects. Lee's *Clockers* employs soundtrack to suggest to viewers that the war metaphor is not only untenable but uncompassionate—and incommensurate with a "kinder, gentler" set of national values. By eschewing sound effects, he dislodges perceptual identification, offering the soundtrack as the film's consciousness. Through his scoring, he suggests that even black violence must be understood to be tragic and in the context of a broader tragic set of circumstances. The score's epic orchestral tones also suggest the grand scale and importance of even this localized "everyday" narrative, challenging the marginalization and desensitization of white Americans toward violence against African Americans (and especially black "criminals"). In *Clockers*, dialogue tracks and lyrical music also serve to complicate and unmoor the stereotypical solidity of the hood film's visual track, providing sites of identification and ways of "knowing" the text outside classical narrative legibility.

While we might question and problematize Lee's choice of melodrama and the epic sadness as participating in an apolitical culture of poverty lament and trace its roots back to the neutering social problem tradition of the cinema (one authored by liberal whites in the 1940s), it is clear that Lee's techniques are designed to provide sites of thoughtful, reflective identification and to promote black consciousnesses. This chapter joins with previous scholarship suggesting the dialogism of Lee's films but seeks to show how that dialogism extends to and is technically accomplished by the unique use of music, music which works on viewers in different ways from those offered in other Hollywood films and with differing effects on viewer identification and ideology.

Notes

1. Corrigan compellingly suggests that contemporary Hollywood cinema is marked by an absence of the sort of legibility presumed common to the classical cinema. He states: "What befuddles interpretive reading is the promise of a textual secret that most readings claim to retrieve but which can never be semiotically discovered or designated" (Corrigan, 1991, p. 55).

2. Paula Massood notes that the film "foregrounds its own processes of manufacture" (Massood, 2003, p. 196).

3. Steve Neale, in his discussion of verisimilitude in genre films has suggested that each genre provides its own internally derived sense of verisimilitude based upon audience expectations,

and premised on the belief that audiences have in these structures. But he has also suggested the possibility of a transgeneric real based upon a set of corroborating indexes borrowed from the broader culture, creating something Neale calls "cultural verisimilitude." As Neale puts it, "gangster films, war films, and police procedural thrillers, certainly often mark that appeal [to cultural verisimilitude] by drawing on and quoting authentic and authenticating discourses, artifacts and texts" (Neale, 2000, p. 159).

4. Among the few studies that grant Lee's sound centrality is Robert Stam's work, which uses Lee's films as a case in point in its invocation of Bakhtinian polyphony in the cinema, arguing that Lee's films host the kinds of dialogical exchanges that point to the relational nature of ethnicity. Stam powerfully uses Lee to argue that understanding the workings of power requires admitting and exploring the contradictory, heteroglossic utterances (both racist and antiracist) that make up interethnic exchange. But Stam's work does not attempt to extend a discussion of dialogism across various aspects of the sonic field but rather focuses on the verbal alone. With implications for understanding Lee's use of sound reaches beyond any one Lee film, Victoria E. Johnson cogently discusses the cultural and historical significance of the musical elements of Lee's *Do the Right Thing*, suggesting provocatively that Lee applies a rap aesthetic, one which includes sampling.

5. The film was originally to be directed by Martin Scorsese, who opted out of the film in favor of directing *Casino*. Scorsese then invited Lee to take on the *Clockers* project. According to Hollywood-lore, *Clockers* was originally intended to be focused on Rocco Klein, the ethnically mixed police chief who attempts to solve the crime, but in Lee's hands, the drama took a different direction, eschewing what Ella Shohat and Robert Stam have termed "compromise focalization" from the perspective of the cop, and making Strike the protagonist and Victor a highly sympathetic figure. Although Lee was the director of the film and therefore presumably had final say on all of its elements, the film was the first project on which Skip Lievsay was credited as sound designer, a position that typically entails overseeing all aspects of film sound, from dialogue, to Foleys, to postproduction sound. The scoring was handled by jazz musician Terence Blanchard, who was also responsible for many of Lee's other films and for a number of other films featuring African American themes and iconography. Shohat and Stam borrow the concept of focalization from Gerard Genette, who complicates the notion of point of view by examining how a text adopts certain characters as their "centers of consciousness" even if these characters never act as narrator. In Shohat and Stam's terms focalization "reaches beyond character perspective to the structuring of information within the story through the cognitive-perceptual world grid of its inhabitants" a "grid" that the audience comes to share through the delimiting effects of focalization. In film, since there is no explicit narrator, the concept is even more useful and is employed to determine which character acts as the "filter" through which we receive information. In general, even texts that are focused on minority characters are often focalized through white characters (e.g., *Pinky* uses Jeanne Crain's whiteness as alibi; *Glory* is focalized through the letters written by Robert Gould Shaw). The relationship between focalization and audience engagement is direct: the characters through whom the text is focalized are those with whom the audience tends to identify. (Shohat & Stam, 2000, p. 205)

6. How viewers identify with films is a question that has been addressed by a variety of those writing on the cinema from the medium's earliest beginnings. But the question of where and how viewers systematically differ in terms of cinematic identification has engaged much the-

oretical attention since the 1970s. Following Mulvey, who was one of the earliest to challenge the notion of the universal spectator, work by Gaylyn Studlar and others has added complexity to Mulvey's theories of female identification by suggesting that various factors mediate audience identification. Studlar's work on Joseph Von Sternberg and Marlene Dietrich not only complicates the notion of a universal female spectator but suggests the possibility that genre, auteurial vision, and actor dynamics all influence modes of screen engagement (Studlar, 1988). Cognitivism, a more recently developed psychological approach which has discussed identification, has contributed both precision to the inquiry and has acknowledged, significantly, that there are various types of identification (emotional empathic, sympathetic, perceptual, among others) that work in different—and not always interdependent—ways. Murray Smith, preferring the term "engagement," has suggested problems with the term identification itself, citing the term's original meaning—"becoming like" and its originary connection to mimesis—when often it is actually closer to emotional sympathy. He suggests instead the term alignment (which, quite similar to Gerard Genette's "focalization," describes perceptual and subjective access to screen characters *provided by the film*) and "allegiance" (the spectator's moral alignment with the character). Second, he explores those types of identification that exist *in consciousness* (rather than unconsciously) and can therefore be measured (M. Smith, 1995; J. Smith, 1999).

7. This is perhaps most obvious in the "under the El" sequences in *Malcolm X*, where Shorty and Malcolm use the nondiegetic sound as a basis for a walk that comes to define their postwar, proud, zoot suit identity and their particular mode of traversing urban space.

8. "Survival of the Fittest/Return of the Crooklyn Dodgers" Written by Chubb Rock, O.C., Jeru the Damaja, and DJ Premier. Used in the film by permission of Getaloadoffatso/Hittage (BMI) Organismz Music (BMI), Almo Irving Music (BMI) Gifted Pearl/EMI Music (ASCAP). Performed by Crooklyn Dodgers '95.

9. As in *Jungle Fever*, where the semidiegetic sounds of Frank Sinatra—on a jukebox, we imagine—punctuate the dialect-driven dialogue between the Italian American men in Pauli's shop, lending the space a sense of local and ethnic authenticity, the music in *Clockers* marks location. For example, the bar known as the "Kool Breeze" is marked not only by the presence of rap music but by its emanation from a music video on the bar's television. Images from this television repeatedly commandeer the screen and add to the milieu. Rather than interrupting the dialogue, this semidiegetic and diegetic music operates to confirm the centrality of music (and its accompanying images) in establishing a sense of place.

10. This tonal mismatch is a consistent feature of Lee's soundtracks in films other than *Clockers*. For example, the light and almost playful tonality and lyrics of Stevie Wonder's "Jungle Fever" would seem to contrast with the seriousness—and ultimate tragedy—of the narrative it introduces and represents.

11. For lyrics for "People in Search of a Life," contact the distributor of the soundtrack, MCA records.

12. "People in Search of a Life" Written by Raymond Jones; Used in the film by permission of Zubaidah Music/MCA music (ASCAP) Performed by Marc Dorsey.

13. This same sonic irony surrounds the verbal treatment of Darryl's dead body that occurs in the course of the film narrative. Rocco and Mazilli and the medical examiners cope with Darryl's corpse with a string of gallows humor designed to distance themselves from the victim. Darryl, although anthropomorphized and directly addressed by the detectives, is only

resurrected in caricature, as his narrated body becomes the receptacle for bullets and male bullet humor, most of which refers to sports (golf, baseball, etc.), further framing the body as spectacle. The film also deals with the horrors done to the live black body by the cops, who publicly undress Strike in the first scene of the film, by Rodney who nearly kills Strike, and by the product Strike drinks, which gives him an ulcer and points to a more systematic victimization through commercial poisoning.

14. "Silent Hero" written by Des'ree and Prince Sampson. Used in the film by permission of Sony Music Publishing UK; Admin. By Sony songs, inc (BMI) Perfomed by Des'ree Courtesy of Sony 5500/Epic Records By arrangement with Sony music licensing.

References

Altman, Rick (1995). The sound of sound: A brief history of the reproduction of sound in movie theaters. *Cineaste 21*(2), 68–72.

Brecht, Bertolt. (1964). *Brecht on theatre: The development of an aesthetic* (John Willet, Trans.). New York: Hill and Wang.

Chion, Michel. (1994). *Audio-Vision: Sound on screen.* New York: Columbia University Press.

Corrigan, Timothy. (1991). *A cinema without walls.* New Brunswick: Rutgers University Press.

Diawara, Manthia. (1993). Black spectatorship: problems of identification and resistance. In Manthia Diawara (Ed.), *Black American cinema* (pp. 211–220). London: Routledge.

Gabbard, Krin. (1992). Signifyin(g) the phallus: 'Mo' Better Blues' and representations of jazz trumpet. *Cinema Journal 31*(1), 43–62.

———. (2000). Race and reappropriation: Spike Lee meets Aaron Copeland. *American Music 18*(4), 370–390.

Genette, G. (1980). *Narrative discourse.* Ithaca, NY: Cornell University Press.

Gilroy, Paul. (1995). "After the love is gone": Bio-politics and etho-poetics in the Black public sphere. In Black Public Sphere Collective, (Ed.), *The Black public sphere: A public culture book* (pp. 53–80). Chicago, IL: University of Chicago Press.

hooks, bell. *Black looks.* (1992). Boston, MA: South End Press.

Johnson, Victoria E. (1993-94). Polyphony and cultural expression: Interpreting musical traditions in *Do the Right Thing. Film Quarterly 47*(2), 18–29.

Lee, S. (Director) (1995) *Clockers* [Motion Picture]. United States. Forty Acres & a Mule Filmworks.

Massood, Paula. (2003). *Black city cinema: African American urban experiences in film.* Philadelphia, PA: Temple University Press.

Metz, Christian. (1982). *The imaginary signifier.* Bloomington: Indiana University Press.

Mitry, Jean. (1997). *The aesthetics and psychology of the cinema.* (Christopher King, Trans.), Bloomington, IN: Indiana University Press.

Neale, Steve. (2000) Questions of genre. In Toby Miller & Robert Stam, (Eds.), *Film and theory: An anthology* (p. 159). Malden, MA: Blackwell Publishers.

Pizzello, Stephen. (2002). Between a rock and a hard place. In Cynthia Fuchs (Ed.), *Spike Lee interviews* (pp. 99–111). Jackson, MS: University of Mississippi Press.

Shohat, Ella, & Robert Stam. (2000). *Unthinking Eurocentrism: Multiculturalism and the media.* New York: Routledge.

Smith, Jeff. (1999). Movie music as moving music: Emotion, cognition, and the film score. In Carl Plantinga and Jeff Smith (Eds.), *Passionate views: Film, cognition and emotion* (pp. 146–167). Baltimore, MD: Johns Hopkins.

Smith, Murray. (1995). *Engaging characters: Fiction, emotion, and the cinema.* New York: Oxford University Press.

Stam, Robert. (1991). Bakhtin, polyphony, and ethnic/racial representation. In Lester Friedman (Ed.), *Unspeakable images: Ethnicity and the American cinema* (pp. 251–276). Urbana, IL: University of Illinois Press.

Studlar, Gaylyn. (1988). *In the realm of pleasure.* New York: Columbia University Press.

They Hate Me

Spike Lee, Documentary Filmmaking, and Hollywood's "Savage Slot"

JASMINE NICHOLE COBB AND JOHN L. JACKSON

In 2004, Spike Lee released his eighteenth feature-length film, *She Hate Me*, to fairly mixed reviews—including some pointedly scathing criticism. Detractors highlighted the story's sprawling and implausible depiction of many seemingly discrete topics—everything from corporate criminality and institutional racism to bioethics and familial strife (with many more themes sandwiched rather conspicuously between those). Some critics (Barton, 2005) even described the film's central depiction of lesbianism as little more than a male heterosexist's wet dream, an ultimately heteronormative fantasy-scape that reduced Sappho-erotic possibility to some kind of penultimate and preparatory stage before the inevitable and unstoppable reemergence of heterosexuality's incontestable primacy.

A steamy threesome by film's end—with the male lead, John Henry "Jack" Armstrong, his ex-girlfriend, Fatimah Goodrich, and her new female partner, Alex Guerrero—serves as a ménage a trois that consummates their newly formed tripartite union. The narrative culminates in a polygynous and patrilineal happy ending of one husband, two wives, and Jack's many, many children. Intertwining this hypermasculine and heterosexual fantasy of sexual conversion-cum-voluntarism with a tale of corporate greed and corruption led many to question the film's lack of focus—and Spike's own sexual politics. At a Harlem screening of the movie during its opening weekend, Jackson (co-author) sat in a Magic Johnson theater where one thirty-something black woman got up from her seat during the

denouement—as the loving threesome kissed and hugged—to vehemently scream at the film as she stormed out of the auditorium: "Motherfuck you, Spike Lee!" A good portion of the audience then erupted in an impromptu round of applause, as if to second her condemnation.

This sort of strange discomfort created by the viewing of *She Hate Me* is nothing new for Spike and his filmic "joints." In fact, most serious filmmakers crave intense responses to their work, and the majority of Spike's films—*Do the Right Thing* (1989), *Jungle Fever* (1991), and *Clockers* (1995)—demand nothing short of such intensity from audience members. One of Spike's most controversially intense "race films," *Bamboozled* (2000) was disparaged for playing with the power of blackface minstrelsy in ways that may not have short-circuited the tradition's utterly racist inflections, while at the same time uncritically deploying offensive stereotypes of the black bourgeoisie (as embodied in the film's over-articulate main character, Pierre Delacroix). But Spike seems to enjoy his own bourgeois class positioning in spite of his racial politics, a positioning predicated on his privileged Morehouse College and NYU film school education. Cultural critic Todd Boyd (1997) sees Spike as part of a group of "African Americans who came of age after the civil rights and Black Power eras, whose initial recognition of African American culture resulted from the images that proliferated during the 1970s" (p. 24). For Boyd, Spike's imagistic tropes of militancy become "racial wolf tickets of black nationalism" that prove "somewhat less threatening when we consider that his films now command the attention befitting a true Hollywood auteur, and that he is one of the few African Americans in Hollywood who can regularly count on their projects being given the coveted 'green light'" (p. 25).

However, being given a version of the highly coveted "green light" is not necessarily proof of regular box office success because there are green lights, and then there are Green Lights. While it is true that Spike is a Hollywood insider, he still had to canvas black celebrities, hat in hand, to finish postproduction on his magisterial *Malcolm X* (1992) after the studio slammed their coffers shut. Additionally, Spike is one of the most high-profile contemporary American filmmakers to embrace the cost-cutting bonuses of mini-DV film formats, which he used almost exclusively for *Bamboozled*, and of Super 16mm film, the lower-end filmic format (compared to 35mm) that he deployed for *She Hate Me*. Artistic preferences have not exclusively driven Spike's decisions in this area. He is also unable to command the film budgets he would desire to complete the projects he is most interested in shooting—his rumored adventures with the idea of a movie about 1950s baseball player Jackie Robinson being a more famous and ongoing example.

Despite his lengthy resume, Spike still enjoys more of a cult following than anything else, someone who appeals to niche markets (especially a certain swath of the middle-class black community) as opposed to more mainstream audiences. For

example, with all the acclaim Spike has received for films such as *Do the Right Thing* and *Malcolm X*, his most successful film by far (in terms of box office receipts) was 2006's *Inside Man*—featuring high-powered superstars such as Clive Owen, Jodie Foster, Christopher Plummer, and Willem Dafoe, alongside Spike mainstay Denzel Washington. At about 90 million dollars in domestic sales, *Inside Man* made more money in the theaters than *Do the Right Thing*, *Malcolm X*, *Bamboozled*, and *She Hate Me* combined. Though *Inside Man* was the highest-grossing film in America during its opening weekend, it still was outperformed that year by arguably mediocre offerings such as *Click* (a flop by Adam Sandler's standards) and *Scary Movie 4* (where the high-point was a cameo by Dr. Phil), neither of which was among the top ten grossing films of that year.

When people try to articulate reasons for Spike's lack of blockbuster success at the box office, they often begin with a discussion of his writing style, arguing that he tries to take on too much (e.g., *Bamboozled*, See Schwarzbaum, 2000), creates too many subplots (*Jungle Fever*, *Get on the Bus*), and ends up with convoluted (*Summer of Sam*) or bloated (*He Got Game*, *Clockers*) narratives. Even when Spike goes out and finds writers whose scripts he can direct—such as Pulitzer Prize-winner Suzan-Lori Parks for *Girl 6* or Michael Genet for *She Hate Me*—the results are usually met with similar head-scratching dismissals as a function of narratological and directorial overindulgences. Invariably, the bulk of Spike's films are said to take on too many stories, develop them too little, and offer racio-ethnic analyses as the beginning and end of all social analyses. They also inevitably exhibit a specifically Spike Lee-esque quality that combines an unflinching commitment to race politics with an equally adamant investment in film as an artistic medium with its own specific aesthetic possibilities.

At the same time, one of the most common responses to Spike's filmic excesses is to portray him as a much-better (and clearer) documentarian than fictional filmmaker. Spike's documentaries are thought to eschew his more solipsistic and theatrical flourishes in favor of just listening carefully to other people's storytelling gestures. He is believed to take fewer artistic liberties in his nonfiction offerings, instead simply staying focused on just one subject: four innocent victims of southern racism (*Four Little Girls*, 1997), an African American sports icon (*Jim Brown: All American*, 2002), or a tragedy in New Orleans (*When the Levees Broke*, 2006). Spike still exhibits some of his patented flair, but it is muted just a bit, deployed exclusively to advance the larger story being told rather than distracting from it.

So, when Spike "documents" he is "brilliant" at capturing the ostensibly real, but when he fictionalizes a black world of his own imagining, he is said to overreach, turning his stories into centrifugal messes. Without a middle ground, this reading hardly ever renders Spike as an actual auteur participating in artistic expression. His hyper-blackness is seen as a hindrance to creating successful fiction films that sat-

Figure 13.1. Shown from left on memorial: Denise McNair, Cynthia Wesley, Addie May Collins, Carol Robertson. Courtesy of Photofest.

isfy mainstream audiences and simultaneously leaves Spike most adept at simply documenting "native" accounts of lived black experiences. These critiques of Spike's work ultimately trivialize his creative capacity in a manner reminiscent of other black artists and their seemingly nativist translations, including anthropologist Zora Neale Hurston, novelist Richard Wright, photographer Gordon Parks, and music mogul Russell Simmons. Collectively, these cultural producers' products are more often than not treated as transparent, even nonconstructed, facsimilizations of a pretextual racial community. The producers themselves are almost deemed inanimate entities that merely offer up their lives in a racially native/ natural/ indexical way, instead of as artists with supple and singular skills.

To render Spike's documentary work as more powerful because of its (individually) self-effacing and (collectively) race-translating features actually demeans him as a fiction filmmaker, a dismissive maneuver that is part of a longer tradition relegating "minority" cultural producers to the equivalent of what theorist Michel Rolph Trouillot (2002) famously labeled "the savage slot." Like Trouillot's much-discussed formulation of the problematically quintessential anthropological gambit, we understand black filmmakers like Spike to be relegated to a kind of cinematic

savage slot, tellers of their own tales in an almost precultural and hard-wired way. As such, Spike finds himself reduced to a flat-footed (and transparent) practitioner, a sheer receptacle for "the real," and not a truly introspective theoretician and architect of alternative realities. He becomes a mere chronicler of facts, an emptied cipher, and not a truly self-conscious auteur.

We want to speak to the caricatured renderings of Spike the cultural producer that constitute this impoverished reading of his work, a reading that polarizes racial realities along the lines of documentation versus fiction to perpetuate modernist notions about realism. We argue that because the racialized *Other* continues to represent a project in *becoming* civilized, Spike's films are thought to be at their best when they employ aesthetic techniques that document blackness and help viewers to better comprehend native perspectives. By choosing his documentaries over his feature films, what people ultimately hate about Spike as a fiction filmmaker is the racial fantasy world he creates, a world where selling out doesn't pay and black martyrs can see their deaths coming. A world where black lesbians still crave the black phallus and remain ready and available for their leading black men (as are their nonlesbian counterparts). In Spike's fictive racial universe good black protagonists almost always triumph—even as everyone else tries to keep them down.

Although Spike's documentary films are clearly different from his fictional ones, we argue that they should not be too readily (or absolutely) compartmentalized from his larger body of fictional work. Not only does such a divide ignore the fact that his motion pictures are part of a larger, single-raced project that cuts across film genres; more importantly, we argue that it fetishizes the fiction/documentary divide in ways that ultimately misread the nature and significance of Spike's films and filmic philosophy. Examining Spike's nonfiction films, his fiction films, and the critiques of his work in each area, we argue that examining Spike's offerings demands a kind of substantive bleed-through between seemingly discrete genres of filmmaking in order to better understand both Spike's brand of realism, as well as his popular reception.

Through this lens, the negative assessments of Spike as a fictional auteur challenge Boyd's somewhat overstated rendering of Spike's Hollywood clout, a rendering that ignores the extent to which both Spike's blackness and people's perceptions of him might inform and deform Spike's celebrity. Spike's development of a filmic language all his own (even in seemingly convoluted and arguably sexist movies such as *She Hate Me*) helps to connect his forays into different filmic genres—and demonstrates that the politics, concerns, and goals inspiring Spike's feature films also make themselves known in his documentary accounts. Taken together, Spike's work most ambitiously represents a desire to implode the very distinction between fiction and nonfiction.

Spike as Genre

Across films and film reviews, Spike's repertoire is most notably recognized for its explicit sexuality—and (as highlighted earlier) its sexism. Specifically, Spike's version of racialist filmmaking often falls into the trap of sexist and classist wagon circling around the political primacy of *racial* identity, a move that usually represents blackness through the prism of black masculinity, which comes to symbolize the entire race. And while Spike's black male protagonists take personal journeys throughout the course of his films, they are usually only *supported* by the black female characters, subordinates who are secondary to a larger story written around black male leads. So, for example, trumpeter "Bleek Gilliam," played by Denzel Washington in *Mo' Better Blues* (1990), selfishly maintains two lovers, "Indigo" and "Clarke," before eventually losing everything, including his musical career, his happiness, and both women. At the film's end, Bleek only finds redemption once he returns to Indigo, who agrees to "save his life" by giving birth to a son, Miles. Though Indigo's black womanhood is supposed to be empowered through her redemptive womb, it is still her ability to produce another black man in the Gilliam patrilineal line that constitutes her ultimate value. This championing of black manhood at the expense of black women aligns Spike with more impoverished versions of "race men" as defined by Hazel Carby (1998), men who make exclusionist "male-centered claims" of racial "representativeness" at the expense of black femininity.

This precarious positioning of women in Spike's films is not limited to a single offering. It is pervasive. His first feature film, *She's Gotta Have It* (1986), prominently features the hypersexualized femininity of "Nola Darling" as a lascivious, yet independent, black woman who refuses to settle for a single lover and gets raped as a consequence. Similarly, sex was also accentuated for his character "Judy" (aka Girl 6) in *Girl 6*, where Teresa Randall played an aspiring actress turned phone sex operator who falls down a kind of rabbit hole of sexual addiction, perversity, and violence. Collectively, Spike's films portray female protagonists who invariably necessitate hypersexuality as an overdetermined aspect of their characters' development. Furthermore, the black men who get involved with these female protagonists do not share the strength that generally characterizes Spike's more successful black male leads, especially when these men are unable to dominate their black female costars' characters.

Of course, Spike's subordination of black women in film has not emerged in a vacuum. Donald Bogle (1994) describes the initial excitement generated by *She's Gotta Have It*, as a film that emerged at a moment when "many feared the commercial Black film might be an anachronism, a relic of the 1970s and the earlier decades of race movies," because Spike's first feature presented "a Black filmic sensibility (a Black aesthetic)" that seemed to "also invigorate American movies" more general-

ly (p. 299). However, the perpetual demonstration of black masculinity and hyper-sexualized female counterparts in Spike's films do help to associate his work with the genre of Blaxploitation and the likes of *Sweet Sweetback's Baadasssss Song, Super Fly*, and the *Mack*. These canonical examples of race-at-the-expense-of-gender black filmmaking accentuate the strength and virile nature of the black male lead who may sell drugs, participate in organized crime, or take down corrupt government officials, but always, always win—whether vis-à-vis black women or white America at large. Although these Blaxploitation films have since been soundly criticized for their unabashed sexism, they are also directly lauded for cultural sensibilities that foster racial pride and emphasize/fantasize the black man's triumph against whiteness and institutional racism. Again, this fact aligns Spike with the Blaxploitation genre through his repeated commentary on black masculinity as a decidedly prized possession, a privileging reiterated through his filmic commentaries on black "sell outs." In films like *Bamboozled* and *Jungle Fever*, Spike continually shows that a fascination with (or overinvolvement in) whiteness—whether it be white women, white men, or white-centered corporate America—ultimately leads to a black man's violent demise, violence that, according to theorist Lindon Barrett (1999), "betrays the original instance of all value" (p. 28), including and especially racial value. So in *Bamboozled*, Pierre Delacroix's willingness to betray blackness by reinvigorating televisual stereotypes for the sake of his own corporate success (akin to Flipper Purify's dedication to his lucrative corporate job and extramarital affair with a white secretary in *Jungle Fever*), a successful black man finds his life ended or ruined, his racial value diminished, through his poor—even racially self-destructive—choices. Devaluing blackness for the sake of mainstream acceptance continually proves unfruitful in Spike's cinematic landscapes.

Problematically for Spike, his films are also imagined to diverge from the Blaxploitation genre in that they are not always considered authentic representations of a larger political sensibility within black America, such as can be found in "Black Power" rhetoric or the Black Arts Movement, and therefore his offerings are not necessarily credited with doing the same kind of work as films such as *Shaft*. Additionally, while at times the class implication of Spike's films show the black bourgeoisie as fatally committed to whiteness at the expense of black difference, critics cite the absence of any apparent self-consciousness and reflexivity on Spike's part with regard to his own aforementioned bourgeois status. A review of *Bamboozled* in the *Village Voice* (Tate, 2000) argued that the film, defeating its maker's political purpose, "is also a minstrel performance of sorts by its director," and that through Spike's choice to execute Pierre Delacroix for selling out, rather than, say, his white boss, Thomas Dunwitty, Spike's film does not "violate the rule of mainstream cinema that politically conscious Black men cannot be shown on-screen inflicting pain on white males—especially if they're the kind of white men who green light film

budgets" (p. 54). Thus for *Bamboozled* to successfully provide a revolutionary racial commentary, one that capitalizes on Spike's mainstream success rather than securing it, Spike might have handled his black protagonist differently. The fact that he does not is read as a result of Spike's own Hollywood success and the limitations and lacunae intrinsic to his own racial politic.

As a body of work, then, Spike's feature films center on black men, and at times, are entirely about black men, such as in *Get on the Bus* (1996). They frequently condemn the pretensions of bourgeois blacks like Flipper Purify and Pierre Delacroix, while rarely reflecting on the middle-class sensibilities of anticorporatist blacks like Bleek Gilliam or a fired Jack Armstrong. Spike's films also feature (especially early in his career) an almost Woody Allen-esque move wherein the characters that Spike himself plays in his own films all tend to blend into one another and end up signifying little more than Spike himself, the extradiegetic figure.

A Black Body Politic

Spike is as blatant and single-minded in his directorial heavy-handedness as he is in his racial heavy-handedness. He crafts his own idiolectic film language of conspicuous jump-cuts and ghostly tracking shots. In many fundamental ways, Spike seems as fixated on the aestheticization of race as on the racializing of filmic aesthetics—a tension that distinguishes his directorial voice and defines his complicated holistic approach to filmic narrativity.

The red-thread running through Spike's work speaks to a heavy-handed cultural politics about the nature of performing black racial identity. What critics understand as an "obsessive" invocation of racial/ethnicity politics occurs through the music that scores Spike's films, the speech of his characters, their styles of dress and body language, their artistic expressions, and other purposeful representations of black popular culture portrayed on camera. Through characterizing his successful characters as eminently black, while giving racial failures (like Flipper Purify) a painfully standard English dialect or (Pierre Delacroix) a seemingly faux-French accent that implies an even further distance from black America, Spike accentuates black racial identity and politicizes the cultural choices made by his male and female characters. Politics, for Spike, refers to the politics of participating in black American culture, and as such, political choices have repercussions not only for his film characters, but also for the viewers forced to read those ethical or unethical choices alongside them. So, just as Flipper's racial impropriety is coupled with faulty ethics around adultery with a white woman, so too do Malcolm X's early moral transgressions involve dating white women (and in ways that consequently scar the black women pining for his affection).

It is on these grounds that critics often dismiss Spike for being too mechanically and flat-footedly "political" around questions of black racial identity. Douglas Kellner (1997) argues that in Spike's work "politics per se are subordinate to creating one's identity and identity is defined primarily in terms of cultural style" (p. 74), a choice that "deflects attention and energy from pressing political and economic issues and may well produce a separatist consciousness that undermines a politics of alliance that would mobilize distinct groups against oppressive forces, practices, and institutions" (p. 89). Moreover, because "identity for Spike is primarily Black identity, and he constantly operates with a binary opposition between Black and white, 'us' and 'them,'" (p. 97) Spike is said to fail politically in that he "does not rise above the repertoires of dominant images already established and reproduces many questionable images of men, women, Blacks, and other races" (p. 99) by unfairly limiting their possibilities for authentic performances of self.

Spike's black cultural ideology/sensibility is further emphasized by his attempts to gesture directly to the camera (to cinematic mediation itself), especially with respect to his famous staccato and/or jumped-cutting sequences. These maneuvers are less generously read as just another (mere) Spike Lee thumbprint, something included at the expense of the narrative itself. These filmic gestures are dismissed for conspicuously catapulting the viewer out of the otherwise realist text, failing to advance the story or symbolize something coherent and self-evident to viewers.

The most obviously "patented" Spike shot of this type consists of characters walking along the street without the slightest hint of a striding gait. They invariably face the camera in a fairly standard medium shot or close-up and commence to walk *without walking*. Instead, the camera and actor are both placed on a dolly and simultaneously/connectedly breeze through the landscape as if fundamentally disconnected from it and from the very rules of spatial physics. Taken collectively and understood in context, this mobility is usually salient to the story being told and always speaks to the floating characters' immediate relationship to the world around them. In *Mo' Better Blues*, Spike's character, the gambling addict "Giant," attempts to evade his bookie's henchmen with recourse to this otherworldly motion. In *Crooklyn*, "Troy" speeds toward the glue-sniffing drug-heads who bullied her little brother with a bat, completely unencumbered by adults or onlookers on the street. Finally, the soon-to-be-slain Malcolm X glides along the streets of Harlem all alone, alienated-almost like a ghost of someone who has already been assassinated, drifting toward his own preordained death. Spike accentuates Malcolm's pensiveness and sense of foreboding by having him shocked out of his floating stupor by an old black woman who seems to break his heart with a canned (even if sincere) invocation of "Jesus" as his only salvation.

To make sense of this scene, and of Spike's approach to filmmaking more generally, it might be helpful to imagine his hyperaware racial politics and his reality-

busting directorial stylings (such as the aforementioned dolly shots) as mutually constitutive forms of the selfsame problem of "excess" and "overkill" said to plague his work. Spike's version of filmmaking—unlike, say, John Singleton's work in *Boyz n the 'Hood* and *Higher Learning*, with whom Spike was often compared in the 1990s—exhibits a kind of hypertheatricality even as it overcommits to a form of hyper-urban (and -racial) realism. In many ways, Spike's films are productively schizophrenic texts: one part verite-esque homage to ultrarealism (almost feeling the closed-fisted blows of racist Italian fathers, experiencing the crack-induced highs of drug-addicted siblings, witnessing the tiniest details of a racial leader's brutal assassination) and one part fanciful, cartoon-like allegory of racial loss and redemption (replete with oversaturated color-palettes, characters deploying grand demonstrative gestures/gesticulations, and a camera's implausible movements through time and space). Such directorially dialectical tensions within Spike's films strike a far different balance between plot and playfulness than any of Singleton's "race films," which seem to proffer a single-minded compunction to simply tell a story, without recourse to many of the particularities of film's genre-specific aesthetic potential. Singleton's commitments to racial realism are just as severe, but without much of Spike's rich aesthetic boldness. In fact, part of what makes Spike's films demanding as texts is their supple short-circuiting of conventional borders between reality and fable, realism and antirealism, the proscenium artificialities of theatre and the indexical/iconic self-evidentialities of photochemical reproducibility.

Documentary Savages

Spike's version of what might be called "theatrical realism," which we would contend is analytically distinct from notions of "magical realism," thrives on his refusal of the arbitrary and contrived choice between aesthetics and politics. His racial realism with a flair for its unreal opposites is actually about a different project of generic and textual confounding: a crossing of the line between fiction and nonfiction, civilized and savaged, exploding assumptions about the discrete difference between those two spheres and their mutual exclusivities. This fiction/nonfiction divide is also important because it speaks to the differences between how Spike's fiction and nonfiction films get received.

Spike's complicated commitments to a kind of "non-non-fiction" fictional filmmaking might be productively linked to what Fatimah Tobing Rony (1996) imagines to be the "third eye" of minoritarian spectatorship. For Rony, there is a way of seeing and photographing that is decidedly predicated on one's structural marginalization vis-à-vis the racist, sexist, and colonialist gazes of the self-congratulatory and narcissistic West (narcissism similar to that unpacked by Trouillot: a

version of seeing that sees only itself, even and especially when viewing its own culturally constructed and demonized other).

Where Rony imagines a form of seeing predicated, ontologically, on the seer's status (in her iteration of things) as a fetishistically photographed woman of color (think of the Hottentot Venus as a kind of quintessential example), Spike imagines a form of racial sight that conflates the real with the made up, the factual with the fictive. Spike's movies are arguably about breaking down that distinction altogether. Whether or not one believes that Spike's move is ultimately a good or bad choice (politically or creatively), it is a necessary aspect of fully recognizing, viewing, and appreciating his work—and its wider, even paradigm-shifting, implications. His aesthetic choices reinforce a skeptical sensibility vis-à-vis too-quick fetishizations of not just realism but reality—the real. For example: the way Spike reintroduces "real world footage," personages, and actual production drama (with people playing themselves in a kind of neo-verite way) at the end of a movie like *Malcolm X* is an ode to previous offerings that recuperate the technique for current filmmakers (for instance, Spielberg in *Schindler's List* a year later). It opened the door for similar invocations at the ends of biopics such as *The Last King of Scotland* and even a pulp piece like *Domino*. The "based on a true story" ethos gets wired to the indexicality of photographic and filmic factuality: images of the "real" Idi Amin and Domino Harvey displayed before the closing credits start to role. In *Malcolm X*, the much more robust and daring "I am Malcolm X" closing sequence (replete with Ossie Davis reprising the eulogy he actually wrote and presented at the slain leader's funeral in 1965) offers a pan-Africanist gesture that stretches across the Atlantic, with Nelson Mandela playing himself (and declaring that he, too, is Malcolm X) in front of a classroom full of South African students. And while other filmmakers make such moves, they are rarely as nuanced and substantive as Spike's layering of storytelling on film. Even his real-life financial troubles during the making of *Malcolm X* get rewritten into the end of the film with his African American benefactors (Bill Cosby, Janet Jackson, Michael Jordan, etc.) shown explicit appreciation by having Spike depict them during the film's closing credits. Again, this is Spike folding fiction and nonfiction (diegesis and extradiegesis) into one another and transforming the porous borderland where they meet. For Spike, not only might they be folded into one another. They must be; they are a part of his selfsame deconstructionist project.

Spike consistently makes interesting attempts to self-consciously embed fiction and nonfiction into one another: by casting Al Sharpton as a version of himself in *Bamboozled*, using noted nonacting basketball player Ray Allen to play a basketball player in *He Got Game*, making a self-immolating cameo as himself in the race-deprogramming film *Drop Squad*, inviting Quentin Tarantino to play a fairly lecherous film director named QT in *Girl 6*, including actual Million Man March

material in *Get on the Bus*, setting Rodney King footage as the backdrop for a Malcolm X speech at the beginning of that movie, and scrawling "Tawana told the truth" graffiti on walls in *Do the Right Thing*. These gestures all signal Spike's vision of how the real and the (seemingly) unreal inevitably interact. However, splices of the real are not deemed real at all in his fictional work, and the imaginary racial world of his feature films get dismissed for failing to offer us anything real and substantive about racial politics that we can hang on to. The savage has gone civilized and lost his native edge.

To most critics, that edge seems sharpest in Spike's *non*fiction films. As a body of work, they are often better received than Spike's fiction films. His first, *Four Little Girls* (1997) received an Academy Award nomination for best documentary, while *When the Levees Broke: A Requiem in Four Acts* (2006) won the Human Rights Film Award and the Venice Horizons Documentary Award at the 2006 Venice Film Festival. Through his work documenting black life, Spike is deemed a superb cataloguer of "native" experiences. His films are lauded for their transparent racial authenticity. Hence, it becomes the nonfiction films' emphases on focus (a single topic), veracity (an actual event or figure), and objectivity (with Spike's individual flourishes relegated to the margins of the text) that result in praise for Spike's work. When Spike illustrates those slotted as "savage" through the seemingly transparent genre of documentary film, his rendering of their racial experiences is continually deemed more satisfying than the more convoluted (murky) terrain of fiction, even as it is peppered by the real.

In "Anthropology and the Savage Slot," Michel Rolph Trouillot (1991) describes "the 'savage' slot" as an ancient position newly reinforced when "the 'scientific' study of the savage qua savage became the privileged field of academic anthropology"(p. 28)—a position Spike is made to share through an uncritical investment in the black filmmaker's ability to translate racial alterity for mainstream audiences. Trouillot explains that anthropology as a discipline "did not create the savage slot. Rather, the savage was the *raison d'être* of anthropology. Anthropology came to fill the savage slot in the trilogy of order-utopia-savagery, a trilogy which preceded anthropology's institutionalization" (p. 40) by becoming the designated space for chronicling the native's distinction. In similar ways, the canonizing cinematic discourse/apparatus that commands easy ethnic self-translation from the "native" filmmaker, Spike, likewise fills the prefabbed savage slot in film by relegating the camera-wielding *other* to little more than a ventriloquized oracle for dominant "Western" preconceptions and misconceptions about diverse cultural and racial groups. However, Spike's stylized blurring of the boundaries between fiction and nonfiction rebukes such puppeteering, by insisting to be recognized for the decidedly artificial (if no less sincere) reconstitution of a racial project that it imagines itself to be, a racial project not entirely reducible to Western fantasies. That's

because it fantasizes itself-and, at least partially, on its own terms. Spike's nonfiction films grope for the same contrarian's positionality that his fiction illustrates, even as they revel in their own easy references to historically verifiable facts.

Talking Heads, Archival Clips

In *Four Little Girls*, which documents the story of the Birmingham church bombing that killed four adolescent girls during the summer of 1963, Spike was credited (McCarthy, 1997) with offering "a compelling, straightforward account of a deeply sorrowful and pivotal event in the civil rights movement," taking a "talking-heads-archival-clips approach to the material" (p. 38). With this, Spike achieves "an admirable balance between touching personal anecdotes and the larger sociopolitical view" by placing individuals related to the event directly before the camera and surveying "evidence" such as autopsy photographs and court documents. Ultimately, the success of *Four Little Girls* is said to stem from the fact that it "lacks the stylistic idiosyncrasies for which the director is known" (p. 39) such as his signature camera angles and dolly shots, or his own conspicuous appearance in the film. For critics, *Four Little Girls* tells a real story of real events unencumbered by Spike's own stylistic (over-) presence as film director. Moreover, the pseudoscientific reading of his use of "talking-heads" and archival footage lends Spike a clinical credibility and objectivity that seems to assume, just a bit too quickly, that Spike makes very few directorial decisions that unduly bear on the story presented to viewers. Of course, all film critics understand that there is no such thing as true "objectivity." As soon as you turn on the camera, you've begun to editorialize—by framing certain elements out, hardening the focus on particular elements still within the frame, and even deciding to turn the camera off again at some point. Still, we are seduced by the documentary form as a kind of hands-off approach to storytelling that simply allows the filmed subjects to "speak for themselves."

Yet it is exactly Spike's camera choices that critics are actually responding to when praising the film, even while noting that he is a bit less heavy-handed and blatant with his racial politics in ways that supposedly open up his films to more nuance and subtlety. Rather than creating a scene emergent from his own imagination, Spike seems to get out of the way, folks say, and let the people tell their own stories. Instead of layering the film with blatant examples of blackness for blackness's sake, Spike's documentaries present viewers with black families and a complicated assortment of whites; so that in films like *Four Little Girls*, good and bad characters do not always appear to be predetermined by racial identification (a feature of his fiction as well). There is a white antagonist, like Bob Chambliss who was found to be responsible for the church bombing, as well as white do-gooders like prosecutor Nicholas

Katzenbach, who clearly fought on the side of justice and equality. Since the diversity witnessed on screen isn't typically attributed to Spike the feature filmmaker (though it should be), Spike is selectively misread as little more than an automatic chronicler of some exclusively black nativity, especially when he has not tainted the scene with his own racial politics, read as the feeble attempt of the native to offer up larger analyses that outstrip the simple facts of his everyday life. Unlike in his feature films, Spike's documentaries supposedly allow audiences to see life and racial identity as they really are—with Spike excluding his own appearance on film and the ostentatious racial politics and aesthetics that pale in comparison to the sheer and uncomplicatedly rendered facts of his native existence.

However, Spike's presence is ubiquitous in documentaries, too; his voice is often distinctively heard even when his face does not appear on camera. In *Four Little Girls*, he pursues answers from Alpha Robertson about the loss of her daughter Carole, jokingly distinguishing himself from Mike Wallace and Ed Bradley. Similarly, in a sequence on white fear in *When the Levees Broke* he asks a well-armed Emil Dumesnil if he was looking for "Bin Laden" when he returned to the Lower Ninth Ward brandishing a 9mm handgun. So, even as viewers are less bombarded by the visual markers that typify Spike films, he continues to guide the story presented, choosing to ask specific questions and to edit in particular responses. In assuming that Spike "gets out of the way" in his documentaries, critics fail to consider how these offerings present stories from a narrative perspective that reiterates Spike's politics, even if a bit less explicitly (and, therefore, more persuasively). The fact that the story of the church bombing was based on actual events, and includes the genuine perspectives of various individuals directly impacted by them, does not negate its dependent relationship to Spike as storyteller and visual artist.

Spike's lesser-known *Jim Brown: All American*, a documentary that presents the life of Jim Brown the football player, actor, and activist, also illustrates the potential for documentary film to speak to Spike's racial project. In this offering Spike scantily deals with the details of Brown's exploits as a questionable father and accused womanizer/abuser. He does, however, emphasize Brown's significance as a black athlete turned actor who starred in a series of somewhat popular films (with exploitative undertones) during the 1960s, 70s, and 80s. Thus, although Spike does not appear on screen or mobilize his dolly shot to move Brown through the world, he does stay true to his larger discursive formula by offering a triumphant narrative of a uniquely important black male protagonist, someone who places a high value on a blackness informed by militant sensibilities and propped up at the expense of subordinated black women.

But *Jim Brown* the documentary is not read as a fictional account affected by Spike's imagination. Where the narrative of this story seems questionable around Brown's objectionable physical violence, critics argue that the film is (Scheib, 2002)

"structured to refute the sensationalistic news breaking, police-blotter image of Brown"—a choice that places "Spike in the inevitable role of apologist" (p. 30). It is the genre of biographical documentary that necessitates Spike's ordering of the narrative in ways that do highlight sensationalized contradictions, such as when he contrasts Brown's and his paralyzed ex-girlfriend's (Eva Marie Bohn-Chins) conflicting accounts of the day she fell/was thrown from the balcony of a hotel. For critics, it is the "built-in-tell-all expectation of shame and disaster" (p. 30) in documentary as a form of filmmaking that fails to vindicate Brown or add clarity to the accusations against him. Ultimately, the problems to be realized in *Jim Brown*, "may stem less from Spike's obvious advocacy than from the biopic genre itself" (p. 30) because Spike is merely a witness to others' accounts of what previously occurred—the perfect place for a slotted savage.

While this more positive reading of his documentary work would seem to come from elsewhere, or result from his different approach to documentaries, they are also predicated on the same understanding of Spike as black film director cinematically treating black life. It is the savage slot, seeing predilections of Spike's critics that tend to blind them to his documentary flourishes, as his nonfiction films are also very self-consciously and heavy-handedly predicated on Spike's liberal use of fictional conceits—for instance, the stylized backdrops for interviews that feature the natural disaster as background to help construct an almost music video-like scene in *When the Levees Broke*, replete with spoken word sequences and liberal use of canted angles. Although Spike includes the mixed-race testimony of various individuals including hurricane survivors, engineering experts, government officials, politicians, and academics alongside storm footage, floating dead bodies, and evacuation of the Louisiana superdome; his directorial choice to pan the camera to include Lieutenant Governor Mitch Landrieu's home in his reckoning of false accounts of discrimination post-Katrina or electing to accentuate the importance of black men like General Honoré and Fred Johnson in restoring order within the chaos remains Spike signatures.

But where the story of *When the Levees Broke* becomes uncomfortable around the articulation of conspiracy, critics believe that (Doherty, 2006) "the downside of giving voice to the voiceless is the babble, blathering, ranting, and raving" of flood victims that "express the word on the street" at the expense of "the balance between the emotional and the analytical, the passionate intensity of the victims on the ground and the need for big-picture orientation from above" (p. 999). Moreover, Spike himself is hardly deemed able to offer this more nuanced understanding of the situation because as a chronicler of Hurricane Katrina, much like his "reports" on Jim Brown and the Birmingham church bombing, "he doesn't have to write anything; he has only to release the flow" (Denby, 2006, p. 139).

It becomes the case that documentary treatment of a seemingly distant *other*

is what Spike is most successful at capturing. While he is thought to poorly fiction-alize (i.e., analyze) blackness, Spike can be allowed to "document" the sheer fact of blackness (ostensibly for other, more reasoned, minds to analyze)—a blackness consistently located in the South as well as Brooklyn, New York (Birmingham, New Orleans), located in the past (the 1960s) as well as the present, and located in a poor ghetto neighborhood (where victims of the lower ninth ward lived) as much as in the tony communities of well-heeled black middle-class families. Praise for Spike's documentary work does not help to move him out of the savage slot because such views neither credit his insertion of his own ideological agenda nor tend to posi-tively acknowledge his creative capacities as an artist.

Authentic Auteur and Black Neo-Verite

When Will Smith was gearing up to play "Paul," the gay lead in *Six Degrees of Separation*, Denzel Washington is said to have advised Smith against kissing anoth-er male actor on screen because "the Black audience" would not separate his fiction-al character from his real identity. As a popular black actor appearing in mainstream films such as *Man on Fire*, as well as frequent Spike Lee productions, this instance of Washington admonishing Smith works to suggest that he is in on the fiction/non-fiction blurring that Spike champions—familiar with the notion that the "real" is not necessarily turned on or off along with the camera. Additionally, as a Spike Lee regular, Washington's insight implies that he sees (and actively participates in) this fiction/nonfiction divide that we argue is very much a part of Spike's brand of film-making. Most importantly, when taken together, the kind of films each has become popular for, whether through acting or producing, signals that this blurring of real-ity is endemic to the viewing practices of black audiences—or at least the way black filmmakers read them.

By implication, then, Spike is expressing something more than just his own idio-syncratic sensibilities. He is creating (and participating in) a kind of black film cul-ture that appreciates fiction but ties it unflinchingly to a recognizable reality beyond the film's storyline. His coupling of aesthetics and politics makes itself available for deconstruction insofar as the viewer/reader is willing to allow (a priori) that Spike is actively attempting to produce a black cultural text that is communicatively constituted—through a genre of film that idiosyncratically melds facts and factual elements with fictionalized flourishes. Accordingly, as race is the tie that binds his cultural ideas and communication acts together, Spike's way of speaking to and for blackness will remain as contestable as black English vernacular and hip hop cul-ture have been over the years. In consequence, viewers and critics (and critics' crit-ics) alike become entrapped then—reanimating the savage slot by giving the "native"

filmmaker an innate power to indexically represent nativity. By imagining that the black cultural producer is merely reflecting a pre-aesthetic trait of his socioracial group, praise for Spike's documentaries becomes just as problematic as condemnation of his feature films, especially when argued on the basis of his ability to represent blackness in an authentically real way.

People will always be able to hate Spike if they so choose because race as fallible and socially constituted predetermines its mishandling in his "race films." This is not to argue simplistically for the primacy of so-called postmodernism (making any story of race equally valid), but it does share a certain postmodern skepticism about supposedly universal categories of reality. Instead, the point is to accentuate the fact that if there is such a thing as what Todd Boyd calls a "Black aesthetic," it is at least partially about deconstructing the dividing line between "the real" and "the really made up" (to use a Taussigian term), between politics and performance—in ways that unmask false notions of blackness as a self-evident way of being. Moreover, if this aesthetic is racialized (as Boyd would claim) then it might actually make sense that its organizing principle is predicated on tangling up reality and fictionality, just as race itself is real and unreal at the exact same time. This is a version of blackness concocted out of realism and magicality simultaneously, a composite blackness that does not dissolve too easily into the creation of its own easy genre-based synthesis.

Taken-for-granted realness dissolves despite the suggestion of objectivity based in documentary filmmaking, as demonstrated by Cheryl Dunye's (1997) *Watermelon Woman*. Here, the director's faux-historical journey (as a black lesbian filmmaker in the 1990s who is engaged in an interracial romance and sets out to find a fictionalized black lesbian actress dating her white director back in the 1930s) brilliantly depicts the way in which reality can be formulaically manufactured in service to a larger story, one that is connected to the director's own ideological agenda. Thus, an epistemology of reception, particularly for African American films, is less about understanding race and difference, and more about a willingness to accept the varied versions of reality and modes of representation in which racial reals are offered. As with any instance of racial reasoning, those political choices and filmic elements can be played up at the director's discretion. Equally wary of notions that assert the director as victim of her own unrelentingly teleological desires, Spike's genre-bending work shows that producing a persuasive real, even a thoroughly racialized real, is very much an artistic act—not a mechanical and nativist self-revelation.

References

Barrett, L.W. (1999). *Blackness and value: Seeing double.* Cambridge: Cambridge University Press.

Barton, B. (2005). Film review: Male fantasies about lesbian desire: A review of Spike Lee's film *She Hate Me. Sexuality & Culture* 9(3), 77–80.

Bogle, D. (1994). *Toms, coons, mulattoes, mammies, and bucks: An interpretive history of Blacks in American films* (3rd ed.). New York: Continuum.

Boyd, T. (1997). *Am I Black enough for you?: Popular culture from the 'hood and beyond.* Bloomington: University of Indiana Press.

Carby, H.V. (1998). *Race men.* Cambridge, MA: Harvard University Press.

Denby, D. (2006, September 4). *When the Levees Broke: A Requiem in Four Acts. New Yorker* 82(27), 139–141.

Doherty, T. (2006, December). Entertainment Review. *Journal of American History* 93(3), 997–999.

Dunye, C. (Writer/Director). (1997). *Watermelon Woman* [Motion picture]. United States: Dancing Girl.

Kellner, D. (1997). Aesthetics, ethics, and politics in the films of Spike Lee. In M.A. Reid (Ed.), *Spike Lee's* Do the Right Thing (pp. 73–106). Cambridge: Cambridge University Press.

Lee, S. (Producer/Writer/Director). (1986). *She's Gotta Have It* [Motion picture]. United States: Paramount Picture.

———. (1989). *Do the Right Thing* [Motion picture]. United States: Paramount Picture.

———. (1990). *Mo' Better Blues* [Motion picture]. United States: Paramount Picture.

———. (1991). *Jungle Fever* [Motion picture]. United States: Paramount Picture.

———, & Perl, A. (Writer). (1992). *Malcolm X* [Motion picture]. United States: Paramount Picture.

———. (1995). *Clockers* [Motion picture]. United States: Paramount Picture.

Lee, S. (Producer/Director), & R.R. Bythewood. (Writer). (1996). *Get on the bus* [Motion picture]. United States: Paramount Picture.

Lee, S. (Director/Producer), & S.L. Parks. (Writer). (1996). *Girl 6* [Motion picture]. United States: Paramount Picture.

Lee, S. (Director). S. Lee,. & S. Pollard. (Producer). (1997). *Four Little Girls* [Motion picture]. United States: Paramount Picture.

Lee, S. (Director/Writer). (2000). *Bamboozled* [Motion picture]. United States: Paramount Picture.

Lee, S. (Director). (2002). *Jim Brown: All American* [Motion picture]. United States: Paramount Picture.

Lee, S. (Director/Producer), & M. Genet. (Writer). (2004). *She Hate Me* [Motion picture]. United States: Paramount Picture.

Lee, S. (Director), & R. Gewirtz. (Writer). (2006). *Inside Man* [Motion picture]. United States: Universal Pictures.

Lee, S. (Director). (2006). *When the Levees Broke: A Requiem in Four Acts* [Motion picture]. United States: Paramount Picture.

McCarthy, T. (1997, July 21–27). Film reviews: *Four Little Girls. Variety.*

Rony, F.T. (1996). *Third eye: Race, cinema, and ethnographic spectacle.* Durham, NC: Duke University Press.

Scheib, R. (2002, April 8–14). Film reviews: *Jim Brown: All American. Variety.*

Schwarzbaum, L. (2000, October). Spike Lee: *Bamboozled.* EntertainmentWeekly.Com, Retrieved December 29, 2006 from Ebsco[www.ew.com/ew/article/0,,277978,00.html].

Tate, G. (2000, November 7). King of coonology. *Village Voice, 45*(44), 53–56.

Trouillot, M.R. (2002). Alternative modernities: Caribbean lessons for the savage slot. In B. Knauft, (Ed.), *Critically modern* (pp. 17-44). Bloomington: Indiana University Press.

No, Baby, No

Sex, Sexuality, and Gender Roles

Race and Sex
IN Black AND White

Essence and Ideology
in the Spike Lee Discourse

MARK LAWRENCE MCPHAIL

> Even when it is clear that the critique is trying to empower and trying to heal certain wounds within our communities, there is not any space within our culture to constructively critique. There is an effort simply to shut people up in order to reify these gods, if you will, who have delivered some image of us which seems to affirm our existence in this world. As if they make up for the lack, but in fact they don't. They can become part of the hegemony.
>
> —Marlon Riggs in Salaam, 1992, p. 5

More than a decade and a half ago, film critic Thomas Cripps criticized the dehumanizing and stereotypical images of African Americans presented in mainstream film. In *Slow Fade to Black*, Cripps (1977) chronicled the negative depictions of African Americans in Hollywood during the first half of this century, and in his historical examination of African American independent filmmaking (Cripps, 1978) called for the continued development of a genre of film that would "illuminate the Afro-American experience" (p. 7). Cripps's (1993) recent explication of African American filmmaking seemed to suggest that the genre he hoped for in the late 1970s had materialized in the 1980s and 1990s in the works of Spike Lee: "More than any other figure in African American film-

making," contended Cripps, "Lee has calculatedly linked himself with the history of Black independent filmmaking, has self consciously reached for a Black audience, and used a rhetoric (of both filmmaking and marketing) that has rendered his work accessible to crossover audiences without compromising the inner values of his work" (p. 172). Lee's films have been both praised and condemned by critics of all persuasions, but most have argued that his presentation of the African American experience offers a positive alternative to the negative images produced by an industry dominated and controlled by whites.

Both academic and popular critics have praised Lee's characterization of black life, and his films have been heralded by many as offering realistic accounts of the African American experience.[1] Baker (1991) argued that "Lee's first films are low-budget, minor masterpieces of cultural undercover work" that "find the sleeping or silenced subject and deftly awaken him or her to consciousness of currents that run deep and signify expansively in Black America" (p. 251). Gates (1991, p. 169) called Lee's *Jungle Fever* "a brilliant exploration of the liminal space that connects, rather than divides, Black America with white," and McMillan (1991) noted that Lee's *She's Gotta Have It* is "a realistic film, and Spike Lee managed to reproduce the surface of reality with a minimum of distortion" (p. 28). Popular critics offered similar observations concerning Lee's Afrocentric intentions and cinematic realism: Blake (1990, p. 136) noted that "Lee has made a point of working outside the establishment as an independent voice of Black America"; McHenry (1986, p. 20), in her review of *She's Gotta Have It*, pointed out that much of Lee's humor "is delightfully, distinctively rooted in Black idiom"; and Kroll, Smith, and Murr (1991), in their review of *Jungle Fever*, suggested that "the real life experience of the actors lends a depth to the interracial theme that no other film has approached" (p. 47). Lee's realistic presentation of the African American experience has indeed made him one of the most prolific and powerful producers of the genre of film called for by Cripps.

Some scholars and critics, however, have looked beyond the surface of Lee's films to suggest that his version of black life is not necessarily representative of the African American experience, and that his realism is essentially no less problematic than that promulgated in mainstream media. While ostensibly offering an alternative, Afrocentric vision, Lee's films exemplify an ideological and epistemological complicity with the culture he so persistently calls into question. Lubiano (1991) most clearly articulated this critique of Lee's ideological and epistemological complicity: "The Spike Lee discourse and his production offer a site for examining possibilities of oppositional, resistant, or subversive cultural production as well as the problems of productions that are considered oppositional, resistant or subversive without accompanying analysis sustaining such evaluation" (p. 254). Lubiano's critique provides an important starting point for the examinations of Lee's

problematic depiction of women and interracial relationships in his films.

My analysis suggests that Lee subscribes to the same ideological and epistemo-logical sensibilities he ostensibly opposes, and that the Spike Lee discourse iden-tified by Lubiano is by virtue of its patriarchal and essentialist commitments much less of an Afrocentric alternative than Lee and his followers would like to believe. In support of this analysis, I will first revisit and amplify Lubiano's discussion of the Spike Lee discourse in terms of its underlying commitment to Eurocentric notions of realism, representation, and essentialism. Next I will consider how these notions emerge in Lee's depiction of women and interracial relationships in his films, and how they undermine his own oppositional project and its revisionary Afrocentric agenda. Finally I will illustrate how an analysis of the Spike Lee discourse that expli-cates its ideological and epistemological complicity helps to clarify the emancipa-tory goals of oppositional academic and popular criticism and provides direction for reconstructing notions of race, class, and culture.

Representing Essential Reality Differently? Lubiano's Critique of the Spike Lee Discourse

In her essay "But Compared to What? Reading Realism, Representation and Essentialism in *School Daze*, *Do the Right Thing*, and the Spike Lee Discourse" (1991), Lubiano offered a powerful critique of Lee's films that goes beyond the prag-matics of negative images to the problematics of ideology and epistemology. Lubiano argued that Lee's films have yet to be contextualized in critical discourse in terms of the function of power in the politics of ethnic identity and social con-trol. By arguing that Lee's vision of black life represents the reality of the African American experience, academic and popular critics have failed to recognize the ide-ological and epistemological forces at work in the social creation of the Spike Lee phenomenon: "Were a variety of African-American filmmakers framed with such a profile, such a salience, critics and commentators (both African-Americans and others) might be less likely to insist that Lee's work is the 'real thing' and celebrate it so uncritically." Given this larger context, Lubiano suggested, "a reductionist African-American representational hegemony would be more difficult to maintain" (p. 256). The social construction of the Spike Lee discourse as representative of African American reality serves to marginalize those voices ignored or silenced by that discourse, and reifies the underlying ideological and epistemological assump-tions it purports to oppose.

Those assumptions emerge most clearly for Lubiano in Lee's commitment to realism, representation, and essentialism. Because Lee presents a vision of African American culture, it is problematic to assume (as many of his critics do) that his

vision serves to represent that culture's reality:

> If Lee's strength is a certain ability to document some of the sounds and sights of African-American vernacular culture—its style focus—that vernacularity cannot guarantee counter hegemonic cultural resistance. One can be caught up in Euro-American hegemony within the vernacular, and one can repeat the masculinism and heterosexism of vernacular culture. (p. 264)

Lubiano continued her critique of Lee's discourse by focusing on *Do the Right Thing* and *School Daze*, the first of which "produces representations that suggest particular Euro-American hegemonic politics," specifically "masculinist representation and its conventional Calvinist realism" (p. 265), and the latter of which is marked by "foul gender politics and horrific homophobia" (p. 267). The emancipatory political possibilities of both of these films, Lubiano argued, is undermined by Lee's reification of "identity politics," in regard to which "unselfconscious realism and representation within the distorted discourse of Euro-American hegemony lead inevitably to a profoundly unstrategic essentialism" (p. 267).

Lubiano's analysis focuses on "specific problem sites of essentialism—Lee, the discourse about Lee, and two of his films," and offers a powerful and insightful consideration of contemporary debates concerning essentialism and antiessentialism.[2] Her critique explores the significance of the issues raised by Spike Lee in *Do the Right Thing* and *School Daze* and then illustrates how the essentializing of race and sexuality in the Spike Lee discourse undermines its emancipatory possibilities and oppositional agenda. She suggests that Lee's films and discourse provide an important discursive space for a continued exploration of such possibilities and a sustained refinement of the agenda they offer. "Therefore, in our critical consideration we do well to heed Fanon's warnings equally against nationalistic nostalgia for a precolonial past and uncritical nativist celebrations in the present," Lubiano concluded. "While beginning with the question of context—Compared to what?—does not foreclose productive discussions, it does make it harder to rest on simple resolutions. And that's the truth, Ruth" (p. 277). Taking the question of context one step further, it becomes evident that the essence of the African American experience cannot be reduced to the symbolic or social realities of the Spike Lee discourse, or, for that matter, any other singular view of culture.

Indeed, to speak of the essence of the African American experience is to subscribe to a set of ideological and epistemological assumptions that African American critical discourse has successfully exposed as problematic. By uncritically accepting Lee's representation of black life in terms of a singular reality, the diversity and richness of the African American experience is undermined and compromised. Nowhere is this more evident in the Spike Lee discourse than in his depiction of women and interracial relationships, and it is in terms of these two specific aspects that Lubiano's

analytical strategy can be usefully extended. Several writers, including Lubiano, have commented on Lee's inability to address the complexities of gender in his films, and his views and characterizations of interracial relationships reflect an unconsciously essentialist understanding of race relations that mirrors the very racism he claims to be critiquing in his works. An examination of these two aspects of Lee's films provides further insight into the ideological and epistemological complicity that marks his work and the problems and possibilities this complicity poses for contemporary African American critical thought and practice.

Spike's Phallacy: It's a Sex Thing

Several writers have commented on Lee's omission or misrepresentation of women in his films, and Lee himself acknowledges this in his work. Hirshey (1991) explained that Lee "calls it a 'weakness' in his work. Critics point to the lack of dimension in his female characters. And in Lee's own coffee-table book, *Five for Five* . . . novelist Toni Cade Bambara scolds him for "backward sexual politics in *School Daze*" (p. 90). Several other critics have taken issue with Lee's characterizations of women and female sexuality. Writing in *The Nation*, Klawans (1990) contended that the female characters in *Mo' Better Blues* "are hardly even shadows of the males" (p. 179), and Wallace (1988) in her review of *She's Gotta Have It* argued that the "film's mistrust of female sexuality is disturbingly obvious in Lee's handling of Nola's relationship with her lesbian friend, Opal Gilstrap, who comes on like the original serpent in the Garden of Eden" (p. 801). Lee's characterizations of women, according to these and other critics, are not significantly different from those presented in mainstream films.[3]

Nor does Lee's Afrocentric vision offer an alternative conception of the feminine. Malveaux (1991) commented on the evident tension between Lee's Afrocentric and patriarchal commitments in his works: "The Afrocentric trappings of Spike Lee's films promise something new, different, exciting. But where women are concerned, he delivers the same old stuff, served up in a provocative, beautifully photographed package" (p. 80). And hooks (1993a) uncompromisingly critiqued Lee's misogynistic tendencies as they emerge in all of his films, concluding that his most recent, *Malcolm X*, represents a revisionistic "version of Black political struggle where the actions of dedicated, powerful, Black female activists are systematically devalued and erased. By writing Ella out of Malcolm's history, Spike Lee continues Hollywood's devaluation of Black womanhood" (p. 15). Elsewhere hooks (1993b) argued that Lee's sexism in *Malcolm X* is not confined to Black women: "Certain stock, stereotypical, sexist images of both Black and white women emerge in the movie—they are either virgins or whores, madonnas or prostitutes. But that,

after all, is Hollywood" (p. 6). hooks contended that Lee's films, by virtue of their ideological commitments, are neither oppositional nor alternative and reify the very values that undermine the possibility of liberation and the emancipatory interests that they claim to represent.

Even those cultural critics who have praised Lee for his depiction of African American experiences in positive terms recognize the limits of representation in his films. Elise and Umoja (1992 in this volume) characterized Lee as a filmmaker who is on the way to realizing Cripps's dream of black film as genre: "Spike Lee is on a quest to effectively use film to capture the texture of Black life and to direct African Americans' attention to the subtle shadings of their existence" (p. 83). Lee's work, they argued, successfully counters the negative images of African Americans presented in mainstream film and media and in doing so offers a potential vehicle for ideological transformation and African American redefinition. Lee's potential, however, is limited by his commitment to patriarchy. Elise and Umoja offered a definitive statement of Lee's marginalization of women in his works:

> In the course of his pursuits, Spike Lee casts a gendered gaze upon the Black communities he portrays. By doing so he consistently delimits a role for Black women which is peripheral and, thereby, subordinated to the Black man. Spike Lee is a work in progress; he promises to capture the transformational potential of Black film, but in order to do so he must traverse the chasm of Black patriarchy. Until Lee's work reflects the realization that Black women are inherently valuable and not merely auxiliary to the liberation of Black men, it will fall short of its potential to galvanize the entire Black community. (p. 83)

The failure of Lee's transformative vision is rooted in its adherence to patriarchal ideology, yet his ethnic essentialism (to which we will return later) is left unanalyzed by Elise and Umoja. Lee's Afrocentric focus is seen as "decidedly political" (p. 85) and offers a clear alternative to "White-oriented filmmakers" (p. 86) as he presents depictions of African American men that "differ sharply from the images cast by Hollywood" (p. 88).

Lee is less kind to the female counterparts to his male characters, however: "Lee's phallacy lies in his construction of the Black woman as a receptacle for the Black man's phallus. He, as a male director, fails to envision her as the equal partner—in struggle—of the Black man." Elise and Umoja concluded that although "Lee plays a pivotal role in the construction of a Black aesthetic and ideological framework that is oppositional to the dominant culture," his works "fail to transcend the strictures of Black patriarchy which bind better than half our population" (p. 89). Lee's patriarchy clearly undermines his oppositional agenda and illustrates an underlying complicity with oppression that emerges when his ideological commitments are exposed. That complicity is further illustrated when the epistemological

assumptions at work in the Spike Lee discourse, and critiques of that discourse, are similarly exposed.

Elise and Umoja's analysis provides an excellent starting point. While they criticize Lee's misogynistic tendencies, they ignore and even assent to his essentialism. In discussing how Lee "Works Hard to Stay Black/Does Not Aspire to Be White," they argued that Lee's vision of the African American experience, unlike white society's, recognizes the diversity of that experience: "Herein lies a crucial characteristic: diversity in the Black community is not a cause for cleavage but is a celebrated aspect of Black life" (p. 85). But for both Lee and the authors, diversity excludes interracial relationships, for as Elise and Umoja explained "Blacks who choose this option, such as the piano player in *Mo' Better Blues* with his French White lover, are viewed as pretentious anomalies who, though tolerated and understood, do not possess viable answers to the question of self-definition that confronts African Americans" (pp. 85–86). African Americans involved in interracial relationships do not and cannot, in the works of Lee and the critique of Elise and Umoja, represent the African American experience.

The essentialism of this perspective is clearly illustrated in Elise and Umoja's explanation of why such African Americans fall outside the realm of the diversity of the black experience: "The reason such an option is rejected is based on the fallacy of the application of White universalism to the Black experience. Those who would decry the particularism of Black culture as confining fail to see the universal truths and emotions that are explored within this context" (p. 86). Elise and Umoja's explanation exemplifies a lack of critical self-reflection that highlights their complicity with the very essentialism that the Black experience has consistently exposed: rejection is the dominant strategy of essentialist praxis; fallacies reflect a commitment to the assumption of binary oppositions between truth and falsity inherent in essentialist discourse; universal truths represent most clearly the epistemological essentialism of their position; and the unsubstantiated assumption that all African Americans who have intimate relationships outside the race "decry the particularism of Black culture as confining" mirrors the generalizing and stereotyping tendencies central to the rhetoric of racism and any language of oppression.

Blacks and whites, for Spike Lee and for these two critics at least, are essentially different, and thus blacks who are involved intimately with whites are not really black. This rejection of the *other* as impure or counterfeit is, of course, the underlying premise of all racist thought and language, and this is precisely why it must be addressed in any emancipatory project. In depicting women in his films, Spike Lee has shown how an oppositional discourse that perpetuates one form of ideological oppression while claiming to address another fails to achieve its transformative possibilities. On an epistemological level, however, oppositional discourse that is positioned as essentially antithetical to dominant discourses also

perpetuates complicity with oppression.[4] Lee's views on miscegenation, notwith-standing, mirror those of the very culture he claims to oppose. An examination of the film *Jungle Fever* suggests that Lee's essentializing of the black experience not only marginalizes a significant sector of the African American community but undermines the emancipatory agenda of those Afrocentric strategies of resistance he claims to employ.

Who's Got the Fever?
Racial Essentialism in the Spike Lee Discourse

Shortly after its release, Lee's *Jungle Fever* was heralded by *Newsweek* (Kroll et al., 1991) as the "34 year old filmmaker's best movie" because it "raise[d] more crucial issues than any American film in a very long time" (p. 44). The article quoted Lee describing the film as being "about two people who are attracted to each other because of sexual mythology" (p. 45) and went on to suggest that "whether the movie endorses or rejects interracial romance is not, ultimately, the point. Because what the movie is really about is a nation polarized by an unabating obsession with color" (p. 46). Most other critics who viewed the film favorably also seemed to be able to separate what the film said about interracial relationships from the social real-ities of race relations, but some of its viewers and critics were unable to make this disconnection.[5] The *Newsweek* article interviewed several interracial couples about the movie whose views suggested that the film's message could not in all cases be separated from its social context.

The responses of the participants in the interview illustrate the marginalization that both African Americans and whites feel in interracial relationships. One respondent observed that Lee "never debunked the myths that he was saying he was attacking," while a second argued that his "implicit message [is] that relationships between Blacks and whites will only be sexual." A third stated, "I did not like the way he ended up portraying the Black man, OK? People do have affairs. People do fall in love with other people. But to reduce the Black man to the point where he only wants the white woman for sex, I didn't like that at all" (p. 48). When asked if they felt that Lee's film offered an acceptable depiction of interracial relationships, the responses of those interviewed were mixed. One woman argued that Lee's "point of view is very racist, even though he makes movies about racist issues. I think he's trying to portray in the movie that interracial couples should not be." Another respondent offered a different opinion: "I think he puts it out there. I don't think he condemns the [interracial] relationship; I don't think he condones them. I think he put them on the screen, and it's up to you to make whatever it is you want to make of it" (p. 49).

This last statement perhaps most clearly illustrates the difficulty of contextualizing Lee's depiction of interracial relationships with the lived experience of miscegenation: it has no essential, singular reality.[6] Unfortunately, both critics and consumers of media often approach symbolic constructs as if they were reflections of some essential reality that is fixed and unchanging. It is this confusion between symbolic representation and "real life" that disturbed Wallace (1992) in her analysis of *Boyz N the Hood* and *Jungle Fever*: "Especially in the context of symbolic representations, gender and race have no essential, irreducible meanings, only the ones we assign them to get from 'here' to 'there.' But neither John Singleton nor Spike Lee is aware of how gender and race are socially and culturally constructed" (p. 125). This lack of awareness leads to an essentializing of these culturally constructed phenomena which, according to Wallace, Singleton successfully manages but Lee does not.

Indeed, Lee's reduction of interracial relationships to nothing other than sex reifies the essentialist assumptions of white racist discourse that sees such relationships in the same light and fails to offer an alternative or oppositional frame for transforming such discourse. Lee's reductionism undermines the possibilities presented by these characters precisely because it repeats the same "truths" of the culture it attempts to critique. As Billson (1991, p. 32) argued, Lee's characters "are not so much people as mouthpieces for what Lee wants to say, which is: Black men are attracted to white women because white skin represents the ultimate status symbol, and white women are attracted to Black men because they are curious about 'zulu dick'." Lee's characters become caricatures, reduced to the same racist stereotypes that define them in the dominant discourse. "To present these ideas as though they were the lovers' sole motive for becoming involved is an insult to the audience as well as to the characters," contended Billson. "Relationships between men and women, whatever their colour, are *much* more complicated—and interesting—than that." Indeed, one can argue that interracial relationships are especially complicated precisely because they illustrate the fallacy of depicting race relations in the black and white terms of oppression and victimization.

While *Jungle Fever* offered an excellent opportunity for exploring and exposing this fallacy, Lee chose not to pursue it, but instead to re-present old racial mythologies. Cardullo (1992) criticized Lee's film for missing the opportunity to challenge mainstream conceptions of interracial relationships:[7]

So Flipper pursued Angie merely out of sexual curiosity, as he finally admits, but by not having this character fall in love with his white girlfriend, Lee missed the opportunity to explore an interracial relationship, perhaps an interracial marriage—a marriage that Drew herself is the product of, and whose mixed race has drawn her the abuse of some Blacks together with the adoration of others, like Flipper, as well as instilled in her the

paradoxical belief that Blacks should stop diluting their blood by procreating with whites. (p. 645)

Other scholars have criticized Lee's film for similar reasons. hooks (1993a) observed that "the film had nothing new or revelatory to share about race, gender, or desire." hooks argued that *Jungle Fever* and later *Malcolm X* show that Lee is either unable or unwilling to challenge essentialized conceptions of miscegenation constructed in the dominant culture: "Spike Lee refuses to allow for the possibility that there could be meaningful affectional ties between a Black man and a white woman which transcend the sexual" (p. 14). hooks went on to argue that Lee's essentialist depiction of miscegenation is merely a reflection of his more general misogynistic tendencies. "Indeed, in Lee's cinematic world, every relationship between a Black man and a woman, whether white or Black, is mediated by his constant sexualization of the female" (p. 15). Lee's acceptance of patriarchal ideology and ethnic essentialism significantly undermines the emancipatory agenda of his oppositional project and also reflects an underlying contradiction that makes problematic his and other Afrocentric critiques of dominant culture.

Such critiques more often than not offer an essentialized conception of race that is as critical of diversity and difference as the hegemonic discourse of Western racism. They accept not only the concept of race but strive for the same assertion of a distinctly racial identity that has characterized the conception of the self in Western culture from its very beginnings.[8] Instead of moving beyond rejection and distinction as strategies for definition, they have offered a mirror image that refuses to address the complexities of marginalization and oppression that confront contemporary cultures across the globe. The Afrocentric agenda that calls for black self-love yet rejects those who do not follow the program (e.g., black conservatives,[9] critics of black popular culture, African Americans involved in interracial relationships) as less than black, is one short step away from the trope of "less than human" that has dominated the rhetoric of racism since its earliest articulations. There is little that is oppositional or emancipatory about such discourse; indeed, those who attempt to point this out are often themselves marginalized or rejected altogether regardless of how "Black" they might be.

This is precisely the point that Riggs (Salaam, 1992) raised in the epigraph at the beginning of this chapter, and it is the most important issue that confronts those like Lee who purport to be (or are depicted as) the architects of a transformational Afrocentricity. As Elise and Umoja pointed out, for Lee's Afrocentric vision to achieve its transformative potential it will have to address the problem of misogyny in the symbolic representations and social realities of African American life. I believe that it will also have to address seriously the problem of an essentialized conceptualization of ethnic identity that itself reifies the very oppression it opposes. In

accepting an Afrocentricity infected with misogyny and ethnic essentialism as a realistic representation of African American life and culture, one runs the risk of trading in one form of hegemony for another and substituting one evil for another. If the African American experience has taught us anything as critics, creators, and consumers of culture, we have little to gain other than ideological and perhaps material comfort from such a trade and far too much of our dignity and morality to lose.

Un-doing the Black and White Thing: Re-presenting the Realities of Gender and Race

Despite its problems, Spike Lee's illumination of the African American experience brings us closer to creating spaces where critique can exercise its transformative emancipatory potential and move beyond the reification of hegemonic dialectics. His films offer opportunities for deconstructing African American ideology and exploring the epistemological assumptions that circumscribe contemporary black thought and behavior, and the problems and possibilities they pose for an emancipatory Afrocentric agenda. And while Lee's depictions of women and intimate relationships between the races may be deemed problematic, we need to recognize that his voice and vision re-present some of the sounds and sights of the diverse and dynamic reality of human symbolic and social interaction. In a world in which race and gender have been constructed in the black and white terms of essential identity, when we stand in judgment of Spike Lee we stand in judgment of ourselves as well, and therein lies the possibility of transforming the discourse of negative difference that undermines the emancipatory potential of social and symbolic critique.

Facilitating such a transformation will mean dealing not only with theoretical and practical issues that emerge in African American discursive and social productions, but with moral issues that transcend the strictures of race, class, and gender. As Marable (1992) observed, African American intellectual pursuits must continue along the lines of a humanistic tradition that has joined "political objectives and ethical prerogatives" to offer "a critical enterprise which educates and transforms the larger society" (p. 34). In the same vein, King (1992) contended that the Afrocentric agenda must be "inclusive of the experiences of African American women *and* men," must take into consideration "the dynamics of class, race, gender *and other oppressions*," and must acknowledge "the various mechanisms of self-determination, empowerment, and resistance that *all* African Americans have designed" (p. 43, emphases mine). An Afrocentric agenda that is exclusive or exclusionary will reify the same ideological and epistemological shortcomings that African American popular and intellectual discourse has so successfully challenged.

In concluding, I wish to end my criticism where it began, following the lead of

Lubiano's (1991) insightful consideration of the Spike Lee discourse and the problems and possibilities it poses for contemporary critical thought and practice:

> The historical moment and the attention given to Spike Lee by an entire spectrum of critics, commentators, and media fora; the effects of his presence and deification on possible productions of African-American presences in the cultural domain; the reductionist tendency in any United States discussions about race and racism—all combine to make it imperative that we continue to think about the issues raised by Lee and his production. It won't hurt and might help to begin by refusing to consider Lee or his production simply within their own terms. Trying to make things "real" has been the problem. What might more contextual criticism of Lee and his production offer us? (p. 277)

I hope that this chapter, in some small way, begins to answer Lubiano's question. An examination of the ideological and epistemological contexts of Spike Lee's work suggests that we still have a long way to go to make the emancipatory project of African American symbolic and social criticism more than a dream, and more than the reality represented in the hegemonic singular visions that we unwittingly, but all too often willingly, reproduce in our own discourse on race, gender, and difference.

Notes

1. Not all Lee's critics have lauded his fidelity to the African American experience. Merod (1991) criticized Lee's *Mo' Better Blues* for presenting "a weak interest in capturing, in representing, the fire and dignity (the indominative beauty) embedded within each genre of the jazz archive. Put bluntly, *Mo' Better Blues* does not portray the world of the jazz musician convincingly or compellingly" (p. 239). In his critique of *Do the Right Thing*, Chrisman (1991) argued that Lee's depiction of the African American experience is ambiguous and incoherent: "Lee has maintained that he is a filmmaker, not a social philosopher, but a filmmaker of substance understands that a movie is more than a sequence of images; it is a carefully and coherently constructed value system. Lee's inability to present a coherent value system in the replication of Black life in his films raises the question, indeed, what is the right thing?" (p. 57).

2. Lubiano thoughtfully responded to Henry Louis Gates's concern with critiques of essentialism by pointing out the inconsistencies in his own position concerning the role of subjectivity in the African American experience. "Within the domain of African-American cultural discourse, African-Americans have been about the business of establishing that tradition's subjectivity and have been fighting about the terms of that subjectivity since the seventeenth century. Some African-Americans, as various critics (among them Gates, Gloria Hull, Valerie Smith, Deborah McDowell and Hazel Carby) have documented, historically resisted essences inscribed in African-American cultural commentary, even when these

essences were meant to counter essences held by the dominant culture" (1991, p. 268).

3. The significant exception to this criticism has been *She's Gotta Have It*, which many critics have seen as a positive affirmation of female sexuality. McHenry (1986), for example, remarked: "What is wonderful about his film is that although what Lee has given us here is most decidedly a male vision of a sexually liberated woman, it is still often very endearing" (p. 20).

4. For a discussion of the hegemonic tendencies of oppositional discourse, see my essay, "Complicity: The Theory of Negative Difference" (McPhail, 1991).

5. Blake (1991), for example, argued that "more than any other America film maker (Lee) has articulated the social crises facing American society at the end of the century" (p. 74), while Quart (1992) suggested that "Lee's prime theme is that Black and white lovers don't get together out of mutual feelings, but because of their respective mythologies. He concludes that Black and white lovers must finally realize that sticking to their own kind is the only real option, since they are rejected by both Black and white communities" (p. 99).

6. The ambiguous and contradictory problems of ethnic essentialism for interracial couples was thoughtfully noted by Early (1991) in his review of *Jungle Fever*: "What is racial identity if someone can be attacked from outside the group for pretentions of purity, and from inside the group because of a 'mongrelized' appearance?" (p. 18).

7. Cardullo (1992) was especially disturbed by Lee's failure to explore this possibility more fully because he touches on it in the film in the relationship between two minor characters: "Instead of spending more time on the relationship between Orin and Paulie, why did Lee base *Jungle Fever* on the short-lived affair between Flipper and Angie, a couple that, according to the director, 'came together because of sexual mythology'? Because, as he did in *Do the Right Thing*, he prefers to do the easier thing: cram his film with incident rather than exploration, with texture rather than subtext. It isn't as if he didn't have examples to draw from: There were 211,000 interracial marriages in the United States in 1990, of which 71 percent were between Black men and white women, while 29 percent paired white men with Black women" (p. 645).

8. For a discussion of how the assertion of a distinct identity in African American discourse reifies the essentialist tendencies of Western racism, see *The Rhetoric of Racism* (McPhail, 1993).

9. Grenier offered insight into how this problem plays itself out in the Spike Lee discourse: "As for Blacks who dissent with his position, Spike Lee recommends that Michael L. Williams, for instance, an Assistant Secretary of Education in the Bush administration whom he regards as an 'Uncle Tom handkerchiefed-head Negro,' should be 'beat with a Louisville Slugger in an alley'" (1991, p. 53).

References

Baker, H.A. (1991). Spike Lee and the commerce of culture. *Black American Literary Forum, 25*, 237–252.

Billson, A. (1991, September). Mixed message. [Review of the motion picture, *Jungle Fever*]. *New Statesman & Society*, 31–32.

Blake, R. (1990, September 15). Black and blue. [Review of the motion picture, *Mo' Better*

Blues]. *America,* 136.

———. (1991, August 10). Feverish. [Review of the motion picture, *Jungle Fever*]. *America,* 74.

Cardullo, B. (1992). Law of the Jungle. [Review of the motion picture, *Jungle Fever*]. *The Hudson Review, 44,* 639–647.

Chrisman, R. (1991). What is the right thing? Notes on the deconstruction of Black ideology. *The Black Scholar, 21,* 53–57.

Cripps, T. (1977). *Slow fade to Black. The Negro in American film, 1990–1942.* London: Oxford University Press.

———. (1978). *Black film as genre.* Bloomington: Indiana University Press.

———. (1993). Film. In J.L. Dates & W. Barlow (Eds.). *Split image: African Americans in the mass media.* (pp. 131–185). Washington, DC: Howard University Press.

Early, G. (1991). Reading the street signs. [Review of the motion pictures *Jungle Fever* and *Five for Five*]. *Times Literary Supplement, 6,* 18.

Elise, S., & Umoja, A. (1992). Spike Lee constructs the new Black man: Mo' better. *The Western Journal of Black Studies, 16*(2), 82–89.

Gates, H.L. (1991). *Jungle Fever:* Guess who's not coming to dinner? In S. Lee (Ed.), *Five for Five* (pp. 163–169). New York: Stewart, Tabori, & Chang.

Grenier, R. (1991). Spike Lee fever. *Commentary, 92,* 50–53.

Hirshey, G. (1991, June). Spike's peak. *Vanity Fair,* 70–92.

hooks, b. (1993a). Male heroes and female sex objects: Sexism in Spike Lee's *Malcolm X. Cineaste, 29*(4), 13–15.

———. (1993b). Consumed by images. *Artforum, 31*(6), 5–6.

King, D. (1992). Unraveling fabric, missing the beat: Class and gender in Afro-American social issues. *The Black Scholar, 22,* 37–43.

Klawans, S. (1990, August 13/20). Review of *Mo' Better Blues. The Nation,* 178–180.

Kroll, J., Smith, E., & Murr, A. (1991, June 10). Spiking a fever. *Newsweek,* 44–49.

Lubiano, W. (1991). But compared to what? Reading realism, representation, and essentialism in *School Daze, Do the Right Thing,* and the Spike Lee discourse. *Black American Literary Forum, 25,* 253–282.

Malveaux, J. (1991, September/October). Spike's spite. *Ms.,* 80.

Marable, M. (1992). Blueprint for Black studies and multiculturalism. *The Black Scholar, 22,* 31–35.

McHenry, S. (1986, October). Odd couplings: Sex, smiles and savvy from two young filmmakers. *Ms.,* 14–16.

McMillan, T. (1991). Thoughts on *She's Gotta Have It.* In S. Lee (Ed.), *Five for Five* (pp. 19–29). New York: Stewart, Tabori, & Chang.

McPhail, M. (1991). Complicity: The theory of negative difference. *The Howard Journal of Communications, 3*(1 & 2), 1–13.

———. (1993). *The rhetoric of racism.* Lanham, MD: University Press of America.

Merod, J. (1991). A world without whole notes: The intellectual subtext of Spike Lee's *Blues. Boundary, 2*(18), 238–251.

Quart, L. (1992). Review of *Jungle Fever. Cineaste, 29*(4), 99.

Salaam, K. (1992). Interview: Marlon Riggs. *Black Film Review* 7, 5.

Wallace, M. (1988, June 4). Review of *She's Gotta Have It* and *School Daze. The Nation,* 800–801.

———. (1992). *Boyz N the Hood* and *Jungle Fever.* In G. Dent (Ed.), *Black popular culture: A project by Michele Wallace* (pp. 123–131). Seattle: Bay Press.

Spike Lee Constructs
THE New Black Man

Mo' Better

SHARON ELISE AND ADEWOLE UMOJA

Introduction

Motion pictures are indeed profound and curious phenomena. They are instruments for *socialization*, mass propaganda, historical vehicles, outlets for aesthetic expression, entertainment, and commercial endeavors. Their significance is derived from the manifold purposes to which they may be put and the fact that the ends sought can be accomplished with minimal social discord. Films can just as easily reinforce the status quo as usher in revolutionary ideas and expand consciousness. The intrinsic power of this medium can be observed in the propaganda films used by Nazi Germany and the United States as both attempted to legitimize their war efforts in order to arouse their populations to greater sacrifices. In the United States this propaganda was pointedly directed at blacks:

> *We've Come a Long, Long Way* (1943) ... was a documentary made in cooperation with the U.S. War Dept. . . . to convince Blacks that they were better off here than under Hitler, and their patriotism was requested in the segregated Army. . . . The NAACP labeled the film "disgusting" (Sampson & Sharp, 1983, p. 80)

Though ostensibly technical and neutral, filmmaking is inextricably linked to the sociopolitical purposes to which it is employed. The objectives and/or perspectives of the filmmakers invest the specific work with its orientation. The orienta-

tion of the film, in turn, directs society's gaze, thus impacting the collective view-ers' social consciousness. Although the viewing experience can contribute to social transformation by a relatively benign process, it cannot be assumed that film view-ing is passive. What occurs is an interaction between the filmmaker's consciousness and the viewers' perspectives, born of experience, which are brought to bear as an intrinsic part of the act of viewing.

Film is not a medium which is merely dictated by social structure and direct-ed upon a passive audience: the audience also imbues the product with meaning. Audience interpretations will diverge, elevating film to social contest, when there are fundamental doubts and differences regarding the basic premises upon which the social order rests. Audience ambiguity reflects the opposition to prevailing norms and creates a context for the transference of ideological struggle to the screen.

The struggle for ideological transformation is just as profound as the struggle for control over material resources. It is the resolution of the struggle of ideas that determines the dominant norms which legitimize the pattern of resources distrib-ution in society. As long as dominant ideas are challenged, the struggle is ongoing. Thus, the battle to control meaning is fundamental to the larger political struggle.

The battle to shape meaning is pivotal to the transformation of predominant norms and perspectives. Since the inception of filmmaking there has been an ongo-ing struggle to wrest this illusive weapon from the inherent conservatism of the sta-tus quo and to harness it for social change. The significance of this ongoing struggle to the black community lies in the quest for black self-definition, a crucial build-ing block for the construction of black self-determination. For black people, then, films are inherently political and potentially transformative.

In truth, *each* characterization of blacks by this medium is a salvo in the battle for racial justice. For African American viewers, characterizations of blacks are never neutral; each characterization either advances or retards the struggle for self-determination and empowerment. Films and those involved in their creation, then, become logical targets of black collective critical analysis. There is no escaping the essential political dynamic at work; there is then, no meta-world of the aesthetic where art exists only for art's sake. In this vein, then, the black artist is held respon-sible to contribute toward the transformation of black America.

Spike Lee is on a quest to effectively use film to capture the texture of Black life and to direct African Americans' attention to the subtle shadings of their exis-tence. In so doing, he is moving beyond the White one-dimensional representations of Blacks, Blackness and Black life. Lee's work proclaims the existence of a dynam-ic, multifaceted Black society peopled with personalities possessing the entire range of human emotion, experience, aspiration, and intelligence—all of which are brought to bear upon their lives in the crucible of America. He has entered the fray to con-

test the meaning of Black life in America. Like his predecessor, Melvin Van Peebles, Lee seeks to ensure that "White standards will no longer be imposed on the Black community" (Jaehne, 1990, p. 7).

In the course of his pursuits, Spike Lee casts a gendered gaze upon the black communities he portrays. By doing so he consistently delimits a role for black women which is peripheral and, thereby, subordinated to the black man. Spike Lee is a work in progress; he promises to capture the transformational potential of black film but in order to do so he must traverse the chasm of black patriarchy. Until Lee's work reflects the realization that black women are inherently valuable and not merely auxiliary to the liberation of black men, it will fall short of its potential to galvanize the entire black community.

Lee's Mode: "So Black"

Spike Lee has a distinctive approach to filmmaking, one that celebrates, while simultaneously analyzing, black culture. For blacks, it is simply that he is

> so black/does not aspire to be white/works hard to stay black/think black/love black/taste black/teach black/bitchblack/inkblack/wants to pitch his voice midnight/drumout his name/say i've known rivers instead of i pledge allegiance/sing god bless the Chile/instead of America. (Kwelismith, 1989, p. 119).

Spike Lee's films have flavor; they tantalize the senses using a combination of black art forms. Black music is as integral to his films as black dialogue and familiar community settings. In addition, Lee uses the emotional release of humor as the device which allows blacks to turn a critical eye upon themselves and their surroundings without becoming defensive or derisive. He uses black foibles to deepen his characterizations of black people: as such, they become mechanisms for collective introspection rather than tools for destruction.

This is a significant departure from the use of humor as a tool to reinforce the stereotypical notions predominant in earlier film productions. This problem is pronounced in movies such as *Green Pastures* (1937), where one is presented with an all-black cast placed in what purports to be a black version of heaven. This film oozes with the perversity of white racism: one sees perpetual fish fries, singing, and cavorting. Whites have even sought to invade the only promised land—the afterlife—with their "ethnic notions." As Ethel Waters once lamented, "Darkies don't dream"; white people have arrogantly abrogated our right to a vision of the afterlife. Their version of the black afterlife reasserts our inferior status. And as they define our position in heaven, they also reassert their own position of supremacy. As Countee Cullen wrote:

She even thinks that up in heaven/Her class lies late and snores/While poor black cherubs rise at seven/To do celestial chores. (Hughes, 1970, p. 231)

These white notions also invade *Stormy Weather*, now considered a classic, wherein humor is a vehicle for the presentation of similar debilitating racial stereotypes. African Americans grit their teeth through the *antics* of black embodiments of white fantasy—characters which include "Zip Coon," shuffling blacks, avaricious black women, minstrels in black face and a female dance troop which parades a denigrating darky's smiling face on the backs of their bonnets. The images are the same as those in *Green Pastures*; only the locale differs from the ethereal to the secular! This humor reveals nothing of black people or black life, and does nothing to illuminate pressing social issues. The humor is significant, however, for its affirmation of white racist notions of blacks. In both *Green Pastures* and *Stormy Weather* the humor, unlike that of Spike Lee, does not advance the plot, does not bring greater sensitivity to the plight of characters, and does not engender examination of volatile social ideas.

Not only do white filmmakers use humor in their attempt to steal black dreams; they also knowingly exploit the most talented black representatives in undertakings which ultimately undermine their collective sense of self-worth. Instead of receiving acknowledgment for their intellectual merits and artistic talents, individuals who, in reality, refute white stereotypical notions are coerced into complicity with the purveyors of African American humiliation. For example, Rex Ingram, who played "de lawd" in *Green Pastures*, possessed a medical degree and a Phi Beta Kappa key before undertaking a theatrical career. So too, was Paul Robeson, a multitalented personage, constricted to feeble roles and, later, total ostracism by white image-makers (Sampson & Sharp, 1983).

Despite the obvious debasement of blacks in these and other films, their subordination in society prompts a deep desire to see any reflection of black life. Unfortunately, this reflection has been grossly distorted through the lens of white America. Blacks have been fed a steady diet of stereotypes which merely reinforce the perverted perceptions of the status quo. In her commentary, "Blacks' Media Burden," Beverly Shepard summons childhood memories which sound familiar: "Among my childhood memories is that of my image-starved family rushing through the house shouting. 'Black people on TV! Black people on TV!'" The same scenario relates to seeing black people in the movies, perhaps even more so, because it is the "Big Screen."

In contrast to the films discussed above, Lee evokes a humor born of the familiar which elicits collective recognition of obstacles and internal shortcomings. It is humor which, because it is shared, reinforces the sense of community and raises the hope of resolution. Simultaneously, it is used as an anesthetic to blunt the pain

of the incisive edge of truth.

The presentation of the "dogs" in *She's Gotta Have It* elicits laughter from audiences who recognize the vacuousness of these familiar "come-on's," and, given the camera angle, view this as it is: a barrage of "bull." Underneath the laughter is the acknowledgment of the need to rectify the bases on which black men and women come together. In *School Daze* humor is consistently used to diffuse tensions. When the "brothers" question Dap's challenge to give up all for protest, it seems their camaraderie is doomed; however, this likelihood is dissipated by their humorous response to Dap's frustration. Here, humor is not used to evade the issue but is a vehicle whereby friends can hold diverse and opposing views without jeopardizing their relations. Similarly, humor is interjected to indicate the underlying love between Mookie and his sister Jade in *Do the Right Thing* in the midst of Jade's criticism of Mookie's shortcomings. When he discusses Sal's overtures toward Jade, a potentially caustic situation is averted by his teasing. And in *Mo' Better Blues*, Bleek's love life is a source of comic relief. The camera shows his quandary in trying to meet the demands of his two lovers. The exasperation that results is aptly captured by the camera. One sees him making love first with Indigo and then with Clarke, back to Indigo, back to Clarke. His head swivels before the camera and he says the wrong name to each. He turns to the camera to beseech the spectators; he is a mess.

Given what has transpired in Hollywood films, Lee's work is black social commentary, conceivably a new genre of black films. Lee is an astute observer of black life; he uses the insider's intimate knowledge of black culture to infuse his films with black music, his characters with black words, and his plots with black sensitivities—giving voice to the voiceless. Each of these elements—the music, the language, and the sensitivities—is essential to the presentation of Lee's agenda.

In this era of the "Pop Top 40" where white music moguls create stars, indigenous black music is usually relegated to the fringes of pop culture. However, the black community asserts its own orientation to music. African Americans celebrate their own stars and styles regardless of their appeal to the white market, or lack thereof. It's not Springsteen, it's James Brown; it's not Barry Manilow, it's Luther Vandross; it's not Kenny G., it's John Coltrane; it's Bessie and Billie and Dinah and Sarah and others who have *no equivalent or parallel in the white community*. Lee uses the magnetism of black music and the statements embodied therein to harness our attention.

In *She's Gotta Have It*, Nola's theme is woven throughout the text of the film, lending magnitude to the character herself by making her omnipresent. In *School Daze* the music comes forward to clearly delineate the many themes explored in this film. The film opens with a song of deliverance, "I'm Gonna Build Me a Home," conveying the quest of black people for a place of their own. And it is "Homecoming Weekend at the College" where "Homecoming" represents more than a football

game and the crowning of a queen; it is the quest of the characters for self-realization and belonging. The musical sparring between the "jigaboos" and the "wannabees" is used to define the conflicts of class and color that retard the construction of the collective home. "Da Butt" is an infectious celebration of youthful sexuality and black physique. The haunting ballad sung during the Homecoming Coronation calls for black self-acceptance, "You can only be you; I can only be me."

Lee opens *Do the Right Thing* with the Negro National Anthem and then immediately beckons blacks to "Fight the Power" repeatedly throughout "one hot summer day." In *Mo' Better Blues* he woos blacks with Coltrane's "Love Supreme" and seduces them with the sensuous strains of Branford Marsalis and his father, Bill Lee. The music he uses is purposefully chosen because it elicits powerful emotional responses and because it reinforces the thematic direction of his films. He goes beyond mere usage of music to revere the artists that create it, as in the "roll call" of black musical contributors proffered by the "We Love Station" in *Do the Right Thing*, and in his thematic focus on the jazz quartet in *Mo' Better Blues*. Thus, he reaffirms the magnitude of African American creativity while creating an environment compatible with the transmission of his ideas.

Lee's text includes not only the written screenplay but a visual text which includes excerpts from speeches, black literature, newspapers, and graffiti. Zora Neale Hurston's words from *Their Eyes Were Watching God* provide the opening theme in *She's Gotta Have It*. Men and women dream different dreams; those of men are often elusive, those of women are "true." This sets the stage for the conflicts which ensue between Nola and her lovers.

Even the collage in Nola's studio apartment carries a message to the viewer: that society, with Nola, remember the victims of injustice. The scrawled name of Tawana Brawley on the wall in *Do the Right Thing* strikes a similar chord of recognition. In his use of graffiti Lee takes a contemporary image which is more often used to connote gang violence and thereby, maligns the black community and he uses this familiar image to project black sensibilities.

Lee's characters speak to blacks directly. He often uses a series of vignettes which focus viewers on issues of particular import to the black community. While other filmmakers use this technique, the manner in which Lee does this is unique. The viewer is focused upon his characterizations of black individuals; Lee views blacks as people who have problems but who are not, themselves, problems.

Through Lee's use of vignettes one comes to know and empathize with individual characters as they confront the everyday drama of black life in America. Through his use of the camera Lee beckons the audience to participate. He establishes intimacy between the actors and the viewing audience. Blacks are not merely observing these actors going through fictitious scenarios; they share their lives. The actors look into black eyes, speaking and grappling with problems blacks

share. Thus, black interaction is assumed assured and essential. Lee, then, is not speaking *for* black people; he is speaking *to* black people.

The creation of this intimacy between the screen and the viewers is significant because it is used to focus viewers on the fundamental issues which plague black communities; the questions raised in the films discussed below are questions which Lee, through his characters, asks of blacks. What is he asking African Americans to consider? He raises questions about the most basic black values regarding love and beauty, black political choices and their consequences, intergenerational cleavages, and about what blacks see when they actively regard themselves. He forces examination of the issues some African Americans would rather bury from public scrutiny; the divisiveness of class differences, the struggle to define black sexuality in the face of the perversity of racialized society, black mimicry of white aesthetic and the impact of internalized oppression on black individual self-worth and, therefore, on blacks' ability to value each other.

Spike Lee's films have become public events because they serve as a contemporary town meeting: He has set the agenda but it is not immutable. He calls the meeting, but it is African Americans who, in coming together, assess their lives and determine the future agenda—both of which are essential ingredients for black empowerment. Lee's works present his diagnosis but it is blacks who affirm it and move to perform the operation that initiates the healing process.

Malcolm X's statement "by any means necessary" applies to Lee's use of everything at his disposal to convey his message. Thus, Lee does not subscribe to the artificial barriers that delimit the appropriate use of various mechanisms for various pursuits; these are not just movies. Lee consciously weaves music, poetry, graffiti, still shots, and an assemblage of the familiar objects of black lives into a subtext which involves the totality of black senses. This subtext also projects a decidedly political agenda.

Lee "Works Hard to Stay Black/Does Not Aspire to Be White"

White society would have one believe that drug addiction, fratricide, and social dependency are the characteristic features of the black community. These characteristics are used to further define and delimit the extent of black personality. Lee refocuses on the oft overlooked reality that blacks know. While not ignoring the social ills that beset African Americans, he reminds viewers that the social problems emanating from the oppressive social order do not define blacks. While African Americans remain distinctive by history, culture, and orientation, blacks are not a monolith. African Americans are a diverse, vibrant people who love those things which remind them of the blackness in each other and yet delight in and

encourage self-assertion. Herein lies a crucial characteristic: diversity in the black community is not a cause for cleavage but is a celebrated aspect of black life. Such a diverse community is a marked departure from Hollywood depictions.

By presenting characters within this context, Lee empowers them and thus provides the hope for the positive resolution for their problems. The blacks in Lee's films, then, have neither to be defeated nor to be *extricated from their blackness* to resolve the issues that confront them. The white option is, therefore, not indicative of success, but represents social blindness and abandonment of the struggle to define one's existence. Therefore, blacks who choose this option, such as the piano player in *Mo' Better Blues* with his French white lover, are viewed as pretentious anomalies who, though tolerated and understood, do not possess viable answers to the question of self-definition that confronts African Americans.

The reason such an option is rejected is based on the fallacy of the application of white universalism to the black experience. Those who would decry the particularism of black culture as confining fail to see the universal truths and emotions that are explored within this context. These same individuals have no problem finding the universal message put forth by whites who use *their* particular national and cultural experience as the basis of their work.

Lee uses the particular cultural experience of black Americans to inform the direction of his works. He draws on the universe of black life in America which results in depictions of African Americans that reveal a wide range of personalities, styles, language, and aesthetics—all within a black context. He makes *no* attempt to situate these black images within the "larger" framework of white society. Because of this, he establishes, within his works, a black norm—it is whites and white sensibilities which are presented as aberrant within this framework.

The difference between Lee and white-oriented filmmakers is that the white view is that of a commuter passing through foreign terrain. Lee views the black community as a resident and participant. The commuter gets, at best, surface impressions while Lee, as the resident, is a participant and an observer. He is acutely aware of the nuances of his community because he is indicating those with whom he is intimate on a daily, interactive basis. As a resident, Lee can explore parts of the black community that whites dare not enter. So, too, can Lee explore aspects of the black psyche that whites cannot comprehend and fear to encounter.

A prime example is shown in Lee's strategic use of photos and quotes from Martin Luther King, Jr. and Malcolm X in *Do the Right Thing*. To whites, this was at best ambiguous and, at worst, potentially volatile because it pitted nonviolent integrationist ideals against the opposition of violence and the maintenance of separatism.

For blacks, such a dichotomy is artificial. It does not address the black political dynamic. In fact, such a dichotomization is antithetical to black culture. In truth,

both Martin Luther King, Jr. and Malcolm X are warmly embraced by the black community. King's ideal of racial harmony and ultimate integration is upheld and understood while Malcolm X captures a deeply rooted sentiment among black people as well. Blacks understand that their strategic objective is to attain human dignity. The competing questions of nonviolence and self-defense are tactical questions for this achievement. Yet, they also represent vital aspects of the black psyche; blacks are caught in a dilemma of desiring unanimity and harmony while being ever aware of the need to protect and defend their person and integrity.

Lee legitimizes black political thought and action, not only in relation to blacks' oppositional stance to white society, but also in their internal struggles to define themselves individually and in relation to one another. In *School Daze*, Lee extols black activism with the opening collage which shifts from the cutaway exposing the hold of a slave ship and its human cargo to Frederick Douglass, Marcus Garvey, Mary McLeod Bethune, and more contemporary figures such as Muhammad Ali, Stokely Carmichael, Martin Luther King, Jr., Malcolm X, and Jesse Jackson. Lee rallies blacks to political action as the collage gives way to the Mission College motto, "uplift the race." The film closes with the admonition to "wake up" and the ringing of an alarm clock. Between the opening and the denouement the film is devoted to an intense examination of various political elements at play in the black community, including black institutional support for divestiture from South Africa, black support for black colleges, and genuine black control of those selfsame institutions. The "wake-up" call bespeaks the fact that it is time, as Du Bois said, for black people to awaken from the slumber of ignorance and to acknowledge their place and thereby their plight.

These symbols are repeated in *Do the Right Thing* which opens with more classic symbols of black rebellion which include the Black National Anthem, Public Enemy's "Fight the Power" and a dancer wearing boxing gloves. Then the alarm clock goes off, and the "We Love" DJ tells his listeners, "Wake up! . . . The color for today is Black!" The use of these symbols is significant because these are symbols which are not commonly presented in any mass medium. They represent what white America wants to forget, while at the same time embodying the black collective ethos of resistance. For example, Adam Clayton Powell is represented in the collage though forgotten by the white community after being expelled from Congress on trumped-up charges only to be vindicated posthumously.

Lee's political discourse is not always explicitly stated in the form of definitive ideological pursuits. Rather, the overarching polemic is one in which black norms are presented as natural, viable and oppositional. Black viewpoints are mutually understood without engaging in the formal discourse necessary to render them visible to whites. They are embedded in everyday life—subtle as each breath taken, and just as vital.

In this context, then, all facets of African American lives take on political meaning: sport is not merely a contest between two teams or individuals, but is a struggle for black affirmation in the face of white supremacy. When Lee refers to Larry Bird versus Michael Jordan, he is recognizing black prowess that is always challenged with the raising up of a mythical white hope. It is not simply Rocky Marciano versus Joe Louis or Randall Cunningham versus Jim Kelly; it is black self-assertion and proficiency versus the maintenance of white hegemony. Lee recognizes this and presents it to black people without polemics because it is clearly understood. As such, it demarcates those blacks such as Greer Childs from Mars Blackmon and whites such as Sal and his sons from the black community.

A rejection of white norms is implied in Lee's disclosure of black norms. This is aptly captured by Ntozake Shange in *For Colored Girls Who Have Considered Suicide When the Rainbow Is Enuf*:

> we deal with emotion too much/ so why don't we go ahead & be white then/ & make everythin dry & abstract wit no rhythm & no reelin for sheer sensual pleasure/ yes let's go on & be white/ we're right in the middle of it/ no use holdin out/ holdin onto our- selves/ let's think our way outta feelin, (Shange, 1977, p. 47)

The tension embodied in the struggle to avoid capitulation to whiteness is omnipresent in the lives of blacks and in Lee's films. It need not be overt. What Lee depicts in his films succinctly conveys black awareness and rejection of the reifica- tion of white standards, particularly as they are applied to black people.

"Thank God for lips," thank God for "de butt," thank God for the presenta- tion of black men and women resplendent in their representation of the variety of their Africanness and for the black sensuality presented in Lee's rendering of black images. This black sensuality bespeaks blacks' attraction for and to each other, embodied in every character Lee presents from the spindly legged Mars and Mookie to the self-possessed Jamie, from the shallow beauty of Greer to the pas- sion of Dap, from the contained rage of Radio Raheem to the self-absorption of Bleek. It is seen in the pouty "kitten," Jane, and the stoic majesty of Mother Sister, in the singularity of Indigo *and* Clarke *and* Nola Darling.

The Phallacy of Lee's Sexual Construction: "It's a Dick Thing"

Lee's films are significant in their presentation of new images of black men and women. These images are new as objects for mass consumption, but because they are "news" for blacks. They generate new images of black men and women for mass consumption. Yet what he brings to the screen is not a surprise to black viewers; it

reflects what they have known all along: their humanity. Love is the persistent theme underlying black humanity, a theme boldly expressed as a sexual love, and more subtly rendered as a deep devotion to each other—a love supreme. Lee brings black sexuality to the screen in a manner not seen heretofore. Since white definitions of black sexuality have served the heinous purposes of destruction of African Americans' conjugal, parental, and community relations and, more pointedly, have threatened their very existence, this is a momentous undertaking. Lee attempts to transform the presentation of black relationships, and black men in particular. For Lee, black men are sexual beings, not brutes: vulnerable to their passions, not victims of them. They are not the sexual predators portrayed in white mythology. Lee shatters whites' illusions of their desirability. His portrayal of black on black intimacy raises the specter of an Afrocentric world independent and unconcerned with whites.

Lee's explicit portrayals of sexual love are unabashedly male-oriented and heterosexual; for Lee, "it is a dick thing." The "dick thing" returns the genitals to the black man; interestingly, this white-depicted sexual omnivore who has been branded as a sexual terrorist was rarely depicted in male-female sexual encounters. Ironically, it was white men who portrayed the black sexual brute (cf., *Birth of a Nation*, 1905).

When black men entered the film industry they were denied their sexuality and relegated to roles as buffoons and loyal eunuchs. They died early in the plot—clearly expendable—and were without any meaningful love interest, defined solely in terms of their service to whites. If a serious relationship developed, particularly if it involved a white woman, she had a serious defect such as blindness (cf., *A Patch of Blue*). If a black female was involved, her role was marginal, asexual and undeveloped or marginal, supersexual, and undeveloped!

Examples of the above include *Lilies of the Field* where Sidney Poitier, as a eunuch in the service of white nuns, does not care about "none" and surely does not get none. And in *Driving Miss Daisy* her "best friend" is content to keep his hands on the steering wheel—a situation lampooned by *In Living Color*'s skit, "Ridin' Miss Daisy" where "best friend" services Miss Daisy in the back seat of the car. In *Silverado* Danny Glover is the only major character left at the conclusion with no conjugal love interest (he goes off with his sister!). In *Lethal Weapon II*, even though Danny Glover is never depicted in sexual intimacy with his wife, his mentally unstable sidekick, Mel Gibson, attracts the sexual attention of the young, blonde Boer.

In rare instances where black women play protagonists, they are generally denied the sexual companionship of black men. This is true in *Sounder*, where Cicely Tyson's husband is whisked off to jail in the first ten minutes of the film for the duration, in *Mahogany* where Diana Ross disappoints black female viewers by choosing a small white man over Billie Dee Williams, and in several of Whoopi

Goldberg's films where she is matched with strange, unattractive white men—and still does not get any!

When a black man is depicted with skills, intelligence, and/or material affluence, he worships at the shrine of the white Madonna, as does Sidney Poitier in *Guess Who's Coming to Dinner*. A notable exception is found in Eddie Murphy's *Coming to America* where the Crown Prince actively seeks an intelligent, autonomous black woman to be his wife. Yet, it was necessary to go all the way to Africa to find a black man possessing wealth *and* stature *and* respect for black women. Unfortunately, Murphy's exceptional treatment of black conjugal relations is confined to this film and aborted in *Harlem Nights*, where black male brutality against black women is unabated.

Lee's depictions of black men differ sharply from the images cast by Hollywood. He presents men who inhabit a sexual universe. Released from the celibacy to which they had been confined, they now revel in their sexuality. They have been freed to develop relationships with black women. While these are relationships which fall, finally, outside the purview of whites, they are mediated solely in male terms, thereby failing the test of mutuality fundamental to equality.

Lee's relationships are, indeed, a "dick thing" because they are defined exclusively by the black male's sexual orientation—genital and phallic. While Lee has grasped the clear need to protect black genitalia literally and figuratively, he does so by defining black genitalia as the property of black men. Long the object of the lynch mob and the subject of coercion and manipulation at the hands of privileged white women, black male genitalia were literally severed from him. Simultaneously, black male power, personality, and familial ties were subject to severance at the hands of white society.

Lee attempts to negate the work of the lynch mob and to contravert the effects of subjugation by explicitly placing black male sexuality at the forefront of his characterizations where it becomes a thematic centerpiece. Like "Sweet Dick Willie" who is defined in terms of his sexual prowess, Lee invests black male sexuality with power and freedom, depicting black male sexuality as an integral component of community life. He attempts the rejuvenation of black male self-esteem by placing them center stage.

In returning sexuality to the black man, Lee also defines the sexuality of the black woman, as the preferred sexual partner of the black man. Yet, Lee does little to transform their relationship beyond the purely sexual. Clearly, Lee's view of black women differs from that of white filmmakers—hence his criticism of Murphy's treatment of black women in *Harlem Nights*, where Murphy punches the older black "madam" played by Della Reese (Lee, 1990, p. 34).

However, Lee's portrayals of black women fail to capture their essence. While it is extremely problematic for black women that he fails to set them at the center

of black life, it is even more problematic that he, having cast aside white stereotypes, fails to cast aside patriarchy with them. He, therefore, substitutes white male hegemony with black male supremacy. Only Bleek sits in the center of the camera's eye while the world revolves around him; the black woman is allowed that place at the core only when she is with her man, as part of him.

Sitting center stage, the black man is allowed to *dick*-tate the movements of the black woman who is essentially a prop on the stage that he dominates. On this stage, it is only his desires which are validated. Hence, in *She's Gotta Have It*, Nola Darling relates that she has been characterized as a "freak" for her frankly stated sexual desires. Thus, Jamie disdains Nola because *she* defines the parameters of the relationship, contesting his primacy in establishing control. She initiates sex: he rapes her. In Lee's films, while men are allowed to have their "dick thing" they are also the possessors of the "pussy" and women are forbidden the comparable autonomy.

For Lee's men, the women are merely

snap crackle pop/ pussy/ born to serve/ born to serve/ snap crackle pop/ pussy/ born to serve/ born to serve (Kwelismith, 1989, p. 501)

"Doin the mo' better" might beat celibacy but it falls far short of meeting black needs for intimacy, emotionality, and the reciprocity that belies mutual respect. Lee's black men are certainly no longer eunuchs. They are paid homage by Lee and his camera through his depictions of them as virile, intelligent, and essential.

In defining his male characters, Lee employs a variety of means to assure their masculinity. They are men because they are *not* women and *not* female, and because they have mastery over women. Their greatest insults embody feminizing each other or questioning each other's heterosexuality and/or virility. Thus, typical taunts include "pussy," "fag," "virgin," and put downs for being unable to control their women. As the young man who receives the greatest homage in *School Daze*, "Big Brother Almighty" Julian exerts the greatest control over a woman; he commands her to surrender herself to another man—in his terms, a less-than-a-man, the virgin "half-pint." He gives his woman's pussy—which is really his—to another man. Thus, Lee's man is defined in terms of having a dick and a pussy to put it in. His women are unfulfilled.

Lee presents black men in all of their humanity, complete with weaknesses and strengths. He abandons the one-dimensional presentation of the black man as a macho hero, eunuch sidekick, amoral pimp/hustler/thug, and the buffoon. Lee's black man does not exist as the aberrant vision of the white man; he exists for himself, his woman/women, and his community.

The counterpart of Lee's black man is the black woman (or *women*). Gone is the premise that the black man wants what the white man has—the white woman. Lee's phallacy lies in his construction of the black woman as a receptacle for the

black man's phallus. He, as a male director, fails to envision her as the true partner—in struggle—of the black man. She is background, color, prop to his struggle. Thus, Lee's principal weakness is his failure to envision the black woman with all of *her* complexity and potential, as he envisions the black male:

> somebody/ anybody/ sing a black girl's song/ bring her out/ to know herself/ to know you/ but sing her rhythms/ carin/ struggle/ hard times/ sing her song of life . . . sing her sighs/ sing the song of her possibilities/ sing a righteous gospel/ the makin of a melody/ let her be born/ let her be born/ & handled warmly (Shange, 1975, pp. 2–3)

The failure of Lee's films to "sing a black girl's song" mirrors the shortcomings of the larger black community to attack patriarchy with the same vigor as racism. The failure to recognize the inextricable linkage of the two portends the collective failure to mobilize the totality of black human and intellectual resources against black oppression.

Conclusion

Clearly, Spike Lee plays a pivotal role in the construction of a black aesthetic and ideological framework that is oppositional to the dominant culture. This is an important contribution because it heralds the potential for the mass emergence and legitimization of progressive black ideologies. While Lee's works contribute to the dismantling of white supremacist definitions of blacks and black life, they fail to transcend the strictures of black patriarchy which bind better than half our population. Lee is, himself, bound by black patriarchy which distorts the lens he wields. Until he examines this shortcoming and rectifies it, his work—although promising—will provide succor only to those who share his limitations.

> We reach for destinies beyond
> what we have come to know
> and in the romantic hush
> of promises
> perceive each
> the other's life
> as known mystery.
> Shared. But inviolate.
> No melting. No squeezing
> into One.
> We swing our eyes around
> as well as side to side
> to see the world.
> To choose, renounce,

this, or that—
call it a council between equals
call it love.

—"Beyond What," Alice Walker, *Revolutionary Petunias*, 1973, p. 69.

References

Hughes, L., & Bontemps, A. (Eds.). (1970). *The poetry of the Negro, 1746–1970: An anthology.* Garden City, New York: Doubleday.

Jaehne, K. (1990). Melvin Van Peebles: The baadasssss gent. *Cineaste*, 18(1), 4–8.

Kwelismith. (1989). *Slavesong: The art of singing.* Washington, DC: Anacostia Repertory Company.

Lee, S. (1990, October). Eddie: An exclusive interview with Eddie Murphy. *Spin 6*, 7, 33–36, 97–98.

Perkins, E. (1990). Renewing the African American cinema: The films of Spike Lee. *Cineaste 17*(4), 4–8.

Sampson, H.T., & S. Sharp. (1983). *History of Blacks in film.* Los Angeles: William Grant Still Community Arts Center.

Shange, N. (1977). *For colored girls who have considered suicide, when the rainbow is enuf: A choreopoem.* New York: Macmillan.

Walker, A. (1973). *Revolutionary petunias.* New York: Harcourt Brace Jovanovich.

A Critical Exploration OF African American Women Through THE "Spiked Lens"

HEATHER E. HARRIS AND KIMBERLY R. MOFFITT

Upcoming Attractions: The Introduction

Spike Lee's filmography elicits controversy. His willingness to confront sensitive issues of race, politics, religion, and even sexual prowess in his films is indicative of his desire to challenge the status quo, enlighten us on matters of the world as well as champion the cause of the underprivileged. Yet, the criticism he has received for approximately 20 years regarding the portrayal of women in his films has created an unyielding tension between Lee and his detractors. hooks (1993a) summarized the words of several feminist scholars, Black Studies scholars, and cultural critics by saying: "Like many females in Lee's audience, I have found his representation of women in general, and black women in particular, to be consistently stereotypical and one-dimensional" (p. 13). As a rebuttal, Lee stressed that his desire is to simply entertain and offer provocative storytelling (Nelson, 1990).

Some of the representations of African American women in Lee's films vary in scope from those as hypersexualized beings (e.g., Nola in *She's Gotta Have It*) to those as unfulfilled partners who provide unconditional love to their men, often at the expense of their own well-being (e.g., Gamma Ray leader Jane of *School Daze*) (hooks, 1993a; Harris & Hill, 1998; Hill Collins, 2005). As a result, Harris and Hill (1998) posited that Lee upholds stereotypes of African American women and "does not present African American womanhood . . . as being complex and multi-

dimensional" (p. 12). To his credit, however, Lee, in an attempt to address society's ills, especially as they relate to issues of race, does challenge the dominant perceptions of the African American experiences. And in doing so, he often utilizes African American (and Afro-Latina) women to tell and share stories of those experiences. Some of these women have included Halle Berry, Rosie Perez, and Tisha Campbell who are noted, well-known examples of actresses featured in Spike Lee films early in their careers. While women of other ethnicities have also been featured in these films, in this chapter we privilege the African American (and Afro-Latina) women's experiences.

The "Spiked Lens"

The year 1985 ushered in the feature film, *She's Gotta Have It* (1986), and a novel perspective of African American filmmaking that we conceptualize as the "Spiked Lens," a style of filmmaking that describes Lee's unique ability to create, in some ways, counter-hegemonic portrayals of African Americans, diametrically opposed to the Blaxploitation representations of the 1970s, which included quasi-empowered, overly aggressive (and at times, violent) "superheroes" that only existed on screen.

Known for his willingness to raise awareness around issues of race, discrimination, and oppression, Lee has utilized the medium of film to offer and explore perspectives typically not seen in mainstream films. Before Haggis's interpretation of American race relations in *Crash* (2005), there was the Spiked Lens (Emerson, 2006). We conceptualize this lens as an unflinchingly racialized, macho, and liberatory style of filmmaking that centers African American lifestyles and life choices. Thought- and dialogue-provoking, his messages are controversial, edgy, assertive, and innovative. Furthermore, the lens often depicts the unvarnished tensions of the interactions of multiethnic America as its members strive to attain or sustain an "American Dream" oftentimes denied. These images appear unpalatable, at times, to mainstream audiences as seen, for example, in *Do the Right Thing* (1989), which portrayed multiethnic families in community and conflict. Lee, however, refuses to pander to mainstream sensibilities and pointedly retorted that "someone has to force America to come to grips with the problem of racism" (Muwakkil, 1988).

While the Spiked Lens is a concept that can be used to analyze a number of issues, for the purposes of this chapter, we have chosen to specifically focus on the depictions of African American women in Lee's filmography. To this end, we selected for analysis six films from Lee's filmography that feature African American women both as pivotal characters (*She's Gotta Have It*, 1986; *Girl 6*, 1996; *Bamboozled*, 2000; and *She Hate Me*, 2004) and as influential, though not central characters (*School Daze*, 1988 and *Mo' Better Blues*, 1990). The analysis of these films

allows for broader application of the Spiked Lens—especially since we perceive its usefulness beyond films written, produced, and/or directed by Lee. Films chosen were those that focused on fictionalized African American experiences; hence, documentaries and autobiographies were excluded. A decade-by-decade analysis also provides space for evidence of longitudinal patterns in the images of the women in these films. Finally, we discuss the implications of the Spiked Lens in an effort to further the dialogue about the portrayal of black women in film.

Views on the Spiked Lens

Scholars (Lubiano, 1991; hooks, 1996b; Hill Collins, 2005) have objected to Lee's depictions of African American women in his quest to unveil aspects of racism and internalized oppression in the United States. They posited that efforts to confront racism are neutralized when the overarching patriarchy of this country is not addressed. Past analyses of these depictions have not been especially critical. Barton (2005) argued that Lee's attempt to characterize women generally, and lesbians in particular, in *She Hate Me* (2004), was no more than "an under the covers mastur-batory fantasy for heterosexual men" (p. 79). She further concluded that the lesbians of the film were not lesbians at all, but simply "Spike Lee lesbians" who can only be content by situating the male as center. Even more compelling, however is her stance that Lee attempts to present gender role reversal and power where the lesbians are the sexual aggressors and sexism is no more. Fraiman (1994) presented an earlier critique of his characterization of women in *Do the Right Thing* (1989) and *School Daze* (1988). She applauded Lee for his efforts to explore the complexities of racism but challenged his persistent relegation of the female characters to the margins of racial politics throughout the films. Specifically, she argued that Lee objectified and "otherized" African American (and Afro-Latina) women by "invoking the vulnerability of Black women" in the face of white male domination and privilege (p. 73). Hill Collins (2005) expanded this idea, adding that under the hegemonic gender ideology, white females are heterosexual and subordinate to their male counterparts, their sexuality exists for their men's pleasure, and their ideal of beauty is narrowly defined. She further explained black gender ideology as a distorted and deviant opposite of the hegemonic gender ideology that is framed within the boundaries of institutional racism in the United States. Within the parameters of black gender ideology, African American women are perceived, for example, as "strong," "financially independent," "single mothers," "bad mothers," "sexually immoral," and "lacking in femininity" (Hill Collins, 2005).

According to McPhail (1996), Lee's efforts to challenge the patriarchy primarily serve to reinforce it. "Lee's films exemplify an ideological and epistemological complicity with the culture he so persistently calls into question" (p. 128). He

added that Lee's apparent commitment to the patriarchy "undermines his opposi-tional agenda" (p. 132). Dates and Mascaro (2005) and Jones (1998) condemned Lee's stereotypical images of African Americans as problematic due to their stag-nant imagery and marginalized nature. Dates and Mascaro (2005) reiterated that the portrayals are "frozen images, often incapable of growth, change, innovation or transformation" (p. 52).

While we agree with the aforementioned positions regarding patriarchal rein-forcement and the resulting sexualized images of these women, in our exploration, we neither condone nor condemn Lee's works but rather unveil another subtext of the "Spiked" African American female character. To that end, we ask, how are African American women viewed through the "Spiked Lens?" In our analysis we present four specific themes that emerge as a result of the Spiked Lens: the mes-sage as paramount; female-from-female alienation and isolation; female-from-male alienation and isolation; and, the peripheral mother. A brief synopsis of the six films selected from Lee's filmography will be provided prior to our discussion of the aforementioned themes.

Opening Credits: A Synopsis of the Films

In the film *She's Gotta Have It* (1986) , the central character, Nola, is presented as a sexually liberated, upwardly mobile and self-confident urbanite. Her appetite for sexual satisfaction is satiated by three particular men: Jamie, Mars, and Greer. While Nola's goal is mutual sexual satisfaction, the goal of the men is the transfor-mation of Nola from a "jezebel" (Hill Collins, 1990) to a nice girl; an unrefined to refined woman; or a whore to what Mars referred to as a "righteous" woman (Lee, 1985). Her lifestyle is perceived as deviant by both men and women. And in the end she is punished for the sin of living the joy of sex. hooks (1996b) referred to the pun-ishment-cum-sexual assault as a turning point:

> It is ironic because until this moment we have been seduced by the image of her as a forceful woman, a woman who dares to be sexually assertive, demanding, and active. We are seduced and betrayed. When Nola responds to the question "Whose pussy is this?" by saying "Yours," it is difficult for anyone who has fallen for the image of her as sexually liberated not to feel let down, disappointed both in her character and in the film. (p. 233)

Three years later with *School Daze* (1988), Lee revisits themes of liberation and empowerment in his re-creation of the historically black college experience at Mission College. Here, we are introduced to Jane and Rachel, the women who love their men of extremes: Julian, a popular fraternity member, whose blackness is nar-rowly defined as that only existing within the boundaries of the United States; and

Vaughn, also known as Dap, a self-professed pan-Africanist. During the course of the film, the predominant female characters exhibit conflict with each other and their men while seeking to understand themselves. They also fragment themselves as African American women by defining themselves primarily by their sometimes-altered physical features (e.g., hair and skin hue) as opposed to their personal consciousness as well as their mutual struggles as African American women.

In *Mo' Better Blues* (1990) African American women are once again in conflict with one another. However while the object of desire seems to be Bleek, a conflicted, philandering trumpeter, in fact, Indigo and Clarke yearn for different aspects of him—security and prestige, respectively. These women consciously "share" Bleek, but bear animosity toward each other and to some extent a self-hatred toward themselves as a result. They more easily view the other as the problem rather than Bleek. And instead of leaving the triangle, they ignore one another and wait for Bleek to choose.

Figure 16.1. Shown from left (on set): Madonna, Spike Lee , Theresa Randle in *Girl 6* (1996). Courtesy of Photofest.

In 1996, Lee selects "Judy" as the lead protagonist in *Girl 6* (1996), a woman journeying toward her dream in spite of a few detours. She transforms herself into a telephone sex siren in order to make a living as she pursues a fledgling acting career. The bitterness from the treatment meted out to her during auditions is quelled by

the fleeting power she feels from participating in phone sex. Her sense of empowerment is short-lived however, as a result of blatant rejection and an unhealthy fixation from two different male clients. "Judy" finds herself seeking solace from her quirky male neighbor, Jimmy, before reclaiming her dream of stardom.

Sloan and Smooth Blak are the women of note in *Bamboozled* (2000). These women are energized by their respective causes: African American representations on screen and in politics. Sloan is the sage but silenced assistant to Pierre, television producer and mastermind of the twenty-first century minstrel show. And the sole female Mau Mau member, Smooth Blak, serves as a small dose of yin to the remaining Mau Mau membership who desire recognition for their "pro-Black" political platform. The women do not know each other but play similar roles in their male-dominated universes—supporters to their causes and the men who lead those causes. In the end, their allegiance results in the destruction of many lives, including their own.

In *She Hate Me* (2004), lesbians confront their perceptions of womanhood when they desire to bear children. Although these women have the financial resources to achieve motherhood through artificial means, they choose to "perform" as heterosexuals in order to become pregnant. John, Fatima's ex-fiancé, is solicited for a fee to impregnate Fatima and her Afro-Latina girlfriend, Alex, in order for them to conceive. These lesbians get their children and John eventually gets his woman, but not without conflict.

The aforementioned synopses highlighting struggles of liberation, identity, empowerment, and consciousness provide the backdrop for the emergent themes of the Spiked Lens.

The Main Attraction: Themes of the Spiked Lens

The films selected using the Spiked Lens revealed the following four themes: (1) the message as paramount; (2) female-from-female alienation and isolation; (3) female-from-male alienation and isolation; and (4) the peripheral mother. A few examples are highlighted exhibiting each theme; however it is apparent that all of the films embody the themes.

The Message as Paramount

In the "message as paramount" theme, Lee's desire to share his message as seen through the Spiked Lens, namely one that is controversial, edgy, innovative, and assertive, as well as one that pricks the racial consciousness of those who watch his films, often results in the loss of complex characters. The explicit antiracism,

antioppression, and antidiscrimination tone of his messages tends to stem not from the complexity of the characters or the subtleness of their interactions, but from the voice of Lee. His messages are reinforced via the "bullhorn" of the script, while characters appear to be mouthpieces for Lee's cause rather than storytellers. Furthermore, he challenges viewers with what he perceives as messages that counter the status quo perceptions of African Americans in a hegemonic and patriarchal society. However, his zeal to share his messages appears to obscure his recognition of how underlying and taken-for-granted assumptions about hegemonic patriarchy and the Black gender ideology that leads from it infuse his work. Because of the emphasis on the message as opposed to complex character development, Lee's attempt to destroy the influence of colonial thought seemingly serves to perpetuate it. His lack of character development, especially as it pertains to women, results in contradictory emancipatory messages within a patriarchal frame. The outcome, though probably not intended, is mostly recycled stereotypical images and fantasies of black women, through the gaze of black men—a sexist bamboozling of sorts.

"Wake up!" Lee challenges us to wake up from the internal racial struggles (in the form of radicals versus frat brothers, dark-skinned women versus light-skinned women, and black women versus black men) and recognize the interconnectedness of the struggle of African peoples worldwide. In *School Daze* (1988) Lee uses Mission College as the backdrop and Vaughn, the antiapartheid activist on campus, for this message. The main female characters in this film, Rachel and Jane, provide external consciousness for their men, namely Vaughn (Dap) and Julian. However, the women also present distorted and incomplete mirror images for themselves. Rachel, for instance, is the dark-skinned girlfriend of Vaughn. In one of their intimate moments, she encourages him to question his reasons for selecting her as a girlfriend as well as his reasons for disliking light-skinned African American women. As a pan-Africanist, Vaughn is asked to recognize that he cannot optimally raise black consciousness without initially processing his feelings about his perceptions of blackness. In her role as external conscience, Julian's girlfriend, Jane, tries to balance his cruelty to the young men pledging his fraternity. For example, during the final hours of pledging, Jane and her fellow Gamma Rays cheer on the pledges as they are being taunted by the brothers of the fraternity they desire to join. The work of these women, then, is not class work, but to provide aid and succor to the men whom they view as fundamentally good in spite of their flaws. However, this view is not reciprocated by the men to their women. In return for their "work," both Rachel and Jane are perceived suspiciously and again punished when questioning their boyfriends' reasoning on various topics. Rachel is denounced by Vaughn for desiring to pledge Delta Sigma Theta Sorority, Inc. And, Jane is cast off by Julian after she has sex with a frat brother, at Julian's request, to prove her love for him.

The manifestation of the distorted and incomplete images of the female characters is the realization that neither woman can be whole without the recognition of herself in the other: Jane must see herself in Rachel and vice versa in order for the wake-up call to resonate. There can be no African diaspora consciousness with the female characters stuck in the "Jigaboo" mentality. The film presents the dark-skinned versus light-skinned tension as a problem, but takes no steps to foster healing. Jane still views herself as entitled to the homecoming queen title, and Rachel does not really see herself at all. We never get a sense of her taking as much pride in herself and her beauty as in Vaughn's causes. She is an attractive woman, but she gives little recognition to her beauty. On the other hand, we know that Jane takes almost as much pride in her own beauty as she does in her man. With so few positive representations of people of African descent on film, opportunities like the tension between the women as well as within the women in *School Daze* (1988) should have been optimized as a teaching tool. The women as well as the men should have made the wake-up call. Instead, the men lead the "wake-up" movement as the women stand on the sidelines licking their relationship wounds.

Indeed, the destructive behaviors propagated by blacks on blacks in the film exemplify the need for the wake-up call. However, the message overshadowed the opportunity to plant several seeds of consciousness for self-love, black love, and affirmation for both men and women at a much deeper level than addressed in the film.

The importance of an authentic and affirming self-perception provides the message of *Bamboozled* (2000). The opening song states "Must never be a misrepresented people." Viewers see the conflicting perceptions among the African American central characters. For instance, Pierre views himself as an accepted part of an all-White writing team. Nevertheless, the writing team views him as a token to be tolerated. All of the major characters grapple with their internal and external perceptions of themselves. Sloan consciously exudes qualities that she believes enhance her credibility and professionalism as Pierre's assistant at the network. She cloaks her sensuality and her intellect in order to be "seen" in the corporate environment. Her clothes, the primary artifact for impression management in the film, are initially nondescript, buttoned up and ill-fitting. However, as Sloan begins to give herself voice at the network by expressing her visceral distaste for *The New Millennium Minstrel Show* her clothes begin to express this freedom. Her clothes also become more flattering as the attraction between her and Manray evolves.

From an intellectual perspective, we know that Sloan is competent, but we have little idea of the depth of her competence because she remains in the shadow of Pierre. It was Sloan who saw the potential of Manray and Womack and brought that knowledge to Pierre's attention. Pierre could not see their use for any of his

mainstream program proposals, but when he decided to spite his boss, he went for those he considered disposable—Manray and Womack.

In her effort to maintain the dignity of all involved with the Mantan idea, Sloan warns Pierre of the proposed show's slippery slope, but she does not abandon her post as supporter in general. Finally exasperated, she tells him bluntly that "This is some bullshit"; yet, she continues in her quest to reason with him by sharing black-face memorabilia. It is obvious that her knowledge goes deeper than research for the show; it comes from a passion for knowledge about the portrayal of blacks in media. Nevertheless, her urgings fall by the wayside, and instead of being reward-ed for her knowledge, she is condemned as a slut by both Pierre and Manray. Her value is connected to their pride as opposed to her professional expertise. Pierre and Manray shun her for her sexual trysts, past and present. Furthermore, they view her decision to romance them as a strategy for professional advancement rather than a choice for intimacy. Even though she literally "picks" Manray off the streets, he per-ceives her more as a conquest than a benefactor.

Smooth Blak of the Mau Mau, wears "gangsta" attire with an African-inspired headdress. She helps sustain and echo the incoherent rhetoric of the Mau Mau. We know nothing of her history. Why is she the only female in the midst of these quasi-revolutionary musicians who stage a murder to make the point about their dislike of the minstrel show? Finally, there is the woman screening the host auditions for the minstrel show. Divided by Pierre when seated, she and Sloan never speak, though they share disgust for the impending variety show. In the end the tension between the internal and external perceptions among the African American char-acters results in their psychological and/or physical destruction. They misrepresent-ed themselves and they have misrepresented each other.

Female-from-Female Alienation and Isolation

The sharing exhibited by Sloan and the other female "producer" seems to be the extent of how African American women commiserate with one another in Lee's films. Little effort is given to developing a sisterly bond or connection with other African American women. We note that in *School Daze* (1988), the women of the college campus have created spaces for themselves to connect with one another, but on a superficial level. The "Jigaboos" and "Wannabes" have similar physical features that intimately bring them together. But rarely are we given the chance to see how these women bond with each other on levels deeper than their beauty aesthetic or the preparation of that aesthetic, generally for the men in their lives. These female characters simply exist in Lee's world as a component to the larger mechanism that conveys his message.

Again, we argue that the value of the message as paramount is admirable;

however that it comes at the expense of replicating one-dimensional female characters that lack depth in their contact with other women seems problematic. This style of filmmaking is reminiscent of Oscar Micheaux, who prided himself on delivering a message to his audiences without regard, at times, to the process in which to convey that message. In *Body and Soul* (1925), Micheaux tells the story of a deceitful and immoral minister of a black congregation. In an effort to present his argument of the premature reliance on the church and/or the men of the church to be responsible for uplifting the race, Micheaux uses the storyline of a female member of the church named Isabelle who turns to Reverend Isaiah T. Jenkins for guidance only to be sexually assaulted by him. Although Isabelle plays an instrumental role in the eventual demise of this preacher, her character is hardly developed and little is known about her. This young, vibrant woman whose only female contact throughout this silent film is with her traditional, always-scolding, Bible-toting mother, has no female friends and is never seen engaging with other women, even in the church.

In *Girl 6* (1996), "Judy" (aka Operator No. 6), unlike Isabelle, is given the opportunity to interact with other women, but it remains superficial. For example, "Judy" is seen at work conversing with other phone sex operators regarding organizational practices. Their connection seems to be one-sided and limited, focusing primarily on "Judy's" life problems as well as their work-related adventures on the telephone. The sole intimate moment between "Judy" and another woman in this film occurs in the workplace restroom between "Judy" and Lil, who also happens to be her boss. The tone Lil uses during this conversation resembles that of a mother comforting her daughter after her first heartbreak. (Interestingly enough, "Judy" was being "comforted" because she had allowed her connection with a phone sex client to escalate into more than business—intimate, not sexual—only to be jilted by him in the end). "Judy" takes Lil's advice and decides to leave the business, albeit only temporarily. Her only remaining social connections lie in the friendship she shares with Jimmy, played by Lee, who likes "Judy" as more than a friend but settles for being a good neighbor.

In *She's Gotta Have It*, we are introduced to another independent spirit in the form of Nola, who carries out a lonely life without female friendships as well. Her character is said to be one of the strongest, most complex female characters ever created by Lee (hooks, 1993a), but even so, she seemingly lacks an ability to create positive bonds with other women. Throughout the film, Nola is presented as a liberated woman in search of sexual gratification (and love). She has numerous escapades with at least three suitors on screen, but it is alluded that there have been more. Nonetheless, she is penalized for that behavior. One of her suitors rapes her in an effort to "put her in her place" and remind her that she is functioning outside of the "appropriate" role of a woman. (Lee has since proclaimed this scene to be his most

significant regret in filmmaking but felt it played a role in painting a face of reality for America regarding issues of race, class, and poverty issues). Harris and Hill (1998) substantiate this point by stating,

> In a patriarchal society where males are in positions of domination or power over females and how women define themselves, several gender roles exist that women have been and still are expected to fulfill. . . . If a female attempts to be nonconformist "social penalties for deviation from these norms" may be incurred in her relationships that admonish such behavioral change. (pp. 9–10)

Essentially, Nola pays the price for being sexually liberated, but she also suffers harm because she does not carry out the roles of a woman that would encourage her to foster and nurture deeper connections with other women, rather than sexual connections with several men.

Female-from-Male Alienation and Isolation

The connections exhibited between African American men and women in Lee's films appear as restricted as those shared by African American women. Beyond the sexual escapades or snapshots of lovers seen in all six of the films analyzed here, we note that the deeper, intimate connection between these individuals rarely exists. The "love problem" is a common storyline in most Hollywood films; however, in films portraying African American men and women, it is usually presented as a dichotomy of "fucking or fighting," (hooks, 1993a). According to Hill Collins (2005), "the patently negative gender ideology reserved for African Americans certainly cannot form a foundation for loving relationships. How can seemingly "wild" women and men learn to love one another?" (p. 258). In *Mo' Better Blues* (1990) Bleek's numerous opportunities to bed multiple women (namely, Indigo and Clarke) convey a sense of vibrancy and excitement in the lovemaking of African American couples (e.g., "fucking"), while "Judy's" attempt, in *Girl 6* (1996) to disassociate herself from her thieving husband by not communicating with him at all, even in public, suggests that these couples are always at odds (e.g., "fighting"). Although given ample opportunities to showcase images counter to this dichotomy, Lee has chosen instead to conform to recycled stereotypes that shed only a negative and limited light on African American relationships, as noted by Hill Collins (2005).

This female-from-male alienation and isolation exists as a result of Lee's character development. He has repeatedly created male characters that may be flawed but are also multidimensional and with boundless possibilities. On the other hand, the female characters are created as one-dimensional and unable to fulfill "alternative" roles without a form of retribution. To that end, men in a patriarchal society are then assured space to grow and evolve into "better" men, while women of this

same society are expected to already be capable of fulfilling their expected roles. Lee, recognizing the systems of racism and oppression impacting African American men in particular, is then providing cinematic space for these men to acknowledge they are lacking in the expectations placed upon them, but will eventually progress toward that goal. It is then the women who simply must wait for that evolution and remain supportive. Hill Collins (1990) proclaimed in Harris and Hill (1998) that this expectation of African American women was "illustrative of the Afrocentric view of maintaining community, which relegates African American women to the role of silent supporters of *all* Black men" (p. 10).

This is apparent in *Mo' Better Blues* (1990) when Bleek is allowed to engage the love or lust of two women (who know about one another), but is neither readily punished nor fearful of consequences even after they both arrive at a jazz club to watch Bleek perform in the same red evening dress (bought for the two women by Bleek). "The Black woman who gets her man in the end does so by surrendering her will to challenge and confront. She simply understands and accepts" that he is a man of potential once he chooses to progress toward those expectations (hooks, 1993a).

John in *She Hate Me* (2004) is given the opportunity to evolve as well when propositioned by his ex-fiancée to serve as the conduit (i.e., sperm) that will allow her and her lesbian lover to have children together. When John shares his dilemma with his brother, who is married with a small child, there is little empathy extended to him. In fact, his brother makes a point of telling John there could never be a problem with being able to have sex with multiple women and not have the responsibility thereafter. John is casually being encouraged to enjoy his "dilemma" for now for his brother knows of the "other" side and what it has to offer. We soon learn, however, that even sex-machine John loses interest and desires a deeper connection. But that desire only comes after he has fathered 38 children and longs for a connection with his ex-fiancée, Fatima, and her lover.

The creativity of Lee in presenting such complex male characters serves the viewing public well. It demonstrates the array of images that African American men can play, but it is typically done at the expense of the image of the African American woman. Their connections seem limited and lacking in depth of intimacy. And they only prosper after the African American woman accepts that her man will evolve, eventually.

Periphery Mother

Mothers through the Spiked Lens exist on the fringe and/or tend to make an overbearing show of mothering when they do appear. Lee's mothers tend to be a negative, manipulative, and marginal presence in the films. hooks (1993b) stressed this point in *Sisters of the Yam: Black Women and Self-Recovery* when she stated: "Overall,

in fiction and autobiography, Black mothers are more likely to be depicted as controlling, manipulative, and dominating, withholding love to maintain power and control" (p. 141). Through the Spiked Lens, it is the fathers who provide a nurturing and enduring presence, while the mothers, if present at all, either rant in order to keep the family members in line or are marginal players in scenes who are recalled during tense times, and then fade into the mist.

According to hooks (1993b):

> One of the most harmful cultural myths that circulates in our daily lives is the notion that we can leave dysfunctional family settings and be ready to love when we meet that "one" special person. . . . In families where the notion of domination reigns supreme, where exercising power and control by any means necessary is the norm, there is little hope that this will be a place where people can learn how to love. (pp. 153–154)

In *Mo' Better Blues* (1990), Bleek's mother appears in the opening scenes of the film, forcing him to practice his trumpet. She is loud and threatening toward her son, and belittling to her husband. Probably meaning well, she forces her son to practice his trumpet while his friends call for him to play outside. Bleek's father urges her to permit their son some playtime with his friends, but she is insistent about his need to practice. After she makes her point to the father, she makes it to Bleek's friends by shouting at them through their brownstone window. Her portrayal as a mother is mean and almost comic in its exaggeration. Viewers do not see or hear of her again until later in the film, as a memory shared between father and son, when Bleek is recovering in the hospital from a severe beating. At this point his mother is already dead. Furthermore, viewers do not see her death impact Bleek's focused climb to success as a bandleader. This seeming lack of emotional connection with his mother is perplexing since it was his mother who instilled his obsession to his craft. His father, with whom he has connection (they share a love of baseball and sometimes play ball together), acts as a confidante about women and life. Based on the pattern of the male/female dynamics in this film and the others analyzed, the advice is not about the love of a woman but rather about her conquest until one is ready to embrace the "shackles" of marriage.

In Bleek's case, his return to Indigo could be viewed as a return to his mother. He had to be "broken" (as a result of violence) before he could embrace the possibility of a monogamous relationship. When he and Indigo marry and have a son, she transforms from wife to shrew. Bleek also morphs into a man who is able to show love to someone beside himself, however that individual is primarily his young son. The affection and connection to his wife appear secondary to the connection and affection that he shares with the men in his life: his father and his son. When we see him interacting with his wife after the wedding, it is to request that she give their son a break from practicing his music so that the son can play with his friends. He

does not want his son to repeat his childhood, yet the familial pattern is virtually the same with outcomes unlikely to differ. This is a result of Lee never addressing the behaviors that result from the dysfunctional female/male dynamic.

Though not stated explicitly, it is likely that Bleek holds resentment toward his mother, in spite of his success. His mother's emphasis on his music cost him his childhood. As a result, his resentment may be a catalyst for the disconnected relationships with Indigo and Clarke. These women seemingly pay the price for Bleek's emotional abuse at the hands of his mother, and his image of his father as browbeaten. He tries to avoid his father's fate by going to the other extreme and becoming nonchalant and emotionally disconnected in his female/male relationships.

The Spiked Lens repeats the negative and marginal image of mothers in *She Hate Me* (2004). In this film John's sister-in-law ushers in the mothers portrayed in the film. Her husband describes Lucy as irritable due to a lack of sleep since the arrival of their newborn baby. She reinforces her unattractive image when she appears in the scene disheveled and asks John why he did not use his key to access the family home (knowing he still has one). Ordinarily, viewers would not expect a new mother void of sleep to appear glamorous, however, the pattern of mothers in the films dictates that the mothers are nagging and matronly, regardless of their age.

John's mother fulfills this nagging and matronly image when she welcomes him home with a question about whether he is in trouble. At first, this might be perceived as an odd question to ask of a son who graduated from Harvard and Wharton and who currently works for a prestigious pharmaceutical company. However, in light of the mother pattern, the question is really the only one she can ask. She is not the nurturer, but the inquisitor. For example, after John tells her of the tragedy at work, she asks which "fool committed suicide." She lacks compassion and sends John to go talk to "G," his father, in order to receive what she is incapable of providing. So, it is with his father that he is given comfort and advice.

Later in the film, John's mother is shown verbally terrorizing his father (she is at the top of the stairs and he is in the basement where he spends most of his time). This scene supposedly provides insight to her current mean-spirited disposition. She has stayed with her husband only because he is ill, not because she loves him. He has ill-treated her in the past and now she lifts herself up as a martyr. But martyr or not, the scene concretizes the negative image of the mother as seen through the Spiked Lens. Viewers see the husband silently listening to her tirade in an emasculated fashion. While he may feel her resentment is deserved, their current situation conjures viewer sympathy for the husband. Even when John enters the home during his mother's verbal attack of his father, he does not immediately stop the abuse. He also does not appear surprised at his mother's venomous expression. In

fact, he lets her notice him before the father is given a respite from what seems to be a recurring event. We see the mother later in court to support her son during his trial, and then she disappears into the shadows. In the end, it is his father who shares in the joy of John's sons and John's relationship with Fatima and Alex.

Finally, the women who became mothers as a result of John's "donation" are side-lined after viewers are updated with a "family" photo that pays homage to John's virility. After that, they too are moved to the margins never to be heard from again, except Fatima and Alex. For although mothers, they remain visible and attractive because they fulfill John's fantasy. He gets the women and children without the grief, and Fatima and Alex become questionable lesbians and honorary mothers instead of overbearing wives and mothers.

The Finale: A Discussion of the Themes

In spite of the edgy, controversial, assertive, and innovative messages in the films studied, and due to the racialized and macho elements, in particular, the Spiked Lens fails to provide true liberation for black women on screen. Lee's portrayals of women appear to be the result of a lack of awareness of the ever-present tension between how the messages of his films confront the hegemonic patriarchy while simultaneously conforming to the limitations of that oppressive framework in terms of his images of females and males.

Without exception, the messages of the films studied, from the wake-up call in *School Daze* (1988) to the need for African Americans to cultivate affirming internal and external perceptions of ourselves as highlighted in *Bamboozled* (2000), force us to confront the mental shackles that can impede our progress as a people. The messages make us think. They make us angry. They make us cheer. But the vehicle for the messages, namely the characters and their lack of complexity and affirming female/male connections, reduce the effectiveness of the confrontational messages. In his effort to confront racism, discrimination, and oppression through his overarching messages, he conforms to the negative perceptions of the hypersexualized African American female and male. His efforts to empower by way of flipping the script, particularly in *She's Gotta Have It* (1986), *Girl 6* (1996), and *She Hate Me* (2004), fail to address the overarching script in which the women in the films operate. The main consequence for the women in these films is a punitive one: Nola's sexual lifestyle has to be questioned by both men and women and is psychologically tormenting for her; "Judy's" sexual dominance as a "White" phone sex operator is short-lived when one of her callers threatens to harm her; and lesbian couple Fatima and Alex are provided with a male lover in their lives in spite of the fact that Alex "doesn't do dick" (Lee, 2004).

Consistent with Harris and Hill (1998), Hill Collins (2005), and hooks (1993b) many of the women in Lee's films are depicted as "strong," "financially independent" mothers (as opposed to single mothers), and "sexually immoral." Furthermore, much of the strength that the women exhibited was ephemeral. The mothers had a surface strength that often did not serve their best interests. They were often domineering and manipulative. For example, in *Bamboozled* (2000), Pierre's mother demands he (in a soft voice with steel undertones) explain his reasoning for developing *The New Millennium Minstrel Show*. Then in the next breath, she tells him to "go check on your father" (probably the real reason for the call). She seemingly does not call for her own needs, but to get an update on the man that left her for another woman years prior. She is portrayed as a pitiful and pining woman sitting alone in the darkness, literally. Moments of strength were also exemplified by Nola, Rachel, Jane, Indigo, Clarke, "Judy," Sloan, Fatima, and Alex. However, these women were all eventually placed into submission by men before the end of the film. Nola loses her power when she is raped by Jamie. Jane crumbles when she is prostituted by Julian and then ousted from his presence. Indigo reaches out in desperation when she does not hear from Bleek, while Clark leans on another man to provide that which Bleek can no longer—prestige. "Judy" runs for cover at Jimmy's house when a phone sex client threatens to kill her. Sloan's professional competence is questioned because she chooses to sleep with more than one man at different times. And Alex's sense of empowerment dissipates when she goes to John for sex in order to feel like a woman and get pregnant.

Most of the women were financially independent at various levels. For example, Nola was able to afford a place in New York City while being self-employed, whereas "Judy" rented a room in New York City and worked several side jobs before the phone sex position in order to support herself. Fatima and Alex were put forward as perhaps the most financially stable of Lee's female characters. (They extended $10,000 for John's "service"). In terms of the mothers, we presuppose that they were financially interdependent as opposed to being supported by their husbands if they were still married. The short conversations between Pierre and his mother inform us that she is estranged from her husband. However, we are given little indication as to her source of financial sustenance. Given Pierre's success and their continued relationship, it is possible that he provides her with a source of income. Though only one mother was portrayed as single, the mothers in the films tended to be "bad mothers" in the sense of their shrewish behavior. Being relatively marginal in the films, the perception that we grasp of them is less than favorable due to their overbearing behavior.

The Spiked Lens is so pervasive that although *Girl 6* (1996) was written by a woman, Suzan-Lori Parks, the influence of the Spiked Lens was evident. The script cannot be flipped effectively or convincingly within a hegemonic patriarchal

framework or the Spiked Lens. A new framework and expanded lens stemming from a liberatory consciousness are necessary. While Lee's work is commendable, what we require are conscious messages along with new and affirming depictions of people of African descent, especially women. It is our shift in consciousness that will provide the space for those combined messages and images, for characters that are complex, for evidence of love and connectedness between black females and black males, and for families that nurture instead of negate their members. A new consciousness may lead to the healing of the female, the male, and the couple. It may also buoy the message that we must wake up and progress side by side. hooks (1993b) explained that despite the subordinate position allotted to black women in the black power movements of the 1960s, the only way we can heal is by taking care of each other and moving forward together. "Were all black people to collectively release the feelings of bitterness we hold towards one another, there would be a great renewal of spiritual strength" (p. 168).

Hill Collins (2005) added that the progress that exhibits this renewed spiritual strength can only exist when we challenge the sexual politics that stem from the hegemonic patriarchy, and in the case of this chapter, the continued media images of bucks and jezebels. "Without challenging the U.S. sexual politics that installs a hegemonic White masculinity in the center of all assessments of human worth as the gold standard against which we are all measured . . . how can African Americans develop a more progressive Black sexual politics?" (p. 304). She says new life-affirming definitions of black femininity and black masculinity and the freedom that accompanies this new orientation is more likely to be manifested when African Americans establish their own rules for living and for loving.

Aware of the criticism and the critics who question his limited depictions of African American women in film, Lee stated in an *Essence Magazine* interview that he believes his work shows his love for [Black] women and that it is unlikely that his films will be instrumental in changing those existing images: "I understand these types of criticisms are coming because Black people have been so dogged out in the media, they're just extra sensitive. . . . I'm just trying to tell a good story and make thought-provoking, entertaining films" (Nelson, 1990, p. 1); hence the Spiked Lens.

References

Barton, B. (2005). Film Review: Male fantasies about lesbian desire: A review of Spike Lee's *She Hate Me*. *Sexuality & Culture, 9*, 77–80.

Dates, J., & T. Mascaro. (2005, Summer). African Americans in film and television: Twentieth-century lessons for a new millennium. *The Journal of Popular Film & Television, 33*, 50–54.

Emerson, J. (2006, March 27). "*Crash:*" Two new eyewitnesses. RogerEbert.com. Retrieved October 18, 2007, from http://rogerebert.suntimes.com/apps/pbcs.dll/ article?AID= /20060327/ SCANNERS/60327002

Fraiman, S. (1994). Geometries of race and gender: Eve Sedgwick, Spike Lee, Charlayne Hunter-Gault. *Feminist Studies, 20*, 67–85.

Harris, T.M., & P.S. Hill. (1998). "Waiting to Exhale" or "Breath(ing) Again": A search for identity, empowerment, and love in the 1990s. *Women and Language, 21*, 9–20.

Hill Collins, P. (1990). *Black feminist thought: Knowledge, consciousness, and the politics of empowerment.* Boston: Unwin Hyman.

———. (2005). *Black sexual politics: African Americans, gender, and the new racism.* New York: Routledge.

hooks, b. (1993a). Male heroes and female sex objects: Sexism in Spike Lee's *Malcolm X. Cineaste, 19*, 13–15.

———. (1993b). *Sisters of the yam: Black women and self-recovery.* Boston: South End Press.

———. (1996a). Crooklyn: the denial of death. *Reel to real: Race, sex, and class at the movies.* New York: Routledge.

———. (1996b). *Reel to real: Race, sex and class at the movies.* New York: Routledge.

Jones, S. (1998). From margin to center?: Images of African-American women in film. *Social Alternatives, 17*(4), 35–39.

Lee, S. (Director/Writer). (1986). *She's Gotta Have It* [Motion picture]. United States: 40 Acres & a Mule Filmworks.

———. (Director/Writer). (1988). *School Daze* [Motion picture]. United States: Columbia Pictures.

———(Director/ Writer). (1989). *Do the Right Thing* [Motion picture]. United States: 40 Acres & a Mule Filmworks.

———. (Producer/Director). (1990). *Mo' Better Blues* [Motion picture]. United States: Universal.

———. (Director), & S. Parks. (Writer). (1996). *Girl 6* [Motion picture]. United States: 40 Acres & a Mule Filmworks.

———. (Director/Writer). (2000). *Bamboozled* [Motion picture]. United States: New Line Cinema.

Lee, S., P. Holmes, & F. Sulichin. (Producers), & S. Lee. (Director). (2004). *She Hate Me* [Motion picture]. United States: Sony Pictures Classics.

Lubiano, W. (1991). But compared to what?: Reading realism, representation, and essentialism in *School Daze, Do the Right Thing*, and the Spike Lee discourse. *Black American Literature Forum, 25*, 253–283.

McPhail, M. (1996). Race and sex in Black and White: Essence and ideology in the Spike Lee discourse. *The Howard Journal of Communication, 7*, 127–138.

Micheaux, O. (Director/Writer). (1925). *Body and Soul* [Motion picture]. United States: Micheaux Film Corporation.

Muwakkil, S. (1988, March 16–22). The Black middle class and Lee's school of hard knocks. *In These Times* (Chicago, IL), p. 21.

Nelson, J. (1990, August). Mo' Better Spike. *Essence Magazine.* Retrieved July 17, 2007 from http://findarticles.com/p/articles/ni_m1264/is_n4_v21/ai_9252055

Subject TO Countermemory

Disavowal and Black Manhood in Spike Lee's *Malcolm X*

MAURICE E. STEVENS

There is no identity—national, cultural, or individual—
which does not imply both a place and a time. There is
no identity that is not both mise-en-scene and narra-
tive—in personal memory and common history.

—Burgin, 1996, p. 193

S peaking comfortably about African-American identity formation is an almost
impossible act. For in order to do so, one must reconcile the relationship
between the African-American subject and the narratives of communal self-
hood that have come to constitute African-American history. The troubled status
of African-American subjectivity and the often-problematic function of recon-
structed African-American historical narratives have produced a profound quandary
for anyone seeking to understand and represent African-Americans as agents in his-
tory and viable subjects of historiography.

Speech about African-American identity is troubled and worried to the point
of near impossibility by more than the historical materiality of events like the
Atlantic slave trade, plantation experiences, community-supported lynching, Jim
Crow laws, systematic social marginalization, and state-sanctioned violence.
Soundings and proclamations about blackness in the United States have also had
to face the meanings attached to these historical episodes in ways that bring sus-

picion on the speaker and banality on their subject. This unsettling dilemma issues from the ubiquitous brutality that constitutes the African-American historical record, brutality that can neither be conceived nor contained within African-American visions of communal selfhood. Consequently, unspeakable features of living (and dying), of being (and not), are submerged within narratives comprising African-American history and are overlooked or unexamined: they are what Julia Kristeva might term abjected. These features fall under the erasure that follows the needful expulsion of distasteful aspects of the self that initially constitutes the boundaries of one's identity.

Because African-American narratives of self and community develop in an American fantasmatic social imaginary that has traditionally dehumanized or dehistoricized "Blackness" (whether conceived as a biological or cultural product), these narratives have had to make use of abjection to function in the service of vindication to both positive and negative effect. As a result, African-American historiographers, precisely because they work within a social context that has understood African-Americans as disempowered and as lacking full humanity, have had great difficulty writing African-Americans into an agency-filled story of historical progress. Indeed, African-American "self-writing" has required the conscious and unconscious excising of images suggesting the devaluation, social infirmity, and inhumanity assigned to African-Americans as people and to "Blackness" as a signifier. Much in the same way that antebellum legal discourse made stealing one's humanity from commodity status a crime, contemporary discursive overdetermination has made African-American historiographic self-writing, as well as other performances of self-in-community, a discursive act of auto-theorization, and sometimes vindication, that produces what George Lipsitz terms counter-memories (1990, pp. 212–213).[1]

Stuart Hall has described popular culture as a "profoundly mythic . . . theater of popular desires, a theater of popular fantasies . . . where we discover and play with the identifications of ourselves, where we are imagined, where we are represented, not only to the audiences out there who do not get the message, but to ourselves for the first time" (1992, pp. 32–33). Countermemory is a form of popular cultural production that provides a space on which the desire for full African-American humanity, full discursive recognition, can be advanced, represented, and ultimately shaped into a viable object of identification. This, combined with the increasingly influential role that the visual plays as an arbiter of American identities, is why the Hollywood production *Malcolm X* is so important. Along with certain other popular cultural productions of countermemory, it obtains a social force and, subsequently, a political relevance to cultural producers interested in increasing identificatory options for African-Americans.

Spike Lee's *Malcolm X* functions as a countermemory-cum-collective social memory that mediates African-American historical trauma, thereby working to define, and in critical ways restrict, the boundaries of "authentic" blackness, which appears to be increasingly a prerequisite for nationalist identification. Wahneema Lubiano has usefully discussed the various functions served by and through the formation of black nationalisms in the United States, illumining both their generative possibilities and limiting pronouncements (1997, pp. 232–252). Her insightful analysis suggests the degree to which nationalist narratives are, in important ways, vindicatory, even as their potent images become incorporated into the state's oppressive structures.

Building on Hall's suggestion that identity is shaped at the "unstable point where the 'unspeakable' stories of subjectivity meet the narratives of history, of a culture" (1987, p. 26), I argue that narratives of origin, place, and agency contain unruly, excessive meanings that bespeak moments of sociopolitical trauma—the facts of death—that mark the fleshy reality of American history. Like scars, stories of self unfold as bumps and grooves in the terrain of subject formation, recording in often displaced, oblique, and sometimes disavowed ways the African-American attempts to reimagine black agency in history. In this way, the countermemory not only overwrites dominant histories but also works to produce new material relations. Authenticated gender becomes racialized memory.

Early in the film's production, Lee insisted that *Malcolm X* be understood as a realistic representation of—if not particular black people—particular truths about black experience. He said that he wanted "our people to be all fired up for this. To get inspired by it," and he assured audiences that *Malcolm X* was "not just some regular bullshit Hollywood movie," that the film dealt with "life and death . . . [with] a mindset," because it faithfully depicted "what Black people in America have come through" (Lee, 1992, p. 68). Rather than attempting to divine the "mind-set" represented in Lee's film, one must explore the features of mind that work powerfully within *Malcolm X* to set boundaries around conceptions of authentic African-American masculinity and femininity. Exactly what does Lee's film suggest "Black people" have to go through in order to be black and people in the United States? Rather than linking phenotype to authenticity, as often occurs in films that reconstruct African-American history in the service of vindication, such as *Daughters of the Dust* (1991), *Sankofa* (1993), *Panther* (1995), and *Rosewood* (1997), Lee connects authentic black being in the United States with the vindication of idealized visions of black manhood and black femininity. To do so, however, his telling of Malcolm X's life repudiates complexity in relation to racialized gender and instead summons (read: interpolates) restricted and condensed notions of black masculinity and womanhood.

Inasmuch as Lee cites the *Autobiography of Malcolm X* ([1965] 1995) as the primary source for the screenplay *Malcolm X*, the film's discursive effects can be read in relation to the *Autobiography*—as a fable of revelation, ascension, and, through the movie, resurrection. Collaboratively produced in 1964–65 by Alex Haley and Malcolm X, the *Autobiography* sought to frame Malcolm's life and work within the cast of traditional epic heroism and American exceptionalism. A primer of sorts, the *Autobiography* demonstrated that Malcolm's form of black militancy could indeed fit within classic (read: white, masculine, and heteronormative) American moral mythologies of hard work, inflexible integrity, and hard-won victories. Moreover, the *Autobiography* reflected the pattern of the religious text of revelation and salvation. In it, for example, Malcolm describes his coming to literacy while in prison. He learns to read, the reader learns, by taking the dictionary and starting with "A." Only later does Malcolm come across the definition for "Black" and still later that for "white." In the *Autobiography*, and through a kind of deferred action, Malcolm's revelation is a function of literacy. He then achieves ascension in the form of political agency after his encounter with the teachings of the Nation of Islam (through communications with his brother while still in prison) and his turn to a life of "Black" uplift. While the *Autobiography* renders Malcolm's narrative of revelation and ascension, its adaptation in Lee's film *Malcolm X* extends that narrative to include resurrection as well. What exactly Lee resurrects, however, is not simply Malcolm X's individualized being.

Malcolm X tells the story of Malcolm Little's transformation from troubled youth to streetwise "hustler" (Detroit Red), to proponent of African-African American cultural nationalism (Malcolm X), and finally to orthodox political nationalist (El Hadj Malik Al-Shabazz).[2] This is a trajectory of metamorphosis, a narrative of transformation, and a dream of evolution into consciousness. Its opening onto a terrain of political potency, however, is matched by its proportionate limitations to the boundaries of proper blackness. Flowing remembrances of Malcolm's early life, depicted through flashback sequences and anchored by voice-overs of Denzel Washington reading from the *Autobiography*, immerse the viewer in the apparently important details of Malcolm's development.

Within the first twenty scenes of the film, four flashback sequences depict what viewers are to understand as traumatic moments in Malcolm's early life. In an episode reminiscent of D.W. Griffith's *Birth of a Nation*, we see the Ku Klux Klan attack his home and ride off into the moonlit night. We also hear that Malcolm's "light-skinned" mother chose his "dark" Garveyite father so that she could have dark children. We see Malcolm's father killed, and we hear of the death being ruled a suicide. In addition, we see Malcolm's mother, who has been determined unfit, having her children "taken away and parceled out," while we hear Malcolm's voice-over say: "It was the beginning of the end for my mother." Except for two other short

flashbacks that enact the intrusive return of traumatic memories, the film here turns away from the use of flashback and voice-over text from the *Autobiography* and relies primarily on diegetic modes of telling what has become, with the beginning of his mother's end, Malcolm's story. While the content of the *Autobiography* continues to constitute the palette from which Lee draws the dramatic hues and textures that he uses to depict Malcolm's life and to authorize his representation of Malcolm's importance, the remainder of the film relies on Lee's racialization of gender and sexuality to define cultural and political authenticity. This racialization works powerfully to protect against threats to the vindicating function of cultural nationalism that Lee creates with his representation of Malcolm X's life.

Through his uses of continuity editing to create a seamless narrative, Lee also presents a picture of black power and pride (denuded of its militancy) that congeals into very precise and apparently unsutured images of what it means to be a black man or black woman in the United States. According to Lee's visual narrative, in order to "be" black in the United States, one has to be gendered and, as Lee's *Malcolm X* would suggest, gendered in very particular ways. Looking closely at Lee's depiction of Malcolm's masculinity, his wife Betty Shabazz's femininity, and the picture of "Black family" that they create highlights the threats that homosociality, feminine agency, and interracial ambiguity pose to a racialized and gendered black nationalism. These sites also generate threats to Lee's strict conception of a gendered (male) black cultural nationalism and make disavowal an essential mechanism in Lee's representation of black political agency.[3] The specificity and effects of disavowal are displayed through its centrality in Lee's definition of the gendered criteria for being a "Black" person in the United States. Psychoanalytic literature outlines how disavowal operates and suggests how we might understand its function(ing) as it is emplotted in reconstructed histories like Malcolm X.

In *The Language of Psychoanalysis*, Jean Laplanche and J.B. Pontalis trace the development of Freud's theorization of disavowal as "a mode of defense which consists in the subject's refusing to recognize the reality of a traumatic perception" (1973, p. 119).[4] Freud, they suggest, found the notion of disavowal particularly useful in describing a "primal defense mechanism" against troubling realities, because it could account for the formation of the castration complex and certain features of fetishism (Laplanche & Pontalis, 1973, p. 120). Elaborating on the process through which the castration complex comes to function as an explanatory narrative illumines one aspect of the work performed by vindicating reconstructed histories in general and Malcolm X in particular.

According to Freud's formulation, children both disavow their perception of the absence of a penis in the girl and recognize this absence as a fact, while experiencing the anxiety (predicated on the threat of castration) it elicits. The castration complex, then, is a sexual theory of childhood that seeks to bind the anxiety provoked

by the threat of castration and the fundamental (anatomical) difference between the sexes. In a similar fashion, though not analogously, a vindicating reconstructed historical narrative works to contain the psychic discomfort that arises from the tension between the material instances of black dehumanization and the ontological incommensurability encoded in racialized difference. Although racial categories are constructed socially, their material and psychic imprints or traces possess an anxiety-producing facticity that must be explained. The white racial phantasm has extruded various justifying narratives that themselves provide the context for the production of African-American explanatory narratives in the form of countermemories. Recasting the castration complex (read: fantasmatic theory that seeks to bind anxiety) through the optic of critical race theory reveals that the existence of inhuman subjects within the social economy of domination requires explanatory narratives capable of guaranteeing that not just any(body) can be stripped of its humanity. In a naturalizing gesture, such explanatory narratives ensure that the ontological meaning signified in racial difference permanently and justifiably subordinates black nonbeing to white human-being. If the white racial phantasm, as the discursive basis for the social reality of racialized oppression of African-Americans, has produced the need for explanatory narratives that seek to replace "traumatic realities" with acceptable stories of African-American agency and black humanity, what, then, is the object of disavowal in African-American countermemories?

The disavowal prevalent in African-American vindicating narratives, as a genre, does not take as its object a kind of "facticity" about African-Americans' "lack of humanity." Rather, it works through dominant discursive regimes that "explain" the justification for perceiving a lack of humanity in "Blackness," through scientific and rationalist narratives of species development, cultural progress, civilization, and national citizenship. Cast on the screen of fantasmatic explanatory and justifying narratives, these films say: "I know very well that notions defining the perimeters of being American, human, and valued in the United States have never included African-Americans as anything but the inhuman, valueless backdrop to the unfolding of whiteness; nevertheless, I shall use fixed concepts of Blackness to cement pieces of countermemory into the mosaic of my auto-theorization."

Still, even as a necessary response to the paucity of identificatory possibilities within the American representational terrain, African-American reconstructed historical narratives working in the mode of vindication fail to destabilize absolute notions of racial difference precisely because they are propped up by and emerge from a white ontological complex of explanatory narratives. Relying on fixed notions of racial difference reinscribes ideas of the cultural incommensurability of African-American humanity and its refutation within the white racial phantasm.

By this calculus, then, racial difference encodes absolute cultural difference, which explains and justifies black suffering and death while simultaneously producing the need to recuperate a sense of a black human being through cultural auto-theorization or countermemory. In the particular case of Lee's *Malcolm X*, ideas of racialized difference are mapped onto categories of gender and sexuality, resulting in even more powerful ideas of incommensurability. Not only are masculinity and femininity "different" in an absolute sense, but also black masculinity and black femininity are fundamentally distinct precisely because of their being situated within a naturalized conception of black culture. In addition to the particular moments of its application within the film's diegetic space, the overall structure of disavowal as a rubric of analysis and as a psychic mechanism naturalizes the gendered and sexualized figure of racialized agency and political possibility that *Malcolm X* conjures.

Lee opens the film with an important montage of images. Beginning with an American flag burning away to a red, white, and blue flaming "X," intercut with found footage from the Rodney King beating, Lee introduces masculinized themes of state control, popular protest, and nationalism. He then combines this montage with a rapid crane-to-dolly shot into a close-up frontal view of Shorty (played by Lee) strutting in 1950s zoot suit fashion to the male space of the barber shop for the first of Malcolm's pivotal hair-conking scenes. In one smooth gesture, Lee interpolates the viewer as witness to an American story, a story of what James Baldwin called growing up "a Black child in a white country" (1993, p. 30). That Lee ends the film in a kind of reverse zoom, moving from Ossie Davis's eulogy of Malcolm as "our shining Black manhood" to more found footage and finally to a simple black "X" against a black background, highlights his insistence that the narrative of black political possibility and social agency is a story of heteronormative masculinity told against the backdrop of racialized oppression and violence. It comes as no surprise then that Lee's *Malcolm X* works relentlessly to defend against threats to heteronormative black masculinity. What is more troubling, and what we must ask of the film, is why its defense of black masculinity rests on creating a very circumscribed vision of black male and female gender performance and sexuality. Before approaching this question, it is important to look at just how Lee's film does this.

Because Lee valorizes a very particular form of black masculinity in the film, moments of implicit homosociality, feminine agency, and interracial ambiguity threaten both Malcolm's black manhood and the film's narrative structure as well. Indeed, Lee's film determinedly defends against the ways that these features of human relations disturb the picture of racialized gender (and gendered racial consciousness) that he creates. Tracing these threats and how the film strips them of their power highlights where and how the film most effectively enacts disavowal and, moreover, the dependence of African-American countermemory on heteronormativity.

From its opening with found footage of the King beating to its closing with Ossie Davis's reference to Malcolm X as "our manhood, our shining Black manhood," *Malcolm X* is a film dominated by all-male spaces and predominantly male relations. Indeed, interactions between men actually structure the plot and motivate story development. Although numerous critiques have been made of the hypermasculinity that buttresses much black nationalist discourse, we can productively examine effects produced through the maintenance of the picture of manhood developed in this film. Three key hair-conking scenes—depicting the barber shop, Malcolm and Shorty's apartment in Boston, and the prison—illumine how the process of hair-conking functions to anchor these scenes' potential meanings to the politics of racialized identity and disavows the homosociality implicit in the mise-en-scene of the frame.

The first of these important moments where homosociality is disavowed comes in the second scene of the movie. Prior to this scene, the point of view has been motivated by Shorty's actions. We look over his shoulder as he walks toward the barbershop and are next ourselves entering its interior; we are then greeted by a medium close-up of one of the barbers saying hello and continuing the in-progress conversation among the men seated in the shop. In Lee's nonparodic caricature of the black barbershop, the men momentarily interrupt their talk about the dangers of women to tell Shorty that "his boy" is waiting in the back for Shorty to conk his hair. Malcolm then enters the scene and is seated in the barber chair to have chemicals applied to his hair, to straighten it. In a medium shot we see Shorty standing behind Malcolm beginning to comb in the white conking cream as he warns that "it's gonna get hot, can you handle it?" The point of view tightens to a medium close-up framing Shorty's bare arms and centering Malcolm's head. This view is cut with occasional overhead shots that again center Malcolm's head and show only Shorty's thin arms and the comb he pulls through Malcolm's straightening hair. The previously lively setting has now gotten quiet as (the viewer assumes) everyone focuses on the transformation happening before him. The men in the shop, instead of bonding through their discussion of women, now direct their attention—as the full-frontal camera view cut with their full-frame watchful gazes suggests—on Malcolm's growing physical discomfort and Shorty's ministering hands. Shorty explains that Malcolm must endure the scalp-burning pain as long as possible because "you gotta make it straight." Once the conking is finished and Malcolm looks into a mirror to see his straightened hair, the men begin congratulating him and affirming his assessment that it "looks white, don't it?"

By predominantly centering Malcolm's head and hair in the frame throughout this early scene, Lee communicates that the transformation Malcolm undertakes carries significant ideological weight. Not only does Malcolm want his hair to "look white," but these shots also metonymically connect it, Malcolm, and anyone

else we may see with conked hair to ideologies of assimilation and collaboration. Change complete, Malcolm Little, now Detroit Red, can join Shorty on a foray into petty larceny and survival by any means available.

Still, visually centering Malcolm's conk-covered head for much of the scene also functions in another way. The all-male space, the focus of the men's gazes, and the framing of Shorty as little more than a pair of delicate arms all underline the homosociality of the scene. Indeed, the political importance of Malcolm's conking (as opposed to the aesthetic values) must be emphasized in order to defend against the emergence of the scene's homoerotic foundation. If, for example, Shorty insisted that Malcolm's hair be "straight" because it would look more attractive, or if Malcolm had been scripted to say "looks good, don't it," the scene could take on another valence. Visually centering Malcolm's head (the light area at the center of the frame draws the viewer's attention to Malcolm's head and the activity it receives) highlights the importance of the scene's action, which anchors the meaning of the scene to the field of identity politics. In this way, the film raises the issue of black manhood while evading difficult questions of sexuality, precisely by screening them with a safely heterosexualized and heteronormativized blackness. Moreover, this screening process allows for the necessary disavowal (enacted within the *Autobiography* as well) of the homosexual encounters Malcolm may have had during his Detroit Red "hustling" period.

Another important hair-conking scene comes one-fourth of the way into the film, shortly after a highly sexualized scene of homoerotic tension between Malcolm and Rudy, one of Malcolm's accomplices in the robbery that ultimately lands him in jail. In the break-in scene following Malcolm's interaction with Rudy, the viewer watches as Malcolm and Shorty creep through the house of an "old pansy," taking valuable items while he sleeps in an upstairs bedroom. The scene closes with Malcolm and Shorty sneaking into the victim's bedroom and actually attempting to remove a ring from his finger as he sleeps. Nearly waking him, Malcolm and Shorty crouch motionless as they gaze on him, waiting to be certain that he is asleep before making their escape. In the following scene (matched thematically by Malcolm and Shorty's intimacy in interior spaces), Malcolm sits in a chair in the center of their apartment while Shorty begins to conk his hair. Lee emphasizes the intimacy of this scene with a signature piece of camera work. With Malcolm, Shorty, and the camera positioned motionless in the center of the space, Lee rotates the entire set 360 degrees around them. In this way, the viewer "sees" the complete interior space without having the composition of the frame or the centrality of Malcolm and Shorty's (visual) relationship disturbed. While the background rotates and Shorty combs Malcolm's hair, the two talk about the robbery and about Malcolm having put Rudy, that "powder puff," in his place.

Once again, the homoerotic undertones of this scene—Malcolm and Shorty's intimacy in this interior space in connection with Rudy's suggested homosexuality—are screened by the scene's reference to the film's racial ideology. This scene reminds the viewer that Detroit Red, rather than possessing the flaw of ambiguous sexuality, merely lacks a clear self-concept, something he will need to attain. He has no sense of belonging to what Baines, the inmate who introduces Malcolm to the teachings of the Nation of Islam, later calls the "tribe of Shabazz." Indeed, Lee's Malcolm has not yet realized either that his manhood is indeed "shining" and "Black" or, above all, that it rests on policed notions of what a sexuality attached to authentic black manhood must not include. Indeed, the film tells us that Malcolm cannot obtain this knowledge until he reaches the proverbial bottom.[5] Only after Malcolm is arrested and sentenced to prison, where we see his final conking scene, do we see the film's ultimate effacement of homosocial threat. Because homosociality and the dangers that it insinuates cannot be disengaged from masculinized nationalist narratives, this concealment ensures the coherence of Lee's black masculine ideal.

Just before Malcolm meets Baines in the prison shower room, Lee depicts Malcolm being sentenced to serve time in Charlestown State Prison for breaking and entering and armed robbery. The rebellious Malcolm is shown refusing to recite his inmate number and being carried to solitary confinement. Diegetic time passes, and Malcolm ultimately breaks down, recites his number, and is released. The next scene opens with Malcolm wrapped in a towel and conking his hair in the prison shower room. Baines enters, offers Malcolm nutmeg to aid in his detoxification, and tells him, "That's the last fix I'm gonna give you." As Malcolm moves to rinse the conk from his hair, Baines asks him why he wants his hair to look white. Malcolm tells him it is the "hip style," and Baines asks, "What makes you ashamed of being Black?" Malcolm looks at him somewhat confusedly and proceeds to rinse as Baines walks out of frame and the scene ends.

In terms of intercinematic reference, the staging of this scene carries much importance. Prison shower scenes have been so overdetermined in their filmic representation that they have become almost a trope in their own right, conjuring stereotyped images of sexualized violence, a simultaneously exaggerated and destabilized masculinity, and a self-justifying punishment industry. That this scene includes Baines as the bearer of a masculinized black nationalism and a broken and vulnerable Malcolm makes it even more suggestive of caricatured and repudiated homoeroticism. It comes as no surprise that the scene's explicit ideological content bears the burden of sealing out the implicit threat of homoeroticism. Thus, Baines's motivation for being in the shower room is made clear at the outset of the scene; he is there to give Malcolm his "last fix" and to recruit him into nationalism properly, as opposed to gratifying some "need" Baines might have to visit Malcolm in

the shower or some other desire that Malcolm himself might possess. Moreover, Malcolm's white conking cream draws Baines's attention, and not the white towel he has wrapped around his midriff. While the scene's opening shot centers Malcolm in the frame at midrange, and the white of both his head and towel call the viewer's attention, subsequent shots in shot-reverse-shot format frame only the head and shoulders of the two men. By literally removing homoerotic possibility from the frame, this shot sequence assures the viewer, as does Baines, that the hair conk covers Malcolm's shame, not the towel. From this point on and through his interactions with Baines, the work performed by conking and the ideological meaning that it carries is taken up under the sign of Malcolm's relationship with black Muslim teachings and black cultural nationalism.

The film's effacement of the threat that interracial ambiguity and sexualized contact present to black masculinity also contributes to this transition. From its early scenes, Lee's *Malcolm X* introduces cross-racial sexual contact and interracial ambiguity as significant issues in the formation of black identity. In Malcolm's first flashback sequence, the viewer learns that his mother, Louise Little, possesses white ancestry following the rape of her mother by a white man. Using excerpts from the *Autobiography*, the narrative informs the viewer that the light-skinned Louise chose Malcolm's father (Earl Little) because of his dark skin and her wish to bear dark children in a gendered (and maternal) reclamation of her authentic blackness. In the continuing voice-over, we hear Malcolm suggest that the black man's attraction to white women originates in his desire to "take something owned by white men" in a racialized recuperation of his masculinity. More than merely foreshadowing Malcolm's later relationship with Sophia, a white woman whom he meets at the Roseland Ballroom, this early moment establishes important ideological positions that anchor potential readings of Malcolm's actions through the rest of the film.

The first of these positions revolves around the question of the agency enacted in one's choice of sexual partners. Lee contraposes Louise Little's choice of the dark-skinned Garveyite Earl Little against the lack of choice available to her mother by emphasizing that the latter was raped. Moreover, by placing Malcolm's analysis of the social-psychological forces motivating the black man's desire for white women between a scene in which Malcolm valorizes his white-looking hair and the scene depicting his choosing Sophia over his black girlfriend, Lee circumscribes the viewer's understanding of Malcolm's attraction to Sophia. Like Louise Little's mother, the unradicalized Malcolm does not yet possess his own agency; like his grandmother, Malcolm is a victim of social relations; and, like his grandmother, Malcolm has been forever changed by his grandmother's rape. The young Malcolm has no "knowledge of self" and has no choice but to desire Sophia, who signifies the possibility of taking something "owned" by the white man. In this sense, the narrative suggests that rape and miscegenation circumscribe Malcolm's desire.

The second ideological position that anchors potential readings of Malcolm's actions also pivots around the question of agency. In relation to one's racial heritage, however, the choice involves identification and not one's sexual partners and, to that degree, entails the writing of one's past in the shaping of one's future. Just as homoeroticism threatens the coherence of a masculinized black cultural nationalism, so too does multiraciality disturb notions of phenotypic purity that support ideas of an essentialized blackness. Malcolm's interaction with Rudy, the self-identified "mixed-race" character, works to confirm the narrative's repudiation of multiraciality, much in the same way as Malcolm's relations with Sophia insist that the desire attributable to authentic black masculinity and femininity cannot cross lines of race. An examination of two important scenes depicting Malcolm's interactions with Sophia and Rudy, respectively, reveals that only through the abrogation of cross-racial sexual attraction and the renunciation of multiraciality can Malcolm obtain or regain black masculine agency and become an indisputable sign of "our manhood, our shining Black manhood."

The first of these scenes, which comes early in the film, opens with nightgown-clad Sophia preparing breakfast for Malcolm in her small apartment. Malcolm reclines on the bed wearing shorts, a white tank top, and a black "gangsta" style "do-rag." We see Sophia from his point of view in the cinematic space and are thus encouraged to assess her coldly from his perspective. Malcolm calls Sophia to the bed with the simple command: "Come here." Sophia replies, "You're the man" from out of frame, as she sits on the bed in front of Malcolm, who begins to question her motivations and her "story" while he tells her to "kiss [his] feet." "You're one of those white chicks can't get enough colored stud . . . that's your story girl." "So when you gonna holler rape, sister?" From orders to assertions to accusations, cut in shot-reverse-shot format with images of Sophia looking injured and asking Malcolm to "just let [her] feed [him]," this sequence emphasizes the rage, suspicion, and issues of control that belie the intimacy suggested by the soft pillows and muted lighting of this scene.

Indeed, the narrative suggests the problematic nature of Malcolm's object choice on two counts. First, Lee's direction conveys the notion that Malcolm's desire originates in the "pathological" space of wanting to take something that the white man owns. Malcolm expresses this when he tells Sophia that he "sure [wishes her] mother and father could see [her] now." Second, Lee suggests the suspiciousness of Sophia's own motivation when she tells Malcolm of her wish that "Laura could see [them.]" By invoking the name of Malcolm's old sweetheart, Lee frames Sophia's desire for Malcolm as merely instrumental in the degradation of black women through the "theft" of black men. Thus, this scene seals the narrative's insistence that cross-racial sexual contact and desire can only occur problematically in the context of racialized relations. Although addressed more centrally and com-

plexly in Lee's *Jungle Fever*, this question's treatment in *Malcolm X* suffers under its having been dramatically reduced and pathologized. Malcolm's authentic black identity cannot be found until after he rejects cross-racial sexualized intimacy, and once found it cannot contain a desire that crosses strict racial boundaries. Looking at Malcolm's interaction with Rudy suggests that more than being unable to possess a desire that can seek objects across lines of race, the black identity constructed in *Malcolm X* must also abjure the ambiguity signaled by multiraciality.

The spoken words "Who's Rudy?" create a voice-over sound bridge from one scene to the next and set the stage for the drama of masculinity and authenticity played out in the extended scene depicting the one and only interaction between Malcolm and Rudy. Immediately prior to this scene, we see Malcolm telling Shorty, Shorty's girlfriend, and Sophia that they are going to "rob Boston blind." He says that they need a driver, and they suggest Rudy. Using a blurringly rapid pan, Lee moves into the next scene, which begins with a close-up shot of Rudy, who declares, "I'm half wop and half nigger, and I ain't afraid of nobody!" When Malcolm asks him what he does, Rudy replies, "You name it fella, and I claim it." Rudy tells them that he has been working for a "rich old fag motherfucker" whom he bathes "every Friday night," toweling "him off, [putting] talcum powder on him, and [putting] him to bed." Finally, Rudy declares that he is the "head nigga in charge." While in terms of the scene's manifest content, Rudy's assertions contest Malcolm's authority, his explicit characterization as biracial and possibly bisexual offers a challenge to the narrative formation of a black masculine ideal that must not go unanswered. Thus, while the scene presents the overt reassertion of Malcolm's position as leader, as "head nigga in charge," its intensely homoerotic undertones and their violent policing stage the narrative's own reassertion of the unambiguous nature of authentic blackness.

Following Rudy's suggestion that he become the "head nigga in charge," Malcolm tells him that he is the "big-head nigga in charge" and that because he "[likes] big-head niggaz like [Rudy]" he will give him a chance to "flip" for it. "We'll flip this," Malcolm says, reaching beneath the table and behind his back. Malcolm pulls out a handgun and five bullets, placing the bullets on the table in front of him, saying, with one and then the next, "She loves me . . . she loves me not." Taking the final bullet and placing it in his mouth, Malcolm removes it and loads it in a chamber with a final "she loves me." In a scene of increasing tension, Malcolm then places the gun to his head and pulls the trigger. He passes the gun to a very reluctant and silent Rudy. Saying that perhaps Rudy did not "know how to do it," Malcolm picks up the gun, puts it to his own head, and again pulls the trigger. After Rudy again hesitates to pick up the gun and join in the Russian roulette, Malcolm walks over to him with the gun, caresses his nose, and says "I'll help you, here." With one hand tightly cupping Rudy's chin and the other pushing the barrel of the gun

against the side of his nose, Malcolm says: "Maybe I should shoot that little wop nose off; or is that the nigga side? What is that, is that the wop side or the nigga side? Is that the wop or the nigga? I guess that's the wop side?" He then pulls the trigger one final time.

"You got it." Rudy whispers, tightly framed in close-up. "Rudy says I got it," Malcolm says as he puts his arm around him. "Rudy," Malcolm says, "don't you ever try to cross someone who ain't afraid to die." With his arm still around Rudy, Malcolm tells everyone what the burglary plan will be, kisses Rudy on the head, and whispers "Merry Christmas, Rudy." From out of frame, we hear Shorty (the character Lee plays) declare that they are "one big happy family!" While the direction of this scene might suggest that Malcolm's actions are intended to call Rudy's sexuality into question and to impugn his blackness, the degree to which the homoeroticism of the scene takes over suggests something more as well.

Because the first half of the film makes frequent reference to Malcolm's head to communicate ideological content and, as I have shown, to contain implicit threats to the narrative's development, it bears comment that in both of these scenes Malcolm wears a black "gangsta-style" head wrap. Lee uses this current style to draw a connection between Malcolm's attitudes and behaviors in these scenes and contemporary stereotypes regarding "gang members." In this way, Lee's visual narrative draws on today's notions of the nihilism inherent in gangsterism and directs them back onto the content of the *Autobiography*. Thus, not only can "Detroit Red" be understood as suffering under the burdens of misdirected rage, nihilistic depression, and self-destructive bravado, but the very discourse that "turned him around" can be cast as possessing liberative potential for today's "at risk" youth. Beyond contributing to the manifest ideological content of these scenes, Malcolm's headwear also takes on meaning in comparison to the conk that plays such an important role in defending against homoerotic threat. Just as the conk drew attention to ideological content and away from narratives disavowed by the film, so too does Malcolm's "gangsta-style" support disavowal.

In relation to Malcolm's interaction with Sophia, the viewer is directed to Malcolm's seething anger and self-loathing. With Rudy, Malcolm's suppressed death wish and trembling self-esteem come to the fore. The first case overlooks any possibility that Malcolm could himself possess amorous feelings for Sophia, and the second "forgets" Malcolm's own multiracial heritage. In both instances, the possibility of cross-racial love and the presence of homoerotic undertones are violently policed, resulting in the narrative's reassertion of the unambiguous nature of authentic black masculinity. Lee also dangerously fuses notions of blackness with his picture of manhood by constructing an idealized femininity that functions most significantly as a prop for masculinity.

Cinematic exaggeration marks Lee's film style. With dramatic crane and dolly shots, Lee gives the space captured within his camera's frame a sense of fluidity and suggests the tension of unpredictability. He manipulates the depth of field and precisely controls visual elements within the raise-enscene to virtually externalize his character's internal emotional states. Moreover, Lee's meticulous continuity editing, usually achieved through the simultaneous use of sound bridges and matches on theme, creates a cinematic environment that almost demands that the characters his actors play take on the quality of caricature. Indeed, the carefully choreographed visual space that he creates seems to undermine the reality he purports to represent, making his characters dancers whose steps are rehearsed and predictable. While the combination of these stylistic features might appear to refuse cinematic realist conventions, they still function in the service of producing what Lee considers "real" and essential features of racialized social relations. Thus, rather than producing a kind of cinematic discontinuity that moves away from classic Hollywood realism, Lee's is a spectacularization meant to codify the "real" in his populist approach to "keepin' it real" and thereby making his own bid for raciopolitical authenticity.

To powerful dramatic effect, then, Lee gives "life" to tropes and stereotypes through condensed character types, thereby enlisting the surreal in the evocation of concrete emotional responses. In *Malcolm X*, Lee achieves this through the repeated citation of popular culture's reserve of Malcolm X iconography. Restaging and then animating popular images, re-creating moments available (and widely disseminated) in found footage, and replaying audio referents (speeches and music)—all these elements give Lee's work a feeling of an unreal reality and make a world of familiar people, spaces, and objects unfamiliar. However, the very techniques that make Lee's work so forceful and capable of eliciting powerful responses from viewers also give his characters a prescripted quality that, while drawing on extant social narratives, reproduces and reinscribes their restrictive boundaries. Moreover, working through caricatured tropes virtually predetermines the prevalence of polarized signifying relations between characters. This dynamic and its effects can most clearly be seen in Lee's representation of women in *Malcolm X*.

In her article "Consumed by Images," bell hooks criticizes Lee's representation of Betty Shabazz and other women in *Malcolm X* for its compliance with accepted conventions in classic Hollywood cinema.

> Again, although Malcolm's widow, Betty Shabazz, told Lee that she and Malcolm did not argue (the Nation of Islam deemed obedience paramount in a wife), the film shows her "reading" him in the same bitchified way that Lee's previous Black women characters talk to their mates. Certain stock, stereotypical, sexist images of both Black and white women emerge in the movie—they are either virgins or whores, madonnas or prostitutes. But that, after all, is Hollywood. Perhaps Lee could not portray Malcolm's sister Ella because Hollywood has not yet created a visual space in which a politically

progressive Black woman can be imagined. (hooks, 1993, p. 5)

While Lee's depiction of women as occupying the position of either Madonna or prostitute could not be more pronounced than it is in *Malcolm X*, the issue of "good" or "bad" images, positive or negative representations, generates fewer useful questions than an exploration into their fixity. The "stock, stereotypical, sexist images" to which hooks alludes do not "emerge" so much as they are used in the film in the same way as props, lighting, or sound cues might be used to signal or even prompt plot development and character transformation. To this extent, female characters must necessarily remain fixed in this narrative of masculine transformation, and their fixity is achieved through their relationship to one another. While hooks astutely points to classic Hollywood cinema's lack of "visual space" as enabling Lee's use of stereotype, the demands of Lee's visual narrative and the narrative economy produced by and through disavowal work most powerfully to delimit the function of female characters in *Malcolm X*.

For example, throughout the film, Sophia (Kate Vernon) functions as the yardstick by which Malcolm's developing consciousness can be measured. Through the first half of the film, she appears in binary relation to Laura (Theresa Randle), whom we see occasionally in flashback sequences. Sophia becomes the location of temptation, greed, "hustling," and a lack of consciousness. This is not to say that Sophia represents these characteristics; rather, in the narrative space of the film, these traits cohere around her and serve to describe Malcolm as a function of his proximity to her. As long as Sophia remains visually present in the narrative space, her function in this regard can only be maintained through her binary opposition to Laura.

That "good girl" whom Sophia tells Malcolm to take home before returning to her becomes the location of all the things that Sophia (as a point referencing Malcolm's movement) cannot hold. "I know what you are doing," Laura tells Malcolm early in the film as he lies to her about returning to the Roseland Ballroom to meet Sophia. Laura can "see" Malcolm as he cannot see himself. Laura can hear Malcolm relate his hurts (in fact, Laura is the only character we see Malcolm telling about his painful childhood experiences). Although present almost solely in flashback or indirect reference, Laura becomes the location of satisfaction, a settled life, and knowledge of self. Prior to his revelation in prison, Malcolm's movement can be measured against the backdrop stretched between the poles of these women's spatialized racial and cultural difference, a difference, of course, that is not so much their own as it is a projection of Malcolm's own struggles as Lee represents them.

Though visually absent through most of the second half of the film, Sophia's character also works in polar relation to Betty (Angela Bassett). Here, however, the register shifts from relationships between individuals to relations between Malcolm

and the bourgeois figure of domesticity and family, which is figured in relation to Betty. Malcolm's closeness with Betty (and his distance from everything represented through Sophia) grows in proportion to his developing political consciousness. Betty teaches "home arts" and nutrition within the Nation of Islam. Whereas Sophia exhorted Malcolm to "let [her] feed [him his] eggs," Betty reminds Malcolm that "even the Prophet had to take nourishment." With the exception of the few scenes depicting Malcolm's assassination and their brief courtship—some of which are cut with shots of Elijah Muhammad telling Malcolm of the dangers and virtues possessed by black women—Betty is almost always placed in the interior space of their home. Depicted as tending to the children, cooking, or supporting Malcolm, Betty is the figure of a femininity that is equated with a racialized domesticity. Although she does not always display the deference expected of Nation of Islam wives, Betty's idealized performance of an authentically black femininity functions as the ever-present prop that supports and makes possible Malcolm's equally idealized masculinity. Lee visually reinforces the interdependence of these idealized performances of racialized gender through strict framing techniques.

In most scenes in which Malcolm and Betty appear together, especially those in which they speak of their relationship or their family, Lee abandons the traditional shot-reverse-shot pattern he elsewhere uses to suggest the intimacy between two speakers. Instead of using one shot to establish the proximity of two speakers and then alternating between shots over their shoulders to suggest conversation, Lee arranges the camera's point of view perpendicular to the line of sight between Malcolm and Betty. From this profiled perspective, both speakers are kept in frame as the shot slowly tightens through the duration of their conversation. Whether in the booth of a storefront mosque or sitting on the edge of their own bed, this framing technique conveys the intimacy of their encounter by limiting the in-frame space. Indeed, everything besides Betty and Malcolm's emotional closeness is pushed out of frame with the evertightening shot and its diminishing depth of field. Again and again, the viewer (or voyeur) witnesses the authenticity of their union. Tightly framed, this idealized black family, like the shot that depicts it, depends on the flattening of subjectivity and the forgetting of background annoyances. Like the narrative of revelation and resurrection Lee has woven, this is a vision of "Black Family" constituted through forgetting and depending on disavowal. Heteronormativized, racialized, authenticated, and dominating the raise-enscene of the frame, the fidelity and coherence of this vision of black family are generated through the disavowal of troubling facts like Betty's difficulties with Malcolm's absences, the emotional stresses suffered by their children, and Malcolm's estrangement from the rest of his family. The story of the black nationalist family that Lee's visual narrative weaves hinges on the structure of disavowal: "I know very well, but nevertheless."

Memory, History, Identity, and Possibility

I would like now to return to this discussion's initial assertion that Lee's *Malcolm X* relies on the structure of disavowal precisely because of his desire to produce political possibility in the present by piecing together an image of black identity from the wreckage of the past. That Lee saw the period in which he produced the film as one of incipient social change is made clear by the material that he uses to bookend the narrative. From King's voiceless beating to Nelson Mandela's pronouncement, "I am Malcolm X!" Lee's film relies on disavowal to make ideological claims about the state of African-African American political affairs and to convey "what Black people in America have come through" (Lee, 1992, p. 68). While the *Autobiography* presented Malcolm's life in the frame of American exceptionalism and epic heroism because of the cultural barriers that barred black admittance to those categories, Lee's *Malcolm X* reinscribes the figure of a "shining" black masculinity in response to the institutionalized and systematic targeting of black men constituted as the embodiment of criminality and threat. Unfortunately, in this instance, disavowal plays a central role in constituting the structure of countermemory and limits the transformative potential of Lee's *Malcolm X*.

By disavowing the fact that Malcolm spent over a year living with his sister Ella in New York before moving to Boston or that Betty threatened, on more than one occasion, to leave Malcolm because of his frequent absences, Lee delimits the images of masculinity, femininity, and family with which viewers might identify. Thus, while perhaps invested in a nationalist mode of social transformation and racial justice, the film cannot encourage the trans(per)formance that brings about changes in African-American subjectivity. *Malcolm X* cannot operate in this way precisely because of the essentialist political position that it relies on and because of the fixed and racialized modes of remembering it invokes. While strategic essentialism has proven useful to social movements and activist efforts to achieve specific gains in limited contexts, and while it can be deployed in the service of trans(per)formance, the fact that Lee's films uniformly marginalize, pathologize, or make suspicious characters located outside of the racialized gender normativity that he represents makes his essentialism strategic in a different way. While countermemories invoked in the service of racial pride and social uplift served to mobilize broad-based social movements in the period depicted in Lee's film, those same countermemories reproduced and presented in the early 1990s cannot produce the same effect. Indeed, even the film's references to the antiapartheid movement ring nostalgic in a moment when South Africa faces the more daunting task of addressing the trauma of apartheid and the possibility of cultural reconciliation. It is telling that it is not the South Africa seeking "truth and reconciliation" that Lee attempts to connect with. Indeed, what Lee presents is a nostalgic and limited vision of South African promise. His

narrative suggests that everyone who fits the vindicatory image of blackness and who struggles for racial equality can be Lee's *Malcolm X* and can reestablish the unbroken link to an African past and future. They cannot, however, enter into the process of working through traumatic history because disavowal ensures that reconciliation through exposure to the truth of racial terror is held always in abeyance. There remains a nostalgic excess to Lee's *Malcolm* that can only contribute to a hobbled and ineffective African-American national culture, especially inasmuch as that culture relies on the writing of a so tragically restricted historical narrative. This excess shows itself in what Lee's film cannot say about Malcolm, but, more important, it shows in what it must say about an authentic blackness whose gendered and sexualized requirements curtail the fullness of humanity promised by less restrictive counternarratives of African-American history.

At their best, countermemories, in halting and labored steps, take up traumatic history and attempt to reweave it into more worked-through theorizations of selfhood. However, when simple vindication remains their function, "uplifting the race" by any semiotic means necessary, disavowal cannot give way to working through, and countermemories take on features of mourning that limit agency, identity, and identification. Confronting complexities of the past, embracing variations in subjectivity, and responding to insights informed by critical sensibilities that do not easily fit idealized visions of black masculinity and femininity cannot take place in narratives that seek to vindicate black humanity and social worth in terms that simply reproduce heteronormative patterns of inclusion and exclusion. Rather than a narrative of countermemory, Lee's is a narrative that counters memory. It asks those seeking the promise of identification, the home of history, and the possibility of a place in the present to disavow, and in that way forget, anything but his newly racialized heteronormative image of gender (and its performance), thereby condemning African-American identity and historical agency to suffer under the weight of its own manhood, its shining black manhood.

Notes

1. Lipsitz says of countermemory that it is "a way of remembering and forgetting that starts with the local, the immediate, and the personal. Unlike historical narratives that begin with the totality of human existence and then locate specific actions and events within that totality, counter-memory starts with the particular and the specific and then builds outward toward a total story. Counter-memory looks to the past for the hidden histories excluded from dominant narratives. But unlike myths that seek to detach events and actions from the fabric of any larger history, counter-memory forces revision of existing histories by supplying new perspectives about the past" (1990, pp. 212–213).

2. *Malcolm X* was completed in 1992 and produced under 40 Acres & a Mule Filmworks/ JVC Entertainment/Largo International N.V., with a running time of 194 minutes. Lee's other works include *He Got Game* (1998), *Subway Stories: Tales from the Underground* (1997; television), *4 Little Girls* (1997), *Get on the Bus* (1996), *Girl 6* (1996), *Clockers* (1995), "Satchel," in *Lumiere et compagnie* (1995), *Crooklyn* (1994), *Jungle Fever* (1991), *Mo' Better Blues* (1990), *Do the Right Thing* (1989), *School Daze* (1988), *She's Gotta Have It* (1986), and *Joe's Bed-Stuy Barbershop: We Cut Heads* (1983). Other cast members of *Malcolm X* include Albert Hall as Baines, Al Freeman, Jr., as Elijah Muhammad, Delroy Lindo as West Indian Archie, Giancarlo Esposito as Thomas Hayer, and Roger Guenveur Smith as Rudy.

3. I rely on the notion of disavowal here instead of the notions of repression or secondary revision for three reasons. First, the unsettling facets of African American identity that I argue are disavowed are not pushed out of consciousness. Indeed, they are readily discernible in the visual text and play an important role in shaping the visual narrative. Second, disavowal plays a particularly important role in the operation of deferred action that is itself singularly important to the perception of traumatic experiences as traumatic. Thus, in this discussion of reconstructed traumatic history, disavowal proves a very important mechanism to examine. And third, useful narratives become evident once the mechanism of disavowal is mitigated. When secondary revision fails, "we find ourselves helplessly face to face with a meaningless heap of fragmentary material" (Freud, 1965, p. 528).

4. Here they refer specifically to Freud's theory as it is articulated in *Three Essays on the Theory of Sexuality* (Freud, 1962).

5. The viewer watches as Malcolm is forced into solitary confinement after refusing to recite his prisoner number. With powerful images of isolation and regression, Malcolm is depicted as being reduced to a sobbing and broken-down inmate.

References

Baldwin, J. (1993). *The fire next time*. New York: Vintage.

Burgin, V. (1996). *In/Different spaces*. Berkeley: University of California Press.

Freud, S. (1962). *Three essays on the theory of sexuality*. New York: Basic.

———. (1965). *The interpretation of dreams*. New York: Avon.

Hall, S. (1987). Minimal selves. In H. Baker (Ed.), *Black British cultural studies* (pp. 114–119). Chicago: University of Chicago Press.

———. (1992). What is this "Black" in Black popular culture? In M. Wallace & G. Dent (Eds.), *Black popular culture* (pp. 21–33). Seattle: Bay.

hooks, bell. (1993). Consumed by images. *Artforum 31*(6), 56.

Laplanche, J., & J.B. Pontalis. (1973). *The language of psychoanalysis*. New York: Norton.

Lee, S. (1992). *By any means necessary: The trials and tribulations of the making of* Malcolm X. New York: Hyperion.

Lipsitz, G. (1990). *Time passages: Collective memory and American popular culture*. Minneapolis: University of Minnesota Press.

Lubiano, W. (1997). Black nationalism and Black common sense: Policing ourselves and others. In W. Lubiano (Ed.), *In the house that race built* (pp. 232–252). New York: Pantheon.

Malcolm X with Alex Haley. (1965, 1995). *The autobiography* of *Malcolm X*. New York: Grove.

Inside Media Mogul Man

Joints AND Jams

Spike Lee as Sellebrity Auteur

ANDREW DEWAARD

I n 2003, Viacom announced it would rename its TNN cable network Spike TV. Protesting that this infringed upon his brand name, Shelton Jackson "Spike" Lee sued. Lee did, in fact, have legal grounds under the "right of publicity" that protects supposed unauthorized commercial appropriations such as these. "People don't realize that I'm a *brand*," Lee argues, "and all the goodwill that I have *invested* in it can be contaminated by 'Spike TV'" (Lee & Fuchs, 2002, p. 288). While the gesture may have been self-aggrandizing (and Lee would later drop the case), it is indicative of the strange new dimension in which Hollywood directors now find themselves. Contemporary cinematic authorship is promoted and highlighted to an unheralded degree, yet earlier arguments for auteurism (as opposition to the studio system as a means of artistic legitimation) no longer seem to apply. Conventional conceptions of film authorship fail to grasp the nuances and complexities of this new context that Lee espouses. Branding and investing are the key words used by Lee here, exemplifying the transformations that have occurred within Hollywood, thus necessitating new formulations for auteurism.

I propose the term *sellebrity auteur* as a paradoxical concept that signals the complexities and contradictions of contemporary commercial cinematic authorship. It highlights, on the one hand, the cultural-economic factors in a film's creation and the struggle between art and commerce that this process involves; on the other, it acknowledges the need for an analysis of the auteur-as-celebrity, looking at the

auteur's brand identity and celebrity cachet as they are exploited both by the auteur in order to get a film made and by the studio in its marketing system. In short, the sellebrity auteur injects the consideration of commerce and celebrity into conventional theories of authorship. While the term auteur can be applied to many different authorial "voices" (producer, screenwriter, actor, cinematographer, etc.), in this instance, emphasis will be placed on the director.

Spike Lee will prove an exemplary case study for the sellebrity auteur, as he occupies a unique position within Hollywood with regard to both economics and celebrity. As one of the few big-name African American directors in a system still reluctant to cede much control to minorities, Lee's career has been one struggle after another to secure funding, especially given his penchant for racially charged subject matter. His production company, 40 Acres & a Mule Filmworks, is a fitting example of the way contemporary filmmakers in Hollywood must be heavily involved in the business end of film production in order to retain artistic control. Furthermore, this concern for economics is central to Lee's own advocacy for African American advancement; namely, more ownership and economic power are needed in the African American community. Lee's own increased economic power has been due in large part to his skill in branding the Spike Lee name, resulting in his transformation into a valuable commodity. From his ability to create controversy incessantly to his numerous and various commercial enterprises, Lee has exploited his celebrity in order to continue his prolific cinematic output over the years.

Before delving into Spike Lee's sellebrity status, a consideration of the contemporary auteur's economic situation requires a brief foray into the economic situation of Hollywood itself. "Blockbuster hits," Thomas Schatz (1993) admits, rather reluctantly, "are, for better or worse, what the new Hollywood is all about, and thus are the necessary starting point for an analysis of contemporary cinema" (p. 10). With the enormous successes of George Lucas and Steven Spielberg, the high-concept blockbuster film became Hollywood's staple product in the 1980s (Wyatt, 1994). With every major studio subsumed by a huge transnational corporation and mercilessly focused on the bottom line, movies were thought of as mere products more than ever; reliable profits and growth were sought through formulaic plotlines, intense market research, a reliance on sequels and remakes, bankable movie stars, and inoffensive topics.

In the 1990s, a middle tier developed within the industry as a result of the rise of niche marketing and the increased economic importance of film festival and award show success, exemplified by Miramax and Sundance, respectively (Biskind, 2004). In 1989, Steven Soderbergh's *sex, lies and videotape* "ushered in the era of the 'indie blockbuster'—films that, on a smaller scale, replicate the exploitation marketing and box-office performance of the major studio high-concept event pictures"

(Perren, 2001, p. 30). Allen J. Scott (2004) formulates a tripartite model for ana-lyzing Hollywood's new structure: majors, independents, and the newly formed "major-independents," speciality companies such as Miramax, which focus on "quality" movies that aspire to the status of "art." In response to a range of newly dis-covered/developed intermediate markets, every major studio (MGM, Paramount, Sony, Fox, Universal, Disney, and Warner Brothers) now has a stable of subsidiaries (Miramax, Focus, New Line, etc.) that operate with a high degree of autonomy.

As the studio system has given way to the "package" system, most film projects are put together on a one-off basis by varying groups of key creative personnel. In this system, the Hollywood director often operates as a kind of "free agent." In order to attain funding and distribution, the director—sometimes aligning with a produc-er or attached star, forming the "package"—pitches a film to a major or major-independent studio. As a free agent, the director must navigate this complex terrain of art and commerce, independent and corporate, art house and mass marketing, minis and majors. Lee is a stellar example of this negotiation, having worked with independents (Island Pictures, his own production company), mini-majors (New Line, HBO, Fox Searchlight), and majors (Universal, Warner Brothers, Sony) to produce smaller films (*She's Gotta Have It*, *Crooklyn*, *Bamboozled*), indie block-busters (*Do the Right Thing*, *Jungle Fever*, *He Got Game*), and big-budget blockbusters (*Malcolm X*, *Inside Man*). It is necessary to keep this shifting playing field in mind as we consider the contemporary auteur, as attending to economic concerns is increasingly becoming one of the many responsibilities of the auteur.

A much-debated theory ever since its development in the 1950s (for an exten-sive history, see Caughie, 2001), auteur theory has always been a heavily fragment-ed discourse circulating around a few predominant ideas. The cinematic exploration of a distinctive set of thematic concerns is typically considered one of the key ele-ments that can "elevate" a filmmaker to the status of auteur. A personal visual style—what Andrew Sarris (1962) famously called the director's "signature"—is another. While much debate surrounds these two formal features that are taken to indicate individual authorship, the most provocative aspect of the auteur theory, in my mind, is the consideration of the auteur's relationship to the industrial structure of Hollywood production. The heavily commercialized and collaborative environ-ment of Hollywood has always constrained the creative freedom of the auteur, and the tensions between the artist and the industry have been central in auteur theo-ry. Fifty years after the inception of auteur theory, in an industry now dominated by summer spectacles, big box-office business, corporate conglomeration, and mas-sive marketing manoeuvres, what are we to make of the auteur today?

Auteurism fell out of favor when its flaws and limitations were articulated, and a multitude of alternative discourses in film theory gained prominence in its place, but there has been a reconsideration of cinematic authorship in recent years. Dudley

Andrew (2000) poignantly welcomes back auteurism: "Breathe easily. *Epuration* has ended. After a dozen years of clandestine whispering we are permitted to mention, even to discuss, the auteur again" (p. 20). "Auteurs are far from dead," in Timothy Corrigan's (1998) view, "in fact, they may be more alive than at any other point in film history . . . within the commerce of contemporary culture, auteurism has become, as both a production and interpretive position, something quite different from what it may have been in the 1950s or 1960s" (p. 135). Hollywood is a constantly changing and evolving industry; there is no reason why considerations of authorship in Hollywood should not evolve correspondingly. By understanding its theoretical limitations and shifting industry conditions, we may reformulate the concept of the "auteur" according to these new contexts.

The primary modification of auteurism has been in terms of the reliance on Romantic and individualist notions of the author. Prompted by such grand literary revelations as Michel Foucault's (1969) "What Is an Author?" and Roland Barthes' (1968) "The Death of the Author," auteur theory has been overhauled in terms of its breadth and scope. Rather than perceiving an auteur film as some sublime expression of individual genius, it is now regarded as a *site* for the interaction of biography, institutional context, social climate, and historical moment. In this rendering, auteurism is meant to "emphasize the ways a director's work can be both personal *and* mediated by extrapersonal elements such as genre, technology, [and] studios" (Stam, 2000, p. 6; original emphasis). What began as an attempt by the French critics of *Cahiers du cinéma* to elevate the director—as opposed to the writer, traditionally held to play the central creative role in French cinema—to the status of an artist, auteurism has since evolved into a complex theory containing various interrelations.

Much of the recent critical analysis surrounding contemporary auteurship (Buckland, 2003; Lewis, 2003; Flanagan, 2004) makes use of the term *blockbuster auteur*, a designation I find lacking because of its reduction of the director to his or her generic product. Instead, I propose the more evocative term *sellebrity auteur* because it incorporates the brand identity and celebrity cachet that is now so integral to today's auteur, while foregrounding the centrality of economic imperatives. As we explore other forays into the intersection between auteurism and commerce, we will witness an evolution in the idea of the auteur, eventually arriving at the sellebrity auteur's unique synthesis of fame and economics.

Taking as its starting point the recent trend toward focusing on the box office success of a film as the dominant measure of its value, Jon Lewis (2003) analyzes the careers of George Lucas and Steven Spielberg in order to come to terms with contemporary auteurism. Over the last 30 years, no two filmmakers have reached a wider international audience or been considered more emblematic as "American movie-men." According to Lewis, Lucas and Spielberg exemplify the trend that

auteurs now "gain notoriety less for a signature style than for a signature product" (2003, p. 4). If a director's claim to auteur status were to be determined solely by the degree to which he or she has control over a project, then Lucas and Spielberg would be auteurs of the highest order. One method by which they have achieved control of their product, one which marks a shift in auteurism writ large, is an aggressive business strategy.

Warren Buckland (2003) continues this line of thought, arguing that authorship status in contemporary Hollywood is no longer achieved simply by mastery of the filmmaking process; the director must also control external factors such as production, financing, and distribution as well. Lucas and Spielberg are, of course, exemplars of this process, each director having constructed a veritable empire out of their commercial enterprises. Lucas's special effects facility, Industrial Light and Magic, has become a central component in the economy of Hollywood by establishing itself as the world's premier special effects company. The Lucas empire also includes his production company, Lucasfilm; his sound divisions, Skywalker Sound and the THX Group; his video-gaming company, LucasArts Entertainment; and his merchandising and licensing company, Lucas Licensing. Spielberg has been equally as successful, forming his own production company, Amblin Entertainment, in order to extend his reach into more personal projects and produce countless features and television shows. In 1994, Spielberg, along with two other media moguls, made a monumental leap forward by creating their own studio, DreamWorks SKG, the first new entrant in the major studio scene in over 60 years (in 2005, it was sold to Viacom, the parent company of Paramount Pictures).

Spike Lee's production company, 40 Acres & a Mule Filmworks, while certainly not as expansive as Lucas or Spielberg's empire, is equally as impressive in terms of the control it has given Lee by enabling alternative revenue streams, as well as the black filmmaking community it has fostered. 40 Acres & a Mule Filmworks is an allusion to the stillborn legislative proposal that was to give "forty acres and a mule" to each freed slave following the American Civil War, "so the name of my company is really a reminder of a broken promise" (Aftab & Lee, 2005, p. 2). With $175,000 and a camera, Lee burst on to the filmmaking scene in 1986 with *She's Gotta Have It*. Since then, Lee has negotiated every one of his productions through 40 Acres and retained final cut on every one of his features, a feat rarely accomplished in mainstream Hollywood. Filmmaking, like farming, is a capital-intensive activity, necessitating ownership of property. With 40 Acres, Lee achieved the economic capacity necessary to compete in Hollywood.

Originally conceived as merely his personal production company, 40 Acres slowly became a burgeoning enterprise with the decision to branch out into music and merchandising after the success of Lee's early films. The success of R&B act EU's "Da Butt," and the corresponding soundtrack for *School Daze*, as well as the

anthemic status of Public Enemy's "Fight the Power," commissioned for *Do the Right Thing*, prompted a new subdivision in the company: 40 Acres & a Mule Musicworks. A division of Sony, Lee's record label was able to sign artists such as Youssou N'Dour and Lonette McKee, as well as release some of his own soundtracks. On the merchandising end, Lee opened Spike's Joint, a retail boutique in Brooklyn (another outlet would later be opened in Los Angeles; both would close in 1997) to sell merchandise that bore the 40 Acres emblem, as well as products by Nike, Gap, and Levi Strauss, for whom Lee had directed commercials. When Michael Jordan donned an "X" cap during an interview following the 1991 All-Star Game, a merchandising storm was created for Spike's Joint, fuelling the popularity of *Malcolm X* at the same time.

Lee's relationship with Jordan and Nike is another lucrative joint venture. Lee's debut feature, *She's Gotta Have It*, features a central character, Mars Blackmon (played by Lee himself), who noticeably sports a pair of Nikes (even in the bedroom). Garnering the attention of a Nike creative director, a deal was made for Lee to direct a series of commercials starring Mars and Michael Jordan, which would go on to become "the template for marketing cool" (Carvell, 1997, p. 84). In *Do the Right Thing*, Lee's brand loyalty is repaid with Buggin' Out's exclamation: "you stepped on my brand new, white Air Jordans I just bought!" Simultaneously, Lee engages in blatant product placement *and* authentic realism, a telling example of his paradoxical role as corporate artist.

Nike is just one of the many businesses Lee has made commercials for over the years; others include Levi's, AT&T, ESPN, the *NY Times*, American Express, Taco Bell, Ben & Jerry's, Diet Coke, Snapple, Pizza Hut, and most controversially, the U.S. Navy. Defending this choice, Lee reasons that he wanted to help reverse the racist reputation of the Navy after they approached him with that concern (Aftab & Lee, 2005, p. 253). In 1999, Lee established an advertising agency, Spike/DDB, a joint venture with one of Madison Avenue's most prominent agencies, DDB Needham, with the aim of tapping into the "urban" market. With a 51 percent stake in the company, Lee has created yet another source of income for 40 Acres. "Because he earns his big-time money in commercials," explains *Variety* editor-in-chief Peter Bart, "he doesn't feel he has to work on pictures that get him a mass audience" (as cited in Thompson, 2002). Music videos are another source of this alternative income, as well as another testament to his African American focused artistry; he has worked with such notable artists as Stevie Wonder, Miles Davis, Michael Jackson, Prince, Arrested Development, A Tribe Called Quest, and Naughty by Nature.

Other unique financial situations have arisen throughout Lee's career. With *Malcolm X*, Lee was locked in a battle with Warner Brothers over a larger budget, which Lee thought necessary. When the bond company shut down production for

Figure 18.1. Denzel Washington in *Malcolm X* (1992). Courtesy of Photofest.

going over budget, Lee resolved this struggle by contributing $2 million of his own salary and appealing to high-profile members of the black community, receiving donations from Bill Cosby, Oprah Winfrey, Michael Jordan, Magic Johnson, Tracy Chapman, and others. This story is a favorite of Lee's, repeated in many interviews. The check from Nike CEO Phil Knight that bailed Lee out when *Jim Brown: All American* went over budget is certainly less publicized.

Get on the Bus reprised the African American finance scheme, an appropriate move considering the film's subject matter: the Million Man March and black empowerment. Assembling a new list of prominent African Americans—including Johnnie Cochran, Reggie Bythewood, Wesley Snipes, Danny Glover, and Ossie Davis, incorporated as "15 Black Men"—Lee raised a production budget of $2.5 million, and by preselling the film, paid back his investors before the film even opened. A testament to the financial imperatives of the sellebrity auteur, Ossie Davis marvels at Lee's skill as a businessman: "For a man to do that—to know *how* to do that—this is equally important to any other talent that you might have as a filmmaker.... He is one of the few people who could have sat at the same table as Cecil B. De Mille, Samuel Goldwyn and Jack Warner" (as cited in Aftab & Lee, 2005, p. 220–221; original emphasis).

The 40 Acres enterprise is not solely about Lee's own work though; it has also fostered an entire African American filmmaking community. One of the primary

goals of 40 Acres was "to demystify the whole filmmaking process. . . . We wanted people of color (male and female) to pursue careers in film, not only in front of the camera but, even more important, behind it" (Aftab & Lee, 2005, p. 305). As the appendix listing the expansive roster (more than a hundred) of 40 Acres in Lee's autobiography indicates, this mission has been an astounding success. A wide range of African American talent has been cultivated in many different filmmaking departments, including directors, writers, actors, and below-the-line workers. Notable names that got their start with 40 Acres include directors Ernest Dickerson and Lee Davis and actors Halle Berry, Mekhi Phifer, Martin Lawrence, and Rosie Perez. 40 Acres was also able to produce a number of African American vehicles, such as *Drop Squad* (David C. Jonson, 1994) and *Tales from the Hood* (Rusty Cundieff, 1995), as well as the debuts of 40 Acres alumni such as *The Best Man* (Malcolm D. Lee, 1999) and *3 A.M.* (Lee Davis, 2001). Lee's many books detailing the struggles he had making his early films, from *She's Gotta Have It* through *Malcolm X*, which include journals and production diaries, also act to "demystify" the filmmaking process. Looking back at the success of 40 Acres, one might even consider Lee himself to be distributing the acres now, equipping and empowering his followers with the necessary tools to flourish.

Returning to our look at recent considerations of auteurism and commerce, a recent trend in Hollywood has been to entrust big-budget productions with auteur or art house directors, a practice Martin Flanagan (2004) seeks to analyze in terms of the conflicting concepts of the auteur and the blockbuster. Looking at the list of box-office hits in recent years, Flanagan finds a full range of auteur identities: veterans of New Hollywood such as Martin Scorsese, Paul Schrader, and Robert Altman; graduates of low-budget horror such as Sam Raimi, Peter Jackson, and Guillermo del Toro; innovators and documentarians such as Terry Zwigoff and Richard Linklater; and art house foreigners, such as Christopher Nolan and Jane Campion. Many of the largest grossing blockbuster franchises even come from auteur directors: Raimi's *Spiderman* franchise, Jackson's *Lord of the Rings* Trilogy, Bryan Singer's *X-Men* franchise, Robert Rodriguez's *Spy Kids* Trilogy, Steven Soderbergh's *Ocean* franchise, and the Wachowski Brothers' *Matrix* Trilogy. The industry has come to see auteurs as another distinctive (and marketable) element that can be added to blockbuster appeal.

While Lee typically works with relatively medium-range budgets, he has flirted with big-budget productions from time to time, notably with *Malcolm X*. Norman Jewison was originally appointed to direct the project for Warner Brothers, but Lee publicly denounced this decision, claiming only an African American could do the film justice. While Jewison did eventually pull out, one cannot help but think this was, at least in part, a marketing decision on Warner Brothers' behalf, choosing to associate a controversial auteur with the already incendiary

Malcolm X in order to make an "event" picture capable of grabbing headlines. Lee shied away from big-budget spectacle after the exhausting struggle of *Malcolm X*, but returned to major box-office success recently by embracing genre and blockbuster impulses with *Inside Man*.

As Flanagan admits, an analysis centered on the terms "auteur" and "blockbuster" is destined to be problematic, as the meanings of both terms are constantly in flux. A corresponding theme is the recurring desire for both critical and commercial success, which was seen even in the early days of auteur theory, especially with Alfred Hitchcock. Flanagan relates this struggle to two other auteurist dichotomies. The first, originally formulated by Buckland (1998), classifies auteurs as either a "classical auteur," the "skilled craft worker who has mastered—and indeed represents—'the tradition'" (p. 84), or a "romantic auteur," the "lone, creative genius who works intuitively and mysteriously outside of all traditions" (p. 85). While Lucas and Spielberg typify the classical, Francis Ford Coppola has become emblematic of the romantic. However, Coppola himself only achieved such enigmatic status after enormous financial success with his blockbuster series *The Godfather* (1972) and *The Godfather: Part II* (1974). To consider Coppola "outside of all traditions" would be to misperceive his important economic role in American Zoetrope and the Director's Company. Coppola's complications aside, careful consideration of today's economic climate in Hollywood would render any such nostalgic pining for a romantic figure "taking on the system" highly problematic.

Expanding upon this romantic/classical dichotomy, Matt Hills (2003) claims that the figure of the auteur produces both an "economy of culture," in which the power of the auteur identity is used to market the blockbuster film, and a "culture of economy," where the auteur works within institutional constraints in an attempt to challenge the conventions of the culture industry. Now that marketing has become as much—if not more—of an economic investment than production, the name of a director is just one of many appeals made by marketers in order to promote films and maximize audiences. Just as sequels, remakes, and presold properties are seen as more bankable to the studio executive, the director's name has become part of the marketing equation as an assurance of quality. The extent to which marketers will exploit previous authorial successes has reached a trivial, almost empty fruition, as *Godzilla* is sold as "from the creators of *Independence Day*."

A useful example of this "economy of culture" can be seen in Geoff King's (2002) analysis of the ultrahigh-concept *Batman* series. While the success of *Batman* (1989) and *Batman Returns* (1992) was pretty much assured with its combination of big-name stars, presold comic book audience, high-budget special effects, merchandising and ancillary products, and soundtrack tie-in, Warner Brothers added a distinctive element to the two films by choosing Tim Burton as

director. Burton's dark and quirky gothic-style of filmmaking not only complement-
ed the material, but it widened the appeal of the film to an audience who might be
averse to another big-budget, over-hyped blockbuster. Tim Burton's dramatic effect
can be seen not just in these films, but on the superhero comic book genre as a whole,
which has taken a distinctly darker and more psychological turn since Burton.
Notably, the franchise began to fail with the critically unfavored Joel Schumacher
behind the camera of *Batman Forever* (1995) and *Batman and Robin* (1997), but was
reinvigorated—critically and commercially—with British art film director
Christopher Nolan at the helm of *Batman Begins* (2005).

As for the "culture of economy," we can look at one final auteurist dichotomy,
Timothy Corrigan's (1990) distinction between the "commercial auteur" and the
"auteur of commerce," which Hills used as the basis for his argument. Corrigan
argues that the newfound auteur marketability marks a significant reversal: "the cen-
tral change in the meaning of auteurism from the sixties to the eighties" was a
"marked shift within auteurism as a way of viewing and receiving movies, rather than
as a mode of production" (1990, p. 44). In this analysis of auteurism, we see the rise
of New Hollywood accompanied by the conception of the auteur as a commodi-
fied property, "a *commercial* strategy for organizing audience reception . . . a critical
concept bound to distribution and marketing aims" (1991, p. 103; italics in origi-
nal). Historically, this makes perfect sense; the rise of New Hollywood in the 1960s
coincided with the rise of the academic study of film, of which the auteur theory
was highly regarded. The new generation of filmmakers was largely a product of film
school, raised on international art cinema where an idea of the "director-as-artist"
is central. These young directors were fully aware of the auteur theory, and the indus-
try was fully conscious of exploiting it through marketing.

As a consequence, Corrigan argues, the auteur's commercial status has been ele-
vated to that of a star, "a kind of brand-name vision that precedes and succeeds the
film, the way that movie is seen and received" (1991, p. 102). Through a torrent of
advertisements, trailers, and magazine profiles, the institutional and commercial
agencies at work in Hollywood have converted auteurism into an "empty display of
material surface" (1991, p. 106). Such an emphasis results in a preconceived inter-
pretation of the film as an articulation of the public image of its author. The auteur
film becomes nothing more than a critical tautology, to be understood and consumed
without any real interaction or effort. As an example, Corrigan shows how Spielberg,
despite his earnest efforts to do otherwise, will inevitably always make "a Spielberg
film."

Forced to negotiate this problematic celebrity, the "auteur-star" is constantly on
the verge of being consumed by his or her emerging star status. Corrigan detects
two outcomes to this trend: the commercial auteur and the auteur of commerce. The
commercial auteur includes the obvious "superstar" directors, Lucas and Spielberg,

who have achieved a considerable measure of stardom as a result of creating many beloved blockbusters. A degree of high visibility is associated with the commercial auteur, perhaps best seen in the star-turned-director, such as Mel Gibson, Robert Redford, Clint Eastwood, Sylvester Stallone, and Kevin Costner. This "on-screen" dimension to auteurism dates back to the days of Alfred Hitchcock and Orson Welles. Corrigan even includes Woody Allen, John Sayles, François Truffaut, and Bernardo Bertolucci in this designation, as all of these directors are united by a "recognition, either foisted upon them or chosen by them, that the celebrity of their agency produces and promotes texts that invariably exceed the movie itself, both before and after its release" (1991, p. 107). The grandiose image of the auteur-star is what anchors the films of these auteurs, rather than ideas, styles, themes, or modes of expression.

The auteur of commerce, on the other hand, is "a filmmaker [who] attempts to monitor or rework the industrial manipulations of the auteurist position within the commerce of the contemporary movie industry" (1991, p. 107). Corrigan chooses Coppola, Alexander Kluge, and Raoul Ruiz as his shining exemplars, formulating the auteur of commerce as a filmmaker who actively employs fissures and discrepancies in his or her work in a conscious attempt to open up a space between self-identity and auteurist-identity in order to break down the oppression of the auteur's brand name. Because films may be reduced to vehicles for directors, the auteur as brand name may threaten the film's artistic standing, moving the focus from the text to the author—Coppola's tremendous self-sacrifice of his health and finances, Kluge's fragmentation of a central, dominating auteurist agency, and Ruiz's multitude of reincarnations across cultural spaces: three different paths toward the same ends. The only way to overcome the all-encompassing weight of the branded image of the auteur, according to Corrigan, is to communicate from *within* the commerce of that image. Fittingly, Corrigan uses Lee and his casting of himself in *Do the Right Thing* as an example of the auteur of commerce using his "image and name as a critical wedge to question his own and other's authority and power" (1991, p. 51).

At the nexus of all these interrelated and correlative dichotomies—the romantic/classical, the economy of culture/culture of economy, the commercial auteur/auteur of commerce—is the contemporary director who must negotiate his or her economic situation alongside his or her star image; in other words, he or she must become a sellebrity auteur. The "sell," as we have seen, is simply the economic imperative of contemporary Hollywood. The auteur has always been constrained by the industrial nature of the system. In fact, auteur theory emerges out of an explicit acknowledgment of the industrial contexts of studio filmmaking in early Hollywood. However, the ever-increasing corporate logic of Hollywood has also forced the auteur to be actively involved in the "business-end" of the business, lest

he or she be reduced to a "director-for-hire." Part of this business venture is exploit-ing—and being exploited by—the celebrity angle of the equation.

The classic definition of celebrity comes from Daniel Boorstin's (1961) critique of commercial culture, *The Image: A Guide to Pseudo-Events in America*: "the celebri-ty is a person who is known for his well-knownness. . . . He is neither good nor bad, great nor petty. He is the human pseudo-event" (p. 57). Talent or achievement has little to do with the fascination; it is not *doing* that is celebrated, but *being*. This des-ignation may not appear to apply to the sellebrity auteur, as his or her work remains a focal point in their popularity, but as Corrigan notes, the transformation into a star may supersede this work. To rewrite Boorstin's formulation for our own purposes then, the sellebrity auteur is a famous director for being a famous director.

Continuing this analysis of "well-knownness," but leaving behind the heavy-handed, Frankfurt School-influenced critique, Joshua Gamson (1994) details the "negotiated celebration" in the contemporary entertainment industry. Quick to distinguish between performer/entertainer and star, Gamson designates the per-former as both a *worker*, pertaining to their qualities and abilities, and a *celebrity*, in which "what is developed and sold is the capacity to command attention" (p. 58). Increasingly, this distinction is becoming apparent in the auteur as well, as Corrigan was astute to note with the auteur-star. What Corrigan fails to consider, however, is the way the auteur must personally engage in this star-making. It is not simply a matter of the auteur's name superseding the text, or that the auteur of commerce can manipulate this image within the text, but that the auteur must also personal-ly play the game of commanding attention. It is not just what is thrust upon the auteur, but what the auteur manufactures to have thrust upon him or herself. In an industry heavily dependent on hype and publicity, "notoriety becomes a type of cap-ital . . . recognition by consumers as a brand, familiarity in itself. The perceived abil-ity to attract attention, regardless of what the attention is for, can be literally cashed in" (Gamson, 1994, p. 62). For Spike Lee, typically taking on commercially unfriend-ly subject matter, any capital he can gain is valuable, and cashing in on his notori-ety has been a particularly lucrative form of capital.

Not one to shy away from the spotlight, Lee takes a highly active role in the definition of his image. True to his namesake, Spike has crafted an identity of sharp opposition, cultivated over years of outspokenness and controversy. This is evident in just about every biography written about him in the news media. As Erich Leon Harris (2002) succinctly summarizes, the press has constructed "a persona of near-mythic dimensions for Spike Lee the man. Angry. Brilliant. Controversial. Outspoken. Maverick. Racist. These are the words one encounters over and over again when reading about Lee" (p. 127). But one should not place the onus solely on the press, despite such provocations as an October 1992 *Esquire* cover story

declaring that "Spike Lee Hates Your Cracker Ass."

Lee himself is responsible for much of this oppositional persona, rarely passing up the opportunity to comment and criticize on current events of concern to him, from his well-publicized dispute with Quentin Tarantino over his overuse of "the n-word," to criticisms of Eddie Murphy and Will Smith, accusations of stereotype perpetuation in African American television sitcoms and rap videos, or attacks on the inaccurate histories proposed by *Mississippi Burning*, *Amistad*, and *The Patriot*. And this is not including the many controversies created by his own films, nearly all of which have caused some degree of strife in the news media. Anti-Semitism, homophobia, race-baiting, misogyny, incitements to riot—Lee has been accused of it all, and rarely misses the chance to supply an indignant quote in return. Ironically, this antagonistic reputation that has fueled his celebrity, and thus his ability to continue producing films, is bemoaned by Lee: "it's reaching the point where *I'm* getting reviewed, not my films" (Lee, 1990, p. 25).

In crafting and asserting this public persona, Lee has established what has come to be essential to every sellebrity auteur and every celebrity for that matter: a brand name. Elaborating on Richard Dyer's (1986) designation of stars as "property" (Dyer, 1986, p. 5), Graeme Turner (2004) argues for a conception of the star as a "celebrity-commodity," a financial asset whose commercialization stands to make profit for a variety of interested parties. A celebrity's public persona is an integral part of this commercial asset: "as the asset appreciates—as the celebrity's fame spreads—so does its earning capacity" (Turner, 2004, p. 35). Turner touches on the specific importance of branding when he invokes Naomi Klein's (2001) pivotal work, *No Logo*. A striking example of our "new branded world," Klein attributes the introduction in 1999 of *Forbes* magazine's "Celebrity Power 100"—which ranks celebrities according to their brand name rather than fame or fortune—as proof that "brands and stars have become the same thing" (Klein, 2001, p. 49). The sellebrity auteur, then, aspires to this quality of living, breathing brand name.

Lee provides a literal example of this coalescence: his name and production company has been emblazoned on all sorts of merchandise at Spike's Joint. The tagline that accompanies all of Lee's films is another element to this brand name. "A Spike Lee Joint" evokes at once a sense of hip, urban populism, the idea of a joint business venture, the legacy of the juke joint, the concept of juncture, as well as a drug connotation. It has come to mean something of an assurance or a guarantee, if not of quality, then at least of attitude. "Lee's films," according to Marlaine Glicksman (2002), "are unmistakably Spike: direct, outspoken, no-holds-barred, tell it like it is, pointed and hard-hitting" (p. 16). Personal opinions aside, people seldom walk out of a Spike Lee film feeling like they did not "get Spike'd." The antagonistic image he has crafted over the years, a result of his careful branding, has created this expectation.

Star power is not to be underestimated in Hollywood; as King (2002) reminds us, "stardom is generally considered the single most important factor in the commercial viability of many films" (p. 160). In the era of the package system, when most films are one-off productions, stars are the closest thing to reliable box-office potential. A recognizable brand in an already overcrowded entertainment marketplace is invaluable; it is not hard to imagine why the sellebrity auteur would want to craft his or her own star image as an assurance of economic stability and why the industry would want to encourage and exploit just such a venture.

Such brazen commercialism, a necessity for the sellebrity auteur, as we have seen, inevitably draws criticism on the grounds of "selling out." In his essay, "No Accident: From Black Power to Black Box Office," William Lyne (2000) claims that as Lee's career has been commercialized, so has his radical political vision. Like the rise and fall of the Blaxploitation era of the early 70s, Hollywood has seized upon the potential profitability of Lee, capitalized on his sensationalism, and left "the undigestable revolutionary morsels behind" (p. 45). Lyne accuses Lee of "mak[ing] peace with the corporate power structure while maintaining a veneer of militant dissent" (p. 57). The most blatant case of this "selling out," according to Lyne, is Lee's handling of *Malcolm X*. By reducing Malcolm's final years to his break with Elijah Muhammad and his trip to Mecca, Lee downplays the politically radical and transformationist side of Malcolm. Lyne draws on the Marxist work of Manning Marable, who believes that the only strategy for substantial change within black politics is "transformationism," which calls for sweeping change in ownership, labor rights, and production relations. With lofty revolutionary goals such as these, it's no wonder Lyne takes such a harsh stance on Lee's career.

Despite his dismissal of much of Lee's later work—even going as far to quote Amiri Baraka's insult of Lee as "the quintessential buppie, almost the spirit of the young, upwardly mobile, Black, petit bourgeois professional" (p. 47)—Lyne cannot help but dedicate much of his essay to the merits of *Do the Right Thing*. A "stew of economic imperialism, ethnic solidarity, and labor relations," (p. 48) Lyne praises the film for its strong transformationist underpinning and the critical discourse it created in newspapers, magazines, and journals across the country. Yet, *Do the Right Thing* contains the same commercial imperative as Lee's other films, perhaps even more so, as the previously mentioned Nike sneakers scene indicates. Surely, every auteur is going to have their stronger and their lesser outings, but apparently a genuine modern day classic (*Do the Right Thing*) and a series of engaging films from an African American filmmaker, deftly maneuvering through the Hollywood system, are not good enough for a "revolutionary" like Lyne.

Another unforgiving critique, Jerome Christensen's (1991) "Spike Lee, Corporate Populist," rebukes Lee for his corporate complicity. Like Lyne, Christensen accuses Lee of playing the "rebel" card, dramatizing his opposition to

the major studios while doing business with them all the same. In particular, Christensen takes issue with the product placement of Air Jordans in *Do the Right Thing*, along with the Mars Blackmon commercials, and the implications this has in terms of corporate art. Christensen perceives the scene of Buggin' Out proclaiming his love for his Air Jordans as "momentarily mov[ing] the film into the inebriating hyperreality of product fetishism" (p. 591). Especially within the context of the outbreak of inner-city black youth being murdered for their sneakers, and the crime surrounding these kinds of materialist symbols, Christensen is right to point out Lee's complicity and refusal to accept at least partial indirect responsibility. To dismiss the entire film—not to mention Lee's career—because of this one act of corporate compliance, however, is unwarranted. Like Lyne's Marxist idealism, Christensen's unabashed romanticism yearns for an art form uncorrupted by capital. His heavy-handed description of Lee's filmmaking as "the most advanced expression of the emergent genre of corporate art" (p. 589) denotes, on one hand, a disregard for cinema and art history (corporate art is not exactly "emerging"), as well as a bias against Hollywood itself. Mainstream Hollywood cinema will always contain the element of commercialism; Christensen's critique would be more appropriately aimed at the industry as a whole rather than Lee's own struggle with art and commerce.

Ultimately, this criticism of Lee's "selling out" is misguided, as "selling out" is, in a sense, his goal:

> Part practical and financial, part ideological and idealistic: he wants to widen the scope—the assumptions and the address—of so-called "minority" images and audiences. He wants to be able to compete, to represent, like any white corporate entity, to sell products and create art that are pitched to multiple "demographics." (Lee & Fuchs, 2002, p. ix)

The legacy of 40 Acres & a Mule Filmworks attests to this pragmatic method of African American empowerment through free-enterprise economics. In the words of Houston A. Baker, Jr. (1993), "Lee understands that his job is to get 'paid in full' so that he can continue producing films of Black cultural resistance" (p. 175). In a highly commercial industry, Lee not only uses commercial means for his own ends, building an impressive career out of his many various forms of "joints," he criticizes and reappropriates this very same commercialism, at times "jamming" the system from within.

In the minefield of economics and celebrity that is contemporary Hollywood, the sellebrity auteur is a necessarily paradoxical conception that helps account for the many seemingly contradictory elements at play. Upon closer inspection, the intersection of art and commerce—whether independent versus corporate, art house versus mass marketing, or mini versus major—reveals itself to be a dialecti-

cal paradox in cohesion, not collision. The most visible proof of this phenomenon would be in the way some of these oppositional terms have literally become conjoined, such as niche marketing, indie blockbuster, and the mini-major. Economically, we see box-office reception tied to critical reception, as well as ownership concerns tied to artistic control. With regards to the auteur, we see rigid boundaries beginning to blur: blockbuster and art house, romantic and classical, economy of culture and culture of economy, celebrity and artist. The sellebrity auteur, as exemplified by Spike Lee, demonstrates that ideas about authorial genius are located not just in the films themselves, but in the way the auteur directs—economically and reputationally—the movie of his or her life.

Note

I would like to thank Keir Keightley, Amanda Grzyb, Brian McIlroy, and Lisa Coulthard for all their help with this chapter.

References

Andrew, D. (2000). The unauthorized auteur today. In R. Stam & T. Miller (Eds.), *Film and theory: An anthology* (pp. 20–29). Malden, Mass: Blackwell.

Aftab, K., & S. Lee. (2005). *Spike Lee: That's my story and I'm sticking to it*. New York: W.W. Norton.

Baker, H. A., Jr. (1993). Spike Lee and the Commerce of Culture. In M. Diawara (Ed.), *Black American cinema* (pp. 154–176). New York: Routledge.

Barthes, R. (1977). The death of the author. In. S. Heath (Ed. & Trans.), *Image, music, text* (pp. 142–154). New York: Hill and Wang. (Original work published 1967)

Biskind, P. (2004). *Down and dirty pictures: Miramax, Sundance, and the rise of the independent film*. New York: Simon & Schuster.

Boorstin, D.J. (1961). *The image: A guide to pseudo-events in America*. New York: Harper and Row.

Buckland, W. (1998). A close encounter with *Raiders of the Lost Ark*. In S. Neale & W. Smith (Eds.), *Contemporary Hollywood cinema* (pp. 166–177). London: Routledge.

———. (2003). The role of the auteur in the age of the blockbuster: Steven Spielberg and DreamWorks. In J. Stringer (Ed.), *Movie blockbusters* (pp. 84–98). London: Routledge.

Caughie, J. (2001). *Theories of authorship*. New York: Routledge.

Carvell, T. (1997, April 14). Spike Lee: Madison Ave.'s gotta have him. *Fortune 135*(7), 84–86.

Christensen, J. (1991). Spike Lee, corporate populist. *Critical Inquiry 17*(3), 582–595.

Corrigan, T. (1990). The commerce of auteurism: A voice without authority. *New German Critique 49*, 43–59.

———. (1991). *A cinema without walls: Movies and culture after Vietnam*. New Brunswick, NJ: Rutgers University Press.

———. (1998). Auteurs and the new Hollywood. In J. Lewis (Ed.), *The new American cinema*

(pp. 38–63). Durham & London: Duke University Press.

Dyer, R. (1986). *Heavenly bodies: Film stars and society*. London: BFI Macmillan.

Flanagan, M. (2004). "*The Hulk*, an Ang Lee film:" Notes on the blockbuster auteur. *New Review of Film and Television Studies 2*(1), 19–35.

Foucault, M. (1998). What is an author? In D. Preziosi (Ed.), *The art of art history: A critical anthology* (pp. 299–314). New York: Oxford University Press. (Original work published 1969)

Gamson, J. (1994). *Claims to fame celebrity in contemporary America*. Berkeley: University of California Press.

Glicksman, M. (2002). Spike Lee's Bed-Stuy BBQ. In S. Lee & C. Fuchs (Eds.), *Spike Lee: Interviews* (pp. 13–24). Conversations with filmmakers series. Jackson: University Press of Mississippi.

Harris, E.L. (2002). The demystification of Spike Lee. In S. Lee & C. Fuchs (Eds.), *Spike Lee: Interviews* (pp. 127–143). Conversations with filmmakers series. Jackson: University Press of Mississippi.

Hills, M. (2003). *Star Wars* in fandom, film theory and the museum: The cultural status of the cult blockbuster. In J. Stringer (Ed.), *Movie blockbusters* (pp. 178–189). London: Routledge.

King, G. (2002). *New Hollywood cinema: An introduction*. New York: Columbia University Press.

———. (2005). *American independent cinema*. London: I.B. Tauris.

Klein, N. (2001). *No logo*. London: Flamingo.

Lee, S. (1990, August 28). I am not an anti-Semite. *New York Times*. p. A25.

Lee, S., & C. Fuchs. (2002). *Spike Lee: Interviews*. Conversations with filmmakers series. Jackson: University Press of Mississippi.

Lewis, J. (2003). The perfect money machine(s): George Lucas, Steven Spielberg and auteurism in the New Hollywood. *Film International 1*(1), 1–12.

Lyne, W. (2000). No accident: From Black power to Black box office. *African American Review 34*(1), 39–59.

Perren, A. (2001). Sex, lies and marketing: Miramax and the development of the quality indie blockbuster. *Film Quarterly 55*(2), 30–39.

Sarris, A. (1962, Winter). Notes on the *auteur* theory in 1962. *Film Culture, 27*, 1–8.

Schatz, T. (1993). The new Hollywood. J. Collins, H. Radner, & A. Collins (Eds.), *Film theory goes to the movies* (8–36). AFI film readers. New York: Routledge.

Scott, A.J. (2004). Hollywood and the world: the geography of motion-picture distribution and marketing. *Review of International Political Economy 11*(1), 33–61.

Stam, R. (2000). The author: Introduction. In R. Stam & T. Miller (Eds.), *Film and theory: An anthology* (pp. 1–6). Malden, MA: Blackwell.

Thompson, A. (2002, December 23). Spike Lee's game. *New York Magazine*. Retrieved May 10, 2007, from http://nymag.com/nymetro/movies/columns/hollywood/n_8161/

Turner, G. (2004). *Understanding celebrity*. London: Sage.

Wyatt, J. (1994). *High concept: Movies and marketing in Hollywood*. Austin: University of Texas Press.

Father, Husband, AND Social/Cultural Critic

An Afrosemiotic Analysis of Children's Books by Spike and Tonya Lewis Lee

MARK P. ORBE AND A. ELIZABETH LYONS

Introduction

In 2002, Spike Lee coauthored his first children's book with his wife, Tonya Lewis Lee. With the publication of *Please, Baby, Please*, he joined an increasing number of African American celebrities, including the likes of Queen Latifah, Bill Cosby, Phylicia Rashad, Jada Pinkett-Smith, Whoopi Goldberg, Terrell Owens, Will Smith, and Tiki and Rhonde Barber, who have utilized their talents to bring representations of black life to the world of children's books. Frustrated with the lack of books that positively reflected the lives of her own children (Jones, 2002), Tonya Lewis Lee was motivated to collaborate with her Academy Award-nominated husband to produce a book that mirrors some of the joys and challenges of family life.[1] Described as a "fast paced, fun-filled book for toddlers" (Garhan Attebury, nd.), *Please, Baby, Please* was bound to "strike a chord with parents and caregivers" and "amuse children" (Dewind, 2002, p. 100). The book was praised for its "rhyming pattern and sing-song repetition" (Arkoff, 2002) and "vivid illustrations of African American family."[2] *Please, Puppy, Please*, the second installment of what is intended as a series of children's books, was published in 2005 (Smiley, 2002).

Without question, the vast majority of scholarship on Spike Lee focuses on analyses of his films and documentaries (Lubiano, 1991; Merod, 1991; Elise &

Umoja, 1992; Bowers, 1994; Rowland & Strain, 1994; McPhail, 1996; Hopson, 2003). This makes sense given his extraordinary accomplishments in film; however, his role as cultural producer is not limited to films. We argue that in order to understand the multidimensional nature of Spike Lee's persona as social/cultural critic, scholars must acknowledge his multiple contributions to U.S. public life. While his role as children's book coauthor is significant in terms of cultural production (Lukenbill, 1976; Henke, Umble, & Smith, 1996; Willis-Rivera & Meeker, 2002), an exhaustive review of scholarly literature leads us to conclude that it remains an important, yet unexplored area.

Our chapter focuses on an analysis of two children's books, *Please, Baby, Please* and *Please, Puppy, Please*, authored by Spike Lee and Tonya Lewis Lee and illustrated by Kadir Nelson (published by Simon & Schuster Books). More specifically, we combine an Afrocentric and semiotic framework to explore two research questions. First, how are Afrocentric values, through representations of black life, signified within children's books authored by Spike and Tonya Lewis Lee? Second, how is Spike Lee's role as father, husband, and children's book coauthor situated within his media persona as social/cultural critic? In this regard, we are interested in exploring the interconnections between children's books and larger media forms (McQuivey & McQuivey, 1998).

Utilizing an Afrosemiotic Analytic Framework

Afrocentricity, as a mechanism for embracing African ideals at the center of intellectual/personal life (Asante, 1998a), provides the theoretical foundation for our analysis. Within his writings, Asante defined an Afrocentric framework as an ideal base to which other scholarly methodologies could be added (Asante, 1998b). For our analysis, we adopt an innovative methodological approach that combines Afrocentricity and semiotics.

Afrocentricity

Molefi Kete Asante is the foremost scholar associated with Afrocentricity (also known as African-centered scholarship).[3] In its most basic form, Afrocentricity places Africans and the interests of Africa at the center of research and practice. According to Austin (2006), Afrocentrism is a concept used in two ways. First, it refers to a paradigm that makes Africans in general, and the ancient Nile Valley civilizations of Egypt and Nubia in particular, central to African Americans. Second, it describes an approach to African American experiences that reflects cultural pride and identification.

Afrocentricity has provided a powerful critique of the problems with tradition-al communication research that is solely situated in traditional Western thought (McPhail, 1998). Afrocentricity is not meant to be placed above other perspectives. Instead it should exist alongside other cultural/historical standpoints; as such, Afrocentric thought provides an alternative to traditional frameworks when explor-ing the perspectives of people of African descent. In short, "The Afrocentric idea is one way of revealing the multicultural essence of our effort to understand the human experience" (Woodyard, 1995, p. 43).

Utilizing an Afrocentric theoretical framework hinges on several foundation-al ideas.[4] First, it involves the development of a theoretical perspective that reflects African ways of knowing and interpreting the world (Ribeau, 2004). Afrocentricity assumes that people of African descent, despite some diverse lived experiences, share a common set of experiences, struggles, and origins. Second, Afrocentricity seeks agency and action through collective consciousness (Asante, 1988). In other words, Afrocentricity serves as a mechanism to embracing African ideals at the center of intellectual/personal life. Third, and lastly, a major component of Afrocentricity—as it directly relates to our analysis—is that it represents an intellectual framework which sees people of African descent as participants (rather than subjects/objects) in their human existence (Asante, 1988).

Semiotics

Semiotics refers to the study of the social production of meaning through interre-lated systems of signs (Barthes, 1972). In its most basic form, semiotics is "the study of signs" (Leeds-Hurwitz, 1993), a methodological framework ideally suited for popular culture texts (Cooks, Orbe, & Bruess, 1993). A sign is composed of two parts, a signifier and the signified. The signifier refers to that which is material (e.g., sounds, objects, and images) and the signified refers not to that which is a "thing" (material), but rather a mental representation of the "thing" (Barthes, 1967). According to Barthes (1972), the ultimate goal of a semiotic study is to increase the reader's understanding as to how seemingly straightforward signs pick up conno-tative meaning.

A semiotic framework cultivates understanding of how initial (paradigmatic) relationships between signs are made more puissant through deeper (syntagmatic) associations within a text (Stam, Burgoyne, & Flotterman-Lewis,1992). According to Orbe (1998), a redundancy of these signs, over time, creates a certain level of pre-dictability that is structured into the text. These signs communicate debilitating ide-ological messages to media users, which ultimately affirm the ideology of the status quo as natural/normal (Barthes, 1972). As seen in existing research (Orbe, 1998; Orbe & Strother, 1996), mediated images have been critiqued in regard to the ways

in which they present race through a set of restrictive codes. Thus, the connotation of the idiosyncrasies within this text becomes a contributing vehicle by which the dominant ideology is forced upon the masses.

Our Afrosemiotic analysis is organized into two different sections, structured around our two research questions. The first section explicates the various ways in which the children's books—through their text, colors, images, and characters—reflect different values consistent with Afrocentricity. The second section is based on our analysis of public commentary regarding Spike Lee (e.g., book reviews, articles, etc.), and in particular how it fails to capture him in a multidimensional way, altogether neglecting his role as children's book author.

Lees' Children's Books: Afrocentric Signifiers of Black Family Life

As stated with our introductory comments of this chapter, Spike and Tonya Lewis Lee were motivated to author children's books given the lack of culturally appropriate materials available. According to Jones (2002), Tonya Lewis Lee was responsible for the general concept and first draft of the book and both authors worked independently of one another before collaborating to produce the final project. The source of inspiration for the content of the book was clearly generated through their roles as parents. Realizing that their children's "high energy and desire to explore the world" ("Q&A," nd.) presented some frustrating tensions for parents, the Lees produced children's books designed to demonstrate the everyday occurrences for parents and their young children. According to one interview, the book "completely draws on [their] experiences as parents" ("Q&A," nd.) and "humorously portrays the age-old struggle between dynamo and disciplinarian" (Snelson, 2002).

The focus of this section is to explore the Afrocentric signifiers that are featured within the two children's books created by Spike and Tonya Lewis Lee. In particular, we explicate: (1) the normalization of black family life, (2) the rhythms of black family life, (3) the improvisations of black family life, and (4) the complications of black family life.[5] Prior to our analysis, it is important to note that Afrocentricity, unlike Eurocentric thought, does not adhere to a linear, clearly demarcated division of ideas. Instead, Afrocentric components are intensified through the ways in which they implicate one another. Accordingly, while we attempt to describe each of the Afrosemiotic signifiers separately in forthcoming subsections, it is important to note that the concepts are interrelated, interactive, and overlapping.

The Normalization of Black Family Life

Afrocentricity places "African ideals at the center of any analysis that involves

African culture and behavior" (Asante, 1988, p. 6). As such, Afrocentricity promotes understanding the culture of African Americans as African centered and is presented as a means through which African Americans become "subject and not object" (Asante, 1988, p. 3). Consistent with their motivation for creating the books, the Lees produced texts that feature the intricacies of black family life. In both books, only African American characters—most notably mother, father, and baby in *Please, Baby, Please* and two siblings and their puppy in *Please, Puppy, Please*—are included in the books. The illustrations in both books have drawn significant praise from reviewers (e.g., Stevenson, 2005).[6] In the first book, for instance, reviewers described the baby in racially specific terms [as a "heroine with her doe-brown eyes, tight-curled hair, luminous golden-brown skin" (Snelson, 2002, p. 695) and as a "baby, with her caramel-colored skin and corkscrew curls" (Dewind, 2002, p. 100)]. Other reviewers spoke of how the powerful artwork helped to capture the essence of the book: "Vivid illustrations of this African-American family full of love and patience for their strong-willed daughter" ("Kirkus reviews," 2002).

While the books speak to the universal experience of family, it is accomplished through the everyday signifiers of black culture (African cultural hair styles, African American dolls, African American cartoon characters appearing on television). Historically, it has been Eurocentric narratives that have been centralized as suitable for teaching universal themes (Orbe, 2005); however, the children's books created by the Lees demonstrate that the reverse can also occur: readers of all racial backgrounds could interact with representations of black family and identify given the commonalties of the human experience. As such, despite their focus on black family life with no explicit representations of other races, the books were designed to appeal to the general public. Consider the synopsis that appears on the inside cover of *Please, Puppy, Please*:

> In page after page of tail-wagging fun, Academy Award nominated filmmaker Spike Lee and his wife, Beacon Award-winning producer Tonya Lee Lewis, take a close-up look at what happens when a couple of high-energy toddlers meet their match in an adventurous pup who has no plans of letting up.

In this regard, black family life is seen from the perspective of the phenomenon itself (Afrocentrism)—rather than that which is seen from opposing perspective (Eurocentrism) which would signify it as deviant and outside the norm.

The Rhythmic Nature of Black Family Life

Using an Afrosemiotic lens to analyze Lee and Lewis Lee's children's books allows cultural critics to see it as a form of resistance to Eurocentric ideals that focus around hierarchy, prediction, and control. Prediction and control can be juxtaposed against

the spontaneous, unpredictable rhythms of everyday life in general, and those in black family life specifically. According to Daniel and Smitherman (1976), one of the tenets of traditional African worldview is that human society is "patterned after natural rhythms" (p. 31). The story concepts of both *Please, Baby, Please* and *Please, Puppy, Please* resist a predicted and/or controlled representation of black family life. Instead, each story leads the reader through a series of scenes that—though they may appear haphazardly organized to some—capture the unpredictability of life for young families. For instance, *Please, Baby, Please* includes family times featuring playing, eating, bathing, sleeping, and a host of other everyday activities—however, they are not presented with any predictable structure. Through these depictions, the Lees accomplish the creation of what Asante (1991) describes as "harmony and balance in the midst of disharmony and indecision" (p. 35).

In addition to the content of the two children's books that reflect the natural rhythms of black family life, the content also flows in ways reflective of Afrocentric speaking. Historically, communication within African cultures has centered on the spoken word (*nommo*) whereby knowledge is encoded within spoken forms of literature. Oral language, in this regard, is a sign and mechanism for transmitting life among a cultural community; accordingly, "Afrocentricity regards the song, or any text, as created in its performance or presentation" (Brummett, 1994, p. 149). In particular, Asante (1988) speaks of rhythm, repetition, and careful word choice as highly valued in the Afrocentric perspective. In comparison, "the phrasing of even a single word and the manipulation of pauses for precise effect are aesthetic choices that are not so highly prized in the Eurocentric tradition" (Brummett, 1994, p. 151). Children's books, like the two analyzed here, are designed to be read aloud. Gates (1988) speaks of this principle in his descriptions of "The Talking Book" which characterizes the highly oral/aural nature of African American writing as an invitation to be read aloud.

Clearly, Lee and Lewis Lee utilize a recurring phrase—manipulated through rhythm and vivid style—consistent with the tenets of Afrocentricity. In fact, multiple reviewers referred directly to this feature. Arkoff (2002) stated that: "altered rhythms keep it fresh and fun to read aloud, the rhymes solidly hit their mark, and the humor is sharp as a tack." Garhan Attebury (nd.) added, "repeating rhyming patterns contain just enough variation to entertain the child listener as a grownup reads this book." In short, according to Del Negro (2003), "the chant-like text . . . is effective and deceptively simple" (p. 242).

The Improvisations of Black Family Life

"Traditional African cultures have historically emphasized experience in daily life as the criteria for when, or at what time, activity occurs. Things happen when the

flow of everyday life leads them to happen" (Bowers, 1994, p. 202). From a Eurocentric perspective, instruments that measure time—such as calendars and clocks—are emphasized in creating an acceptable time to coordinate behaviors. Alternatively, within Afrocentric thought, participation and activity are emphasized over time. Accordingly, the precision of time is viewed as less important than those activities that interactively emerge from participant interactions. Both of Lee and Lewis Lee's books feature Afrocentric time orientations—which appear particularly suited for the unpredictable rhythms of family life. While *Please, Baby, Please* focuses on the normal, everyday activities of a toddler, *Please, Puppy, Please* revolves around the interactions between two siblings, a new puppy, and to a smaller extent, the larger family.

An Afrocentric view of time promotes an appreciation of improvisation—those everyday activities that cannot be predicted or controlled (Bowers, 1994, p. 203). Afrocentricity values the unpredictable nature of life—especially that which emerges from the constant activity of action and reaction. For instance, on the first page of *Please, Baby, Please*, the focus is on baby who is energetically bouncing on mother. A small clock—alerting the reader that this scene is taking place at 3:01A.M.—helps to contextualize the written text: "Go back to bed, baby, please, baby, please." In the next thirteen pages, various activities are displayed, each with a small clock signaling the reader to the time in which the activity (eating, playing, bathing, teasing, and sleeping) takes place. However, within each of these scenes the volume, color, and powerful depiction of the activity dominates the page; one only notices the time on the clock upon closer scrutiny. Interestingly, the final page of the first book features a mother kissing her sleeping baby; it is the only page with no signification of time. The second book continues to promote everyday activities without any explicit recognition of time. The progression of time is implied through the various interactions; however, formal time is never acknowledged or expressed. In this regard, true to Afrocentricity, activities are foregrounded while time is pushed to the background.

The Complications of Black Family Life

The fourth, and final, signifier revealed within our Afrosemiotic analysis relates to the complications of black family life. "[O]pposed to the bias of categorizations is the wholistic view found in the traditional African world view" (Asante, 1988, p. 184). Accordingly, the ideas of right *or* wrong, good *or* bad, and love *or* hate are criticized as Eurocentric divisions that result in false understandings of the complexity of human life. Instead, *Please, Baby, Please* and *Please, Puppy, Please* use simplistic representations of everyday family life to speak to the complex ways in which occurrences resist traditional dichotomies.

The common, everyday experiences featured with the books—including those facilitating joy and frustration for families—speak to the realities of those embracing Afrocentric ideals. For example, the focus of the joys and frustrations of parenthood in *Please, Baby, Please* is signified through several interactions. One scene, for instance, depicts an impatient mother rushing a baby intent on picking dandelions as she goes. Within this, and other pages, both positive and negative attributes are woven seamlessly together. In fact, displays of childhood freedom, creativity, dependence, mischief, independence, resistance, and expression are incorporated throughout the book. The same range of behaviors is vividly depicted in *Please, Puppy, Please*. However, in both cases, the existence of family is seen as naturally inclusive of occurrences (e.g., a child's resistance to being hurried by an impatient parent) that resist dichotomous categorization into neatly defined divisions. As such, an Afrosemiotic reading of the texts allows the overarching values of harmony and unity to transcend traditional contradictions of right/wrong, good/bad, and love/hate.

Both of Lee and Lewis Lee's books resist the Eurocentric "bias of categorization" (Asante, 1988, p. 184) by featuring how individuals are both good/bad, right/wrong, and independent/interdependent. Asante also speaks of the powerful ways in which individuals function simultaneously as both teacher and student. Within *Please, Baby, Please*, this dynamic is evident through the ways in which parents socialize children as well as how toddlers remind parents about the value of seeing life through the eyes of their children. The notion of child as teacher becomes more explicit in *Please, Puppy, Please* when the two siblings become the primary source of socialization for their new puppy. Consequently, the pleading for preferred behaviors by parents is replaced by the pleading of the children in attempts to guide their new puppy.

Summary

Understanding a text, according to Gadamer (1975), consists of examining the enduring meanings of the text within a larger context and apart from the creator's original intentions. To summarize, we have established that *Please, Baby, Please* and *Please, Puppy, Please* feature a number of signifiers that reflect the core tenets of Afrocentricity. One unique contribution of our analysis is that it demonstrates the subtle ways in which simple, straightforward media texts—such as children's books—can be based within Afrocentric ideals and still attract a universal audience. While this is significant, it remains limited given that the meaning of any narrative is inextricably connected to a larger context (Gilmour, 1994). Accordingly, we facilitated a second analysis that examined how Spike Lee has been signified through texts generated through mass media outlets. In particular, we were inter-

ested in exploring how Lee's roles as children's book author, husband, and father were situated within the larger context of Lee's public persona.

Mass Mediated Signifiers of Spike Lee

This section focuses on the ways in which Spike Lee has been traditionally signi-fied by the media for the better part of two decades. Although we sought to explore media coverage of the Lees' children's books, we quickly found that that area of Spike Lee's life has largely gone unrepresented in the mainstream media venues. In fact, our exhaustive review of diverse mass mediated texts regarding Spike Lee revealed very few instances that made passing reference to Lee's children's books. Even when forums were created to focus on promoting his children's books, interview-ers were more interested in discussing his more controversial public persona. For instance, in an NPR interview dedicated solely to the promotion of *Please, Baby, Please*, the interviewer appeared more interested in talking about the New York Knicks, suggesting that he had never heard Lee so depressed about their perfor-mance. This topic continued until Lee finally interjected that he is "excited about the book, so let's talk about the book" (Smiley, 2002). This confirms our assertion that despite Lee's varied contributions to society, including his children's books, he continues to be signified in unidimensional and stereotypical ways. Instead, the mainstream mass media representations reinforce four signifiers: (1) Spike Lee as angry, (2) Spike Lee as confrontational, (3) Spike Lee as controversial, and (4) Spike Lee as audacious.

Spike Lee as Angry (Black Man)

"You the maddest black man in America," declared Chris Rock in 1999 to Spike Lee when he appeared as a guest on Rock's show (Levy, 2006). "That's not me," Lee responded. "That's the way I've been portrayed" (quoted in Levy, 2006). Indeed it is. Yet, Rock went on to say, "No, we've seen you mad, Spike. We've seen you on TV just complaining all the time [audience laughs]. They ain't laughing because I'm lying" (Levy, 2006). Given the mass mediated representations of Lee, Chris Rock is certainly not unique in his perception that Spike Lee is angry.

Spike Lee has been called one of the most "incendiary Americans of [the twentieth] century" (Baxter, 1999). In 1989, Lee "lashed out at Whoopi Goldberg for wearing Caucasian-looking blue contacts, and brand [ed] Arsenio Hall an Uncle Tom (Kirn, 1990, p. 92). He argues that "a lot of black artists start off with a black base, and once they get big, they get co-opted and cut all ties to the black community." Referring to Michael Jackson, he says, "That's when you start seeing

the nose jobs and the Jerri curls, the skin lightener and the music videos with the light-skinned love interests" (quoted in Rohter, 1986). Similarly, he waged an ongoing battle with Eddie Murphy, in which Murphy asserted Lee utilized "militant-brother stuff" and Lee challenged Murphy to use his influence to support other African American artists (Kirn, 1990, p. 100). Spike Lee has been known for fits of anger on the set (Sellers, 1994), but according to one critic of Lee, "Nobody gets mad on-screen like Spike Lee. His anger roils and simmers, spits and struts. When he channels his rage into sturdy material—the drama *Do The Right Thing* or the documentary *Four Little Girls*—he's unbeatable" (Ringel Gillespie, nd.). In his 1989 film, *Do the Right Thing*, Spike concludes the film with quotes from both Martin Luther King and Malcolm X, which reveals Lee's internal conflict toward the philosophies of the two (Sanoff, 1989). While Martin Luther King condemns violence, "Malcolm X validates violence as intelligent self-defense; but . . . their implied equality has already been overwhelmed by Lee's images of violence" (Kroll, 1989, p. 64). Lee acknowledges that he "understands the anger that drives black violence in a nation where 'black lives are just not considered as important as those of whites'" (as quoted in Sanoff, 1989, p. 51). Yet, while Spike clearly understands the social conditions that incite this violence, he recoils from being considered as an "angry black man" himself.

In 1998 Lee was nominated for an Oscar for his documentary, *Four Little Girls*, and instead of merely delighting in his success, he used his platform to illuminate the lack of achievement awarded African Americans as a whole. Lee states, "With African-American artists in front and behind the camera, the academy has been slow to recognize their work. What I am saying is not sour grapes or playing the angry Black man, it's just the truth" (as quoted in *Jet*, 1998, p. 54). It is this very commitment to truth-telling, combined with the color of his skin, that creates the signifiers of Spike Lee as not only angry, but highly confrontational as well.

Spike Lee as Confrontational

Spike Lee has made a name for himself by not only making unconventional films, but by having a relentless stand to bring about justice and social change through an in-your-face approach. In doing so, Lee challenges not only white Hollywood, and his white audiences, but his black colleagues and audiences as well. Lee acknowledges over and over again that Hollywood typically refuses to present a broad portrayal of African American life (Iverem, 2003; Huntley, 2004; Levy, 2006), which is why this has become his personal mission statement: to tell the stories that aren't being told and to challenge the stereotypes promoted and maintained by all, black and white alike (Fernandez, 2006; Levy, 2006).

Lee acknowledges that "Hollywood still has a limited viewpoint on the type of Black films they'll make. Gangster, hip hop, shoot-em-up or low-brow comedy" (as quoted in Iverem, 2003). Likewise he openly and ferociously challenges the lack of diversity found in prominent positions in Hollywood. He also confronts African American audiences to support films that are different and more representative than such comedies as *Barbershop* (Iverem, 2003), and *The Honeymooners*, or "hip-hop, shoot-'em up drug films like, *Get Rich or Die Tryin*" (quoted in Alvarez, nd.). Essentially, Spike challenges Black audiences to "grow up" and become more selective in their entertainment choices, instead of showing support for stereotypical movies, sitcoms, or "pimp and ghetto rap" (Alvarez, nd.; Clark, 2000; Iverem, 2003). Yet, perhaps most importantly, Spike challenges other African American artists, musicians, and athletes to use their clout to bring about change. In challenging today's prominent African American celebrities, Lee asserts that "artists have a responsibility . . . more so now than people like [*Gone with the Wind*'s] Hattie McDaniel . . . [who] didn't have a choice . . . if they wanted to work" (quoted in Clark, 2000).

Finally, true to Lee's form, he doesn't limit his battles to the entertainment scene, but he confronts the larger political and economic sphere as well. In the making of his 2004 film, *She Hate Me*, Lee declares that his muse for the film was "Enron, WorldCom, Tyco, Adelphia . . . all these big, big corporations and the people who run them, who are just stealing money left and right" (quoted in Papamichael, 2004). In that regard, he knocks President George W. Bush as being "just a menace to mankind in general," who not surprisingly, according to Lee, was related to such scandals: "Once Bush got into office, all these scandals started to happen. Bush was supportive of . . . I mean he is big business" (quoted in Papamichael, 2004).

In one of Lee's most recent films, *When the Levees Broke: A Requiem in Four Acts*, Lee takes aim not only at the abominable federal response to the devastation in New Orleans following Hurricane Katrina, including Mayor Ray Nagin and Governor Kathleen Blanco, but at the Army Corp. of Engineers who was responsible for the maintenance of the levees (Harrison, 2006). Lee calls their response "a criminal act" and he asks, "Was it a conspiracy, it took five days for the United States government to get here? Was it a conspiracy, it took President Bush 12 days to get here? These questions need to be asked" (Wolf, 2006). Asking such strong and seldom-asked questions has become Lee's trademark, and it is what has led him to be known as not only confrontational, but equally controversial.

Spike Lee as Controversial

From the instant Spike Lee came on the scene with *She's Gotta Have It*, he has been

known for the controversy he incites (Rohter, 1986). Whether challenging sexual stereotypes, such as in *She's Gotta Have It*, or issues of race, Lee has proven that he will present the scene often not seen. Lee's film career has spanned several decades and his movies today are no less controversial.

Lee's second film, *School Daze*, emerged in 1988 within a storm of racial tension. While the movie takes place at an all-black college, Lee's principal aim was to bring forth the division found between light- and dark-skinned African Americans (Conant & Springen, 1988). In the film, Lee pitted the dark-skinned, southern students, who Spike called the "Jigs" for Jigaboos, against the wealthier, light-skinned, northern students, who had blue or green eyes and "good hair," whom Lee dubbed the "Wannabees" (Conant & Springen, 1988, p. 62). Yet, his film was so controversial that he was forced to stop filming it at his alma mater, Morehouse College, after three weeks of filming, and the United Negro College Fund also canceled a large benefit premiere (Conant & Springen, 1988; Sanoff, 1989). However, it has been said that the controversy that stemmed from *School Daze* pales in comparison with *Do the Right Thing* (Sanoff, 1989).

Lee's third film, *Do the Right Thing,* portrays overwrought black and white Brooklyn relations that culminate in an incensed riot that brings about not only great destruction but also death. Lee was accused by critics for following a "fascist aesthetic" in the movie and for encouraging young African Americans to believe that "the police and white people are [their] enemy" (Sanoff, 1989, p. 51). The film was accused of being "dynamite under every seat lit by Lee" (Kroll, 1989, p. 64). One critic argues that Spike neither fully supports violence nor outright condemns it, as seen in the Malcolm X and Martin Luther King quotes at the end of the movie, and that "By refusing to hand simple bromides to comfort his audience, Spike Lee leaves the ultimate responsibility to finding the answers (what is the right thing?) to the viewer" (Scott, 2006). Not providing gratuitous answers but sparking difficult questions is clearly Lee's mission.

In 2000, Spike Lee directed the movie *Bamboozled*, which "follows the life of a black television writer who, under pressure to drive up ratings, creates a black minstrel show" that he neither expected nor wanted to be aired (Samuels, 2000, p. 75). When *Bamboozled* was released, it was recognized as being Lee's most controversial film to date (Samuels, 2000). True to Spike Lee form, the film promised to "inspire, antagonize, and divide [the] audience" (Guthmann, 2000, p. C-3). Yet, despite such statements, Lee refuses to kowtow to claims that he is controversial. When asked if he felt "that the only way to promote change in a conservative system is to be controversial," Lee countered, "I don't think I am controversial; I think I make thought-provoking films" (Entertainment Chat, 2000).

Spike Lee as Audacious

Fearlessly daring; bold; unrestrained by convention: all of these aptly describe Spike Lee's personality as an audacious auteur. Lee has been described as "a brazen, risk-taking filmmaker with something strong to say and the nerve to say it. . . . Lee can disturb us better than anyone in the business" (Ringel Gillespie, nd.). When Spike has a story to tell he will do it with relentless determination and audaciously requires others to do the same:

> When kids are in school and they're learning about motherfucking George Washington, say the motherfucker owned slaves. . . . Say what Christopher Columbus did! Kids are still learning in-1942-he-sailed-the-ocean-blue bullshit. George Washington could never tell the truth; he did chop down that motherfucking cherry tree. . . . Let's stop the lies! (as quoted in Levy, 2006)

Lee's audacious determination can be seen within his first film, *She's Gotta Have It*. Filmed in twelve days and edited in Lee's New York apartment on a budget of $175,000, which he had to scramble to gather after a $20,000 grant fell through from the American Film Institute (Rohter, 1986). Lee's resolve was sparked after meeting with two talent agencies that couldn't provide him with any support, and as a result, Lee acknowledges, "that [experience] just cemented in my mind what I always thought all along: that I would have to go out and do it alone, not rely on anyone else" (as quoted in Rohter, 1986). As a result, Lee went so far as to sell tube socks on the street (Otto, 2004). Yet, Lee's goal seems to be much larger than merely making a movie; "he cut[s] a path of critical and financial success, paving the way for a host of new Black directors" (Baxter, 1999).

Standing in stark opposition to the ways in which *She's Gotta Have It* was filmed is Lee's 1992 landmark film, *Malcolm X*, which was filmed in nearly ten months on a budget of $33 million (Als, 1992). However, the original budget was $28 million, so when Warner Brothers refused to proceed (Randolph, 1992; Baxter, 1999), Spike was "determined to make it by any means necessary" and not only contributed $2 million of his $3 million salary (Randolph, 1992, p. 124), but also "appealed directly to the power brokers of African America." Coming to his aid and standing by his dauntless vision were Oprah Winfrey, Bill Cosby, Prince, Michael Jordan, Janet Jackson, Tracy Chapman, and Magic Johnson, who financed his project for two more months (Als, 1992; Baxter, 1999).

Lee brings this indomitable force to everything he does, whether that is movies, documentaries, music videos, or television commercials. In 2007 Lee approached New Era, a company that specializes in sports-related caps and urban headgear, about directing their new line of television commercials (Kearns, 2007). When Spike first pitched his ideas to New Era CEO, Gerry Matos, Lee was turned down. Yet,

typical for Lee, he persisted. Unwilling to be defeated, Lee returned with a pitch that Matos bought, claiming, "Who can say no to Spike Lee?" (Kearns, 2007).

Conclusion: Extending the Restrictive Coding of Spike Lee's Mass Media Persona

We conclude this chapter by discussing how mass mediated signifiers fail to portray Spike Lee as multidimensional, particularly as it relates to his roles as husband, father, and children's book author. Lee's demands to be perceived as something other than angry, confrontational, controversial, and audacious have largely gone unnoticed. Yet, there are signs that the early Spike Lee, who may have indeed fit these signifiers, no longer dominates. Clearly these signifiers are limited in terms of capturing the complexity of Spike Lee's multidimensional life. In order to remain true to our Afrosemiotic methodological framework, two important considerations must be made. First, attention must be given to those signifiers that are absent from mass mediated texts (Fiske, 1994). Second, through such an extended analysis, we are able to avoid Eurocentric conceptualizations that create false dichotomies (Asante, 1998a) and instead advocate for more holistic understandings. As such, we conclude by describing mass mediated signifiers of Spike Lee—all of which were determined through our analysis of his role in writing children's books—that remain largely absent in dominant media outlets.

Spike Lee as a Family Man

Married to Tonya Lewis in 1993 (Norment, 1994), Lee has two children, daughter Satchel and son Jackson (Levy, 2006). "Lee is, by all accounts, a dedicated father. He flew home from the New Orleans set of *When the Levees Broke* to be with his son for the night of his birthday; he calls both his children several times a day" (Levy, 2006). He acknowledges that having children has not only changed him tremendously and made him a better person (Entertainment Chat, 2000), but that his filmmaking has changed as a result. Tonya Lewis Lee has influenced him to make his female movie characters more multidimensional (Ringel Gillespie, 2004), and to create story lines that he would be proud for his children to see (Smiley, 2002).

Yet family has always been an integral aspect of his life. The son of an art teacher mother and a jazz musician father (Sellers, 1994), Lee acknowledges the influence his parents had on his life: "We grew up in a very creative environment and were exposed to the arts at a very young age so it's not a surprise that [he and all four of his siblings] are in some form of the arts" (Baxter, 1999). Lee's love of family is made

evident in his filmmaking as he incorporates their influence and participation in his projects. His father, Bill Lee, scored many of Lee's earliest films; his sister Joie appeared in several films including, *She's Gotta Have It* and *Crooklyn*; his brother, Cinque, has also appeared in his films, and his brother's photography was used in *Summer of Sam* (Baxter, 1999).

Spike Lee as an Indispensable Activist

A fervent advocate for youth, especially for children of color, Spike Lee stands for their education. He says, "We cannot have a generation of young black kids growing up not being able to read or write. More importantly, not *wanting* to know how to read and write" (as quoted in Ringel Gillespie, 2004). Likewise, many black youth, he says "equate being intelligent with being white, being black with being ignorant" (as quoted in Kane, 2004). As a child himself, Lee became impassioned to portray a realistic picture of African American life in the media (Fernandez, 2006); it is clear that he did this not only to educate and correct the dominant European American culture's perspective of African American life, but also to present broad and diverse images of African American lifestyles *for* African Americans. While Lee may challenge and confront his viewing audience in unconventional ways, Lee has indisputably made his mark. As one critic says, "I love his energy and his verve and his refusal to shut up about the kind of America this is, and the kind of America it should be" (Martin, 2003, p. 37).

Spike Lee as Changing and Evolving

"I've noticed a growth in Spike . . . he has changed so much," says actress Rosario Dawson, following the filming of Lee's 2002 film, *25th Hour* (Murray & Toppel, nd.). Dawson's costar, Barry Pepper, agrees: "He's just become so much more of a beautiful person . . . [in the past] people just found he was angry, and he's just changed. He's just really blossomed into a much more peaceful person" (Murray & Toppel, nd.). As far back as 1994 changes in his personality were being noticed within the industry; however this personal growth has never been signified within mass media representations.

Lee admits that he has learned to practice discernment when choosing his battles and to be more diplomatic in his desire to bring about change (Sellers, 1994). Likewise, his students at Morehouse College have noticed changes in his personality, calling him "more reserved" and as "going off less often" (Sellers, 1994). He has also learned to listen to others. Lee admits that his wife, Tonya Lewis Lee, is the first to read his scripts and that unlike in their early years of marriage when he would argue with her perspective, he says, "But I got smart. If she feels that way,

there must be something to it, and I'll go back and take a look at what she cited" (Ringel Gillespie, 2004).

In summary, our Afrosemiotic analysis reveals that dominant media outlets have failed to capture the dynamic, multidimensional nature of Spike Lee's role as social/cultural critic. In particular, a focus on his coauthored children's books allowed us an alternative vantage point from which to critique pervasive signifiers that have come to represent him as an angry, confrontational black man whose audacious persona seeks controversy. Our analysis demonstrates the unidimensional nature of Spike Lee's public persona—something that is perpetuated within a Eurocentric cultural frame.

Notes

1. Without question, Tonya Lewis Lee—an accomplished attorney and visual media artist—played a central role in the conceptualization of both children's books. Our analysis of the books themselves, and ultimately of Spike Lee specifically, is not meant to diminish her role but deemed necessary given the focus of the edited volume.

2. Fans of Spike Lee will recognize the title of this first book as reminiscent of Lee's character (Mars Blackmon) in his 1986 film, *She's Gotta Have It*. While it is not clear if Spike or Tonya penned this title (Jones, 2002), utilizing such a hypersexual phrase for a children's book reportedly offended several individuals to the point where it was prohibited from some schools and daycares (R.M. Coleman, personal communication, June 25, 2007).

3. Of note, Molefi Asante, formerly known as Arthur Smith, has published more than 40 books and 200 articles. His work has gained a substantial amount of attention from scholars across multiple disciplines; interestingly, his ideas remained marginalized in the field of communication (Jackson, 2002).

4. Note that being African American does not make you Afrocentric (Asante, 1998a). In fact, non-African Americans who embrace the principles of Afrocentricity can produce Afrocentric research (Asante, 1991; Brummett, 1994).

5. These themes notwithstanding, "we must also acknowledge that some traditional Afrocentric concepts have been assimilated into Eurocentric life and vice versa" (Bowers, 1994, p. 200]). In fact, our analysis revealed that several Afrocentric signifiers that might be expected—like those associated with collectivism, extended family, spiritual agents, and black vernacular styling, etc.—are noticeably absent from the Lees' children's books. Given Bowers' (1994) assertion, we conclude that this may be due to the effects of European American assimilation on black family life.

6. Kadir Nelson, the illustrator for both books, is a well-known African American artist who has contributed the visual signifiers for many of the books authored by African American celebrities cited in the beginning of this chapter.

References

Als, H. (1992, November 10). Picture this: On the set, the street, and at dinner with "X" director Spike Lee. *The Village Voice*. Retrieved April 6, 2007 from http://www.villagevoice.com/specials/0543,50thals,69272,31.html

Alvarez, G. (nd.). *Shot caller: Spike Lee*. Retrieved January 23, 2007 from http://www.complex.com/index.php?task=Articles&id=252&issue=1§ion=64

Arkoff, V. (2002). Children's literature reviews: Please, baby, please. Retrieved January 25, 2007 from:http://clcd.odyssi.com/cgi-bin/sirsi/search/r?dbs+child:@term+@isbn+ 689832338

Asante, M.K. (1988). *Afrocentricity*. Trenton, NJ: Africa World Press.

———. (1991). The Afrocentric idea in education. *Journal of Negro Education 60*(2), 170–180.

———. (1998a). *The Afrocentric idea*. Philadelphia: Temple University Press.

———. (1998b). Identifying racist language, linguistic acts, and signs. In M.L. Hecht (Ed.), *Communicating prejudice* (pp. 87–98). Thousand Oaks, CA: Sage.

Austin, A. (2006). *Achieving blackness: Race, black nationalism, and Afrocentrism in the twentieth century*. New York: New York University Press.

Barthes, R. (1967). *Elements of semiology*. New York: Hill and Wang.

———. (1972). The world of wrestling. In A. Lavers (Trans.), *Mythologies* (pp. 15–25). New York: Hill and Wang.

Baxter, B. (1999, Dec. 4). The Spike Lee Interview. Retrieved February 25, 2007 from http://efilmcritic.com/feature.php?feature=141

Bowers, D.L. (1994). Afrocentrism and *Do the Right Thing*. In B. Brummett, *Rhetoric in popular culture* (pp. 199–222). New York: St. Martin's Press.

Brummett, B. (1994). *Rhetoric in popular culture*. New York: St. Martin's Press.

Clark, M. (2000, October). Spike Lee: The well-rounded interview. Retrieved February 24, 2007 from http://www.well-rounded.com/movies/reviews/spike_intv.html

Conant, J., & K. Springen. (1988, February 18). A question of class and color: Spike Lee takes a hard look at Black college life. *Newsweek*, p. 62. Retrieved March 18, 2007 from Lexis/Nexis database.

Cooks, L. M., M. Orbe, & C.S. Bruess. (1993). The fairy tale theme in popular culture: A semiotic analysis of *Pretty Woman*. *Women's Studies in Communication 16*(2), 86–104.

Daniel, J., & G. Smitherman. (1976). How I got over: Communication dynamics in the Black community. *Quarterly Journal of Speech 62*, 26–39.

Del Negro, J.M. (2003). Please, baby, please. *Bulletin of the Center for Children's Books 56*(6), 242.

Dewind, A. (2002). Please, baby, please. *School Library Journal 48*(12), 100.

Elise, S., & A. Umoja. (1992). Spike Lee constructs the new Black man: Mo' better. *Western Journal of Black Studies 16*, 82–89.

Entertainment Chat. (2000, October 12). Filmmaker Spike Lee on his newest film *Bamboozled*. *CNN.com*. Retrieved March 13, 2007 from http://www.cnn.com/COMMUNITY/transcripts/2000/10/12/lee/

Fernandez, M. (2006, March 6). Spike Lee caps historical month. Retrieved March 12, 2007 from http://media.www.campustimes.org/media/storage/paper371/news/2006/03/02/News/Spike.Lee.Caps.Historical.Month-1650705.shtml

Fiske, J. (1994). Ethnosemiotics: Some personal and theoretical reflections. In H. Newcomb (Ed.), *Television: The critical view* (pp. 411–425). New York: Oxford University Press.

Gadamer, H. (1975). *Truth and method.* New York: Seabury Press.

Garhan Attebury, N. (nd.). Children's literature reviews: Please, baby, please. Retrieved January 25, 2007 from: http://clcd.odyssi.com/cgi-bin/sirsi/search/r?dbs+child: @term+@isbn+ 0689832338

Gates, H.L., Jr. (1988). *The signifying monkey: A theory of African-American literary criticism.* New York: Oxford University Press.

Gilmour, P. (1994). The healing dimensions of classic and contemporary texts. *Religious Education, 89*, 195–211.

Guthmann, E. (2000, October 20). Spike Lee's rant against selling out: 'Bamboozled' satirizes TV's Black stereotypes. *San Francisco Chronicle*, p. C-3. Retrieved April 5, 2007 from http://www.sfgate.com/cgibin/article.cgi?file=/chronicle/archive/2000/10/20/DD116716.DTL&type=movies

Harrison, E. (2006, August 21). Devastation, hope remain: During his search for answers, Spike Lee captured the anger, anguish and laughter of New Orleanians living a nightmare. *Houston Chronicle*, p. 1A. Retrieved February 28, 2007 from http://www.chron.com/disp/story.mpl/front/4129538.html

Henke, J.B., D.Z. Umble, & N.J. Smith. (1996). Construction of the female self: Feminist readings of the Disney heroine. *Women's Studies in Communication 19(2)*, 229–249.

Hopson, M.C. (2003). For Denise, Carole, Cynthia, and Addie Mae: Gazing at 1963 Birmingham whiteness in Spike Lee's *4 Little Girls. Journal of Intergroup Relations 30*(3), 39–55.

Huntley, M. (2004, February 12). Spike Lee criticizes media stereotypes. *The Ithacan Online.* Retrieved March 8, 2007 from http://www.ithaca.edu/ithacan/articles/0402/12/accent/1spike_lee_cr.htm

Iverem, E. (2003). *Spike Lee to Black audiences: Grow up.* Retrieved January 25, 2007 from http://www.seeingblack.com/2003/x020403/spike_lee.shtml

Jackson, R.L. (2002). Exploring African American identity negotiation in the academy: Toward a transformative vision of African American communication scholarship. *Howard Journal of Communications 13*(43), 43–57.

Jet (1998, March, 2). Blacks who should have received Oscar nominations. *Jet*, p. 54. Retrieved March 18, 2007 from Lexis/Nexis database.

Jones, L. (2002). The Lees do the write thing. *Black Issues Book Review 4*(6), 40.

Kane, D. (2004, February 3). The world according to a not-so-angry Spike Lee. *Sign on San Diego.com. Part of the Union Tribune.* Retrieved March 8, 2007 from http://www.signon-sandiego.com/news/features/20040203–1956-cnsspikelee.html

Kearns, M. (2007, March 9). New Era hangs its hat on Spike Lee: Director lobbied hard for a chance to publicize his favorite cap in $10 million ad campaign. [Electronic Version]. *Buffalo News.* Retrieved March 13, 2007 from Lexis/Nexis Database.

Kirkus reviews (2002). Children's literature reviews: Please, baby, please. Retrieved January 25, 2007 from http://clcd.odyssi.com/cgi-bin/sirsi/search/r?dbs+child:@term+@isbn+ 0689832338

Kirn, W. (1990, August). Spike it already: Spike Lee's shrill rhetoric is threatening. *GQ*, pp. 92–100.

Kroll, J. (1989, July 3). How hot is too hot: The fuse has been lit. *Newsweek*, p. 64. Retrieved March 18, 2007 from Lexis/Nexis database.

Leeds-Hurwitz, W. (1993). *Semiotics and communication: Signs, codes, cultures.* Hillsdale, NJ: Lawrence Erlbaum Associates.

Levy, A. (2006, August 21). The angriest auteur: Spike Lee, along with his wife, Tonya Lewis, is wealthy, hugely successful, at the top of W.E.B. DuBois's "Talented Tenth" of Black society in America. But does that mean Spike has mellowed? Hardly. [Electronic version]. *New York Magazine.* Retrieved January 25, 2007 from http://nymag.com/movies/profiles/19144/

Lubiano, W. (1991). But compared to what? Reading realism, representation, essentialism in *School Daze, Do the Right Thing*, and the Spike Lee discourse. *Black American Literary Forum 25*, 237–250.

Lukenbill, W.B. (1976). Who writes children's books? *Journal of Communication 26(1)*, 97–101.

Martin, P. (2003, January 24). Spike and the city: Director Spike Lee puts his audacious stamp on New York drug dealer's final hours of freedom. *Arkansas Democratic Gazette*, p. 37. Retrieved March 18, 2007 from Lexis/Nexis database.

McPhail, M.L. (1996). Race and sex in Black and White: Essence and ideology in the Spike Lee discourse. *Howard Journal of Communications 7(2)*, 127–138.

———. (1998). From complicity to coherence: Rereading the rhetoric of Afrocentricity. *Western Journal of Communication 62*, 114–140.

McQuivey, J.L., & M.K. McQuivey. (1998). Is it a small publishing world after all? *Journal of Media Economics 11(4)*, 35–48.

Merod, J. (1991). A world without whole notes: The intellectual subtext of Spike Lee's Blues. *Boundary 2(18)*, 238–251.

Murray, R., & F. Toppel. (nd.). *Barry Pepper talks about 25th Hour.* Retrieved February, 5, 2007 from http://movies.about.com/library/weekly/aa25thhourintb.htm

———. (nd.). *Rosario Dawson talks about 25th Hour.* Retrieved February 5, 2007 from: http://movies.about.com/library/weekly/aa25thhourintb.htm

Norment, L. (1994, May). New wife, new film, new features: A revealing look at Spike Lee's changing life. *Ebony*, p. 28. Retrieved April 13, 2007 from Lexis/Nexis Database.

Otto, J. (2004, July 29). *Interview: Spike Lee. IGN chats with the often controversial, always interesting filmmaker.* Retrieved March 10, 2007 from: http://movies.ign.com/articles/534/534153p1.html

Orbe, M. (1998). Constructions of reality of MTV's "The Real World": An analysis of the restrictive coding of Black masculinity. *Southern Communication Journal 64(1)*, 32–47.

———. (2005, August). *Playwriting in the diaspora: Queries regarding the process of discovery.* Presentation at the annual meeting of the Black Theatre Network, Winston-Salem, NC.

Orbe, M., & K. Strother. (1996). Signifying the tragic mulatto: A semiotic analysis of *Alex Haley's Queen. Howard Journal of Communications 7*, 113–126.

Papamichael, S. (2004). Spike Lee: She Hate Me. Retrieved February 26, 2007 from http://www.bbc.co.uk/films/2004/09/14/spike_lee_she_hate_me_interview.shtml

Q&A. A conversation with Spike Lee and Tonya Lewis Lee—Authors of Please, Baby, Please. Retrieved January 25, 2007 from http://www.simonsays.com/content/book.cfm?tab=1&pid=410976&agid=8

Randolph, L.B. (1992, December). Denzel Washington and the making of *Malcolm X. Ebony*, p. 124. Retrieved April 6, 2007 from Lexis/Nexis database.

Ribeau, S.A. (2004). How I came to know in self-realization there is truth. In A. Gonzalez, M. Houston, & V. Chen (Eds.), *Our voices: Essays in culture, ethnicity, and communication* (pp. 32–37). Los Angeles: Roxbury.

Ringel Gillespie, E. (nd.). Bamboozled. *Access Atlanta*. Retrieved April 6, 2007 from: http://www.accessatlanta.com/movies/content/shared/movies/reviews/B/bamboozled.html.

Ringel Gillespie, R. (2004, September 2). Never short on words: The Spike Lee story. *Milwaukee Journal Sentinel Online*. Retrieved April 6, 2007 from http://www.jsonline.com/story/index.aspx?id=255850&format=print

Rohter, L. (1986, August 10). Spike Lee makes his movie. *The New York Times Film Review*. Retrieved April 5, 2007 from: http://partners.nytimes.com/library/film/081086lee-filmmaking.html

Rowland, R.C., & R. Strain. (1994). Social function, polysemy and narrative-dramatic form: A case study of *Do the Right Thing. Communication Quarterly 42*(3), 213–228.

Samuels, A. (2000, October 2). Spike's minstrel show. *Newsweek*, p. 75. Retrieved March 18, 2007 from Lexis/Nexis database.

Sanoff, A.P. (1989, July 10). Doing the controversial thing. *U.S. News & World Report 107*(2), 51. Retrieved March 18, 2007 from Lexis/Nexis database.

Scott, C.C. (2006, May 2). Spike Lee's *Do the Right Thing*: An explosive film that continues to spark questions about racism in America. The People's Media website. Retrieved April 5, 2007 from http://www.associatedcontent.com/article/26545/spike_lees_do_the_right_thing_an explosive.html? page=6

Sellers, P. (1994, May 20). Do the light thing: Spike Lee's new movie *Crooklyn. Entertainment Weekly 22*(4). Retrieved March 13, 2007 from http://www.ew.com/ew/article/ 0,,302293,-00.html

Smiley, T. (2002, November 20). *The Tavis Smiley Show*. Retrieved January 20, 2007 from www.npr.org/templates/story.php?storyID=849746.

Snelson, K. (2002). Please, baby, please. *The Booklist 99*(7), 695.

Stam, R., R. Burgoyne, & S. Flotterman-Lewis. (1992). *New vocabularies in film semiotics: Structuralism, post-structuralism and beyond*. New York: Routledge.

Stevenson, D. (2005). Please, puppy, please. *Bulletin of the Center for Children's Books, 59*(4), 190–191.

Willis-Rivera, J.L., & M. Meeker. (2002). De que colores: A critical examination of multicultural children's books. *Communication Education 51*(3), 269–279.

Wolf, B. (2006, August 18). Spike Lee's Katrina "Requiem" mixes anger, sorrow. ABC News. Retrieved February 28, 2007 from http://abcnews.go.com/Entertainment/story?id=2330610&page=1

Woodyard, J.L. (1995). Locating Asante: Making use of the Afrocentric idea. In D. Ziegler (Ed.), *Molefi Kete Asante and Afrocentricity: In praise and criticism* (pp. 27–43). Nashville: James C. Winston.

Spike Lee
AS Entrepreneur

Leveraging 40 Acres and a Mule

YANICK RICE LAMB

helton Jackson "Spike" Lee has leveraged his "40 acres and a mule." Though Major Gen. William Tecumseh Sherman's post–Civil War promise of land to freed slaves died along with President Abraham Lincoln and modern-day calls for reparations have largely fallen on deaf ears, Spike Lee has been able to capitalize on the idea of 40 acres and a mule beyond adapting the phrase for the name of his production company and other spin-offs. He has built an enduring brand on the back of that mule and has personally emerged as a marketing force. Like Apple or Coca-Cola, many people clearly recognize a "Spike Lee Joint."

Lee's creative work has witnessed (here) extensive scholarly evaluation and critique. However, his role as an entrepreneur has not been explored in great scholarly detail. As a professor of journalism, a journalist, and a long-time neighbor to Lee's 40 Acres and a Mule Filmworks production company in Brooklyn, New York, I would like to offer in this final chapter to *Fight the Power! The Spike Lee Reader* a reminder to scholars that the entrepreneurial side of Lee should also capture our analytical attention. This chapter prompts scholar–researchers to consider an (political economy) examination of Lee's role as a media mogul as a gap in the literature that needs to be filled. This historically oriented review of Spike Lee's business savvy and brand extensions serves as a catalyst for potential "future research questions" by asking, "what social and industrial impacts have Lee's business practices had to-date?" While Lee has often been criticized for artistic flaws in his work, for his array

of commercial pursuits and even for simply being Spike, he has built a measure of independence—financial and otherwise—that has allowed him to play by his own rules to a far greater extent than many filmmakers of any background. It has allowed him to pressure studios for concessions and to thumb his nose at the Hollywood establishment on occasion. The benefit is that Lee's independence and convictions have allowed him to force society to look in the mirror and confront issues of race and inequality—no matter how unevenly some of these issues might have been presented. They have allowed him to create projects that might not have otherwise been made such as the feature film, *Malcolm X*, and documentaries, such as *When the Levees Broke* about the aftermath of Hurricane Katrina, and *Four Little Girls* on the 1963 murders of four children during a church bombing in Birmingham, Alabama. They have also allowed him to provide opportunities and heightened visibility for a multicultural cast of artists, filmmakers, students, and vendors. He has demonstrated over and over again that people of color have the artistic talent, technical savvy, managerial skills, and business acumen to master any detail of making movies from A to Z.

A key factor in Lee's entrepreneurial success has been his ability to build brand awareness and loyalty through his status as an auteur—although it is surprisingly rare to find the words "Spike" and "auteur" in the same sentence when reviewing the literature. Lee's signature style and themes clearly fit the definition of auteur, coined by Andrew Sarris in the 1960s and championed a decade earlier by French critic François Truffaut and the father of auteurism, Andre Bazin, who founded Cahiers du Cinema in 1951. The theory has been associated with auteurs ("authors" of film, or directors) such as Alfred Hitchcock, Woody Allen, Martin Scorsese, and Quentin Tarantino. Lee has been called the most recognizable director in film history besides Hitchcock. Like Hitchcock, you know him, and his movies, when you see them. In addition, even if a film is not a "Spike Lee Joint," per se, it is still relatively easy to spot Lee's fingerprints. *Inside Man*, which Lee directed but did not write, is a case in point. The dolly shots, racial nuances, and not-so-subtle message on the evils of video games and cheap malt liquor are all Lee. These auteuristic touch points have contributed to making Lee's brand-building strategy a success. Over the years, Lee has maintained a loyal following of fans who will buy tickets to his movies or purchase his products simply because they see his name or the logo for 40 Acres and a Mule Filmworks.

In *New Venture Creation: Entrepreneurship for the 21st Century,* Jeffry A. Timmons and Stephen Spinelli explain, "successful entrepreneurs know that it is important to "think big enough." They understand that they aren't simply creating a job for themselves and a few employees; they are building a business that can create value for themselves and their community" (2004, p. 1). Lee clearly thinks big. Starting out as a "very independent" independent filmmaker, he has worked inside

and outside the system, navigating Hollywood on his own terms. For better or worse, he has left an indelible mark on the cultural, sociopolitical, and economic landscape while helping to stimulate a new wave of filmmaking.

"Spike is one of those few people who could have sat at the same table as Cecil B. DeMille, Samuel Goldwyn, Jack Warner, and all those guys who invented Hollywood," said the late actor, Ossie Davis, who appeared in several of Lee's films and worked with a host of theatrical and cinematic directors since the 1930s. "Spike both in the techniques of production and in the arena of business and distribution is out there at the cutting edge. Spike is watching out for our interests, and it is good to know that there is somebody from our team, from our corner, where the big boys are playing" (Lee & Aftab, 2006, p. 279). Having "somebody from our team" committed to "watching out for our interests" was important to actors and activists like Davis, who was an early supporter of Malcolm X and gave the eulogy at his funeral.

"As an African-American entrepreneur, it's important to recognize that he's always maintained his principles," Barron H. Harvey, Ph.D., dean of the School of Business at Howard University in Washington, D.C., said of Spike Lee. "It's sometimes a challenge, but he's done that consistently" (personal communication, 2007). George A. Watson witnessed this firsthand as the lead attorney for Universal Pictures, MCA, Inc., on two of Lee's films, *Mo' Better Blues* and *Jungle Fever*. An entertainment lawyer since 1984 and chair of the American Bar Association's Forum on the Entertainment and Sports Industries from 2005 to 2007, Watson described Lee as a shrewd businessman and skillful negotiator. Unlike many novice filmmakers, Lee negotiated contracts in which he maintained final say on the content of his films, specified certain marketing details, and worked around union constraints to open up employment opportunities for newcomers, including women and people of color who might otherwise have been shut out. "Spike Lee is important as a filmmaker—if not the most important filmmaker for African Americans in our lifetime," added Watson, who also represented the fifteen Black men who invested in *Get on the Bus* (Watson, personal communication), one of Lee's many attempts at creative financing.

The Birth of a Film Entrepreneur

Lee exhibited entrepreneurial traits from the outset. He sought the necessary preparation and technical skills to achieve success, surrounded himself with like-minded individuals, and learned the value of networking with the right people. He developed a strong work ethic, the ability to shift gears at a moment's notice, and a stomach for the risks inherent in business ventures. He trusted his instincts and

stepped fearlessly outside all sorts of the boxes. He was comfortable in asking for what he needed and in cultivating investors, beginning with his late grandmother, Zimmie Shelton of Atlanta.

A Morehouse man, Lee pursued a Master of Fine Arts in Film Production from New York University and studied the work of filmmakers ranging from Jim Jarmusch and Woody Allen to Haile Gerima and Charles Burnett. While Lee especially holds the latter in high esteem, he was determined to avoid their struggles. "I did not want to be in the position they were in," Lee said. "They worked four years raising money for a film, eked out one print, and then spent two years traveling around the world with this one print under their arms, going to black film festivals, screenings on university campuses, and stuff like that. I said there has got to be a way we can make the films that we want to make and still get distribution. Since I wanted people to see my work, that is what . . . I set out to do" (Mosley, Diawara, Taylor & Austin, 1999, p. 21).

Lee's breakout film, *She's Gotta Have It*, was also his redemption film. After winning the Student Academy Award for his thesis project, *Joe's Bed-Stuy Barbershop: We Cut Heads*, produced for $10,000 from his grandmother, Lee was ready to rock the film world. As he waited for calls, he made contacts with a wish list of actors from Laurence Fishburne to Giancarlo Esposito and talked up scripts for *The Messenger* and *It's Homecoming*, the precursor to *School Daze*. In the summer of 1984, he began work on *The Messenger*, spending $40,000 before hitting snags on additional funding and being turned down for a waiver from the Screen Actors Guild to use experimental film rates to pay SAG actors such as Fishburne and Esposito. "I had to recast the entire picture in four days with non-SAG people. And it never came together so we were all devastated," Lee recalled. "I knew that to save my filmmaking credibility I had to come back with a film the year following *The Messenger*. When you ask people to do a job, to work in your film, it's an act of faith, an act of trust. They are setting aside a block of their time for your film. They say, 'No, I'm committed to another project' when they're offered work" (Lee, 1987, pp. 38–39; Lee & Aftab, 2006, pp. 25–34).

Feeling like a failure, the 26-year-old spent the rest of the year writing the script for *She's Gotta Have It*, about a woman named Nola Darling who juggled sexual relationships with three men. When he was done, he pieced together credit card payments, grants, and investments from family and friends to keep the project afloat. "We started by saving our empty soda cans and bottles, and the nickels added up to the cost of another roll of film," Lee recalled. "The total budget was $175,000. We never had that amount of money in one lump sum. When we began, we only had $10,000" (Mosley et al., 1999, p. 23). Lee shot the film in his Brooklyn, New York, neighborhood during the summer of 1985 over 12 days that he characterizes as the worst of his life. In addition, while he was editing the film for investor

screenings and festivals, a lab threatened to auction the negative unless he immediately paid a $1,000 bill. Lee found a savior in author, critic, and producer Nelson George. "He gave me $500 in cash and $500 in American Express traveler's checks," the filmmaker said of his friend (Lee, 1987).

Once *She's Gotta Have It* hit the circuit, it generated considerable buzz. Companies such as Orion Classics and the Samuel Goldwyn Company vied for the right to distribute it. Lee sold the distribution rights to the highest bidder, Island Pictures, for $475,000, some of which was used for salaries due and lab expenses. Lee also felt that Island would be most comfortable and adept at promoting the film to black audiences, a concern that has endured from project to project throughout his career. "Island did a great job marketing this film," Lee said in his 1987 book, *Spike Lee's Gotta Have It: Inside Guerilla Filmmaking* (pp. 48, 50).

Additionally, Lee went into the trenches in true guerilla fashion, from dispatching street teams to selling T-shirts and even autographing postcards at a booth during the West Indian Day Parade that jams Eastern Parkway each year in Brooklyn. "We had to be entrepreneurs; we had to be innovative," explained Lee, who made $15,000 at the parade alone. "Millions of dollars weren't being spent on print or TV ads. I'd always made and sold T-shirts when I was growing up—I had a ton of them. We made up some shirts for the crew, and we started selling them" (Lee & Aftab, 2006, p. 60). This grassroots formula was effective and a cornerstone of Lee's early brand building strategy. It eventually grew to be a key component of promoting his later films and led to the opening of his retail stores. These are the type of nontraditional marketing efforts that also paid off for author Terry McMillan, who reached out to black bookstores and churches—steps that many mainstream publishers now employ.

Despite the low advertising budget for *She's Gotta Have It*, word of mouth was strong and drove moviegoers to the box office for theater tickets. Investors typically seek a return on investment (ROI) of at least 25 percent to 30 percent—more for studios seeking blockbuster returns, notes Brenda Doby-Flewellyn, a partner in FilmBankers International in Los Angeles and former Union Bank executive, who has financed more than 100 films throughout her career (personal communication, 2007). *She's Gotta Have It*, for which Lee won the Prix de la Jeunesse at the Cannes Film Festival, made $8.5 million (Mosley et al., 1999; Thomson Gale, 1999). In dollar terms, this was a modest figure compared to new millennium goals of grossing $100 million or more at the box office. However, it exceeded some blockbuster returns with a ROI of about 1,200 percent—a benefit of $12 on each dollar invested—and positioned Lee on the radar of studio executives. His face showed up everywhere, with the cover of the *Village Voice* proclaiming the "Birth of a Salesman."

"Spike is a kind of inspirational entrepreneur, particularly in the way in which we went about realizing his dream," said Dean Harvey, who is nationally recognized

for spearheading a campus-wide focus on entrepreneurship at Howard. "He actually reflects what is necessary to be a successful entrepreneur—that you have to go after your dream at all costs, and that is what he's done."

"If one were to investigate how he went about his commitment—and to get *others* to believe in his dreams—that's classic entrepreneurship," Harvey points out. "He's a significant role model for entrepreneurs no matter what their color" (personal communication, 2007).

Inside Man: Mr. Lee Goes to Hollywood

"Since the day I started working, I have always had final cut on my films," Lee said (Mosley et al., 1999, p. 24). According to Lee, one reason he has been able to gain such control is his track record of producing relatively inexpensive films that are profitable. Watson, the former Universal attorney, and others also attributed it to Lee's bankable name, which carried enough cachet for studios to green light a Spike Lee Joint. "He had become a figure of interest," Watson said (personal communication). "This happened because he's No. 1 at merging his talents as an artist, an entrepreneur, and a marketing 'genius,'" explained Warrington Hudlin, founder of the Black Filmmaker Foundation, who collaborated with his brother, Reginald, on *Boomerang, Cosmic Slop,* and the *House Party* movies, among others. "The thing that I'm just overwhelmed by is his marketing sense," Hudlin said. "From Day One, he didn't simply become a filmmaker; he became a *film persona*. He was brilliant in that sense, and all the filmmakers thereafter tried to imitate him" (personal communication, 2007).

Lee stood out not only because of the success of *She's Gotta Have It* and the growing interest in independent films, but also because of a money-saving move to star as Mars Blackmon, one of Nola Darling's trio of suitors. Film historian Donald Bogle describes the character as "a loony, hopped-up bespectacled sparkplug who talks, talks, talks" (2001). Mars resonated with viewers so much that he found an afterlife in a series of popular Nike commercials with basketball star Michael Jordan. His oft-repeated line from the movie—"Please baby, please baby, please baby, baby, baby, please!"—was later adapted as the title of a 2002 children's book coauthored by the filmmaker and his wife, Tonya Lewis Lee. The role was also a nod to Alfred Hitchcock and Woody Allen, both of whom appeared in their films. Hudlin notes that Lee and Allen are now singular peers in their ability to write, direct, produce, and star in their respective back-to-back movies (personal communication), a characteristic of Sarris' auteur theory. "Rarely do you find a filmmaker who has all of those talents," Watson said. "A lot of filmmakers may have one of those talents, or maybe two" (personal communication).

Lee has also stood out as a persona because he is not afraid to speak his mind or to tackle controversial topics. After *She's Gotta Have It*, Lee examined color discrimination among African Americans at the fictional Mission College in Atlanta. Originally called *It's Homecoming*, he reshaped the project and changed the name to *School Daze*. "Island executives had expressed reservations about the content of the film, about the production team, and about my ability to handle the project," Lee explained. "But when all was said and done, it was da money, moolah, cash dollar bills they didn't have." Unable to meet its $4 million limit, let alone the higher figure that Lee sought, Island backed out the deal during preproduction (Lee & Jones, 1988). Despite the setback, Lee was quickly able to double Island's figure at Columbia Pictures, which had earlier entered into an unprecedented but failed $40 million partnership with Richard Pryor, giving the comedian carte blanche to make four films. Lee also negotiated full artistic control in his $6 million deal, a negative pickup arrangement in which a bank finances a project and the filmmaker delivers a completed movie by a certain date. The studio backs the note, pays it off, and handles marketing and distribution. Many of Lee's films have been produced in negative pickup deals. *School Daze*, released in 1988, made $14.5 million (Lee & Aftab, 2006, p. 72), an ROI of 241 percent, or $2.41 for every dollar invested.

The next year he released *Do the Right Thing*, set largely at an Italian pizzeria in the Bedford-Stuyvesant section of Brooklyn, New York, during a 24-hour period on the hottest day of the summer. The film was inspired by the 1986 death of Michael Griffith who wandered onto the Belt Parkway after being beaten by Italian American mobs in Howard Beach, Queens. Griffith and two friends had stopped at a pizzeria there after their car broke down. Critics claimed that life could imitate art and spark riots, because of the highly charged racial scenes in the film. Paramount was concerned about some of the violence and asked Lee to tone down the ending. He refused and looked for another studio, landing at Universal, which gave him a $6.5 million budget, a third lower than the $10 million he wanted (Lee & Aftab, 2006, pp. 96–98, 101).

Universal did not shy away from controversy under the then-president Tom Pollack. "He was more sensitive to clients than some studio heads," Watson explained. Pollack and other studio executives had endured boycotts by theater owners and religious groups over Martin Scorsese's *Last Temptation of Christ*, discovering that the controversy was a "double-edged sword" that yielded lots of free publicity. They knew that any brouhaha over Lee's themes in *Do the Right Thing* would pale by comparison. "They understood that he was a skilled filmmaker and a successful filmmaker," Watson added. "They let him do his thing. It could be a huge success for everyone" (personal communication). It was not huge in the blockbuster sense, but a success nevertheless. The movie went on to make $28 million (Thomson Gale, 1999), an ROI of 430 percent, or $4.30 for every dollar invested.

Watson said that many studios that turned to independent filmmakers between blockbusters asked themselves: "Do you get a hit that takes you to first base, or do you get a hit that's going to give you a homerun? For Universal Pictures at that time, they were very happy with the opportunity to make it to first base" (personal communication). In addition, all the public hand-wringing over the film's potential to spark violence or mar New York's mayoral race proved to be unfounded. "Despite the hullabaloo," Bogle said, "the movie neither provoked riots nor had any effect on black mayoral candidate David Dinkins, who was elected to office" (2001).

Another controversial film was *Malcolm X,* an off-and-on project since the legendary leader's death in 1965. Lee drew the ire of whites by claiming that only an African American could do the story justice, while blacks warned Lee to tread carefully with the legacy of Malcolm X. Lee's stance was not totally unwarranted, given the range of movies that compromised their authenticity by filtering history through the lens of secondary figures from *Cry Freedom,* which really was not about Steven Biko, to *Ghosts of Mississippi,* which really was not about Medgar Evers. As with *She's Gotta Have It,* Lee employed nontraditional financing methods to complete *Malcolm X* and later *Get on the Bus.* He turned to outside financial sources after a tug of war with Warner Brothers over the budget and length of *Malcolm X.* Warner Brothers put up $20 million, just half of the $40 million Lee sought, and unleashed a bond company to take over production. "Among the things Malcolm talked about were self-determination and self-reliance. That's what it took to finish *Malcolm X*" (Mosley et al., 1999, p. 29), said Lee, who sold the film's foreign rights, gave up his salary, and solicited $1.3 million in "gifts" from Bill Cosby, Oprah Winfrey, Magic Johnson, Michael Jordan, and others. After publicly thanking his benefactors on Malcolm X's birthday during an announcement in Harlem— much to the surprise and embarrassment of Warner Brothers—the company eventually wrote another check (Mosley et al., 1999; Thomson Gale, 1999). After all of that, and extensive merchandising of X hats, posters, and other paraphernalia, the film made only $48 million. Film financier Brenda Doby-Flewellyn and others noted that expectations were high for blockbuster returns and that the drama surrounding the making of the movie had left a sour taste in the mouths of some Hollywood executives (personal communication, 2007). Additionally, Amiri Baraka led a group called the United Front to Preserve the Memory of Malcolm X and the Cultural Revolution in publishing an open letter denouncing the film when it debuted in 1992 (Fuchs, 2002, p. xvii).

Four years later, Lee used a similar financial approach for *Get on the Bus,* a film written by Reggie Rock Bythewood about a bus trip to the Million Man March. When Columbia Pictures offered only $2.4 million—less than half of what Lee earned per picture at the time—he declined the money. "If we really wanted to stay true to the spirit of the march, which I feel was about self-determination and self-

reliance, we should try to raise the money ourselves," Lee explained. "Then once we'd made the film we could go back to Columbia and let it distribute the film in a negative pickup deal" (Mosley et al., 1999, p. 26). Fifteen investors, from the late lawyer Johnnie Cochran to entrepreneur Robert L. Johnson, put up $100,000 to $200,000 each. Distribution rights for the film, shot in 18 days within the original $2.4 million budget, went to Columbia for $3.6 million. "We hope that the way we financed *Get on the Bus* will serve as a model not just for financing films but for financing anything," Lee said (Mosley et al., 1999, p. 28). It's an investment model that hasn't been widely replicated despite repeated calls to pool the resources of moneyed African Americans or even the masses that disproportionately spend their disposable incomes on consumer goods. Before *Get on the Bus* was released, on the anniversary of the Million Man March, Lee assembled the 15 men and handed out checks. "The investors made their money back, plus a nice little bonus," Watson said (personal communication, 2007).

"He had pre-sold the film before it went into major distribution and, from the pre-sell, paid the investors," Ossie Davis, a wise elder in the film, said of Lee. "For a man to do that—to know *how* to do that—this is equally important to any other talent that you might have as a filmmaker. I think that Spike is at the top of his game" (Lee & Aftab, 2006, p. 279).

However, 1996 turned out to be a light year at the box office for Lee with *Girl 6* grossing just $4.9 million domestically and then *Get on the Bus* coming in a little higher at $5.75 million but with far better reviews. "It could have performed better if the marketing and public relations had been stronger," Watson said of *Get on the Bus*. "People thought it was a documentary, because it was based on a true story. . . . That was a huge problem, because it wasn't as successful financially" (Watson, personal communication, 2007). John Singleton's *Rosewood*, which was also based on a true story of a massacre in Florida, had a domestic gross of $13.1 million, far short of its $30 million budget (Internet Movie Database—IMDB, 2007a). Some of Lee's films that followed—*He Got Game, Summer of Sam, Bamboozled, 25th Hour, She Hate Me*—also drew mixed feelings and mixed returns.

Although Lee's detractors have lamented for years that he has yet to produce and/or direct a blockbuster, the filmmaker may be well on his way. If the success of *Ray* is any indication, Lee is likely to see dollar signs once completing the biopic on Ray Charles' fellow music pioneer, the late James Brown (Movie Web Inc., 2006). In addition, *Inside Man*, which featured A-list actors Denzel Washington and Jodie Foster in a twist on bank heists, grossed $184 million worldwide on a production budget of $4.5 million. While black filmmakers typically do not do as well in foreign markets, Lee pulled in 52 percent of the gross ($95.86 million) for *Inside Man* from foreign theaters, with 48 percent ($88.5 million) from U.S. theaters. By comparison, *Scary Movie*, a 2000 Wayans brothers' spoof of horror pictures, holds

the box-office record among black directors, grossing $278 million worldwide, according to the Internet Movie Database (IMDB, 2007b). *Scary Movie*, which had a $19 million production budget, grossed 43.5 percent ($121 million) overseas and 56.5 percent ($157 million) domestically. In 2006, Will Smith starred in and produced *The Pursuit of Happyness*, which grossed $304.64 million worldwide on a production budget of $55 million. Based on a true story, the film made 46.3 percent of its gross ($141.07 million) in foreign theaters and 53.7 percent ($163.57 million) domestically.

With or without a blockbuster and despite any misses, Lee is considered a success for leveraging his 40 Acres and a Mule to produce a financially viable body of work, among other accomplishments. Since the debut of *She's Gotta Have It* in August 1986, Lee has produced nearly two dozen films with combined box-office receipts around $500 million (Pulley, 2006). His salary was most recently reported at $3 million (IMDB, 2006).

Doing the Right Thing: Creating Opportunities for Others

"I want to bring as many people along with me as possible," said Lee (1987, p. 62). "There are a lot of really good black filmmakers out there." Lee has gone beyond filmmakers and has been credited with heightening the careers of legions in the film industry on both sides of the camera, including grips, best boys, costume designers, editors, publicists, accountants, and actors. In many cases, he has gone against the grain to open doors, winning concessions from studios, wrangling with unions, and annoying veterans who felt stymied by the learning curves of the novices to whom they reported on the set. But Lee did not care. He understood what a good break could do for one's career and was willing to go out on a limb for a talented upstart with heart and hustle who could later go forth and multiply. Malik Sayeed, for example, was just 26 when Lee hired him as cinematographer on *Clockers*. Previously, he had worked on the electrical crew for *Malcolm X* and as director of photography for music videos and commercials (Lee & Aftab, 2006, p. 245).

In addition to being a "shrewd negotiator" who changed the complexion of some unions while saving money, Lee is also responsible for giving a long list of artists their first big acting break on the big screen. The list includes Halle Berry (*Jungle Fever*), S. Epatha Merkerson (*She's Gotta Have It*), Jasmine Guy (*School Daze*), Martin Lawrence (*Do the Right Thing*), Rosie Perez (*Do the Right Thing*), Mekhi Phifer (*Clockers*), and Nick Turturro (*Mo'Better Blues*), while elevating more experienced actors such as Denzel Washington (*Malcolm X*). "Rarely do you get a chance to be the star," Watson said of Washington's leading roles in *Mo'Better Blues* and then *X*. "It took Denzel from being considered potentially a Best Supporting

Actor to Best Actor, period." Some Universal executives were unfamiliar with Wesley Snipes, who had a breakout performance in the jazz band of Washington's character in *Mo' Better Blues*. "What was great about it was they trusted the film-maker," Watson said, recalling comments about Snipes such as "Who is he?" and "As long as Spike wants him, it's fine."

Lee's cachet as a director, ability to entice talent, work ethic, business savvy, and experimentation with cinematic techniques have made studios comfortable with green-lighting additional Spike Lee Joints as well as projects by other black film-makers. Brenda Doby-Flewellyn (personal communication) notes that today it is somewhat harder for would-be Spike Lees to cover the cost of their dreams, because some studios prefer films with financing intact and are pulling back on negative pickup deals. However, she says, an innovative film project can always find investors and a home. Consultant Peter Broderick (personal communication, 2007) also notes that hybrid distribution deals, often incorporating digital technology on the Web and in theaters, afford filmmakers more control and creativity in presenting their work to the public. Filmmakers can roll out their movies when and where they see fit, rather than being at the mercy and whim of the distributors who might cut their losses after a lackluster opening weekend. "There's a huge amount of venture capital out here, and people are not tapping it," Hudlin (personal communication) adds. "I talk to bankers all the time who say, 'Hey man. We've got more money than we've got good ideas.'"

Business Beyond Film

Over the years, Lee has extended the brand and entered into cobranding arrange-ments in advertising. The bulk of Lee's work has been created under the umbrella of 40 Acres and a Mule Filmworks, housed since 1987 in an old firehouse on Dekalb Avenue in the Fort Greene section of Brooklyn where he grew up. In addi-tion, Lee opened Spike's Joint, a retail store, to sell movie merchandise in 1990; Spike's Joint Kids, a short-lived children's store, in 1993; and 40 Acres and a Mule Musicworks, which became part of MCA Records in 1994 (Thomson Gale, 1999). Lee's "side hustle" has also included writing books, directing commercials for a min-imum of $50,000, starring in them, and creating them through Spike DDB, a joint venture with DDB Needham Worldwide in which he owns a 51 percent stake. Lee claims that Spike DDB is the first black-owned agency to run a commercial during the Super Bowl—a spot for Lay's potato chips featured entertainer MC Hammer at Super Bowl XXXIX in 2005 (Blackburn, 2005; Frito-Lay, 2005). The filmmaker even has a sneaker, Air Jordan Spiz'ike (Air Jordan Spiz'ike, 2006).

Lee's Brooklyn "empire," as many local residents referred to his cluster of busi-

nesses, served as a visual symbol of his entrepreneurial spirit. Before Lee married and moved to Manhattan, he was a constant presence in the Fort Greene/Clinton Hill area. Passers-by often stopped him on the street, and he served as a role model for students at nearby Brooklyn Technical High School and Long Island University (LIU), where he established the 40 Acres and a Mule Film Institute to help aspiring filmmakers learn the dollars and sense of making movies. Lee has been credited with stimulating economic development, enhancing tourism, and contributing to the cultural renaissance of the area. He endeared residents to him by hosting "thank you" block parties, where celebrities mingled with everyday people, and by featuring scenes of Brooklyn in his movies, such as Fort Greene Park, which serves as a grassy divide between the haves and have-nots. Lee looked out onto the park from his brownstone to the east, with his businesses on the park's southern edge in a rapidly gentrifying historic district where the median income approaches $50,000; the Fort Greene housing project to the north where the median income dips to $11,641; and LIU and Brooklyn Hospital to the west (City of New York, 2005). Lee's impact has been such that some people identify the park's Doric tower and granite stairs more as the fictional rendezvous point in *She's Gotta Have It* than as a real-life memorial to thousands of prisoners of the Revolutionary War. Some Fort Greene residents continue to praise Lee, but others feel that he abandoned the neighborhood once he moved his family to Manhattan—prompted in part by random visits by strangers at all hours of the day and night. Although his 40 Acres and a Mule Filmworks remains on Dekalb Avenue, Spike's Joint quietly closed and in its place moved another burgeoning black business, the beauty emporium Carol's Daughter.

The entrepreneurial relationship between Lee and his various publics is symbolic of the ethnic solidarity framework of Dyer and Ross (1997), based on the family business model of Davis and Tagiuri (1989). These overlapping publics include residents of Fort Greene and members of the African American community at large, which has a buying power of $656 billion (Target Market News, 2006) and includes viewers and nonviewers of his films. While community ties can be as strong as family bonds, company decisions can turn controversial and almost personal "when companies are institutions of special significance to the community—when they come to be seen as symbols of Black economic progress," as have Lee's business ventures, note Dyer and Ross (1997, p. 1). "In some cases then, business enterprises acquire a social meaning, highlighting the notion that the individual entrepreneur is not independent of the community in which he or she operates" (p. 2). Taken further, Dyer and Ross explain: "Members of the ethnic community see the firm as a symbol of ethnic progress, a caretaker of less fortunate members of the ethnic group, and a permanent fixture in their lives. They feel that the whole community has a stake in the existence of the firm and should have influence in company deci-

sions." These observations might play a role in the love-hate relationship that Lee has with members of the public and their level of support for his business decisions as well as his films—whether they watch them or not.

The film *Malcolm X* marked "shifting responses to Spike Lee's career," according to Bogle (2001). "With *She's Gotta Have It*, he was the critic's darling: a little, unknown independent working outside the established film community," Bogle explains. "Yet once Lee was perceived as a successful, commercial filmmaker, once he made TV commercials and music videos, and emerged as possibly, next to Steven Spielberg, the most famous film director in America, Spike Lee found himself faced with the critical backlash, partly from segments of the African American community."

Conclusion

While critic Esther Iverem (2007) credits filmmaker Euzhan Palcy for "greasing the skids" to allow greater receptivity for Lee's debut, she praises him for launching a new era in filmmaking. Iverem, founder of SeeingBlack.com, even looks at the last two decades of filmmaking through Lee's lens with *She's Gotta Have It* as a cinematic milestone in her latest book, *We Gotta Have It: Twenty Years of Seeing Black at the Movies, 1986–2006*. Similarly, Hudlin, Watson and others also place Lee on a pedestal as a filmmaker and entrepreneur. "He is a landmark," Hudlin said (personal communication). "He stepped through at a defining moment of black cinema. You've got to mention him in the same way that you mention Melvin Van Peebles." Watson recalls this defining moment as "a very exciting time—one that commanded the attention of the studios" (personal communication). The revered Haile Gerima contends that Lee's contributions, despite any shortcomings, are as significant as those of Oscar Micheaux (personal communication, 2007). Peter Biskind, former executive editor of *Premiere* magazine and author of *Down and Dirty Pictures: Miramax, Sundance, and the Rise of Independent Film*, positions Lee as part of a resurgence in independent films, period—not just those created by black filmmakers.

Biskind notes that John Sayles provided a "preview of things to come" at the start of the eighties with a serious film about the "post–war exhaustion of the peace movement" called *The Return of the Secaucus 7*. "Financing really didn't exist when we started," Sayles said." It was hard to get an independent script to an actor, and you didn't bother going to a studio unless your script was commercial. And even then, if you weren't connected through an agent, they wouldn't read it. Independent films were truly on the outside." Sayles' film, which was "appropriated by Columbia and morphed into *The Big Chill*," cost $60,000 and grossed $2 million. A number

of other movies during the decade had similar grosses, from *My Dinner with Andre* by Louis Malle in 1981 to *Stranger Than Paradise* by Jim Jarmusch in 1984. *Eating Raoul* by Paul Bartel grossed $4.7 million in 1982, but Lee doubled that with *She's Gotta Have It* in 1986 (Biskind, 2004). Lee helped to push independent filmmakers from the outside to the inside of Hollywood.

For many independent filmmakers—especially adherents to the Black Arts Movement—the outside was the place to be. To dabble with Hollywood on any level is considered selling out. So what are the pros and cons of going Hollywood? What does a filmmaker gain or lose? "You benefit financially, and you lose all other control," Hudlin points out. "You are working for them, and they have control. . . . They have the power to change *everything*." Even though Hudlin lacked control contractually, he often ruled the day with his powers of persuasion and insistence, which might have earned him a reputation as not being malleable, he says (2007). As far as Hollywood, Gerima won't even go there—ever. He's committed to remaining on the outside and proud of "the fact that I control everything, the fact that I do not allow forces to dictate my imagination." He acknowledges that the downside of his commitment to remaining independent is that he might have gaps as wide as nine years between films, but he wouldn't have it any other way. "To enjoy this privilege is also the penalty that it takes me a long time to do the films," says Gerima, whose funding ranges from grass-roots to foreign sources for such films as the widely acclaimed *Sankofa* and his latest project, *Teza*. However, Gerima praises Lee for his ability to make the system work for him and to open doors for others along the way (personal communication, 2007).

The question of Lee's relationship to "the system" brings me back to my initial purpose in writing this review essay; to raise new questions worthy of scholarly attention. I wonder, how will we write about Lee's impact on the business of filmmaking, on Hollywood, and on the next generation of creators? What can Lee's case reveal about independent versus Hollywood/conglomerate business structures and practices? After working closely with a host of filmmakers on business, legal and creative issues as a studio executive and as an independent entertainment lawyer, George Watson believes that Lee stands out from the pack and that his overall contributions overshadow any criticism about the progression of his movies or their endings. "All in all, I think he's done a brilliant job—uniquely so," Watson said. "He's still a relatively young man, so it'll be interesting to see what he does in the next 20 years." Indeed, it will be equally interesting to see what scholars say about Lee over the coming decades.

References

Air Jordan Spiz'ike (2006). Retrieved December 28, 2006, from http://www.myairshoes.com/air–jordans/nike–air–jordan–spizike.html

Biskind, P. (2004). *Down and dirty pictures: Miramax, Sundance, and the rise of the independent film*. New York: Simon & Schuster.

Blackburn, D. (2005). *Spike's world: Filmmaker, businessman, lightning rod to speak at Writers Institute*. Retrieved December 28, 2006, from http://www.albany.edu/writers--inst/tu_lee_spike.html

Bogle, D. (2001). *Toms, coons, mulattoes, mammies, & bucks: An interpretive history of Blacks in American films* (4th Ed.). New York: Continuum International Publishing Group, Inc.

City of New York (2005). Brooklyn Community District 2. Retrieved December 29, 2006 from http://www.nyc.gov/html/dcp/pdf/lucds/bk2profile.pdf

Davis, J. & R. Tagiuri. (1989). *The advantages and disadvantages of the family business*. Owner Managed Business Institute. Reprinted in Ibrahim, A.B. and W. Ellis. (1994). *Family business management*, Kendall/Hunt Publishing Co.

Dyer, L., & C. Ross. (1997). The entrepreneur in the community. Best Theoretical Paper presented at the 1997 United States Association for Small Business and Entrepreneurship Annual National Conference, Entrepreneurship: The Engine of Global Economic Development, San Francisco, California. Retrieved December 27, 2006, from http://www.usasbe.org/knowledge/ proceedings/1997/index.asp

Frito-Lay (2005). Lay's, America's favorite potato chip, returns to the Super Bowl with ad featuring MC Hammer. Retrieved December 28, 2006, from http://www.fritolay.com/fl/flstore/cgibin/ProdDetEv_Cat_304_SubCat_385726_NavRoot_303_ProdID_385724.htm

Fuchs, C. (2002). *Spike Lee interviews*. Jackson, Mississippi: University Press of Mississippi.

Internet Movie Database Pro (2007a). *Rosewood*, main details. Retrieved December 28, 2006, from http://pro.imdb.com/title/tt/120036/maindetail

Internet Movie Database Pro (2007b). *Scary Movie*, main details. Retrieved December 28, 2006, from http://pro.imdb.com/title/ tt0175142/maindetails

Internet Movie Database Pro (2006). Spike Lee, main details. Retrieved December 28, 2006, from http://pro.imdb.com/name/nm0000490/

Iverem, E. (2007). *We gotta have it: Twenty years of seeing Black at the movies, 1986–2006*. New York: Thunder's Mouth Press.

Lee, S., (1987). *Spike Lee's gotta have it: Inside guerilla filmmaking*. New York: Fireside/Simon.

Lee, S., & K. Aftab. (2006). *Spike Lee: That's my story and I'm sticking to it*. New York: W.W. Norton & Company Inc.

Lee, S., & Jones, L. (1988). *Uplift the race: The construction of* School Daze. New York: Simon & Schuster.

Mosley, W., M. Diawara, C. Taylor, & R. Austin. (1999). *Black genius: African American solutions to African American problems*. New York: W.W. Norton & Company Inc.

Movie Web Inc. (2006). Retrieved December 28, 2006, from http://www.movieweb.com/movies/film/41/3241/boxoffice/

Pulley. B. (2006). Flings: The reel world. Retrieved December 28, 2006, from http://www.forbes.com/business/global/2006/1211/101.html

Reid, M.A. (1993). *Redefining Black film*. Berkeley/Los Angeles/Oxford: University of California Press.

Target Market News (2006). The buying power of Black America. Retrieved December 29, 2006, from http://www.targetmarketnews.com/ BuyingPower04.htm

Thomson Gale (1999). Spike Lee, Black history, Gale Research Inc. Retrieved December 27, 2006, from http://www.gale.com/free_resources/bhm/ bio/lee_s.htm

Timmons, J. & S. Spinelli (2004). *New venture creation: Entrepreneurship for the 21ⁱ Century* (6th ed.). New York: McGraw-Hill.

Spike Lee

Cultural Provocateur

Director

Miracle at St. Anna—2008
Inside Man—2006
When the Levees Broke: A Requiem in Four Acts—2006
Miracle's Boys—2005
All the Invisible Children—2005
She Hate Me—2004
Sucker Free City—2003
We Was Robbed—2002
25th Hour—2002
Jim Brown: All American—2002
Ten Minutes Older: The Trumpet—2002
A Huey P. Newton Story—2001
Bamboozled—2000
The Original Kings of Comedy—2000
Summer of Sam—1999
Pavarotti & Friends 99 for Guatemala and Kosovo—1999
Pavarotti & Friends for the Children of Liberia—1998
He Got Game—1998
4 Little Girls—1997

Girl 6—1996
Get on the Bus—1996
Clockers—1995
Lumiere and Company—1995
Crooklyn—1994
Malcolm X—1992
Jungle Fever—1991
Mo' Better Blues—1990
Do the Right Thing—1989
School Daze—1988
She's Gotta Have It—1986
Joe's Bed-Stuy Barbershop: We Cut Heads—1983
Sarah—1981
The Answer—1980

Executive Producer

Sucker Free City—2004
Good Fences—2003
Afrocentricity—2000
Get on the Bus—1996
Tales from the Hood—1995
New Jersey Drive—1995
Drop Squad—1994

Producer

When the Levees Broke: A Requiem in Four Acts—2006
She Hate Me—2004
25th Hour—2002
Jim Brown: All American—2002
Ten Minutes Older: The Trumpet—2002
3 A.M.—2001
Bamboozled—2000
The Original Kings of Comedy—2000
Love & Basketball—2000
Summer of Sam—1999
The Best Man—1999

He Got Game—1998
4 Little Girls—1997
Girl 6—1996
Clockers—1995
Crooklyn—1994
D.R.O.P. Squad—1994
Malcolm X—1992
Jungle Fever—1991
Mo' Better Blues—1990
Do the Right Thing—1989
School Daze—1988
She's Gotta Have It—1986
Joe's Bed-Stuy Barbershop: We Cut Heads—1983

Actor

Edge of Outside—2006
How to Eat Your Watermelon in White Company (and enjoy it)—2005
3 A.M.—2001
The Concert for New York City—2001
Michael Jordan to the Max—200
Lisa Picard Is Famous—2000
Summer of Sam—1999
Girl 6—1996
The Fine Art of Separating People from Their Money—1996
When We Were Kings—1996
Clockers—1995
Crooklyn—1994
Backbeat—1994
Ghostwriter: Into the Comics—1994
Hoop Dreams—1994
D.R.O.P. Squad—1994
World Beat—1993
The Last Party—1993
Seven Songs for Malcolm X—1993
Malcolm X—1992
Jungle Fever—1991
Lonely in America—1991
Mandela in America—1990

Mo' Better Blues—1990
Spike Lee & Company—1990
Making "Do the Right Thing"—1989
Do the Right Thing—1989
School Daze—1988
She's Gotta Have It—1986

Screenwriter

She Hate Me—2004
Bamboozled—2000
Summer of Sam—1999
He Got Game—1998
Clockers—1995
Lumiere and Company—1995
Crooklyn—1994
Malcolm X—1992
Jungle Fever—1991
Mo' Better Blues—1990
Do the Right Thing—1989
School Daze—1988
She's Gotta Have It—1986
Joe's Bed-Stuy Barbershop: We Cut Heads—1983
The Answer—1980

Music Videos

Lizz Wright: *Open Your Eyes*—2003
We Are Family: Nile Rogers & Friends—2001
Mau Maus: *Blak Iz Blak*—2000
Public Enemy: *He Got Game*—1998
Curtis Mayfield: *New World Order*—1996
Michael Jackson: *They Don't Care About Us*—1996
Chaka Khan: *Love Me Still*—1995
Bruce Hornsby: *Swing Street*—1995
Crooklyn Dodgers: *Return of the Crooklyn Dodgers*—1995
MCAT: *Oh My Precious*—1994
Branford Marsalis: *Breakfast at Denny's*—1994

Marc Dorsey: *People Make the World Go Around*—1994
Crooklyn Dodgers: *Crooklyn*—1994
Eros Ramizotti: *Cose Della Vita*—1993
Guru: *Loungin*—1993
Bruce Hornsby: *Talk of the Town*—1993
Naughty by Nature: *Hip Hop Hurray*—1992
Arrested Development: *Revolution*—1992
State of Art: *Beating Heart*—1992
State of Art: *Laughing at the Years*—1992
Prince: *Money Don't Matter*—1992
Stevie Wonder: *Make Sure You're Sure*—1992
Stevie Wonder: *Gotta Have You*—1991
Stevie Wonder: *Jungle Fever*—1991
The Home Boy Project: *Do Your Dance*—1991
Fishbone: *Sunless Saturday*—1991
Cynda Williams: *Harlem Blues*—1990
Gangstarr: *Jazz Thing*—1990
E.U.: *Buck Wild*—1989
Public Enemy: *Fight the Power*—1989
Perri Sisters: *Feel So Good*—1989
E.U.: *Da Butt*—1988
The Rays: *Be Alone Tonight*—1988
Phyliss Hyman: *Be One*—1988
Keith John: *I Can Only Be Me*—1988
Steel Pulse: *Reachin Out*—1988
Anita Baker: *No One in the World*—1987
She's Gotta Have It: *'Nola*—1986
Miles Davis: *Tutu Melody*—1986
Branford Marsalis: Royal Gardens—1986

Short Films

NY Yankees: *Come Rain or Shine/Concert for New York City*—2001
We Wuz Robbed: *10 Minutes Older*—2001
Progressive Networks: *The Craft of Acting*—1997
Progressive Networks *Computer Wiz*—1997
Progressive Networks: *Dance*—1997
HBO: *Real Sports "John Thompson" Coach*—1995
HBO: *Iron Mike Tyson*—1991

MTV: *Five One Minute Spots*—1989
Horn of Plenty: Saturday Night Live—1986

Commercials

New Era: New Era Caps—2007
Microsoft: Secret Agent Man—2003
TNT: Basketball Promos—2003
UNCF: Neighborhood/Schedule—2003
State Farm: *Dinner Time/Hot Tip/Baby Talk*—2003
Pepsi: Code Red and 1 Ballers—2003
Pepsi: Beyonce—2003
State Farm: *Dinner Time/Barbershop*—2002
Coors: *Sir Charles Rap*—2002
Sprite: Kobe Bryant Campaigns—2002
Kmart: Spring/summer Campaigns—2002
Jordan 17 Campaign—2002
You In: New York Knicks/MSG Campaign—2001
New Order/X-Type: Jaguar—2001
ABC Promo Black History—2001
Telecom Italia: *Mandela*—2001
NFL Playoffs Campaign: *You Gotta Show Me Something*—2000
IAM.COM—2000
McDonald's Industrial—2000
State Farm—2000
Compaq—2000
Jaguar—2000
Telecom Italia—2000
Ecko—2000
IAM.COM—2000
ABC—2000
United Negro College Fund—1999
Navy Seal—1999
Finlandia: *Sin*—1998
Swatch: *Wake Up!*—1998
The Miami Heat—1998
NHL: *Rev*—1998
Budweiser: *Explanation*—1998
HBO: *4 Little Girls* & *Rosewood* Promo—1998

New Era: *Proud Player*—1998
Clearasil: *The Dance*—1998
Soft Sheen: *Alternative Hair Jones*—1997
Fox Sports: Star-Interviews—1997
Fox Sports: Star-Game Film—1997
Fox Sports: Star-Laps—1997
Opel Corsa—1997
Finish Line: *Huddle*—1997
Finish Line: *Time Out*—1997
Finish Line: *Choosing Sides*—1997
Showtime: *The Sound & The Fury*—1997
Philips: *The Crowd*—1997
Showtime: *Chances Are*—1996
David Blaine—1996
UNCF: Michael Jordan—1996
Nike: Swoopes—1996
UNCF: Edwin Moses/Anheuser Busch—1996
Snapple—1996
Nike: Reggie Miller—1996
Nike: Li'l Penny/Tyra Banks—1996
Nike: Li'l Penny/Spike Lee—1996
NY Times—1995
Nike: *Pick-Up Game*—1995
Taco Bell: *Shaquille O'Neal & Hakeem Olajuwon*—1995
Nike: *Mike & Spike*—1995
American Express: *Charge Against Hunger*—1995
Smooth Ice Cream: Ben & Jerry's—1994
Mascot: ESPN 2—1993
Tucked—ESPN—1993
3 Point Line: ESPN 2—1993
DORM 1–800-OPERATOR: AT&T—1993
Girls Night Out: AT&T—1993
Urban Jungle Gym: Nike—1992
Is It Da' Shoes Air Jordan: Nike—1991
Levi's 501: *Butterfly Jeans Series*—1991
En Vogue: DIET COKE—1991
Genie/ Air Jordan: Nike—1991
Stay in School/ Air Jordan: Nike—1991
Flight School/ Air Jordan: Nike—1991
Levi's Button Fly Jeans Series: Levi's—1990

Opinions/ Air Jordan: Nike—1990
Rappin/Air Jordan: Nike—1989
Can . . . Can't /Air Jordan: Nike—1989
Nola Air Jordan: Nike—1989
Hang Time/ Air Jordan: Nike—1988
Cover/ Air Jordan: Nike—1988
Charles Barkley: Nike—1988
Jesse Jackson Drugs: New York State Primary—1988

Books

Please, Puppy, Please: Coauthor Tonya Lewis Lee, Kadir Nelson—2005
Please, Baby, Please: Coauthor Tonya Lewis Lee—2002
Best Seat in the House: A Basketball Memoir—1997
By Any Means Necessary: The Trials and Tribulations of Making Malcolm X—1993
5 for 5—1992
Mo' Better Blues—1991
Do the Right Thing: A Spike Lee Joint—1990
Uplift the Race: The Construction Of School Daze—1989
Spike Lee's Gotta Have It: Inside Guerilla Filmmaking—1988

Contributors

Jamel Santa Cruze Bell (Ph.D. University of Kansas) is Assistant Professor of Media Studies in the Communication Department at Boston College. Her critical approach to media research is grounded in notions of social justice and focuses on the cultural politics of media. More specifically, Dr. Bell examines the role of media in determining popular culture trends as well as the social implications of non-majority group depictions.

Phil Chidester (Ph.D. University of Kansas) has studied a wide range of popular culture texts and concepts, from the reinforcement of whiteness inherent to *Friends* and *Seinfeld* to the mythic qualities of America's fascination with professional sports figures. He is currently working on a book which will examine songs' function as a transcendent symbol system.

Jasmine Nichole Cobb (M.A. University of Pittsburgh) is a doctoral candidate at the Annenberg School for Communication, University of Pennsylvania. Her dissertation examines the relationship between visual and verbal forms of persuasion representing African American women in antebellum Philadelphia. She is the coauthor of the article "No Way of Seeing: Selling and Mainstreaming the Gaze of Homo-thug Hip Hop" (*Journal of Popular Communication*) and the chapter "*Training Day* and *The Shield*: Evil Cops and the Taint of Blackness" in the book *The Changing Face of Evil in Film and Television*.

Robin R. Means Coleman (Ph.D. Bowling Green State University) is Associate Professor of Communication Studies, and in the Center for Afro-American and African Studies at the University of Michigan. Dr. Coleman's research and teaching focuses on the cultural impact media and popular culture have upon diverse communities. She is the author of *African American Viewers and the Black Situation Comedy: Situation Racial Humor*, and the editor of *Say It Loud! African American Audiences, Media, and Identity*. Additional publications include articles in *Television and New Media, Popular Communication, Journal of Black Studies, Howard Journal of Communication, African American Research Perspectives, Journal of Popular Film and Television*, and other edited volumes.

Rachael Ziady DeLue (Ph.D. Johns Hopkins University) is Assistant Professor in the Art and Archaeology Department and affiliated faculty in the Center for African American Studies at Princeton University. She specializes in American art from the colonial period to the present day, with special emphasis on the nineteenth and early twentieth centuries; interactions between art and science; and the history of African American art. Her most recent research and writing consider landscape representation and artistic investigations of the problems of visual function and perception, as exemplified by her book, *George Inness and the Science of Landscape*.

Norman K. Denzin (Ph.D. University of Iowa) is Research Professor of Communications at the Institute of Communications Research at the University of Illinois. Denzin's primary interest includes cultural studies and interpretive research, cinema and critical race theory, performance studies, and performance ethnography. Denzin's publications include *Screening Race: Hollywood and a Cinema of Racial Violence, Interpretive Ethnography, The Cinematic Society, Images of Postmodern Society, The Research Act, Interpretive Interactionism* and *Hollywood Shot by Shot*.

Andrew deWaard is an M.A. Candidate in Film Studies at the University of British Columbia in Vancouver, Canada. He is the editor of *Cinephile*. He is currently writing his thesis entitled "The Intertextual Museum (and Gift Shop): Towards a Cultural Economy of Intermediality." His broad research areas are consumer, corporate, and celebrity cultures; networks, rhizomes, and internets; the film, television, and popular music industries; and Deleuze, Zizek, and Baudrillard. His most recent works include *The Cinema of Steven Soderbergh* (coauthored with R. Colin Tait, forthcoming), "The Global Social Problem Film" (*Cinephile* 3:1), and "The Geography of Melodrama, the Melodrama of Geography: Race, Space, and Place in the 'Hood Film" (forthcoming, *Cinephile* 4:1).

Sharon Elise (Ph.D. University of Oregon) is Professor of sociology and Coordinator of Ethnic Studies at California State University, San Marcos. Dr. Elise teaches courses in race and ethnic relations, gender, social movements, critical race theory, and community and social theory. Her current research interests are in the criminalization and "prisonification" of African Americans, changing racial and ethnic identities in diverse California, educational equity postcolonial theory and feminism. Elise's work has appeared in *Sociological Perspectives*, *The Western Journal of Black Studies*, and numerous edited volumes.

Mikal J. Gaines (M.A. College of William and Mary) is a doctoral candidate in the American Studies program at the College of William and Mary. His research interests include African American literary, film and cultural studies, as well as critical theory. His dissertation will be an examination of the black audience for horror films from 1960–2000.

Janice D. Hamlet (Ph.D. Ohio State University) is Associate Professor of Communication at Northern Illinois University. Dr. Hamlet teaches courses in rhetorical theory, rhetorical criticism, and intercultural communication. Her current research interests include womanist theology and methodology, autoethnography, the rhetoric of spirituality, and African American rhetoric. She is the editor of *Afrocentric Visions: Studies in Culture and Communication* and her work has been published in various journals and other edited works.

Heather E. Harris (Ph.D. Howard University) is Associate Professor in the Department of Business Communication, and Director of Multicultural Affairs at Villa Julie College. She teaches intercultural, conflict, interpersonal, professional, and organizational communication as well as public speaking. Her research interests include the influence of culture and ethnicity on organizational communication and the communication resulting from representations of women of African descent in media.

William A. Harris's past research focuses on social problems, legitimation, and the sociophysiology of status organizing processes. His research has appeared in *Social and Economic Studies* and *Sociological Theory*.

Kerr Houston (Ph.D. Yale University) is Professor of Art History at the Maryland Institute College of Art. Dr. Houston's primary area of interest involves Italian medieval and Renaissance painting, but he has also written on film, in journals such as *Camera Obscura* and *African American Review*, and on contemporary language usage, for the online journal *Vocabula*.

John L. Jackson, Jr. (Ph.D. Columbia University) is currently the Richard Perry University Associate Professor of Communication and Anthropology

at the University of Pennsylvania. An urban anthropologist and ethnographic filmmaker, Jackson is the author of two books, *Harlemworld: Doing Race and Class in Contemporary Black America* and *Real Black: Adventures in Racial Sincerity*. He is also editor of *Racial Americana.*

Kara Keeling (Ph.D. University of Pittsburgh) is Assistant Professor at the University of Southern California. Keeling's research focuses on Third World Cinema and feminist film, representations of race, sexuality, and gender in cinema, critical theory, cultural studies, and African cinema. Keeling is the author of *The Witch's Flight: The Cinematic, the Black Femme, and the Image of Common Sense* and several articles published in journals and anthologies.

Yanick Rice Lamb (M.A. Howard University) is Associate Professor and Print/ On-line Journalism Sequence Coordinator in the Department of Journalism at the John H. Johnson School of Communications at Howard University. An award-winning journalist, Lamb has covered a variety of topics from arts and entertainment to business for more than two decades. She is the founding editor of *BET Weekend*, a consultant for *Heart & Soul* magazine, and she has also worked as an editor for *Essence* and *Emerge* magazines.

A. Elizabeth Lyons (B.A., Western Michigan University) is a graduate student studying organizational communication, leadership, and diversity in the School of Communication at Western Michigan University.

Paula Massood (Ph.D. New York University) is Associate Professor of Film Studies at Brooklyn College and in the Ph.D. Program in Theatre at the Graduate Center. She is the author of *Black City Cinema: African American Urban Experiences in Film* (2003) and is also the editor of *The Spike Lee Reader* (2008). Her articles on African American Cinema, the City and Film and other topics have appeared in *Cinema Journal, Cineaste* , and *Literature/Film Review* and a number of collections on African American film, the city and film, film adaptation, and Hollywood violence.

Audrey McCluskey (Ph.D. Indiana University, Bloomington) is Associate Professor of African American and African Diaspora Studies and Director of the Black Film Center/Archive at Indiana University in Bloomington. Her work as been published in a number of books and periodicals, and she has edited such volumes as *Mary McLeod Bethune: Building a Better World* (with Elaine M. Smith), and *2000 Frame by Frame III: A Filmography of African American Images, 1994–2000*. Her most recent publication is *Imaging Blackness: Race and Racial Representation in Film Poster Art.*

Deborah McGriff (Ph.D. University of Wyoming) is an Assistant Professor in counselor education and African American Studies at the University of

Wyoming. Her teaching and research interests include multicultural counseling, attachment in mother-daughter relationships, and identity development in African American adolescents.

Mark Lawrence McPhail (Ph.D. University of Massachusetts) is Chair of the Division of Corporate Communications and Public Affairs at the Meadows School of the Arts at Southern Methodist University in Dallas, Texas. Dr. McPhail is the author of two books, *Zen in the Art of Rhetoric: An Inquiry in Coherence* and *The Rhetoric of Racism Revisited: Reparations or Separation?*. He has also published scholarly essays in international, national, state and regional journals and has presented numerous papers at national and regional conferences.

Kimberly R. Moffitt (Ph.D. Howard University) is a Visiting Assistant Professor in the Department of American Studies at the University of Maryland, Baltimore County. Her teaching interests include media studies and criticism, sports and media, and intercultural communication. Dr. Moffitt conducts research in the areas of mediated representations of marginalized groups as well as sports icons. She has a forthcoming coedited volume entitled, *Blackberries and Redbones: Critical Articulations of Black Hair and Body Politics in Africana Communities* (2008). In addition to the introduction, she wrote a chapter on the images of physically disabled black men in urban films.

Mark P. Orbe (Ph.D. Ohio University) is Professor of Communication and Diversity in the School of Communication at Western Michigan University where he also holds a joint appointment in the Gender and Women's Studies Program. He is widely published in the areas of race, culture, media, and communication.

Tracey Owens Patton (Ph.D. University of Wyoming) is Associate Professor in the Department of Communication and Journalism as well as African American Studies at the University of Wyoming. Dr. Patton's area of expertise is critical cultural communication and rhetorical studies. Her research focuses on the interdependence of race, gender, and power, and on how these issues interrelate culturally and rhetorically in education, media, and speeches.

Ellen C. Scott (Ph.D. University of Michigan) is currently a Mellon Postdoctoral Teaching Fellow at the University of Pennsylvania in the Program of Cinema Studies. Dr. Scott's scholarly interests include sound theory, African American reception and spectatorship, and film censorship. She is currently working on a book project examining the relationship between the civil rights movement, film production and censorship, and African American reception of film in the 1940s and 1950s.

Ronald Jemal Stephens (Ph.D. Temple University) is Chair and Associate Professor of the Department of African American Studies at Ohio University-Athens. With research and teaching interests in African American urban history, black towns and resort communities, and popular culture, he has written other topics in African American Studies journals. Professor Stephens is currently completing *Idle Men and Wild Women in the Black Eden of Michigan,* and *Robert Franklin Williams Speaks,* an edited book with a biographical essay focusing on Williams' experiences as a civil rights veteran, freedom fighter and Afrocentric Internationalist.

Maurice E. Stevens (Ph.D. University of California, Santa Cruz) is Associate Professor in the Department of Comparative Studies at the Ohio State University, where he teaches and conducts research in critical race and legal history, critical psychoanalysis, visual culture, critical gender studies, narrative, historiography, ethnic and American studies, semiotics and trauma theory. He is the author of *Troubling Beginnings: Trans(per)forming African American History and Identity* and has published in numerous journals and edited works.

R. Colin Tait (M.A. The University of British Columbia) teaches Asian Cinema and Contemporary Film Authorship at the University of British Columbia. His current research interests include contemporary Hollywood politics, film genre, and Fredric Jameson. Tait is currently coauthoring a book on Steven Soderbergh with Andrew deWaard.

Adewole Umoja (Ph.D. University of Georgia) currently teaches Political Science at Los Angeles Southwest College. His interests include strategies for black empowerment, municipal government, and developing societies.

Index

Abraham, Roger, 13
African American(s): diaspora, 183, 184;
 community diversity of, 279, 294–95;
 consciousness movements, 5; filmmaking,
 4–6, 304; in films, 273, 289–90; in Lee
 films, 274, 276–77, 283, 284n1, 289, 304;
 identity, 321–22; masculinity, 327–32,
 333–34; and music, 291–92; neo-verite,
 264–67; oppression of, 24–27, 309–10;
 patriarchy, 300; symbols of rebellion, 295.
 See also film; **Get on the Bus**; Hollywood;
 Mau Maus
Afrocentricity: and the complications of
 black family life, 369–70; defined,
 364–65; and the improvisations of black
 family life, 368–69; and normalization of
 black family life, 366–67; and the
 rhythms of black family life, 367–68
Altman, Rick, 42, 47
Armstrong, Louis, 5
Atlanta University Center (AUC), 8–9
auteur theory, 224, 347–49, 353–55

Autobiography of Malcolm X, 324–25, 329,
 331, 334, 338

Baldwin, James, 62
Bamboozled: and digitization, 191–92; and
 offensive imagery, 197, 206; message of,
 309; as satire, 203–4, 205–6, 207; and the
 power of seeing, 208; and stereotyping,
 66; synopsis of, 66–67, 206–7, 310–11;
 women in, 308, 311. *See also* Mau Maus;
 minstrelsy; satire; women (in Lee films)
Basie, Count, 5
Bell, Jamel Santa Cruze, xxv
Bird, Larry, 131–32, 296
black, conceptualization of, 191, 193–95,
 197
Black Arts Movement, 104, 105, 106, 257,
 396
black collectibles: in *Bamboozled*, 72, 77, 82,
 198; "Jolly Nigger Bank," 68, 69–70,
 77–78; owned by Lee, 85n18; as racist
 imagery, 79–80, 82, 84, 198–99
blacks. *See* African Americans